The Craftsman
in Early America

EDITED BY

Ian M. G. Quimby

PUBLISHED FOR
The Henry Francis du Pont Winterthur Museum
WINTERTHUR, DELAWARE

W · W · Norton & Company
NEW YORK LONDON

The text of this book is composed in Electra, with
display type set in Garamond. Composition and
manufacturing by The Maple-Vail Book Manufacturing Group.

First Edition

Library of Congress Cataloging in Publication Data
Main entry under title:

The Craftsman in early America.

 Includes index.
 1. Artisans—United States—History. I. Quimby,
Ian M.G. II. Henry Francis du Pont Winterthur Museum.
HD2346.U5C67 1984 331.7'94 94–1562

ISBN 0-393-61856-3

ISBN 0-393-95449-8 (pbk.)

W. W. Norton & Company, Inc., 500 Fifth Avenue, New York, N.Y. 10110
W. W. Norton & Company Ltd., 37 Great Russell Street, London WC1B 3NU

1 2 3 4 5 6 7 8 9 0

Contents

The Craftsman
in Early America

Introduction:
Some Observations on the
Craftsman in Early America
Ian M. G. Quimby

It was a felicitous coincidence that the 1979 Winterthur conference, the event for which the papers in this volume were originally prepared, marked the thirtieth anniversary of the completion of Carl Bridenbaugh's important book *The Colonial Craftsman*. The book is still in print and is likely to remain so for the foreseeable future.[1] His was the first major scholarly attempt to examine the role of the craftsman in early American society rather than the products of the craftsman. Instead of discussing just the cabinetmakers, the silversmiths, and the practitioners of other luxury crafts, he embraced the full range of crafts necessary to sustain life in eighteenth-century America. Thus he included carpenters, coopers, cordwainers, and tailors—the four largest crafts in Philadelphia in 1773. Bridenbaugh provided a wealth of specific details on the lives and work of all manner of artisan. The book is loosely organized into two chapters on rural and village craftsmen, two on urban craftsmen, and a chapter each on craftsmen at work and craftsmen as citizens. He relied heavily on eighteenth-century newspaper advertisements and on secondary sources.

In retrospect, of course, *The Colonial Craftsman* suffers from myopia.

[1] Carl Bridenbaugh, *The Colonial Craftsman* (1950; reprint ed., Chicago: University of Chicago Press, Phoenix Books, 1961). The author's preface is dated September 1949.

It is too obviously a cut-and-paste collection of information from colonial newspapers accepted at face value. It lacks a sense of movement as if, somehow, things really did not change much from 1700 to 1776, and the author ignored the seventeenth century. It also lacks a transatlantic context, assumes too much continuity of British traditions, and is fairly oblivious to the larger forces shaping Western society. Finally, of course, it seems unsatisfactory because we have been treated to so much more sophisticated scholarship in the last three decades. Although it may seem unfair, it is hard to avoid comparing Bridenbaugh's *Colonial Craftsman* with E. P. Thompson's *Making of the English Working Class* published only thirteen years later (1963). Bridenbaugh's book is a modest though welcome contribution. Thompson's is a monumental and original study of great importance to social historians on both sides of the Atlantic. Thompson's subject is not merely craftsmen; it is the process by which one group of Englishmen came to see their interests as distinct from those of other Englishmen. Class, Thompson says, is not a matter of structure; it is a set of historical relationships. These relationships are not abstract, for, as he says in his preface, "the relationship must always be embodied in real people and in a real context. . . . We cannot have love without lovers, nor deference without squires and labourers."[2]

Thompson is deeply concerned with the impact of technological change on working people, as indeed he must be since he focuses on the period 1780 to 1832. The book could easily have been called "The Impact of the Industrial Revolution on British Labor." Such a title suggests a narrower study which Thompson's is not. It is in fact an analysis of cultural change where radical protestantism is at least as important as technological change. Thompson does not merely chronicle change; he explains how and why. With all the fine American scholarship on industrialization, labor history, modernization, and so on, we still lack a comparable major synthesis of the American experience. Americans specialize in case studies which, I hasten to add, are essential too. Such specific studies as those of Howard Rock on New York City, Susan Hirsch on Newark, and Bruce Laurie on Philadelphia are admirable contributions. These studies suggest, however, that the thrust of American historical research has shifted to the nineteenth century when the

[2] E. P. Thompson, *The Making of the English Working Class* (1963; reprint ed., New York: Random House, Vintage Books, 1966), p. 9.

impact of industrialization was the greatest. They tell us relatively little of the fate of the traditional craftsman discussed by Bridenbaugh.[3]

Who was this traditional craftsman? He is easy enough to describe in the abstract. In a preindustrial society he was a workman who possessed specialized skills that set him apart from a common laborer. These skills were his most valuable possession, for they gave him varying degrees of independence, mobility, and status. In the ritualistic language found in the indentures of apprenticeship, the craft skills to be learned by the apprentice are referred to as "the art and mystery"—no matter what the craft. Here *art* is used in its now obsolete sense of practicing technical skills with the aid of magic. *Mystery* connotes more than something unknown or a puzzle to be solved; it suggests the spiritual element, the essential knowledge without which the artisan would be a mere automaton. *Mystery* also smacks of secret rites, and, indeed, the process of apprenticeship is one long rite of passage that earned the apprentice special privileges in society. Apprenticeship assured the continuity of technical skills from one generation to another, but it served other purposes as well. Its primary purpose was educational in the broadest sense and involved the intergenerational transfer of culture itself. Masters stood in loco parentis to their apprentices and servants which, together, helped to constitute the extended family. The craftsman with his leather apron was thus more than a mere producer of goods. All members of the extended family were well advised to heed the biblical exhortation to "Obey them that have the rule over you, and submit yourselves: for they watch for your souls, as they that must give account."[4]

At least that was the ideal. Any serious treatment of the craftsman in early America, however, has to take into consideration the fact that the traditions of preindustrial society were disintegrating under the impact of New World conditions and those technological and commercial changes that we call the industrial revolution—even in the eighteenth century. Full terms of apprenticeship were difficult to enforce in an economy with a chronic labor shortage. No effective municipal or guild

[3] Howard B. Rock, *Artisans of the New Republic: The Tradesmen of New York City in the Age of Jefferson* (New York: New York University Press, 1979); Susan E. Hirsch, *Roots of the American Working Class: The Industrialization of Crafts in Newark, 1800–1860* (Philadelphia: University of Pennsylvania Press, 1978); Bruce Laurie, *Working People of Philadelphia, 1800–1850* (Philadelphia: Temple University Press, 1980).

[4] Ian M. G. Quimby, "Apprenticeship in Colonial Philadelphia" (M.A. thesis, University of Delaware, 1963). Heb. 13:17; a somewhat altered version appeared in *American Weekly Mercury* (Philadelphia), November 1–7, 1772.

ordinances governed who could practice a craft in any colonial American city. Attempts to control the quality of goods and their prices were, by and large, unsuccessful. And then there was always land to be had by those willing to work hard enough to clear it and make it productive. The lure of land was irresistible for many immigrants fresh from countries where holdings were often too small to support a family. Such freedoms and such opportunities were destabilizing to the social structures of a preindustrial society.

How the craftsman was affected by modernization and industrial capitalism is a complicated story that varies considerably from one craft to another. It was not just a question of substituting machines for manual labor. From the 1790s to the 1830s Philadelphia cordwainers experienced declining real income. They fell victim to competition between masters for wider markets. The expanding export market should have insured their prosperity, but instead it had the opposite effect. The shoe industry mechanized late, and when it did Lynn, Massachusetts, led the way—not Philadelphia. Mechanization of the textile industry is a familiar story, but there are some less familiar aspects. Philadelphia and its northeastern suburbs became a major center for the production of textiles and textile machinery. As elsewhere, power-loom operatives were mostly women. But the Philadelphia carpet industry continued to use hand looms until about 1860. These looms required the brawn of male weavers. It was not considered a highly skilled craft, and, indeed, the pay was low. By 1850, not surprisingly, 76 percent of those weavers were Irish immigrants.[5] Textile manufacturing did not move from home production for home use directly to factory production; in fact, the industry mechanized in stages and relied heavily on outwork. Cotton was fully integrated very early, but the production of woolens was industrialized at a much slower rate because of the nature of the fiber itself. Water-powered carding mills served families making their own woolen cloth before there were woolen mills. Massachusetts had carding mills in abundance from at least the 1790s, and some of them remained in operation into the twentieth century. Unlike cotton, which was spun by a continuous process from the time of Sir Richard Arkwright in the eighteenth century, woolen spinning remained a discontinuous and, hence, a slower process until the twentieth century.

[5] Richard A. McLeod, "The Philadelphia Artisan, 1828–1850" (Ph.D. diss., University of Missouri, 1971).

Thompson noted fundamental changes in English society between 1780 and 1832, England's period of industrialization. A comparable fifty-year period in the United States is less easily identifiable. Herbert Gutman uses 1843–93 as the critical half century that changed America from a preindustrial to a major industrial society. He identifies the period 1815–43 as "predominantly preindustrial," noting that "most workers drawn to its few factories were products of rural and village preindustrial culture." Gutman also identifies a third period, 1893–1920, in which he compares the expectations and work habits of first-generation immigrant factory workers with those of pre-1843 American factory workers who were predominantly native-born. His point is, of course, that throughout all three periods, covering the years from 1815 to 1920, preindustrial customs and attitudes were present and were a significant factor in labor unrest.[6]

While most of the crafts and the social structure they represented were headed for virtual extinction, this state of affairs was little understood at the time. Many traditional urban crafts continued to prosper, and there appeared little reason to suppose that they would one day disappear. Indeed, there was in the 1790s and the early decades of the nineteenth century a flowering of mechanics' associations and libraries. One of the most prominent among these was the Massachusetts Charitable Mechanic Association organized in 1795 with eighty-two founding members led by Paul Revere, the venerable goldsmith who was unanimously chosen president. Among the artisans were bricklayers, blacksmiths, coopers, cordwainers, housewrights, ropemakers, printers, and tailors. Other crafts were represented as well. Most members appear to have been artisans in the classical sense. This would not be surprising were it not for the fact that their constitution called for the association to consist of "mechanics and manufacturers." Few manufacturers or merchants joined, and a petition to twenty of the latter specifically inviting their support was coldly rejected, ostensibly on the grounds that such an organization could only be a "combination to extort extravagant prices for labor."[7]

The association had some of the attributes of earlier artisan benev-

[6] Herbert G. Gutman, "Work, Culture, and Society in Industrializing America, 1815–1919," *American Historical Review* 78, no. 3 (June 1973): 531–87.

[7] Joseph T. Buckingham, comp., *Annals of the Massachusetts Charitable Mechanic Association* (Boston: Crocker and Brewster, 1853). All subsequent references to the association are derived from this source.

olent societies, but its goals were more ambitious and its concerns more serious. While its general purposes were subsumed in such phrases as "promoting mutual good offices and fellowship by assisting the necessitous, encouraging the ingenious, and rewarding the faithful," the organization had very specific interests. Number one among those interests was the matter of apprenticeship. It is probable that the organization grew out of the failure of a petition from Boston mechanics in December 1794 to the legislature asking for legislation "to better regulate apprenticeship." When the legislature failed to respond, the mechanics took matters into their own hands by organizing an association with coercive powers. Built into the constitution of the association were the requirements that mechanics be "master workmen" (that is, have served a full apprenticeship) and, as a condition of membership, that they agree not to employ any apprentice still bound to another master. The latter point was precisely what had been requested in the way of new legislation. The association further provided that every apprentice upon reaching the age of twenty-one and who had faithfully complied with the terms of his indenture would receive a certificate from the association which in effect provided the young man with a stamp of approval. Should any member of the association "employ or entertain any bound apprentice, who shall have left the person he was bound to, without said person's consent," that member automatically forfeited his membership. The better regulation of apprenticeship, therefore, was the primary reason for the existence of the association.

In a society dedicated to the inviolability of contracts, something had clearly gone awry. The terms of the contracts between masters and servants were being violated with impunity. Traditionally the time of servants or apprentices was considered property, and upon the death of a master unexpired portions of that time were assigned a cash value and became part of the decedent's estate. If an apprentice could depart before completing the term of years specified in the indenture, then the master was deprived of property as well as inconvenienced. The master craftsman's importance in the social structure diminished as his power over his servants declined. Notions of individual freedom assumed greater importance and took precedence over the bonds of voluntary servitude. And finally, of course, short, unstable apprenticeships had to affect technical training adversely. The Boston mechanics tried through their association to put things right. Even without the cooperation of government they hoped to gain control over the apprenticeship issue. It seemed

possible, they assumed, because the regulations were in the interest of all mechanics.

Gradually the Massachusetts Charitable Mechanic Association came to take on a different character. By 1817 the goals of the association were defined as *"the diffusion of benevolence; the encouragement of improvements in the mechanic arts and manufactures; the reward of fidelity in apprentices;* and *the promotion of fellowship and good feeling among the associates."* It will be noticed that the once all-important question of apprenticeship, while given lip service, is no longer the preeminent issue that it was in 1795. In fact, the certificates were awarded only to those apprentices who had been bound to members of the association. This seems perverse because the constitution of the association clearly intended them to be awarded to *every* apprentice completing his term. During the 1820s, after a generous donor provided books for an apprentices' library, the officers fretted over the trouble and expense of operating it. In 1832 the library was turned over to the apprentices themselves to run for their own benefit and for as long as they exercised good judgment. An 1843 report commended the apprentices for their success in maintaining, supporting, and using it. The report recommended the establishment of a library "to which *all* the members of the association could have free access . . . for their moral and intellectual improvement."[8]

One suspects that these enterprising apprentices who ran a library for their own benefit—and actually used it—were a far different lot from their earlier counterparts. Although the ideal of the learned mechanic had existed at least since the establishment of the American Philosophical Society in Philadelphia in the 1740s, it was a remote prospect indeed for most craftsmen. These Boston apprentices of the 1830s had far more in common with modern craft apprentices than with their eighteenth-century brethren. They were, for the most part, paid employees who lived not with their masters but elsewhere. They were no longer children to all-powerful surrogate fathers. James Alexander, writing under the pen name of Charles Quill, in *The Working-Man* (1839), commented:

The relation of master and apprentice was a closer and warmer one in former days. The lad was willing to allow that he had a *master,* for a certain time and a certain purpose, and in expectation of being one day a master himself. He

[8]Buckingham, *Annals of the Association,* pp. 146, 323 (emphasis added).

thought this was no more disgraceful than the subordination of the scholar to his teacher, or the soldier to his captain. And, in return, the employer felt a responsibility proportioned to his authority. Good men were accustomed to treat their apprentices as their sons. . . . It is unnecessary to say, that the state of things is very much altered. . . . The whole affair of indentures, as my readers very well know, is in some places becoming a mere formality. It is less common than it used to be for boys to serve out their whole time. Many influences are at work to make lads impatient, and loath to continue in one place, however good. And when they abscond from their proper service, it is not every employer who now thinks it worth his while to take the legal measures for recovering their time. . . . The old-fashioned system is found to be ineffectual.

Alexander went on to lament the decline of craft training and the loss of jobs requiring high skills to well-trained immigrants. His final concern was with the moral consequences of the new system whereby the apprentice lacked the constructive influences of home life. The apprentice lived neither with his own family nor with that of his employer, "at least under the system prevailing in our cities and large towns."

In great manufactories, where there are at least a dozen boys—these of course cannot be allowed to overrun the employer's house: they are often put out to board elsewhere. In neither case have they a *home.*—Even where there is only an ordinary number, as the master is no longer a parent, the apprentice feels no longer like a son. Where can he spend his evenings? Not in the garret or loft where he sleeps: in winter it is cold; in summer it is suffocating.—Not in the kitchen: he would be in the way. Not in the sitting-room: that would be too familiar.—Where can he spend the long hours of his Sunday? Let us look the truth in the face: *The apprentice has no home.* . . . Is it any wonder that they crowd our oyster-houses, porter-cellars, bar-rooms, shows, and wait for checks about the doors of our theatres?[9]

One man's definition of social decay may be another's prescription for opportunity. Austrian immigrant Francis J. Grund found conditions for the craftsman far better in America than in Europe. In *The Americans in Their Moral, Social, and Political Relations* (1837), he extolled the prosperity and ingenuity of the American mechanic.

On entering the house of a respectable mechanic, in any of the large cities of the United States, one cannot but be astonished at the apparent neatness and comfort of the apartments, the large airy parlours, the nice carpets and mahog-

[9]Charles Quill [James Alexander], *The Working-Man* (Philadelphia: Henry Perkins, and Boston: Perkins and Marvin, 1839), pp. 114–15, 117–18.

any furniture, and the tolerably good library, showing the inmates' acquaintance with the standard works of English literature. These are advantages which but few individuals of the same class enjoy . . . in Europe.

Grund noted the lack of "a certain *mechanical* perfection" in American machines and products, unlike England where "a greater division of labour and long-followed practice in a narrow circumscribed trade" assured a nicety of execution. What the American mechanic lacked in perfecting his mechanical skills was more than compensated for by his willingness to innovate.

An American mechanic does not exercise his trade as he has learned it: he is constantly making improvements, studying out new and ingenious processes either to perfect his work or to reduce its price, and is, in most cases, able to account for the various processes of his art in a manner which would do credit to a philosopher.

According to Grund, the genius of the mechanic flowered because the primary needs of life were met with time to spare for thought and reflection.

In America not only the master mechanic, but also his journeymen have the means of earning more than is required for a mere living; they are able to procure for themselves comforts which would hardly enter the imagination of similar orders in Europe. They are enabled to command a portion of their time; and their minds being free from the anxieties of a precarious life . . . are better qualified for study or improvement, the only sure means by which they can hope to better their conditions.[10]

The fact is, it is hard to get a grip on the American craftsman, who becomes increasingly hard to identify in the early nineteenth century. The traditional craft structure of apprentice, journeyman, and master was breaking up. Stuart Blumin in his study "Mobility and Change in Ante-Bellum Philadelphia" identifies a tripling in the number of journeymen relative to masters between 1820 and 1860. At the same time, the number of masters relative to the total work force declined to less than half. The total manual-labor work force grew in the forty-year period, but the number of masters did not. According to Blumin,

In 1820 . . . there was a skilled, proprietary position for almost every skilled and unskilled wage-earning position. . . . The demand for master craftsmen

[10] Francis J. Grund, *The Americans in Their Moral, Social and Political Relations*, 2 vols. (1837; reprint ed., New York: Augustus M. Kelley, 1971), 1:47, 2:158, 161–62.

was great enough to provide any ambitious and competent journeyman with the opportunity to set up his own shop. . . . During the next forty years, the number of shops remained substantially the same. But at the same time the population had quadrupled, and in this new city of a half-million people . . . a few thousand proprietorships [could not] give much hope to forty or fifty thousand journeymen.[11]

There appears to be some confusion in Blumin's study between journeymen and the unskilled which makes his reference to forty or fifty thousand journeymen somewhat suspect. One might also ask where all these journeymen had come from if the masters no longer had need of them. There had to be apprentices before there could be journeymen, and the apprenticeship system was breaking down. Journeymen are notoriously difficult to identify in the records because they usually did not own property and, earlier at least, did not have the ballot. Hence, questions concerning their social, economic, and political status remain difficult to answer.

Another element in the labor picture that has received insufficient attention is the merchant capitalist who, because of his access to capital and credit, was often in a position to dictate the price of labor. While many a merchant capitalist was no doubt a merchant in the eighteenth-century sense, that is, one who bought and sold goods in foreign trade, at least some of them were master craftsmen whose growing wealth gave them access to loans and credit so that they, in turn, were in a position to extend credit. The master cordwainers of Philadelphia during the first decade of the nineteenth century had at one time been craftsmen, and perhaps some still were. That they had become merchant capitalists, however, is evident from their many disputes over wages with journeymen, a conflict that resulted in the trial for conspiracy of key journeymen in 1809. The transcript of the trial sets forth with great eloquence the economic views of both parties.[12] This was the first major confrontation between labor and capital in the United States, and labor lost.

[11] Stuart Blumin, "Mobility and Change in Ante-Bellum Philadelphia," in *Nineteenth-Century Cities: Essays in the New Urban History*, ed. Stephen Thernstrom and Richard Sennett (New Haven: Yale University Press, 1969), pp. 199–200, 165–208.

[12] John R. Commons et al., eds., *A Documentary History of American Industrial Society*, vol. 3 (Cleveland: Arthur H. Clark, 1910), pp. 59–248. See also Ian M. G. Quimby, "The Cordwainers Protest: A Crisis in Labor Relations," in *Winterthur Portfolio 3*, ed. Milo M. Naeve (Winterthur, Del.: Winterthur Museum, 1967), pp. 83–101. For Commons's theory of the merchant capitalist, see John R. Commons et al., *History of Labour in the United States*, vol. 1 (New York: Macmillan Co., 1926), pp. 338f.

The journeymen were found guilty of conspiracy to regulate wages, and an important impetus to union organization was effectively blunted. The master cordwainers were no longer craftsmen in the classical sense, in spite of the fact that they insisted on being identified as cordwainers; they were merchant capitalists. How often was this practice repeated in other trades? Was the housewright or bricklayer who belonged to the Massachusetts Charitable Mechanic Association still framing houses or laying bricks, or had he become a general contractor? By the 1820s or 1830s, and perhaps earlier as in the case of the cordwainers, many craft designations were not necessarily accurate. Scholars are advised to check against other records before deciding whether someone who called himself a craftsman was so in fact.

With the realization that this discussion has included neither factory operatives nor the unskilled laboring classes, perhaps the changing nature of the Massachusetts Charitable Mechanic Association can become the paradigm for the fate of the preindustrial craftsman. There were few if any leather aprons left in 1860 when the compiler of the annals of the association noted with satisfaction that, in contrast to the early years, the membership was approaching a thousand, "chiefly men of substance,—many are men of wealth,—all are enterprizing and prosperous, except a few, on whom adversity has laid its iron hand."[13] Merchants and manufacturers may have looked upon the association with suspicion in its early days, but they soon learned there was little to fear, and many of them joined. Professional men too came into the association. When in the 1820s it was proposed that the association hold a series of lectures on chemistry and other sciences, some of the members objected on the grounds that such subjects were not suitable for mechanics. But by that time, and increasingly thereafter, the association was dominated by the better educated and the more well heeled. In the face of at least a generation of heavy immigration, the ethnic composition of the association remained steadfastly Waspish. It was a private club of small businessmen that came increasingly to resemble a twentieth-century Rotary club more than a late eighteenth-century artisans' association.

In some ways the Massachusetts Charitable Mechanic Association fulfilled a dream of eighteenth-century mechanics by according recognition and status to working men. The image of the literate and articulate mechanic who provided society with its comforts and improvements

[13] Buckingham, *Annals of the Association*, p. 588.

was a compelling one, as the annals of the association show, and it lingered long after it ceased to have meaning. In retrospect all the attempts to organize the life of urban artisans were aimed at staving off change, at preserving what were perceived as the traditional features of craftsman life: dignity and status because they possessed special skills, a sturdy apprenticeship system to assure intergenerational continuity of those skills, and, perhaps most important of all, economic opportunity to become an independent entrepreneur (that is, a master) with relative ease. The two generations of craftsmen following national independence also inherited the heady rhetoric of freedom and equality. Their speeches and writings are laced with references to their rights as free men, and any policies that limited their economic freedom are regarded as assaults on the broader freedoms due them as American citizens. Starting with the great processions celebrating ratification of the federal constitution on every Independence Day, craftsmen marched in parades segregated by craft. Each group of craftsmen used such occasions to demonstrate the importance to society of their particular craft. Underlying the bravado of such occasions was the fear of slipping in the social order, of falling back into a servile condition.[14] And while some continued to prosper, others found their way barred. As Stephen Mayer put it, "The journeyman of the 1820s and 1830s was in a perilous position. He was caught on the middle rung of the crumbling apprentice system. The promise of upward mobility had vanished." According to a contemporary source quoted by Mayer this was so because " 'monopolists and capitalists' " had "usurped the rights of journeymen, 'abridging their privileges with the advantage of large capital.' " If Stuart Blumin's assertions about Philadelphia hold for other urban centers, that the loss of opportunity by journeymen contributed to the emergence of a large wage-earning lower class by midcentury, then craftsmen were everywhere divided into sheep and goats, some to prosper as tradesmen but most others doomed to dependency as wage slaves. Blumin calculated that economic change in Philadelphia between 1820 and 1860 resulted in lessened opportunity for working people but vastly expanded opportunity for a few people of means. "Philadelphia, on the eve of the Civil War, was a society of extreme economic stratification." Thus the worst

[14] Howard B. Rock, "The American Revolution and the Mechanics of New York City: One Generation Later," *New York History* 57, no. 3 (July 1976): 367–94.

fears of Rock's "artisans of the new republic" were realized. For all practical purposes the craftsman had ceased to exist.[15]

Literature on the craftsman in early America has greatly expanded since Carl Bridenbaugh's book was published in 1950, and yet with all the fine scholarship done since then the craftsman remains an elusive figure. As David Montgomery has astutely noted, "Our concern has been either with the journeyman's economic circumstances (where there is still much to be learned) or with whether he voted for Andrew Jackson," and he called for further research in a number of potentially interesting areas.[16] Certainly, one of the problems is the great diversity of crafts and the vastly different circumstances between those crafts that required only a few hand tools and those that required major capital investment. The tailor required a set of needles and a tailor's goose, but a glassmaker required a plant, a labor force, fuel, and raw materials, all of which required the outlay of considerable funds before the production of the first piece of glass.

The contributors to this volume provide insights into a wide variety of crafts over a 200-year span of American history: seventeenth-century woodworkers in Massachusetts and Rhode Island; goldsmiths in early eighteenth-century Boston; peripatetic glassblowers of the eighteenth and early nineteenth centuries; the ceramics industry during the years 1780–1840; the industrialization of shoemaking in Lynn, Massachusetts; America's first professional architect and his working relations with his builders and stonecutters; and the craft structure of a religious community. Complementing the specific craft studies are four papers of a broader nature: the social and political role of mechanics in colonial Philadelphia, the historiography of craftsmen in early America, a review of primary documents for the study of craftsmen, and a complementary study on the pitfalls of visual evidence for studying the craftsman. The range of techniques used in these papers is suggested by the types of scholars represented: historians, art historians, a folklorist, American-studies specialists, and museum curators. The emphasis on specific crafts reaf-

[15] Stephen Mayer, *"People v. Fisher:* The Shoemakers' Strike of 1833," *New-York Historical Society Quarterly* 62, no. 1 (January 1978):13, 6–21; Blumin, "Mobility and Change," pp. 204–6.
[16] David Montgomery, "The Working Classes of the Pre-Industrial American City, 1780–1830," *Labor History* 9 (1968): 21, 3–22.

firms the necessity for understanding the peculiarities existing in crafts which industrialized at different times, different rates, and in different ways. These papers also demonstrate the complexities of the preindustrial period for craft study and suggest that an oversimplified view has warped our understanding of the preindustrial period, a failing that inevitably skews any attempts to analyze the process of industrialization itself.

Documentary Sources for the
Study of the Craftsman
Stephanie Grauman Wolf

In 1958 E. McClung Fleming proposed the use of artifacts as social documents to enrich the historian's understanding, since "the verified object and the verified text serve to supplement and fortify each other and should be used together." Some years later he outlined a method of approach to artifactual study that would facilitate this goal. His model for study differentiated between the informational level of object under-standing—that is, traditional museum concerns of identification, description, and evaluation—and the conceptual levels of understand-ing which include cultural analysis and interpretation. These categories are roughly equivalent to those a historian asks of written sources, such as tax lists, land records, and census returns, when attempting to use specific data in explaining the more abstract problems of process and relationship. Fleming felt it was necessary to present a carefully articu-lated plan for working with objects since "it is the rare historian who can read the museum's artifact as freely and accurately as he can read the library's printed book or written manuscript."[1] Granted it requires a great deal of background and training before the historian—or anyone else for that matter—can "read" the artifact, but does it follow that the document is readily accessible to anyone with the ability to recognize

[1] E. McClung Fleming, "Early American Decorative Arts as Social Documents," *Mississippi Valley Historical Review* 45, no. 2 (September 1958): 277, 276. See also E. McClung Fleming, "Artifact Study: A Proposed Model," in *Winterthur Portfolio 9*, ed. Ian M. G. Quimby (Charlottesville: University Press of Virginia, 1974), pp. 153–73.

words as they appear on a piece of paper? I would like to suggest that it does not: that the written record itself is a very special sort of artifact, all the more susceptible to misunderstanding because it seems to be obvious and available.

As a material object—in this case a piece of paper marked upon by a person often unknown and long since departed from a society whose ways are not known with certainty but are, in fact, the object of the study itself—the written record shares most of the basic problems of other bits of material culture which have drifted down to us across time and which bid us to explore them for their long-kept secrets. Like the object, the document does not really "speak for itself." It must be identified, to borrow the vocabulary of artifact analysis, as to its maker, its method, time, and place of construction, and the use for which it was intended. To misconstrue, as does James Deetz, the purpose of early American estate inventories as having been "taken for tax purposes" at the time of an individual's death, is inevitably to misinterpret the information included therein.[2] To take at face value the signature of, for example, a Simple Cobbler of Agawam on a religious tract or a Mechanic on a political letter to the *Pennsylvania Gazette* is to add false information to an understanding of the *mentalité* of the craftsman in American society. Second, the vocabulary used in the document must be understood within its own context, just as the student of material culture must compile a vocabulary of construction techniques and artistic styles. The problems are even greater because the words themselves are still readable and do have a meaning in our own vocabulary. But what did the people of seventeenth-century Massachusetts or Maryland mean by a looking glass, a bedstead, a burning glass? Did the definition of the word *coarse* or even of the most basic terms for the purposes of this paper—*artisan, mechanic, craftsman*—change over time? The logic of the past must be understood in terms of the present to make documentary sources speak to us intelligibly.

Furthermore, it is of significance—again, obvious in relation to objects, less so for documentary sources—in what form the information comes to us. The original document offers the most fruitful material; small marginal marks or changes in ink might provide clues to its manufacture and meaning. Of course, the condition of the document must

[2] James Deetz, *In Small Things Forgotten: The Archaeology of Early American Life* (Garden City, N.Y.: Anchor Books, 1977), p. 8.

be considered. Just as the replaced stretchers on a chair may change its value as artifactual document, so do missing or rewritten parts affect our judgment of the document. Xerox or microfilm copies are next best, just as a good picture of an object is useful when the original itself is unobtainable. But readability as well as subtlety can be lost through distance from the original. Since mechanical copying procedures often reduce the opacity of paper, documents written on both sides appear as totally undecipherable rows of crosses, while the original document itself may be quite readable. Finally, a transcription is least satisfactory: it is a reproduced artifact. So many questions of authenticity arise; so many errors are perpetrated by filtration through the mind and pen of an intermediary; so much may be lost in the translation. The transcriber might even have been trying to help—correcting arithmetic errors, making guesses on illegible words, alphabetizing tax lists to make the search for individual names easier when the original was written on a geographical basis or through some contemporary gradation of social standing. Each of these changes diminishes the value of the source. One would expect that the sensitivity of editors to the importance of *exact* reproduction, akin to using eighteenth-century tools and materials to recreate eighteenth-century furniture, had increased with changing notions of the purposes of historical research, so that the more recent the transcription, the more faithful it would be to the original. But the recently published version of the diary of Philadelphia merchant Thomas Cope, in which editorial discretion was exercised (without even the use of deletion marks) over material that, in the opinion of the editor, was felt to be repetitious or unnecessary, illustrates that a serious problem of accuracy and completeness still exists in the use of printed or transcribed material.[3]

By far the most serious difficulty to overcome in the use of documents, as in the use of objects, is the problem of survival. While all of us work on specific materials—since evidence is only available in concrete unique examples—we hope somehow to be able to transmute the particular into the universal, to transform the study of *a* craftsman into knowledge of *the* craftsman, to turn the life experience of some weavers in Pennsylvania into the situation of all weavers in colonial America. In the same way, the object analyst looks at surviving court cupboards

[3] Eliza Cope Harrison, ed., *Philadelphia Merchant: The Diary of Thomas Cope, 1800–1851* (South Bend, Ind.: Gateway Editions, 1978).

from Essex County, Massachusetts, and hopes to see them as represen-
tative of a much larger body of no longer existing furniture. This works,
perhaps, if we can be assured of the typicality of our sample and if
selection by accident of time is truly as mathematically random as the
sample of the modern statistician. But, of course, it is not. It does not,
unfortunately, even represent the idiosyncratic selection made by a tor-
nado when it leaves one house standing in a ten-block area. Historical
survivals, both artifactual and documentary, are highly selective. This
is obvious for artifacts if one merely counts the number of known sur-
viving high-style chairs from the colonial period and compares it to the
number of authenticated plain benches and stools. A simple tally in
combination with basic common sense informs us that we cannot use
this body of data to generalize about the universe of seating furniture in
colonial America.

The bias of documents extends much further than the numbers of
their survival; it extends to their inherent qualities as well. Up to the
last generation, documents used by historians were almost entirely
selective in terms of elite orientation; that is, so-called literary evi-
dence—diaries, journals, travel accounts, and newspaper articles—were
conscious attempts to set down facts and impressions of the contempo-
rary scene. It was not as if benches were rare because they had not been
preserved; it was as if they had never existed at all. Diaries and journals
were not kept by the illiterate nor travel accounts by those who moved
in search of work rather than pleasure. The life of the craftsman, when
described at all, was filtered through the perceptions of one who was
attempting to describe the unique or the picaresque rather than the
commonplace and average. Thus, it is Benjamin Franklin, Plunkett
Fleeson, and Paul Revere who become "typical" artisans, lending cre-
dence to the mythology that the American experience was one of oppor-
tunity and advancement for those who worked with their hands; that in
a land of labor scarcity, society was primarily made up of an undiffer-
entiated middle class of independent craftsmen and yeomen whose lives
were characterized by the dignity of ownership and access to modest
competency, if not to abundance. To be sure, there was the dark side of
the picture: newspaper and diary accounts of rowdy mobs of mean and
vicious mechanics, references to growing numbers of poor, especially
in the cities, requiring poorhouses, hospitals, and jails. But these allu-
sions have barely touched the deeply ingrained belief in the favored
position of the craftsman in early American life.

With the introduction of a social-science methodology to study the lives of the inarticulate and an interest in questions that focus on the typical rather than the exceptional, historians began, some fifteen or twenty years ago, to develop what they called the new history. No longer new and now incorporated into the mainstream of American historiography, this discipline, using models derived from the Annales school of French historians and the Cambridge group for population studies in England, has sought the answers to its questions through exploitation of a long, underutilized body of nonliterary sources. Broadly defined, these sources include all materials susceptible of quantification. They contain "bits" of hard data, to borrow the language of the computer, and can be not only measured as simple frequencies but also compared by holding some factors constant and working with others as variables. Since they involve "objective" rather than "impressionistic" material, they may be handled by a computer, making possible a whole range of potentially interesting considerations denied to the pencil-and-paper researchers on the grounds of time alone.

It is to a consideration of these sources, their advantages and limitations, that I will devote the rest of this paper. Although many of these materials had long been used by genealogists and antiquarians in searching out specific individuals or families, they were for the historians what the discovery of King Tut's tomb was for the archaeologist. And they enjoyed the same kind of instant popularity—one might almost say superstardom. They have been, perhaps, overexploited in much the same way as that once-obscure deity, and, for the most part, little thinking has gone into a real examination of their nature.

While escaping the biases of personal idiosyncracy and elitism so often condemned in literary sources, nonliterary sources have their own built-in problems that must be understood and taken into account before we dare to use them in the quest for historical "truth." The broadest criticism of such sources has been made by the radical French historian Jean Chesneaux who charges that quantifiable materials "originate with the state or its adjuncts" and are therefore imbued with institutional, if not individual, selectivity.

The historian's territory is completely marked out by the apparatus of repression . . . the power structure . . . functions as a gigantic recording machine, using the official archives of Government services (Tax Offices, Treasury, etc.), church archives (ecclesiastical accounts, hospitals, parish records, etc.), the archives of powerful private interests (trusts, big commercial firms, etc.). We know nothing

of reality except what can be inferred from the information the power structure has recorded and made available.

Furthermore, according to Chesneaux, the state may control the past by withholding information, keeping certain facts secret, and even destroying embarrassing material.[4]

It is neither necessary nor desirable to accept Chesneaux's view which would condemn the entire range of institutional documents and a priori render suspect any results based on its use. His polemic does, however, serve to alert the researcher to the biases lurking within apparently objective materials. Since the nature of all institutional records tends to place undue emphasis on the wealthy, the stable, and the urban, such records may be especially prone to skew the results of those working specifically on early America, where the vast majority of the population was nonaffluent, mobile, and rural. Moreover, European methods and models are frequently unadaptable to the needs of American scholars because of the vagaries of record taking and record retention in the New World. Sheer geographic size and cultural variation may make generalization from a localized collection of documents impossible. A heavy leaning in American historiography toward both New England studies in particular and a general interpretation of the American experience as New England writ large is at least partially explained by a mania for record keeping among New Englanders, unmatched in any other region.

Biases of survival, region, and socioeconomics aside, nonliterary sources differ in basic composition and, therefore, are not all equally useful in answering the same kinds of questions or in testing the same large-scale hypotheses. To return to the artifactual metaphor of Fleming's model, it is necessary to understand their basic design, construction, and functional properties before attempting to subject them to cultural analysis and interpretation.

Nonliterary sources may be divided into three general categories. The first group is composed of genuinely aggregative data which present a limited body of information about most of the inhabitants of a community at the same time. Tax lists, census records, and business directories are the most widely available survivors in this group. Using methods of quantification, aggregate sources allow the researchers to form a pro-

[4]Jean Chesneaux, *Pasts and Futures: Or What Is History For?* (New York: Thames and Hudson, 1978), p. 19.

file of the whole population in cross section, to compare the relationships among its members, and to make visible those formerly invisible groups who established no family lines, signed no masterworks of high-style craftsmanship, and, in general, left no "footprints on the sands of time." Depending on the nature and quality of such aggregative sources, they can provide a great deal of information about the life of craftsmen in colonial America.

Tax lists are, perhaps, the most obviously rewarding, particularly where they are the raw work of assessors who itemized property rather than final lists which tend to contain merely names and amounts owed. A really fruitful tax assessment, such as the Massachusetts list of 1771 (now available in computer printout), the Philadelphia County lists of 1767 and 1780, or the Federal Direct Tax of 1798 (where it still survives) can enlighten us on the economic standing, shop practices, and material life of early craftsmen. Sometimes these lists give occupational status; sometimes they indicate it by enumeration of a shop or work space and the kinds of goods on hand contained therein. Since these early lists are usually compiled geographically rather than alphabetically, they can also be made to reveal shop size as well as the economic spread between the master and his workmen. A carriagemaker, owner of substantial property, may be followed on the list by a couple of other men, also listed as carriagemakers but designated renters or boarders and with little real property to declare. They, in turn, may be followed by men of related occupations—trimmers or wheelwrights perhaps—but of less economic status. If the shop is quite large, there may be a day laborer or two, occupations unspecified and property nonexistent, assessed at the lowest tax provided for by law and levied on their wages rather than on their holdings. The move to the next property is indicated by the list of another person of property, engaged in another occupation, accompanied or not by another set of dependents. Some assessments provide interesting extra details on life-styles by indicating slaves held or the possession of investment property or such status-bearing luxuries as plate, carriages, and vacation houses. Since this information is given on a communitywide basis, it becomes possible to compare craftsmen in an overall evaluation of their position with other segments of society—merchants and farmers, for example. On the level of material life, the 1798 Federal Direct Tax offers a detailed picture of housing and property arrangement. It included building dimensions, number of stories, construction materials, number of windows (includ-

ing number of lights), and outbuildings in proximity to the dwelling, with their usage and construction details also noted. As the earliest compilation of this kind of information on a common base across the entire breadth of the young Republic, this particular list allows a rare opportunity to make comparisons from state to state.

During the course of the nineteenth century, the federal census became an even more complete source for understanding the economic life of craftsmen as well as presenting a picture of their family structure and household makeup. Early state and local census lists and the earliest of the national censuses, 1790 and 1800, while they frequently list occupation, thereby making it possible to identify craftsmen, generally produce the skimpiest outline of their lives. Those local lists that enumerate only heads of households require certain dubious assumptions by the researcher to arrive at so-called conversion figures for estimating total population size. These very loose results give their tentative answers for community rather than family size. Even on this level, one need only compare total population figures for pre-Revolutionary Philadelphia produced by Carl Bridenbaugh, Sam Bass Warner, and John Alexander—they range from 23,000 to 40,000 and are based on essentially similar data—to see how dangerously misleading such extrapolations can be.[5] The early national census is also frustrating for those who seek information concerning individual craftsmen since, again, only heads of household are listed by name, and females are not even separated into the most general age divisions of over and under sixteen.

A third major type of aggregate document can be used in combination with the census lists to throw more light on otherwise elusive topics. Take, for example, the importance and extent of female artisanship in early national economic life. Business or street directories of urban areas, which began to appear in the 1790s, have long been used by the researcher in hot pursuit of the life movements of a given individual. In addition, as data fulfilling the most stringent requirements for quantifiable material, they may be used to help form a generalized picture of craftsmen as well as for tracing the single example. Philadelphia

[5]Carl Bridenbaugh, *Rebels and Gentlemen: Philadelphia in the Age of Franklin* (New York: Oxford University Press, 1962), p. 3; Sam Bass Warner, Jr., *The Private City: Philadelphia in Three Periods of Its Growth* (Philadelphia: University of Pennsylvania Press, 1968), p. 12; John K. Alexander, "The Philadelphia Numbers Game: An Analysis of Philadelphia's Eighteenth-Century Population," *Pennsylvania Magazine of History and Biography* 98 (1974): 314–24.

census lists and business directories for the last decade of the eighteenth century were examined by two University of Delaware graduate students who were investigating female occupations. Their research not only provided a model for integration of these nonliterary sources but also drew a rough outline of the craft and working orientation of Philadelphia women at the turn of the nineteenth century. They indicated what kinds of work were done by women who had to support themselves and traced, in preliminary form, the extent to which a woman's occupation was dependent on that of her husband or father. Tracing several of these documents over a period of years helped to point out the way in which women frequently maintained their husbands' businesses as a holding action until their sons were old enough to take over.[6]

One of the major flaws of the business directories as a source is that they are essentially urban based and, therefore, tend to exaggerate the urban bias of early American studies. Only 10 percent of eighteenth-century Americans lived in cities, but research on this minority far exceeds the amount of work done on the other 90 percent of the population. This aspect of the survival bias may be as serious a defect in the work of new social historians as the bias toward elite sources was for an earlier generation that worked primarily with literary sources.

The urban bias unfortunately extends to most other documents within the aggregative category. These other sources cannot be readily catalogued. Each is a fortuitous survival having escaped file consolidation or house cleaning by falling behind the cabinet, by being kept as a souvenir by some nineteenth-century antiquarian, or by being relegated to someone's attic with a lot of old papers nobody wanted to deal with at the time. These unique bits of jetsam might include such items as ship passenger lists, communion lists of a church, sheets of subscriptions (including amounts) to a local charity, or petitions to open roads or undertake other civic improvements. The possibilities are endless. One excellent example of how useful the discovery of such a cache of documents can be—equivalent perhaps to finding the entire contents of an eighteenth-century craft shop locked up in a shed and forgotten— is the jury lists for some of the wards of New York City in the second decade of the nineteenth century that were used to great advantage by

[6]Dona McDermott and Carolyn Stallings, "Female Occupations in Philadelphia, 1790–1800" (Paper presented at Artifact in American History seminar, Winterthur Museum, 1979), Office of Coordinator, Winterthur Program in Early American Culture.

Howard Rock in *Artisans of the New Republic*. While the social picture of craftsmen's lives presented in this work is largely used as a background for focusing on political participation, the reader has more confidence in the description of that life because it is drawn from broad-based documentation in the jury lists. The lists include information on age, family and household size and structure, servants and slaves, occupational status, race, and general wealth and property holding for whole neighborhoods of potential jurors.[7]

No matter how excellent and complete a source of aggregative data may appear to be, however, it must be carefully weighed and checked against as many other sources as possible to insure its objectivity. In the first place, it may be just plain wrong as Gary Nash illustrated so graphically when he described how a slip of a clerical pen inadvertently added 2,000 persons to the population of New York in 1737. Only by referring to other sources, both nonliterary and literary, was it possible to expose the error, correct it, and make a valid interpretation of population growth and its relationship to economic change. Second, the same biases toward the survival of upper-class data existing in other sources are present in aggregate data, although to a lesser degree. Those persons most likely to be skipped by the tax collector are the numerous poor who have the least to give, those least apt to appear on the census are the faceless and mobile members of the lowest socioeconomic class, and these same groups are the ones who are eliminated from business and street directories. Still, where the total population of these groups is not systematically eliminated by the nature of the document, we can obtain some information about the structure of their lives even if in the end we underestimate their numbers.[8]

The second major category of documentary sources is even more prone to the biases of survival and elitism. This category might be called one of false aggregation, since it involves bodies of data which on the surface appear to be collec*tive* but in reality are collec*tions* of individual materials. Included here are church records of baptisms, marriages, and deaths, newspaper advertisements, and court records of all sorts: land grants and deeds, wills, inventories, and estate accounts. Groups of these

[7] Howard B. Rock, *Artisans of the New Republic: The Tradesmen of New York City in the Age of Jefferson* (New York: New York University Press, 1979).

[8] Gary B. Nash, "The New York Census of 1737: A Critical Note on the Integration of Statistical and Literary Sources," *William and Mary Quarterly*, 3d ser., 36, no. 1 (July 1979): 428–35.

materials have been gathered together into collections either in their own time, as in the case of wills and inventories, or later, as is frequently true of newspaper ads. Once gathered they are treated as true aggregative material, and quantitative methods are employed to derive the percents, medians, and averages of—what? Certainly not of the population at any given moment, because the essence of these compilations is that they are made up of documents representing a span of time, usually many years, frequently several decades, and occasionally more than a century. Once the time factor has entered into the equation, the common base of measurement is lost.

Let us use as an example the typical collection of household inventories, so popular with scholars of material culture, as evidence for the nature of craft production, the usage and popularity of objects, and the life-style of past generations. There is no question that as a baseline for the actual existence of objects and collections of objects by specific individuals, and even as representations of the contents of particular rooms at particular times, the inventories are invaluable. They represent the closest thing to a photograph of the past that we possess; they are far more inclusive than paintings, for example. The problem is that they are so rich in evidence that we find it impossible to resist the temptation to overgeneralize from them. But the time element alone raises a host of difficulties that cannot be factored out. Some of these difficulties include changing monetary systems across time, changing perceptions of the value of things, and the changing nature and purpose of the inventories and of the people who took them. In different times, even in the same place, the standard of what items should be included may change radically. How, for example, does one compare wealth across time in eighteenth-century Philadelphia based on inventories that cease to include land holdings by the 1730s? Can one really be sure that very few beds were available because they were not regularly listed in inventories of certain places at certain times? Is it not possible that, as large and not easily moved pieces, bedsteads were considered part of the house just as stoves are today? A person who had lived in rental quarters might not have one listed as part of his possessions even though bedding might clearly form part of his personal estate.

Where inventories provide the only real evidence available, they may, through injudicious use, involve the researcher in a variety of logical fallacies, the most serious of which is a tautology. Here the hypothesis and its proof rest on exactly the same material. For example,

take the proposition that the wealthier a person has become, the most likely he or she is to own a good deal of expensive porcelain. First, a wealth ranking of estates is made by total value of the inventories. The inventories are then quantified to see what percentage of each estate's value is represented by porcelain. But if porcelain is, in fact, a significant part of the estate, it will have seriously affected the original wealth structure, and the result that one finally obtains merely indicates that wealthy people had more valuable possessions, including porcelain, than poorer folk, which is why they were rated rich in the first place.

A second problem of quantifying collections that represent a long span of time is functional. In order to have enough material to work with, the time factor is collapsed, and what emerges is a static picture. An average number of tools (representing the possessions of no real person) is derived for the colonial period. But an even more important historical question might concern itself with exactly that information that the process has destroyed; namely, to what extend did the craftsman's ownership of his tools change over time? Dividing the material by shorter time periods may remove the possibility of quantification altogether. Representative samples for decades are too small, other decades seem not to list contents of shops at all, or the changing nature of the craft may make the items considered in one decade irrelevant to another.

A sophisticated and subtle method for transforming collections of inventories into truly quantifiable material was successfully attempted by Alice Hanson Jones in *American Colonial Wealth*. Three volumes of inventories—a total of 919 documents for the thirteen original colonies in 1774—were chosen by careful mathematical techniques to insure the valid nature of the sample. Jones's sampling and weighting procedures are explained in the appendix of her interpretive work *Wealth of a Nation to Be*, which analyzes the inventories of the earlier volumes. By restricting the time period of the collection and using weighting factors to correct for variation in the number of inventories from one place to another, Jones was able to eliminate the time variable as a source of error; by developing a constant standard for currency valuation throughout the colonies, she was able to measure the economic status of various groups, including artisans and craftsmen, on an accurately comparative scale. Although Jones pursued only the goal of outlining wealth as expressed in monetary values, former Winterthur fellow Nancy Carlisle outlined a method for dealing directly with the material objects listed in inventories through the use of a specially developed object

classification system. Of course, the results obtained are only as good as the sample on which they rest; in this case validity is supported by the use of the Jones collection.[9]

Where the collection of such individual sources rests at least on an attempt by its compilers to be all inclusive, as is the case with inventories from early Maryland or church records in colonial New England, it may be possible to derive from them an overall picture of contemporary life. Valid examples of this process may be seen in the results of the work sponsored by St. Mary's City Commission or in Philip Greven's exploration of four generations of family experience in colonial Andover, Massachusetts. In most other cases, it is necessary to stop and ask ourselves some hard questions about why and how the collection exists at all. Land records, after all, produce conclusions only about the condition of craftsmen who actually owned, sold, or deeded land and wills and inventories about those who had property to leave; church records tell only of those who maintained membership in a religious institution; and newspaper advertisements deal with those, usually, urban craftsmen who had come to recognize and make use of this modern opportunity to enlarge their pool of customers beyond an immediate circle of acquaintances and their contacts.[10]

Finally, the most serious drawback to the category of false aggregation or, to put it more positively, of collections, lies in the very richness of its individual detail. After looking over hundreds of deeds, inventories, or newspaper ads, the researcher is apt to pluck out one to use as an example. There is no doubt that a little personal detail enlivens a page filled with tables, graphs, and other statistical generalizations. But an illustration of typicality already proved by other methods is different from a one-quotation proof, or, as David Hackett Fischer more colorfully labeled it, the "fallacy of the lonely fact." Beware of sentences or paragraphs that begin "there is no reason to consider

[9] Alice Hanson Jones, *American Colonial Wealth: Documents and Methods*, 3 vols. (New York: Arno Press, 1977); Alice Hanson Jones, *Wealth of a Naton to Be: The American Colonies on the Eve of the Revolution* (New York: Columbia University Press, 1980); Nancy Carlisle, "A Methodology for Inventory Use" (Independent study course paper, 1982), Office of Coordinator, Winterthur Program in Early American Culture.

[10] For example, see Lois Green Carr and Lorena S. Walsh, "Changing Life Styles in Colonial St. Mary's County," *Working Papers from the Regional Economic History Research Center* 1, no. 3 (1979): 73–118; Philip J. Greven, Jr., *Four Generations: Population, Land, and Family in Colonial Andover, Massachusetts* (Ithaca, N.Y.: Cornell University Press, 1970).

untypical" and then go on to cite a single newspaper advertisement showing that such and such an upholsterer was willing to rent bed hangings or curtains in the 1780s. If the examination of decades of colonial newspapers has turned up only one such ad, there is, in fact, every reason in the world to consider the craftsman, his modern grasp of the leasing phenomenon, and his emphasis on status consumerism highly untypical. The same holds true of the "typical" inventory or any other source that is really chosen, not because there are so many like it, but rather because it is the only document available that illustrates a point the researcher believes and wants to make.[11]

The third and final general category of documentary sources, which must be used in still different ways to arrive at different sorts of insights, is made up of individual materials that cover a significant period of time. Many literary forms fall within this area—diaries, letter books, and travel accounts, for example—but there are a great many nonliterary ones as well. Most important of these are the financial records of public institutions, businesses, and individuals. In structural composition, these documents are the opposite side of the aggregative data coin; that is, they deal with a single member (whether personal or institutional) of a society across time in contrast to aggregative data which provide information for a whole community at a single time. Since the individual sources possess a time dimension, they have the great advantage of being useful in investigating the all-important historical questions of continuity and change. Aggregative data require more than one source to perform this function. On the other hand, without supporting evidence from other material, the individual records operate in a kind of vacuum outside the totality of the social structure.

Nonliterary individual documents are, perhaps, most often abused by assuming that the accounting numbers in the right-hand columns can be used as measures of value. That so-and-so turned out expensive chairs worth $15 or £13 has no significance for so-and-so's standing within the community as a craftsman and is only marginally useful when compared to other chairs listed at other times in the same daybook. After all, the value of a cow in Pennsylvania went from £6 in 1779 to £120 in 1780 because of a change in the value of the pound,

[11] David Hackett Fischer, *Historians' Fallacies: Toward a Logic of Historical Thought* (New York: Harper & Row, 1970), pp. 109–10.

not in the value of the cow relative to other cows and to other items appearing on the tax list.

When supporting information from other categories of documents is available, however, the nonliterary documents have a special role to play in illuminating craftsmen of the past. They help to enrich the socioeconomic analysis of the individual within the larger environment, since they involve transactions between the record keeper and other members of the community. A seminar paper by one of my former students may be used to illustrate a point. In her study of the business records of Rea and Johnston Company of Boston, Susan Mackiewicz was able to show in great detail the way in which the economic function of a firm of decorative painting artisans was directly affected by the political events and economic conditions in that major city between 1773 and 1802. Primary and secondary materials on the general situation were combined to form a backdrop against which the craftsman's work would be studied. Quantitative analysis of the kinds of work performed and the amount of profit it produced allowed measurement among three different types of work. The first, staple production, included house, shop, and ship painting. The second, decorative-utilitarian jobs, added material "beyond necessity" to the painting of a floor or a wall as in, for example, the addition of a trompe l'oeil dog to the floor or a curtain to the wall. The third, suprautilitarian work, covered items which in themselves filled ceremonial or status roles rather than necessary ones. When Boston was evacuated in 1775/76 house painting dropped 84 percent; in 1777/78, when privateers were being outfitted at the docks, ship painting expanded from 15 percent of the firm's total business to 86 percent; and in the healthier economic climate of the years between 1793 and 1802, suprautilitarian work grew from 4.2 percent to 32 percent of total production. These are just a few of the conclusions drawn from this remarkable work. Nowhere has the direct relationship between the overall condition of the larger economic sphere and the working life of a producer-artisan, whose numbers comprised up to 40 percent of Boston's total population, been so clearly revealed. For the historian, the study suggests methods for approaching the large and fascinating questions of political process; for example, relationships between day-to-day economic life and political participation and radicalization. For the student of material culture, a combination of documentary evidence with artifactual survivals provides an opportunity for relating value,

technique, and style to employer-employee job division and shop practices. A good deal is revealed about material and marketing.[12]

The important thing to remember, however, is that comparable studies must be done on many other specific cases before the model becomes acceptable as more than an illustration. The transformation of a particular craftsman into a representative of his class can never be achieved from the single source, even when supported by other evidence about the same individual. And when the creation of generalization is accomplished by using several documents taken from different individuals perceived as "typical," a totally false picture is obtained, one that is not only untrue to the universal but irrelevant to the specific as well. No degree of generalization can be created by combining one man's diary with someone else's account book, the probate record of still another, and, perhaps, to lend a spurious air of reality, pictures of yet another's shop. One does violence to every aspect of historical unity: time, place, and person. Again Fischer has named this not uncommon procedure. Under the category of fallacies of statistical nonsense it appears as the fallacy of shifting bases.[13]

The sloppy combination of noncompatible sources does not advance the goal of generalization for either the expert in material culture, who uses history to illustrate the background of the artifact and its makers, or the historian who seeks to illustrate history by the inclusion of artifactual study. No document or artifact can speak to us a cappella. Each requires a supporting chorus of other materials for contrast and comparison. The ways in which such a chorus can be formed and the kinds of documents that go into its makeup are as varied as the goal of the researcher and the surviving documents that pertain to the answers he seeks. This paper has discussed the advantages and disadvantages of three distinct types of nonliterary documents out of the many different possible sources. Within these categories are vast numbers of survivals, each of which must be adapted to the special procedures most likely to produce general results. Even when carefully used these materials are not enough. The artifacts themselves, the literary manuscript sources, and

[12] Susan Mackiewicz, "A Case Study in Early American Economics: The Rea and Johnston Company of Boston, 1773–1802" (Paper presented at Artifact in American History seminar, Winterthur Museum, 1979), Office of Coordinator, Winterthur Program in Early American Culture.

[13] Fischer, *Historians' Fallacies*, p. 117.

published material from the period under consideration must all go into the equation as well. Only through this synthesis can we hope to understand the craftsman, his world, and his production in a way that transcends the individual experience.

Artisans and Craftsmen:
A Historical Perspective
Thomas J. Schlereth

As Carl Bridenbaugh suggested almost thirty years ago, "crafts—and the artisans who practice them—played an important part in early American life; even more than historians have generally supposed. Next to husbandmen, craftsmen comprised the largest segment of the colonial population; whereas the former made up about eighty per cent of the people, artisans constituted about eighteen per cent." While Bridenbaugh's statistics pertained almost solely to the white, male, adult population, his claim still commands our attention three decades after the publication of his short, but seminal, study of the colonial craftsman.[1]

As the study of the colonial craftsman provided the rationale and focus for the papers, commentaries, and discussions of the twenty-third Winterthur conference, so the study of the *studies* of the colonial craftsman is the subject of this bibliographical survey. Fully cognizant of Alfred Young's admonitions about the dangers of historiographical "mailboy pigeonholing" and John Higham's caveats regarding the "occupational narcissism of the historiographer," I maintain that a brief

For assistance in the preparation of this essay, the author wishes to thank Alfred F. Young, Arlene Palmer Schwind, Charles F. Hummel, and Howard B. Rock.
[1]Carl Bridenbaugh, *The Colonial Craftsman* (1950; reprint ed., Chicago: University of Chicago Press, Phoenix Books, 1966), p. 1. Bridenbaugh offered token acknowledgment of colonial America's women artisans (pp. 105–8), but for a more extended treatment, see Frances Magnes, "Women Shopkeepers, Tavernkeepers and Artisans in Colonial Philadelphia" (Ph.D. diss., University of Pennsylvania, 1955); and Linda Grant Depauw, *Remember the Ladies: Women in America, 1750–1815* (New York: Viking Press, 1976).

intellectual history of the scholarship on the craftsman can afford us a useful perspective by which to evaluate several lines of inquiry that have emerged on this topic in the past half century and that continue to inform the field today. We who use the historical perspective on others assuredly ought also to apply it to our own past. For, as L. P. Curtis reminded us, we are all toilers in the "historian's workshop," laboring at what Marc Bloch aptly labeled the "historian's craft."[2]

Permit me to state here at the outset what I have deliberately excluded from my analysis. Although husbandmen were occasionally called "artisans of the fields" and "craftsmen of the soil," no assessment of the writing about their role will be proposed here. Also, a more comprehensive essay should give a broader account of the French, Spanish, and African colonial and regional traditions in artisan research.[3] Finally, my evidence has been primarily books, monographs, and journal literature written by an assortment of historians. I recognize that such a singular angle of vision neglects a significant body of data: that is, the museum historian's "curatorial publications" that have been conceptualized, researched, and mounted as gallery exhibitions or museum installations tracing the history of the early American artisan. Merrimack Valley Textile Museum's *Homespun to Factory Made* and Brockton Art Center's *The Wrought Covenant* are recent examples of this important genre of historical research which is published in a three-dimensional format.[4] A comparative study should be done on what might

[2] Alfred F. Young, *The American Revolution: Explorations in the History of American Radicalism* (DeKalb: Northern Illinois University Press, 1976), p. xiv; John Higham, *Writing American History: Essays on Modern Scholarship* (Bloomington: Indiana University Press, 1970), pp. ix, 157; L. P. Curtis, *The Historian's Workshop: Original Essays by Sixteen Historians* (New York: Alfred A. Knopf, 1970); Marc Bloch, *The Historian's Craft* (New York: Alfred A. Knopf, 1953). The historian-as-artisan motif recurs in a historiographical survey by Richard E. Beringer, *Historical Analysis: Contemporary Approaches to Clio's Craft* (New York: John Wiley & Sons, 1978).

[3] On the impact of French culture on artisanry in America, consult Detroit Institute of Arts, *The French in America, 1520–1880* (Detroit, 1951); and Antoine Roy, *Les lettres, les sciences et les arts en Canada sous le regime français* (Paris: Jouve, 1930); George Kubler and Martin Soria, *Art and Architecture in Spain and Portugal and Their American Dominions, 1500–1800* (Baltimore: Johns Hopkins University Press, 1959), provided a solid introduction to crafts practiced in the Spanish tradition. John Michael Vlach, *The Afro-American Tradition in Decorative Arts* (Cleveland: Cleveland Museum of Art, 1978), is superb in its context; and still useful is Leonard P. Stravicky, "Negro Craftsmanship in America," *American Historical Review* 54 (1949): 315–25.

[4] E. McClung Fleming, "The Period Room as a Curatorial Publication," *Museum News* 60, no. 10 (June 1972): 39–43; Merrimack Valley Textile Museum, *Homespun to Factory Made: Woolen Textiles in America, 1776–1876* (North Andover, Mass., 1977);

be termed the historiography of the early American craftsman in history museums in contrast to the historiography of that craftsman in history books.

Three types of investigators wrote those books: academic historians, museum historians, and avocational historians. By academic historians I simply mean those men and women who, since the beginning of institutional study of American history in the country's universities in the 1880s, have "done history" in the academy. An example of such a scholar interested in the American artisan is Thomas Jefferson Wertenbaker who, for most of his career, taught at Princeton University. For the museum historian (such as C. Malcom Watkins at the Smithsonian Institution), the historical society or the historical museum provided an institutional identity. Henry Mercer, author of *Ancient Carpenter's Tools* (1929) and other early studies on American tools, is my prototype for the avocational historian. Mercer is an example of a man who made the tile business his living and craftsman history his life. Widespread interest in the personalities, the processes, and the products of the early American craftsman has preoccupied all three research cadres for the past half century; appropriately, all three constituencies were represented at the Winterthur conference on the craftsman in early America and are, to various degrees, represented in this volume's essays.

Such a diversity of scholars and scholarship has, understandably, prompted some confusion as to nomenclature. No one has been able to agree, for example, which is the more proper or the more precise term, *craftsman* or *artisan*. Essayists in the following studies will use both. To muddle the issue still further, who are tradesmen and mechanics? Are they the same as craftsmen and artisans? In this volume Barbara Ward speaks of Boston silversmiths (she also calls them craftsmen), but in *The London Tradesman* such individuals are called "goldsmiths, the most genteel of any in the Mechanic Way."[5]

To put the issue another way, what do Marlowe's Faust, William Sawyer (a member of the Philadelphia Carpenter's Company in 1772), the Choice Tool Set described on page 533 of the 1902 Sears, Roebuck catalogue, and the second rank earned by members of the Horizon Club

Robert Blair St. George, *The Wrought Covenant: Source Materials for the Study of Craftsmen and Community in Southeastern New England, 1620–1700* (Brockton, Mass.: Brockton Art Center, Fuller Memorial, 1979).

[5] R. Campbell, *The London Tradesman* (1747; reprint ed., Newton Abbot: David and Charles, 1969), pp. 141–42.

of the Camp Fire Girls of America have in common? Answer: Each is called artisan. Or, what links an eighteenth-century Boston shoemaker named Elizabeth Shaw, Gustave Stickley's furniture, and the stationary drill press found on page 742 of the 1979 Sears, Roebuck catalogue? Answer: All are craftsmen.

In seventeenth-, eighteenth-, and nineteenth-century parlance, as in twentieth-century book titles and conference programs, the terms *artisan, craftsman, tradesman,* and *mechanic* are frequently used interchangeably. Is this accurate? It has been suggested that there is a progression of usage that would accord *artisan* more popularity in the seventeenth and early eighteenth centuries, *craftsman* continually in vogue from the eighteenth century onward, with *mechanic* gaining ascendancy in the late eighteenth and early nineteenth centuries. In any event, a tentative consensus seems to exist among modern scholars that during most of eighteenth-century American history, the terms *artisan, mechanic,* and *craftsman* are roughly synonymous.[6] I will also use them.

In craftsman research, some scholars blithely assume that the subjects about which they write—artisans or craftsmen—are individuals of the same social, economic, political, religious, or cultural background; others, such as Charles Olton, spend a book chapter attempting to define what they mean by an artisan or a craftsman in the particular time (for example, Revolutionary America, 1765–83) and the particular place (for example, Philadelphia) they are investigating. In addition to locating the craftsman/artisan within definite chronological and geographical limits, a definition should also include (1) occupational identity, (2) technological sophistication, (3) level of economic wealth, and (4) rank in social status. In order to give some precision to their discussions of occupational identity, scholars such as Olton, Stephanie Wolf, Edwin Tunis, Warren Roberts, and Howard Rock have prepared classification systems wherein distinctions are made, for instance, between furniture crafts and forging crafts, between comb crafts and construction crafts.[7]

[6] Bridenbaugh, *Colonial Craftsman,* p. 1. Contemporary scholar Herbert Gutman also adheres to the artisan/craftsman synonymity; see his essay, "Work, Culture, and Society in Industrializing America, 1815–1919," *American Historical Review* 78, no. 3 (June 1973): 558.
[7] Charles S. Olton, *Artisans for Independence: Philadelphia Mechanics and the American Revolution* (Syracuse, N.Y.: Syracuse University Press, 1975), pp. 7–18, 4–5; Stephanie G. Wolf, "Artisans and the Occupational Structure of an Industrial Town: 18th-Century Germantown, Pa.," *Working Papers from the Regional Economic History*

However, the major methodological difficulties inherent in devising an adequate classification system must be recognized, as Michael Katz and Thomas Smith deftly point out in two studies on the techniques of reconstructing occupational structures. Katz and Smith question, for example, whether one should define artisanry or craftsmanship in a fairly narrow sense, say, limiting it rigidly to hand production alone, to the craftsman's production of the entire object, or to a production process that is wholly controlled by the workman.[8]

Ascertaining the exact economic and social status of the artisan, craftsman, or mechanic has bedeviled many a modern historian of colonial America. A degree of consensus, however, seems to exist as to what the eighteenth-century craftsman was *not*: part of the preindustrial, pre-proletariat lower class of unskilled laborers (for example, sailors, free blacks, many new immigrants, servants, slaves) who lived solely by manual work, did not own their own tools, moved readily from job to job (and often from city to city), were excluded from craft organizations, and, in general, could not vote. On the other hand, the master-craftsman population in most colonial American cities constituted a broad and indeterminate stratum ranging from master artisans in highly skilled trades like instrumentmaking and silversmithing to the "inferior sort" of craftsmen such as coopers and soap boilers. Conscious of their social rank below the merchants, government officials, clergy, and attorneys, but clearly above the status of journeymen and apprentices, most artisans apparently were able to escape dire want, acquire some property, educate their children, and take part in politics. Moreover, as Rock argues, master craftsmen shared several social and economic experiences that gave them common cause and identity whether they worked in Boston, New York, or Philadelphia. Such experiences included an apprenticeship of some sort, a shared mode of functional dress, often a clearly differentiated workers' neighborhood in which to live within a city, fra-

Research Center 1, no. 1 (1977): 33–56; Edwin Tunis, *Colonial Craftsmen and the Beginnings of American Industry* (Cleveland and New York: World Publishing Co., 1965), pp. 7–8; Warren Roberts, "Material Culture: Folk Crafts," in *Folklore and Folklife: An Introduction*, ed. Richard Dorson (Chicago: University of Chicago Press, 1972), pp. 242–49; Howard B. Rock, *Artisans of the New Republic: The Tradesmen of New York City in the Age of Jefferson* (New York: New York University Press, 1979), p. 13.

[8] Michael Katz, "Occupational Classification in History," *Journal of Interdisciplinary History* 3, no. 1 (Summer 1972): 63–88; Thomas Smith, "Reconstructing Occupational Structures: The Case of the Ambiguous Artisans," *Historical Methods Newsletter* 8, no. 1 (June 1975): 34–46.

ternal craft-oriented societies and clubs devised as social and recreational outlets but which periodically became the forum for voicing political and economic grievances, and, finally, a definite political identity in that "mechanics were without question the single group to whom most [local] election appeals were addressed."[9]

Interconnected with the methodological issues of terminology and definition is the question of historical periodization in artisan/craftsman studies. When does the age of the early American craftsman begin? Was it with the early achievements of the native Americans, with the first arrival of Europeans, or only when the first native-born artisans reach their majority? Even more difficult to pin down is a terminal date for the era of the American craftsman: Does it peak, as Charles Hummel has argued, around 1760 and then enter "the time of its rapid decline" until the 1840s? Or, can we identify, as Kenneth Ames claimed, "unsung artisans at work in American industry thoughout the nineteenth century"? Of course, the National Conference of American Craftsmen and the American Crafts Council, through publications such as *Craft Horizons*, labor to persuade us that the great American artisan is still very much alive and running two-harness looms and potter's kick wheels all over modern suburbia.[10] The cultural history of the craftsman in the contemporary United States is, I propose, an important research area to which sociologists, social psychologists, museologists, and cultural historians might profitably turn since an abundance of literature on the topic has surfaced in pre- and postbicentennial America.[11] Contemporary crafts have also infiltrated the college curriculum, and artisans now practice in the academy. For example, Boston University's accredited Program in Artisanry offers courses in the traditional crafts of metals, wood, ceramics, and textiles. To successful apprentices in the program, the university awards a certificate of mastery. So prolific

[9] Rock, *Artisans of the New Republic*, p. 9.

[10] Charles F. Hummel, *With Hammer in Hand: The Dominy Craftsmen of East Hampton, New York* (Charlottesville: University Press of Virginia, 1968), p. 3; Kenneth L. Ames, "Meaning in Artifacts: Hall Furnishings in Victorian America," *Journal of Interdisciplinary History* 9, no. 1 (Summer 1978): 36. For a rapid survey of the role of these organizations, see Patricia Raymer, "The Scene Today," in *The Craftsman in America* (Washington, D.C.: National Geographic Society, 1975), pp. 164–75.

[11] See, for instance, Julie Hall, *Tradition and Change: The New American Craftsman* (New York: E. P. Dutton, 1977); Edward Lucie-Smith, *The World of the Makers: Today's Master Craftsmen and Craftswomen* (New York: Paddington Press, 1974); and Martin Lawrence, *The Compleat Craftsman: Yesterday's Handicrafts for Today's Family* (New York: Universe Books, 1979).

have craft courses become in modern America that the American Crafts Council now publishes an annual directory of craft courses.[12]

I raise these modern instances only to point up the complexity that the historian faces in deciding upon the end of a historical period. When, for example, does craft production stop and industrial production begin in America? Should this be the chronological watershed by which to differentiate the artisan in colonial America from the worker in Victorian America? Obviously, such a transition does not take place simultaneously in all crafts nor with the same velocity, as we see in this volume's essays by William Mulligan on shoemakers and by Susan Myers on potters. Advanced mechanization of craftsmanship came in different ways and at different times. Hand coopers, as Herbert Gutman has documented, continued to work in distinctly preindustrial patterns well beyond Gutman's cutoff date of 1843 as the advent of American industrialization. Roberts, an American folk-crafts scholar, thinks that in most areas of the United States it was not "the progress of manufacturing but the progress of transportation" that terminated the traditional craft era. "As long as transportation costs were high, the purchaser who lived some distance away from a factory could often buy an item made locally by a craftsman more cheaply than the manufactured item. During the second half of the nineteenth century, cheap and efficient transportation spelled doom for the age-old system of craft production wherein the craftsman produced items as needed for his own neighbors." In patiently sorting out the intricate chronology of different craftsmen's responses to industrialization, we need to recognize, as have British labor historians such as Sidney Pollard, E. P. Thompson, and Eric Hobsbawm, that such a transition often meant nothing short of "a severe restructuring of working habits—new disciplines and new incentives" whereby "a society of peasants, craftsmen, and versatile labourers became a society of modern industrial workers."[13] In short, considerable careful

[12] *Craft Courses* (available from American Crafts Council, 44 W. 53rd St., New York, N.Y. 10019); also consult John Coyne and Tom Herbert, *By Hand: A Guide to Schools and Careers in Crafts* (New York: E. P. Dutton, 1975).

[13] Gutman, "Work, Culture, and Society," p. 559; Roberts, "Material Culture," p. 237; Sidney Pollard, "Factory Discipline in the Industrial Revolution," *Economic History Review* 16, no. 2 (June 1963): 254–71; Sidney Pollard, *Genesis of Modern Management* (Cambridge: At the University Press, 1965); E. P. Thompson, "Time, Work-Discipline, and Industrial Capitalism," *Past & Present*, no. 38 (December 1967): 56–97; E. P. Thompson, *The Making of the English Working Class* (New York: Pantheon Books, 1963); Eric J. Hobsbawm, *Labouring Men: Studies in the History of Labour* (London: Weidenfeld and Nicolson, 1964).

research needs to be done in charting the post eighteenth-century evolution (and, sometimes, extinction) of the assorted craft activities we label colonial or early American.

Most scholarship since the Encyclopédistes (whom I consider to be the first significant historians of the transatlantic artisan) has, with a few exceptions, primarily focused on the American craftsman in the eighteenth century.[14] Since Diderot and his fellow philosophes first published their detailed entries, ranging from bookbinder to wainwright, in some seventeen volumes containing illustrations of 1,700 working figures and 1,100 types of equipment, a substantial literature (itself evidential of the the printer's craft) has described, romanticized, classified, and analyzed the craftsman and his works. Since I know that I cannot conquer this corpus, I propose to divide this published material, like Caesar's Gaul, into three parts; that is, I am persuaded that the significant contours of American craftsman scholarship can be separated into three major historiographical configurations depending on which facet of the artisan's life the historian decides to give primary emphasis in his research design, in his interpretation of his data, and in his mode of communicating that data's significance to others (table 1).

In brief, these three approaches consider, first, the craftsman as principally a creative *artiste*, producing an identifiable object, often highly valued as either classic, folk, or vernacular art; second, the craftsman as participant in a specific craft tradition, wherein he practices his *artisanry* by means of his mental and manual acumen aided by an assortment of tools; and, third, the craftsman as historical *actor* in society, principally as a citizen and as a consumer. This typology can be further explained by noting that in the craftsman-as-artiste tradition it is the *works* of the craftsman that the historian primarily chronicles, whereas in the craftsman-and-his-artisanry tradition it is principally the *working* of the craftsman that is studied, and while in the craftsman-as-historical-actor tradition it is the craftsman as a *worker* that primarily concerns the researcher. I recognize that the symmetry in these three categories of the craftsman and his products, his technological processes, and his social and political involvements cannot accommodate all the published scholarship in the field. Like any abstraction, my analytical schema cannot accurately characterize the nuances of craftsman history. The

[14] As early as 1950, Bridenbaugh claimed that "the great age of the colonial craftsman began with the eighteenth century" (*Colonial Craftsman*, p. 6).

TABLE 1. Artisan and Craftsman Scholarship in America, 1876–1976: Three

	A. Researching the product (Emphasis on the work)
Biographical emphasis	Craftsman practicing his *art*
Sociological focus	*Artiste* creating artifacts
Disciplinary divisions	Research by art/decorative arts historians
Pioneering scholars	Irving W. Lyon
Serial publications	*Antiques, EAIA Chronicle*
Publication genres	Museum exhibition catalogues/monographs
Research centers	Winterthur/Cooperstown programs
Professional organizations	Decorative Arts Society/Society of Architectural Historians
Bibliographical digests	Whitehill, *Arts in Early American History* (1965)
Iconographic symbols	Copley, *Paul Revere*, ca. 1764

NOTE.—Both the categories and their examples proposed in this diagram merely can indicate.

best work done in any of the three traditions singled out for study has almost always involved components of the other two traditions as well. Artifact-centered studies of any value deal with process because an understanding of how an object is made is vital to knowing whether the object in question is what it purports to be. Benno Forman's work on furniture and furniture craftsmanship is an outstanding example of what can be learned about craft techniques from a direct study of the furniture.[15] His scholarship should rightly be included in both of the first categories. The issue of overlap can also be noted when discussing a publication such as *Winterthur Portfolio* which has been consciously not included in any one of the three categories under representative

[15] Benno M. Forman, "Delaware Valley 'Crookt Foot' and Slat-Back Chairs: The Fussell-Savery Connection," *Winterthur Portfolio* 15, no. 1 (Spring 1980): 41–64; Benno M. Forman, "German Influences in Pennsylvania Furniture," in Scott T. Swank et al., *Arts of the Pennsylvania Germans*, ed. Catherine E. Hutchins (New York: W. W. Norton, 1983); see also his forthcoming publication on seventeenth-century furniture.

Historiographical Traditions

B. Researching the process (Emphasis on the working)	*C*. Researching the person (Emphasis on the worker)
Craftsman practicing his *artisanry*	Craftsman participating in societal *activity*
Technician working in a craft tradition	*Citizen/consumer*-involved communal life
Research by historians of technology/folkways	Research by political/economic/social historians
Henry Chapman Mercer	Thomas Jefferson Wertenbaker
Technology and Culture	*William and Mary Quarterly*
Craft demonstration/exhibition catalogues and film	Monograph/biography
Smithsonian/Hagley programs	Institute of Early American History and Culture
Society for History of Technology	Organization of American Historians
Hindle, *Technology in Early America* (1966)	Rock, *Artisans of the New Republic* (1979)
Four Tradesmen, ca. 1825	Seal, New York Mechanicks Society, 1791

suggest a *pattern* of a historiography that is far more detailed than this simple outline

serial publications because it rightly should be listed under all three divisions. As a hardbound annual from 1964 to 1979, *Winterthur Porfolio* printed articles with strong emphasis on the type of work identified in categories A and B. Now as a triannual journal, the serial publishes excellent scholarship in all three types of craftsman history.

Hence the reader should remember throughout the following analysis that historiographical reality is never as compartmentalized as the table might suggest. I have resorted to three categories solely for heuristic purposes. The divisions are only typologies of emphases, not taxonomies of dogmas. Like any typologies, they were fashioned to serve the objectives of their creator. In this case, that purpose was simply to analyze the major ways in which researchers have conceptualized their approaches to the study of the American craftsman over the past 100 years. A survey of the popular and professional literature suggested that there have been three such major emphases.

THE CRAFTSMAN AND HIS PRODUCTS

The first historians to pay serious attention to the early American craftsman were those who collected his products. A zealous cadre of antiquarians, preservationists, librarians, and private collectors—avocational historians I have called them—sought to identify who had made what, when, and where. They believed, as Scripture testifies, that "by their works you shall know them." Much like their counterparts of a century earlier who, during the first phase of the American natural-history movement, collected every new species for their cabinets of curiosities, these object-oriented gentlemen-scholars focused their energies on the discovery, description, and classification of the artifacts of early American craftsman history. Richard Saunders and William Dulaney have begun to document this late nineteenth- and early twentieth-century interest in the antique and the collectible which nurtured works such as Irving W. Lyon's *Colonial Furniture of New England* (1892), Wallace Nutting's *Furniture of the Pilgrim Century* (1921) and *Furniture Treasury* (1928–33), Luke Vincent Lockwood's *Colonial Furniture in America* (1913), E. Alfred Jones's *The Old Silver of American Churches* (1913), J. B. Kerfoot's *American Pewter* (1924), and Fiske Kimball's *Domestic Architecture of the American Colonies and of the Early Republic* (1922). This generation of patrician proponents of American art found in American objects an inspiring chronicle that stirred their pride. "These things," wrote Wendell and Jane Garrett, "buttressed the structure of the [nineteenth- and early twentieth-century] culture of liberty, progress and nationality." Sociologists Cesar Grana and C. Wright Mills suggested a parallel rationale when arguing that "the destruction of local traditions and the assault upon the past perpetuated by industrialization and world-wide modernization seems to make large numbers of people susceptible to an appetite for relics of pre-industrial life."[16] In addition

[16] Richard H. Saunders, "Collecting American Decorative Arts in New England," *Antiques*, pt. 1, "1793–1876," 109, no. 5 (May 1976): 996–1003; pt. 2, "1876–1910," 110, no. 4 (October 1976): 754–63; William L. Dulaney, "Wallace Nutting: Collector and Entrepreneur," in *American Furniture and Its Makers: Winterthur Portfolio 13*, ed. Ian M. G. Quimby (Chicago: University of Chicago Press, 1979), pp. 47–60; Wendell D. Garrett and Jane N. Garrett, "A Bibliography of the Arts in Early American History," in Walter Muir Whitehill, *The Arts in Early American History* (Chapel Hill: University of North Carolina Press, 1965), p. 37; Cesar Grana, *Fact and Symbol* (New York: Oxford University Press, 1971), p. 98; C. Wright Mills, *White Collar* (New York: Oxford University Press, 1951), pp. 220–24.

to an expanded, if often filiopietistic, interest in colonial craft products, fin de siècle America also witnessed cultural developments such as the colonial revival in architecture and the decorative arts, an unprecedented proliferation of local historical societies, an expansion of historic preservation activities, and, of course, the spread of the arts and crafts movement.[17] Although the research has yet to be done, it seems plausible that the manifestos and manufacts of, say, William L. Price, Isaac Scott, Elbert Hubbard, and Gustav Stickley may have had some indirect influence on the pioneering collecting and writing of the avocational historians on the colonial craftsman and his works.[18]

Be that as it may, these early researchers gathered an enormous amount of data on the "things" of early American life. With certain exceptions, however, their effort was primarily an aesthetic evaluation of the porringer, the highboy, or the decanter. The object of craft became the objet d'art. Such studies, ranging from erudite, highly disciplined evaluations by connoisseurs and museum curators to loosely arranged catalogues by antique enthusiasts with little knowledge of the history of craft technology, flourished from 1876 to 1924—from the opening of the United States Centennial Exposition in Philadelphia to the opening of the Metropolitan Museum of Art's American Wing in New York. As the Garretts suggest, the fault of that period "was the fault of insularity, of separation from the main currents of American historiography. It was a fault, begun not in carelessness or haste, but in a quest for 'some good old golden age.' "[19] Thus historical associationism, romantic nationalism, and a celebration of craft products almost solely as the artistic achievements of gifted individuals rather than the artifacts of a particular society tended to characterize this early trend in artisan research.

The best work in this historiographical tradition usually dealt with those products (silver, furniture, glass, ceramics) that have had the highest monetary value with American collectors. Such research began to appear

[17] For this background, see William Rhoads, *The Colonial Revival* (New York: Garland Publishing Co., 1977); Charles Hosmer, *Presence of the Past: A History of the Preservation Movement in the United States before Williamsburg* (New York: G. P. Putnam's Sons, 1965); and Robert Judson Clark, ed., *The Arts and Crafts Movement in America, 1876–1916* (Princeton: Princeton University Press, 1972).

[18] Walter Muir Whitehill, "Boston Artists and Craftsmen at the Opening of the Twentieth Century," *New England Quarterly* 50, no. 3 (September 1977): 387–408; Charles F. Montgomery, "Classics and Collectibles: American Antiques as History and Art," *Art News* 76, no. 9 (November 1977): 126–36.

[19] Garrett and Garrett, "Bibliography," p. 36.

in Homer Eaton Keyes's influential journal, the *Magazine Antiques*, founded in 1922 and my nominee for the most representative (and most carefully edited) serial publication of the craftsman "product" school. The school gained further impetus by the opening of the two major historical reconstructions of the 1920s, Colonial Williamsburg and Greenfield Village, and by the "flowering of American folk art" collecting in the 1930s. Holger Cahill's *American Folk Sculpture: The Work of Eighteenth- and Nineteenth-Century Craftsmen*, an exhibition catalogue published by Newark Museum in 1931, might be cited as the opening manifesto in a decade that concluded with the work of the Federal Art Project's Index of American Design. Cahill's early work betrays the tendency of so many subsequent folk art scholars to celebrate folk *art* rather than the folk *artist*, a tendency thoroughly exposed and analyzed by Kenneth Ames in *Beyond Necessity*.[20] A similar tendency underlay the Index of American Design in that it recruited unemployed contemporary artists to record over 15,000 examples of the work (furniture, textiles, ceramics, glassware) of earlier "artists." In 1950, Erwin Christensen published a selection of the index's most vivid color renderings in a lavishly illustrated book, *A Treasury of American Design*, a coffee-table volume depicting American crafts but no American craftsmen. In our own decade, Clarence Hornung has similarly "treasured" the work of the index and other American "popular folk arts and crafts." The recently published ten-volume microfiche edition of the entire index, along with multiple finding aids, attests to the continued viability of the *artiste* tradition of artisan historiography.[21]

In the past thirty years, however, the scholarship in this mode has become increasingly sophisticated in methodology, in the scrupulous use of evidence, and in greater receptivity to the techniques of other disciplines besides art history and its progeny, the history of the decorative arts. Work by Charles van Ravenswaay, Walter Muir Whitehill, Anthony Garvan, and Charles Montgomery exemplifies what might be

[20] Beatrice T. Rumford, "Uncommon Art of the Common People: A Review of Trends in the Collecting and Exhibiting of American Folk Art," in *Perspectives on American Folk Art*, ed. Ian M. G. Quimby and Scott T. Swank (New York: W. W. Norton, 1980), pp. 13–53; Kenneth L. Ames, *Beyond Necessity: Art in the Folk Tradition* (New York: W. W. Norton, 1977).

[21] Erwin O. Christensen, *The Index of American Design* (New York: Macmillan Publishing Co., 1950); Clarence Hornung, *A Treasury of American Design* (New York: Harry N. Abrams, 1972); Sandra Shaffer Tinkham, *The Consolidated Catalog to the Index of American Design* (Teaneck: Somerset House, 1979).

the origins of a "new" decorative arts history. Such researchers recognize, as Whitehill so poignantly put it, that "no amount of aesthetic incest of sitting and gazing at a chair or a piece of silver will tell one anything of great value about the object beyond its existence."[22]

Younger historians—Arlene Palmer Schwind, Charles Brownell, and Barbara Ward—and their recent scholarship (on glass, architecture, and silver respectively) have continued this revisionist critique. Increasingly cognizant that much of the data with which material cultural historians must work is only the most elite or the most expensive of the past craftwork, they have been as interested in the technical role of the craftsman as they have been in his artistic work and its provenance, influences, and imitators.[23]

THE CRAFTSMAN AND HIS PROCESSES

Such scholarship, emphasizing as it has the processes of past craftsmanship, takes particular interest in the tools, skills, methods of production, and working conditions of housewrights and potters, ironmasters and pewterers, cabinetmakers and cordwainers. Understandably such research has often been seen as a branch of economic history, folk-life or ethnographic studies, or the history of technology. The earliest work in this second tradition of craftsman historiography was done by avoca-

[22] Whitehill, *Arts in History*, p. 22; Charles van Ravenswaay, *The Arts and Architecture of German Settlements in Missouri: A Survey of a Vanishing Culture* (Columbia: University of Missouri Press, 1977); Walter Muir Whitehill, *Dumbarton Oaks: The History of a Georgetown House and Garden, 1800–1866* (Cambridge, Mass.: Harvard University Press, Belknap Press, 1967); Anthony Garvan, *Architecture and Town Planning in Colonial Connecticut* (New Haven: Yale University Press, 1951); George B. Tatum, *Philadelphia Georgian: The City House of Samuel Powel and Some of Its Eighteenth-Century Neighbors* (Middletown, Conn.: Wesleyan University Press, 1976); Charles F. Montgomery, *American Furniture: The Federal Period* (New York: Viking Press, 1966).

[23] In addition to their essays below, one should also consult Arlene Palmer, "Glass Production in Eighteenth-Century America: The Wistarburgh Enterprise," in *Winterthur Portfolio 11*, ed. Ian M. G. Quimby (Charlottesville: University Press of Virginia, 1975), pp. 75–101; Dwight P. Lanmon and Arlene M. Palmer, "Jack Frederick Amelung and the New Bremen Glassmanufactory," *Journal of Glass Studies* 18 (1976): 9–136; and Barbara McLean Ward and Gerald W. R. Ward, *Silver in American Life* (New York: American Federation of the Arts, 1979). See also Ian M. G. Quimby, "Apprenticeship in Colonial Philadelphia" (M.A. thesis, University of Delaware, 1963); and Martha Gandy Fales, *Joseph Richardson and Family, Philadelphia Silversmiths* (Middletown, Conn.: Wesleyan University Press, 1974).

tional historians such as Henry Mercer. His *Ancient Carpenters' Tools* (first published by Bucks County Historical Society in 1929), for example, continues to be a major reference work on woodworkers' tools. From Mercer (the subject of an important study by Donna Rosenstein) a line of historiographical lineage and methodological proclivity extends forward to popular books by Scott Graham Williamson, Edwin Tunis, and Eric Sloane and to detailed scholarship by modern historians such as Frank H. Wildrung, Robert Woodbury, Brooke Hindle, Merritt Roe Smith, and Charles Hummel. *Tools of the Woodworker* by Ralph Hodgkinson further demonstrates the thriving contemporary interest in this segment of craftsman research.[24]

Along with a fascination with American tools—particularly woodworking tools and tools made of wood—craftsmanship historians have become increasingly interested in artisan technical skills and modes of production.[25] In addition to careful examination of the extant workmanship, one way to explore the possible levels of competence and efficiency of early American craftsmen is to analyze trade primers and craft handbooks as did Benno Forman and Charles Montgomery in the reprint edition of Joseph Moxon's 1703 *Mechanick Exercises*. Another type of data gathered by researchers, particularly from the 1920s through the 1940s, would be what I call sourcebooks in regional arts and crafts. Beginning in 1927 with Henry Wyckoff Belknap's and George Francis Dow's works on New England craftsmen,[26] numerous researchers in

[24] Donna G. Rosenstein, "Historic Human Tools: Henry Chapman Mercer and His Collection, 1897–1930" (M.A. thesis, University of Delaware, 1977); Scott Graham Williamson, *The American Craftsman* (New York: Crown Publishers, 1940); Tunis, *Colonial Craftsmen*; Eric Sloane, *A Museum of Early American Tools* (New York: Funk and Wagnalls, 1962); Frank H. Wildrung, *Woodworking Tools of Shelburne Museum* (Shelburne, Vt.: By the museum, 1957); Robert S. Woodbury, *History of the Milling Machine* (Cambridge, Mass.: MIT Press, 1960); Brooke Hindle, *The Pursuit of Science in Revolutionary America* (Chapel Hill: University of North Carolina Press, 1956); Merritt Roe Smith, *Harpers Ferry Armory and the New Technology: The Challenge of Change* (Ithaca: Cornell University Press, 1977); Hummel, *With Hammer in Hand*; Ralph Hodgkinson, *Tools of the Woodworker: Tools to Be Pushed*, American Association for State and Local History technical leaflet no. 119 (Nashville, Tenn., 1979).
[25] Brooke Hindle, ed., *America's Wooden Age: Aspects of Its Early Technology* (Tarrytown: Sleepy Hollow Restorations, 1975); Paul Kebabian and Dudley Witney, *American Woodworking Tools* (New York: New York Graphic Society, 1978).
[26] Benno M. Forman and Charles F. Montgomery, eds., *Joseph Moxon's Mechanick Exercises; or, The Doctrine of Handy-Works Applied to the Arts of Smithing, Joinery, Carpentry, Turning, Bricklaying* (New York: Praeger Publishers, 1970). In this context, see also Charles C. Gillespie, ed., *A Diderot Pictorial Encyclopedia of Trades and Industry* (New York: Dover Books, 1959); and Charles Tomlinson, *Illustrations of Trades*

various regions went on to collect and publish elaborate compendiums containing detailed information about artisans extracted from probate and vital records as well as from advertising and news items in colonial newspapers.[27] Such documentary data was and continues to be of considerable use to scholars working on the craftsman as an agent in either technological or economic history.

In the quest for accurate documentation of what the craftsman actually did or made in the shop or factory, two organizations—Early American Industries Association (EAIA) (founded 1932) and Society for the History of Technology (SHOT) (founded 1954)—gave a popular and a professional focus and parallel publishing forums (*Chronicle of the Early American Industries Association* and *Technology and Culture*) to individual research efforts. The EAIA tended to be composed mostly of avocational and museum historians, whereas SHOT, at least in its early years, involved mostly academic historians—from universities (for example, Massachusetts Institute of Technology, Case Institute of Technology) with growing programs in the history of technology or from museums (for example, Hagley Museum or Smithsonian Institution) with extensive technological collections.

In addition to communicating past craftsmanship via the usual modes of scholarly discourse (for example, monographs and articles), early American work processes have been explained by the craft demonstration, a museum interpretive technique borrowed from European outdoor folk museums, and by the motion picture, a largely American technological innovation. While few historic activities are as widely illustrated to the general public as craft demonstrations and there is

(Ambridge, Pa.: Early American Industries Association, 1972). Henry Wyckoff Belknap, *Artists and Craftsmen of Essex County, Massachusetts* (Salem, Mass.: Essex Institute, 1927); Henry Wyckoff Belknap, *Trades and Tradesmen of Essex County, Massachusetts, Chiefly of the Seventeenth Century* (Salem, Mass.: Essex Institute, 1929); George F. Dow, *The Arts and Crafts in New England, 1704–1775: Gleanings from Boston Newspapers* (1927; reprint ed., New York: Da Capo Press, 1967).

[27] Other regional examples of such biographical directories of craftsmen include Rita Susswein Gottesman, comp., *The Arts and Crafts in New York: Advertisemenets and News Items from New York City Newspapers*, 3 vols. (New York: New-York Historical Society, 1938–65); Walter Hamilton Van Hoesen, *Craftsmen of New Jersey* (Rutherford, N.J.: Fairleigh Dickinson Press, 1973); James H. Craig, *The Arts and Crafts in North Carolina, 1699–1840* (Winston-Salem: Museum of Early Southern Decorative Arts, 1965); Alfred Coxe Prime, *The Arts and Crafts in Philadelphia, Maryland, and South Carolina: Gleanings from Newspapers*, 2 vols. (Topsfield, Mass.: Walpole Society, 1929–32); and Dean F. Failey, *Long Island Is My Nation: The Decorative Arts and Craftsmen, 1640–1830* (Setauket, N.Y.: Society for the Preservation of Long Island Antiquities, 1976).

hardly an American outdoor living-history museum without its role-playing craftsmen or artisans-in-residence, to my knowledge, no systematic historiographical assessment of craft demonstrations currently exists as to their accuracy or as to the role they have played in shaping the average American's perception of the colonial craftsman. One thing, however, is certain: They are of mixed quality. In some museum contexts, craft demonstrations are presented with conscientious research informing practically every move the living craftsman makes; in other situations, uninformed interpreters-as-surrogate-craftsmen perpetuate innumerable myths about the colonial artisan—myths suggesting that the craftsman was always an individualistic, relatively prosperous, upwardly mobile, consistently ingenious, white, Anglo-Saxon democrat who, independent of his European counterpart and largely by preferring hand tools over more efficient labor-saving machinery, developed an impressive range of aesthetically pleasing, indigenous American artifacts.[28]

Film, a medium seemingly perfectly suited to capturing the turner at his lathe or the ironworker at his tilt hammer, has been employed by the historians at Colonial Williamsburg to depict eighteenth-century work processes ranging from those of the apothecary to those of the wigmaker. Since World War II, folkways scholars and rural sociologists working in the South and Southwest have also been particularly taken with the use of film, both as a research tool and as a medium of communicating research. The New School of Social Research each year sponsors the International Craft Film Festival, screening a wide range of new 16-mm films dealing with all aspects of traditional and contemporary crafts.[29]

Many films on craft processes, like many books on the subject, often fail to delineate artisan intra- and intershop competition and

[28]Thomas J. Schlereth, "It Wasn't That Simple," *Museum News* 56, no. 3 (February 1978): 36–44. See also Ian M. G. Quimby and Polly Anne Earl, eds., *Technological Innovation and the Decorative Arts* (Charlottesville: University Press of Virginia, 1974), pp. vii–xiv.

[29]To secure the current listing of available films on craft activities, write Colonial Williamsburg Foundation, Film Section, Box C, Williamsburg, Va. 23185. For further information, contact International Craft Film Festival, New York State Craftsmen, Inc., 37 W. 53rd St., New York, N.Y. 10019. One of the best directories to filmed craft demonstrations is Don Tippman, comp., *Film Etc.: Historical Preservation and Related Subjects* (Washington, D.C.: Preservation Press, 1979), esp. "Buildings Crafts," "Handicrafts," and "Vanishing Trades."

cooperation. We need to know, for example, much more about the role of the journeyman in all craft shops and about his working arrangements with the master craftsman, other journeymen in the shop, and apprentices. On a related point, as the recent scholarship of Brock Jobe has demonstrated, the division of labor in many craft operations was much more commonplace than earlier research had suggested. Thus, for example, in the furniture trades a considerable degree of specialization took place with what almost amounted to the mass production of certain decorative parts (for example, finials, hand terminals) distributed by local jobbers. Revisionist scholars, however, have not entirely demolished one generalization propounded by the first generation of craftsmanship historians. In studies of both individual artisans and multigenerational craft families such as the Dominys of East Hampton, Long Island, ample evidence suggests that, despite specialization of work within the shop, most colonial craftsmen were jacks-of-all-trades. For instance, the Dominys concurrently pursued several lines of craft activities, working as cabinetmakers, carpenters, clockmakers, watch repairers, wheelwrights, gun repairers, and metalworkers in order to support themselves and their families.[30]

Other important issues have intrigued craftsmanship historians. Issues such as: In what proportions are spontaneity and adaptation found in American artisanship? When and where do American craftsmen first develop the idea of the interchangeability of parts? What is "American" about early American work processes? None, however, has monopolized this historiographical tradition like the question of where and when to divide the period of hand production from that of machine technology in early American history. In Lewis Mumford's periodization schema, the technology that the colonists brought with them to America was paleotechnic, while the new machine technology they later developed he called technic.[31] Other scholars have used less esoteric terms in the ongoing effort to locate precisely the introduction of various power sources, the expanded use of the machine, or the advent of true mass production.

As is evident from the growing scholarly literature on the shift from

[30] Brock Jobe, "The Boston Furniture Industry, 1720–1740," in *Boston Furniture of the Eighteenth Century*, ed. Walter Muir Whitehill (Boston: Colonial Society of Massachusetts, 1974), pp. 12–26; Hummel, *With Hammer in Hand*, pp. 3–26.

[31] Lewis Mumford, *Technics and Civilization* (New York: Harcourt, Brace, 1934), pp. 151–267.

"craft to national industry" or from "the manual arts to the machine arts," by the nineteenth century some type of division is inescapable in most American crafts.[32] Such a division is, however, by no means a sharp one. The difficulty in the history of each of the early American crafts is to state precisely what separates the earlier technology from the later. The earliest gristmills and iron plantations of the 1720s represented powered, machine operations; while in the 1850s, individual handicraft continued to be a part of much production in the shop and on the farm. Steam power was used as early as 1750, but as late as 1860 waterpower still dominated much industrial production and was even advancing in technological efficiency. Nevertheless, as Brooke Hindle and others have argued, "certainly between those two dates [1750 and 1850] the great technological divide was crossed, not only in America but in Britain and Europe as well."[33]

THE CRAFTSMAN AS A PERSON

Parallel with the scholarly investigation of the craftsman as a participant in a technological tradition has been a third line of inquiry that primarily studies the artisan as an important actor on the historical stage. It is an examination of, in the words of Alfred Young, "the craftsman as citizen."[34] In this endeavor, the focus is not so much on work or on working as it is on the worker, on the craftsman as an economic and political person, playing a significant role in society at large.

Biographies of individual craftsmen have always been popular in early American artisan study. Beginning with Walter Alden Dyer's 1915

[32] Lucius F. Ellsworth, *Craft to National Industry in the Nineteenth Century: A Case Study of the Transformation of the New York State Tanning Industry* (New York: Arno Press, 1977); Deborah Dependahl Waters, "From Pure Coin: The Manufacture of American Silver Flatware, 1800–1860," in *Winterthur Portfolio* 12, ed. Ian M. G. Quimby (Charlottesville: University Press of Virginia, 1977), pp. 19–33; William H. Mulligan, Jr., "The Family and Technological Change: The Shoemakers of Lynn, Massachusetts, during the Transition from Hand to Machine Production, 1850–1880" (Ph.D. diss., Clark University, 1982); Alan Dawley, *Class and Community: The Industrial Revolution in Lynn* (Cambridge, Mass.: Harvard University Press, 1976).

[33] Brooke Hindle, *Technology in Early America: Needs and Opportunities for Study* (Chapel Hill: University of North Carolina Press, 1966), p. 17.

[34] Alfred F. Young, *The Craftsman as Citizen: Mechanics in the Shaping of the Nation, 1760–1820* (forthcoming); see also Alfred F. Young, *The Democratic Republicans of New York: The Origins, 1763–1797* (Chapel Hill: University of North Carolina Press, 1967); and Young, *American Revolution*.

survey, *Early American Craftsmen*, through a myriad of studies on prominent cabinetmakers and architects (for example, Duncan Phyfe, Samuel McIntire), silversmiths and glassmakers (Jeremiah Dummer and Baron Stiegel), the individual American artisan has been repeatedly studied. Unfortunately, he has often been portrayed by writers prone to hagiography and historicism. Nonetheless, several excellent artisan lives have been written. Among them I would include Eric Foner's *Thomas Paine and Revolutionary America* (New York: Oxford University Press, 1976), Carl Van Doren's *Benjamin Franklin* (New York: Viking Press, 1938), Esther Forbes's *Paul Revere and the World He Lived In* (Boston: Houghton Mifflin, 1942), and Brooke Hindle's *David Rittenhouse* (Princeton, N.J.: Princeton University Press, 1964).

The collective biography of colonial artisans has been an equally durable mode of inquiry in craftsman research. Among academic historians, I am persuaded that this approach begins with Thomas Jefferson Wertenbaker in the 1920s. In his 1927 study, *The First Americans*, Wertenbaker was among the first historians to use inventories of craftsmen. His trilogy, *The Founding of the American Civilization* (1938–47), demonstrated an impressive knowledge of Anglo-American seventeenth- and eighteenth-century artifacts and artisans. To document his research, Wertenbaker made extensive use of the records of the Historic American Buildings Survey, the Pictorial Archives of Early American Art and Architecture at the Library of Congress, and research reports then in preparation at Colonial Williamsburg.[35]

Wertenbaker's work deserves mention because he was practically alone among early academic historians in recognizing the value of material culture as a resource for American artisan history. This state of affairs began to change after the Second World War when, in 1946, Richard Morris published *Government and Labor in Early America* and when, four years later, Carl Bridenbaugh brought out his Anson G. Phelps lectures under the title *The Colonial Craftsman*. Bridenbaugh sought to focus on the "artisan and his place in the colonial community" because in 1950 "no such treatment existed." It was the contributions of early American craftsmen as social, political, and economic groups that primarily interested Bridenbaugh, "rather than the anti-

[35] See, for instance, Thomas Jefferson Wertenbaker, *The Founding of American Civilization: The Old South* (New York: Charles Scribner's, 1942), pp. 220–70; and Thomas J. Schlereth, "Material Culture Studies in America: Notes toward Historical Perspective," *Material History Bulletin* 8 (1979): 89–98.

quarian quaintness of a Betty lamp or the exclusiveness attached to the possession of a unique Revere creamer or a block-front desk by Goddard."[36]

Bridenbaugh, like the social, labor, and political historians who followed his lead over the next three decades, aspired to focus colonial history on the study of large nonelite groups such as artisans and craftsmen. Researchers with this particular interest in the American artisan have been almost exclusively academic scholars. Many began their careers as straight political historians and, predictably, retained an absorbing preoccupation with the artisan's role in the Revolution. Some started out as labor historians with an obvious interest in the role the colonial craftsman played in American economic history.

No matter where they began, almost all have been influenced by at least one of two important methodological schools of historical interpretation: the work of British labor historians such as E. P. Thompson and E. J. Hobsbawm on the English working class and the pioneering studies of French social historians such as Marc Bloch, Georges LeFebvre, Georges Duby, Pierre Goubert, Emmanuel LeRoy Ladurie, and Fernand Braudel. The social science techniques of these European historians, promulgated in monographs and in two historical serials *(Annales, Economies, Societes, Civilisations* and *Past and Present)*, have influenced American scholars.[37] They have, in turn, established a network of new journals where artisan research by the so-called new social historians is to be found. These include *Comparative Studies in Society and History, Journal of Interdisciplinary History, Journal of Social History, Historical Methods Newsletter,* and *William and Mary Quarterly.* Stephanie Wolf, in the introduction to *Urban Village,* also reminded us that this expanded focus by American scholars on the social roles and the social institutions of colonial America was also nurtured at home.

[36] It should be noted that Samuel McKee's early work, *Labor in Colonial New York, 1664–1776* (New York: Columbia University Press, 1935), preceded Morris's study and that Jackson T. Main, *The Social Structure in Revolutionary America* (Princeton: Princeton University Press, 1965), followed (and expanded) Bridenbaugh's initial foray into craftsman history. Bridenbaugh, *Colonial Craftsman,* p. 1.

[37] Eric J. Hobsbawm, "From Social History to the History of Society," *Daedalus* 100, no. 1 (Winter 1971): 20–45; see also Lawrence Stone, "History and the Social Sciences in the Twentieth Century," in *The Future of History,* ed. Charles F. Deltzell (Nashville, Tenn.: Vanderbilt University Press, 1977), pp. 3–42. The semiannual, and appropriately named, *History Workshop: A Journal of Social Historians,* published by the Labor History Group at Ruskin College, Oxford, has also begun to have a significant influence on craftsman scholarship in the United States.

In 1954 a group of American scholars comprising the Committee on Historiography issued a provocative report for the Social Science Research Council. Bulletin 64, as it is often known, began by defining history as one of the social sciences. The report then suggested that the historians' agenda for the latter half of the twentieth century should include ample use of the other social sciences—anthropology, sociology, demography, and social psychology as well as the more familiar (to historians) disciplines of economics and political science.[38]

This contemporary scholarship on artisans as functional social aggregates or political-interest groups has evolved along several different but obviously related lines of inquiry. Demography, for example, has informed analyses of local craftsmen by Wolf in Germantown, Pennsylvania, by Paul Faler in Lynn, Massachusetts, and by Robert St. George throughout southeastern New England.[39] Taking clues from Wertenbaker, some later historians of the craftsman as a community participant have tended to restrict their investigations to separate regions (for example, rural south, rural north), homogenous, religious, ethnic, or racial communities (for example, Paula Welshimer Locklair on Moravians), single urban areas (for example, Howard Rock's study of the tradesmen of New York City), or comparative cities (for example, Gary Nash's study of the artisans in seaports of Boston, New York, and Philadelphia.[40]

[38] Richard M. Beeman, "The New Social History and the Search for Community in Colonial America," *American Quarterly* 29, no. 4 (1977): 422–43; Lawrence Vesey, "The 'New' Social History in the Context of American History," *Reviews in American History* 7, no. 1 (March 1979): 1–12; Herbert Gutman and Gregory Realey, *Many Pasts: Readings in American Social History*, vol. 1 (Englewood Cliffs, N.J.: Prentice Hall, 1973), pp. 1–6; Beringer, *Historical Analysis*, pp. 203–306; Stephanie G. Wolf, *Urban Village: Population, Community, and Family Structure in Germantown, Pennsylvania, 1683–1800* (Princeton: Princeton University Press, 1980), pp. 3–7; *The Social Sciences in Historical Study: A Report of the Committee on Historiography*, Bulletin 64 (New York: Social Science Research Council, 1954).

[39] Wolf, *Urban Village*, chaps. 2–5; Paul Faler, "Cultural Aspects of the Industrial Revolution: Lynn, Massachusetts, Shoemakers and Industrial Morality, 1826–1860," *Labor History* 15 (Summer 1974): 367–94; St. George, *Wrought Covenant*, and his contribution to this volume.

[40] For separate regions, see, for example, Richard Pares, *Yankees and Creoles: The Trade between North America and the West Indies before the American Revolution* (Cambridge, Mass.: Harvard University Press, 1956); Alfred F. Young, "The Mechanics and the Jeffersonians: New York, 1784–1801," *Labor History* 5, no. 3 (Fall 1964): 247–76; and Gary J. Kornblith, "From Artisans to Businessmen: Master Mechanics in New England, 1789–1850" (Paper presented at the Seventy-first Annual Meeting of the Organization of American Historians, New York, April 14, 1978). For communities, see Locklair's essay

Ever since Bridenbaugh followed up his influential social history of the colonial craftsman with his equally pioneering studies, *Cities in the Wilderness* (1938) and *Cities in Revolt* (1955), urban history has given a distinctive cast to craftsman studies. Thus, for many scholars, the urban context, be it pre- or postindustrial, has been the geographical lodestone around which to wrap their research.[41] In chronological terms, however, the Revolution has usually been the historiographical watershed. Not surprisingly, some monographs examine the role of those whom Bryan Palmer has called the "most uncommon common men" in the most extraordinary event in the life of their generation. Other historians, such as Gary Nash, have concentrated their energies on the pre-Revolutionary period, studying craftsmen by combining analyses of social/economic history with narrative histories of local urban politics. In *The Urban Crucible*, Nash traces the periodic political mobilizations of urban craftsmen, for example, in Philadelphia in the 1720s and 1760s. He sees much more class identity and radical ideology within artisan ranks (using explanatory concepts such as deference or cultural hegemony) than previous historians thought existed in the pre-Revolutionary craftsman community.[42]

A third cadre of scholars pushes the socio-political-economic story into nineteenth-century America in works such as Rock's previously

in this volume as well as June Sprigg, *By Shaker Hands* (New York: Alfred A. Knopf, 1975); and Delores Hayden, *Seven American Utopias: The Architecture of Communitarian Socialism, 1790–1975* (Cambridge, Mass.: MIT Press, 1976). For urban areas, in addition to Rock, *Artisans of the New Republic*, see Dirk Hoerden, "Boston Leaders and Boston Crowds, 1765–1776," in Young, *American Revolution*, pp. 335–71; Gary B. Nash, "Up from the Bottom in Franklin's Philadelphia," *Past & Present*, no. 77 (November 1977): 57–83; and Ian M. G. Quimby, "The Cordwainers Protest: A Crisis in Labor Relations," in *Winterthur Portfolio 3*, ed. Milo M. Naeve (Winterthur, Del.: Winterthur Museum, 1967), pp. 83–101. For comparative cities, see Gary B. Nash, "Wealth and Poverty in Pre-Revolutionary America," *Journal of Interdisciplinary History* 6, no. 4 (Spring 1976): 545–84; and Joseph Ernst, "Ideology and an Economic Interpretation of the Revolution," in Young, *American Revolution*, pp. 161–85.

[41] David Montgomery, "The Working Classes of the Pre-Industrial City," *Labor History* 9, no. 1 (Winter 1968): 13–16; see also Charles Steffen, "Between Revolutions: The Pre-Factory Urban Worker in Baltimore, 1780–1820" (Ph.D. diss., Northwestern University, 1972).

[42] Richard Walsh, *Charleston's Sons of Liberty: A Study of the Artisan, 1763–1789* (Columbia: University of South Carolina Press, 1959); Young, *Democratic Republicans*; Olton, *Artisans for Independence*; Bryan D. Palmer, "Most Uncommon Common Men: Craft and Culture in Historical Perspective," *Labour* [Canada] 1, no. 1 (1976): 5–31; Gary B. Nash, *The Urban Crucible: Social Change, Political Consciousness, and the Origins of the American Revolution* (Cambridge, Mass.: Harvard University Press, 1979).

cited *Artisans of the New Republic*, Bruce Laurie's " 'Nothing on Impulse,' " Young's *Craftsman as Citizen*, and Herbert Gutman's *Work, Culture, and Society in Industrializing America*. Mention of Gutman's research suggests a final focus which I see emerging within my third historiographical movement, a methodological approach that scholars are now often calling working class culture studies.[43] These historians tend to be interested in sorting out several strains of what Gutman has labeled "craft cultural consciousness," what Joseph Ernst designates as "craft ideology," and what Nash terms "the artisans' constellation of values."[44]

Historiography as a branch of intellectual history does not lend itself easily to the use of artifacts as evidence. In this essay discussing colonial crafts, craftsmanship, and craftsmen, I have not offered a single visual illustration. If I were to do so, however, I think I could reduce my interpretation of the topic to three images which would symbolize the three major ways in which artisans, mechanics, and craftsmen have been viewed by the last several generations of American academic, museum, and avocational historians.

To symbolize the craftsman and his product, for instance, I would propose John Singleton Copley's 1770 portrait of Paul Revere holding the famous teapot he has made, perhaps pondering the final artistic design before taking up an engraving tool to finish the masterpiece (fig. 1). Of course, visual conceits of the craftsman at work (for example, his leather, sand-filled pad, his burin and needle) and of the craftsman as worker (for example Revere in simple linen body shirt and unpowdered hair) are in the painting. But I think it can be argued that both the viewer's and Revere's eyes are drawn to the teapot, the object, the craftsman's product.

A less well known group portrait, *Four Tradesmen* by an unknown German folk painter of the first quarter of the nineteenth century (fig.

[43] Bruce Laurie, " 'Nothing on Impulse': Life-Styles of Philadelphia Artisans, 1820–1860," *Labor History* 15, no. 3 (Summer 1974): 343–44; Herbert Gutman, *Work, Culture and Society in Industrializing America: Essays in American Working-Class and Social History* (New York: Alfred A. Knopf, 1976). See also Milton Cantor, ed., *American Working Class Culture: Explorations in American Labor and Social History* (Westport, Conn.: Greenwood Press, 1979).

[44] Gutman, "Work, Culture and Society," pp. 542–43; Ernst, "Ideology and the Revolution," pp. 161–85; Gary B. Nash, "The Transformation of Urban Politics, 1700–1765," *Journal of American History* 60, no. 3 (December 1973): 626–32.

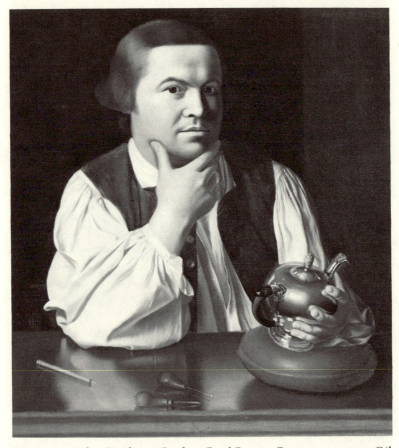

Figure 1. John Singleton Copley, *Paul Revere*. Boston, ca. 1770. Oil on canvas; H. 35″, W. 28½″. (Museum of Fine Arts, Boston, gift of Joseph W., William B., and Edward H. R. Revere.)

2), conveys the craftsman as active participant in his craft tradition. In the painting, a blacksmith, a cobbler, a baker, and an innkeeper are depicted with the tools of their trades. In Copley's painting, Revere contemplated his finished art, whereas in the folk portrait the focus is on the unknown artisans and how they are equipped to practice their crafts.

A third image that I think symbolizes the colonial craftsman as a

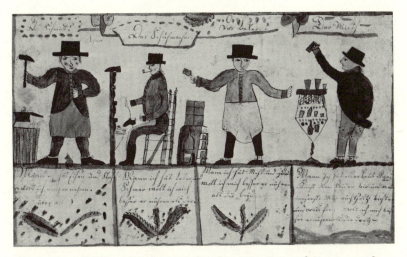

Figure 2. *The Four Tradesmen*. Southeastern Pennsylvania, ca. 1815. Watercolor on paper; H. 7½", W. 12½". (Courtesy Sotheby Parke Bernet, New York.)

legal, economic, and political person is the seal and motto of the New York Mechanick Society (fig. 3) as found on the society's membership certificates. The engraving depicts a muscular mechanic's arm, bared to the bicep and holding a hammer upright. Above the arm is lettered "By Hammer & Hand, all Arts do stand," a logo and epigram used by numerous colonial craftsmen's organizations.[45]

Unlike the first two graphics, where specific craftsmen are identified, the artisan on the society's certificate remains anonymous. We neither see his face nor know his name. I think he might serve, therefore, as an emblem for my third historiographical trend, indebted as it is to the "new" social history and its interest in "history from the bottom up." The iconography of this craft membership certificate serves at least two twentieth-century scholars as an appropriate colophon for their publications. In addition to its use by Hummel, Nash prefaces his essay in Young's *American Revolution* with this graphic.[46]

[45] Hummel, *With Hammer in Hand*, p. vii.
[46] Palmer, "Uncommon Common Men," pp. 5–9; Staughton C. Lynd, "The Revolution and the Common Man: Farm Tenants and Artisans in New York Politics, 1777–1788" (Ph.D. diss., Columbia University, 1962); Nash, "Up from the Bottom," pp. 57–

Figure 3. Detail of 1791 membership certificate of the New York Mechanick Society. (Winterthur Museum.)

The three historiographical traditions also have their own historiographers. Whitehill's *The Arts in Early American History* surveys the scholarship done on the colonial craftsman and his products, whereas Hindle's *Technology in Early America* documents the literature on the colonial craftsman and his work processes. To date there is no single bibliographical compendium that collects "new" political and social history of the craftsman as citizen and consumer, but the bibliography in Rock's *Artisans of the New Republic* might serve as a reference point for anyone seeking a listing of the basic sources.[47]

Despite the impressive scholarship that has been done to date by academic historians, museum historians, and avocational historians, one must report that craftsman history is only slowly becoming an integral part of American history. In Abraham Eisenstadt's selected essays on the craft of American history, for example, there is hardly a mention

64; Gary B. Nash, "Social Change and the Growth of Prerevolutionary Urban Radicalism," in Young, *American Revolution*, pp. 3–36.
 [47] Rock, *Artisans of the New Republic*, pp. 328–31.

of American craftsmen and their role in the American past.[48] The 1979 Winterthur conference, focusing as it did on three major perspectives that historians have taken when studying the craftsman in early America, sought to overcome this myopia as well as to stimulate a cross-disciplinary dialogue among decorative arts scholars and social historians, private collectors and historians of technology, art and architectural historians, as well as political and economic historians. The essays that follow, in addition to testifying to the conference's success in achieving that dialogue, are a superb documentary record of the current state of historical scholarship on crafts, craftsmanship, and craftsmen in early America.

[48] Abraham Eisenstadt, *The Craft of American History: Selected Essays* (New York: Harper & Row, 1966).

Artisans and Politics in Eighteenth-Century Philadelphia
Gary B. Nash

The political history of colonial America has only recently begun to take account of the crucial role played by urban artisans in the forging of a revolutionary mentality and a revolutionary movement. Yet the Revolution began in the seaboard towns and then spread outward to the countryside; and within these commercial centers artisans possessed great political potential, composing about half the taxable inhabitants and about the same proportion of the voters. In Philadelphia, the port to which this study of artisan political consciousness is devoted, 1,682 of the 3,350 taxable males in 1772 were artisans. Their political weight was critical in any contested election in the first two-thirds of the eighteenth century. And in the wake of the Seven Years' War, as the imperial crisis unfolded, they played a dynamic role in the formation of a revolutionary movement in the largest city of British North America. This essay examines the shaping of a highly politicized artisan community in Philadelphia during the eighteenth century and assesses the ambivalent nature of its political stance.

"Artisan community," of course, is only a phrase of convenience. At no time were artisans a unified body, identifying themselves as a class or a united interest group. They were divided by occupation, wealth, religion, status, and ideological position. They ranged from impecunious apprentice shoemakers to wealthy master builders. At the lower end of the scale were tailors, shoemakers, and coopers who had much in common with merchant seamen and porters; both groups shared low

wages, uncertain prospects of advancement, and exclusion from the ranks of property holders. At the upper end were brewers, tanners, bakers, sugar boilers, and some construction tradesmen who blended into the ranks of shopkeepers, proprietors, and even real estate developers. In spite of these differences, artisans had much in common, most importantly their craft skills and a life defined by productive labor. In the broadest view we can see two seemingly contrary trends at work among eighteenth-century Philadelphia artisans. On the one hand, the spectacular growth of the city—from about 5,000 in 1720 to 25,000 on the eve of the Revolution—caused greater occupation specialization and greater differentiation of wealth within the body of artisans. On the other hand, a greater feeling of common interest, extending across craft lines, occurred in the late colonial period as many artisans reshaped their views of their relations to other parts of their community and transformed their understanding of their political roles, rights, and responsibilities. Nonetheless, no homogeneous artisan political community emerged, and the radical potential of the mechanics was severely limited because of the wide range of roles occupied by these tradesmen within the eighteenth-century urban economy.

Any inquiry into the political consciousness of the eighteenth-century artisan requires some definition of the mechanics' values and goals, for politics was not an end in itself for laboring men, but the accomplishment, through laws and public policy, of privately held notions of how society should function. No Philadelphia artisan at the beginning of the eighteenth century imagined that he should stand for election to the assembly, shape governmental policy, or challenge the prevailing wisdom that those with social status, education, and wealth were best equipped to manage civil affairs. But artisans did understand their own interests, had deeply held values, and possessed a keen sense of whether social equity and justice prevailed in their community. This was so notwithstanding a long history of upper-class attempts to define them as a part of the "unthinking multitude," the "base herd," and, when they took to the streets, the "vile mob."[1]

In discussing the artisan's mentality it is best to begin with the con-

[1] For contemporary definitions of mechanic and upper-class attitudes toward artisans, see Carl Bridenbaugh, *The Colonial Craftsman* (1950; reprint ed., Chicago: University of Chicago Press, Phoenix Books, 1966), p. 155; and Howard B. Rock, *Artisans of the New Republic: The Tradesmen of New York City in the Age of Jefferson* (New York: New York University Press, 1979), pp. 4–8.

cept of opportunity because that concept, central to the "economic man," is deeply embedded in almost all discussions of early American society. It is of primary importance in understanding the obstacles that stood in the way of artisan political unity. For most urban artisans at the beginning of the eighteenth century opportunity did not mean the chance to accumulate great material wealth or to achieve high social status. Philadelphia's laboring men grew up in societies where intergenerational mobility was, with some exceptions, extremely slow, where sons unquestioningly followed their father's trade, where the Protestant work ethic did not beat resoundingly in every breast, and where warding off dire need rather than acquiring riches was the primary goal. It was economic security rather than rapid mobility that was uppermost in their minds.

The urban laboring man's constraint about what was possible was shaped by the distinctly preindustrial nature of economic life in the ports of early eighteenth-century America. Work patterns were irregular, dictated by weather, hours of daylight, erratic delivery of raw materials, and vacillating consumer demand. When the cost of fuel for artificial light was greater than the extra income that could be derived from laboring before or after sunlight hours, who would not shorten his day during winter? When winter desended on the Delaware River seaport, business often ground to a halt, for even in the southernmost of the northern harbors ice often blocked maritime traffic. This meant slack time for mariners and dockworkers, just as laborers engaged in digging wells, building roads, and excavating cellars for house construction were idled by frozen ground. The hurricane season in the West Indies also forced slowdowns because few shipowners were willing to place their ships and cargoes before the killer winds that prevailed in the Caribbean from August to October.[2] Other urban artisans were also at the mercy of the weather. If prolonged rain delayed the slaughter of cows in the country or made impassable the rutted roads into the city, then the tanner laid

[2] Joseph J. Kelley, Jr., *Life and Times in Colonial Philadelphia* (Harrisburg, Pa.: Stackpole Books, 1973), p. 48. Richard Pares analyzed the effects of weather on the North American–West Indies trade in *Yankees and Creoles: The Trade between North America and the West Indies before the American Revolution* (Cambridge, Mass.: Harvard University Press, 1956), p. 18. Two excellent accounts of the irregular pace of northern mercantile life are W. T. Baxter, *The House of Hancock: Business in Boston, 1724–1775* (Cambridge, Mass.: Harvard University Press, 1945), pp. 184–220; and Virginia D. Harrington, *The New York Merchant on the Eve of the Revolution* (New York: Columbia University Press, 1935), pp. 76–125.

his tools aside, and, for lack of his deliveries, the cordwainer was also idle. The hatter was dependent upon the supply of beaver skins which could stop abruptly if disease struck an Indian tribe or war disrupted the fur trade. Weather, disease, and equinoctial cycles all contributed to the fitful pace of urban labor—and therefore to the difficulty of producing steady income. Every urban artisan knew "broken days," slack spells, and dull seasons.[3]

While moving to America could not change the discontinuous work patterns of preindustrial European life, it did bring about an adjustment in perception about what was achievable. Fernand Braudel tells us that in Europe "the frontier zone between possibility and impossibility barely moved in any significant way, from the fifteenth to the eighteenth century." But it moved in America. Philadelphia's artisans could anticipate more favorable conditions than prevailed in the homelands that they, or their parents, had left. Unemployment was virtually unknown in the early decades of settlement, labor commanded a better price relative to the cost of household necessities, and urban land was purchased reasonably.[4]

This did not mean that artisans and laborers worked feverishly to ascend the ladder of success. Craftsmen who commanded 5s. a day and laborers who garnered 3s. knew that weather, sickness, and the inconstancy of supplies (and sometimes demand) made it impossible to work more than 250 days a year. This would bring an income of about £35 to £60, hardly enough to send aspirations spiraling upward. Even if the margin between subsistence and savings was greater than in Europe, it was still thin enough that years of hard work and frugal living usually preceded the purchase of even a small house. Hence, laboring people

[3] "The grand complaint with laborers among us," wrote Benjamin Rush in 1769, "is that we do not pay them sufficient prices for their work. A plain reason may be assigned for this; we consume too little of their manufactures to keep them employed the whole year around" (*The Letters of Benjamin Rush*, ed. Lyman H. Butterfield, vol. 1 [Princeton, N.J.: Princeton University Press, 1951], pp. 74–75). The irregularity of work for Philadelphia's artisans lasted into the nineteenth century, as Bruce Laurie explained in " 'Nothing on Impulse': Life-Styles of Philadelphia Artisans, 1820–1850," *Labor History* 15, no. 3 (Summer 1974): 343–44. Much can be learned on the subject from Keith Thomas, "Work and Leisure in Pre-Industrial Society," *Past and Present*, no. 29 (December 1964): 50–66; and E. P. Thompson, "Time, Work-Discipline, and Industrial Capitalism," *Past & Present*, no. 38 (December 1967): 56–97.
[4] Fernand Braudel, *Capitalism and Material Life, 1400–1800*, trans. George Weidenfeld (New York: Harper Torchbooks, 1973), p. ix. On wage-price relatives in England and the colonies, see Victor S. Clark, *History of Manufacturers in the United States*, vol. 1, 1607–1860 (Washington, D.C.: McGraw-Hill Book Co., 1929), pp. 155–58.

were far from the day when the failure to acquire property or to accumulate a minor fortune produced guilt or aroused anger against those above them. Most artisans did not wish to become lawyers, doctors, or merchants.[5] Their desire was not to reach the top, but to get off the bottom. Yet they expected to earn a "decent competency" and did not anticipate the grinding poverty of the laboring poor everywhere in Europe.

Philadelphia, for three-quarters of a century after its founding, richly nurtured this expectation of economic security and limited mobility. Not everyone succeeded in the early years, but, with the exception of a depression in the mid 1720s, the city experienced steady growth and general prosperity from 1681 to the late 1750s. From 1685 to 1753, 55 percent of the artisans whose estate inventories have survived left personal property worth between £51 and £200 sterling, and another 25 percent left in excess of £200, an amount that signifies a very comfortable standard of living.[6] The city to which Benjamin Franklin came as a printer's apprentice in 1725 was filled with young artisans who ascended steadily, if not quite so spectacularly and stylishly as Poor Richard.[7] Success for so many in the first eight decades of Philadelphia's history must have affected the aspirations of other new arrivals. No wonder that Franklin became the hero of the city's "leather apron men" and that his little booklet, variously entitled *Father Abraham's Speech*, *The Way to Wealth*, and *The Art of Making Money Plenty in Every Man's Pocket* became a best seller in Philadelphia. It was not, however, a formula for "unlimited acquisition," but rather a comfortable existence "which was the midpoint between the ruin of extravagance and the want of poverty."[8]

A degree of economic ambition, then, was nourished by actual

[5] Bridenbaugh argued that among artisans the "driving desire" was "to raise themselves and their families above their present level" and "to get into the 'white-collar class' " (*Colonial Craftsman*, p. 165). It is the second part of this statement to which I take exception.

[6] Gary B. Nash, *The Urban Crucible: Social Change, Political Consciousness, and the Origins of the American Revolution* (Cambridge, Mass.: Harvard University Press, 1979), table 5, pp. 397–98.

[7] James G. Lydon, "Philadelphia's Commercial Expansion, 1730–1739," *Pennsylvania Magazine of History and Biography* 91, no. 4 (October 1967): 401–18. The occupational careers of these artisans can be followed in part through the deed books, which can be used to chart property acquisition and occupational change. For this period, see Deed Books E-5/7, E-6/7, and E-7/8, City Archives, City Hall Annex, Philadelphia.

[8] J. E. Crowley, *This Sheba, Self: The Conceptualization of Economic Life in Eighteenth-Century America* (Baltimore: Johns Hopkins University Press, 1974), p. 84.

experience with what was possible. By the same token, ambition varied with occupation and to an extent with the particular era we are considering. It must be kept in mind that mechanics varied considerably in terms of income, wealth, and property ownership and that this affected their aspirations and, ultimately, the cast of their political thinking. Thus, those at the bottom of the hierarchy of artificers—coopers, tailors, shoemakers, stocking weavers, and ship caulkers—had more limited goals than silversmiths, house carpenters, brickmakers, and instrumentmakers. This modesty of aspiration at the lower levels of the artisan hierarchy was expressed clearly in 1779 by the shoemakers and tanners of Philadelphia. "For many years," they wrote, "the prices of skins, leather, and shoes were so proportioned to each other as to leave the tradesmen a bare living profit; this is evidently proved by this circumstance well known to everybody, that no person of either of these trades, however industrious and attentive to his business, however frugal in his manner of living, has been able to raise a fortune rapidly, and the far greater part of us have been contented to live decently without acquiring wealth; nor are the few among us who rank as men of property, possessed of more than moderate estates. Our professions rendered us useful and necessary members of our community; proud of that rank, we aspired to no higher."[9]

The last phrase of the shoemakers' petition—"our professions rendered us useful and necessary members of our community"—spoke directly to a second important part of the artisans' constellation of values—respectability. Craft pride and a desire to be recognized for contributing to the community were of great importance to them and functioned, as an English historian said, as "an alternative to wealth as a criterion for social judgement."[10] One of the keys to Franklin's success as an urban organizer was his skill in appealing to this dignity that artisans felt as members of the producing class. For example, in 1747, with the threat of a French attack looming and the assembly dragging its feet on military mobilization, Franklin exhorted the artisans of Philadelphia to organize a voluntary militia. Writing as A Tradesman, he argued that the "plain truth" of the matter was that the artisans had always been

[9] *To the Inhabitants of Pennsylvania in General, and Particularly Those of the City and Neighbourhood of Philadelphia* ([Philadelphia, 1779]), Library Company of Philadelphia.
[10] Geoffrey Crossick, *An Artisan Elite in Victorian Society: Kentish London, 1840–1880* (Totowa, N.J.: Rowman and Littlefield, 1978), p. 135.

at the heart of civic improvements and now must solve for themselves a problem that their upper-class leaders were cravenly evading.[11] The result was the formation of the Associators, who became a symbol of artisan strength and respectability. Called into being by the artisan par excellence among them, acting where upper-class leaders had failed, and electing their own officers, they never engaged the enemy, but nonetheless conferred upon themselves a collective strength and a confirmation of their value to the community.

Throughout the preindustrial period this artisan self-esteem and desire for community recognition jostled with the upper-class view of artisans as "mean," "base," and "vulgar," to invoke the contemporary definitions of *mechanic*. When wealthy urban dwellers referred to skilled craftsmen as "meer mechanics" or made generalized statements about laboring people as inferior, ignorant, and morally suspect, they ran squarely athwart the self-image of artisans, "the meanest" of whom, as one Philadelphian noted in 1756, "thinks he has a Right of Civility from the greatest" person in the city.[12]

In their attempts to gain respectability in the eyes of the community and maintain self-respect, artisans placed a premium on achieving "independence," or, to put it the other way around, on escaping dependency. At the most primary level, economic independence meant the capacity to fend off the need for charity and poor relief. "The ability to maintain oneself by one's labour without recourse to such things as charity" was "a crucial material and psychological dividing-line," wrote I. J. Prothero of the preindustrial London artisan, and the same may be said of his Philadelphia counterpart. In Philadelphia this self-maintenance proved attainable for almost every artisan for three generations after Penn's colony was founded. At a higher level, economic independence meant making the transition from apprentice to journeyman to master craftsman—the three-step climb from servitude to self-employment. This transition was of critical importance to eighteenth-century

[11] *The Papers of Benjamin Franklin*, ed. Leonard W. Labaree, vol. 3, *January 1, 1745–June 30, 1750* (New Haven, Conn.: Yale University Press, 1959), pp. 200–201.

[12] Jacob Duche, *Pennsylvania Journal* (March 25, 1756). Sixteen years later the same author would rephrase the notion, writing that "the poorest labourer upon the shore of *Delaware* thinks himself entitled to deliver his sentiments in matters of religion or politics with as much freedom as the gentleman or scholar. . . . For every man expects one day or another to be upon a footing with his wealthiest neighbour;—and in this hope shews him no cringing servility, but treats him with a plain, though respectful familiarity" (*Pennsylvania Packet* [March 30, 1772]).

artisans because it meant more than economic rewards and the freedom to control hours of work; it also meant respectability and an autonomous existence outside the workplace, something that often proved difficult when one's livelihood was dependent upon another man.[13]

Care must be taken in using words such as *autonomy* and *independence* to describe artisan values because these goals were framed by a broader corporate and communitarian outlook. The notion of belonging to a "trade" carried with it a sense of cooperative workshop labor where master craftsman, journeyman, and apprentice were bound together in service to themselves, each other, and the community. A man was not simply a carpenter or a cooper in Philadelphia, striving independently to make a living; he was also a member of a collective body, hierarchically structured but organized so that all mechanics, theoretically at least, would in time become masters. Men might aspire individually—Franklin could not brook the role of apprentice or journeyman and competed fiercely with his fellow printers in Philadelphia once he established his own shop—but this striving was reined by a collective trade identity and a commitment to the community in which he labored. "When I was a boy," wrote John Watson of the late eighteenth-century artisans, "there was no such thing as conducting their business in the present wholesale manner, and by efforts at monopoly. No masters were seen exempted from personal labor in any branch of business—living on the profits derived from many hired journeyman."[14]

This traditional outlook, stressing the mutuality of relations between craftsmen at different ranks within a trade and the community responsibilities of the trade itself, was challenged in the eighteenth century by the rise of the laissez-faire ethos which celebrated entrepreneurial, atomistic competition and the accumulative spirit. In the older view, labeled the "moral economy" by E. P. Thompson, all economic activity carried social responsibilities with it and was necessarily tied to the

[13] Iorwerth J. Prothero, *Artisans and Politics in Early Nineteenth-Century London: John Gast and His Times* (Hamden, Conn.: Dawson Publishing, 1978), p. 26. In those trades requiring greater organization and capital, the rise from journeyman to master proved impossible for many, if not most, men; nonetheless, the ideology of the independent craftsman figured importantly in the producer mentality of the eighteenth century.

[14] John F. Watson, *Annals of Philadelphia, and Pennsylvania, in the Olden Time*, vol. 1 (Philadelphia: Edwin S. Stuart, 1900), pp. 240–41. Watson completed his annals in 1842. For an exploration of the preindustrial artisan's collective trade identity, see Robert Sean Wilentz, "Class Conflict and the Rights of Man: Artisans and Radicalism in Antebellum New York" (Ph.D. diss., Yale University, 1979), chap. 2.

good of the community. This put limitations on what an artisan was entitled to charge for his product or his labor and even extended to hold "every man accountable to the community for such parts of his conduct by which the public welfare appears to be injured or dishonoured, and for which no legal remedies can be obtained."[15] But the newer outlook, "possessive individualism" which C. B. MacPherson has probed, legitimated unrestrained economic activity. The craftsman, like every member of the community, could charge as much as the market would bear for his goods and services, and his rights in holding property were inviolate. These jarring views surfaced dramatically at moments of economic crisis such as in Philadelphia in 1779 when food shortages and burgeoning inflation put severe pressure on many artisans and laborers. Bitterly opposed to the shipment of grain by the wealthy merchant Robert Morris at a time when bread was in short supply in the city, many artisans argued that Morris's property rights in the vessel were limited by the needs of the community. "We hold," they stated, "that though by the acceptance of wages [the shipbuilders] have not, and cannot have any claims in the property of the vessel, after she is built and paid for, we nevertheless hold, that they and the state in general have a right in the service of the vessel, because it constitutes a considerable part of the advantage they hoped to derive from their labours." This assertion that property was social in origin, carrying with it responsibilities to the commonweal, was the basis upon which they might concede that "the *property* of the vessel is the immediate right of the owner" but "the service of it is the right of the community collectively with the owners."[16]

It is impossible to chart precisely the advance of the new capitalistic mentality and the receding of the old corporate ethic. To some extent, in fact, the two were fused into a "collective individualism" where the values of community-oriented petty-commodity workshop production commingled with the new notions of economic rationality and pursuit

[15] Joyce Appleby, "The Social Origins of American Revolutionary Ideology," *Journal of American History* 64, no. 4 (March 1978): 935–58; E. P. Thompson, "The Moral Economy of the English Crowd in the Eighteenth Century," *Past & Present*, no. 50 (February 1971): 76–136; *Pennsylvania Packet* (June 29, 1779).

[16] C. B. MacPherson, *The Political Theory of Possessive Individualism: Hobbes to Locke* (Oxford: Clarendon Press, 1962); *Pennsylvania Packet* (September 10, 1779), as quoted in Steven Rosswurm, "Arms, Culture and Class: The Philadelphia Militia and the 'Lower Orders' in the American Revolution, 1765–1783" (Ph.D. diss., Northern Illinois University, 1979), p. 419.

of self-interest.[17] Very loosely one might argue that in times of prosperity the new bourgeois stance dominated the consciousness of artisans, particularly those in the more profitable trades, where opportunity for advancement was the greatest, and that in times of economic stress the moral economy compelled greater allegiance, especially among the lower artisans whose opportunities were far more circumscribed. Overarching this dialectic was the long-range tendency within many crafts for the bonds of mutuality to fray between masters and journeymen. Eventually the ties would be virtually severed as a class of capitalist entrepreneurs confronted rather than cooperated with a class of perpetually dependent wage laborers.

With these values of the workplace in mind we can turn to the political life of Philadelphia's mechanics. Here again the ideal was participation in the civic life of the community, with the public good the great end to be accomplished. Serving the commonweal, however, depended heavily on the independent exercise of political "will." As the Whig scientists of politics insisted in the eighteenth century, a republican form of government could only exist when its citizens were not cajoled, bribed, or dominated into making political decisions and choices, but freely exercised their independent judgment. This concept led directly back to economic independence because it was impossible for a man freely to assert his political will when he was beholden to another for his economic existence. Without economic self-sufficiency, the laboring citizen inevitably fell prey to the political desires of his patron, employer, landlord, or creditor. Economic dependency destroyed true political liberty—the essence of the "Independent Whig."[18]

Such an emphasis on the independent exercise of political will brings us face to face with the concept of deference. In the historical literature

[17] The phrase is from Yehoshua Arieli, *Individualism and Nationalism in American Ideology* (Baltimore: Penguin Books, 1964).

[18] [John Trenchard and Thomas Gordon], *Cato's Letters; or, Essays on Liberty, Civil and Religious*, 4 vols. (6th ed.; London, 1755), 2:16; 3:207–8. Another quite different way of surrendering one's political will to those with economic power was to accept election-time "bribes" in the form of liquor or other treats, as New York's *Independent Reflector* explained at length in an essay, "Elections and Election-Jobbers," in 1753 (see *The Independent Reflector; or, Weekly Essays on Sundry Important Subjects, More Particularly Adapted to the Province of New York, by William Livingston and others*, ed. Milton M. Klein [facsimile ed.; Cambridge, Mass.: Harvard University Press, 1963], pp. 278–84).

of the last generation this is the key concept for laying bare the dynamics of eighteenth-century politics because it provides the mediating device that seemingly reconciles two contrary tendencies in colonial politics: the conferring of the vote upon a broad group of property owners and the persistent management of politics by a small elite. *Deference* is the term employed to describe the unquestioning acceptance of an eighteenth-century moral order which consigned laboring people to economic, social, and political subordination. "Deference," wrote J. G. A. Pocock, "is the product of a conditioned freedom, and those who display it freely accept an inferior, nonelite, or follower role in a society hierarchically structured."[19]

From deference it is only a step to speaking of cultural hegemony, the notion that the ruling classes are able to obtain and maintain the consent of those subject to them because their rule gains legitimacy even in the eyes of the most oppressed members of society. "By diffusing its own concept of reality, morality, meaning, and common sense through the schools, press, religious bodies, the daily life of the streets, the workplace, and the family," the ruling class fosters the notion that they use their authority responsibly and for the good of the whole. Ultimately, this idea becomes a more powerful instrument in the hands of those in control than guns or clubs, for while class or racial conflict is not eliminated, it is largely muted by an acceptance of "the system" at the lower levels of society.[20]

The concepts of deference and cultural hegemony can be usefully employed in studying artisan politics in Philadelphia, but they must be used with care. For example, there is voluminous evidence that upperclass Philadelphians believed in and promoted as "natural" (or even ordained from on high) a system of social relations marked by gentle domination from above and willing dependency from below; but there

[19] J. G. A. Pocock,"The Classical Theory of Deference," *American Historical Review* 81, no. 3 (June 1976): 516. For theoretical considerations of deference, see Howard Newby, "The Deferential Dialectic," *Comparative Studies in Society and History* 17 (April 1975): 140–62; Edward Shils, "Deference," in *Social Stratification*, ed. J. A. Jackson (Cambridge: At the University Press, 1968), pp. 104–32; and Erving Goffman, "The Nature of Deference and Demeanor," in *Interaction Ritual: Essays in Face-to-Face Behavior* (Chicago: Aldine Publishing Co., 1967), pp. 47–95. John Alexander challenged the notion that deference was freely given in Philadelphia in "Deference in Colonial Pennsylvania and That Man from New Jersey," *Pennsylvania Magazine of History and Biography* 102, no. 4 (October 1978): 422–36.

[20] Alan Dawley, "E. P. Thompson and the Peculiarities of the Americans," *Radical History Review*, no. 19 (Winter 1978/79): 43.

is also evidence that laboring people did not always accept elite rule and cultural authority complaisantly. The key to making sense of the political activities of Philadelphia's artisans in the eighteenth century is to recognize that "a lived hegemony is always a process, . . . a realized complex of experiences, relationships, and activities, with specific and changing pressures and limits." As Raymond Williams has advised, cultural hegemony, as a form of dominance, "has continually to be renewed, recreated, defended, and modified" because in most historical circumstances it is "also continually resisted, limited, altered, challenged by pressures not at all its own." In other words, there is nothing static and immutable about a hegemonic condition; rather, it is "an institutionally negotiable *process* in which the social and political forces of contest, breakdown, and transformation are constantly in play."[21] It is therefore necessary to identify the changing conditions in eighteenth-century Philadelphia that altered class relations and political ties between artisans and those above them who functioned as the cultural standard-bearers and political magnates of their day.

Only twice in the long period from 1682 to 1776 were the basic goals of the artisans deeply threatened by severe economic adversity. On both occasions they quickly challenged the political dominance of Philadelphia's upper-class merchants and professionals. In the severe depression of the 1720s, when a steep decline of shipbuilding, trade, and house construction brought unemployment and harassment for debt to hundreds of artisans, the mechanics provided an opposing ideology that stressed the self-interest of the wealthy and, hence, the necessity for common people to organize in their own behalf. The immediate question around which artisans organized was the issuing of paper money, which they regarded as an antidote to the severe trade slump that affected almost every sector of the city's economy. But political contention soon leaped across this boundary, broadening to include debates on the accountability of representatives to their constituents, the organization of politics, and the nature of the body politic itself.[22]

It was in the early 1720s that Philadelphia's artisans first entered

<hr>

[21] Raymond Williams, *Marxism and Literature* (Oxford: Oxford University Press, 1977), pp. 113–14; Geoff Elay and Keith Nield, "Why Does Social History Ignore Politics?" *Social History*, no. 5 (1980): 269.

[22] This is examined more closely in Nash, *Urban Crucible*, pp. 148–56; and Thomas Wendel, "The Keith-Lloyd Alliance: Factional and Coalition Politics in Colonial Pennsylvania," *Pennsylvania Magazine of History and Biography* 92, no. 3 (July 1968): 289–305.

into electoral politics in large numbers and thereby began to sense the power they commanded when they acted collectively. Instruments of a new form of popular politics appeared in the formation of party tickets through caucuses, the recruitment of immigrant German and Scots Irish voters, direct appeals to the electorate through broadside "advice" where positions on specific issues were announced and the wealthy denounced, outdoor political rallies that welcomed voters and nonvoters alike, political parades and demonstrations, and the formation of tavern-based artisan political clubs.

The cries of the wealthy gentry politicians under attack tell us how thoroughly alarmed they were at the sight and sound of artisans participating in politics on a mass basis. "Ye people head and foot run mad," wrote Isaac Norris, one of Philadelphia's wealthiest merchants. "All seems topside Turvey. Our publick Speeches tell ye Country & ye World that neither knowledge or riches are advantageous in a Country. . . . The Mobb is Hallood on to render obnoxious Every Man who has any proportion of those." Political power was no longer in the hands of "ye Wise, ye Rich or the learned," but had fallen to "Rabble Butchers, porters & Tagrags," and the political arena had shifted from gentlemen's parlors to "dramshops, tiff, & alehouses" where "a great number of modern statesmen & some patriots" could be found "settling affairs, cursing some, praising others, contriving lawes and swearing they will have them enacted cum multis aegis." The practical results were assembly elections in 1721 and 1722 that were "very mobbish and carried by a levelling spirit." They swept from office conservative men of wealth and replaced them with smaller traders and landowners.[23]

The opposition of the merchant-professional elite to paper money was a major factor in the growth of artisan-based politics in this era. Intensifying the hostility of laboring men to the wealthy were the attacks on artisan respectability led by merchant and proprietary officeholder James Logan. Always ready to take up the cudgels in defense of hierarchy, social order, and wealth, Logan argued in publicly distributed

[23] Isaac Norris to Stephen DeLancey, February 12, 1723, Norris to Jonathan Scarth, October 21, 1726, Norris Letter Book, Historical Society of Pennsylvania (hereafter cited as HSP); James Logan to John Penn, October 17, 1726, Penn Papers, Official Correspondence, vol. 1, pp. 237, 239, 247, HSP; Logan to Henry Gouldney, February 9, 1722/23, in *Pennsylvania Archives*, 2d ser., vol. 8 (Harrisburg, 1890), pp. 70–71. Five of Philadelphia's wealthiest merchants were swept from office in 1722, and two others lost their seats in the following year.

pamphlets that the depression of the 1720s was caused mainly by laboring-class perversity. It was idleness and fondness for drink that made men poor and the charging of high wages by artisans that drove away employment. Those who tried "new politics" and invented "new and extraordinary Measures" such as paper money misunderstood the roots of economic distress. The rich were rich because of their "Sobriety, Industry and Frugality," the poor were poor because of their "Luxury, Idleness and Folly." Logan paid a price for this personal attempt at cultural hegemony. His house was attacked by an angry mob who tore off the window shutters, bombarded his bedchamber with bricks, and threatened to level one of Philadelphia's most gracious structures.[24] He was publicly attacked in pamphlets for his contempt of the "poorer sort" and for leading a group of Pennsylvanians who wished to recreate, it was charged, "the Old English Vassalage."[25]

The political mobilization of artisans in the mid 1720s and the distinctly undeferential behavior of laboring people shows how quickly the sense of interclass partnership, the basis of hegemonic rule by Philadelphia's solons, could be shattered. Previously, the superior wisdom of the elite, and, hence, the legitimacy of their rule, had been generally accepted, although Philadelphia's early years had been so filled with contention and its social ranks had been so fluid that no firm legacy of merchant family political dynasties had been handed down to the 1720s. Now the affective bonds between social ranks were shattered. Nothing was more important in undermining the sense of partnership than the published pronouncements by men such as Logan and Norris that the mechanics themselves were responsible for Philadelphia's economic difficulties because they demanded too much for their labor and squandered their earnings at the taverns. Mercantile opulence was indispensable to the economic health of the community, argued Logan, in an early form of the trickle-down theory, and only the "Sot, the Rambler,

[24] James Logan, *The Charge Delivered from the Bench to the Grand Jury* (Philadelphia, 1723), HSP; Logan to James Alexander, October 23, 1749, Logan Letter Book, HSP. Logan was recalling an incident that occurred almost twenty-five years before, which indicates how searing the experience must have been to a man who regarded himself as one of Pennsylvania's chief assets.

[25] Among the many pamphlets published from 1723 to 1728 that indicted Logan as arrogant, power hungry, and insensitive to the difficulties of laboring people, the fullest is the forty-five page pamphlet attributed to William Keith, *The Observator's Trip to America, in a Dialogue between the Observator and His Country-man Roger* ([Philadelphia], 1726), HSP.

the Spendthrift, and Slip Season" found themselves in economic straits.[26] Such comments struck at the artisans' self-respect, their search for independence, and their sense of belonging to an organic society where people of different statuses were mutually involved in a social partnership. It was plain that those who lived by the labor of their hands had suffered most in the depression. Thus aroused, what had been a politically passive, deferential laboring class at one moment became a politically conscious, highly active body of mechanics at the next.

Leadership of the artisans, however, remained in the hands of those near the top of the social hierarchy. The chief pamphleteer for paper money was Francis Rawle, a lesser merchant, and the leader of the political mobilization was none other than the ex-Jacobite Tory placeman, Sir William Keith, appointed by William Penn in 1717 as governor of Pennsylvania but by the early 1720s thoroughly alienated from Penn's widow and her proprietary officeholders led by Logan. It was Keith who not only endorsed the issuing of paper money in 1722 but also proposed legislation for reducing the interest rate, curbing lawyers' fees, and restricting the imprisonment of debtors. By the next year he had organized the first artisans' political group in Philadelphia's history—the Leather Apron Club—and for the next few years masterminded the artisan-based political campaigns.[27]

Politics *cum multis aegis* came to an end when prosperity returned to Philadelphia in the 1730s. Now artisans reassumed their former role of acting as a check on the exercise of power by those in the upper ranks through annual assembly and local elections but otherwise leaving public affairs to their betters. They had intervened only when those with more time (and presumably more learning) to apply to politics abused the trust placed in them by their constituents. But the 1720s left a legacy to succeeding generations. It included not only the necessity of laboring-class political mobilization in times of adversity but also residual distrust of the wealthy and a suspicion that they did not, as they claimed, always act for the public good because they were better educated and therefore, in theory, disinterested.

Finally, the 1720s shattered the belief that in Pennsylvania eco-

[26] Gary B. Nash, *Quakers and Politics: Pennsylvania, 1681–1726* (Princeton, N.J.: Princeton University Press, 1968); Logan, *Charge Delivered*; James Logan, *A Dialogue Shewing, What's Therein to Be Found* ([Philadelphia], 1725), HSP.

[27] Nash, *Urban Crucible*, pp. 148–55; Wendel, "Keith-Lloyd Alliance," pp. 289–305.

nomic opportunity was limitless and that therefore one man's rise to wealth was not accomplished at somebody else's cost. Pennsylvanians had been casting off the European conception of societies containing fixed quantities of wealth that must be distributed like a pie, so that when one man's piece was cut larger, others had to satisfy themselves with narrower slices. Now the artisan had learned that in Philadelphia too the aggrandizement of wealth and power by the few could be costly to the many. The point was driven home in a parable of class relations spread through the streets near the end of the depression. "A Mountebank," ran the story, "had drawn a huge assembly about him: Among the rest, a fat unwieldy Fellow, half stifled in the Press, would be every Fit crying out, Lord! what a filthy Crowd is here! Pray, good People, give Way a little! Bless me! what a De[vi]l has raked this Rabble together? What a plaguey squeezing is this? Honest Friend, remove your Elbow. At last, a Weaver that stood next him could hold no longer; A Plague confound you (said he) for an overgrown Sloven! and who in the De[vi]l's Name, I wonder, helps to make up the Crowd half so much as your self? Don't you consider (with a P–x) that you take up more Room with that Carcass than any Five here? Is not the Place as free for us as for you? Bring your own Guts to a reasonable Compass (and be B[un]ged) and then I'll engage we shall have Room for us all."[28]

During the postdepression generation, from 1730 to the early 1750s, Philadelphia's rapidly expanding economy offered most artisans the opportunity to achieve their goals of economic security, respectability, and independence. This is indicated in hundreds of deeds recording acquisitions of property by artisans and scores of estate inventories showing substantial artisan wealth. In such a climate the inflamed politics of the 1720s subsided and laboring men were content to leave the management of public affairs in the hands of those above them. This may be called deference, but we should employ that term only in the limited sense that artisans saw no need to intervene directly in politics, other than to cast their ballots, so long as those for whom they voted were responsive to their needs. Rapid urban growth and full employment after 1730 restored the atmosphere of interrank solidarity. The artisans, wrote Brother Chip some years later, for years had "tamely submitted" to the nomination of all candidates for office in Philadelphia by a

28 [William Keith], *A Modest Reply to the Speech of Isaac Norris, Esq.* ([Philadelphia, 1727]).

"Company of leading Men" who did not permit "the affirmative or negative voice of a Mechanic to interfere."[29]

Yet, while the hegemonic control of the elite had been reestablished, it had constantly to contend with the ideal of the independent voter. Pamphleteers such as Constant Trueman kept artisan voters alert to the idea that the preservation of political "will" or "independence" required habits of mind that abhorred subservient behavior. "Let me tell you, Friends," wrote Trueman in 1735, "if you can once be frightened by the Threats or Frowns of great Men, from speaking your Minds freely, you will certainly be taught in a very little Time, that you have no liberty to act freely, but just as they shall think proper to Command or Direct; that is, that you are no longer Freemen, but Slaves, Beasts of Burden, and you must quietly submit your Necks to the Yoke, receive the Lash patiently let it be ever so Smart, and carry all the Loads they think proper to clap on your Backs, without kicking or wincing."[30]

Trueman's admonitions spoke directly to the fact that many artisans, especially those in the service and retail crafts, lived in a world of economic clientage where their economic security was bound up with an employer, landlord, or extender of credit. This, of course, was the antithesis of the ideal world where they would enjoy economic independence; and to the extent that artisans deferred politically to powerful men with economic leverage on them, they alienated their political selves because their independent exercise of judgment had been abridged. In Philadelphia, however, the ability of patrons to strong-arm their laboring clients was somewhat muted by the use of the secret ballot.[31]

In the depression that beset Philadelphia at the end of the Seven Years' War the interclass trust, which alone could sustain political deference that was based on affective bonds between different social strata, melted away. When the postwar commercial depression bottomed out early in 1765, hopes revived for better times. But within a year the

[29] A detailed account of the placid period of politics from the end of the depression of the 1720s until the beginning of the Seven Years' War is given in Alan Tully, *William Penn's Legacy: Politics and Social Structure in Provincial Pennsylvania, 1726–1755* (Baltimore: Johns Hopkins University Press, 1977); Brother Chip, *Pennsylvania Gazette* (September 27, 1770).

[30] Constant Trueman, *Advice to the Free-Holders and Electors of Pennsylvania* ([Philadelphia, 1739]), pp. 1–2.

[31] In the context of nineteenth-century England and Virginia, see the valuable discussion by Paul F. Bourke and Donald A. Debats, "Identifiable Voting in Nineteenth-Century America: Toward a Comparison of Britain and the United States before the Secret Ballot," *Perspectives in American History* 9 (1977/78): 259–88.

Philadelphia grand jury reported that many of "the labouring People, and others in low circumstances, who are willing to work, cannot obtain sufficient Employment to support themselves and their Families." Reports of unemployment continued for the next two years, and by the end of 1769 forced sales of property reached an all-time high. An economic revival occurred in 1770, but it was short-lived because within two years a severe contraction of British credit again brought widespread unemployment.[32]

Compounding the difficulties of laboring Philadelphians was the upward movement of food prices, which had risen sharply during the Seven Years' War. Although they fell modestly between 1765 and 1769, they then began a climactic five-year climb that elevated the cost of a weighted nineteen-item laboring man's diet 23 percent between 1769 and 1774. This punishing upswing caused no *crise de subsistance* in Philadelphia, but the situation was serious enough to put hundreds of artisans in difficult straits and for the Philadelphia overseers of the poor to begin distributing bread for the first time in the city's history.[33]

The severity of the post-1760 depression can be seen most clearly in the rapid growth of a large class of indigents in Philadelphia for the first time in its history. Urban poverty challenged the governing modes of thought in Philadelphia, shook artisans' confidence in the internal economic system, and intensified class feeling. "He that gets all he can honestly, and saves all he gets (necessary Expenses excepted)," printer Ben was fond of saying to his fellow mechanics, "will certainly become RICH."[34] Now, the inapplicability of this system of moral economics was made plain. Even for those who escaped poverty in the 1760s in Philadelphia, the impoverishment of so many below them was impossible to ignore because when indigency befell a large portion of the lowest laboring ranks, not simply the aged and infirm, it signified sickness in the entire economic body.

[32] *Votes and Proceedings of the House of Representatives of the Province of Pennsylvania*, ed. Gertrude MacKinney, in *Pennsylvania Archives*, 8th ser., vol. 7 (Harrisburg, 1935), p. 5830; Nash, *Urban Crucible*, pp. 319–20.

[33] Billy G. Smith, "The Material Lives of Laboring Philadelphians, 1750–1800," *William and Mary Quarterly*, 3d. ser., 38, no. 2 (April 1981): 172–75; Minutes of the Overseers of the Poor, 1768–74, City Archives, City Hall Annex, Philadelphia. See especially entries for January 27, 1772; March 9, November 1, December 13, 1773; February 28, October 17, 1774; February 1, March 1, April 5, 1775.

[34] Gary B. Nash, "Poverty and Poor Relief in Pre-Revolutionary Philadelphia," *William and Mary Quarterly*, 3d ser., 33, no. 1 (January 1976): 3–30; *Papers of Benjamin Franklin*, 3:308.

The response of the laboring poor to the new system of poor relief that was instituted in 1767 in Philadelphia indicates how the respectability as well as the economic security of the lower artisans was undermined and how strongly they resented this. Faced with ballooning poor-relief costs, which necessitated heavier taxes, the Assembly agreed to let a group of Quaker merchants dismantle the old out-relief system and replace it with a "bettering house" where the poor would be confined and, it was said, taught better work habits. The decision to end out-relief drew the Quaker merchants who managed the bettering house into a heated dispute with the overseers of the poor. The overseers, drawn mostly from the ranks of established artisans, were far closer to the needy in their neighborhoods and understood the resentment of the non-Quaker poor who were being driven into a Quaker-dominated institution. Underlying these upper-class Quaker attempts at moral management was the old notion that unemployment and poverty were attributable not to structural weakness in the economy, but to moral weakness within the laboring class. In effect, these indictments were attacks on laboring-class respectability. As such they were staunchly resisted, not only by the overseers of the poor but by the poor themselves. Many of them, the overseers reported, "declared in a Solemn manner that they would rather perish through want" than go to the bettering house, whose very name was an insult to their struggles for respect and a secure place in society. Charity was in itself distasteful to laboring Philadelphians, but charity that carried with it an accusation of moral failing was not to be endured.[35]

In the face of the economic ills of the 1760s and 1770s Philadelphia's artisans embarked on the most intense period of organizing in their history. The cordwainers organized a craft guild in 1760, journeymen carpenters established their own company and attempted to set wage rates a few years later, and tailors drew together in 1771 in order to fix prices at levels that would yield them a decent subsistence. All of this, of course, was taking place in the midst of the gathering storm between the colonies and England. And central to the response of the seaport cities to British attempts to extract greater economic advantages from the North American colonies were three nonimportation movements which drew artisans into the political arena as never before.

All of the instrumentalities of popular politics that had appeared in

[35] Nash, *Urban Crucible*, pp. 327–31; Minutes of the Overseers, June 15, 1769.

the 1720s reemerged in the turbulent 1760s. Outdoor political rallies, vitriolic political campaign literature, petition drives, club activity, and attacks on the wealthy as subverters of the community's welfare characterized the elections of 1764 and 1765 when the voter turnouts reached all-time highs in Philadelphia.[36] In the following decade, however, a transformation of mechanic consciousness ushered in a new era of politics. Most striking, artisans began to exert themselves as a separate political entity. This can be traced in the newspaper and pamphlet appeals, beginning about 1767, which were addressed specifically to the mechanic segment of the community as a separate interest. Popular politics gathered momentum in 1768 when artisans, attempting to spur foot-dragging merchants to adopt nonimportation, themselves called public meetings, published newspaper appeals, and organized secondary boycotts of importing merchants. Thereafter artisans began to transcend mere craft allegiances and build political strength which Franklin had anticipated twenty years before when he declaimed that within their separate crafts the mechanics "are like separate Filaments of Flax before the Thread is form'd, without Strength because without Connection, but UNION would make us strong and even formidable," even when opposed by "the *Great* . . . from some mean views of their Own."[37]

Moreover, the 1760s brought into the political arena the younger and poorer artisans, who, for lack of property, were not yet entitled to vote. Pamphlets and broadsides were read by the unenfranchised, outdoor political rallies and street demonstrations were open to all, organizers of petitions gathered signatures from voters and nonvoters alike.

[36]Gary B. Nash, "The Transformation of Urban Politics, 1700–1765," *Journal of American History* 60, no. 3 (December 1973): 626–32. By this time—and, in fact, for several decades before—the level of political literacy and popular participation in politics was far higher in Philadelphia than in English towns of equivalent size. In Birmingham, for example, which had a population of about 24,000 in 1750 and perhaps 30,000 on the eve of the American Revolution, the parliamentary election of 1774 drew a record 405 voters—the high-water mark of "popular articulacy" in this era. Philadelphia, by contrast, with about 15,000 inhabitants in 1765 (not including Southwark and Northern Liberties), drew 1,448 voters to the polls in 1764 and 1,798 in 1765. For Birmingham, see John Money, "Taverns, Coffee Houses and Clubs: Local Politics and Popular Articulacy in the Birmingham Area in the Age of the American Revolution," *Historical Journal* 14, no. 1 (March 1971): 33.

[37]Nash, *Urban Crucible*, pp. 305–9, 374–75; Charles S. Olton, *Artisans for Independence: Philadelphia Mechanics and the American Revolution* (Syracuse, N.Y.: Syracuse University Press, 1975), pp. 33–41. Franklin's statement about union is from *Plain Truth; or, Serious Considerations on the Present State of the City of Philadelphia, and Province of Pennsylvania* (Philadelphia, 1747) in *Papers of Benjamin Franklin*, 3:202.

By usage, if not by law, the lower artisan became politically conscious and politically active long before the electoral laws conferred the right of "citizen" upon him.

It took until March 1769 for popular pressure to bring Philadelphia's merchants into the nonimportation fold, and by that time the disillusionment with them in the artisan community was widespread. A year later the merchants tried to break free of the agreement, confirming the suspicions of leather-apron men that, whatever the situation in the past, a community of interest no longer existed between mechanic and merchant. Desiring to end nonimportation after drawing down their inventories, the merchants imperiously informed the artisans that they had "no *Right* to give their sentiments respecting an importation" and called the artificers a "Rabble."[38] Here was additional evidence to craftsmen that the partnership between men in different ranks was at an end and that they must work independently for their objectives, even assuming responsibility for defining and enforcing the community's goals.

Artisans were not able to halt the merchants from resuming importations in the spring of 1770. This contributed to the feeling that the organic connection between those who labored with their hands and those who did not was broken and hence accelerated the change of artisan consciousness. Deciding to jettison their reliance on upper-class leadership—this had not occurred in the 1720s—mechanics called a public meeting of their fellows and formed their own Mechanics Committee. They took another unprecedented step by deciding that they must not only use their votes to elect men above them who were responsive to their needs but must also now elect men from their own ranks. Their dominance under severe attack, the merchant elite attempted to invoke the old norms: "The Mechanics (though by far the most numerous especially in this County)" they sputtered, "have no Right to *Speak* or *Think* for themselves."[39]

In the fall of 1770, for the first time in many decades, an artisan proudly announced himself as a candidate for sheriff. Artisans soon began to fill elected positions as tax assessors and collectors, wardens, and street commissioners, and insisted on their right to participate equally with merchants and gentlemen in the nomination of assemblymen and other important officeholders. The day was past, announced Brother

[38]*To the Free and Patriotic Inhabitants of the City of Phila. and Province of Pennsylvania* (Philadelphia, 1779), as quoted in Olton, *Artisans for Independence*, p. 43.

[39]*Pennsylvania Gazette* (September 27, 1770).

Chip, taking a moniker with special meaning to ships carpenters, when laboring men would tamely endorse men nominated by the elite. Chip occupied still more radical ground by asserting that it was "absolutely necessary" that one or two artisans be elected to the Assembly from Philadelphia. Appalled at this crumbling of deference, merchants and other members of the elite hurled "Many Threats, Reflections, Sarcasms, and Burlesques" against the artisans. This did little to deter laboring men because secret balloting went far to keep them immune from economic retaliation by those they offended.[40]

Possessing many votes and inspirited by success in electing their own kind to important offices, the artisans began pressing the legislature in 1772 for laws that would benefit them. They vigorously opposed excise taxes on liquor, called for the weekly publication of full assembly debates and roll calls on important issues, and demanded the erection of public galleries to end forever "the absurd and Tyrannical custom of shutting the Assembly doors during debate." It was enough to leave some genteel Philadelphians muttering, "It is Time the Tradesmen were checked—they take too much upon them—they ought not to intermeddle in State Affairs—they will become too powerful."[41]

Intermeddling in state affairs was also taking another direction in the 1770s: the de facto assumption of governmental powers by committees called into being by the people at large, artisans most numerous among them. Tradesmen had first clothed themselves in such extralegal authority in policing the nonimportation agreement in 1769. In 1774, in the wake of the Boston Port Bill, they showed that they were far more unified and aggressive than in the past by putting forward a radical slate of candidates for enforcing the Continental Association that drubbed a slate offered to the electorate by the city's conservative merchants.[42]

This heightened artisan consciousness culminated in the final year before independence. A new surge of radicalism, led by middling men such as Thomas Young, James Cannon, Thomas Paine, and Timothy Matlack and centered in the thirty-one companies of the Philadelphia

[40] Olton, *Artisans for Independence*, pp. 50–52; Brother Chip, *Pennsylvania Gazette* (September 27, 1770). The elite are quoted in Olton, *Artisans for Independence*, p. 53.

[41] A *Trademan's Address to His Countrymen* ([Philadelphia, 1772]), Library Company of Philadelphia; *Pennsylvania Gazette* (September 22, 1773), as quoted in Olton, *Artisans for Independence*, p. 56.

[42] Richard Alan Ryerson, *The Revolution is Now Begun: The Radical Committees of Philadelphia, 1765–1776* (Philadelphia: University of Pennsylvania Press, 1978), pp. 79–86.

militia that had been organized in the spring of 1775, produced demands for the most radical reforms yet suggested by the colonists. Curbing the individual accumulation of wealth, opening up opportunity, divorcing the franchise from property ownership, and driving the mercantile elite from power became explicit objectives enunciated in a flood of polemic literature that swept over Philadelphia. "Our great merchants . . . [are] making immense fortunes at the expense of the people," charged a Tradesman in April 1775, just before a special Assembly election. Sounding the tocsin on economic inequality that English and European republican writers warned against but genteel American Whigs usually saw fit to ignore, Tradesman argued that the merchants "will soon have the whole wealth of the province in their hands, and then the people will be nearly in the condition that the East-India Company reduced the poor natives of Bengal to." Men of this kind must be stopped in "their present prospect of making enormous estates at our expense." Invoking the older notion of an organic community, Tradesman yearned for the day when their "golden harvests" were put to an end and "all ranks and conditions would come in for their just share of the wealth."[43]

This acerbic language, hurled across class lines, was delivered anonymously so the writer would need not fear retaliation from a landlord, employer, or creditor. It reveals the alternative culture that some artisans sought to create through seizing control of the political process. Three days earlier in another newspaper an account appeared that takes us deeper into the hegemonic crisis that was occurring in Philadelphia. "A poor man," it was stated, "has rarely the honor of speaking to a gentleman on any terms, and never with familiarity, but for a few weeks before the election. How many poor men, common men, and mechanics have been made happy within this fortnight by a shake of a hand, a pleasing smile and a little familiar chat with a gentleman: who have not for the seven years past condescended to look at them. Blessed state which brings all so nearly on a level."[44] The account can be read as evidence that the poor man and the artisan had truly internalized the message promulgated from above—that society was best governed when the elite ruled and laboring men deferred. But the barbed tone of the statement and its thinly disguised disdain of the upper class also portray an urban society where interclass relations were no longer marked by

[43] Tradesman, *Pennsylvania Packet* (April 30, 1776).
[44] *Philadelphia Evening Post* (April 27, 1776).

trust, harmony, mutual respect, and a sense of partnership within hierarchy. When we consider such a description of veiled interclass hostility alongside a knowledge of what was actually happening in the streets of Philadelphia in the spring of 1776, where artisans and small traders were taking power from the hands of the old elite, it becomes clear that while a deferential pose may have still been maintained by the most vulnerable in the society, the old social equilibrium was now in disarray.[45] It could have survived only within an economy where laboring people were able to fulfill their goals of a "decent competency," dignity, and economic independence.

By autumn 1775 the Philadelphia militia had become a school of political education much in the manner of Oliver Cromwell's seventeenth-century New Model Army. The militia, wrote Eric Foner, "quickly developed a collective identity and consciousness, a sense of its own rights and grievances," and "became a center of intense political debate and discussion."[46] Organizing the Committee of Correspondence, which included men of no previous political experience, such as tailor Frederick Hagener and paperhanger Edward Ryves, the privates began exerting pressure on the Assembly to take a more assertive stand on independence. They also made three radical demands for internal change: first, that militiamen be given the right to elect all their officers, rather than only their junior officers, as the Assembly had specified in the militia law; second, that the franchise be conferred on all militiamen, regardless of age and economic condition; and, third, that the assembly impose a heavy financial penalty, proportionate to the size of his estate, on every man who refused militia service, using this money to support the families of poor militiamen.[47]

Although upper-class Whigs might call the militia privates "in general damn'd riff raff—dirty, mutinous, and disaffected," there was no denying the power of these men.[48] Generally from the lowest ranks of the laboring population, as opposed to the master craftsmen who from 1770 to 1774 had gradually gained control of the extralegal committees,

[45] The rapid disintegration of the old elite's political power is most fully analyzed in Ryerson, *Revolution*.

[46] Eric Foner, *Tom Paine and Revolutionary America* (New York: Oxford University Press, 1976), p. 64.

[47] Olton, *Artisans for Independence*, p. 74; Foner, *Tom Paine*, p. 65; Ryerson, *Revolution*, pp. 133–34, 138–45, 160–62.

[48] Quoted in Foner, *Tom Paine*, p. 63.

they played a major role in the creation of the radical Pennsylvania constitution of 1776. "An enormous proportion of property vested in a few individuals," they advised the convention, "is dangerous to the rights, and destructive to the common happiness of mankind, and therefore every free state hath a right by its laws to discourage the possession of such property." This distinctly uncomplaisant call for a ceiling on wealth was accompanied by the advice that in electing representatives the people should shun "great and overgrown rich men [who] will be improper to be trusted [for] they will be too apt to be framing distinctions in society, because they will reap the benefits of all such distinctions."[49]

The ability of Philadelphia's artisans to organize and assert their collective strength was best exemplified in the move to broaden the franchise. This required breaking through one of the foundations of elite domination—that only property ownership entitled one to political rights. In the other northern cities voices were raised occasionally for the political rights of the propertyless and the poor.[50] But only in Philadelphia, where a combination of artisans, shopkeepers, and small traders captured control of the political process and then were themselves pressured from below by a highly politicized militia composed mainly of lower artisans, was the franchise given to all taxpayers, regardless of whether they owned property. In a society where the proportion of those without property was growing among artisans, this was a break with the past of enormous significance. It swept away "the basic economic presupposition that the ownership of a specified amount of property was an essential guarantee of political competence."[51] Many avid patriots, such as Bostonian John Adams, were aghast at this, for "it tends to confound and destroy all distinctions, and prostrate all ranks to one common level."[52] That, of course, was what the radical architects of Pennsylvania's constitution had in mind.

[49] *An Essay on a Declaration of Rights* (Philadelphia, 1776); *To the Several Battalions of Military Associators in the Province of Pennsylvania* ([Philadelphia, 1776]). For a general discussion of the eruption of egalitarian sentiment, see Foner, *Tom Paine*, pp. 123–26.

[50] For example, in New York, see *New-York Journal* (August 18, 1774; June 20, 1776); and Merrill Jensen, *The American Revolution within America* (New York: New York University Press, 1974), pp. 72–74.

[51] J. R. Pole, *Political Representation in England and the Origins of the American Republic* (New York: St. Martin's Press, 1966), p. 273. The issue of broadening the franchise was first raised in April 1776 (Olton, *Artisans for Independence*, pp. 76–77; Foner, *Tom Paine*, pp. 125–26).

[52] Quoted in Pole, *Political Representation*, p. 273n.

There emerged in the revolutionary era no perfect crystallization of artisan consciousness or all-craft solidarity. Artisans were still bound in part by allegiance to particular crafts, and, more important, long-range changes in trades such as shoemaking, tailoring, and printing were increasingly separating journeymen from masters. But, most of all, the revolutionary potential of the Philadelphia artisanry was limited by the strong hold that the "liberal" economic outlook held on large numbers of property-owning, modestly prosperous mechanics in the more lucrative trades. Although these men figured powerfully in the nonimportation movements and in the swelling sentiment for independence after 1774, they did not share the radical social perspective that lay behind the insurgency of the lower artisans of the Philadelphia militia. It was here that a genuine counterideology, stressing egalitarianism and communitarianism, resonated with greatest force.

The tensions within the artisan population of the city that always lurked behind the appearance of unity on questions such as nonimportation and independence became tragically evident in the price control crisis of 1779. Lower artisans for the most part advocated strict regulation of prices as a way of reinstituting the moral economy at a time when inflation was pushing the cost of life's necessaries beyond the reach of ordinary families, many of whom had sacrificed the male head of household to military duty. The majority of upper artisans, however, hewed to the ideology of free trade and laissez-faire principles of political economy. They thereby demonstrated how resilient were the bourgeois values of the old leadership which had been swept from office in the final days before independence and had been overpowered in the struggle over the Pennsylvania constitution of 1776.[53] This, then, would be one of the legacies of the Revolution in its largest commercial center: a struggle within the artisanry between those who, while united by an ideology of productive labor, were divided on how far political rights should be extended, how far the powers of government should reach in regulating the economy for the public good, and how relations within the workplace should be structured. It was by no means evident at the time, in the midst of the greatest social and political upheavals ever experienced in the Pennsylvania capital, what the outcome of these

[53] The price-control crisis of 1779 and the civil strife that accompanied it are covered fully in Foner, *Tom Paine*, pp. 145–82; and John Alexander, "The Fort Wilson Incident of 1779: A Case Study of the Revolutionary Crowd," *William and Mary Quarterly*, 3d ser., 31, no. 4 (October 1974): 389–612.

internal tensions would be. But to virtually every Philadelphia artisan it became apparent that in the course of defining issues that were palpable in terms of their daily existence, and through the process of struggling around these issues, they had gained a new political self-awareness and a new understanding of their role vis-à-vis those who stood above them in the social order.

Fathers, Sons, and Identity: Woodworking Artisans in Southeastern New England, 1620–1700

Robert Blair St. George

William Bradford, governor of Plymouth Colony, walked the dusty streets of Plymouth slowly, restlessly. Worried by the number of "strangers" who had come to the town with hopes of gaining quick and lasting fortunes, he carefully noted any new faces in the village. And one day, early in 1631, he saw that a young carpenter had arrived from Massachusetts Bay, their new neighbor to the north. Bradford returned home and promptly penned a letter to his counterpart John Winthrop, complaining how "Richard Church came . . . as a sojourner to worke for the present, though he is still here resident longer then he proposed . . . and what he will doe, neither we nor I thinke he himselfe knows, because he came to us upon falling out with his partner."[1] Despite his concern for the wayward artisan's fate, Bradford's tone belies a distinct

The author is indebted to Richard Bushman and the late Benno M. Forman for their criticism of an earlier version of this essay which was presented at the 1979 Winterthur conference and received the Colonial History Essay Prize for 1980 from the Colonial Society of Pennsylvania.

[1] *The Mayflower Descendant*, 34 vols. (Boston: Society of Mayflower Descendants, 1899–1937), 9:8.

belief that Church was somewhat confused, drifting aimlessly in the wake of discovering that not every dream he had of life in New England would easily come true. Church, born in the small village of Ashton in Northamptonshire, had arrived in Boston at the age of twenty-two in 1630 and within six months had already moved twice due to difficulty in practicing his trade. His unsettled career suggests that woodworking artisans, as a distinct subset of settlers bound by both common technical knowledge and economic dependence on the same natural materials, warrant the attention of social historians and historically minded folklorists interested in what made people move at particular times to particular places.

For the time being, if we choose to read geographical mobility as one index of changing motivations and expectations, the difficulties that Church undoubtedly confronted seem to have followed him the rest of his days. He lived successively at Plymouth—where he first climbed onto the historical stage—Duxbury, Hingham, Eastham, and Sandwich before dying at the house of his son Caleb in Dedham in 1668 (fig. 1).[2] Yet beyond being merely interested in the frequency of his travels, we must also realize that along another axis of change moved the individual artisan's drive to manifest cultural continuities with England and construct the New World as a secure society. In general, the careful study of woodworking artisans in southeastern New England during the seventeenth century suggests at once that the stereotypical view of the first period of settlement as one of comfortable, bucolic stasis may prove largely false for certain economic sectors of the population. So much is apparent from the lives of Church's first-generation contemporaries— men like Dolar Davis, a joiner who moved five times, or Thomas Painter, a carpenter who moved no fewer than nine times in his life—and their sons and grandsons in the next two generations. More significantly, close study of woodworkers suggests that the process of guiding New

[2] For demographic data on Church, see Robert Blair St. George, "A Retreat from the Wilderness: Pattern in the Domestic Environments of Southeastern New England, 1630–1730" (Ph.D. diss., University of Pennsylvania, 1982), pp. 40–41, 50, 62, 383, n. 105. Biographical data on the 438 woodworkers and builders represented in the tables that accompany this essay are abstracted in the same volume, pp. 369–415. Each worker is listed alphabetically and indexed according to the trade(s) he practiced; his dates of birth, marriage, working lifetime, and death; the location(s) where he worked; his place of English regional origin (for first-generation workers); and his relations among other artisans listed. All members of trades dependent on wood for their livelihood are included (see table 11); all other artisans cited in this essay, except where noted, may be consulted in this list.

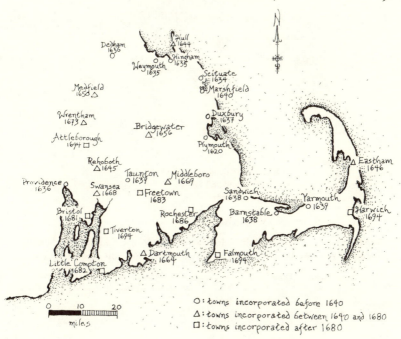

Figure 1. Map of southeastern New England region: incorporated towns and the progress of seventeenth-century settlement. (Drawing, Robert Blair St. George.)

England through its first three generations of social and occupational life also framed a series of complex negotiations which effectively transformed the cultural identity of the artisan as an individual and redefined the shape of colonial society as a whole; it is this transformational process that serves as the focus of the present essay.

Before moving to analysis we should first address the issue of whether the artisans who underwent such a change in cultural identity actually formed a percentage of the colonial population significant enough to support claims that such a change could really have affected society at large. In examining the lives of sometimes illiterate and always obscure craftsmen whose actions typically lie beneath the level of historical scrutiny, we must pause to consider exactly how much of past reality we are including. In southeastern New England in the seventeenth century 438 artisans found either full- or part-time employment in the wood-

TABLE 1. Shop Generations, 1620–1700

Generation	Cohort (No.)	(%)
First	123	28.1
Second	225*	51.4
Third	46	10.5
Unaccountable	44	10.0
Total	438	100.0

* Of the 225 second-generation artisans, 33 (14.7%) were born in England and arrived in New England either before or during their training.

TABLE 2. Percentages of Adult Male Householders Working in the Woodworking/ Building Trades in the Plymouth Colony Area during the First Two Generations

Generation	Estimated population	Number of adult householders	Tradesmen (No.)	(%)
First	2,520 (1653 census)	420.7	87	20.7
Second	10,105 (1690 census)	1,686.9	174	10.3

working and building trades (table 1). Of these, 394 can be located in one of three shop generations. While this does not seem to be a very large number of workers in a region that extended more than 2,000 square miles into the wilderness, estimates indicate that the 87 first-generation workers within Plymouth Colony alone comprised fully one-fifth of the adult male householders, while their second-generation followers made up one-tenth (table 2).[3] At proportions of one-fifth and

[3] In defining shop generations in table 1 I have used the following distinctions based on the artisans' "fresh contact" with old English culture: First-generation workers include only those who received all of their training in England and were twenty-one years of age and working upon arrival. Artisans of the second generation include those who completed their training—having begun it here or not—in New England under first-generation masters. Third-generation artisans include those who both began and completed their training in New England under the second-generation master. This framework allows for the fact that some third-generation artisans may have had fellows of their own age who, having been trained by a grandfather, may have had craft knowledge comparable to second-generation workers. The estimated numbers of adult male householders presented in table 2 are derived from detailed research on militia lists for the years 1653 and 1690 published

one-tenth respectively, artisans of the first two generations formed a significant quantitative sector of their societies, and available evidence further suggests that the same high percentages held for most places in the English colonies in the seventeenth century and in certain locations until the close of the eighteenth.[4] Strictly in numerical terms, then, it would be a serious oversight to ignore them in any study of local social change during the period.

in Richard LeBaron Bowen, *Early Rehoboth: Historical Studies of Families and Events in This Plymouth Colony Township*, vol. 1 (Rehoboth, Mass.: Privately printed, 1945), p. 1–24. See also data presented in Joseph B. Feet, "Population of Plymouth Colony" *American Statistical Association Collections* 1, pt. 2 (1845): 143–44; and Herbert A. Whitney, "Estimating Precensus Populations: A Method Suggested and Applied to the Towns of Rhode Island and Plymouth Colony in 1689," *Annals of the Association of American Geographers* 55 (1965): 179–89. The total number of inhabitants projected by Bowen for 1653 and 1690 (2,520 and 10,105) indicate that for those years artisans must have comprised 3.4% and 1.7% of the respective Plymouth Colony populations. The reader is reminded that although table 1 records 123 first-generation and 225 second-generation workers, these include everyone working in the various political jurisdictions in the southeastern region: Massachusetts Bay Colony (Suffolk County), Plymouth Colony (after 1685 divided into Plymouth, Barnstable, and Bristol counties of the Province of Massachusetts Bay), and Rhode Island and Providence Plantations.

[4]Charles Henry Pope, *The Pioneers of Massachusetts* (1900; reprint ed., Baltimore: Genealogical Publishing Co., 1965), pp. 523–24, presents an overall occupational breakdown for 1,725 first-generation heads of households. Of this total, 348 (20.2%)—a percentage in agreement with my own findings—found employment in the woodworking and building trades as carpenters, joiners, housewrights, clapboard rivers, coopers, dish turners, ship carpenters, shipwrights, traymakers, turners, wheelwrights, masons, plasterers, millwrights, nailers, pipe-stave makers, plowwrights, and sawyers. Benno M. Forman, "Boston Furniture Craftsmen, 1630–1730," typescript, 1969, personal collection, p. I–4, indicates that 16% of the 853 taxable heads of Boston households in 1676 were woodworkers; this figure is slightly low in that his findings report only those artisans capable of making furniture. It should be noted that of the available town studies of local woodcrafting in seventeenth-century New England, none to date has been inclusive of all the trades connected by economic demands. For selective treatments, see Robert F. Trent, "The Joiners and Joinery of Middlesex County, Massachusetts" (M.A. thesis, University of Delaware, 1975), pp. 46–49, for detailed information on early Watertown and Concord; and Robert Blair St. George, "Style and Structure in the Joinery of Dedham and Medfield, Massachusetts, 1635–1685," in *American Furniture and Its Makers: Winterthur Portfolio* 13, ed. Ian M. G. Quimby (Chicago: University of Chicago Press, 1979), pp. 3, 37–46. Alan Kulikoff, "The Progress of Inequality in Revolutionary Boston," *William and Mary Quarterly*, 3d ser., 28, no. 3 (July 1971): 377, indicates that 351 members of the woodworking and building trades in Boston in 1790 claimed the highest percentage of that city's 2,754 known artisans (12.8%), although this, too, is biased because it excludes a number of shipwrights who fall into Kulikoff's further category of "marine crafts." Carville V. Earle, *The Evolution of a Tidewater Settlement System: All Hallow's Parish, Maryland, 1650–1783*, Department of Geography Research Paper no. 170 (Chicago: University of Chicago, 1975), pp. 64–67, reports that between 1660 and 1790 woodworkers in this area of the Chesapeake accounted for 18% of all "occupational persons."

Any discussion of artisan life in seventeenth-century New England falls logically into two parts. First we must examine the general trends in English society in the decades immediately preceding the Great Migration and how specific considerations of geography and local economy may have contributed to a defined set of expectations for life in the New World. Second, we must monitor the progress of these expectations as they affected the delicate relationship between family power and occupational status in New England. In other words, our attention should focus on the related problems of cultural separation, accommodation, and development, where accommodation demands at the very least the psychological confrontation of inherited needs and environmental realities.[5]

In the years before the Great Migration England was in the throes of a long and often violent process of internal change, the course of which has been well charted by several modern historians.[6] The turmoil of the times is apparent to modern historians even as it had been to contemporary diarists, who saw that their country was in agony. One in their midst, Robert Cushman, a wealthy backer of the first *Mayflower* voyage, took the time in 1621 to set down some of the reasons why England was almost daily becoming a less and less attractive place to raise a family. The towns of England, he wrote, "abound with young tradesmen, and the hospitals are full of the ancient; the country is replenished with new farmers, and the almshouses are filled with old laborers. Many are there who get their living with leaving burdens; but more are fain to burden the land with their whole bodies. Multitudes get their means of life by prating, and so do numbers more by beg-

[5] David Sabean, "Aspects of Kinship Behavior and Property in Western Europe," in *Family and Inheritance: Rural Society in Western Europe, 1200–1800*, ed. Jack Goody, Joan Thirsk, and E. P. Thompson (Cambridge: At the University Press, 1976), p. 113.

[6] The key recent studies that should be consulted for background reading on the upheaval and turmoil of seventeenth-century England (in order of publication) are Christopher Hill, *The Century of Revolution, 1603–1714* (New York: W. W. Norton, 1966), esp. pp. 1–101; Lawrence Stone, *Social Change and Revolution in England, 1540–1640* (New York: Barnes & Noble, 1965); Peter Laslett, *The World We Have Lost: England before the Industrial Age* (1965; rev. ed., New York: Charles Scribner's Sons, 1971); and Christopher Hill, *The World Turned Upside Down* (London: Temple Smith, 1972). More specific topics are treated with balance and care in Paul S. Seaver, ed., *Seventeenth-Century England: Society in an Age of Revolution* (New York: New Viewpoints, 1976); and Alan Macfarlane, *The Origins of English Individualism* (New York: Cambridge University Press, 1979), pp. 34–61, 165–88.

ging."[7] Fortunately, Cushman was sensitive and sympathetic to the struggles of New England settlers, and his words summarize the historical issues that need exploration in depth: the effect that a rising class of landowners (called by historians alternately the yeomanry or the "English Bourgeoisie"[8]) had on the national economy, the influence of their sudden rise on the occupational opportunities of young and old and men and women, and the disciplinary problems posed by vagrants and unlanded migrant laborers. He touched also on two closely related points which bear directly on the position of the younger artisan in a changing society. First, chronic underemployment was brought on by unpredictable economic fluctuations in which men are reduced to misfits, but not deservedly, through their own failings: not "always through intemperance, ill husbandry, indiscretion, &C., as some think, but even the most wise, sober, and discreet men go often to the wall, when they have done their best."[9] Second, there followed from this an implied fear that economic and social demise might not be related directly to individual moral corruption, a fear that must have shaken the seventeenth-century artisan soundly, as it forced him to recognize that his own actions, no matter how rational and morally correct they seemed, could easily go awry. He feared, too, that God's reason may have turned to wrath aimed at punishing not merely the individual for his particular sins but all men for generations of earthly depravity and moral backsliding.

The problems related to the rise of the yeomanry may be grouped conceptually around two poles, one social and the other economic, which defined status in terms of genealogical longevity and material wealth. Without question, the single most important determinant of status in early seventeenth-century England was the firm ownership of land. Unlike most artisans in the woodworking and building trades, yeomen were freeholders of the lands they worked. As a result, they were blessed with a surplus of crops in years of good harvest, while in leaner years they could always manage to fend off utter starvation.

[7] Robert Cushman, "Reasons and Considerations Touching the Lawfulness of Removing out of England into the Parts of America," in *Chronicles of the Pilgrim Fathers of the Colony of Plymouth, from 1602–1625,* ed. Alexander Young (1844; reprint ed., Baltimore: Genealogical Publishing Co., 1974), p. 247.

[8] See C. F. George, "The Making of the English Bourgeoisie, 1500–1700," *Science and Society* 35, no. 4 (Winter 1971): 385–414.

[9] Cushman, "Reasons and Considerations," p. 247.

Whatever happened at the market, the yeoman could pride himself on his economic autonomy, and so deeply embedded in his world view was the need to feel self-sufficient that the resultant boom in "cottage industry" expanded beyond its origins in the East Anglian textile trade and threatened to put local artisans out of business. Instead of purchasing everything from farmyard implements to household furniture from the village joiner, for instance, farmers insisted on making them in their own cellar shops. Instantly, then, the English yeoman not only wiped out the artisan's hope of ever accumulating much freeheld land, but he also made direct inroads on the artisan's means of survival.

Perhaps the country artisan's fear of imminent bankruptcy was not too far from the truth. At least one commentator observed by the late sixteenth century that unlanded folk had almost no civil power, claiming that "all artificers, as tailors, shoemakers, carpenters, brick-makers, brick-layers, etc. . . . have no voice nor authority in our commonwealth and no account is made of them, but only to be ruled and not to rule others," while just three years into the seventeenth century John Stowe could state that "it is no marvaile that . . . Artificers . . . do leave the Countrie townes, where there is no vent, and do flie to London, where they can be sure to find quick and ready market."[10] Yet while the city offered more work and money to anxious artisans, it also left them entirely dependent on the success of the yeomanry for their food-stuffs and clothing. In years of poor harvest—and there were several in the two decades preceding the Great Migration[11]—yeomen picked up

[10]Thomas Smith, *The Commonwealth of England* (1583), as quoted in Laslett, *World We Have Lost*, p. 32; John Stowe, *Survey of London* (1603), as quoted in Benno M. Forman, "Continental Furniture Craftsmen in London, 1511–1625," *Furniture History* 7 (1971): 94. One of the most underresearched problems in the early economic history of England is determining the extent to which rural artisans owned land. I have followed the cautious lead of W. G. Hoskins, "The Leicestershire Farmer in the Seventeenth Century," in W. G. Hoskins, *Provincial England: Essays in Social and Economic History* (London: Macmillan, 1963), pp. 159–60, in assuming that while a few artisans may have had small holdings, the great majority were either tenants on larger estates or unlanded migrants. Additional information on the lucrative opportunities London offered to rural artisans should be consulted in F. J. Fisher, "The Development of London as a Center of Conspicuous Consumption in the Sixteenth and Seventeenth Centuries," in *Essays in Economic History*, ed. E. M. Carus-Wilson, vol. 2 (London: Edward Arnold, 1954), pp. 197–207.

[11]W. G. Hoskins, "Harvest Fluctuations and English Economic History," *Agricultural History Review* 16 (1968): 15–17, 19, 24, 28–29. Mildred Campbell, *The English Yeoman under Elizabeth and the Early Stuarts* (New Haven: Yale University Press, 1942), p. 159, adds that the combined effects of a depression in the East Anglian cloth trades

the slack by turning again to their cottage crafts, leaving mechanics destitute through no fault of their own. As Cushman himself intimated, the artisan's existence had by the 1620s become little more than a sad game, a wheel of fortune which would spin out years of prosperity only to follow them ruthlessly with the wreck of famine.

By the time emigration to New England began, the apparent irrationality of artisan life had been further aggravated by the fact that while commodity prices had continued to soar, wages had not exceeded ten pence per diem since reaching that rate in the late 1580s. This combined with the other problems to prevent young artisans just reaching their majority between 1620 and 1635 from opening new shops. The evils of crowdedness, chronic underemployment, and fierce competition for what little business there was led the younger woodworker "to pluck his meanes as it were out of his neighbor's throat, there is such pressing and oppressing in town and country . . . so as a man can hardly set up a trade, but he shall pull down one or two of his neighbors."[12]

Competition within the woodworking and building trades took on a more terrifying aspect when one's neighbor and embittered rival for local support was also one's father, grandfather, or brother. On one hand, perhaps the most honored customs of "traditional" English culture urged sons to defer to parental discretion, remain at home, and toil in the shops of their fathers. Yet on the other hand, economic conditions were such that if sons did take up the family trade, they would risk challenging patriarchal authority by usurping part of the elder craftsman's local clientele. Indeed, to stay in one's ancestral village in the face of such sobering circumstances would have meant social and economic demise for both father and son and would have all but guaranteed the brand of foreseeable collapse so lamented by Cushman. One solution offered a way to alleviate generational tensions and avoid fam-

beginning in the late 1620s and a particularly poor corn crop in Norfolk in 1632 resulted in an unusually high percentage of yeomen who "crossed over" into the occupational domain of woodworkers and builders in order to augment sagging incomes. This coincidence of events may have been a direct cause of the migration of many artisans from East Anglia to New England in the mid 1630s (see table 4). See also "Depression in the English Cloth Industry, 1629" and "The Essex Cloth Industry in Depression, 1629," in *Seventeenth-Century Economic Documents*, ed. Joan Thirsk and J. P. Cooper (Oxford: Clarendon Press, 1972), pp. 32–33, 224–32.

[12] E. Phelps Brown and Sheila V. Hoskins, "Seven Centuries of Building Wages," *Economica*, n.s. 22, no. 87 (August 1955): 198; A. C. Edwards, "Sir John Petre and Some Elizabethan London Tradesmen," *London Topographical Record* 23, no. 115 (1972): 75; Cushman, "Reasons and Considerations," pp. 246–48.

ily conflict: migration to New England.

For young artisans especially, migration provided a means of venting hostility toward a competing family member without causing a real breakdown in the family unit. In short, New England offered hope to English artisans that at least their children might be raised in a less unsteady context. As their numbers indicate (table 2), the decision to emigrate resulted, ironically, in a density of woodworkers in New England higher than that which prevailed in most parts of England at the time. [13] The extent to which the first-generation artisan's family served as a stabilizing force in settlement may be explored in terms of two overarching patterns: *generational continuity*, as outlined by inheritance customs in wills of estates; and *territorial continuity*, as measured by the frequency and distance of migration within the region. In turn, each of these was further conditioned by a third pattern—*vocational continuity*, assessed by the trade(s) chosen by succeeding generations. Pertinent and detailed questions appear on every front: Why did the early New England artisan bequeath the tools of his trade with such caution? Why did the early artisan move? Was it in most cases, as in that of Richard Church, caused by disagreements between business partners? Or did they regard frequent migration as normative behavior for an artisan? More broadly speaking, did families in the woodworking trades in southeastern New England recover the strength that in old England had been sapped by generational tensions and tightened purse strings?

In the woodworking trades in the seventeenth century the influential links between generations (our first pattern of family stability) were related in part to the length of their members' lives and the frequency

[13] For example, while first-generation artisans in the woodworking and building trades accounted for one in every five first-generation heads of households in Plymouth Colony, their counterparts in seventeenth-century Gloucestershire totaled far fewer. In a 1608 muster role of that western county, only 6% of those reporting an occupation were woodworkers or builders (A. J. Tawney and R. H. Tawney, "An Occupational Census of the Seventeenth Century," *Economic History Review* 5, no. 1 [October 1934]: 36, table 1). Probably more typical of the first-generation artisan's native village was Goodnestown-next-Wigham in Kent, which had only two carpenters among its 62 households in 1676, or the rural deanery of South Malling in Sussex, which had but three woodworkers to sustain its 242 households between 1580 and 1640 (Laslett, *World We Have Lost*, pp. 68–69; Julian Cornwall, "Evidence of Population Mobility in the Seventeenth Century," *Bulletin of the Institute of Historical Research* 40, no. 2 [November 1969]: 143–44). Additional information on Kent may be consulted in Peter Clark, "The Migrant in Kentish Towns, 1580–1640," in *Crisis and Order in English Towns*, ed. Peter Clark and Paul Slack (London: Routledge & Kegan Paul, 1972), p. 121.

with which the aged held onto their possessions. For example, first-generation workers in the southeastern region lived almost as long as did the elders of seventeenth-century Andover—a mean of 69.8 years as compared with 71.8 years—while their offspring of the second generation lived nearly as long (table 3).[14] Their long tenancy in shops and on the land had both positive and negative effects on the shape of early New England artisan culture.

Without doubt, the long lives of the first generations—who often lasted well into the 1680s—insured that members of the succeeding generations learned well the proper rules for upholding established standards of workmanship and the "artificial" environment, or as one first-generation Charlestown shipwright phrased it in 1672, "the rules of art and the Custum of building amongst the English."[15] Ideally, members of the first generation would "retire" slowly, beginning with the marriage of the first son, who often inherited not only his father's farm but also the tools of his trade—powerful and recognized symbols of parental sanction and occupational status. In return, he cared for his aging parents until their deaths. In one instance, Francis Smalley of Truro on Cape Cod explicitly stated in his will: "my Carpenters Tools I give to my *Elder* son Francis," while in Providence Henry Brown, a well-equipped turner and joiner, specified that although he was bequeathing tools to both his sons, only the *eldest* was privileged to receive a complete set with which to continue running the family shop. Brown wrote that "all manner and sorts of my Working Tooles (only Excepting my Coopers tools), shall be Equally given to my two sons Richard & Joseph," but added the clause that his "Coopers tooles shall be all & wholy given to Richard."[16] Clearly, the fact that obedient eldest sons of the second

[14] Philip J. Greven, Jr., *Four Generations: Population, Land, and Family in Colonial Andover, Massachusetts* (Ithaca, N.Y.: Cornell University Press, 1970), pp. 21–40, 73–99.

[15] Records of the Quarterly Courts of Middlesex County, Massachusetts, Middlesex County Court House, East Cambridge, 3:59. The social significance of transferals in material culture is an aspect of New England's seventeenth-century settlement which historians repeatedly overlook or to which they assign a secondary value. The importance of making connections between material forms and social relations is discussed in Robert Blair St. George, *The Wrought Covenant: Source Materials for the Study of Craftsmen and Community in Southeastern New England, 1620–1700* (Brockton, Mass: Brockton Art Center, Fuller Memorial, 1979), p. 16; and Abbott Lowell Cummings, *The Framed Houses of Massachusetts Bay, 1625–1725* (Cambridge, Mass.: Harvard University Press, Belknap Press, 1979), pp. 95–117.

[16] Barnstable County Wills and Inventories (photostatic copies of original manuscripts), Barnstable County Court House, Barnstable, Mass., 3:338–39; *Early Records of*

TABLE 3. Ages at Death of First- and Second-Generation Artisans

Age	First generation (No.)	(%)	Second generation (No.)	(%)
22–29	1	2.6	4	4.0
30–39	1	2.6	5	5.0
40–49	3	7.9	10	10.0
50–59	4	10.5	16	16.0
60–69	8	21.1	26	26.0
70–79	6	15.8	29	29.0
80–89	12	31.6	9	9.0
90–99	3	7.9	1	1.0
100+	0	0.0	0	0.0
Total	38	100.0	100	100.0
	(Years)		(Years)	
Mean	69.8		62.0	
Median	71.0		65.0	

generation dutifully obeyed their fathers and remained in town rein-
forces our image of the seventeenth century as an era of family strength.

There is little reason to doubt that both Smalley and Brown would
have wholeheartedly agreed with the general themes sketched by one
Puritan divine, who felt that "Children should be very willing and ready,
to Support and Maintain their Indigent Parents. If our Parents are Poor,
Aged, Weak, Sickly, and not able to maintain themselves; we are bound
in duty and conscience to do what we can, to provide for them, nour-
ish, support, and comfort them." Some children seem to have taken
these thoughts seriously, too. Children like those of Hingham joiner
Stephen Lincoln did help their parents—and not just after the patriarch
had quit the daily grind of shop and fields. In fact, an artisan's offspring

the Town of Providence, 23 vols. (Providence: Snow & Farnham, 1892–1915), 6:210–11
(emphasis added). The most detailed study of aging and retirement for the period is John
Demos, "Old Age in Early New England," in *Turning Points: Historical and Sociological
Essays on the Family,* ed. John Demos and Sarane Spence Boocock, supplement to *The
American Journal of Sociology* 84 (Chicago: University of Chicago Press, 1978), pp. S248–
87; see esp. pp. S271–72. Additional information should be consulted in Gene W. Boy-
ett, "Aging in Seventeenth-Century New England," *New England Historical and
Genealogical Register* 134 (July 1980): 181–93.

were expected—perhaps were even planned—to serve as an invaluable source of free labor. This is a long-ignored aspect of *preindustrial* family structure, which recently has led R. M. Hartwell to include a well-wrought chapter titled "Children as Slaves" in *The Industrial Revolution and Economic Growth.*[17] In 1684 Lincoln used the labor of his sons, Stephen, Daniel, and David, all of whom were then in their teens, to gain credit in the account book of James Hawke, Hingham's town constable. Recording the payments with scrupulous attention, Hawke compiled Lincoln's credit for the single month of March 1684, showing the degree to which the latter relied on the strong backs of his sons to remain financially solvent:

	£. s. d.
due for 3 dais of daniel	00.03.00
due for 1 day of david	00.01.00
due for 1 day of steven	00.01.06
due to you for david two dais	00.02.00
due for 1 day of David	00.01.03
due to you for: three dais of David	00.03.09
two dais of David	00.02.00
two dais of David	00.02.00
four dais of David	00.05.00 [18]

Because most woodworking artisans in seventeenth-century New England were skilled with the plow as well as with the plane, the need for additional hands dramatically increased, especially at harvest. In some instances householders could find enough laborers for seasonal hire to gather crops with little delay; but for other less wealthy workers, children provided a means of keeping pace with the exigencies of year-round work in two occupations (fig. 2).[19] The demand for children on

[17]Benjamin Wadsworth, *The Well-Ordered Family; or, Relative Duties* (1712), reprinted in David T. Rothman and Sheila M. Rothman, eds., *The Colonial American Family* (New York: Arno Press and New York Times, 1972), pp. 99–102. In preindustrial England "the supply of children was determined by parents as investment decisions, decisions arrived at by balancing the gains and costs of rearing children" (R. M. Hartwell, *The Industrial Revolution and Economic Growth* [London: Methuen, 1971], p. 401).

[18]Account book of James Hawke, Constable of Hingham, Mass. (1677–85), on deposit at Massachusetts Historical Society, Boston, [19–20]. For additional information on children as a labor resource, see Lawrence Stone, *The Family, Sex, and Marriage in England, 1500–1800* (New York: Harper Colophon, 1979), pp. 295–96.

[19]The monthly division of farm work presented in figure 2 is drawn from Campbell, *English Yeoman*, pp. 209–11, and from a late sixteenth-century husbandry calendar

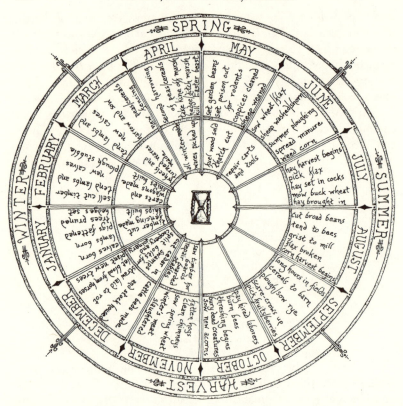

Figure 2. The farmer-craftsman's annual work cycle: inner circle describes artisan work; outer circle represents farm work. (Drawing, Robert Blair St. George.)

the seventeenth-century New England farmstead was realized very soon after settlement. By 1652, the mean size of artisans' families in Medfield, for example, had stabilized at a little over 6.0 members, a sizable

reprinted in Dorothy Hartley and Margaret M. Eliot, *Life and Work of the People of England*, vol. 2 (London: B. T. Batsford, 1925), pp. 24–27. The difficulties the farmer-craftsman had in scheduling work were typified in 1634 when sawyers William Hammond and Nicholas Prestland told their employer, Edward Winslow, that although they would be faithful workers, they reserved the right to quit his service when it came time to bring home the harvest (Nathaniel B. Shurtleff, ed., *Records of the Colony of New Plymouth in New England*, vol. 1 [1855; reprint ed., New York: AMS Press, 1968], p. 30).

increase over the average of 3.6 members in at least one comparable English village in the period.[20]

In return for the assistance of sons on the farm and in the shop, fathers who had moved into a state of gradual retirement would sometimes help the sons they had blessed with name, trade, and property. Not unexpectedly, a patriarch would help his son in matters related to the craft(s) that they had both mastered; in this way, too, a parent could continue to assert his seniority in a real and a symbolic sense. Nathaniel Winslow, a shipwright working along the busy banks of the North River at Marshfield, noted in his daybook an indebtedness to his father for both cash and labor:

> What I have reseived of father
>> mony [£]3.00.00
>> drawing spruse plank
>> drawing plank from Leftenant Thomas Sawmill
>> mony [£]4.10.00
> The account of what Father hath don for me
>> 1 day going to bie plank
>> 7 tun of timber and drawing of it in the yard
>> drawing plank 2 days
>> more timber one tun and 22 fet
>> 33 fet of bord
>> 1 day drawing the keel.[21]

With sons helping fathers make the transition into old age and fathers helping sons when labor ran short, life in the woodworking and building trades in southeastern New England rested squarely on the continuity defined by work roles unchanged over several generations.

Such intergeneration trust, with its implications for role stability and status maintenance, fostered the development of local craft "dynas-

[20] The mean size of Medfield artisans' families in 1652 is derived from the relevant entries in a nearly complete transcription of a town rate listing (now lost) for that year reprinted in William S. Tilden, *History of the Town of Medfield, Massachusetts, 1650–1886* (Boston: George H. Ellis, 1887), pp. 51–56. The mean size of artisans' families in Medfield conforms to the general findings for other New England towns during the period, which are summarized in John Demos, "Demography and Psychology in the Historical Study of the Family," in *Household and Family in Past Time*, ed. Peter Laslett and Richard Wall (Cambridge: At the University Press, 1972), p. 561, n. 2. See also Laslett, *World We Have Lost*, pp. 66–67.

[21] Daybook of Nathaniel Winslow of Marshfield, Mass., entry of November 28, 1728, Joseph Downs Manuscript and Microfilm Collection, Winterthur Museum Library.

TABLE 4. Migration Distances during Working Lifetime

Generation	Nonmigrant (No.)	(%)	Less than 15 miles (No.)	(%)	15–30 miles (No.)	(%)	Over 30 miles (No.)	(%)	Total (No.)	(%)
First	44	35.8	12	9.7	39	31.7	28	22.8	123	100.0
Second	157	69.8	18	8.0	35	15.6	15	6.6	225	100.0
Third	34	73.9	6	13.0	5	10.9	1	2.2	46	100.0
Total	235		36		79		44		394	
	(59.6%)		(9.1%)		(20.1%)		(11.2%)		(100.0%)*	

* This represents the total number (N = 394) of those workers who can be placed in a working generation; it does not include the 44 who remain unaccountable (see table 1).

ties" or strong families whose active participation in a specific trade or group of trades grew to extend over many decades. When migration distances—one measure of territorial continuity—are compared for each of the first generations of woodworking artisans (table 4), we see that the foundations of kinship set by first-generation workers held firm despite an apparently high rate of movement. Two of every three first-generation artisans migrated to some degree, and almost all of those who did moved more than fifteen miles away from their home village.[22] Through the succeeding two generations overall migration decreased noticeably and, while localized migration within a fifteen-mile radius in the second and third generations increased by as much as one-half, long-distance migration decreased dramatically from its peak in the first generation (remember artisans like Dolar Davis, who moved five times, or Thomas Painter, who moved nine times). This pattern indicates perhaps that once local kinship had developed to a point where migration between nearby towns caused little or no occupational or family stress, population stabilized spatially. In addition, because the pattern suggests the emergence of more highly localized social groups, it confirms the findings of other scholars who have noted that the declining ability of towns to regulate social movement during the second generation was countered by a rise in the power of families.[23]

[22] A fifteen-mile radius is used here as a standard of significant migration because it was the average distance between adjacent towns in the region and the average limit of a day's return ride by horse and cart during the period.

[23] James A. Henretta, "The Morphology of New England Society in the Colonial Period," *Journal of Interdisciplinary History* 2, no. 2 (Autumn 1971): 397. Thomas R.

Part of the variations in first-generation migration may be related logically to the English regional origins of the immigrant artisans themselves (table 5 and fig. 3). The origins of a little over half of the documented first-generation woodworkers and builders in southeastern New England can be traced. Fully one-third of this group came from the eastern English counties of Norfolk, Suffolk, and Essex, where a high percentage of yeomen engaged in cottage crafting, where there was early enclosure of open fields, and where the predominance of primo- and ultimogeniture had made life for trained artisans especially difficult. When these craftsmen arrived in the New World, they labored to recreate the small nucleated village of the East Anglian countryside. Thus it is no surprise to find that almost all of the East Anglian artisans in southeastern New England settled and worked in the two towns of Dedham and Hingham (table 6), both of which were characterized throughout the period by extremely high percentages of sons remaining in the shops of their fathers.

TABLE 5. English Regional Origins of First-Generation Artisans in Southeastern New England

| | Artisans | |
Region	(No.)	(%)
East Anglia	22	33.8
London/Southeast	16	24.6
Midlands	8	12.4
West Country	16	24.6
Northern Counties	2	3.1
Foreign (Holland)	1	1.5
Total identified	65	100.0

Cole, "Family, Settlement, and Migration in Southeastern Massachusetts, 1650–1805," *New England Historical and Genealogical Register* 132 (1978): 174–75, presents migration distances for the inhabitants of Sandwich, Mass., which are in fundamental agreement with those in table 4. For general theoretical concepts concerning the relation of social structure and occupational stress, see Eugene Litwak, "Occupational Mobility and Extended Family Cohesion," *American Sociological Review* 25, no. 1 (February 1960): 9–21; and Eugene Litwak, "Geographical Mobility and Family Cohesion," *American Sociological Review* 25, no. 3 (June 1960): 385–94. Julian Wolpert, "Migration as an Adjustment to Environmental Stress," *Journal of Social Issues* 22, no. 4 (October 1966): 92–102, proposes an ecological model for mobility stimulus which is in fact relevant to the plight of some seventeenth-century woodworkers who were forced to migrate because of depletions in materials necessary to their trades; for instance, some carpenters were forced to quit towns where wealthy tanners refused to limit their practice of bark stripping, which resulted in the retarded growth and premature death of timber trees.

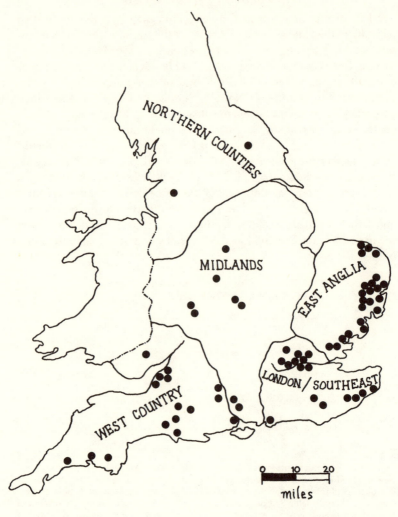

Figure 3.　Map of English regional origins of woodworking artisans who migrated to southeastern New England (see table 5). (Drawing, Robert Blair St. George.)

In a similar effort, the Kentish artisans working along the eastern coast of Plymouth Colony—with their highest concentration at Scituate—attempted to duplicate the demographic profile and social structure of their home county. Kentish carpenters and joiners like Dolar Davis, who was born near East Farleigh, moved frequently in New England between contiguous towns. Arriving in Boston in 1634, he was at Cambridge the following year and by 1634 had spent time at Duxbury, Scituate, and Barnstable. In 1655 he moved up to Concord in Middlesex, where some of his fellow emigrés from the marshy lowlands of Kent had settled. After twelve years there he returned to Barnstable, where he remained until his death in 1673. Along the way he had left some sons settled in Concord and some in Barnstable.

This pattern, chaotic as it may seem to those used to stories of Puritan utopian closed communities, closely relates to migration patterns found by recent scholars in the southeastern English counties of Kent, Sussex, and nearby Surrey, three areas characterized less by demographically insular villages than by settlement unified by an extensive kinship system which spread over a fairly wide expanse of the local landscape. In other words, a kind of overarching kin structure—what Alan Everitt has termed a "county community" in Kent—connected families in small villages into a cohesive and systemic totality. Thus Kentish society, for example, was typified more by clanlike kin groups than by the independent nuclear families so readily associated with East Anglia. The strength of the Kentish structure was fostered inevitably by the local prevalence of gavelkind, which urged children to marry within the general area and settle on local family lands. As a result, children in the southeastern counties rarely strayed more than fifteen to thirty miles from their home villages, despite the high frequency of their travels. Kentish woodworkers, one of them probably Davis's father, while moving almost continually, seldom roamed beyond immediate adjacent villages.[24]

[24] Joan Thirsk, "Industries in the Countryside," in *Essays in the Economic and Social History of Tudor and Stuart England in Honour of R. H. Tawney*, ed. F. J. Fisher (Cambridge: At the University Press, 1961), p. 70, discusses the ramifications of gavelkind for the rural inhabitants of the north downs of Kent. A more elaborate picture of the custom as it developed in the Weald is available in Joan Thirsk, ed., *The Agrarian History of England*, vol. 4, 1500–1600 (Cambridge: At the University Press, 1967), pp. 57–59. For the local migration habits of woodworkers in Kent, see Clark, "Migrant in Kentish Towns," pp. 126–29; and W. K. Jordan, "Social Institutions in Kent, 1480–1660," in *Essays in Kentish History*, ed. Margaret Roake and John Whyman (London: Frank Cass,

TABLE 6. English Regional Origins of First-Generation Immigrants to

Region	Dedham (No.)	(%)	Hingham (No.)	(%)
East Anglia	43	79.6	63	73.3
London/Southeast	2	3.7	3	3.5
Midlands	4	7.4	9	10.5
West Country	1	1.9	9	10.5
Northern Counties	4	7.4	2	2.2
Total identified	54	100.0	86	100.0

By contrast, East Anglian villages seem to have been more insular. Families came and went less often and land passed from father to son more often as an undivided unit of blessing. We should be careful, however, not to confuse insularity with complexity and stability. The towns of Norfolk, Suffolk, and Essex, from which came a great many of the townsmen of Dedham and Hingham, were comprised of a high percentage of relative newcomers to the area who had been lured from remote locations in the north and west by the promise of an economy bolstered by the prosperity of the textile trade.[25] As a result, these rural villages—the prototypes for New England's introspective, reflexive towns—had not yet had sufficient time to develop the extensive and deeply embedded kinship structures of their Kentish counterparts. In

1973), pp. 87–89. The concepts of county community and clan are well explained in Alan Everitt, "Social Mobility in Early Modern England," *Past & Present*, no. 33 (April 1966): 57–60. Evidence that similar patterns of intense local migration along kinship lines also pervaded nearby Sussex and Surrey shows that an overwhelming percentage of migrants in these southeastern counties moved more than twice during their lifetimes—as did many of the artisans from these counties who later moved to the southeastern New England region. The English artisans rarely died more than three parishes away from their place of birth (Cornwall, "Evidence of Population Mobility," p. 150; E. E. Rich, "The Population of Elizabethan England," *Economic History Review*, 2d ser., 2, no. 3 [1950]: 258).

[25] A notable example occurred when John Thurston, a master joiner trained in Thornebury, Gloucestershire, moved to Wrentham, Suffolk, before eventually migrating to Massachusetts (Frank Thurston, Thurston family genealogist, to St. George, December 15, 1977). Another instance of a young woodworker migrating eastward in England (although not specifically to take advantage of East Anglia's prosperity) occurred when Jenkyn Davis traveled from Haverfordwest in Wales to Sandwich in Kent prior to setting sail for Lynn, Mass., in 1638; see Benno M. Forman, "The Seventeenth-Century Case Furniture of Essex County, Massachusetts, and Its Makers" (M.A. thesis, University of Delaware, 1968), p. 58.

Four Towns in Southeastern New England

Scituate		Taunton		Total for region	
(No.)	(%)	(No.)	(%)	(No.)	(%)
3	3.9	—	—	139	27.7
50	65.8	1	5.0	132	26.4
9	11.8	5	25.0	88	17.5
9	11.8	14	70.0	103	20.6
5	6.7	—	—	39	7.8
76	100.0	20	100.0	501	100.0

effect, the assumed insularity of East Anglian villages in the period may have been little more than a reflex to their own youth. In Kent, where years of undisturbed settlement were less subject to rapid economic change, mobility among rural artisans was indicative of a different kind of social structure.

Keeping these regional variations in mind, we must be careful when attempting to claim that the more migratory of the first-generation artisans were also the more unstable and insecure. For, in fact, geographical mobility alone does not prove an adequate measure of all patterns underlying past behavior. Clearly, the problem of evaluating family cohesion on the basis of first-generation migration alone must be viewed in relation to the demographic continuities manifest by the individual worker. Different artisans from different places in England possessed different regional models or timetables for the correct recreation of optimum cultural order. And although these regional habits may have endured only for a short time in the New World, they may account for certain kinds of spatial behavior which reappear frequently in studies of seventeenth-century New England society.

The general trend through the first three generations of artisan life in the southeastern region shows that the frequency of craftsman migration—our second measure of territorial continuity—was greatest in the first generation and then steadily declined as families gained local prominence. For instance, Richard Church, our original protagonist, lived in no fewer than seven towns in thirty-six years. His sons Nathaniel, Joseph, Caleb, and Benjamin were all woodworkers—although Benjamin is more famous for having killed "King Philip," the Wampanoag sachem Metacom. Three of these four sons moved only twice,

while Church's grandson Thomas never moved from the town of his upbringing, Little Compton. The powerful Carpenter family of Rehoboth also exemplifies the pattern well. While the family patriarch, William Carpenter, a native of Horwell in Hampshire, had migrated from Weymouth to Rehoboth in the late 1640s, his sons remained in the area. William and Samuel, both carpenters and joiners, remained in Rehoboth proper; Joseph, wheelwright and turner, set up shop in Swansea just a few miles down the road. Even the grandson remained in town as wheelwright, joiner, and turner. (Note that here late generations were known to practice secondary and tertiary crafts—more of this later.) And in other towns other families became no less firmly entrenched. In Scituate the Stetsons and Stockbridges were dominant; Barnstable had the Davises and Crockers. By far the most dramatically kinship-bound was early Hingham, where the Lincolns, Hobarts, and Beals accounted for all but a few of the town's woodworkers throughout the century. And miraculously, by 1680 these three families formed almost one-fourth of the town's population.[26]

Both generational and territorial continuity were reinforced by the frequent location of woodworking shops in domestic contexts. As sons grew into apprentices, the boundaries between home life and work were never clear, and the family gained additional meaning as an agent of vocational continuity—our third pattern of stability. The well-equipped shop of Jonathan Fairbanks, wheelwright of Dedham, for example, was spread throughout the family dwelling. His inventory of 1668 records that tools and stock were found in the "Roome called the New House," the "working Celler," and the "Hall Chamber."[27] If an artisan's shop was not actually in his house—although most often the shop *was* there— it was never far away. Usually it stood next to the house, still within reach of growing children and nearby kin, as did the small weaver's

[26] John Coolidge, "Hingham Builds a Meetinghouse," *New England Quarterly* 34 (1961): 442. The remarkable consolidation of dominant Norfolk kin groups in seventeenth-century Hingham is charted in John J. Waters, "Hingham, Massachusetts, 1630–1661: An East Anglian Oligarchy in the New World," *Journal of Social History* 1, no. 4 (Summer 1968): 351–70.

[27] Suffolk County Probate Records, Suffolk County Court House, Boston, 5:112–14. Fairbanks's house, built ca. 1637, survives on its original site in Dedham, Mass., and is described in detail in Cummings, *Framed Houses*; and Abbott L. Cummings, "Appendix I: Summary Abstracts of the Structural Histories of a Significant Sampling of First Period Houses at Massachusetts Bay," in *Architecture in Colonial Massachusetts*, ed. Abbott L. Cummings, Publications of the Colonial Society of Massachusetts, vol. 51 (Boston: By the society, 1979), pp. 135–37.

Figure 4. Peak House, Medfield, Mass., late seventeenth century, with later shop structure. From Joseph Warner Barber, *Historical Collections of Massachusetts* (Worcester, Mass.: Dorr, Howland, 1839).

shop which survived alongside the so-called Peak House in Medfield (fig. 4). When younger artisans went into business, they often built adjacent to their father's property. In 1677 Barnstable "Granted to John Davis, Junr. Leiberty to Set up a Shop on a Knoll of Ground over against his house adjoyning to his fathers fence." In Providence almost thirty years later the impulse to keep house and shop adjacent was so strong that the town selectmen, "Upon the request of [carpenter] Joseph Whipple . . . Granted unto him that he may have Liberty to remoove his little house which he calleth his old shopp & to set it on the west side of the highway . . . over ag[ainst] his new dwelling house."[28]

[28] Barnstable Town Records, manuscript transcriptions by Mary R. Lovell and Gustavus Hinckley (1895), Office of the Town Clerk, Hyannis, Mass., 1:115; *Early Records of Providence*, 11:95. A similar instance of a son's being located by town mandate next to his father occurred when carpenter Thomas Thurston, son of joiner John Thurston of Medfield, petitioned that town for his own land in 1653. After due consideration the selectmen permitted him "six acres for his House lot of upland Adjoyning unto His fathers

The close proximity of a father's labor to his sons' upbringing made it inevitable that a crafting family could reinforce its current status in the community and provide for its future economic security by training its own members to take over the shop when the patriarch wearied. The pervasive trend toward "in-family" training held firm and even strengthened between the second and third generations. While the total number of legal apprenticeships recorded in the region dropped to zero, the number of artisans trained by family members (fathers, uncles, or grandfathers) almost tripled, and the number trained by non–family members fell by more than half of what it had been between the first and second generations (table 7). Logically, as families tightened their networks of local power, they consolidated their craft knowledge and chose to channel it through their own youth. Overall, this trend suggests that the extensive practice of nonfamily apprenticeship, which characterized the training of the second generation, may have become less customary a means of social control as the emergence of strong kin groups guaranteed the occupational security of the next generation. Seen in this light, the "tribalism" of the first generation, rather than having been a practice by which indulgent adults could minimize spoiling their own children, may have functioned as a social mechanism designed to hold children steady in the shaky first years of settlement before relations could supervise the growth and calling of the child on their own.[29]

Beyond question, however, a large majority of second-generation woodworkers were not trained by members of their own families, while those of the third generation clearly were, although some second-generation artisans did risk punishment by law in order to train their own sons. So important was the idea of family training to Benjamin Hearndon, carpenter of Providence, that he tried to keep his son at home despite the youth's legal obligation to another worker. In short order the selectmen of Providence responded, "In Answer to a Letter from the

House loote on the North este" (Medfield Town Records as quoted in Tilden, *History of Medfield*, p. 59).

[29] Edmund S. Morgan, *The Puritan Family: Religion and Domestic Relations in Seventeenth-Century New England* (New York: Harper & Row, 1966), pp. 77, 168–86, first put forward the concept of "tribalism"; see also John Demos, *A Little Commonwealth: Family Life in the Plymouth Colony* (New York: Oxford University Press, 1970), pp. 73–74. Another explanation might be that when older couples took on young servants after their natural children had already left home, tribalism may have functioned as a means by which disoriented parents could preserve a quasi-normative family structure rather than confront life alone. See pp. 117–19 of this essay.

TABLE 7. Training the Second and Third Generations

Generation	Legal apprenticeship recorded		Trained in family		Trained outside family		Total	
	(No.)	(%)	(No.)	(%)	(No.)	(%)	(No.)	(%)
Second	10	4.4	59	26.2	156	69.4	225	100.0
Third	—	—	33	71.7	13	28.3	46	100.0

Massachusetts Colony touching the returning of an Apprentice of his Master in the Bay: It is Ordered, that if the said Apprentice his father Benjamin Hearndon, in whose keeping, the said Apprentice is, do not returne the said Apprentice speedily unto the Bay, that the Constable shall forthwith apprehend him, & convey him to his Master."[30] In turn, the migration patterns of those second-generation woodworkers who *were* trained by family members confirm that increasingly strong kin ties fostered geographical stability (table 8). Here again long-distance migration dropped by 100 percent, while local migration increased. A general pattern emerged through the second and third generations of either complete nonmigration or limited migration within a fifteen-mile radius, both of which attest to the rise in importance of the association between kinship structure and place of habitation.

This relationship between family and location was supported as well by the ties linking artisans' families. The two most influential networks were those created by the bonds of marriage and by business partnership, each of which functioned differently. Marriage to the daughter of an elder woodworker or to the widow of a deceased contemporary artisan insured the selection of a mate used to the seasonal nature of the farmer-craftsman's life and meant a chance to acquire the decedent's tools. It guaranteed as well a hand in the shop. Indeed, some women in the region seem to have been skilled at handiwork, although documentary references are only suggestive. The presence of "Joyners tooles with other things" in the 1633 inventory of Martha Harding of Duxbury deserves consideration, as does the 1666 will of Francis Godfrey. A joiner and carpenter who had built the first Bridgewater meetinghouse just four years earlier, Godfrey specified that while a few of his tools were to go to a grandson, he wished to reserve for "my Wife

[30] *Early Records of Providence,* 2:78.

TABLE 8. Migration Distances of Family-Trained Second- and Third-Generation Artisans from Their Place of Training

Generation	Nonmigrant (No.)	(%)	Less than 15 miles (No.)	(%)	15–30 miles (No.)	(%)	Over 30 miles (No.)	(%)	Total (No.)	(%)
Second	35	59.3	7	11.9	8	13.6	9	15.2	59	100.0
Third	20	60.6	9	27.2	2	6.1	2	6.1	33	100.0

Elizabeth Godfrey one broad and one narrow axe, one hand saw, one hatchett, one square, one Drawing knife, one adds, one hammer, one pair of Chisells, two augurs (one mortising auger and one smaller augur), and three planes (one smoothing plane, one rabbeting plane, and one Joynter), all of the best I have."[31] A well-planned marriage could function in at least three additional ways for the seventeenth-century artisan: it could affect upward social and economic mobility if one's bride were born of wealth; it could gain a migrant artisan acceptance in a new community if he married one of its residents; and it could link together for economic protection all of the artisans who practiced a particular trade in a town.

An artisan's relationship to other workers in his family, particularly as manifest in business partnerships, also affected the texture of family cohesion in the woodworking trades. Almost without exception, partnerships in the southeastern region fell along family lines and consisted of either brothers or brothers-in-law working side by side in the same shop. Typically, tools were owned in common, as were those of Joseph and Anthony Waterman of Marshfield. Joseph's inventory of 1715 listed among their common possessions "the Tools in partner between his

[31] Plymouth Colony Wills and Inventories, Plymouth County Court House, Plymouth, Mass., 1:19–20. Circumstantial evidence that Martha Harding may have been a working artisan is offered by the complete absence of historical references to her husband, suggesting that he may have died either in England or on an early Atlantic crossing; see *Mayflower Descendant*, 17:156. Impetus to marry and remarry artisans' widows, like the incentive for having children, might be attributed to the need for free labor as well as to emotional demands. The economic functions of marriage are summarized in K. H. Connell, "Peasant Marriage in Ireland: Its Structure and Development since the Famine," *Economic History Review*, 2d ser., 14, no. 3 (1962): 503ff. See also Lois Green Carr and Lorena S. Walsh, "The Planter's Wife: The Experience of White Women in Seventeenth-Century Maryland," *William and Mary Quarterly*, 3d ser., 34, no. 4 (October 1977): 561–62.

brother Anthony Waterman & him" at £3.12.06. In no instances did
artisans working in the same town go into partnership with other than
a kinsman and in only one case did an artisan team up with workers in
another town—that being when Charles Stockbridge of Scituate was
retained by the town of Hingham to mastermind the construction of its
second meetinghouse (Old Ship) in 1680. When Stockbridge acknowl-
edged payment for the job in the spring of 1682, he signed his name
after writing "Received by me . . . and my partners Stephen & Joshua
Lincoln of Hingham."[32] But surely this was an exception due to the
elaborate construction and special nature of the project.

Decreased migration, increased power of the family, sons trained
by fathers in domestic settings, marriage, and partnership: the list reads
like a survey of social unity. Yet underneath such a calm surface not all
the currents of family cohesion and generational stability flowed so
smoothly. While the nearness of one's kin was significant in channeling
the growth of the woodworking trades, the very qualities that promoted
strength at times also provoked uncertainty. The resulting instability—
and it must have been in large part a psychological one—seems to have
resulted from the reluctance with which some older artisans passed tools,
shops, and lands to their eager offspring. In their conservative attitudes,
many first-generation workers placed their sons in a position essentially
identical to that in which they had found themselves before leaving
England, suggesting that their deep need to prove their independence
to strict parents resulted not only in migration but, later, also in the
overbearing treatment of their own children. Intent on maintaining their
established brand of patriarchal order, first-generation artisans held on
to the firm ownership of land and trade—often until death—and thereby
forced their sons to remain in town with less than full economic status
in one trade, remain in town and take up alternate trades, or leave town
entirely in order to prove their status as independent householders. We
will see that second- and third-generation woodworkers increasingly chose
the second of these options.

The manner in which this New World generational crisis found
resolution differed from its antecedent in England due to the wide-

[32] Plymouth County Wills and Inventories, Plymouth County Court House, Plym-
outh, Mass., 3:390–91; quoted from the Selectmen's Records of the Town of Hingham
in Arthur Marble, "The Old Ship, the Ancient Meeting House of the First Parish of
Hingham," unpaginated typescript in the Office of the First Parish (Unitarian) Church,
Hingham, Mass.

spread availability of land for artisans. In one sense, the presence of land made elder farmer-craftsmen closefisted. Their fields were cleared, well manured, and in a good year brought a decent profit at the local market. Because land insured them secure balance between agriculture and craft which they had so envied in the English yeomanry, they were sorely hesitant to relinquish its control too quickly. For once they had, they risked becoming ancillary social creatures dependent on others. Carpenter John Paine of Eastham was likely not the only younger artisan to conceive of the elder worker as "some older infirm person whose life is Even a burden to them Selves and they them Selves a burden & a trouble to all about them." First-generation craftsmen, therefore, were often very specific about the restrictive transfer of both land and tools. Frequently they would permit their sons to use their property as if it were their own while still retaining legal ownership. Artisans in the southeastern region did this with their land almost as often as did the husbandmen of Andover. Thus John Gorham, joiner and turner of Yarmouth on Cape Cod, ordained that his eldest son should "have the Dwelling house that hee now lives in, with the barne and halfe the upland belonging to the said farme."[33] By retaining titles to lots already being worked by their sons, parents may have continued to wield disciplinary power and insure that their old age would be spent comfortably. Other artisans treated the tools of their trade with similar caution. In 1663 Thomas Lumbert of Barnstable willed to his son Caleb "the three yeare old mare that was alwaies accounted him, and his Carpenters tooles." In nearby Sandwich John Chipman declared, "I will and

[33] "Deacon John Paine's Journal," in *Mayflower Descendant*, 9:99; Plymouth Colony Wills and Inventories, 3, pt. 1, bk. 2:164. Greven, *Four Generations*, pp. 80–84, discusses the implications of land transfer by will rather than by deed and maintains that Andover parents used property as a kind of leverage for their future security. Demos, *Little Commonwealth*, pp. 164–70, states that in Plymouth Colony as a whole parents do not seem to have used land in such a manner. While I have found that many artisans in Plymouth Colony did—suggesting perhaps that rules of inheritance and attitudes toward land varied due to vocation or an emerging sense of class distinction—we must remember that artisans represented only one specific sector of colonial society. The notion that parents could prolong their children's dependence on them and alter the timing of the family life cycle must be treated with caution, for, depending on age, vocational choice, and order of birth, a child's expectations of substantive inheritance could have ranged from high to nil. In the latter case an attempt at control on the part of parents would have caused no discontinuities. See also Robert V. Wells, "Family History and Demographic Transition," *Journal of Social History* 9, no. 1 (Fall 1975): 11; and R. A. Schofield, "Age-Specific Mobility in an Eighteenth-Century Rural English Parish," *Annales de Demographie Historique* (1970): 265–68.

bequeath to my son Sam[uel] . . . all my Carpinters Tools & Husbandry Implements which are now in his possession and occupation in Barnstable."[34]

Presumably these arrangements usually worked smoothly and proved an effective and efficient way to restore the sharp swaths cut by the Grim Reaper. At the very least, they urge us not to forget that the family is a unit with both social and temporal meaning. Yet in some instances the timing and technique of inheritance may have caused a few problems for younger artisans of the second and third generations, subject as they sometimes were to parental discretion well into middle age. An occasional artisan, lacking a sizable landed inheritance, also found himself blessed with too few of his father's tools with which to start a shop of his own. While it was not very serious when John Crocker of Barnstable directed that his "Carpenters tools be equally Divided between . . . sons Jonathan and John," this kind of partible inheritance could be very damaging in cases where too many brothers competed for their father's attention. John Thomson of Middleboro died in 1696, having decreed, "my four sons shall Have All my Tooles of all Sorts for Carpentry," while William Nickerson of Harwich willed that his carpenter's and cooper's tools worth only two pounds, ten shillings be split five ways— each share worth a meager ten shillings—among five sons. Worse still, a father could always use the bequethal of tools to motivate his sons to follow in his footsteps. In some trades the value of tools alone warranted compliance with parental pressure. While not a woodworker, William Bassett, a Duxbury blacksmith, willed over twelve pounds' worth of tools to his son Jonathan with the caveat that he could have "all the tooles Conditionally that he shall use them in my trade or else they shalbe Devided to my fouer [other] Children." Gorham limited his son in both land and career when he inserted into his will a clause giving the youth "the use of . . . the land that lyeth between the said dwelling house and the tanyard, during all the time he shall keep tanning in that place and no longer."[35]

To a limited degree the delay of adult status affected all generations, implicit as it was in a predominantly agrarian society. As long as

[34] Plymouth Colony Wills and Inventories, 2, pt. 2:24; Barnstable County Wills and Inventories, 3:228–29.

[35] Barnstable County Wills and Inventories, 3:130–31, 618–19, 4:3; Plymouth County Wills and Inventories, 1:241–42; Plymouth Colony Wills and Inventories, 1:128, and 3, pt. 1, bk. 2:164.

TABLE 9. Migration and Aging of First- and Second-Generation Artisans*

	Move to New England		First move in New England				Second move in New England			
	First generation		First generation		Second generation		First generation		Second generation	
Age	(No.)	(%)	(No.)	(%)	(No.)	(%)	(No.)	(%)	(No.)	(%)
20–29	17	60.7	6	24.0	12	70.6	6	46.1	5	41.7
30–49	11	39.3	14	56.0	5	29.4	3	23.1	6	50.0
50+	0	0.0	5	20.0	0	0.0	4	30.8	1	8.3
Sample	28	100.0	25	100.0	17	100.0	13	100.0	12	100.0

* See note 36 for key to age categories.

farming served as the mainstay of economic security and tools continued to function as symbols of occupational responsibility, parents were cautious about passing property to the next generation. Throughout the seventeenth century the effects of inheritance were felt most acutely by artisans in their twenties—the same years that witnessed the termination of apprenticeships, marriage and parenthood, and the highest frequency of migration. Indeed these intersecting patterns suggest that one function of migration may have been to intensify a shift in social status by accentuating a change in social milieu (table 9). In some instances artisans in their twenties moved more than once; perhaps for them social adjustment came less easily, for over 70 percent of the second-generation artisans whose ages at the time of their first move are known moved while in their twenties and over 40 percent of those known to have moved a second time did so while in the same age group. Migration remained fairly frequent throughout the middle years, when wealth was rising and full economic status was developing, indicating a relationship between economic change and geographical mobility. Notably, more than half of the first-generation artisans whose ages at the time of their first move within New England are known moved between the ages of thirty and fifty, a period in the life cycle that for two reasons may have been characterized by a kind of midlife crisis. The first was the departure of children from the family circle. Here again parents threatened by the dissolution of the nuclear family may have moved as a way of marking the inevitable restructuring of their social world. For the sev-

enteenth-century family was, after all, more than a series of blood relations; it was a way of categorizing experience.

The second factor which may have contributed to a high rate of migration during midlife was the death of one's aged parents, an event that frequently leaves children painfully aware that they themselves are entering the last phase of life. In some cases parental death stimulated a new interest in the passage of time and a feeling of having been deserted by society. For example, carpenter John Paine of Eastham began to note his birthdays in his diary shortly before the death of his mother in April 1704, writing: "I am just now entering the fourty Sixth year of my pilgrimage." Three years later, when his father died, a more shaken Paine grieved: "On the Sixteenth day of august 1707 My aged father Thomas Paine departed his life: I am now left fatherless and motherless as to my natural parents but my God is a father of the fatherless upon whose providence I cast my Self o thou god of my father do not cast me off though my father and my mother have forsaken me." The additional fact that almost a third of the first-generation artisans for whom data exist moved a second time after the age of fifty may indicate that in a good many instances the stabilization of wealth did not guarantee a sedentary existence. This was no doubt due to the occasional artisan who kept working well into "'old age" and therefore had little or no reason to alter established habits of geographic mobility.[36] So long as he possessed knowledge (the "rules of art") valued by other men in town and region, the willing craftsman could quite literally work his way to the grave.

Implicit in the fundamental relations described—those of generation, territory, vocation, and, as we have seen, maturation—was a key transformation, a key shift in the identity of the artisan and the organization of his world. Specifically, this change came about as the delicate balance of family structure and individual aspiration was upset. As outlined, the progress of the seventeenth-century artisan was typically measured in increments of family strength and decreasing frequency and

[36]"Deacon Paine's Journal," pp. 49–50; Demos, "Old Age," p. S261. Table 9 structures the aging process in groups of 20 to 29 years, 30 to 49 years, and 50 and more years in keeping with Demos's suggestion that these divisions are most revealing of overall trends in wealth accumulation ("Old Age," p. S266). Forman, "Boston Furniture Craftsmen," p. IX–1, refers to Henry Fane, turner of Boston, who was still engaged in "bottoming chairs" at age eighty-three.

distance of migration—both of which are distinctly social-scientific trends. Yet rising from between these two processes came something whose importance far exceeded them, something that may just help answer the prodding question, Why should social historians study the role of artisans in the past life? For upon peering into the preindustrial culture of southeastern New England, we learn that more was happening than just the slow, clocklike mutation of a cool, agrarian society. We must dig deeper than the statistical surface if we are to discover how people felt about their own lives.

If, like some recent social scientists, we interpret "identity" as a reference to degrees of unity or fragmentation existing within the personality of the individual as he relates his image of himself to his image of the surrounding society,[37] the evidence presented by the careful analysis of the behavior of southeastern New England's early woodworking artisans indicates that two types of personal fragmentation took place. And behind both stood not the breakdown of the family unit—as modern social critics would have us believe—but rather the tenacity and ultimate vindication of the family in local culture. Most noticeable is a trend suggesting that as families became more geographically rooted and more kindship-bound over the course of the first three generations, their heads became less identified with one calling and instead divided their time not only between farming and a craft (as they had always done) but also between farming and two, three, four, and even five crafts (table 10). The inventories of many artisans show this to have been the case. Thomas Tingley of Attleborough owned "Carpenters and Masons tools" at his death in 1724; William Blanton died in Rehoboth later that same year with "augers and chisels and other tools belonging to the Trade of a housewright and all Husbandry tools" in his estate, along with "Lombs, slays, and other tools belonging to the weaver's trade"; Thomas Paine of Truro died in 1721 possessed of tools for carpentry, coopery, surveying, and smithing; and Robert Millerd of Rehoboth, although calling himself a tanner in his will, died in 1709 the owner of tools for tanning, blacksmithing, and shoemaking worth a total of fourteen pounds, ten shillings.[38]

[37] See Tamara Hareven, "The Search for Generational Memory: Tribal Rites in Industrial Society," *Daedalus* 107, no. 4 (Fall 1978): 137–38; and Eric Erikson, *Life History and the Historical Moment* (New York: W. W. Norton, 1975).

[38] Bristol County Wills and Inventories, Bristol County Court House, Taunton, Mass., 2:265; 5:8, 31; Barnstable County Wills and Inventories, 4:10.

TABLE 10. Number of Trades Practiced: Occupational Identity Trends, 1620–1700

Generation	One trade (No.)	(%)	Two trades (No.)	(%)	Three or more trades (No.)	(%)	Total (No.)	(%)
First	102	82.9	18	14.6	3	2.5	123	100.0
Second	162	72.0	54	24.0	9	4.0	225	100.0
Third	31	67.4	12	26.1	3	6.5	46	100.0
Total	295 (74.8%)		84 (21.3%)		15 (3.9%)		394 (100.0%)	

In effect, a man's occupational identity—his image of his own work and his conception of how his work functions in local society—at the close of the seventeenth century no longer rested on a single calling. Men who had been trained for one task branched out into several others, changing their self-image and reputation and, in so doing, changing the relations of production in their community as well. Many of the secondary trades practiced by second- and third-generation artisans would in the first generation have commanded the skill of an individual trained specifically *for that task and no other.* For example, in a 1671 court case that found a first-generation shipwright named William Carr guilty of breach of contract, another shipbuilder named Abell Osuff testified that Carr had caused grave problems by letting a worker perform a task which clearly fell out of his defined occupational domain, his niche in the local hierarchy of task distribution. Osuff's words attest to the first generation's sense of discrete roles for individuals: "He the said Carr had a man named Isaac Sheffield, that was unskilled in that kind of labor . . . for caulking the vessell; and the said Sheffield spent a considerable time about Caulking as his master appointed him, but it plainly appeared that as he had no experience, so the most that he did was ineffectual, and some sort was worse than if he had never meddled therewith, especially considering the danger thereby occuring (the place where he wrought being neer the Keel)."[39]

Perhaps the younger mechanics picked up these added skills strictly to keep down prices by eliminating needless middlemen. Yet, in a deeper vein, the reluctance of the first generation to grant the second generation the tools of their trade forced that younger generation to diversify

[39] Records of the Quarterly Courts of Middlesex County, 3:59.

The Craftsman in Early America

TABLE 11. Breakdown of Woodworking/Building Trades by Generation

Trade	First generation (No.)	(%)	Second generation (No.)	(%)	Third generation (No.)	(%)	Total per trade (No.)	(%)
Carpenter	45	36.7	114	50.8	17	37.0	176	44.6
House carpenter	2	1.6	7	3.1	2	4.3	11	2.8
Joiner	14	11.4	14	6.2	3	6.5	31	7.9
Turner	1	0.8	4	1.8	3	6.5	8	2.0
Dish turner	2	1.6	—	—	—	—	2	0.5
Wheelwright	1	0.8	4	1.8	3	6.5	8	2.0
Cooper	14	11.4	15	6.7	—	—	29	7.4
Setwork cooper	—	—	—	—	1	2.2	1	0.3
Pumpmaker	—	—	1	0.4	—	—	1	0.3
Shipwright	11	8.9	5	2.2	3	6.5	19	4.8
Blockmaker	1	0.8	—	—	—	—	1	0.3
Millwright	2	1.6	—	—	—	—	2	0.5
Sawyer	5	4.1	1	0.4	—	—	6	1.5
Clapboard river	1	0.8	—	—	—	—	1	0.3
Plasterer	1	0.8	—	—	—	—	1	0.3
Nailer	2	1.6	1	0.4	—	—	3	0.8
Combined two of above trades	13	10.6	40	17.8	9	19.6	62	15.6
Combined three or more of above trades	2	1.6	5	2.2	1	2.2	8	2.0
Combined above trade(s) with other trade(s)	6	4.9	14	6.2	4	8.7	24	6.1
Total	123	100.0	225	100.0	46	100.0	394	100.0

if it did not leave town. As we have already noticed, more artisans chose to diversify rather than leave, and in the end this pattern transformed the well-structured society of the first decades of settlement—replete with specialized artisans like dish turners, set-work coopers, clapboard rivers, and plasterers—into a world where the roles of everyday life were more complex, more overlapping, more interdependent, and more tightly integrated (table 11). In this new order the distinctions between one artisan's work domain and that of his neighbor were less clear. In turn,

when the second generation was faced with training their offspring, they sometimes deliberately specified that the youngster should learn two (often related) trades. Although it does not involve a woodworker, one case is particularly instructive. In Providence in 1676 Zachariah Mathewson and his wife promised John Taylor that they would take his son Benjamin and not only "learn him to Read & to Write" but also "to Tann leather & to make shoes."[40] Once on his own, Benjamin would be fully able to practice two legitimate trades: tanning (the curing and preparation of hides) and shoemaking (the transformation of the leather into costume). And because this meant that his future customers would have only one stop to make when in need of a pair of shoes, the diversification of occupational skill seems to have resulted in less social interaction among *all* townsmen but more intense and frequent interaction with a few select individuals. Writ large, this pattern could easily have been an underlying force for the early emergence of self-regulating neighborhoods, so-called self-sufficient households, or the gradual evolution of social class distinctions based on moral preference.

If we view the urban-rural continuum in terms of specialized versus integrated occupational identities or concentrated versus diffused roles, the changing profile of task distribution among southeastern New England artisans shows a general emergence of social class distinctions over the course of the seventeenth century. The trend troward seeing "rural" as different from "urban" is further evident when we check the migration into and out of the Boston–Charlestown area from and to the hinterlands (table 12). The migration activity shows that about one in every five first-generation woodworkers at least attempted to live in a setting

[40]*Early Records of Providence*, 15:76. The continuum from simple to complex (or single to multiple) roles is a more useful model for the analysis of relative ruralism than that derived from vague notions of geographical isolation or "folk versus elite" oppositions. See Gwyn Evan Jones, *Rural Life: Patterns and Processes* (London: Longmans, 1973); and Louis Wirth, "Urbanism as a Way of Life," *American Journal of Sociology* 44, no. 1 (July 1938): 1–24. The effects that occupational diversification has had on modern industrial society are summarized in E. A. Wrigley, "The Process of Modernization and the Industrial Revolution," *Journal of Interdisciplinary History* 3 (1972): 223ff.; the more subtle changes brought about by such diversification are discussed in Margaret Mead, "The Implications of Culture Change for Personality Development," *American Journal of Orthopsychiatry* 17 (1947): 641; Michael Zuckerman, "The Fabrication of Identity in Early America," *William and Mary Quarterly*, 3d ser., 34, no. 2 (April 1977): 192–93; and Richard Bushman, *From Puritan to Yankee* (New York: W. W. Norton, 1970), pp. 267–88.

TABLE 12. Urban-Rural Migration of Artisans

Migration pattern	First generation (No.)	(%)	Second generation (No.)	(%)	Third generation (No.)	(%)
Boston–Charlestown to hinterlands	11	8.9	1	0.4	—	—
Hinterlands to Boston–Charlestown	9	7.3	1	0.4	1	2.2
Boston–Charlestown to hinterlands and returned	—	—	—	—	—	—
Hinterlands to Boston–Charlestown and returned	4	3.3	11	4.9	—	—
Total urban-rural migrants	24	19.5	13	5.7	1	2.2
Total rural nonmigrants	99	80.5	212	94.3	45	97.8
Total	123	100.0	225	100.0	46	100.0

that was distinctly urban by the late 1640s,[41] but the percentage fell to one in every twenty second-generation artisans, and fell still further to include only one in every fifty workers in the third generation. A steady movement toward a self-conscious rural stasis pervaded the period, again suggesting that while first-generation artisans, secure in their more narrowly defined economic roles, migrated easily from city to country, their offspring somehow felt less confident in areas outside those described by the tight circle of relations. And despite our modern tendency to assume that artisans will inevitably seek a market that, like seventeenth-century Boston, could afford the highly specialized crafts of upholsterer, carver, pailmaker, wine cooper, and pipe-stave maker, the artisans of the second and third generation clearly *preferred* their rural world, where family matters were of increasingly central concern. Watching the medieval universe recede behind them, these artisans rejected a firm occupational identity and opted instead to keep family and household together.

Insofar as both a newly arrived consciousness of rural society and its foundation in moral economy came as by-products of increasing family cohesion, we can see that the growth of seventeenth-century New England society as a whole cannot be explained as a process of

[41] Darrett B. Rutman, *Winthrop's Boston: A Portrait of a Puritan Town, 1630–1649* (Chapel Hill: University of North Carolina Press for the Institute of Early American Culture, 1965), pp. 164–201.

preservation and extension alone.[42] Built solidly into the *mentalité* of this agrarian culture was a mechanism that pushed families together but broke the individual apart, leaving him to contemplate a relentless dialectic between his obligation to local society and the larger world of upward material mobility.

The first three generations of artisan existence in early New England tell us much about moments in the transition from medieval to modern society which would be difficult to approach if we assumed that an agrarian economy meant a kind of occupational sameness. In summary, the four essential qualities of artisan life in southeastern New England during the period included an overall stabilization of demographic movement, which saw the concept of family more closely identified with the concept of place than it had been in medieval society; a rise in the power of families—not society as a whole—in educating and influencing the occupational direction of their own offspring; a steady rate of role diffusion, which meant that more and more people were becoming more and more alike in vocational skills and social status; and, finally, a constant movement by families toward isolated farmsteads within town boundaries as lots at the town center grew scarce and unaffordable.[43] This made similar people live farther and farther apart. Joined to a steadily decreasing level of lay piety in the church, these processes are at the root of modern individualism. And while we have focused specifically on the changes in the artisan's world, these patterns grew from the same vital issues that affected a widespread segment of colonial American society. Working from obscure carpenters like Richard Church, we can spin webs in which to catch for analysis later moments in time. For if the ground rules of modern American individualism were adumbrated by the close of the seventeenth century, they would not be codified until the Industrial Revolution.

[42] James A. Henretta, "Farms and Families: *Mentalité* in Pre-Industrial America," *William and Mary Quarterly*, 3d ser., 35, no. 1 (January 1978): 7–8.

[43] Kenneth A. Lockridge, *A New England Town: The First Hundred Years* (New York: W. W. Norton, 1970), pp. 93–118.

Boston Goldsmiths, 1690–1730
Barbara McLean Ward

Between 1690 and 1730 Boston was the undisputed colonial leader in the production of gold and silver objects, and some of the finest American silver ever produced was made in Boston at this time. The goldsmithing craft thrived in Boston during the last decade of the seventeenth century and the first decade of the eighteenth century. The influx of English officials into Boston following the establishment of the Dominion of New England and the proclamation of the Royal Charter in 1691 jarred the traditional preferences of the town's social elite and stimulated a demand for stylish objects on a par with those made in London.[1] With the end of Queen Anne's War in 1714, however, inflation and recession slowed economic growth in Boston, and by the 1730s many goldsmiths were unable to make more than a subsistence-level wage. Fewer native craftsmen entered the trade, and the influx of fully trained immigrant craftsmen slowed considerably as opportunities diminished.

Details of the lives of the craftsmen who worked in Boston during this period not only reveal the inner workings of a particular craft but also shed light on the role of the artisan in pre-Revolutionary urban society. Examination of correlations between wealth, occupational mobility, family background, and social status for one craft group allows for a better understanding of the diversity of the artisan class and the widening gap separating laboring artisans from merchant-producer

[1] For the changing political status of the colony and its social consequences, see Bernard Bailyn, *The New England Merchants in the Seventeenth Century* (1955; reprint ed., New York: Harper & Row, 1964), pp. 192–97; and Richard S. Dunn, *Puritans and Yankees: The Winthrop Dynasty of New England, 1630–1717* (1962; reprint ed., New York: W. W. Norton, 1971), pp. iii–vi, 219–20.

craftsmen during the colonial period. The inner dynamics of the gold-smithing craft, as revealed through the exploration of the hierarchy within the trade, relationships between masters, journeymen, and apprentices, and the variety of business practices common among goldsmiths of this period, provide data for further study of the work culture of the urban craftsman.

Goldsmiths are a particularly fruitful group for study because we know who they were, what they made, and who were their patrons. They marked the objects they produced with distinctive hallmarks and often engraved the initials and coats-of-arms of the purchasers / owners. Thus, we can both discover the forms and techniques of a particular craftsman and learn the identity of his clients. Within the last fifty years much biographical work has been done on Boston goldsmiths by schol-ars in the field of American decorative arts. This essay seeks to bring together the points of view of the social historian and the art historian, to present new information, and to analyze the biographical data com-piled by Kathryn C. Buhler, John Marshall Phillips, Francis Hill Bige-low, Martha Gandy Fales, and others on the members of the craft who worked in Boston during the period 1690–1730.[2]

[2]Extensive biographical work on Boston goldsmiths by Kathryn Buhler has been extremely helpful in the preparation of this essay. Much of this work has been published in Kathryn C. Buhler, *American Silver, 1655–1825, in the Museum of Fine Arts, Boston,* 2 vols. (Greenwich, Conn.: New York Graphic Society, 1972); Kathryn C. Buhler, *Massachusetts Silver in the Frank L. and Louise C. Harrington Collection* (Worcester, Mass.: Barre Publishers, 1965); and Kathryn C. Buhler, *Colonial Silversmiths, Masters and Apprentices* (Boston: Museum of Fine Arts, 1956). The principal primary sources con-sulted include Boston vital records printed in *Record Commissioners Reports of the City of Boston,* vols. 9 (1883), 24 (1894), and 28 (1898); *Suffolk County Probate Records,* (Waltham, Mass.: Graphic Microfilm of New England, 1957); Records of the Inferior Court of Common Pleas for Suffolk County, Social Law Library, Suffolk County Court House, Boston; and Suffolk County Court Files, Office of the Clerk of the Supreme Judicial Court of Suffolk County, Suffolk County Court House (hereafter cited as SCCF). Published works consulted include Henry N. Flynt and Martha Gandy Fales, *The Heri-tage Foundation Collection of Silver with Biographical Sketches of New England Silver-smiths, 1625–1825* (Old Deerfield, Mass.: Heritage Foundation, 1968); Oliver A. Roberts, *History of the Military Company of Massachusetts Now Called the Ancient and Honor-able Artillery Company of Massachusetts, 1637–1888,* vol. 1 (Boston: Alfred Mudge & Son, Printers, 1895); Hermann Frederick Clarke, *John Coney, Silversmith, 1655–1722* (1932; reprint ed., New York: Da Capo Press, 1971); and Hollis French, *Jacob Hurd and His Sons Nathaniel and Benjamin, Silversmiths, 1702–1781* (1939, addenda printed 1941; reprint ed., New York: Da Capo Press, 1972). Francis Hill Bigelow and John Marshall Phillips manuscript notes at Yale University Art Gallery (hereafter cited as Bigelow-Phil-lips notes) have also been a valuable source of information. The full results of my work to date appear in Barbara M. Ward, "The Craftsman in a Changing Society: Boston Goldsmiths, 1690–1730" (Ph.D. diss., Boston University, 1983).

In contrast to traditional studies which have singled out exceptional craftsmen as the basis for broad generalizations, this paper attempts to analyze the available data from documentary evidence and surviving objects for all of the eighty-two goldsmiths so far identified. It is hoped that this method will provide new insights into (1) the hierarchy that developed within the craft; (2) the distribution of wealth among gold-smiths and how it related to wealth distribution in the community as a whole; (3) the apparent decline in the social mobility of goldsmiths toward the end of the period; (4) the working relationship between master craftsmen and between master craftsmen and their journeymen and apprentices; and (5) the range of work performed by men working within the same craft.

Much of the literature on the craft of the goldsmith has focused on the special respect accorded to the members of the trade because they understood the mysteries of working with precious metals. In medieval times goldsmiths were innovators in the arts, and they enjoyed impor-tant royal and church patronage. By the seventeenth century, however, the goldsmith was principally an imitator of the stylistic innovations in the other arts and was regarded by his contemporaries as merely a mechanical artist. When Jaspar Danckaerts visited Boston in 1680, he took it as a symbol of declining piety and incipient materialism that the sons of four clergymen were apprenticed to goldsmiths, but this may also suggest that Bostonians considered the craft of the goldsmith to be an honorable and lucrative calling.[3]

Although there was generally a high level of prosperity among Bos-ton goldsmiths of the seventeenth century, there was by no means an equality of either status or interests among craftsmen. Goldsmiths, like all craftsmen, "could be found in every rank from that of the privileged urban gentry all the way down to that of the white indentured servants and Negro slaves. They constituted a vertical, not a horizontal, section of the colonial population." One's position within the craft was deter-mined by birth and family position and enhanced by financial success and prudent marriage alliances. Because the goldsmith worked in pre-

[3]Eva M. Link, *The Book of Silver*, trans. Francisca Garvie (New York: Praeger Publishers, 1973), p. 47; R. Campbell, *The London Tradesman* (1747; reprint ed., New-ton Abbot, Devonshire: David and Charles, 1969), pp. 141–42; Bartlett Burleigh James and J. Franklin Jameson, eds., *Journal of Jaspar Danckaerts, 1679–1680* (New York: Charles Scribner's Sons, 1913), pp. 274–75.

cious metals, his business required that he make a substantial capital investment in order to become an independent master craftsman. This usually required that he have either family resources or sufficient personal contacts with local and foreign merchants to command substantial amounts of credit. Such personal connections might come as a result of the skill that he had shown as a journeyman or the good will of his former master. Brock Jobe noted the latter circumstance in his study of Boston furniture craftsmen of the early eighteenth century. As James Henretta has said, for Bostonians of the late seventeenth century, "the best opportunities for advancement rested with those who could draw upon long standing connections, upon the credit facilities of friends and neighbors and upon political influence."[4]

It is little wonder, then, that a man like Jeremiah Dummer, whose father, Richard, was one of the largest landowners in Massachusetts and a leading political figure in the colony, had no trouble setting himself up as an independent goldsmith and attracting the most distinguished patrons. Not only did he produce fine silver for many homes, but he also received commissions from churches, some as far away as Connecticut. It is clear that his neighbors respected him for his leadership qualities as well as for his skill in the craft. During most of his life Dummer served in positions of responsibility in both town and colony governments. Because of his father's extensive connections he was readily accepted by the Boston elite. In addition, he was resourceful and industrious enough to turn the profits of his goldsmithing business into wise investments in shipping and other enterprises.[5]

Not all goldsmiths had Dummer's ready access to the upper classes, but their trade potentially gave them several advantages over other craftsmen. In a money-scarce economy, which ran on a system of debits and credits "by book," the artisan often waited for long periods of time before he was paid for his labors. When he eventually received payment

[4] Carl Bridenbaugh, *Cities in the Wilderness: The First Century of Urban Life in America, 1625–1742* (1938; reprint ed., New York: Oxford University Press, 1971), p. 143; Brock Jobe, "The Boston Furniture Industry, 1720–1740," in *Boston Furniture of the Eighteenth Century,* ed. Walter Muir Whitehill (Boston: Colonial Society of Massachusetts, 1974), p. 11; James A. Henretta, "Economic Development and Social Structure in Colonial Boston," in *Colonial America: Essays in Politics and Social Development,* ed. Stanley N. Katz (Boston: Little, Brown, 1971), p. 452.

[5] Hermann Frederick Clarke and Henry Wilder Foote, *Jeremiah Dummer: Colonial Craftsman and Merchant, 1645–1718* (1935; reprint ed., New York: Da Capo Press, 1970), pp. 3–51.

it might well be in the form of inflated paper money and credits on other shops.[6] The goldsmith was one of the few craftsmen likely to have access to hard money on a fairly regular basis. Customers were encouraged to bring metal directly to the goldsmith as the raw material for the goods they ordered, and, in this way, the largest manufacturing goldsmiths received payment for the goods they made even before they began to fill the order. Most goldsmiths eagerly sought used objects, but only the wealthiest could pay cash for old silver and gold. The volume of the merchant-producer goldsmith's business demanded that he have a constant supply of precious metals on hand in his shop. Journeyman goldsmiths or any workman who lived by piecework received only enough silver from their employers to do the job, and they were required to account strictly for all the metal they used. These marginal craftsmen were not apt to have the credit resources of the most affluent members of the craft. The established merchant-producer goldsmith, on the other hand, enjoyed a favorable position within the local merchant community because his stock appreciated with the rate of inflation.

The most successful goldsmiths served a luxury market and constantly came into contact with the most affluent members of society. They could often boast of friendly relationships with the local clergy, justices and gentlemen, and the wealthiest merchants. These men trusted the goldsmith to produce wares of the latest fashion and of sterling quality. With no assay offices and guilds to certify the quality of the metal in a given piece, the maker's hallmark became the customer's only guarantee of quality. The goldsmith's success in business no doubt depended at least in part on his reputation for integrity and honest dealing. The craftsman who received the trust and respect of his social superiors also received the general notice of his fellow citizens. Many goldsmiths were elected to fill responsible positions in the town, militia, military company, and church.

Not all goldsmiths received the same measure of trust. The patterns of patronage revealed by the diary and ledger of Samuel Sewall help to illuminate the hierarchy among goldsmiths. For instance, when purchasing large or important objects—such as a beaker (1700), the half pike for the Artillery Company (1701), two tankards (1701, 1710), a cup for a prize (1702), or a salver and a spout cup for wedding presents

[6] Carl Bridenbaugh, *The Colonial Craftsman* (1950; reprint ed., Chicago: University of Chicago Press, Phoenix Books, 1966), pp. 153–54.

(1710)—Sewall usually patronized John Coney. Although he ordered a tankard from Edward Winslow in 1719, the ledger shows that Sewall was more likely to purchase from this goldsmith such lesser objects as spoons (1702, 1714), a gold necklace (1708), porringers (1709), gold buttons (1712), and rings (1722, 1726). It is surprising that from his close friend and cousin, Jeremiah Dummer, Sewall mentions ordering only a ring (1702), spoons (1706), several porringers (1710), and a whistle (1710). Other accounts with Dummer for unspecified services exist for the years 1694 to 1701, and it is possible that Sewall ordered plate from Dummer during those years. After 1710 Dummer's health failed, and it is evident that Sewall was more inclined to take his important orders to Coney after that date.[7]

On several occasions, particularly after 1710, Sewall also patronized John Edwards, buying gold rings from him in 1716, 1723, and 1724, spoons in 1711 and 1725, silver shoe buckles in 1719, and a porringer in 1724. A tankard with the Sewall arms, which was later given to the Old South Church, bears Edwards's mark and may be either the tankard Edwards mended for Sewall in 1724, which is listed in the ledger, or a separate commission which was never noted. For small work Sewall frequently went to the shop of William Cowell. In his accounts Sewall listed clasps for two Psalters (1711), a gold locket and gold beads (1719), silver spoons (1725), and a chain (1726) purchased from Cowell. At the time of his daughter's funeral in 1710, he recorded single orders to his former ward Samuel Haugh for six rings and to Peter Oliver for ten rings. In 1723 he ordered a ring from Nathaniel Morse, and in 1725 he purchased a spoon from Jacob Hurd.

These accounts show that Sewall considered John Coney to be the foremost producer of hollowware in Boston. He purchased lesser items from Edward Winslow on most occasions, but he must have considered Winslow to be a competent smith when he commissioned him to make a tankard in 1719. After 1710 Sewall patronized John Edwards frequently, and he seems to have been impressed with William Cowell's selection of jewelry. Sewall sometimes visited two or more goldsmiths' shops in the same week, which suggests that he matched the job to the craftsman rather carefully instead of habitually going to the same man. When he had an order too large to be filled by one firm alone, he

[7] Samuel Sewall account book and ledger, 1670–1728, New England Historic Genealogical Society, Boston; M. Halsey Thomas, ed., *The Diary of Samuel Sewall*, 2 vols. (New York: Farrar, Straus & Giroux, 1973), 1:253, 568, 2:672, 741, 914, 939, 989.

divided his order according to his regard for the abilities of the crafts-
men. No doubt other customers followed similar patterns. Although
personal preference and family and business connections served to divide
the market among a number of goldsmiths, certain men achieved local
renown. Coney's important government, college, and church commis-
sions show that Sewall's preference was shared by other influential Bos-
ton citizens. Although they produced much fine silver, Dummer and
Winslow were probably best known for their government service. Dum-
mer served as selectman and justice of the peace for many years, Wins-
low was well known as the sheriff of Suffolk County (fig. 1), and both
were appointed justices of the Inferior Court of Common Pleas in their
later years.

Other goldsmiths, like Thomas Savage, David Jesse, and John Noyes,
produced work of high quality proving that they too were accomplished
craftsmen. However, they did not enjoy the same level of private and
church patronage as did Dummer, Coney, and Winslow. Although
probate records are not available for either Savage or Noyes, evidence
of property holding and office holding for these men, and for Jesse as
well, indicate that all of them belonged to the upper ranks of the middle
class. Productivity figures and documentary evidence suggest that all
three were independent craftsmen employing apprentices and an occa-
sional journeyman.

Below Savage, Jesse, and Noyes in the hierarchy of the craft were
others who seem to have produced very few objects. These men proba-
bly relied for their income on small work, such as jewelry, and a steady
stream of repair work. Some may also have been jobbers or piecework-
ers whose livelihood was based on making objects for the larger shops
on special order. No doubt many served as journeymen for at least a
part of their careers. Although we cannot know for sure how many men
actually worked as goldsmiths independently, the fact remains that of
the eighty-two men included in this study, only thirty-three are known
today by more than a handful of surviving objects, and at least twenty
men appear in the records for whom no objects have yet been discov-
ered. Although the rate of survival may not be constant for all gold-
smiths' work of this period, such figures indicate that hollowware
commissions, the most lucrative part of the market, were controlled by
a very few craftsmen. There can be little doubt that John Coney, from
whose shop more than 110 objects survive, produced more silver than

Figure 1. John Smibert, *Edward Winslow*. Boston, 1730. Oil on canvas; H. 32½", W. 27½". (Yale University Art Gallery, Mabel Brady Garvan Collection.)

did John Noyes or Thomas Savage, known by fewer than two dozen objects each.

The fortunes of the goldsmith rose and fell with the fortunes of his customers. During the 1690s most Bostonians were employed and wages were relatively high. Numerous merchants engaged in shipping and enjoyed a comfortable prosperity; a few of them amassed considerable wealth. When royal officials arrived in Boston in the late 1680s and 1690s, following the revocation of the old company charter, they brought with them the ostentatious life-style of Restoration England. The Bos-

ton mercantile elite sought to compete with these new officials for power and prestige, and one result was a growing demand for luxury goods. Boston goldsmiths prospered as a consequence.

During this decade the market in silver was dominated by Coney and Dummer, followed by John Allen and John Edwards, William Rouse, Edward Winslow, and Timothy Dwight. The remaining business was divided among such men as Noyes, Savage, Jesse, and immigrants Richard Conyers, Edward Webb, and William Cross. Other men working at the end of the seventeenth century, who may have been journeymen or jobbers, were James Barnes, Jr., Jonathan Belcher, Samuel Foster, René Grignon, Samuel Haugh, Eliezur Russell, Robert Sanderson, Jr., and Thomas Wyllys. In 1685 Samuel Sewall wrote in his diary that young Samuel Clark, a goldsmith trained with Hull and Sanderson, had chosen to go to sea for a short time because he had "no work in the shop." In spite of the fact that he had served his apprenticeship in a well-known firm and came from a good family, Clark apparently found that he could not make a living working as an independent goldsmith. Another craftsman who came to Boston toward the end of the seventeenth century, Henry Hurst, is documented as having worked as a journeyman until at least 1701.[8]

By the early years of the eighteenth century some Bostonians were reaping large profits from the production and shipping of war materials. Such men had more money to spend on luxury goods than previously, a fact that may account for the survival of so many superbly crafted silver objects in the early baroque style. Between 1700 and 1710 Coney and Dummer continued to be the leading goldsmiths in Boston. The bulk of Edward Winslow's finest work dates from this period and shows a skill and sophistication that attracted the notice of his contemporaries. John Allen and John Edwards made several outstanding individual pieces, and the many church commissions that they were called on to fill are a clear indication that the partners were widely respected. Records reveal that all of these men earned a very comfortable living from their craft.[9]

During the decade from 1710 to 1720, Boston experienced postwar

[8] Thomas, *Diary of Sewall*, 1:77; SCCF, no. 5565a.

[9] Gary B. Nash, *The Urban Crucible: Social Change, Political Consciousness, and the Origins of the American Revolution* (Cambridge, Mass.: Harvard University Press, 1979), pp. 54–58; Clarke, *John Coney*, inventory printed between pp. 12 and 13; Clarke and Foote, *Jeremiah Dummer*, pp. 42–43; *Suffolk County Probate Records*, nos. 8478, 10609, 12211.

recession coupled with a rapid depreciation of the provincial currency. The economic instability of the period suggests that there was less opportunity for the young goldsmith just starting his career than had been the case in the previous two decades. With Dummer forced to retire because of ill health, Coney, Winslow, and Edwards continued as the leading goldsmiths in Boston. John Dixwell and William Cowell, two other craftsmen who had begun to receive attention before 1710, were established enough to make quite a good living during this period. Others such as Benjamin Hiller, Nathaniel Morse, John Noyes, and Thomas Savage (who returned to Boston from Bermuda in 1714) were also factors in the market. Morse was probably best known then, as now, for his exceptional abilities as an engraver. John Noyes also made beautiful silver and is now particularly well known for a pair of candlesticks in the Museum of Fine Arts, Boston (fig. 2). Edward Webb and William Cross continued to practice the craft until the midteens, and Webb died with a considerable estate. Thomas Milner, whom Webb names in his will as his "kind friend," may well have worked alongside him in his shop. Peter Oliver made some exceptional pieces of plate shortly before he died at the age of thirty in 1712. Other goldsmiths who are known only by name probably worked as journeymen or had their primary business in repair work. Among these are Abraham Barnes and Daniel Gibbs who arrived in Boston aboard the *Globe* from Ireland in 1716. The pathetic example of Daniel Legaré of Braintree, son of a Huguenot goldsmith, emphasizes the competitiveness that characterized the Boston market. Although Legaré inherited his father's business and enjoyed some success in the craft while he was working in his hometown, when he set up shop in Boston in 1714 he found it difficult to obtain customers where so many accomplished goldsmiths already were established. In 1722 he was imprisoned for debt but was released when he was able to prove solvency.[10]

During the 1720s a whole new generation of native goldsmiths came into prominence. They entered the business at a time when Boston's economic future was becoming increasingly bleak, and it is not surprising that many found it difficult to establish themselves in the craft.

[10]Nash, *Urban Crucible*, pp. 82–83; *Suffolk County Probate Records*, no. 4086; William H. Whitmore, comp., *Port Arrivals and Immigrants to the City of Boston, 1715–1716 and 1762–1769* (Baltimore: Genealogical Publishing Co., 1973), p. 12; Winifred Lovering Holman, "Legaré—L'Egaré Notes: Francis of Boston and Braintree, Massachusetts, and His Son Daniel" (genealogy), New England Historic Genealogical Society.

Figure 2. Candlesticks, John Noyes. Boston, 1695–1700. Silver; H. 9¼", W. (base) 6⅜". (Museum of Fine Arts, Boston.)

Among them were men like John Burt and Jacob Hurd, who, with their sons, would dominate the goldsmithing trade in Boston for the next two decades. Edward Winslow increasingly devoted his energy and time to public duties, particularly after his appointment as sheriff of Suffolk County. It can be assumed that he left most of his routine work to his journeymen, as nothing of significance survives from this period and documentary references mention only minor pieces from his shop.[11]

The Edwards family also played a major role in the trade, with Thomas and Samuel joining their father, John, in the business. Paul Revere I, father of the patriot, won his freedom after the death of his master, John Coney, in 1722 and established himself in the craft. John Potwine, George Hanners, Samuel Burrill, and Joseph Goldthwait finished their apprenticeships during this decade and enjoyed moderate

[11]G. B. Warden, "Inequality and Instability in Eighteenth-Century Boston: A Reappraisal," *Journal of Interdisciplinary History* 6, no. 4 (Spring 1976): 589; Nash, *Urban Crucible*, pp. 110–18; Buhler, *American Silver*, 1:79; Bigelow-Phillips notes.

success. Knight Leverett had difficulty making a living in the craft, in spite of the skill demonstrated in his surviving works.

Of the fifty-five goldsmiths who began working in Boston between 1700 and 1730, approximately 73 percent achieved some degree of independence as artisans, and marks can be identified for 69 percent. Thirty-five men operated shops large enough to require the services of journeymen, and another 11 percent worked alone and were reasonably successful. Those who were semidependent or who operated marginal independent shops account for another 33 percent. Approximately 20 percent of the second-generation goldsmiths, as opposed to approximately 7 percent of the first-generation goldsmiths, were wholly dependent journeymen for most of their careers. John Edwards and his sons Samuel and Thomas owned adult male slaves who may have worked as goldsmiths, but slaves appear to have made up only a very small proportion of the craft, and there is no definite reference in the records to any slave goldsmiths. Only the very high valuations of the slaves owned by the Edwardses suggest that some slaves may have worked in Boston as goldsmiths.[12] Other members of the craft owned youths who may have been apprentices or general errand boys, but the need for strict security within the goldsmith's shop may have discouraged the practice of taking slave apprentices.

During the 1690s goldsmithing was a promising trade for a young man to enter, but by the 1730s Boston was no longer an attractive place to send one's son for training in the craft. Immigration of craftsmen from abroad also decreased significantly during the period. Whereas 60 percent of the young men who began their careers in Boston during the 1690s were foreign born, by the 1720s the makeup of the craft was increasingly native Bostonian (65 percent) and native colonial (79 percent). The ratio of goldsmiths to inhabitants fell from 1 in 240 in the 1690s to 1 in 290 in the 1720s. It then took a precipitous drop in the 1730s, and by 1742 only 1 of every 430 inhabitants was a goldsmith. This decline not only reflects the fact that fewer young men were entering the trade but also shows the extent to which out-migration of craftsmen weakened the goldsmithing trade. Epidemics and hard economic conditions forced many craftsmen—like John Potwine, William Pollard, Benjamin Savage, and Thomas Edwards—to try their luck elsewhere.

[12] *Suffolk County Probate Records*, nos. 8478, 12962.

Although probate information is available for only 48 percent of the goldsmiths in the study, it seems clear that only a few individuals gained a substantial fortune from goldsmithing. Figures published by Gary Nash allow us to compare the wealth distribution among goldsmiths to the population in general.[13] The figures that follow are based on estate inventories and therefore represent wealth at the time of death.

Of the twenty-seven men who were trained and working in Boston before 1700 (Appendix 1), estate information is available for fourteen (52 percent).[14] Of these, five (18.5 percent of total) had estates sufficient to place them in the wealthiest 10 percent of Boston's population. Only three—John Coney, John Edwards, and Edward Winslow—made their fortunes in Boston. The other two, René Grignon, who died in Norwich, Connecticut, and F. Solomon Legaré, who died in Charleston, South Carolina, failed to achieve financial success until they left Boston. Another six (22 percent) fall within the upper middle class (61st to 90th percentile), and another three (11 percent) fall within the lower middle class (31st to 60th percentile). None of the goldsmiths probated from this generation had estates placing them within the poorest 30 percent of the population. Some transient individuals may have had lower incomes, but the shortness of their stay in Boston makes it impossible to determine their economic status.

The next generation of goldsmiths, those who came of age after 1700 (Appendix 2), fared less well. Of the fifty-five men in this group, estate information is available for twenty-five (45 percent). Seven men

[13] Nash, *Urban Crucible*, p. 400. Monetary figures have been converted to pounds sterling based on the changes in the price of silver as recorded in *The Statistical History of the United States from Colonial Times to the Present* (Stamford, Conn.: Fairfield Publishers, 1966), p. 773; and in the tables included in John J. McCusker, *Money and Exchange in Europe and America, 1660–1775: A Handbook* (Chapel Hill: University of North Carolina Press, 1978).

[14] Inventories exist for Benjamin Coney (Connecticut Probate, Town of Stratford, Fairfield Probate District, file 1707) John Coney (Suffolk County Probate [hereafter cited as SCP], 22:813–16), Richard Conyers (SCP, new ser., 4:421), Timothy Dwight (SCP, 8:228), John Edwards (SCP, 38:515–18), René Grignon (Connecticut Probate, Town of Norwich, New London Probate District, file 2317), Samuel Haugh (inventory missing, value of estate given in administration accounts, SCP, 22:405–6), Henry Hurst (SCP, 21:276–77), David Jesse (SCP, 16:143–45), Francis Legaré (SCP, 17:374–75), F. Solomon Legaré (E. Milby Burton, *South Carolina Silversmiths* [Charleston: Charleston Museum, 1968], pp. 109–10, records the value of Legaré's estate as probated in Charleston in 1760), William Rouse (SCP, 16:86–87), Robert Sanderson, Jr. (SCP, 21:170–71), and Edward Winslow (SCP, 49:341–44).

(12.7 percent of the total group) had estates that placed them within the wealthiest 10 percent of Boston's population.[15] Five of these seven spent most of their careers in Boston. Another eight had estates in the upper-middle wealth category (61st to 90th percentiles), and nine had estates in the lower-middle category (31st to 60th percentiles) or had estates that were declared insolvent.[16] Of those whose estates were insolvent, only two, those of Daniel Legaré and Knight Leverett ranked in the lowest wealth category before payment of debts. The mean value of probated goldsmith's estates for men who came of age between 1700 and 1730 was £484.18 sterling, and the median figure was £350.00 sterling with 60 percent of the estates falling below the average figure. Of those goldsmiths who came of age during the 1720s, however, 70 percent fell below the average of £527.00 for their group, and the median figure of approximately £175.00 indicates a highly unequal distribution of wealth. Whereas those goldsmiths who came of age during the first two decades of the eighteenth century fell for the most part in the moderate or the upper-middle wealth ranges, nearly 50 percent of those who came of age during the third decade of the century fell within the lower-middle range, and the estates of 24 percent were insolvent. Only two men (9.5 percent), Thomas and Samuel Edwards, died with estates

[15] The seven men were John Burt (SCP, 39:160–61), William Cowell (SCP, 33:66–67), Samuel Edwards (SCP, 63:37; Smith-Carter Family Manuscripts, notebook kept by Isaac Smith as one of the executors of the estate of Samuel Edwards, Massachusetts Historical Society, Boston [hereafter cited as MHS]), Thomas Edwards (SCP, 51:52), Samuel Gray (Connecticut Probate, Town of New London, New London Probate District, file 2276), Benjamin Savage (Probate Court, Charleston, S.C., inventories 1748–51, p. 333, as transcribed by Emma B. Richardson, Bigelow-Phillips notes), and Edward Webb (SCP, 21:261–62).

[16] The eight men in the upper-middle wealth category were John Dixwell (SCP, 25:274–80), Joseph Goldthwait (Middlesex County Probate, 64:4), George Hanners (SCP, 35:89–90), William Jones (Essex County Probate, no. 15237), Joseph Kneeland (SCP, 35:137, 168), Job Prince (SCP, 16:437); inventory missing from his docket in Connecticut Probate, Town of Milford, New Haven Probate District, file 8504), William Simpkins (SCP, 79:286–89), and Andrew Tyler (SCP, 66:74, partial figures only). The estate of Daniel Russell was inventoried but not valued, but it probably falls within this category (Ezra Stiles itinerary, May 9, 1780, p. 415, Stiles Papers, Bernecke Library, Yale University). The nine men in the lower-middle category were James Boyer, insolvent (SCP, 35:400–402, 37:293), Peter Feurt, insolvent (SCP, 36:186), John Gray (Connecticut Probate, Town of New London, New London Probate District, file 2274), Rufus Greene (SCP, 89:372–77), Jacob Hurd (SCP, 54:58), Daniel Legaré, insolvent (SCCF, no. 16553), Knight Leverett, insolvent (SCP, 48:460, 49:385, 50:712), Nathaniel Morse (SCP, 41:199, 42:160), and Jonathan Reed (SCP, 36:240–41).

large enough to rank them in the top 10 percent. These figures clearly demonstrate that by 1730 goldsmithing did not provide the financial security that it had prior to 1700.

There is also reason to believe that the social mobility of the goldsmith declined in the later period and that the goldsmith was becoming more entrenched as a member of the artisan class than he had been in the seventeenth century. Evidence for this view lies in the fact that more men trained sons in the craft than previously. Of the twenty-seven men trained before 1700, for instance, three were sons of clergymen, three of merchants, one of a gentleman, two of mariners, and one of a surgeon. Eight, or 30 percent, came from the families of artisans and, surprisingly, only two (7.4 percent), Robert Sanderson, Jr., and F. Solomon Legaré, were sons of goldsmiths. Of the craftsmen trained between 1700 and 1720, 38 percent came from artisan families and 12.7 percent were sons of goldsmiths. Those men who entered the craft after 1700 were more likely to follow the paths of their fathers than were their predecessors. Furthermore, several of the men in the later group—most notably William Cowell, John Burt, and Jacob Hurd—continued the tradition by training their sons in goldsmithing. While the most successful men from the earlier period saw their sons become wealthy merchants, like Joshua and Isaac Winslow, or public servants, like William and Jeremiah Dummer, Jr., the most successful men in the later period trained their sons to carry on their business.

Even for the goldsmith, "the most genteel of any in the Mechanic Way,"[17] success was a matter of good business sense, strong local connections, and skill in the craft. For the young man trying to establish himself in a highly competitive market, the surest way to advance in his profession was to serve an apprenticeship under one of the best goldsmiths in town. Another possible road to success was to work as a journeyman in a prestigious shop where one would have a chance to make his abilities known to the most influential clients.

The master goldsmith employed journeymen and accepted apprentices according to the size of his business. Kathryn Buhler credited the shop of John Coney with seven apprentices. In light of new evidence, we may tentatively add Peter Oliver, who chose Coney to be his guardian in 1697, and Coney's youngest brother, Benjamin, whose identity as a goldsmith was recently discovered by Edward S. Cooke, Jr. Count-

[17]Campbell, *London Tradesman*, pp. 141–42.

ing his apprentices alone, Coney could have had as many as five men working in his shop at any one time. A master craftsman would have had trouble supervising and teaching so many young men by himself, but he was probably aided by the older apprentices and one or two journeymen. In addition, as Carl Bridenbaugh has pointed out, the craftsman was often aided in his work by his wife.[18] Perhaps Mrs. Coney worked with the youngest boys, teaching them to polish the goods displayed in the glass case and to weigh the silver on the large scales usually kept in the showroom area of the shop. The fact that the goldsmith's wife often played a role in the management of the business is borne out by the apprenticeship agreement in general use for all the crafts in Boston. Although the actual indenture does not survive, the apprenticeship agreement between Joseph Soames and René Grignon, contracted in 1697, is referred to at length in a writ of 1704. This agreement bound Soames

unto the sd Rene Grignon to lerne his arts and with him and Mary his wife after the maner of an apprentice to serve from the first day of November unto the full end and term of five years from thence Next ensuing and fully to be Compleat and ending Duering all which sd Term the sd . . . Rene Grignon and his wife faithfully to serve their secrets keep Hose and Lawfull Commands Every where Gladly doe and obey he should do no damage to his sd Master or Mrs: nor Suffer to be Don of others but that he to his power should let or forthwith make knowne the same to them he should not purloin Imbezell wast or spend the moneys or Goods of his sd Master or Misrs nor Lend them to any without Leave he should not Commit fornication nor Contract matrimony within sd term nor frequent taverans ordniaryes nor places of gameing nor absent himself from the service of his Master or Misrs: by day nor by night unlawfuly but in all things a good faithfull and deligent and obedient servant and an apprentice should bear and behave himself towards his sd master and mistress During the sd Term In Cosideration where of the sd Rene Grignon the sd master for him selfe and in behalfe of his sd wife did Covenant Promise grant and agree to teach and In struct or cause the sd apprentice to be taught and Instructed in the arts trades and Callings of Goldsmith and Jeweller.[19]

Some agreements also bound the master to provide his apprentices with a basic education. A few required the apprentice's father to put up a

[18] Buhler, *Colonial Silversmiths*, pp. 30–32; *Suffolk County Probate Records*, no. 2518; Fairfield, Conn., Probate District, file 1707; Bridenbaugh, *Colonial Craftsman*, pp. 127, 129.
[19] SCCF, no. 6035.

sum of money to guarantee the boy's reliability or, as in the case of
Kiliaen Van Rennselaer, as surety "in case he should undertake some
big piece of work and spoil it, so that he would have to stand the loss."[20]

A good apprentice, particularly in the later years of his term, was a
valuable asset to a goldsmith, allowing him to take on additional busi-
ness without a large outlay of money for labor costs. At the end of their
terms, the more talented apprentices were ready to work as journeymen,
being paid either by the job or by the day. In spite of the evidence that
journeymen goldsmiths existed in considerable numbers in Boston
between 1690 and 1730, very little is known about their actual duties
in the shop or their working arrangements with their masters. A rare
document preserved in the court files of Suffolk County refers to an
agreement between a journeyman and his master.

whereas by certain Articles of Agreemt had made concluded declared & agreed
upon the Sixteenth day of October Anno Domini 1699 between the sd plt.
[John House, citizen and goldsmith of London, the plaintiff] of the one part &
the sd Hindrich Huss [later known as Henry Hurst] of the other part. It is
amongst other things agreed upon that whereas the sd Hindrich Huss was will-
ing & desirous by Gods permission suddenly to undertake a voyage [from Lon-
don] to Boston in New England in order to serve Richard Conyers of Boston
aforesd after the manner of a plateworker or worker in silver Imboster, Graver
or otherwise howsoevr. according to the utmost of his skill & diligence for &
during the full Term of Two years from the time of the sd Hindrich Huss his
Entrance into the imediate service of the sd. Rich. Conyers in Boston in New
England aforesd. after the rate of thirty pounds p anum to be paid quarterly by
the sd Richd. Conyers to the sd Hindrich Huss & convenient meat drink &
lodging during wch. sd term or space of two years And one whole year to com-
ence from the expiration of the sd two years he the sd Hindrich Huss was not
to serve any person in Boston aforesd in any quality or condition whatsoevr.
neither to follow any manner of Imploymt. upon his own proper account. In
pursuance of wch. sd agreemt. the sd Hinderich Huss for himself . . . did
Covenant promise & agree to . . . diligently carefully & faithfully give his due
attendance to the sd Rich. Conyers during the space of two whole years from
the time of Entrance into his sd Masters service in Boston in New England
aforesd & should work in plate Ingrave Imbost or hammer Silver at all reason-
able & convenient times & seasons that his sd Master Richd. Conyers should
think fit to appoint & desire him & for no other person or persons whatsoever.

[20] Quoted in Buhler, *Colonial Silversmiths*, p. 26.

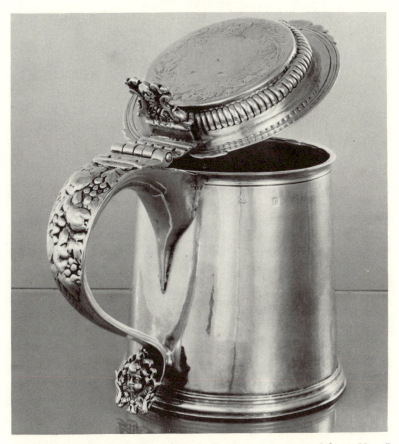

Figure 3. Tankard, Henry Hurst. Boston, ca. 1700. Silver; H. 7″ (including thumbpiece); Diam. (base) 5³⁄₁₆″, (lip) 4⅜″. (Museum of Fine Arts, Boston.)

Hurst arrived in Boston on March 1, 1699 or 1700, and on June 6, 1701, "did depart & leave the sd Richd. Conyers."[21] From the surviving objects made by Hurst, particularly the tankard with chased handle and cover now in the Museum of Fine Arts, Boston (fig. 3), we know that he was a very competent craftsman. Once in the colonies, Hurst no

[21] SCCF, no. 5565a.

doubt realized that even a laborer could expect to earn £30 per year, and that as a skilled craftsman he could make double what Conyers was paying him. Even with the penalty of £100 that he was obliged to pay for forfeiting his contract, he could make a better living working for other Boston goldsmiths—or on his own—than he could if he remained in Conyers's employ. When Hurst was summoned by the court in 1702, Edward Winslow and James Barnes, Jr., "goldsmiths," came forward as sureties for Hurst and posted bond of £200. That they were willing to post bond strongly suggests that Hurst was working with them. If so, it is interesting to speculate on Hurst's contribution to the design and production of Winslow's magnificent sugar boxes, two of which are dated 1702. Perhaps Hurst did the chased work on the cover of the sugar box that Winslow retained for his own use (fig. 4). Certainly its fine workmanship and sophisticated iconography suggest that it was made by a craftsman who had worked in London.[22]

The fact that Conyers included a clause in Hurst's work contract prohibiting him from working for other Boston goldsmiths indicates that Conyers was aware of Hurst's skill and hoped that having Hurst at work in his shop would give him an advantage over his competitors. In most cases, the shortage of labor in Boston in the late seventeenth century necessitated the sharing of journeymen. Since an individual master would not have had several large commissions in progress at all times, the need for journeymen in many shops would have been occasional. Work was often sent out to pieceworkers who produced objects for several different shops. Conyers's stipulation that Hurst work only for him was therefore somewhat unusual and reflects common practice in England where long-term employment contracts were more usual.[23]

Lacking such evidence for other craftsmen, it is difficult to determine the contribution of journeymen to the appearance of surviving objects. Perhaps the talented Nathaniel Morse, who witnessed a deed for John Coney three years after his apprenticeship would have terminated, was responsible for some of the fine engraving of his master's

[22] Nash, *Urban Crucible*, p. 12; SCCF, no. 5565a; Edward J. Nygren, "Edward Winslow's Sugar Boxes: Colonial Echoes of Courtly Love," *Yale University Art Gallery Bulletin* 33, no. 2 (Autumn 1971): 38–52.

[23] Lawrence Towner, "A Good Master Well Served: A Social History of Servitude in Massachusetts" (Ph.D. diss., Northwestern University, 1955), p. 51; Richard B. Morris, *Government and Labor in Early America* (New York: Columbia University Press, 1946), pp. 208–13, 219–21.

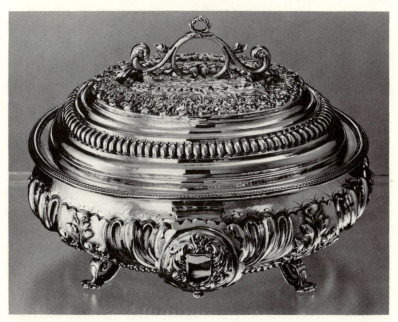

Figure 4. Sugar box, Edward Winslow. Boston, 1700–1710. Silver; H. 5⅜″, W. 6⅝″, L. 7¹³⁄₁₆″. (Yale University Art Gallery, Mabel Brady Garvan Collection.)

silver. It may have been this connection that led to his being chosen successor to Coney as the engraver of Massachusetts currency.[24] Coney's magnificent monteith may have required the work of specialists in chasing and casting; the repoussé around the rim of the bowl and the fine casting of the lion handles and the cherubs around its scalloped edge show superb technical skill (fig. 5). Jeremiah Dummer may have employed one Robert Punt, apparently a watchmaker, to mend watches for his customers as early as 1670. A watch "was delivered to Robert Punt at Mr Dumars shop brought there to be mended," and Dummer testified in court as to the condition of the watch on December 3, 1670. In 1697 partners John Allen and John Edwards sued goldsmith Jona-

[24] Buhler, *Colonial Silversmiths*, p. 31; Martha Gandy Fales, "Heraldic and Emblematic Engravers of Colonial Boston," in *Boston Prints and Printmakers, 1670–1775*, ed. Walter Muir Whitehill (Boston: Colonial Society of Massachusetts, 1973), p. li.

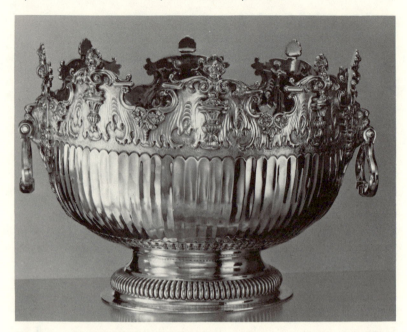

Figure 5. Monteith bowl, John Coney. Boston, 1700–1710. Silver; H. 8⅝″, Diam. (base) 6¹¹⁄₁₆″, (lip) 10¾″. (Yale University Art Gallery, Mabel Brady Garvan Collection.)

than Belcher for the cost of a coat, shoes, a hat, and "4 neckcloaths & 4 hankerchers" as well as "money lent him at Severall times." What business relationship existed among Belcher and Allen and Edwards remains pure speculation; possibly Belcher had served the partners as a journeyman and considered these perquisites due a journeyman. Belcher may also have served John Noyes who signed as his surety at the time of the suit. Edward Winslow employed a journeyman called Tom Cully (Thomas Maccollo) as early as 1743, and in his will Winslow stipulated that his wife was to pay Maccollo "twenty shillings a week weekly, that is to say fifteen shillings by herself & five shillings by Mr Hurd or any others that may employ him."[25] Martha Gandy Fales found that Philadelphia silversmith Joseph Richardson also employed jobbers, often

[25] SCCF, nos. 1043, 98567; Benjamin Walker diary, vol. 2, January 16, 1742 or 1743, MHS; *Suffolk County Probate Records*, no. 10609.

giving them silver on account and paying them for their labor when he received the finished object. There is little doubt that such practices were common in Boston by the 1730s. Brock Jobe found evidence of similar activity in the furniture-making trades.[26]

Division of labor was common in London where goldsmiths registered as small workers or large workers; some craftsmen were even more specialized, like those who referred to themselves as candlestick makers. The striking similarity in porringer handles, finials, thumbpieces, and handle terminals on objects made in Boston during this period suggests that some goldsmiths specialized in cast parts. Those specializing in casting may have found a lucrative trade in making and finishing candlesticks which, from the surviving examples, seem to have been produced by a relatively small number of goldsmiths using nearly identical molds (figs. 6, 7). Porringer handles occasionally bear the maker's mark in the casting which was later struck over by the mark of another maker (fig. 8). Other porringer handles are known with English marks in the casting. This may indicate that someone was casting handles from English porringers and selling them to local Boston craftsmen or that handles were imported from England.[27] Later documents reveal several instances of goldsmiths sending their pieces out to be engraved in other shops, and, although no such direct evidence exists for the period in question, detailed inventories of goldsmiths' tools show that many shops lacked even the simplest engraving tools. The presence of quicksilver, or mercury, and touchstones in some inventory listings and not in others suggests specialization. The processes of refining and gilding required the use of mercury, the vapors from which were known to be dangerous even in the seventeenth century. It is reasonable to assume, therefore, that not all goldsmiths were anxious to take on these tasks themselves. The larger shops may have found it necessary to perform these functions in order to assure that they had enough refined metal on hand to meet their demands, and John Coney's shop was so equipped. Smaller shops could then rely on his expertise (or that of his journeymen) as needed.

[26] Martha Gandy Fales, *Joseph Richardson and Family, Philadelphia Silversmiths* (Middletown, Conn.: Wesleyan University Press, 1974), pp. 66–67; Jobe, "Boston Furniture Industry," pp. 12–26.

[27] Arthur G. Grimwade, *London Goldsmiths, 1697–1837: Their Marks and Lives from the Original Registers at Goldsmiths' Hall and Other Sources* (London: Faber and Faber, 1976); Wendy A. Cooper, "New Findings on Colonial New England Goldsmiths and English Sources," *American Art Journal* 10, no. 2 (November 1978): 107–9.

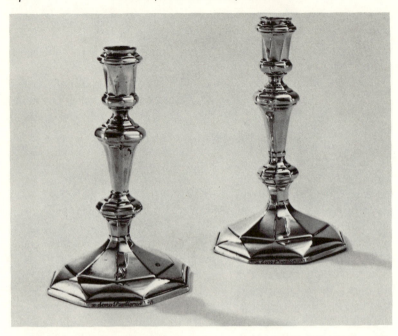

Figure 6. Candlesticks, John Coney. Boston, 1716. Silver; H. 7½",
W. (base) 4⅟16". (Historic Deerfield.)

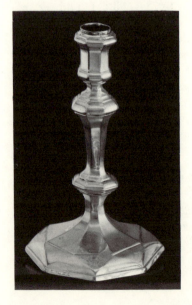

Figure 7. Candlestick,
Nathaniel Morse. Boston,
ca. 1720. Silver; H. 7¼".
(Historic Deerfield.)

Figure 8. Detail of silver porringer handle, bearing marks of both Samuel Edwards and Joseph Edwards (1737–83). Boston, ca. 1750. (Gebelein Silversmiths: Photo, G. M. Cushing.)

Others, like Richard Conyers whose inventory lists an incredible variety of working tools, may have been importers and retailers of fine-quality tools as well as goldsmiths. Given Conyers's dismal financial situation (he was imprisoned for debt in 1701), it is unlikely that he would have had use for so many tools himself.[28] He may have found that with his

[28] *Suffolk County Probate Records*, no. 4641. The inventory of Conyers's shop tools was published in John Marshall Phillips, *American Silver* (New York: Chanticleer Press,

connections in England he was able to supplement his income by importing the tools that were constantly in demand by Boston goldsmiths.

In a barter economy where goldsmiths, like other craftsmen, were sometimes paid in kind, it was occasionally necessary for craftsmen to sell items unrelated to their craft. In 1696 David Jesse sold to one Mrs. Hill:

Twelf yards & ½ of Caliminco att	
6s 4d = pyd	3.19.2
five pare of hose att 9 = ppr	2.05.0
one pare of Silver Shoe buckles	0.08.6
	6.12.8[29]

Five years later Jesse performed an unusual task for a business acquaintance named Joseph Mallinson, which resulted in a long and bitter court battle. According to a bill filed with the court, Mallinson delivered 948 pieces of eight "to sd Jesse . . . wch Mr Mallinson saith he was to hand Cutt to twelve penny weight & is willing to allow two pence per pieice for the Cutting, but Mr Jesse saith he will give his oath he was to have five shillings for Each peice of Eight when Cutt as aforesd."[30] The act of clipping coins, usually a criminal offense, was not a matter of concern to the court, for by this time it had become common practice to weigh all coins used in payment of debts. Why Mallinson wanted the coins clipped is a mystery; perhaps there was a shortage of coins of this weight. The goldsmith, then, was called on to do all sorts of work involving gold and silver, some of which has little meaning in today's terms.

Little has been said about the import/export business in the goldsmithing trade. Fales found ample evidence of this activity in the letter books of Joseph Richardson, but there is little documentation of the practice in the period treated by this paper. A few pieces, such as a tobacco box marked by John Coney (fig. 9), also bear the mark of a London goldsmith. Other English pieces that belonged to Bostonians in this period are known, and many of these were published by E.

1949), pp. 14–16. Richard Conyers, Petition to the Inferior Court of Common Pleas, Suffolk County, Mass., December 16, 1701, Photostat, Miscellaneous Bound Volumes of Manuscripts, MHS.

[29] SCCF, no. 3475.

[30] SCCF, no. 5559.

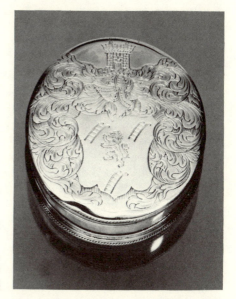

Figure 9. Tobacco box,
bearing marks of both John
Coney (Boston) and L. S.
(London). Ca. 1701. Silver;
H. 1⁵⁄₁₆″, W. 3⅛″, L. 3¹³⁄₁₆″.
(Yale University Art Gallery,
 Mabel Brady Garvan
 Collection.)

Alfred Jones in *The Old Silver of American Churches*. Other notable
examples have been discovered by Fales and Buhler in small local
museums and in private collections. We do not know if these pieces
were ordered directly from England (or Europe) by their owners, as
seems to have been the custom in the South, or if they were purchased
through local goldsmiths.[31] Inventories sometimes mention foreign sil-
ver, such as the "spanish dishes" owned by Wait Winthrop and the
"french cup" mentioned in the will of Daniel Gookin, Sr., in 1685. It
has been said that, aside from special orders, most goods imported by
Boston goldsmiths were probably small items such as buckles and rings.
In 1699 Samuel Shrimpton, a local merchant, sent plate from Boston
"to be disposed of either at Amsterdam or London." Samuel Sewall sent
"a Skillet of fine silver" to Edward Hull of London in 1688 in payment
for goods he had received. According to an account dated April 1, 1700,
between Richard Conyers of Boston and Charles Groome of Saint Mar-
tin in the Fields, Middlesex, England, Groome owed Conyers fourteen

[31] Fales, *Richardson*, pp. 2310–60; Kathryn C. Buhler and Graham Hood, *Ameri-
can Silver, Garvan and Other Collections in the Yale University Art Gallery*, vol. 1 (New
Haven: Yale University Press, 1970), pp. 41–42; "Letters of William Fitzhugh," *Virginia
Magazine of History and Biography* 6, no. 1 (July 1898): 71.

shillings for "18 Silver buttons wt 1 oz: 11 pt fashion & silver agreed."[32] Conyers apparently exported the buttons in return for which he ordered from Groome two swords (which he may have planned to equip with silver grips), various flasks, pots, a hammer, pumice, files, linen, and scales. How many other Boston silversmiths were in the habit of exporting wrought silver to England is still a matter of speculation. The Conyers bill at least suggests the possibility that paying for imports with the products of one's own shop was a distinct possibility at the time and was thoroughly consistent with prevailing trade practices.

The question of whether the goldsmith also acted as a banker has been debated for several decades. As the title of a London treatise of 1676 would indicate—*The Mystery of the New Fashioned Goldsmiths or Bankers*—there were men working in London who called themselves goldsmiths but who devoted themselves completely to the business of banking. In Boston there is evidence that some goldsmiths accepted money for safekeeping. In 1694, for instance, Daniel Westfield of Boston bequeathed twenty pounds to a minor named Thomas Pemberton. The will stipulates, "[the money is] to be put into the hands of my very good Friend Jeremiah Dummer of Boston aforesd. Esqr. to be put out at Interest for the use of the sd. Thomas Pemberton until he comes of age and then to be paid him with the improvement thereof." Francis Legaré, who was called a "Merchant Goldsmith" by one of his fellow Huguenot émigrés, is known to have held mortgages on the property of at least two citizens of the town of Braintree in 1707.[33] Such activities, however, were commonplace among merchants in Boston and the surrounding area. Probably only those goldsmiths deeply engaged in general mercantile activities accepted deposits of cash for safekeeping. As

[32] Buhler and Hood, *American Silver*, 1:19; *Suffolk County Probate Records*, no. 1553; Martha Gandy Fales, *Early American Silver* (rev. ed.; New York: E. P. Dutton, 1973), pp. 195–212; Records of the Inferior Court of Common Pleas for Suffolk County, Docket Book 1701–6, p. 80; "Letter Book of Samuel Sewall," in *Collections of the Massachusetts Historical Society*, vol. 1, 6th ser. (Boston: By the society, 1886), pp. 85–86; SCCF, no. 4825.

[33] *The Mystery of the New Fashioned Goldsmiths or Bankers. Their Rise, Growth, State and Decay. Discovered in a Merchants Letter to a County Gent. Who Desired to Bind His Son Apprentice to a Goldsmith* (London, 1676; reprinted in *Quarterly Journal of Economics* [January 1888]: 253–62). I wish to thank Edward S. Cooke, Jr., for bringing this piece to my attention. *Suffolk County Probate Records*, no. 2180½; E. T. Fisher, trans., *Report of a French Protestant Refugee in Boston, 1687* (Brooklyn, 1868), p. 35; Holman, "Legaré," p. 7.

yet there is no evidence that these activities were especially reserved for goldsmiths.

In addition to their goldsmithing activities, many craftsmen branched out into other kinds of business. David Jesse is just one of many engaged in general shopkeeping; others, such as William Cowell, Sr., William Rouse, and Francis Legaré, are known to have been innkeepers or taverners. In 1715 Samuel Sewall hired a horse from William Cowell, Sr., which suggests that Cowell may have had a stable of sorts in addition to his tavern. Samuel Clark is mentioned as a mariner as well as a goldsmith. John Coney, Jeremiah Dummer, and Edward Winslow invested in land, and each of them held interests in Boston wharves. When he left Boston and set up shop in Hartford, Connecticut, John Potwine gradually changed his business and became more a dry-goods merchant as he got older. René Grignon held an interest in a wash-leather mill with Gabriel Bernon at Oxford, Massachusetts, and later, when he went to Norwich, Connecticut, he was called a mariner as well as a goldsmith.[34] Other goldsmiths, particularly those who did not achieve financial success in the trade, turned to professions that seemed more lucrative.

Such extraordinary diversity prevented the goldsmiths of Boston from developing a strong group identity. Although there is evidence that members of the craft had numerous business dealings with one another, there is no evidence that they ever joined together for group action. It is perhaps the freedom of endeavor allowed in Boston and other colonial seaport towns that helps to explain why American craftsmen of the early eighteenth century never established strong guild organizations such as those known in Europe.

It appears that the craft of goldsmithing, while it could be a very lucrative trade, was not necessarily a sure route to financial success. The men at the top of the profession, particularly those who came of age before 1700, sometimes became respected public servants and wealthy

[34] James and Jameson, *Journal of Danckaerts*, p. 260; SCCF, no. 5591; Buhler, *American Silver*, 1:123; Samuel Sewall ledger, April 11, 1715; Thomas, *Diary of Sewall*, 1:77; SCCF, no. 14367; *Suffolk County Probate Records*, no. 10609; Clarke and Foote, *Jeremiah Dummer*, pp. 22–44; George F. Daniels, *History of the Town of Oxford, Massachusetts* (Oxford, 1892), pp. 23–24; A. R. Chase, "René Grignon, Silversmith," *Antiques* 34, no. 1 (July 1938): 26–27.

merchants, but the great majority of goldsmiths were men of modest families who earned modest incomes. Although people from outside of Boston continued to patronize Boston goldsmiths regularly up through the end of the eighteenth century, those goldsmiths who left Boston for the outlying towns achieved a status far above what would have been possible for them in New England's metropolis. Further statistical analysis of the craftsmen and their place in the society promises to yield interesting new information. So far the evidence is that Boston's goldsmiths were constantly in contact with one another and that, probably, a substantial proportion of the men whose names we know served as journeymen or jobbers during some portion of their careers. In addition, accounts and court records suggest some interesting connections among craftsmen. Unfortunately, in the absence of documentary evidence, the work of the men who never became master craftsmen—and thus never used their own maker's marks—may remain a mystery. Perhaps through the analysis of construction techniques known to have been used in the shops of certain goldsmiths, it will be possible to substantiate the presence of identifiable apprentices and journeymen. It may also be possible to suggest additional relationships and areas of specialization from the physical evidence. The role of the immigrant craftsman and his status in relation to the native craftsman also need study. Clearly many questions remain in our efforts to fully understand the early American goldsmith.

APPENDIX 1

Goldsmiths Included in This Study Whose Careers in Boston Began before 1700

NOTE.—A plus sign indicates that I believe the goldsmith lived or worked past the latter date, which is based on the last recorded reference to him as a working goldsmith in Boston.

Goldsmith	Life dates	Working in Boston
John Allen	1671/72–1760	1693–1736+
Francis Bassett	1678–1715	1699–1715*
Jonathan Belcher	1661–1703+	1682–1703+
Samuel Clark	1659–1705	1681–1705
Benjamin Coney	1673–1721	ca. 1694
John Coney	1655/56–1722	1677–1722
Richard Conyers	1668–1709	ca. 1697–1709
William Cross	1658–1716+	1692–95+
Jeremiah Dummer	1645–1718	1667–1710
Timothy Dwight	1654–92	1675–92
John Edwards	1671–1746	1692–1746
Samuel Foster	1676–1702	1697–1702
René Grignon	1652/53–1715	1696–1700
Samuel Haugh	1676–1717	1698–1717
Henry Hurst	1666–1718	1699–1718
David Jesse	1668–1705/6	ca. 1692–1705/6
F. Solomon Legaré	1674–1760	1687–95
Francis Legaré	1636–1711	1687–95
John Noyes	1674–1749	1695–1749
Moses Prevereau	ca. 1675–1701+	ca. 1699–1701
Daniel Quincy	1651–90	1672–90
William Rouse	1641–1704/5	ca. 1675–1704/5
Eliezur Russell	1663–91/92	1684–91/92
Robert Sanderson, Jr.	1652–1714	1673–1714
Thomas Savage	1664–1749	1685–1705, 1714–37
Edward Winslow	1669–1753	1690–1735+
Thomas Wyllys	1666–pre-1720	ca. 1690–94

* And in Charlestown.

APPENDIX 2

Goldsmiths Included in This Study Whose Careers in Boston Began after 1700 and before 1730

NOTE.—A plus sign indicates that I believe the goldsmith lived or worked past the latter date, which is based on the last recorded reference to him as a working goldsmith in Boston.

Goldsmith	Life dates	Working in Boston
Isaac Anthony	1690–1773	1711–ca. 1727
John Banks	1696–1737+	1717–37+
Abraham Barnes	ca. 1692–1716+	1716
James Barnes	1680–1703+	1702–3
Peter Boutet	ca. 1685–1715+	1714–15
James Boyer	ca. 1700–1741	1723–41
Thomas Bradford	1697–1740	1718–40
Samuel Burrill	1704–40	1725–40
John Burt	1692/93–1746	1714–46
William Caddow	ca. 1692–pre-1746	1726–38+
Thomas Coverly	1708–78	1729–78
John Cowell	1707–pre-1736	1727–31+
William Cowell	1682/83–1736	1704–36
Mathew Delaney	ca. 1698–1723+	ca. 1722–23
Peter Denman	—	ca. 1710–12
John Dixwell	1680/81–1725	1702–25
Shubael Dummer	1687–1709+	1708–9
Samuel Edwards	1705–62	1726–62
Thomas Edwards	1701/2–55	1723–30, 1745–55
Peter Feurt	1703–37	1727–37
Daniel Gibbs	ca. 1691–1716+	ca. 1716
Joseph Goldthwait	1706–80	1727–73
Daniel Gookin	1683–1705	1704–5
John Gray	1692–1720	1713–19
Samuel Gray	1684–1713	1705–7
Bartholomew Green	1697–pre-1746	1718–34+
Rufus Greene	1707–77	1728–75
George Hanners	1696–1740	1717–40
Benjamin Hiller	1688–1739+	1709–39+
Jacob Hurd	1702/3–58	1724–55
William Jones	1695–1730	1716–21
Joseph Kneeland	1700–1740	1721–40
Daniel Legaré	1689–1725	1714–25

Goldsmith	Life dates	Working in Boston
John LeRoux	1695–1725 +	1723–24
Knight Leverett	1702/3–53	1724–53
Thomas Maccollo	ca. 1708–53 +	ca. 1729–53 +
Thomas Milner	ca. 1682–1745 +	ca. 1708–45 +
Nathaniel Morse	ca. 1688–1748	1709–48
Thomas Mullins	ca. 1680–ca. 1752	1708–ca. 1752
Peter Oliver	1682–1712	1703–12
John Pitts	—	ca. 1728–30
William Pollard	1690–1740	1711–30
John Potwine	1698–1792	1719–ca. 1737
Job Prince	1680–1703/4	ca. 1701
Jonathan Reed	ca. 1695–1742	ca. 1724–42
Paul Revere I	1702–54	ca. 1725–54
Michael Rouse	1687–1711 +	1708–11
Daniel Russell	1698–1780	1719–22
Moody Russell	1694–1761	ca. 1715
Benjamin Savage	1699–1750	1720–32
William Simpkins	1704–80	1725–80
Joseph Soames	1681–1705	1702–5
Thomas Townsend	1704–52 +	1725–52 +
Andrew Tyler	1692–1741	1713–41
Edward Webb	1666–1718	ca. 1706–18

The Glassmakers of Early
America
Arlene Palmer Schwind

Throughout history there has been an aura of mystery and magic surrounding the craft of the glassmaker. As one Englishman observed in 1620, it was "a rare kind of Knowledge and Chymistry to transmute Dust and Sand . . . to such a diaphanous pellucid dainty Body as you see a Crystal-Glass is." Although published technical treatises dispelled some of the magic,[1] successful glassmaking in the seventeenth and eighteenth centuries still depended chiefly on the craftsman's experience in evaluating raw materials and his practiced skill in mixing and manipulating them. The style of a glass object, its shape and decorative detail, will reflect the glassmaker's origins and training. At the same time, the peculiar properties of glass and the way it must be worked insure the prevalence of certain techniques regardless of time and place.

Glassmakers were among the first craftsmen in America, arriving in Jamestown, Virginia, in 1608. From then on, there was an almost continuous interest in glassmaking in this country, encouraged by the abundance of raw materials, especially wood fuel, and the universal need for window glass, bottles, and drinking vessels. This interest in glass led to the establishment of at least twelve factories in the colonial

[1] James Howell to his brother, as quoted in Eleanor S. Godfrey, *The Development of English Glassmaking 1560–1640* (Chapel Hill: University of North Carolina Press, 1975), p. 156. The first printed work devoted exclusively to glassmaking was *L'Arte Vetraria*, published in Florence in 1612 by Antonio Neri. Christopher Merret published an English edition with additions and comments in 1662.

period and another fourteen in the years immediately following the Revolution, although by no means did they all prosper.

The exact number of glass craftsmen practicing their art in the factories built before 1800 cannot be determined. The 1820 Census of Manufactures records 1,031 workers in thirty glasshouses, and by 1843 eighty-two factories employed 4,236 people.[2] These numbers represent the entire labor force of glassmaking, only a minority of whom were skilled glassblowers, cutters, or engravers. For example, in 1820 at the Cincinnati Glass Works of Pugh and Teater only ten of the staff of thirty-one were glassblowers. The rest performed such necessary duties as washing and otherwise preparing ingredients for the batch, building and maintaining the furnaces, chopping wood and keeping the fires going, and packing and delivering the finished glassware.

Because of the large physical plant and the number of employees required, glassmaking has not fit comfortably into the category of hand-icraft. The actual process of glassblowing, however, is very much a craft that requires a trained eye, skillful hands, and powerful lungs and mouth. The tools are simple, the same as those used when glassblowing was invented in the first century B.C., yet the shaping of the simplest object entails the cooperation of at least two people. In large establishments the tasks of the workers were highly specialized, but machinery did not begin to reduce the need for skilled labor until 1825 with the introduction of mechanical pressing. None of the other factory-type crafts in America required laborers with skills as developed as those of glassmakers, and probably no other craftsmen produced their goods against such persistent competition from foreign manufacturers. The glassblowers themselves were overwhelmingly foreign-born and foreign-trained. All of the twelve colonial factories employed craftsmen who came to America from Europe for the express purpose of making glass. Native-born craftsmen began to penetrate the glass industry at the end of the eighteenth century, but the labor force remained predominantly immigrant until the mid nineteenth century.

In these and other ways, glass craftsmen occupy a unique and interesting position in the history of American industry. Nevertheless, as a

[2] United States Bureau of the Census, "Record of the 1820 Census of Manufactures," National Archives, Washington, D.C. (microfilm, Joseph Downs Manuscript and Microfilm Collection, Winterthur Museum Library [hereafter cited as DMMC]); T. B. Wakeman, "Glass," in *The American Laborer* (New York: Greeley & McElrath, 1843), p. 78.

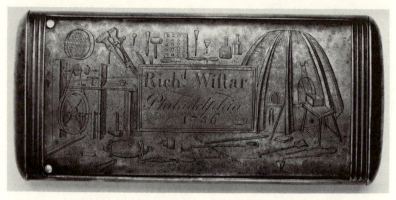

Figure 1. Tobacco box made for Richard Wistar by Thomas Shaw.
London, 1756. Steel. (Collection of the late Vincent D. Andrus: Photo,
Winterthur.) Although Wistar owned a glassworks in New Jersey, he
was by training a brass-button maker. The engraving on the box illus-
trates the tools of both trades.

group and as individuals the glassmakers of early America have been
ignored by historians and, ironically, by historians of the glass industry
in particular. Attention has centered instead on those who owned the
glass factories, men who were glassmakers by virtue of investment, not
skill. Caspar and Richard Wistar, owners of America's first successful
glassworks, were brass-button makers by trade (see fig. 1), while the
flamboyant Henry William Stiegel was an ironmaster. Benjamin Bake-
well was a merchant, in both England and America, before he opened
the glasshouse in Pittsburgh. Of the owners of the major glass factories
in early America, only John Frederick Amelung, of the New Bremen
works in Maryland, had practical experience as a glassmaker.[3]

This paper summarizes research in progress on the glassblowers,
cutters, and engravers in America before 1860, over 900 of whom have
been identified by name. Information is being gathered about their

[3] See Arlene Palmer, "Glass Production in Eighteenth-Century America: The Wis-
tarburgh Enterprise," in *Winterthur Portfolio 11*, ed. Ian M. G. Quimby (Charlottesville:
University Press of Virginia, 1976), pp. 75–101; Frederick William Hunter, *Stiegel Glass*
(Boston: Houghton Mifflin Co., 1914); and Dwight P. Lanmon and Arlene M. Palmer.
"John Frederick Amelung and the New Bremen Glassmanufactory," *Journal of Glass
Studies* 18 (1976): 9–136.

European origins, migration patterns, families, status, and so on.[4] Research sources include factory records and other manuscripts, newspapers, city directories, and official documents. Few letters or diaries written by glassmakers survive. Many were illiterate or were fluent only in German or another foreign language, while their foreign-sounding names stymied census takers and directory compilers. Glassblower William Hinds, for example, is listed in the Boston directories at the same address over a twenty-year period with his name spelled five different ways; Adam Kersthaler is recorded variously as Keftoaler, Kinthaler, and Keasbelter.

The first two factories in America, erected in Jamestown, were run by Polish and Venetian glassblowers. The Virginia Company sponsored these works to bolster England's floundering industry by providing some of the glassware needed by British consumers. Of the remaining glasshouses in the colonial period, two were staffed with English-trained artisans and the rest with glassblowers from central Europe. These factories competed with English manufacturers in their attempts to supply the colonists with bottles, windowpanes, and table glass. Caspar Wistar unabashedly pointed out to the New Jersey provincial House of Representatives, "the Making of Glass is . . . a Considerable Advantage to the Country, not only as it saves the Money that must otherwise be sent abroad for that Commodity, but as it brings Cash in, for Quantities exported to other Colonies." At the very heart of the colonial system, however, was the idea that colonies did send money abroad for the manufactured goods of the mother country. Therefore, as Caspar's son Richard observed in 1760, "It was not for the Honour of England to Suffer Manufactories in the Colonies."[5]

Although contrary to official policy, glasshouses were suffered. During the Seven Years' War, Richard Wistar petitioned the earl of Loudon, saying, "if his Majesties Officers continued to Inlist our Servants, we shall be disabled from carrying on the Works, to our great

[4]The author's research of the European origins of American glass craftsmen was funded partially by a grant from the American Philosophical Society.

[5]See Godfrey, *English Glassmaking*, for discussion of the English context of the Jamestown glasshouses; "Petition to exempt the Glass works from Taxes," Caspar Wistar, Martin Haltar, and Johann William Wentzel to the House of Representatives, Province of New Jersey, January 29, 1752, New Jersey State Library, Trenton; Richard Wistar to Daniel Taylor, October 21, 1760, Richard Wistar Letterbook (microfilm), DMMC.

Prejudice and Ruin." The request was, apparently, granted, and the works remained open. Colonial entrepreneurs openly sought craftsmen in England, and at least one placed advertisements in British newspapers for glassmakers wanted in Boston.[6] Before 1770, however, so few glasshouses sustained any measure of success, particularly in tableware, that the English glass industry was by no means threatened.

In 1767 the Townshend Acts levied increased duties on imported glass which had the effect of greatly encouraging American manufacturers. Their successes were minimized in the reports of colonial officials, but within two years the secret of lead-glass technology—the core of England's vitreous supremacy—had arrived in America. The bearer of the secret, John Allman, realized full well the importance of this knowledge when he petitioned the Pennsylvania legislature for recognition, claiming, "without his Assistance and particular Management of American materials at the Glass Work of Henry William Stiegel . . . The Manufacture of white Flint Glass could not have been brought to its Present Degree of Perfection." But Stiegel, not Allman, received the £150 premium, and Allman took his secrets to a rival firm in the Kensington section of Philadelphia. That venture was beset with so many problems that the owners were convinced Allman was a saboteur, "an artful designing man, one who probably was sent to America to blast such undertakings." Nonetheless, lead glass continued to be made at Kensington. In 1773 William Logan sent a box of Kensington-made wine glasses to Bristol to prove that glass equal in quality to England's export ware—and actually cheaper—was being made in America.[7]

After the Revolution, Britain's fear of American competition seems to have increased. In 1784 as Amelung prepared to leave Hanover for America, with a large crew of glassblowers, English merchants conspired to detain him. Amelung reported:

some English Merchants, and sea Captains, who were at that time in Bremen, wrote to England about it, and this jealous Nation, who look on the glass trade as an important one, desired the Government of Hanover, to do all that was in

[6]Petition of Richard Wistar to John, earl of Loudon [1756–57], Henry E. Huntington Library, San Marino, Calif.; *F[elix] F[arley's] Bristol Journal* (January 11, 1766).
[7]T. Kenneth Wood, "A Gratuity for Baron Stiegel," *Antiques* 7, no. 1 (January 1925): 30; Joseph Leacock to John Nicholson, December 23, 1794, John Nicholson General Correspondence, 1772–1819, John Nicholson Collection, Manuscript Group 96, Division of History and Archives, Pennsylvania Historical and Museum Commission, Harrisburg (hereafter cited as NGC); William Logan to Cornelius Fry, May 17, [1773], Smith Papers, Library Company of Philadelphia.

their power to frustrate a plan which they feared, would be to their loss, and greatly to the benefit of this country. Brunswick, Hesse, and other neighbouring Princes of the Roman Empire, were called upon to join for that purpose—now all possible obstacles were partly by intrigue, partly by force and despotic behaviour thrown in my way—the workmen I had engaged were detained, and nothing left untried to oppose me.[8]

When the city of Hanover declared it illegal to advertise for emigrants, Amelung immediately left with what workmen he had assembled. He claimed his ship eluded capture by the English only by virtue of an unusually quick passage. Great Britain continued to monitor the growth of the American glass industry in the early nineteenth century. When the agent of the Rensselaer Glass Factory at Sandlake, New York, was sent to England to hire workers in 1806, he had to resort to clandestine tactics: "dressed as a beggar, he travelled as a bag-pipe player and visited the principal glass manufacturing districts and engaged the number of employees desired." Getting workmen out of England could also be a problem, as evidenced by the arrest of five glass craftsmen as they boarded an America-bound ship at Liverpool in 1815.[9]

The constraints of governments and employers aside, it was often difficult to find glassblowers who were willing to leave Europe for America. In their search for blowers for their Philadelphia glasshouse, Robert Towers and Joseph Leacock sought the aid of Benjamin Franklin who was then in London. According to Franklin, it was "always a Difficulty here to meet with good Workmen and sober that [were] willing to go abroad." Glassblowers were probably among the craftsmen least anxious to set off into the unknown because their livelihood depended not just on their own skill but also on the investment of others in land, buildings, and raw materials and on an auxiliary labor force. As one glasshouse clerk reminded his employer, the "teazers, the men that smelts the Glass, takers-in &c. [were] a[s] much if not more necessary to keep [the works] together, [men] without whose help the Glass Blowers can do nothing."[10]

[8] John F. Amelung, "Remarks on Manufactures, Principally on the New Established Glass-House, near Frederick-Town . . . ," 1787, p. 11 (facsimile in Lanmon and Palmer, "John Frederick Amelung," p. 135).
[9] Arthur J. Wiese, *History of the 17 Towns of Rensselaer County* (Troy, N.Y., 1880), pp. 136–37; *Raleigh Star* (December 22, 1815).
[10] Benjamin Franklin to Robert Tower and Joseph Leacock, August 22, 1772, American Philosophical Society, Philadelphia; Thomas Joubert to Nicholson, May 29, 1797, NGC.

A major concern of potential emigrants was the availability of suitable raw materials in America, because without ingredients of very specific type and quality glass could not be made. Good glassmaking sand does not occur on every beach. More difficult to locate was the fireclay needed to make the pots, or crucibles, in which the sand and other ingredients were melted. John Winthrop, Jr., of the Massachusetts Bay Colony, received word from London in 1636 that the glassmen recruited for a works at Salem would "not undertake to goe over till there be claye found out fitt for them: least They should be a burthen to those that transport them, or else live miserably; for they have not wherewithall to defray theire owne charges over." As it happened, their fears were well founded; the lack of suitable clay plagued the enterprise and led to its abandonment.[11]

Another concern of emigrant glass craftsmen must have been the potentiality of the American market. The need for windowpanes, bottles, and drinking glasses was great, but the willingness of the American consumer to eschew fashionable imported glass in favor of domestic products was uncertain.

In two cases foreign craftsmen themselves were willing to take the risk and made unsolicited offers to establish glasshouses in America. In 1709 Philadelphia merchants considered a proposal from Daniel Tittery of Bristol, whose brother, Joshua, had come to Philadelphia in 1683 to manage a glassworks for the Free Society of Traders. Probably because the earlier venture had not been successful, the Philadelphians forwarded Tittery's plan to acquaintances in Boston, but nothing came of it there. At the end of the century some Norman plate-glass makers petitioned Franklin for help with their scheme to build a manufactory in America. Again, no support was forthcoming.[12]

There is some evidence, however, that the Wistarburgh glassworks,

[11] From medieval times *glassman* was the term used to describe one who actually made glass. Later, after the seventeenth century, it meant only merchants involved in the glass trade. Samuel Reade to John Winthrop, Jr., March 5, 1635/36, as quoted in Allyn Bailey Forbes, ed., *Winthrop Papers*, 5 vols. (Boston: Massachusetts Historical Society, 1943), 3:234; Robert Child to Winthrop, March 15, 1646/47, as quoted in Forbes, *Winthrop Papers*, 5:141; Petition of John Conklin and Ananias Conkloyne, October 1, 1645, Massachusetts Archives, vol. 59, p. 21 (Photostat, Massachusetts Historical Society, Boston).

[12] Thomas Fitch to Edward Shippen, August 15, 1709, Thomas Fitch Letterbook 1702–11, American Antiquarian Society (microfilm, DMMC) (courtesy Neil Kamil); Franklin Manuscripts, vol. 4, p. 58, Historical Society of Pennsylvania (hereafter cited as HSP).

which operated in Salem County, New Jersey, between 1738 and 1777, may also have been the result of foreign initiative and not Caspar Wistar's own vision. Wistar's agreement with the four glassblowers who built and carried on the factory proves they had a partnership in which the craftsmen would share in the profits. Known as the United Glass Company, it was a unique arrangement among eighteenth-century American glasshouses.

Some laborers employed by the Wistars and other glass manufacturers in the colonial period came to America as indentured servants. In return for their passage across the Atlantic they agreed to work for a specific length of time. The evidence for indentured servitude in the glass industry comes largely from newspaper advertisements for runaways. Unskilled laborers, or those with no glass skills like stonemason Philip Jacobe, were often indentured servants (fig. 2). In the 1770s, however, three glassblowers, one glass cutter, and one glass polisher traveled from England to be bound by indenture for service in colonies where no glasshouses existed.[13]

Occasionally, political circumstances abroad compelled glass craftsmen to emigrate without previous arrangements for employment. Such was the case of Saxon-born Peter William Eichbaum, a glass cutter at the court of Louis XVI, who, with six glassblowers, fled the French Revolution and landed in Philadelphia on May 31, 1794. They were fortunate in securing immediate employment with entrepreneur John Nicholson, who was eager to implement his plans, drawn up the previous summer, for a glasshouse in the Philadelphia area.[14]

Few details are known of the hiring procedures used by glasshouse proprietors to obtain workmen from overseas. Some relied on the assistance of friends and factors who lived abroad, while others sent agents or traveled themselves. When Philip Friese journeyed to Germany in the early 1800s, he hired blowers not only for his own factory in Baltimore but also for the Chelmsford, Massachusetts, glasshouse. After the War of 1812 Benjamin Bakewell sent representatives to England to engage glassworkers for his Pittsburgh glasshouse. When one of them, Thomas Pears, had no luck in England, he proceeded to Paris. There he found

[13] Those glassworkers were Francis Simpson, William Oakes, Joseph Brittle, John Mackay, and Jacob Johnson (Gerald Fothergill, trans., *Emigrants from England, 1773–1776* [Baltimore: Genealogical Publishing Co., 1976], pp. 29, 39, 78, 83).

[14] For an account of the Nicholson glassworks, see Arlene M. Palmer, "A Philadelphia Glasshouse, 1794–1797," *Journal of Glass Studies* 21 (1979): 102–14.

Twelve Dollars Reward.

Run away, on the Second of this Inftant, from the Glafs-Houfe in *Salem* County, *Weft New-Jerfey*, a *Dutchman*, named PHILIP JACOBE, about Five Feet Six or Seven Inches high, light grey Eyes, fandy Hair, thick Lips, fpeaks but little *Englifh*; had on, when he went away, a blue Cloth Coat with Metal Buttons, red Plufh Jacket, ftriped Ticken Trowfers, good Shoes, with large Brafs Buckles, and a Caftor Hat about half worn; took fundry other Things with him, alfo a Fiddle, upon which he is much addicted to play; both his Legs are fore. Whoever brings the faid PHILIP JACOBE to the Subfcriber, at the Glafs-Houfe aforefaid, fhall have the above Reward.

Wiftarburgh, Nov. 6, 1767.

RICHARD WISTAR.

N. B. He ferved his Time in fome Part of *Maryland*, about *Canawaka*, and it is fuppofed he is gone that Way again. He is a Stone-Mafon by Trade.

Figure 2. Advertisement for runaway stonemason Philip Jacobe placed by Richard Wistar in the *Pennsylvania Chronicle* (November 9, 1767). (Collection of Elizabeth Morris Wistar: Photo, Winterthur.)

that glassblowers were difficult to hire because they were in great demand to make wine bottles, so many having been destroyed during the Napoleonic Wars. Although he offered three-, six-, and nine-year contracts, with passage paid overseas and wages starting immediately upon signing a contract, Pears was able to hire only one glass cutter. Two years later he traveled to France on his own behalf and was more successful, returning with a foreman, four glassblowers, four journeymen, and two apprentices. Sometimes families migrated to America as family units,

but many more craftsmen came on their own. Single men were preferred by some glasshouse owners because, in the words of one of them, married glassblowers bred "like minks."[15]

In general, the cream of the craft did not choose to emigrate. Some of those who did so choose may have been prompted because they had neither the skills nor the temperament to retain their employment at home. Joshua Tittery was "accompted no workman" by his peers who claimed he had been dismissed from an English factory and had never made any broad (window) glass. In 1772 Stiegel complained his workmen were "bunglers," while in the opinion of a Connecticut manufacturer, in 1790, there were in this country "very few if any of them [glassblowers] who [were] expert in the trade."[16]

Some competent glassblowers were doubtless willing to emigrate from the Continent because, for them, the trade had traditionally been a migratory one. In medieval times, entire glasshouses moved at regular intervals as forests were denuded for furnace fuel and new wooded areas were sought. Indeed, glassmakers were often hired by local rulers for the specific purpose of clearing a forest. By the seventeenth century wandering was confined to the workers. Journeymen glassblowers were expected to "journey," and master blowers, or gaffers, and factory superintendents were just as likely to change jobs frequently. Historian Ada Polak offered an explanation of the glassmaker "on the move": "Tempted by monetary rewards, by the wish for adventure and the desire to break out of the closed family circle, many glassmakers were persuaded to leave their homes and use their skills in countries where these were not taken for granted but considered as something out of the ordinary, and where they had chances of reaching higher grades than at home."[17]

The experience of John Martin Griesmayer and his family may be typical. In 1702 Griesmayer is known to have left the glasshouse at Herrenberg to blow glass at Klosterwald. After seven years he joined the

[15] Kenneth M. Wilson, *New England Glass and Glassmaking* (New York: Thomas Y. Crowell Co., 1972), p. 86; Lowell Innes, *Pittsburgh Glass, 1797–1891: A History and Guide for Collectors* (Boston: Houghton Mifflin Co., 1976), pp. 15–16, 13.

[16] Richard B. Morris, *Government and Labor in Early America* (1946; New York: Octagon Books, 1965), p. 217; H. W. Stiegel to John Dickinson, December 2, 1772, Logan Papers, vol. 38, p. 91, HSP; Mark Leavenworth, May 18, 1790, as quoted in Wilson, *Glass and Glassmaking*, p. 75.

[17] Ada Polak, *Glass: Its Makers and Its Public* (London: Weidenfeld & Nicholson, 1975), p. 25.

works at Zwiefalten but by 1712 had moved to Mattsthal. The Rodalben glasshouse was his next employer, between 1715 and 1723. Then he became superintendent of the Hassell glassworks and remained there until 1730. Griesmayer then returned to Mattsthal where he finished his glassmaking career. His sons did not accompany him on his final move but set out on their own. John George Griesmayer went to the glasshouse at Forbach where he made glass from 1731 until 1737, and then he spent four years at Dunkerque. Before his death in 1768 or 1769 he worked for five more glasshouses: Amblève, Bruxelles, Amblève again, Chênée-lez-Liège, Monthermé, and Eikenvliet. Another son, Simeon, left his brother at Forbach in 1737, traveled to Rotterdam, and sailed from there to Philadelphia.[18] Along with Martin Halter, Caspar Halter, and John William Wentzel, Griesmayer built the glasshouse in New Jersey for Caspar Wistar. Griesmayer remained at Wistarburgh until his death in 1748. He had no opportunity to wander because Wistar's was the only glassworks known to have been in operation in America during those years.

By 1817, when Franz Georg Hirsch came to this country, there were many glasshouses, yet it appeared that he worked only at the Chelmsford, Massachusetts, glasshouse for his entire career, in marked contrast to his experience abroad. Born in Bohemia, Hirsch blew glass at Habichsbach, Alsberg, Theissen, Schmalenburg, and Ober Alsbach. His peregrination throughout central Europe caused no ill will with management, as notes written by two of his employers demonstrate. "Because Mr. Hirsch has been so loyal and honest a worker," wrote Ludwig Greiner at Ober Alsbach, "I am happy to give him this certificate and impress on it our seal."[19] The labor pool was large, and other migrant workers would undoubtedly fill the places of Hirsch and others who left.

This was not the case in eighteenth-century America where there was a handful of skilled glass craftsmen. Because of this, glasshouse proprietors viewed their competition with suspicion. Their fears were well founded because several manufacturers sought their blowers not in Europe but among the ranks of their rivals in America. At least one

[18] Léon-Maurice Crismer, "Origines et Mouvements des Verriers Venus en Belgique au XVIIIe Siècle," in *Annales du 7e Congrès International d'Etude Historique du Verre, Berlin-Leipzig, 15–21 août 1977* (Liége: Edition du Secrétariat Général, Association pour l'Histoire du Verre, 1978), p. 351.

[19] Hirsch Papers, translation, Chelmsford Historical Society, Chelmsford, Mass.

Wistarburgh blower yielded to offers from Stiegel when the ironmaster started a glassworks in Lancaster County, Pennsylvania. In 1795, when John Brown planned to build a glassworks in Providence, his agent, John Hurley, journeyed to factories in East Hartford, Philadelphia, and New Jersey to procure a staff.[20] Such recruiting methods sometimes prompted reciprocal action. James O'Hara of Pittsburgh complained to a friend about Frederick Magnus Amelung, then manager of the Port Elizabeth, New Jersey, glassworks, claiming, "he is employed in endeavors to get my best glassblowers to desert my works." O'Hara then urged his friend to do what he could to get two or three of Amelung's best. Proprietors of Lake Dunmore Glass Company took great pains to see that their recruiting agent reached the Keene, Clyde, and Geneva factories before the agent of a rival firm.[21] Some factories agreed to avoid competing for labor. When Isaac Craig, O'Hara's partner, noted the disappearance of blower James Clark, he reminded the owner of the nearby New Geneva glasshouse, "You will not employ him particularly as we have in all our transactions since the establishment of our works scrupulously avoided a Competition or rivalship." Craig bolstered his request with threats of a lawsuit.[22]

Craig, like many other glasshouse owners, had signed a contract with his blower. That Clark chose to ignore it was not uncommon in the glass trade. An indentured servant at a glassworks in Hilltown, Pennsylvania, deserted his master no less than six times, while at least four apprentices are known to have run away from their masters.

As the numbers of glass factories increased in the late eighteenth and early nineteenth centuries, there were more opportunities for employment, and many glass craftsmen resumed the traditional migratory ways of the Continent. Within the Middle Atlantic region alone, there is considerable evidence of migration. Wistar blowers went to Stiegel's factory in Lancaster County; Stiegel workers went to Kensington, Philadelphia, and to Frederick, Maryland, where they started a factory that Amelung later bought. Some Amelung craftsmen worked

[20] Messrs. Brown and Francis in Account with John Hurley, 1795, Brown-Francis Papers, private collection, as quoted in Wendy A. Cooper, "The Furniture and Furnishings of John Brown, Merchant of Providence, 1736–1803" (M.A. thesis, University of Delaware, 1971), app. 3.

[21] Quoted in Innes, *Pittsburgh Glass*, pp. 19–20; Peter H. Templeton, "Glassmaking in Addison County, Vermont," p. 36 (Course paper, Middlebury College, 1978), copy, author's collection.

[22] Quoted in Innes, *Pittsburgh Glass*, p. 13.

for Nicholson in Philadelphia, and some moved to Baltimore, while others operated the Gallatin works at New Geneva near Pittsburgh. Kensington people advised Nicholson, then Nicholson blowers went to Kensington. They also headed for Boston and Pittsburgh. Glassblowers in New York and New Jersey have been traced to Pittsburgh, and artisans from New Geneva migrated to Baltimore.

The mobility of glass craftsmen has certain important implications for the identification of glassware from a particular region or factory. Just as an immigrant blower continued to fashion the shapes and decorations he had learned in Europe, so too did he carry his own particular style—and sometimes his tools. Iron and brass molds, even more than hand tools, directly determined the shape, size, or pattern of an object, and they, too, traveled back and forth with the craftsmen. The evidence of migratory craftsmen suggests that the traditional regional approach to the identification of American glass is in need of revision.

Mobility was not always a matter of choice. When glassblowers signed on, they had no assurances that the glasshouse would survive the vicissitudes of the marketplace. Of the twelve glasshouses of colonial America, only Wistarburgh endured more than twelve years. When glass craftsmen found themselves out of work, they sought employment at other glasshouses or encouraged new investors to try their luck. Fearing that the troubled Boston Glass Manufactory would not last another season, "the complete set of Glass Blowers" advertised their "wish to be employed in the same line, by any Gentleman or Company" with an agreement for one or two years.[23] Sometimes, as in the case of Basil and Louis Fertner, glassblowers pooled their resources and opened works of their own. When the glassworks of John Frederick Amelung closed in 1795, a group of workers leased one of the furnaces to keep the craft alive at New Bremen.

Many circumstances other than closing of the factory could lead a glassblower to leave his situation to seek employment elsewhere, but lack of payment was the most frequently recorded complaint. Joshua Tittery, for example, sued the president of the Free Society of Traders in 1685 for back wages and won.[24]

Often workers were not paid because the great capital investment required to set up a glasshouse left insufficient funds for operating

[23] *Columbian Centinel* (Boston) (June 1, 1796).
[24] Morris, *Government and Labor*, p. 217.

expenses. No one had more problems of this nature than Nicholson, who included a glassworks among his many ill-fated ventures of the 1790s.[25] The glasshouse superintendent, William Eichbaum, reported to Nicholson in June 1795, "[I have] Experienced of the Fertners so much Insolence which I can't account for any other Reason then that the Money is not here." In September he reported, "our people an[d] my Self are so Distreset for Money that [w]e must Endeavoar to Seek other [e]mployment in order to procure Subsistance." In October the Fertner family declared that they would not work beyond the end of the month. They took their case to the German Society, established to assist German immigrants, and through that organization put pressure on Nicholson to pay. The relief was temporary, however, because Nicholson had greatly overextended himself and the end was in sight. In 1797 Nicholson vainly tried to reduce his mountain of debt by paying his creditors in glassware and urged his staff to produce. The glassblowers, however, staged a sit-in strike in Nicholson's office. The company clerk "went to see each of them to order them to their work, their answer was that they will not work a stroke unless they get all the money which is due to them."[26]

Little information survives concerning the wages of glassmakers. In Europe, in all periods, glassblowers were among the most highly paid craftsmen. In America, as Mark Leavenworth noted on May 18, 1790, they were "in such demand that they obtain[ed] very high pay."[27] At the top of each factory organization was the glasshouse master, or superintendent, whose duties in American glasshouses would have varied little from those spelled out by the elector of Brandenburg in 1674:

He is to keep a watchful eye on the furnace and see that all that is necessary to bring and keep the furnace and glasshouse in good order is there: wood for fuel, clay, stone for the furnace, ash and other materials, and take care that nothing is missing as great trouble can ensue; he shall see to it that hard-working journeymen are retained, and he shall keep them in order, also see that nobody

[25] See Robert D. Arbuckle, *Pennsylvania Speculator and Patriot: The Entrepreneurial John Nicholson, 1757–1800* (University Park: Pennsylvania State University Press, 1975).

[26] William Eichbaum to Nicholson, June 5, September 18, October 30, 1795, and Joubert to Nicholson, June 1, 1797, NGC; Nicholson to Henry Keppele, December 14 and 28, 1795, John Nicholson Letterbooks, vol. 3, pp. 286, 303, HSP.

[27] See, for example, Joan Wallach Scott, *The Glassworkers of Carmaux* (Cambridge, Mass.: Harvard University Press, 1974), pp. 38–42; quoted in Wilson, *Glass and Glassmaking*, p. 75.

sells and takes home his work of the week, but make sure that everyone each week gives what he had done to the glass-house clerk.[28]

The master of a European glasshouse generally came from the ranks of the glassblowers, but in America superintendents had diverse backgrounds. Although Edward Lambert had been hired only to keep the books, he felt he had become, in effect, the "master overseer" and clerk of the Germantown, Massachusetts, glassworks in the 1750s. Ebenezer Hall came to the Franklin Glassworks in Warwick, Massachusetts, with experience as a teacher and physician. Hall left Warwick in 1815 to become superintendent of the Keene, New Hampshire, glasshouse for an annual salary of $500. The glasshouse in Woodstock, New York, then hired him for $600 per year. Henry Schoolcraft at the age of twenty-one was hired as superintendent by the Vermont Glass Works for $1,000.[29]

The only complete record of the activities of an American glassworks superintendent dates from 1795–97 and was made by Eichbaum at Nicholson's factory at Falls of the Schuylkill near Philadelphia. His duties were the same as those outlined for the Potsdam master, but they also included control of worker housing. Eichbaum's problems were probably atypical because of Nicholson's constant interference and mismanagement. At one point, when Eichbaum felt his authority threatened, he complained:

I cannot omit to mention the Disagreable news at my arival on Saturday night last which Mr. Groves had Published that Mr. Nicholson was going to Confine in joal the Glass Makers for Burning the Coals & making no Glass, now Sir if you have anything to alidge to my misconduct I should be very Glad if you would be pleased to acquaint me of it yourself & not let it come through the means of such a worthless old villian as he is.[30]

For his efforts Eichbaum received $1,000 per year—about £31 per month—three times the salary of a glassblower.

At Falls of the Schuylkill, as at many other glasshouses, the wages of a glassblower depended directly on the amount of glass he produced.

[28] Quoted in Polak, *Glass*, p. 18.

[29] Edward Lambert to Thomas Flucker and Isaac Winslow, February 13, 1754, as quoted in Wilson, *Glass and Glassmaking*, p. 45; Julia D. Sophronia Snow, "The Franklin Glass Factory—Warwick's Venture," *Antiques* 12, no. 2 (August 1927): 133–39; Templeton, "Glassmaking," p. 8.

[30] Eichbaum to Nicholson, October 17, 1795, NGC. The coal-fired furnaces at the Nicholson works were the first in America.

Records for 1797 show that Nicholson's seven gaffers were given one-fifth the value of the glass each made. For the month of March their wages ranged from £8.13.4 to £12.4.1½, with an average wage of £10.15.1, calculated on a total of 12,338 claret, snuff, and square bottles blown. The average wages for February, April, and May were £13.14.11, £13.10.1, and £10.17.2 respectively.

Caspar Wistar and his glassblowing partners shared in various proportions the value of glass bottles and windowpanes blown. For the eight-month season, or "blast," between October 1745 and May 1746, Wentzel was responsible for making glass worth £400.18.3; he received a third of that sum, £133.12.9, or approximately £16.14.1 per month. Martin Halter and Simeon Griesmayer apparently worked together, and for the 1745–46 blast they produced glass to the value of £953.8.7. They each received one-sixth of the total, or £158.18.1. Eleven years later when only Wentzel and Halter remained of the original partnership, each of them earned £359.12.7.

For some glass craftsmen income depended not only on their productivity but also on the type of object manufactured. According to the terms of his contract drawn in 1752, John Martin Greiner of Saxe-Weimer was required to inform his New York employers "in Ev'ry respect in the Art & Mistery of Erecting and Building a Glass House & allso in Blowing & Making of Glass." In return Greiner would be paid twenty-four stivers for every 100 one-quart bottles made and three gilders per 100 half-gallon flasks. An 1825 contract between the owners and employees of the Chelmsford, Massachusetts, glasshouse set forth a salary based on the size of the windowpanes made: for 8-by-10-inch and smaller sizes the glassblower got £0.6.9 per 100 feet and £0.8.3 for larger sizes.[31]

Although early American glassmakers primarily blew bottles and windowpanes, it is the table articles fashioned of the same melts that have survived in collections. These are described in the literature as "offhand" or "end-of-day" wares (fig. 3), the assumption being that blowers worked on a quota per diem basis. Supposedly, after he had completed the stipulated number of bottles or cylinders, the blower was free to empty the pot by shaping items of his own desire and for his own use, but this is not well documented. While certain whimsies were undoubt-

[31] Draft of agreement, New-York Historical Society; "Articles of Agreement between the Proprietors & the Blowers at the Chelmsford Glass Works," August 16, 1825, Corning Museum of Glass.

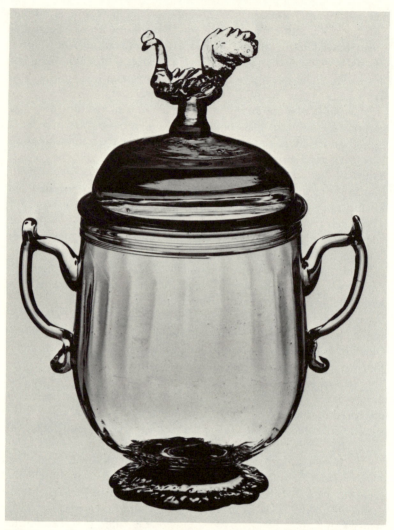

Figure 3. Covered bowl, green glass. Probably New Jersey, early nine-teenth century. H. 8⅞″. (Winterthur 59.3018.) Often considered "off-hand" glass, such wares blown of unrefined glass were probably made for commercial sale and not solely for the glassblower's amusement.

edly made for pleasure, factory records suggest that table forms of common glass were intended for commercial sale. From one glassblower's diary it is clear that his daily goal was to "finish" his pot, whether it be with bottles or bowls. [32]

Entries in the record books of Stiegel show that he paid his workers a flat rate rather than base their wages on productivity, a system that was also practiced at several English factories. A fragmentary wage record for 1768 from the Taylor glasshouse in Bristol shows that master blowers received £1.7.9 for seven days' work, or £5.11 per month. At the Northumberland glassworks of Lord Delaval, master craftsmen earned £1.0.0 per week in 1773, while journeymen were paid between 20s. and 14s. At about the same time, Stiegel was paying his master blowers £5.10.0 per month. To the parents of apprentices he paid £0.1.5 per month. In 1773 Stiegel signed a contract with an English-trained glass engraver, Lazarus Isaac, and agreed to pay him £5.10.0 each month for twelve months. In addition, Isaac would receive a house, land for a garden, and, like all the other employees at Manheim, firewood hauled to his door for 5s. a cord. Monthly wages may also have been paid at the New Bremen Glassmanufactory of John Frederick Amelung. When it closed in 1795, several glassblowers, sought employment with Nicholson, informing him, "it will be out of our power to work for less than Thirty dollars per Month if the Furnace is inclos'd and if not then half the wages are usually given, and a free house includet." [33]

When evaluating the wages of glass craftsmen in early America, two points should be kept in mind. First, piecework wages may have been paid to a team, not to an individual. Second, there were other forms of remuneration in the glass industry besides cash. The glasshouse labor force was usually organized into teams, or "chairs," with one team assigned to each pot of molten glass in the furnace. Christopher Triepel and Charles Ehrhard informed Nicholson that they were "able to furnish good capable Glass blowers for one oven." Louis Fertner was described at one point as Triepel's "pot companion." [34] The

[32] George Whitefield Foster, diary, as quoted in John Morrill Foster, *Old Bottle Foster and His Glass-Making Descendants* (Fort Wayne, Ind.: Keefer Printing Co., 1972).

[33] Taylor Records, Bristol Record Office, Bristol, Gloucestershire; Royal Northumberland Glassworks, Delaval Papers, Northumberland Record Office, Newcastle upon Tyne; facsimile reproduction of Lazarus Isaac contract in Hunter, *Stiegel Glass*, after p. 72; Christopher Triepel and Charles Ehrhard to Nicholson, June 14, 1795, NGC.

[34] Triepel and Ehrhard to Nicholson, June 14, 1795, and Eichbaum to Nicholson, January 29[?], 1796, NGC.

master blower, or gaffer, occupied the glassmaker's chair. He was responsible for the final shape and finish of the object. He was assisted by journeymen, apprentices, and boys. The wages recorded at Wistarburgh and at Nicholson's works were, apparently, paid to heads of teams who were then responsible for distributing shares to their assistants. The exact number of assistant positions depended on the type of vessel made and the scope of the establishment. There could be, for example, a gatherer who took up the initial gather of glass from the melting pot onto the blowpipe, a marverer who shaped the parison on a marver, while a boy may have had the task of opening molds, applying the pontil, or carrying off finished ware to the annealing oven.

As Stiegel's contract with Isaac and the Triepel letter demonstrate, glassworkers were often provided with living quarters. There was a practical reason for this because glassworks were often located in remote areas. Before 1795 all the furnaces of American glasshouses were wood fired, and in order to minimize the expense, factories were located within or near wooded areas. Caspar Wistar acquired over 2,000 wooded acres eight miles from Salem, New Jersey, and his ovens consumed 2,400 cords of wood annually. The ambitions of John Frederick Amelung were such that New Bremen became a manufacturing town containing, by 1787, dwellings for 135 people. Schools were built for the children, and a Masonic lodge was founded for the workers.

Three eighteenth-century glasshouses existed as part of larger industrial communities. The Germantown (now Braintree), Massachusetts, settlement of the 1750s included, besides a glasshouse, a chocolate factory, a pottery, weaving establishments, and a spermaceti processing plant. A town was laid out to accommodate the workers, all of whom were German immigrants. Stiegel founded and administered the town of Manheim for his glass- and ironworkers. At Falls of the Schuylkill Nicholson followed the pattern of the Paterson, New Jersey, textile experiment because he believed that diversification was the key to success. Nicholson built an ironworks, a button factory, and a glasshouse in addition to the textile factory. The complex was never completed, however, and surviving records suggest that worker housing was inadequate. Glassblower Mathias Fertner lamented, "[I am] under an Obligation to make a Complaint [as] . . . the Condition that I now labour under Is too tedicous and hard for any human Mortal to bear As there is no regulation to be had here [and] I have to Lay on the flore & have

not where[withal] to accomplish my Dyet."[35] Five months later he died of a fever.

Many of the nineteenth-century glasshouses were built as independent undertakings in rural areas. Written descriptions and pictorial views prove that workers continued to be furnished with lodgings. Even in urban areas housing for the workers was often available. "Glasshouse Row" on Hughes Street, Baltimore, housed the first workers at the Baltimore Glassworks in 1800, while the Boston tax lists for 1798 show that three glassblowers for the Boston Crown Glass Works occupied company-owned houses in South Boston. Other workers for the company were tenants in noncompany houses, while blower Adam Hartwick owned and occupied his own two-story wooden dwelling on a 3,600-square-foot lot near the factory.

Whether in countryside or in town, American glassblowers were a group apart. Their physical isolation made political involvement difficult, and social intercourse beyond the glassworks was limited. To the outside world, the practitioners of this mysterious art were even more mysterious because so many spoke only a foreign tongue. As late as 1850 a visitor to Pittsburgh reported hearing only German in one glasshouse. Their isolation was strengthened by the peculiarities of the manufacturing process. They kept unusual hours, often working in six-hour shifts around the clock. The furnaces were tended constantly, and when the batch was ready it had to be worked, regardless of the hour. During the glassblowers' strike at Nicholson's factory, the clerk reported of Nicholas Fertner, the founder, or mixer of the ingredients, "[he cannot] continue longer the Glass blowers having not been working he is forced to stay in the Glasshouse in order to Watch the Glass and this evening he will have been 30 hours on duty without taking any rest."[36]

Glassmaking was a business full of risks, and if disaster struck all hands were needed to help out. Melting pots frequently broke in the oven; during the month of March 1797, nine pots broke at Falls of the Schuylkill. When this happened the broken fragments had to be removed and a new pot filled with batch and reset. Joseph Leacock, part owner of the Kensington glassworks in Philadelphia in 1771, vividly recalled his joy at seeing the first table glass made. He reported, however,

[35] Mathias Fertner to Nicholson, February 19, 1795, NGC.
[36] Joubert to Nicholson, June 2, 1797, NGC.

[My joy was] quickly damped by the terrific Cry "A pot is broke"—O the confusion that ensued. The Palace of a King in flames could not have created more hurry & hubbub—away all hurry to the furnace, down comes the side on which the pot had broke, out it was ha[u]led—another introduced in its place—the side of the furnace built up again, & all well once more. ["]O these little misfortunes must happen now and then["] cry'd out the pot maker—["]I suppose so["] was my reply ["]but I hope not too often or the glass men must be metamorphosed into Salamanders to Endure such hot work.["][37]

The work of a glassblower was indeed long, hot, and difficult. Glassblowing required strong lungs and arms. In making crown window glass a blower might have as much as thirty-two pounds of glass at the end of his blowpipe, and forty-pound cylinders up to seventy inches in length had to be swung on the blowpipe in the manufacture of cylinder glass (see fig. 4). Glassblowers were susceptible to lung diseases, and infections of any sort spread rapidly because the blowpipe passed from mouth to mouth in the manufacturing process.

With the physical efforts required of their lungs and mouth and the intense heat to which they were exposed, glassblowers were constantly thirsty. Beverages of alcoholic content were the usual thirst quenchers, and without them little glass was made. The clerk at Falls of the Schuylkill glassworks beseeched his employer saying, "if you have some *good Wine* pray send us some, even if it is *coloured tarr.*" A few weeks later he was again in want and argued that "a few Gall[ons] of any thing might operate wonders among the Glassmakers."[38]

Nicholson's reluctance to send liquor is understandable considering the drunken brawl that had occurred at his factory a few months before. According to the factory superintendent, three blowers, Louis Fertner, Christopher Triepel, and Frederick Wendt, had been drinking all afternoon.

& when the two George & Bassil [Fertner] Came up to persuade Louis to bed upon which he was obsternate and a Quarel insued and Blows, upon which Triepel went to the assistance of Louis and his Pot Companion and used the other two George & Bassil as you find them. and followed Them to Their house and got no admitance there. I had pot setting to do which could not be done till this morning about ten O'Clok, which ou[gh]t to have be done last night about the same hour. but having most hands Intoxicated and others Bruised was obliged to Defer it till this morning and how it will go this Day I know not

[37] Leacock to Nicholson, December 23, 1794, NGC.
[38] Joubert to Nicholson, April 27, May 20, 1796, NGC.

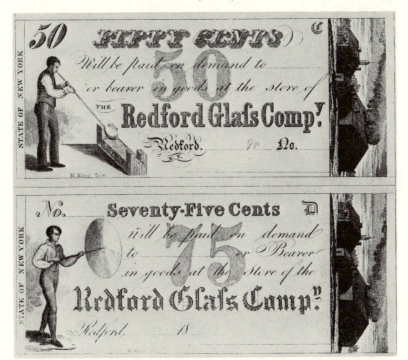

Figure 4. Scrip notes for 50¢ and 75¢, Redford Glass Co. Redford, N.Y., 1831–51. Paper. (Winterthur 73.248.) Redeemable at the company store, these notes illustrate the manufacture of window glass by the crown method.

as drinking has been gone on all this day, and George Godwald living so very handy and so very agreeable to Drinkers, makes it impossible to have the place, but I shall wait on you as Soon as Bacchus Reign is over."[39]

Inebriation was a widespread problem. At Stiegel's works Henry Sharman had to pay five shillings "for getting Drunk and Leaving an [pot] Arch Empty about three hours." James O'Hara fired two workers from his Pittsburgh plant in 1806. In his opinion, blower Charles Haines "forfeited all claim to indulgence by his constant practice of getting drunk and neglecting his business to the great loss and disgrace of the works." The other became "unworthy of any confidence" in conse-

[39] Eichbaum to Nicholson, January 29[?], 1796, NGC.

quence of his "many repeated abuses of his duty in being drunk in the composition room."[40]

The absence of "spiritous beverages" in the factory at Sandwich, Massachusetts, was a source of pride and a matter of comment. An 1832 newspaper account reported: "No ardent spirit has been admitted within the factory for the last four years. . . . Of the 200 employed at the Factory, not more than 100 drink ardent spirits on any occasion; and of the 100 who occasionally drink, five of that number only, have ever been intoxicated."[41]

When Philadelphia entrepreneur and self-styled physician Thomas W. Dyott reorganized his glassworks as a model temperate manufacturing village, he found it necessary to dismiss those "workmen from Europe, tainted by the habits of a degenerate caste, which rendered intemperance an inveterate habit." He concentrated instead on instilling temperate habits into apprentices.[42] Dyott's crusade against alcohol did not extend beyond the factory gates, however, because wine bottles and fancy pocket liquor flasks were among his staple products.

Rules and regulations—and Dyott was not the first to prescribe them—did not insure that employer-employee relations in the glasshouse were always smooth. The Eichbaum–Nicholson correspondence illustrates some of the difficulties between superintendent and workers, albeit in a glassworks that was more or less doomed from the start. Similar problems must have plagued the Germantown glasshouse in the 1750s; clerk Edward Lambert stated, "[I am] certain there's not one young man in fifty would have stayed here and been so oppressed, threatened and abused by the glassman as I have."[43]

The failure of glassblowers to "perform their duty in a sober peaceable & workmanlike manner" could lead to disaster. Although the crew at the Rensselaer glassworks was described as "a set of the best workmen," they proved to be lazy and "addicted to carousing and extravagance." During a card game in 1815 they accidentally set fire to the works. The carelessness of the furnace stokers at the Vermont Glass

[40] H. W. Stiegel Records, Glass Factory Day Book, September 17, 1771, HSP; quoted in Innes, *Pittsburgh Glass*, p. 13.

[41] *Daily Evening Transcript* (Boston) (September 8, 1832) as quoted in Wilson, *Glass and Glassmaking*, p. 264.

[42] T. W. Dyott, *An Exposition of the System of Moral and Mental Labor Established at the Glass Factory of Dyottsville* (Philadelphia, 1833).

[43] Quoted in Wilson, *Glass and Glassmaking*, p. 44.

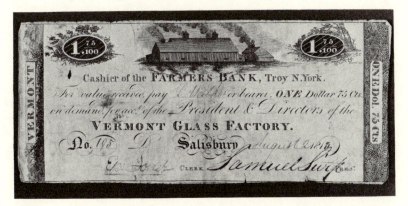

Figure 5. Vermont Glass Factory $1.75 bank note drawn on Farmers Bank, Troy, N.Y. Salisbury, Vt., 1815. Paper. (Joseph Downs Manuscript and Microfilm Collection 74 x 14.1, Winterthur Museum Library.) Shows factory as it appeared prior to a fire carelessly set by workers.

Factory near Lake Dunmore caused the destruction of that works by fire in 1815 (see Fig. 5).[44]

When they were not coping with such major disasters, superintendents tried to keep peace among workers on the factory floor. The creation of every glass object required the cooperation of at least two individuals, and a spirit of teamwork was essential. Caroline Harrison, visiting the Brooklyn Flint Glass Works in 1824, "looked with astonishment" at the process she observed: "every man seems to have his part to perform—they work into each others hands as it were—Therefore none of them can spend any idle time." The pressure on the workers was increased by the fact that glass can only be manipulated at a certain temperature maintained by constant reheating. Harrison marveled at "the red hot ball of Glass flying in all directions."[45] The material and the manufacturing process gave to glassmaking a sense of urgency unparalleled in other crafts.

There was another side of the glass business where the individual craftsman could act alone, and that concerned lampwork production

[44]"Articles of agreement"; *Columbia Patriot* (March 29, 1815) as quoted in Templeton, "Glassmaking," pp. 24–25.
[45]Caroline Harrison to Thomas Harrison, July 1, 1824, Leib-Harrison Papers, Miscellaneous Collections, HSP.

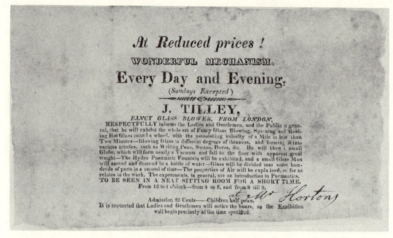

Figure 6. Broadside, J. Tilley. Possibly Philadelphia, ca. 1820. Paper. (Joseph Downs Manuscript and Microfilm Collection 76 x 404. 1, Winterthur Museum Library.)

and certain decoration that took place outside the factory setting. Men and women with skills in these areas emigrated on their own intiative to seek their fortunes in America. Perhaps more in the category of entertainers than craftsmen, were "fancy glassblowers," or lampworkers, who fashioned whimsical articles from prefabricated glass rods softened at a concentrated heat source. Men like James Tilley and Lawrence Finn traveled throughout the states in the nineteenth century demonstrating the remarkable qualities of glass to admiring audiences (fig. 6).

Decorators of glass, wheel cutters, engravers, and painters on glass did not need to be associated with a glassworks and could set up independent shops. They obtained their blanks from private clients or factory agents or purchased them at auction. The identification of their work is problematical; they undoubtedly embellished glass of both American and European manufacture. Patterns of their work could be seen in their shops, but they also executed designs on order. In spite of their flexibility and a desire to please, it is certain that their training and experience would be reflected in the style of their work.

The first glass engraver known to have practiced the art in America was Lazarus Isaac who came to Philadelphia from London in 1773. From his advertisement in the *Pennsylvania Packet* (May 17, 1773), it

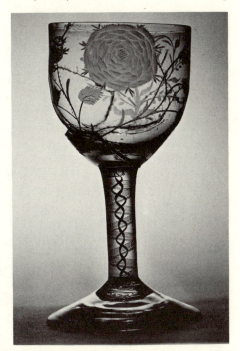

Figure 7. Blown goblet, attributed to Henry William Stiegel, American Glass Manufactory, and probably engraved by Lazarus Isaac. Manheim, Pa., ca. 1773. H. 7". (Private collection: Photo, Sheldon Butts.)

is clear that Isaac was prepared to decorate glass in the English manner: "he undertakes to cut and engrave on glass of every kind, in any figure whatsoever, either coats of arms, flowers, names, or figures. . . . He cuts upon decanters a name of the wine, &c. for 1s tumblers for 6d each, wine glasses for 2s per dozen, and the stems cut in diamonds at 2/6 per dozen." Isaac worked under contract with Stiegel starting in June 1773, but he may have returned to London at the outbreak of the Revolution.[46]

A lead-glass goblet recently discovered in the possession of Stiegel descendants appears to be an example of Isaac's work (fig. 7). It is engraved W & E / OLD for Stiegel's daughter Elizabeth who married William Old in 1773. On the reverse is a rose reminiscent of English work of

[46] No mention of Isaac has been found in American post-Revolutionary records. A Lazarus Isaacs was a warden ca. 1830 in the Western Synagogue of London (Arthur Barnett, *The Western Synagogue through Two Centuries (1761–1961)* [London: Valentine Mitchell, 1961], p. 159).

the period. The goblet has an opaque enamel twist stem, conforming to the fashion of the 1770s and fitting the contemporary description of "enameled" glass found in Stiegel's advertisements. The glass supports the theory that Stiegel's engraved glass would have been in the English style because Isaac learned his craft in England. Over the years, enormous quantities of nonlead glass engraved in a Continental folk style have been attributed to Stiegel. The designs on these glasses resemble those in a Bohemian glassmaker's catalogue of about 1800. They could not have been the work of Isaac, and, as yet, no engravers of Germanic origin have been identified for the colonial period.

Between 1788 and 1792 an anonymous craftsman of Germanic origin engraved glass for John Frederick Amelung (fig. 8). Close examination of the two dozen surviving decorated glasses suggests that he worked alone in a consistent manner. No evidence of his pre– or post– New Bremen activity has come to light. Besides Isaac there were at least three other engravers and cutters with English training practicing their art in late eighteenth-century America. Among them was John Moss who worked for Turner and Abbott in their Fleet Street, London, shop. After at least eight years as an independent glass engraver in Philadelphia, he became a general merchant. One of the few women in the early American glass industry was Madame Descamps from Paris who opened a glass-engraving store in Philadelphia in 1795. By 1804 she had moved to Boston. Descamps is the first glass decorator in America known to have run a shop with several artisans. As she notified the public in 1800, she was now "assisted by several persons whom she [had] successfully enabled to be proficient in that art."[47]

When the fine table glass industry became firmly established in the nineteenth century and a market was created for expensive decorated glass, a few of the larger glassworks included decorating shops. In 1826 the Pittsburgh firm of Bakewell, Page, and Bakewell, for example, employed among sixty-one hands twelve who "constantly" engraved and ornamented glass. It was reported that New England Glass Company had "an establishment for *Cutting Glass*, in all its variety, operated by Steam Power and conducted by experienced European Glass Cutters, of the first character for workmanship in their profession" (figs. 9, 10). Before 1840, however, most of the fancy cut and engraved glass in America emanated from independent cutting enterprises. Joseph Bag-

[47] *Pennsylvania Packet* (June 25, 1795); *Aurora* (Philadelphia) (April 4, 1800).

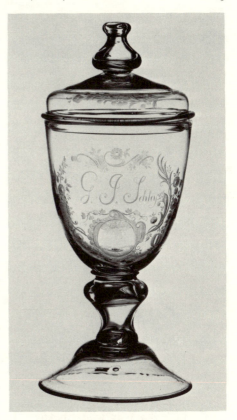

Figure 8. Blown and engraved glass goblet made for George Jacob Schley by John Frederick Amelung, New Bremen Glassmanu-factory. Frederick County, Md., probably 1791–93. H. 11⅞". (Winterthur 59.47.)

gott and Edward Yates in New York, Robert Smith in Charleston, and Henry Tingle of Baltimore all operated large glass-cutting factories. Fourteen members of Tingle's Baltimore Cut Glass Works marched in the Fourth of July parade in 1826, each of whom "bore in his hands a piece of BALTIMORE CUT-GLASS, the beauty and richness of which elicited general admiration."[48]

Perhaps the best-known glass cutter was George Dummer who, after learning his trade in Albany, opened a retail glass shop in New York City where he decorated and sold glass. He then started a glass-

[48] Pittsburgh City Directory, 1826, p. 70; *Commercial Gazette* (Boston) (April 13, 1818) as quoted in Wilson, *Glass and Glassmaking*, p. 230; *Baltimore American* (July 7, 1828).

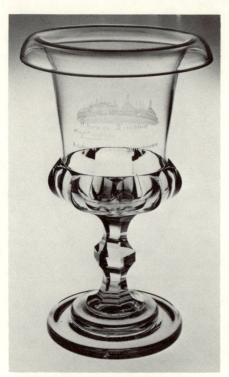

Figure 9. Blown, cut, and engraved presentation vase, New England Glass Co. East Cambridge, Mass., 1843. H. 13⅜". (Metropolitan Museum of Art, Purchase, Robert G. Goelet and Mr. and Mrs. William H. Hernstadt gifts, 1980.)

works in Jersey City where he manufactured glass of all types, from "rich cut" to pressed utilitarian wares. His success prompted him to undertake the manufacture of fine pottery, and he opened the Jersey City Porcelain Works. His prominence in manufacturing gave him a certain stature in the community, and between 1826 and 1830 he was president of Jersey City. His portrait, painted by Waldo and Jewett and now owned by Newark Museum, is one of the few known likenesses of an American glassmaker.

Research of American glass cutters is somewhat hampered because *glass cutter* describes both those highly skilled craftsmen who executed ornamental designs upon glass as well as those workers of low skill employed in window-glass factories to cut the finished cylinders or crowns into panes of the desired size. All window-glass factories had "cutting shops" where this activity took place.

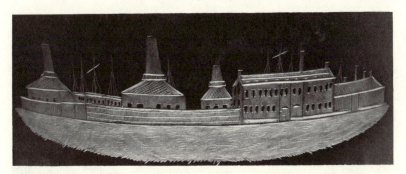

Figure 10. Detail of engraved view of vase in figure 9, showing factory buildings.

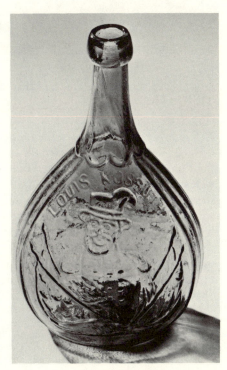

Figure 11. Blown-molded calabash bottle commemorating the visit to America of Hungarian patriot Louis Kossuth, Millford Glass Works. Millford, N.J., 1850–60. H. 10½″. (Winterthur 73.429.2.)

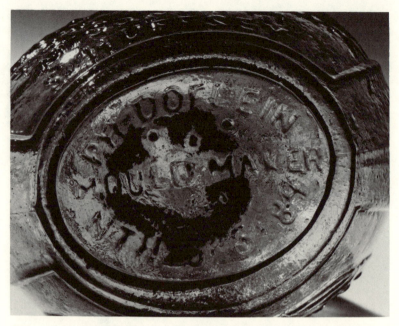

Figure 12. Detail of bottom of bottle in figure 11 showing name of Philadelphia moldmaker Philip Doflein and his address, "N[or]TH 5T[h] ST. [No.] 84."

Blown-glass windows and bottles continued to be the mainstay of the glass industry in the nineteenth century. Mechanized processes for their production were introduced only in this century. The table glass industry, however, was revolutionized by 1830, first with the improvement of full-size molds into which the gaffer blew his gather and then with the invention of mechanical pressing where the role of the glass-blower was eliminated entirely.[49] Here the size, shape, and pattern of the object were determined by the skill of the moldmaker, not the glass-maker. Little is known of the glass moldmakers. The name of one, Philip Doflein, appears in glass, molded in relief in the bottom of an 1850s bottle (figs. 11, 12).

[49] See Kenneth M. Wilson, "American Contributions to the Development of Pressed Glass," in *Technological Innovation and the Decorative Arts*, ed. Ian M. G. Quimby and Polly Anne Earl (Charlottesville: University Press of Virginia, 1974), pp. 167–206.

Still, throughout the nineteenth century, glassblowing traditions were kept alive in America. Although the growth of technical knowledge may have diminished some of the mystery of the ancient craft, the glassblower remained a craftsman set apart. From sand and ashes he created transparent articles of utility and beauty, articles that were at once fragile and enduring. The epitaph on the tombstone of Chelmsford glassblower John Joseph Stickelmire, who died of "dropsy by intemperance" in 1814, suggests something of the way in which glassmakers may have viewed themselves and their art. It seems a fitting end to this discussion.

> This verse reminds the heedless as they pass
> That life's a fragile drop of un[an]nealed glass
> The slightest wound ensures a fatal burst
> And the frail fabric shivers into dust.
> So he whom in his art could none surpass
> Is now himself reduced to broken glass.
> But from the grave, and fining pot of man
> From scandiver and glass galls pursed again
> New mixed and fashioned by almighty power
> Shall rise a firmer fabric than before.

The Business of Potting,
1780–1840
Susan H. Myers

The American pottery industry underwent a transformation between the end of the revolutionary war and about 1840. At the beginning of the period the average pottery manufacturer was—as had been true since the early seventeenth century—a master craftsman producing household red earthenware by traditional handcraft methods with the assistance of a small work force. By 1840 such traditional potteries were in decline, challenged by the more sophisticated products of a new ceramics industry. Changes in technology, more complex raw materials, new forms of business organization, and a diminished role for the craftsman accompanied the introduction of the new wares. Some of these changes occurred slowly in the course of expanding production of such things as household stoneware which retained many ties with the traditional handcraft. Other changes came abruptly, particularly with the manufacture of refined molded earthenware. Fineware enterprises required more capital and involved greater risk. Bearing little resemblance to red earthenware potteries, usually they were initiated by an entrepreneur who, although he might take an active role in the business, was not a potter but hired skilled workers, commonly from England or the Continent, to produce the ware.

There was little development in the American ceramics industry in the years immediately following the end of the Revolution. The general economic depression and an excess of imported goods temporarily created an unfavorable atmosphere for expansion. By the 1790s, with

improved economic conditions encouraged by America's greater commercial role during the Napoleonic Wars, there were signs of renewed activity in the ceramics industry. While the early tariffs were for the most part intended to produce revenue rather than to protect nascent industries, some interests saw them as an aid in the development of domestic manufactures and as a means of adding economic independence to political independence. The development of American industry was encouraged as well by societies of mechanics and tradesmen. One of these, the Pennsylvania Society for the Encouragement of Manufactures and the Useful Arts, in 1792 offered awards for "the best specimen of [Pennsylvania, New Jersey, or Delaware] Earthenware or Pottery, approaching nearest to Queen's Ware, or, the Nottingham or Delf Ware, of the marketable value of fifty dollars" and for "the best specimen of Stone Ware, or that kind of Earthen Ware which is glazed with Salt, of the marketable value of 50 dollars."[1] Although some wares of these types were being made in America by 1800, success in the potting business would for some years remain concentrated on the red earthenware manufacturer who operated very much in the traditional manner of his colonial counterparts.

The diary of Concord, New Hampshire, potter Daniel Clark, covering the years 1789 to 1828, reveals a great deal about the conservative business of making earthenware in early nineteenth-century New England.[2] It also suggests the nature of many small potteries located in inland communities far from the major urban centers of the East Coast. In time-honored fashion, Daniel was trained in the shop of his father, Peter Clark, in Lyndeboro, New Hampshire. As the third among four sons learning the potter's trade, he could not expect to succeed to the management of the family works. This may explain his move to nearby Concord in 1792 to establish his own manufactory. Since the city had no pottery at the time, Clark thought—correctly—that he would find a good, noncompetitive market. Concord, established in the 1720s, was a promising location. It became the state capital in 1808, and completion of the Middlesex Canal in 1815 stimulated its growth by providing

[1] *New Jersey Journal and Political Intelligencer* (Elizabeth) (January 25, 1792).

[2] Daniel Clark diary, 1789–1828, New Hampshire Historical Society, Concord. I am indebted to the historical society for allowing me to study a copy of their recent transcription of the Clark diary. Although the diary covers the period 1789 to 1828, it has been analyzed only for the years 1794 through 1825 when entries appear to be most complete. Except where otherwise noted, data concerning Clark is derived from that analysis.

a water route between Concord and Boston via the Merrimack River. Although Clark did not long remain the only potter in the area, he was quite successful (fig. 1).[3]

Daniel Clark's yearly potting activities fell into a regular cycle that interlocked with farming. His most invariable crop was hay, some of which he sold and some he kept for his animals. It had a short and early growing season, and its harvest did not interfere with potting. Other crops such as corn, potatoes, and peas were commonly planted in May. The diary indicates that the hay was mowed in July while harvesting of the vegetables rarely is mentioned. Presumably they were grown on a small scale for family use and were not a cash crop.

The materials required to make earthenware are few and easily obtained. Like most earthenware potters, Clark could find both clay and wood to fire the kiln in the immediate vicinity. Working around the farming schedule, clay was dug and carted usually between April and August. Wood most often was cut in March and April and carted the following winter between January and March. The elapsed time between cutting and transporting the wood to the pottery permitted the wood to dry.

The purchase of lead for glazing followed no particular pattern. More difficult to obtain than clay and wood, apparently it was available only in the eastern, more developed areas, and not along the western path where Clark chose to market his ware. The acquisition of lead often required a trip of twenty miles or more, and in one case it was necessary to go as far as Boston, a journey of about sixty miles. Clark purchased lead in whatever form he could get, usually bar or red lead and, occasionally, litharge. In 1814 and 1815, presumably as a result of the diversion of lead to the war effort, he was forced to use lead ore.

Working at a traditional potter's wheel, Clark turned his ware during the summer or early fall and glazed as time permitted. The diary entries for grinding lead are too infrequent to suggest a pattern. The inhalation of toxic lead—one of the earthenware potter's major occupational hazards—is suggested in the diary by Clark's periodic references to "dysentary," "rheumatism in stomack," and "billious chollick." During the last six years of his life he was often sick with "chollick," sometimes for long periods, probably the cumulative effect of many

[3] Lura Woodside Watkins, *Early New England Potters and Their Wares* (Cambridge, Mass.: Harvard University Press, 1950), pp. 120–23.

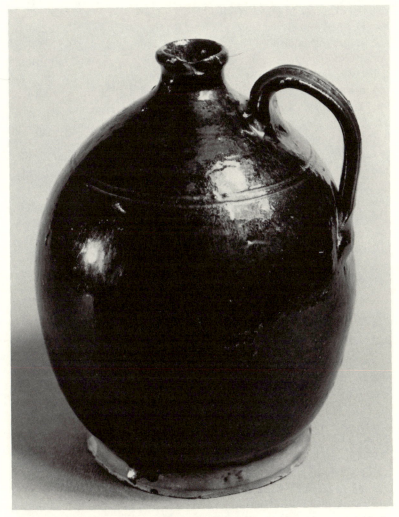

Figure 1. Jug attributed to Daniel Clark. Concord, N.H., 1792–1828. Dark-brown-glazed red earthenware; H. 7⅜″. (New Hampshire Historical Society.)

years of exposure to powdered lead.

Formed and glazed ware was fired throughout the year, although it was done most commonly in June. Firing rarely took place in September or October when Clark's time was most heavily devoted to turning. If he was particularly busy, finished ware might wait in the shop for months to be fired. In January 1806, he noted that he had just burned the "20th & last kiln made in 1804," over a year previously.

On the basis of the diary's breakdown of labor, Clark appears to have done a great deal of the work himself, although he did have help of various types. Most assistance came from his brother Benjamin (before 1798), his sons Daniel and Peter, and Samuel Whittemore, a Lyndeboro potter who established his own shop in Concord in 1798 but who continued to work with Clark. Also at the pottery was Peter Flanders, who began as an apprentice in 1795 and stayed with Clark for ten years. One employee worked for him about four years and two others were hired for one year each.[4] The names of various other people appear irregularly in the diary, and often they seem to have been hired to assist only with a specific chore.

Clark family members, as well as Whittemore and his son Peter, are noted in the diary as doing almost all types of work around the pottery—skilled and unskilled. The entries for other workers are limited to peddling ware, cutting and hauling wood, hauling clay, and helping to load the kiln. Flanders, however, must have had experience in other jobs in his ten years with Clark. He learned the business well enough to establish his own pottery in Concord by 1807 (figs. 2, 3). In that year his kiln "fell down in burning," a not uncommon catastrophe. Keyes Powell, mentioned off and on for four years, also may have done more skilled jobs, for the diary indicates that he worked "in the shop."

The interaction of the Clarks and Whittemores in Concord and in Lyndeboro is of interest. Daniel's brothers, his sons, and Daniel himself traveled back and forth between the two family potteries helping each other as needed. Samuel Whittemore, whether living in Lyndeboro or after his move to Concord, helped Clark by, among other things, supervising the firing. The help was reciprocated by Daniel and his sons.

The few diary entries concerning payment of workers indicate no wages greater than $15 per month. Workers were probably paid in kind rather than cash, as in the case of John Libbey who was hired for a year

[4] Watkins, *New England Potters*, pp. 122–26.

at "11.00 pr month in ware, & give in the house rent, & pauster [*sic*] his cow, summer season."

Like most rural craftsmen, Clark was both producer and merchandiser of his earthenware. Insofar as the diary specifies the market to which he sold his pottery, it appears that he concentrated on the Concord area and on the regions to the west where few potteries were established. Even though Concord is on the Merrimack River, there is no reference to transporting goods by boat. Rather, his pots were sledded or carted overland since no water transport could take him to his western markets.

The range of his market rarely exceeded forty miles. The only diary entry that suggests a possible deviation from his usual orientation and range concerned a January 1823 trip to Boston. Noting that two of his workmen bought bar lead there, he also commented that the "Markets [were] Dull."

Little is said in the diary concerning the ways in which Clark was paid for his earthenware. A common method of dealing was barter, and occasional entries refer to that practice. In December 1799 he noted that he "Bot yoke oxen" from William Simpson, "price 40 dols ware"; in April 1803 he "measured & took a deed of Barron hill gave 165 dollars for 18 acres in ware." That some cash did change hands is indicated by at least one partial cash transaction in January 1823 when he "Sold kiln ware to Libbey for $50.00 ½ cash & ½ pro. @ cash price."

With little competition and a growing population Clark's business thrived. Lura Watkins noted that by 1810 his was "the most successful pottery business in New Hampshire." His prosperity is suggested by the building of a new house, a barn, and a shed in 1804 and the subsequent building of a considerably more substantial house in 1810.[5] He made modest investments in the pottery, expanding it as demand grew. During his first year in Lyndeboro he must have worked in an old abandoned pottery, an "old durty shop" by his description, but in 1793 he built himself a new pottery shop and kiln. In July 1806 he had a "stone clay mill" built at a cost of $70; in August 1808 he raised a shed "by the Kiln house"; by May 1815 he had a new lead mill; and in September 1817 he "sett up tub to grind clay." In 1792 and 1800 he bought land from a local family which he used both for digging clay and for haying.

Throughout the period covered by the diary, Clark continued the

[5] Watkins, *New England Potters*, pp. 128, 124.

Figure 2. Plate, attributed to Peter Flanders. Concord, N.H., 1807. Clear-glazed red earthenware; Diam. 12″. (New Hampshire Historical Society.)

hand production of household red earthenware of the types common in traditional American potteries. His success never tempted him to try to make the more sophisticated products—stoneware or refined earthenware—that were beginning to be produced elsewhere. His reasons undoubtedly were those of most traditional earthenware potters of the period. The demand from Clark's market was primarily for household utilitarian ware. What demand existed for stoneware or refined tableware could be met by imports from other parts of the country or from England and the Continent. Introduction of the manufacture of either of these products involved different skills and represented a substantial

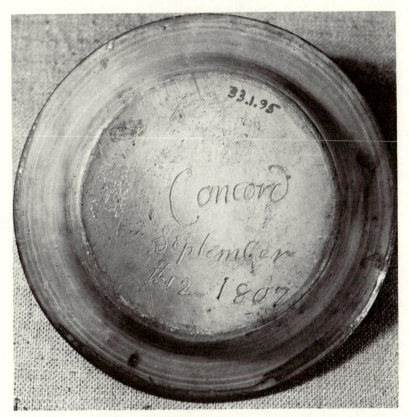

Figure 3. Reverse of plate in figure 2.

expense. The more refined wares required different raw materials, forming techniques, and firing methods.

Stoneware, hard and durable, was a better type of pottery for most purposes than the porous and friable earthenware that Clark made. It was, however, made from a type of clay that was far less readily available than the ubiquitous red clay. It also required a somewhat different type of kiln and a higher firing temperature. Unless a pottery was located at the source of clay, the costs of shipping that raw material could be substantial. Before the expansion of overland transportation, location on a major waterway was essential for obtaining clay. In an age of poor overland transportation, Daniel Clark and other inland traditional

earthenware potters had no easy access to clay for stoneware. Until national transportation networks improved, they were unlikely to attempt its manufacture. Clark could have brought New Jersey stoneware clay up the coast and along the Merrimack to Concord, but the cost surely would have been prohibitive, preventing him from pricing his wares competitively with imported counterparts.

A few pioneer stoneware manufactories had been established in several East Coast cities before the revolutionary war. After the war, particularly in the early nineteenth century, their numbers grew substantially. A significant phenomenon characterized some of these stoneware ventures. It was the association between an entrepreneur who provided the capital and marketing and a potter, or potters, who provided the expertise needed for production.

An early postwar example is the Boston manufactory established in 1793 by potters Frederick Carpenter and Jonathan Fenton, almost certainly with the financial backing of William Little, a Boston merchant (fig. 4). Little had been importing German and Belgian stoneware via Liverpool for his wholesale firm. Apparently he thought that he could save money by making his own.[6]

Little brought to the business capital, an existing sales network, and an understanding of the market for such products. Without these advantages, it is unlikely that Carpenter and Fenton would have attempted the venture. Although the site had the advantage of a coastal location, it was still a considerable distance from New Jersey clay, and costs for that raw material must have been great.

Precisely how these associations of merchants and potters affected the division of responsibility in the pottery—and the status of the craftsmen—is a matter of conjecture. Presumably Little concerned himself with marketing the products and, perhaps, with the other major "outdoor" activity, getting raw materials. Fenton and Carpenter, who appear to have been trained in the New Haven stoneware pottery of Jacob Fenton, Jonathan's brother, undoubtedly took care of the actual production.[7]

[6] Lura Woodside Watkins, "New Light on Boston Stoneware and Frederick Carpenter," *Antiques* 101, no. 6 (June 1972): 1052–57. Little's decision to establish a stoneware factory no doubt was influenced to some extent by a postwar change in methods of levying freight on goods imported from England. Previously levied on the basis of value, freights now were charged according to weight. Because it is heavy, imported stoneware became more expensive which had the effect of encouraging domestic production.

[7] Watkins, "Boston Stoneware," p. 1052. Other examples of the association of out-

Figure 4. Pot, made at the Boston manufactory of William Little, Jonathan Fenton, and Frederick Carpenter, probably by Jonathan Fenton, 1794–96. Salt-glazed stoneware with stamped and cobalt filled decoration; H. 12¼". (Smithsonian Institution, gift of Lura Woodside Watkins.)

Not all stoneware ventures were backed by merchants like William Little. William Seaver, an earthenware potter in Taunton, Massachusetts, also began to manufacture stoneware, evidently on his own, in the 1790s. Located on the Taunton River, which gave access to the coastwise trade of southern Rhode Island, Seaver had relatively easy access to New Jersey stoneware clay. His account book for the period from 1791 to 1806 suggests some of the ways in which he was similar to—and different from—his more conservative counterpart Daniel Clark.[8] Both men produced common household forms using traditional hand production methods, but Seaver's business required greater capital investment, and his operating expenses were higher than Clark's. The

side entrepreneurs and stoneware potters include a second association in which Frederick Carpenter was the master potter, this time at a Charlestown, Mass., site owned by two nonpotters, Barnabas Edmands and William Burroughs (Watkins, "Boston Stoneware," pp. 1056–57). Entrepreneur Benjamin DuVal operated Richmond Stoneware Manufactory in Richmond, Va., in 1811, although the names of his potters are not known (Bradford L. Rauschenberg, " 'B. DuVal & Co / Richmond': A Newly Discovered Pottery," *Journal of Early Southern Decorative Arts* 4, no. 1 [May 1978]: 45–75).

[8] William Seaver account book, 1779–1811, Old Colony Historical Society, Taunton, Mass. Unless otherwise noted, statements concerning Seaver's pottery are derived from an analysis of the diary for the years 1791–1806, which appear to be complete.

Figure 5. Pot, inscribed
TAUNTON / POT and
attributed to William
Seaver. Taunton, Mass.,
1799–1815. Salt-glazed
stoneware; H. 11¾". (Cur-
rier Gallery of Art.)

manufacture of stoneware forced Seaver to deal with the larger eco-
nomic community to develop a degree of interdependence absent in the
more self-sufficient Clark manufactory.

Seaver shipped his stoneware clay up the Taunton River from South
Amboy, although probably he also used some local clay. It was not an
uncommon practice among New England stoneware potters to stretch
the expensive Jersey clay by mixing it with some of the local red ear-
thenware. Seaver is said to have owned his own small vessel, the *Sam
Adams*, in which he transported the clay. Salt for glazing was acquired
in several different places. He once mentioned buying it in Providence
and another time in Boston. The only piece of stoneware attributed to
Seaver has no ornamentation (fig. 5), but it seems likely that the "paint"
listed in the accounts was cobalt for decorating. There is no indication
of where it was obtained. Rather than gather his own wood for fuel, as
Clark did, Seaver purchased or bartered for what was needed.[9]

[9]Watkins, *New England Potters*, p. 82. Stoneware usually was glazed by throwing
salt into the kiln during the firing. A vitrified and hard glazed surface was formed by a
combination of the sodium in the salt and the silica in the clay.

Seaver probably did not make stoneware in an extensive way until 1799 when he began building a new kiln representing a considerable investment of time and money. The "Company Account" from March through July of that year contains repeated entries mentioning such activities as "Lying Stone [presumably for the foundation] in kiln," and "work half Day on kiln" by Seaver and two hired workers. Time and money were devoted to "geting Stone in Lighter," to "getting out Stone," and to the purchase of bricks, probably refractory bricks capable of withstanding the high and fluctuating temperatures present in firing stoneware. By 1800 Seaver was selling stoneware in volume, which led to a change in his merchandising methods. Of the fifty-six individuals who bought pottery from him between 1791 and 1804, only eleven bought goods worth more than £1 at a time, and only two customers bought on what could be called a large scale. Simon and Enos Burt, merchants and probably importers, were the major purchasers of Seaver's stoneware. In sales of stoneware to the Burts, Seaver wholesaled his ware at half price, something he had never done with his earthenware.

Accounts usually were paid by barter, although occasional cash sales were made. The range of Seaver's market and his methods of transporting goods are not explained in the account book. Watkins stated that he sent ware to New London (roughly 80 miles by water) and to New York (roughly 200 miles by water).[10]

Like most traditional craftsmen, Seaver did not rely exclusively on pottery for his livelihood, although it was his main source of income. He also sold wooden heels and bartered with various farm products and services. Obviously an educated man, he also provided schooling for some of the local children. This is indicated in his account book by such charges as "Schooling Charles and Salley 4½ month 0-10-8" and "Schooling your Daughter Polley 3 months 0-7-3." In 1799, however, as he embarked on his stoneware venture, he sold his "right in the School house" for $3 and gave up that occupation.

As transportation improved and the population expanded in the first quarter of the nineteenth century, more and more stoneware potteries were established, especially in the Middle Atlantic and northeastern states. Jefferson's 1807 embargo, the subsequent nonimportation acts, and the doubling of import duties during the War of 1812, stimulated the stoneware industry as it did domestic industries generally. In

[10] Watkins, *New England Potters*, p. 82.

the face of these restrictions, capital previously directed primarily toward commerce was increasingly invested in manufacturing ventures.

William Myers, a Baltimore china and glass merchant, illustrated this phenomenon. Myers was able to maintain a stock of imported goods during the immediate prewar years. By June 1812, however, undoubtedly feeling the pinch, he turned his attention and capital to domestic manufacturing. He had, he announced, "purchased of Mr. James Johnson, his well known Manufactory of Stone Ware . . . [and intended to carry] on business on a more extensive plan." As late as October of that year, he could still provide "a handsome assortment of [imported] Queen's and Glass Ware, which he [would] put up at the lowest prices." But by February he had "disposed of his stock of *China, Glass,* and *Queens'* Ware" and announced his intention "to devote his whole attention to his manufactory of *Stone-ware.*" Like Little, Myers was not a craftsman but a merchant who saw the enterprise as a good investment. Also like Little, he had an established sales network for marketing his ware. His June 1812 announcement of the purchase of the pottery indicated that "the Factory will be conducted under the immediate care of Mr. Johnson, (the former proprietor) whom he has engaged for that purpose." By October he had "engaged Mr. Remmey, from New York, to superintend the Factory." Henry Remmey was the grandson of German immigrant John Remmey (Johannes Remmi), one of the first stoneware potters in America.[11]

The postwar depression had a limiting effect on the stoneware industry, but it soon flourished again. By this time the industry was established on a solid footing, and it could withstand such economic fluctuations.

The expansion of the manufacture of stoneware was an event of some importance in the history of American ceramics. It suggests a growing sophistication in the industry. The necessary location of stoneware potteries on major water or overland routes for shipping in clay also provided access to more distant markets, offering the opportunity to expand production and to interact with a wider economic community than did most earthenware potteries.

Stoneware potteries generally were larger than their earthenware counterparts and the value of their output greater. The 1820 Census of

[11] *American and Commerical Daily Advertiser* (Baltimore) (June 2, October 13, 1812; February 5, 1813); John N. Pearce, "The Early Baltimore Potters and Their Wares, 1763–1850" (M.A. thesis, University of Delaware, 1959), pp. 44–47.

Manufactures provides a basis for comparing the two types of potteries. An analysis of the returns for Pennsylvania, New York, and Connecticut shows that the annual output of common redware potteries in those states averaged around $1,260, while that of stoneware manufactories averaged $3,560. The difference—almost three times as much—reflects the larger volume of output and the higher prices for comparable items in stoneware. The Seaver account book, where it is specific enough to allow such comparison, shows that prices for stoneware were about double those for the same items in earthenware. A difference is apparent in the average number of workers: 2.12 in an earthenware pottery and 6.10 in a stoneware pottery. Differences in capital investment are dramatically illustrated in the data which show an average of $817 for earthenware potteries and $4,335 for stoneware potteries. In other words, a stoneware pottery required an investment five times as great as an earthenware pottery.[12]

The merchants who backed some of the stoneware manufactories of the period stimulated the industry by providing it with capital for ventures that might never have gotten started without them. As suggested by the Boston example, they also introduced a different form of work organization. As financial backers, and sometimes as active participants in the management of the business, they took over roles formerly held by the master potter. In doing this, they eroded the independent position previously held by master craftsmen in more traditional potteries.

Enthusiasm for the manufacture of a ceramic ware more refined than common earthenware and stoneware grew during the 1790s and in the following decades. As noted above, in 1792 the Pennsylvania Society for the Encouragement of Manufactures and Useful Arts placed "the best specimen of Earthenware or Pottery, approaching nearest to Queen's Ware" top on a list of desirable manufactures. Occasional advertisements from people like J. Mouchet who announced his "New Manufactory of yellow or cream ware" in 1798 indicate that attempts were indeed under way.[13] Not until the War of 1812, however, did the same factors that stimulated development in the stoneware industry—

[12] Bureau of the Census, "Record of the 1820 Census of Manufactures, Schedules for Pennsylvania, New York, and Connecticut," Record Group 29, National Archives, Washington, D.C. (microfilm); Seaver account book.

[13] *New Jersey Journal and Political Intelligencer* (January 25, 1792); *Greenleaf's New Daily Advertiser* (New York) (March 1, 1798) as quoted in Alfred Coxe Prime, *The Arts and Crafts in Philadelphia, Maryland, and South Carolina, 1786–1800: Gleanings from Newspapers*, 2d ser. (Topsfield, Mass.: Walpole Society, 1932), p. 148.

Figure 6. Teapot, marked JOHN. GRIFFITH / TH / [ELIZA-BETHT]OWN / N.J. 1820(?)–24. Black-glazed red earthenware; H. 6⅜". (Yale University Art Gallery: Photo, E. Irving Blomstrann.)

availability of capital, scarcity of imported ware, and doubled tariff rates—combine to create an economic atmosphere sympathetic to even limited success in American refined tableware production.

In responding to the new market for domestic tableware, manufactories adopted varying degrees of sophistication. Traditional potteries in Pennsylvania and New Jersey began a considerable production of red, brown, and black coffeeware and, particularly, teaware made from the common red clay and lead glaze familiar for generations (fig. 6). Made from the same materials, the teaware was a natural outgrowth of traditional manufacture. It required no large capital investment and, consequently, no outside financial backing.[14] Although not a radically different or more complex product, these teawares were viewed by potters and consumers as distinct from coarse earthenware. Philadelphia

[14] Susan H. Myers, *Handcraft to Industry: Philadelphia Ceramics in the First Half of the Nineteenth Century* (Washington, D.C.: Smithsonian Institution Press, 1980), pp. 12–13, 18–19, 46.

potter Abraham Miller noted in 1820 that his pottery had for the last ten or twelve years made "Black & brown tea pots and a great variety of other articles, known in commerce, by the terms black and brown *china.*" These he distinguished from his "common coarse earthen ware." His "china" was, he claimed, "esteemed as highly as the European articles of which they are an imitation." "Black glazed TEA POTS" of "American Manufacture" were offered for sale in Boston in 1812, and ten crates of "Jersey Teapots . . . of an excellent quality" were auctioned in 1816 at Hartford.[15] The brown-glazed teapot shown in J. L. Krimmel's 1813 painting *The Quilting Frolic* may be an example of American red-bodied teaware of the war period (fig. 7).

Other potteries made teaware and tableware more closely resembling imported light-bodied earthenware. These products represent a more radical departure from traditional patterns than the black-glazed teaware. Philadelphia, long a center of American pottery manufacture, was the logical place for the most concentrated effort to make the new type of ware. Between 1807 and 1817 four Philadelphia potteries advertised that they had begun production of what may have been a true "queensware" using light-colored clay.

Only one of the four refined-ware manufactories was established by a local potter. Daniel Freytag, whose family earthenware pottery was in operation by 1794, is noted in the 1811 city directory as a maker of "a finer quality of ware, than has been heretofore manufactured in the United States. This ware is made of various colours, and embellished with gold or silver; exports annually to foreign countries, about 500 dolls." Nothing further is known of Freytag's fineware.[16] The other three manufactories were established through the joint efforts of an entrepreneur and a master potter.

Archibald Binny and James Ronaldson, Philadelphia typefounders, by 1807 had combined with "A PERSON, who [had] been bred in Britain to the POTTERY BUSINESS, in all its branches, with the express view of establishing that important Manufacture in Philadel-

[15] "1820 Census of Manufactures, Schedules for Pennsylvania"; *Columbian Centinel* (Boston) (February 5, 1812); *Connecticut Courant* (Hartford) (September 3, 1816) as quoted in Helen McKearin, notes, Joseph Downs Manuscript and Microfilm Collection 69 x 208.3, Winterthur Museum Library.

[16] James Hardie, *The Philadelphia Directory and Register* (Philadelphia: Printed by Jacob Johnson, 1794); *Census Directory for 1811* (Philadelphia: Printed by Jane Aitken, 1811).

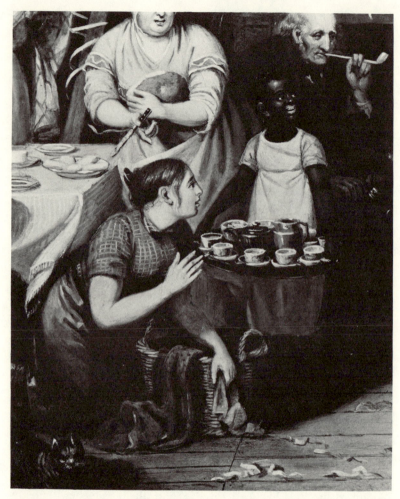

Figure 7. John Lewis Krimmel, *The Quilting Frolic* (detail). Pennsyl-
vania, 1813. Oil on canvas; H. 16⅞", W. 22⅜". (Winterthur Museum.)

phia." The typefoundry was itself a joint effort by Ronaldson as finan-
cial backer and Binny as tradesman. For the pottery business, the master
craftsman was Alexander Trotter, a potter in Philadelphia by 1808 and
noted as an associate of Binny and Ronaldson in an 1812 indenture for

an apprentice in the pottery works.[17]

Trading under the name Columbian Pottery, in 1808 the firm advertised "Red-tea pots, coffee pots and sugar boxes" which, no doubt, were very like the ware made in traditional earthenware manufactories. They also made a yellow teaware and coffeeware that could have been a coarse red clay with a yellow glaze but which, more likely, was made from a yellow or buff clay covered with a clear glaze. Binny and Ronaldson also made a white-bodied ware—the ultimate goal in refined earthenware production. In 1807, they had advertised in Savannah for white clay "free from all ferruginous or irony matter, as the presence of iron totally unfits them for the uses for which they are intended, and all those which assume a reddish color when burnt will not answer, as the purest white is desired." Their ultimate success at whiteware production is evidenced by an 1813 newspaper notice announcing, "their new manufactory of White Queensware will be ready for delivery in all May." The same advertisement offered for sale "American Manufactured Queensware . . . less than half the price of the cheapest imported Liverpool Queensware." Clearly a lesser quality product than "White Queensware," presumably this was yellowware or redware.[18]

John Mullowny opened a queensware manufactory in Philadelphia in 1810 of which he was the "proprietor" and "Mr. James Charleton (an englishman by birth) the manufacturer." Mullowny advertised in that year that he made "Red, Yellow, and Black Coffee Pots, Tea Pots, Pitchers, etc, etc," all of which could have been made from red clay. By 1812 he may have introduced a more refined yellow or white clay body because he dropped the above description and noted that he was making "new and handsome patterns . . . much improved in fashion, neatness and utility . . . [and] much reduced in weight."[19]

The Mullowny manufactory appears to have been taken over after

[17] *Savannah Public Intelligencer* (Georgia) (September 8, 1807); *Philadelphia: Three Centuries of American Art* (Philadelphia: Philadelphia Museum of Art, 1976), pp. 237–39; James Robinson, *The Philadelphia Directory for 1808* (Philadelphia, n.d.); Guardians of the Poor, Indentures, May 18, 1812, Inventory 35.133, Archives of the City and County of Philadelphia.

[18] *Virginia Argus* (Richmond) (November 25, 1808); *Savannah Public Intelligencer* (September 8, 1807); *Relfs Philadelphia Gazette and Daily Advertiser* (April 27, 1813).

[19] John Mullowny to James Madison, October 26, 1810, James Madison Papers, Library of Congress, Washington, D.C. (hereafter cited as JMP); *Aurora General Advertiser* (Philadelphia) (May 19, 1810, February 10, 1812).

Figure 8. Pitcher,
attributed to David Seixas.
Philadelphia, 1816(?)–22.
Green-glazed white ear-
thenware; H. 9¼".
(Museum of the City of
New York, gift of Mrs.
Louis J. Reckford.)

his death in 1815 by David Seixas, the son of a well-known New York
rabbi. The pottery was one among many varied enterprises in which
Seixas was involved during his life. Seixas himself was not a potter. A
Baltimore newspaper described him as among those "many persons
stimulated by a desire somewhat connected with patriotic views of national
independence, [who] have retired from mercantile pursuits, and applied
their ingenuity and pecuniary means to mechanical arts." Like Binny
and Ronaldson, Seixas succeeded in making a white-bodied ware. The
same newspaper article is filled with praise for what is called "the only
white ware pottery in the United States."[20] A press-molded pitcher with
a portrait medallion of David's father, Gershom Mendes Seixas, almost
certainly was produced at the Seixas manufactory (fig. 8). It is made
from a white clay and covered with a green glaze on which traces of
gilding can be seen.

Other war-period efforts to make refined earthenware include those
of Thomas Vickers and Son in Chester County, Pennsylvania, who
advertised in 1809 that they had made "a flattering essay towards the
establishment of a Queens Ware Manufactory"; Crockery Ware Cor-

[20] *Niles Weekly Register* (Baltimore) (November 1, 1817). Although the location of
Seixas's factory was noted only as "near this city," logically it would have been at Phila-
delphia (see Myers, *Handcraft to Industry*, pp. 8–10).

poration, which made refined earthenware in Vermont in 1813; and Englishman William Jackson, who undertook fineware production in Saugus, Massachusetts, in 1811.[21]

The absence of a counterpart to the rich Daniel Clark diary makes impossible a detailed comparison of these refined-ware manufactories with traditional earthenware potteries. Enough information does exist, however, to suggest significant ways in which they differ. The investment of outside capital appears to have been essential to the success of the refined-ware potteries in this period. As with the stoneware ventures, outside capital brought to the manufactories a change in the role of the master craftsman. Indeed, Mullowny had specifically drawn a distinction between himself as the "proprietor" and James Charlton as the "manufacturer."[22] How work, authority, and responsibility were divided is unknown, but this type of association, by definition, meant that the master potters had less autonomy than traditional earthenware potters operating their own shops. Although highly skilled, they did not share the position of Clark who was both proprietor and manufacturer, owned his own shop, and controlled all aspects of production and marketing.

A further and very significant difference lay in the national origins of some of the master potters in these ventures. The known examples of stoneware potteries in which an outside entrepreneur was involved suggest that craftsmen generally came from the ranks of traditional potters working in America. In the few war-period refined earthenware manufactories for which data exists, on the other hand, at least two and probably more of the master potters came from England where they had acquired skills in methods of production unknown among traditional American potters. It was this pattern that became commonplace in such ventures in the next two decades.

There is evidence that sometimes Americans were trained in the skills required in such potteries. John Mullowny noted in 1810 that his manufactory would "be extended as soon as workmen [could] be obtained or boys taught the art of manufacturing as in England." Whether he intended to take these boys from traditional potteries or from among

[21] *Pennsylvania Herald and Eastern Intelligencer* (February 22, 1809) as cited in Edwin AtLee Barber, *The Pottery and Porcelain of the United States* (3d ed., rev. and enl.; New York: G. P. Putnam's Sons, 1909), p. 437; Watkins, *New England Potters*, pp. 115, 72–73.
[22] Mullowny to Madison, October 26, 1810, JMP.

the ranks of untrained individuals seeking apprenticeships is not known. *Niles Weekly Register* in 1817 made a point of noting that "no foreigner has ever had any concern, or superintendence or employ in his [David Seixas's] manufactory." The comment suggests that this was a rare rather than a commonplace phenomenon.[23]

Refined-ware manufacture required more complex raw materials, a more sophisticated technology, and greater knowledge and skill on the part of the potters. While simple red clay, lead, and sand sufficed for earthenware production, and clay, salt, and cobalt were the basic ingredients of stoneware, whiteware production was more complex. In addition to suitable clay, Seixas used flint (in the clay body and the glaze), lead oxide (in the glaze), other "metalic oxides [for underglaze colors]— zinc for straw yellow, cobalt for blue, iron for red, chromate for green . . . [and] coloured glasses . . . melted on the ware in an enamel kiln."[24]

Most traditional earthenware and stoneware potters of the period brought clay to the pottery, cleaned it by hand, and mixed it in the pug mill. Sometimes it was also set aside to age before it was ready for use. By contrast Seixas's clay was prepared by the following complex process:

The clay is copiously diffused in water and passed through fine lawn sieves to detach the larger particles of sand, &c.

The flint . . . is exposed to a strong heat, and is suddenly plunged into cold water. By frequent repetition of calcination and refrigeration, whiteness and friability ensue. It is then ground to powder finer than super fine flour, so perfectly impalpable that it will remain many hours suspended in water, it is then subjected to a purification to extract the small portion of oxide of iron it usually contains.

It is then mixed by measure with the purified liquid clay . . . and the mixture poured into vats, the solids in time subside—the water is run off—the residuum further exposed to the solar heat until the remaining water has evaporated to suit it for forming into the required vessels.[25]

Forming technology likewise was more complex in refined-ware potteries. John Mullowny advertised in 1812 that he was lathe turning (decorating or refining the shape of an unfired piece by applying a sharp tool to its surface as it turned on a horizontal lathe) and press molding (forming by pressing slabs of clay into a mold). The latter process was

[23] Mullowny to Madison, October 26, 1810, JMP; *Niles Weekly Register* (November 1, 1817).
[24] *Niles Weekly Register* (November 1, 1817).
[25] *Niles Weekly Register* (November 1, 1817).

the more significant, allowing for speed and repetition in the production of relatively complex relief-molded ware. David Seixas also made press-molded ware, and it is very likely that the process was in use elsewhere. Press molding contributed to the declining status of the handcraftman because little skill was required in the actual molding once the master mold had been created.[26]

During the depression following the War of 1812 many American potteries closed, particularly the budding fineware ventures. The reopening of American ports brought a great influx of imported ceramics, and the ending of the doubled tariff in February 1816 took from domestic producers the protection that was critical to their survival.

As the industry revived in the 1820s, expansion occurred in some established traditional potteries, but it was characterized by a conservatism undoubtedly born of the hard times of the preceding decade. Black-glazed coffeeware and teaware survived the depression and continued to be good, solid, salable products. Probably marketed primarily to those lower in the social strata, by the 1820s black-glazed ware was a great market success. In 1824, the Franklin Institute in Philadelphia noted, "our Potters have discovered the Art of making it [Red & Black glazed Teapots, Coffeepots & other Articles of the same description] equally good, if not superior to the Article imported, & rendered it at a price equally low, it has finally excluded the imported Article from the American market." Even if this was an exaggeration, it is certain that the volume of output was great. When New Jersey potter Edward Griffith died in 1820, the inventory in his shop included 1,796 dozen "Prest Tea Pots" and first- and second-quality "Common Black Tea pots" valued at a total of $2,009.56. Coffeepots, apparently a minor product, numbered only 14 dozen at a value of $31.50. John Griffith, his successor in the teapot and coffeepot manufactory, died in 1824 leaving the considerable value of $5,465.40 worth of "Tea Pots on hand" (see fig. 6).[27]

Another "safe" product was refractory ware for use in homes and by the nation's growing industries. In the 1820s, 1830s, and 1840s,

[26] *Aurora General Advertiser* (February 10, 1812); Myers, *Handcraft to Industry*, pp. 7–10.
[27] "Report of the Committee on Earthenware" (first annual exhibition of Franklin Institute, 1824), Franklin Institute Archives, Philadelphia; Wills 11255G (1820) and 11568G (1824), Wills and Inventories, Bureau of Archives and History, New Jersey State Library, Trenton.

potters commonly added to their production firebrick and tile which could be used for such things as liners for domestic heating stoves and industrial boiler settings and furnace linings. Small ceramic cooking furnaces, presumably made from the same refractory clay, experienced a period of popularity, and many potters made these simple devices (fig. 9). Varying in size, the furnaces were used for cooking or laundering in summer when it became uncomfortably hot to perform these jobs inside at a large fireplace or stove. In the 1830s, stoneware for use by the chemical industry began to be produced (fig. 10).[28]

More speculative were the renewed efforts at refined-ware production during the 1820s. Developments during this and the following decade laid the groundwork for its manufacture in this country. The association of entrepreneur and potter continued to be critical to development as did the employment of foreign skilled workers. Success was enhanced by the formation of corporations. Not unknown before the Revolution, the incorporated business had advantages over single ownership or a partnership, and it fostered the general trend toward outside investment in the ceramics industry. In the post-Revolutionary period, state chartering of companies became a common means of encouraging what governments perceived to be projects in the public interest. Although these charters were granted primarily for internal improvements, some manufactures also received them.

The most successful incorporation in the American ceramics industry before 1840 was that of the American Pottery Manufacturing Company. The company grew out of the pottery established in 1828 by David and J. Henderson in the old Jersey City works of Jersey Porcelain and Earthenware Company, which itself had been incorporated in 1825. David Henderson took over the major role in the pottery, and, in January 1833, he "and all and every person, or persons, who may become subscribers, . . . [were] constituted a body politic and corporate, by the name of '*The American Pottery Manufacturing Company*' [soon changed to American Pottery Company], for the purpose of manufacturing the various kinds of Pottery, at the works already erected."[29]

States could grant wide and varying privileges to corporations, but

[28] Myers, *Handcraft to Industry*, pp. 20–22.

[29] Lura Woodside Watkins, "Henderson of Jersey City and His Pitchers," *Antiques* 50, no. 6 (December 1946): 388–92; State of New Jersey, "An Act to Incorporate 'The American Pottery Manufacturing Company' " (1833), Smithsonian Institution Collection of Business Americana, Washington, D.C.

Figure 9. Advertisement of M. W. Bender in *Hunt's Albany Commercial Directory for 1848–9*, comp. William Hunt (Albany: By the compiler, 1848).

Figure 10. Vessel for chemical use, marked H[ENRY] NASH. /
UTICA. Utica, N.Y., 1837–39. Salt-glazed stoneware; H. 17½". (Photo,
Smithsonian Institution.)

even in the basic form assigned the American Pottery Manufacturing Company, an incorporated business offered inducements to invest scarce capital funds in high-risk ventures. Corporations could issue their securities in face values low enough to encourage many small investors. The Jersey City enterprise was to have a capital stock of $75,000 which was to be "divided into seven hundred and fifty shares of one hundred dollars each." Strict regulation by the chartering state also guaranteed that at least minimum standards of business management would be met. The limitation of liability to the assets of the company had, by this time, become the rule unless otherwise stipulated in the charter.[30]

Incorporation was important to the future success of the business. It was chartered just in time to help the company over the economically difficult years of the mid and late 1830s. Over the next twenty years the company was reasonably prosperous. By 1849 the factory employed about sixty people and produced nearly $40,000 in ware annually.[31]

Henderson almost certainly was not a potter. Rather, he provided capital and management to several different ventures during his lifetime. One of these, the Adirondack Iron and Steel Company, of which he was part owner, absorbed much of his time during the 1840s, although he appears to have retained ownership of the pottery until he died in 1845. After his death the pottery continued to operate under different ownership.[32]

Technical expertise at the Henderson factory was supplied by skilled workmen such as Englishmen James Bennett (1834), Daniel Greatbach (by 1839), and James Carr (1844). Many of Henderson's imported skilled workers later established potteries of their own on this side of the Atlantic.[33]

The products of the American Pottery Manufacturing Company were innovative to an extent unimaginable in conservative traditional manufactories. The Hendersons' first product, exhibited at the Franklin Institute in 1830 and advertised in a "List of Prices" of the same year, was "flint stoneware" (figs. 11, 12). The term here refers to a refined

[30] State of New Jersey, "Act to Incorporate."

[31] *Directory of Jersey City, Harsimus and Pavonia for 1849–50* (Jersey City: John H. Voorhees, 1849).

[32] Bruce Seely, "The Adirondack Iron and Steel Company Survey" (Paper prepared for the Historic American Engineering Record, Washington, D.C., 1978), chap. 3, pp. 1–14.

[33] Barber, *Pottery and Porcelain*, p. 179; Watkins, "Henderson of Jersey City," p. 391.

Figure 11. Pitcher, D. &
J. Henderson. Jersey City,
N.J., 1828–30. Stoneware;
H. 7½". (Collection of
Newark Museum: Photo,
Stephen C. Germany.)

Figure 12. Detail of base of pitcher in figure 11 showing mark HEN-
DERSON'S / FLINT STONEWARE / MANUFACTORY, / JERSEY
CITY.

Figure 13. Teapot, marked American Pottery Co. / Jersey City, N.J. Ca. 1840. Blue "sponged" decoration on white earthenware; H. 5¼". (Brooklyn Museum, gift of Mrs. Franklin Chace.)

molded stoneware in styles currently popular in England, as distinguished from common household stoneware. Flint provides whiteness, strength, and freedom from warping to an earthenware or stoneware body. Also in 1830, the pottery exhibited at the American Institute in New York "cane colored earthenware" as well as flint stoneware. They soon turned entirely to earthenware, including whiteware, rather than stoneware production (fig. 13).[34]

In 1833, perhaps stimulated by the act of incorporation of that year, the company exhibited an impressive list of products at the Franklin Institute. Their "Queensware . . . consisting of cream couloured ware;

[34] *Address of the Committee on Premiums and Exhibitions of the Franklin Institute of the State of Pennsylvania* (Philadelphia: Printed by J. Harding, 1830), p. 3; *Antiques* 26, no. 3 (September 1934): 109.

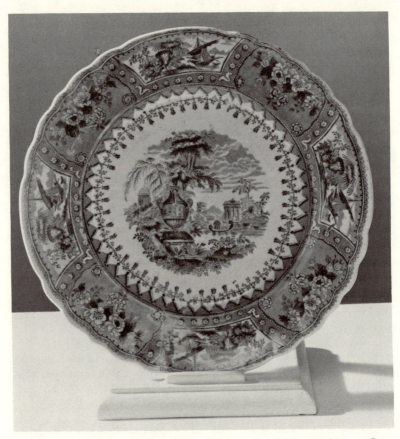

Figure 14. Plate, marked American Pottery Co. / Canova / Jersey City. 1833–40. Blue transfer-printed white earthenware; Diam. 9⅛″. (Brooklyn Museum.)

painted, moco, and printed ware" were judged "but a slight shade inferiour to the imported article." Appearing only in the judges' notes and not in their abbreviated published comments, the reference to "printed ware" is of particular interest. The process of transfer printing copperplate engravings on ceramic ware had been in use in England since the mid eighteenth century. The company has been acknowledged for the first successful use of the process in America, but it had been thought that this occurred around 1839 or 1840 (fig. 14). The Franklin Institute

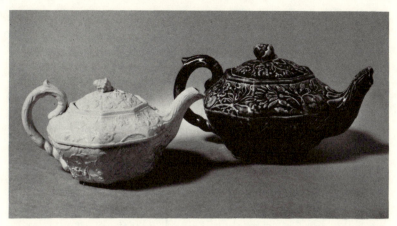

Figure 15. Teapots, American Pottery Co. Jersey City, N.J., 1835–45. Buff-yellow earthenware with clear glaze (yellowware) and with mottled brown glaze (Rockingham ware); H. 3⅜″ and 4⅜″. (Smithsonian Institution, John Paul Remensnyder Collection.)

reference shows its use as early as 1833. Perhaps the technique was introduced by David Henderson himself. His interest in the graphic arts is revealed in an 1824 patent that he received for a lithographic process.[35]

Products available from the factory in 1833 are listed in an advertisement of their New York agent, George Tingle, who stated, "The American Pottery Manufacturing Company . . . works are in full operation, in the manufacture of C. C. dipt, painted and edged Earthenware, which they offer for sale, in connection with a full assortment of Printed China and Glass Ware, . . . Just received from the Factory, a fresh supply of the celebrated fire-proof Yellow Nappies and Pie Dishes. Also, an assortment of Stone Pitchers, variously ornamented: Spittoons, Tea Tubs, &c." The reference to "Printed China" is unfortunately ambiguous. It could have been imported. What ultimately proved to be their most reliable products were relief-molded yellowware and "Rockingham," or mottled brown-glazed, ware (fig. 15). Yellowware and

[35] "Report of the Committee on China Glass & Earthenware" (eighth annual exhibition of Franklin Institute, 1833), Franklin Institute Archives; Patent Office, *A List of Patents Granted by the United States from April 10, 1790, to December 31, 1836* (Washington, D.C., 1872), p. 273.

Rockingham ware would become the most successful refined wares in American factories up to the Civil War.[36]

Among the other fineware ventures established in the pre-1840 period was the Horner and Shirley pottery in New Brunswick, New Jersey, which exhibited flint stoneware at the Franklin Institute in 1831. Shirley may have been William W. Shirley, an English potter who had been an incorporator and director of the factory for the unsuccessful Jersey Porcelain and Earthenware Company. It probably was this pottery that advertised in 1831 for "an active man with a small Capital, say 1,500 to 2,000 dollars, . . . [to be] a Partner in the improved Flint Stone Ware Factory, New Brunswick, . . . a person who can advance an equal capital to that now employed." No knowledge of pottery manufacture was specified; rather, "he would be preferred if acquainted with the selling and management of the finished goods, to keep the books, and to attend to all outdoor business."[37]

Another fineware venture of the period, and one about which little is known, is the Salamander Works, originally established in New York City as a firebrick manufactory. The company was making refined ware by 1835 when it exhibited "a fine specimen of flint stone ware" at the American Institute. An 1837 handbill (fig. 16) lists some of their wares, including an "antique" pitcher with strainer (fig. 17).[38]

Although the East Coast cities offered factories the advantage of access to raw materials (particularly from New Jersey, Pennsylvania, and Delaware), large markets, and good transportation, they had the disadvantage of competition from imported ceramics with a well-developed merchandising system. In the 1820s and 1830s several fineware ventures were established along the Ohio River where there was access to clay and good transportation by water. A further advantage was the abundance of coal, a more efficient fuel than wood for firing kilns. Imported refined ware was also less abundant, and the market consequently less competitive.

A series of fineware potteries involving English potter Jabez Vodrey operated in Pittsburgh, Louisville, and Troy, Indiana, between 1827

[36] *National Intelligencer* (Washington, D.C.) (July 16, 1833).

[37] *Address of the Committee on Premiums and Exhibitions of the Franklin Institute of the State of Pennsylvania* (Philadelphia: Printed by J. Harding, 1831), p. 7; Arthur W. Clement, *Our Pioneer Potters* (York, Pa: Maple Press Co., 1947), pp. 67–68; *Daily Chronicle* (Philadelphia) (July 2, 1831).

[38] "List of Premiums Awarded by the Managers of the 8th Annual Fair of the American Institute," *Journal of the American Institute* 1, no. 2 (November 1835): 80.

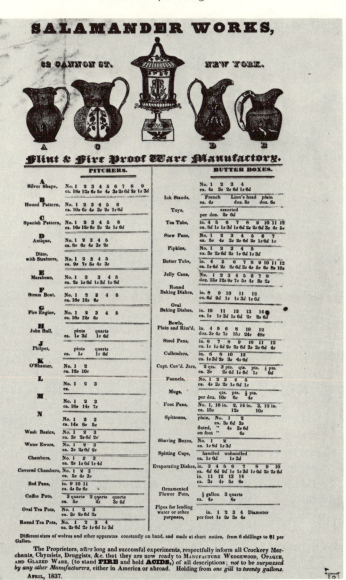

Figure 16. Advertising handbill, Salamander Works. New York, 1837.
(New-York Historical Society, Bella Landauer Collection.)

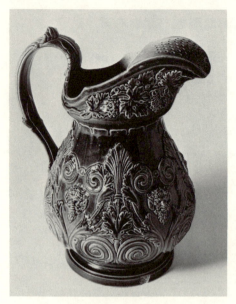

Figure 17. "Antique" pitcher, marked Salamander / Works / New-York / 1. New York, ca. 1837. Buff-yellow earthenware with mottled-brown, Rockingham, glaze; H. 11¼". (Smithsonian Institution.)

and 1847. Vodrey's diary, which includes scattered entries before 1840, and related papers have been preserved in the Vodrey family and provide information about these early midwestern fineware ventures.[39]

Vodrey and, apparently, William Frost emigrated in 1827 from Staffordshire to Pittsburgh where they began the manufacture of refined ware. The men seem to have been brought to the city by William Price, a Pittsburgh entrepreneur involved in glass manufacturing and brass and iron founding as well as pottery making. According to a brief history, published in 1879, Price had made tobacco pipes from local white clay and "was led to suppose good earthenware could be made from the same material." His interest in this manufacture led him—during a trip to England in search of glassblowers—to visit Staffordshire where he convinced Vodrey and Frost to come to Pittsburgh, bringing with them "the necessary tools and machinery to enter upon the manufacture of

[39] I am indebted to J. Garrison and Diana Stradling for directing me to the Vodrey family materials and to William H. Vodrey for allowing me to study them. They are now in the possession of the descendants of William H. Vodrey in East Liverpool, Ohio. The diary is being prepared by the Stradlings and J. Jefferson Miller for publication by the American Ceramic Circle.

white ware." Whether this is true, and, if true, whether any formal business arrangement was involved, is not known. An 1830 letter from Price to Vodrey indicates that, at the least, the men had been friends in Pittsburgh.[40]

A yellowware pitcher in the collection of Historical Society of Western Pennsylvania further suggests a connection between Price and the pottery (figs. 18, 19). Inscribed "Friendships Gift to Wm Price" and dated 1828, the pitcher almost certainly is of local manufacture and quite probably was made by Vodrey and Frost. Although it is in the English style, the pitcher lacks the refinement one expects of a piece special-ordered from England. It is unlikely, in any case, that such a celebratory piece would have been made in common yellowware rather than whiteware. The method of decoration—painting in cobalt under the glaze—is a very simple and unsophisticated one and would have been a logical choice in such a fledgling manufactory. The likelihood that Vodrey and Frost made the pitcher is reinforced by the 1879 history. "The wife of Jabez Vodrey," it notes, "was the 'decorator' of the establishment, and would, when desired, put the names of purchasers on their dishes. She used blue for this work. Mr. Hatfield resided near the pottery, which stood on an acre of ground owned by Mr. Price, near Fifth and Marion streets. In his possession is a covered dish, on the top of which is this inscription, 'E. Hatfield, February, 1829'; this article having been made for his wife. A granddaughter of Mr. Price has a pitcher made by the firm and presented to him, with a similar inscription applied by Mrs. Vodrey. It was made in 1828."[41]

Also painted on the Price pitcher are various scenes relating to his life in Pittsburgh. On one side is a glass furnace and "Fort Pitt Glass Works." Price was briefly involved in that glassworks along with Robert Curling, a former potmaker and clerk at the Bakewell glassworks. A cannon and various hollowware items seen near the furnace suggest Price's brass- and iron-founding interests. On the opposite side of the pitcher is the inscription "Round House" and a drawing of Price's house which was fashioned after the Pittsburgh Episcopal Round Church,

[40]Jabez Vodrey diary, February 25, 1860; "51 Years Ago in East Liverpool, O, As Recorded by D. B. Martin, Editor 1878" (newspaper article from an unidentified source); W. Price to Vodrey, February 19, 1830, Vodrey Family Papers (hereafter cited as VFP); "The First Western Pottery," *Brick, Pottery, and Glass Journal* 6, no. 8 (August 1879): 89.

[41]"First Western Pottery," p. 89.

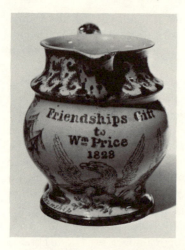

Figure 18. Pitcher, attributed to Jabez Vodrey and William Frost. Pittsburgh, 1828. Yellowware with painted underglaze blue decoration; H. 7". (Historical Society of Western Pennsylvania.)

Figure 19. Side view of pitcher in figure 18.

actually an octagonal brick structure. It has been suggested that the pitcher was presented to Price by his colleagues at the glassworks.[42] In light of the connection between Price and Vodrey, however, it may have been made as a gift from the potter to the man who, the year before, had brought him to Pittsburgh.

[42] "Collector's Notes," *Antiques* 93, no. 2 (February 1968): 246; Lowell Innes, *Pittsburgh Glass, 1797–1891: A History and Guide for Collectors* (Boston: Houghton Mifflin Co., 1976), pp. 17–19, 34.

The move of Vodrey and, apparently, Frost to Louisville within only a few years of their arrival in Pittsburgh has been attributed to the unsuitability of the local clay for fineware manufacture. It is also possible that they were attracted by the offer of capital by the Lewis Pottery Company, incorporated in 1829 by five businessmen.[43]

An 1832 agreement concerning ownership of the pottery property allows a rare look at the breakdown of responsibilities in a fineware manufactory of this early period. Most of the incorporators presumably provided financial support only. One of them, however, Louisville merchant Jacob Lewis, was the business manager of the pottery. His responsibilities included getting raw materials, making sales, and keeping the books.[44] David Henderson, as manager of the American Pottery Company in Jersey City, probably played a role very like that of Lewis. There is no evidence that either man was a potter; rather, they managed the financial affairs of the business, leaving the actual production to others.

The two principals in the production process of the Louisville factory were Jabez Vodrey, described as a "turner of fine ware," and another Staffordshire potter, George Nixon, a "fine ware thrower." They were responsible only for making the ware and superintending the factory. The 1832 agreement stipulated that bills were to be made out to "Lewis, Vodery [sic] & Nixon" and the ware marked "in like manner." It called for "each party," apparently referring to the three men, "to draw an equal amount of Money every Saturday night, after meeting the running expenses of the week."[45]

Another fineware manufactory, the Indiana Pottery Company, was incorporated near Troy, a town on the Ohio River west of Louisville, in January 1837. Among the partners were Jacob Lewis, from the Louisville corporation; Samuel Casseday, a Louisville earthenware importer; and Reuben Bates, a Troy merchant who contributed land to the venture. James Clews, from the famous Staffordshire family of whiteware manufacturers, held three shares and, presumably, superin-

[43] Frank Stefano, Jr., "James Clews, Nineteenth-Century Potter," *Antiques* 105, no. 3 (March 1974): 553.

[44] Agreement between Vodrey, George Nixon, and Jacob Lewis, agent for John Shallcross and guardian for Jane, Alice, and Thomas D. Lewis, June 18, 1832, VFP.

[45] Agreement between Vodrey, Nixon, and Lewis, VFP. *Turning* as used here and as commonly used among refined-ware potters refers to lathe turning (see p. 227) and should not be confused with Daniel Clark's or some other American potters' use of the term to mean "throwing," or forming ware on a potter's wheel.

tended the factory.[46] He brought many English workers into the factory and appears to have had every expectation of success. His efforts ended in failure, however, probably because he could not find suitable clay or because he could not work with the unfamiliar clay that he did find. An 1839 letter written by Lewis to Vodrey refers deprecatingly to "Clews & his mud digers . . . [who thought] that any dirt [would] do to make ware for this country."[47]

Clews had left the manufactory by 1839, in which year Vodrey and an associate, John Hutchinson, leased from the Indiana Pottery Company "the Pottery Establishment, with part of the lands and tenements belonging and pertaining thereto . . . near the Town of Troy." The pottery was fully appointed, for the two men were "loaned or hired . . . tools, Saggers, moulds, blocks, wheels and implements of every description" as well as the pottery buildings. The company retained the right to develop for commercial use the marl, clay, and coal on the property, permitting Vodrey and Hutchinson to use them only for pottery making. They were also allowed "coal for their use in their families." The company likewise retained the right to "erect buildings thereon or to manufacture fire or clay Brick." The two men were directed that the property was leased "for the purpose of Manufacturing the ware for which the establishment was made and for no other purpose whatever."[48]

The indenture for the lease suggests that the Indiana Pottery Company had given serious consideration to the question of using foreign versus native workers in the pottery. Indeed, the document suggests that the company saw the presence of Vodrey and Hutchinson only as a means of training Americans to carry on the pottery after the two-year term of the rental expired. The two men were required to keep and train twelve apprentices who had to be "native born American." This not only suggests a patriotic desire to use an American labor force but also may indicate a disenchantment with foreign workmen. Interestingly, sometime before 1832, Benjamin Tucker, father of Philadelphia porcelain manufacturer William Ellis Tucker, had counseled Jacob Lewis: "the enterprising genius of Americans, if they are called in, at a proper age, will furnish you with equally excellent, and much more confiden-

[46] Stefano, "James Clews," pp. 553–55; Barber, *Pottery and Porcelain*, p. 159.

[47] Stefano, "James Clews," p. 554; Lewis to Vodrey, May 1, 1839, VFP.

[48] Indiana Pottery Company and Jabez Vodrey and John Hutchinson, indenture, March 12, 1839, VFP.

tial work men than you can generally speaking, obtain from Europe. Some of the apprentices that my son has brought up under his own hand fully verify this statement. The hostility and intrigue which many of his [William Ellis Tucker's] foreign workmen displayed, proved highly injurious to his interests. . . . A few good European workmen you will necessarily want in order to instruct American youths."[49]

The indenture signed by Vodrey and Hutchinson stipulated the jobs that apprentices were to learn and reveals something of the technology in use and the degree of job specialization. It noted,

of the twelve American apprentices named, the Second parties are only bound to take in Six immediately or during the Spring, One of which is to be put at throwing, two at turning and three at flat and hollow pressing and Squeesing. One of these last to be learned to handle [presumably to apply handles], the other Six apprentices to be taken in and put to work One Year from this time at the same branches, unless the contracting parties mutually agree to learn them Some other branches. Again the parties of the Second part engage to select and Keep a smart inteligent boy at the buisket & Gloss Kilns and to instruct him as far as practicable in the art of Burning.[50]

Throwing, the dominant method of forming in red earthenware and stoneware potteries, was to be learned by only two apprentices, while six of the twelve apprentices learned press molding. Lathe turning, rarely found in other than fineware manufactories during this period, was to be taught to four boys.

The indenture suggests a degree of task specialization unknown in traditional potteries. Unlike Daniel Clark's sons and his apprentice, Peter Flanders, who worked at all or most of the jobs in the pottery, these apprentices were expected to learn only certain aspects of production. There is no suggestion that they should be trained in jobs other than those specifically noted.

Whatever the company's plans may have been for the "Americanization" of the factory, Vodrey stayed in Troy until 1847 when he moved to East Liverpool, Ohio. There a pottery had been established in 1839 by English potter James Bennett with financial assistance from one Anthony Kearns. By the time Vodrey arrived, several other potteries

[49] Benjamin Tucker to Lewis, n.d., Benjamin Tucker letter books, 1830–31, Philadelphia Museum of Art (hereafter cited as PMA) (microfilm, Archives of American Art, Smithsonian Institution, Washington, D.C.).

[50] Indiana Pottery and Vodrey and Hutchinson, indenture, VFP.

were in operation in this small town that was in the process of becoming a major center for American ceramics production. [51]

The manufacture of porcelain—the most difficult and the most valued of all ceramics—achieved little success in America before 1840. Before the Revolution, Bonnin and Morris briefly made porcelain in Philadelphia in 1771 and 1772. In New York, Henry Mead was making porcelain by 1818 as evidenced by his 1824 newspaper notice that he had "expended a large sum of money and six years of perseverance" in the manufacture in that city. He also indicated that he was seeking public support for his manufactory, noting that he found "himself compelled to abandon the object, for the want of sufficient funds." The pottery apparently closed soon thereafter. [52]

The Jersey Pottery and Porcelain Works of Jersey City, established in 1825, by the next year had located "the materials both for the body . . . and for the glazing . . . in the United States" and they had induced "skillful and experienced workmen . . . to come over from France." When the company exhibited its porcelain at the Franklin Institute in 1826, the judges gave it reserved praise in their published notes. The manuscript version of their report, however, reveals their more candid opinion that the product "abounds in faults." Boston Porcelain and Glass Company and the Monkton Argile Company in Vermont briefly attempted porcelain manufacture during the War of 1812. [53]

The only venture to achieve any degree of success was that of William Ellis Tucker whose factory operated in Philadelphia between 1826 and 1838, but it too was always in financial difficulty. Following the familiar pattern, Tucker was the proprietor but not himself a potter. He is said to have hired an Englishman, John Basten, as foreman of the works. His other workmen were of English, French, and American origin. It was William's father, Benjamin Tucker, who had advised Jacob Lewis to train native workers for his pottery. [54] William's brother Thomas

[51] Barber, *Pottery and Porcelain*, pp. 161, 192.

[52] *Gazette and Advertiser* (Alexandria, Va.) (November 4, 1824).

[53] *Phoenix Gazette* (Alexandria, Va.) (July 31, 1825); "Abstract of the Report of the Committee on Premiums and Exhibition on the Subject of the Third Annual Exhibition [1826]," *Franklin Journal and American Mechanics' Magazine* 2, no. 5 (November 1826): 264; "Report of Committee on Pottery" (third annual exhibition of Franklin Institute, 1826), Franklin Institute Archives; Watkins, *New England Potters*, p. 41; John Murry to Abijah Bigelow, Joseph Downs Manuscript and Microfilm Collection 63 x 107, Winterthur Museum Library.

[54] Barber, *Pottery and Porcelain*, pp. 130–35, 151–53.

served an apprenticeship at the factory and eventually became its manager and chief decorator.

William Tucker devoted much effort to technical questions concerning the clay, glaze, and enamel colors. Henry Mead, a New York physician and a partner in the Mead and Beekman chemical business, probably played a similar role in his porcelain manufactory. Such technical questions were particularly critical in a porcelain works. Although materials for porcelain production were available in America, they were entirely new to potters and proved difficult to work with. Tucker's father complained of "foreign substances in our American materials, that, at a high temperature form new chemical combinations, which destroy either the beauty or the texture of the ware."[55]

Because porcelain was fired to a very high temperature, decoration applied under the glaze had to be executed with a coloring agent that could withstand the heat. Unable to master this problem, Tucker decorated all his porcelain in colors that were applied over the high-fired glaze. The piece then was refired at a low temperature to fix the colors. Good underglaze decoration was not perfected in America until several decades after Tucker's manufactory closed.

William Tucker was also concerned with finding sufficient capital and raw materials and with marketing the ware. These efforts were often shared with his father who was not only an investor but also a constant—and not always welcome—"guiding influence" in the business.[56]

The actual work of forming, decorating, and firing the ware was the province of his skilled workers. Thomas Tucker's formula and price book indicates that they were paid by the piece for turning, painting, burnishing, and making saggers (protective cases within which the ware was fired).[57]

Although the Tucker factory produced creditable copies of currently fashionable French and English porcelain (figs. 20, 21), the business was not a financial success. The reason lay to some extent in the national economic difficulties of the 1830s, but their business practices may also have been a factor.

[55] *Longworth's American Almanac, New-York Register, and City Directory* (New York: David Longworth, 1812); Benjamin Tucker to Isaac C. and Hannah Jones, February 16, 1827, Benjamin Tucker letter books, 1823–29, PMA.

[56] Benjamin Tucker letter books, 1823–29, 1830–31, PMA.

[57] "Prices for Burnishing . . . Making Sagers . . . Turning . . . Painting," September 26, 1832, Thomas Tucker formula and price book, PMA.

Figure 20. Vase, William Ellis Tucker or successor. Philadelphia, 1825–38. Porcelain with polychrome and gilt decoration; H. 11⅞". (Winterthur Museum.)

The possibility of incorporating the business—as other potteries were doing—must have occurred to the Tuckers, but they chose instead to rely for capital funds on partnerships and on pleas to the federal and state governments for subsidies. The firm was finally incorporated as the American Porcelain Company in 1835, two years after William's

Figure 21. Tea and coffee service, William Ellis Tucker or successor. Philadelphia, 1825–38. Porcelain with gilt decoration; H. (coffeepot) 9⅝". (Winterthur Museum, gift of Philip Hammerslough.)

death, but the company was never actually formed. Tucker's first two partnerships were failures, neither lasting more than a year; the third, with Joseph Hemphill, provided badly needed capital, but only in the amount of $7,000. In their letters to President Jackson and to the Congress, the Tuckers had requested $20,000 and $40,000 respectively in return for "a complete and perfect Knowledge of every branch of [our] business in the formation of American Porcelain, so that the discovery shall for ever be secured to the country." Neither request met with success.[58]

In marketing their ware, the Tuckers again showed an independent or, perhaps, provincial outlook that must have worked against their business. Phillip Curtis's study of the Tucker works reveals almost no advertising in Philadelphia newspapers. Indeed, one of Tucker's contemporaries noted that the porcelain works needed "the bell and the speaking trumpet. It is [in] vain that he makes the most splendid ware

[58] Phillip H. Curtis, "Tucker Porcelain, 1826–1838: A Re-Appraisal" (M.A. thesis, University of Delaware, 1972), pp. 15–24; William Ellis Tucker to the president of the United States, March 3, 1830, Benjamin Tucker letter books, 1830–31, PMA.

in the world, unless he lets the public know it."[59]

By 1840 the American ceramics industry had polarized into roughly three avenues of development, each illustrating a different response to economic and industrial changes. At one end of the spectrum were redware potters who conservatively adhered to tradition as had Daniel Clark in Concord. They were a dying phenomenon, especially in large cities, but would continue to exist in diminishing numbers in rural areas and small towns for many decades.

Other potters found the changing economic climate conducive to the introduction of new products. The most widespread choice was stoneware which, before the Revolution, had almost all been imported. More complex and expensive, but still sharing many of the character-istics of redware production, stoneware manufacture for the most part brought with it changes of an evolutionary nature. They grew out of the American pottery traditions in an essentially nondisruptive way. Tech-nology and raw materials were altered to some degree, a larger work force usually was employed, and potters operated within a wider eco-nomic community. In some stoneware manufactories, like that of Wil-liam Seaver, the master potter himself provided the requisite capital and took the risks of this new endeavor. Others involved outside entrepre-neurs who made possible ventures requiring capital beyond the means of most potters. Such infusions of capital also altered the independent status of master craftsmen.

Very different in almost every respect from redware or stoneware potteries were the refined-ware manufactories established in America before 1840. Dramatically different in raw materials, technology, and work organization, they almost always were initiated by outside entre-preneurs. They shared with stoneware manufactories of similar organi-zational structure a diminished role for master potters. Significantly, however, most master craftsmen in the early fineware manufactories were not traditional American potters but skilled foreign workers trained largely in the British factories that provided the model emulated on this side of the Atlantic.

Before 1840 fineware manufactories probably had little impact on American potters. Not only were they quite different from traditional potteries; they were also few in number and had not yet concentrated

[59]Curtis, "Tucker Porcelain," p. 62; *Poulson's American Daily Advertiser* (Philadel-phia) (January 24, 1831).

in such highly visible centers as those that later developed at East Liv-
erpool, Ohio, and Trenton, New Jersey. Potters located near the fine-
ware works or in large urban areas must have been aware of their existence,
and perhaps they could see their significance for the future. More than
likely, however, most potters viewed fineware manufacture as distinctly
separate from their own interests and concerns.

The Transmission of Skill in the Shoe Industry: Family to Factory Training in Lynn, Massachusetts
William H. Mulligan, Jr.

It is probably fair to say that until quite recently the shoe industry had been largely ignored by scholars interested in the transition from craft to factory modes of production. Largely because it was the earliest to enter this process the textile industry has attracted the greatest amount of scholarly attention. The history of the industrial revolution, in both Great Britain and the United States, has been the history of the textile industry. While in England the mechanization of textile production displaced skilled workers, profoundly changing their lives, it is not at all clear that such was the case in the United States. The shoe industry, however, is an excellent arena within which to study this important transition. For about 100 years, roughly between the 1750s and 1850s, American shoemakers produced large quantities of shoes for sale throughout the country and the West Indies entirely by hand. Over this long period these artisans developed a strong sense of craft pride and identity and passed their skills and traditions from generation to generation. The transmission of skill is an essential part of any artisan community, and the skill needed to make a pair of shoes by hand took years to acquire. In those communities that were heavily or, in some cases, almost exclusively involved in shoe production, learning how to make shoes was part of growing up for most youngsters. Obituaries of nine-

teenth-century residents of Lynn, Massachusetts, often mention that the deceased had entered a ten-footer, as the front-yard workshops were called, between the ages of ten and fourteen as was "the custom at that time" or "as everyone did."[1] With the mechanization of the shoe industry, beginning in 1850, this long period of training became obsolete; it was replaced by a short period of training as an operator of a specific machine. This paper will examine the ways in which shoe workers were trained in Lynn during the handicraft period and after machinery was introduced as part of the larger transformation of American industrial life from an artisan to a factory system.

Lynn was the largest, in terms of shoe production, of a number of nineteenth-century shoe towns. Like the other shoe towns of Massachusetts, Lynn was dominated by its major industry which shaped the character of the community. The town had begun to emerge as a major center of the industry after 1750, and it was the nation's leading producer of women's shoes by 1800, a specialization it maintained until the 1920s when the industry declined. It was also a center for innovation both in materials for shoes—morocco was first used in Lynn—and in machinery; nearly all of the machines that transformed shoe production were either invented or introduced in the town.[2]

Shoemaking had a long history in Lynn. The first shoemakers, Henry Elwell and Philip Kirkland, settled in the community during the 1630s. By the time of the American Revolution Lynn was firmly established as a leading center of the industry, and it was beginning to become involved in the world market. Early in the development of the industry Lynn specialized in women's shoes. Largely because the material used for the uppers of women's shoes was lighter than that used in men's shoes, women and children became involved in the shoe industry in Lynn much earlier and in greater numbers than in the other Massachusetts shoe towns. By 1800 the family was the basic unit of work in the town, with mother and daughters "binding" the shoes (that is, sewing the uppers together) and father and sons "making" the shoes (that is, attaching soles and heels to the bound uppers).[3]

[1] These obituaries are in *The Register of Lynn Historical Society, Lynn, Massachusetts*, vols. 1–22 (1897–1918/21).

[2] The most convenient overview of the history of the shoe industry remains Blanche E. Hazard, *The Organization of the Boot and Shoe Industry in Massachusetts before 1879* (Cambridge, Mass.: Harvard University Press, 1921).

[3] Hazard, *Boot and Shoe Industry*; see also Alonzo Lewis, *History of Lynn* (Boston, 1829), and subsequent editions by James R. Newhall.

The hand skills of the adults in the family were essential elements in the manufacture of shoes and were the basis of the entire way of life of the cordwainers of Lynn. While the shoe manufacturers tried to increase both production and their own control over the process by the division of labor, they enjoyed only limited success. The way shoes were made remained essentially the same in 1850 as it had been 50 or even 100 years earlier, despite a tremendous expansion of the market in both size and scope. The independent position of the skilled cordwainer ended only with the total mechanization of the industry which occurred rapidly after 1850.

Hand skills, as either a binder or a cordwainer, were the essential elements underlying the way of life of Lynn's skilled artisans. There were very few other economic opportunities in Lynn and even fewer that offered the prestige and independence of shoemaking. Transmission of this skill was essential to the continuation of the town's economy. Making shoes was an activity in which all elements of the community had an interest, and it was predominantly a function of the family before mechanization.

Clear evidence about how and when young women learned the part of shoemaking that was their sphere is not abundant, but it does exist in sufficient quantity that some definite statements can be made. We know from the descriptions of mothers teaching their daughters "needle skills" that young girls in Lynn learned binding as a most important part of this general package of talents. Binding was the lot of a great number of Lynn's young women, both while they were single and after marriage. Lucy Larcom, poet, factory girl, and shoe binder, described the binders' life in a frequently cited poem entitled "Hannah Binding Shoes."

> Poor lone Hannah,
> Sitting at the window, binding shoes.
> Faded, wrinkled
> Sitting, stitching, in a mournful muse.
> Bright-eyed beauty once was she,
> When the bloom was on the tree:
> Spring and winter
> Hannah's at the window, binding shoes.
> .

Twenty winters
Bleach and tear the ragged shore she views.
Twenty seasons:
Never one has brought her any news.
Still her dim eyes silently
Chase the white sails o'er the sea:
Hopeless, faithful
Hannah's at the window, binding shoes.[4]

Fortunately, we know a good deal more about the training of boys from several autobiographies, diaries, and a large number of obituaries. David Newhall Johnson in his autobiographical *Sketches of Lynn* described entering a ten-footer at age ten to learn the shoemaker's art. Ten is the youngest age recorded in any of the sources; fourteen is far more common. Joseph Lye recorded in his diary for December 22, 1817: "This day began to learn my brother Robert to make shoes." Robert Lye was fourteen, and Joseph, while only twenty-five, was the head of the family because his father, who had "learned" him, was dead. John Basset Alley was apprenticed at fourteen and a half and a "jour" at twenty.[5] In account after account the basic story is the same; they left school to learn the shoemaker's art "as was the custom of the times." Formal apprenticeship is occasionally mentioned.[6] John Lewis Loring came to Lynn in 1832 at age fourteen with his mother and was apprenticed to George Atkinson. Formal apprenticeship was generally reserved for those from outside the artisan community, usually boys

[4] David N. Johnson, *Sketches of Lynn; or, The Changes of Fifty Years* (Lynn, 1880), pp. 336–40.

[5] Johnson, *Sketches of Lynn*, p. v; Henry F. Tapley, "An Old New England Town as Seen by Joseph Lye, Cordwainer," in *Register*, 19:42; *Vital Records of Lynn, Massachusetts, to the End of the Year 1849*, vol. 1, *Births* (Salem, Mass.: Essex Institute, 1905).

[6] In this essay the term *formal apprenticeship* is used only in those cases where a youth learned shoemaking from someone to whom he or she was not related. The term *master* has not been used to designate the fully trained craftsman because changes in the organization of work that occurred as the market for Lynn shoes expanded after 1750 made the term anachronistic. Lynn's cordwainers referred to themselves as "jours," an abbreviation or a corruption of the term *journeymen*. The levels within the industry at the height of the putting-out system were, for male workers, bosses, or manufacturers, who owned the raw materials and who controlled access to markets; jours, or cordwainers, fully trained artisans who made shoes; and "boys," who were learning the craft. A number of artisans specialized in cutting and worked in the central shops of the manufacturers after 1830. Women in the industry were almost entirely binders.

either newly arrived in Lynn or whose fathers were dead. There is strong evidence that a formal apprenticeship was less common than the informal method of learning from a father, an older brother, or an uncle. Jacob Meek Lewis was, in many ways, typical of his generation. In his obituary his career summary begins, "left [Lynn Academy] to learn the trade of a shoemaker in his father's ten by twelve shoemaker's shop, according to the custom of those times [late 1830s]." As late as the 1850s it was common for young boys like Luther Johnson and George A. Breed to enter their father's ten-footer after completing a "town school" education. The family played a decisive role even when technical training was received outside the family. In an autobiographical note, William Stone described how he chose where to start his career: "For twenty six years prior to 1840, my grandfather made shoes for Micajah C. Pratt, and my grandmother bound shoes for him the same length of time. . . . In 1854, when I left school, it was natural that I should go into his shop and learn to make shoes."[7] This pattern is clearly reflected in the 1850 census population schedules. Lynn's cordwainers emerge as a very tightly knit group. In households headed by a cordwainer nearly every son over fifteen is also listed as a cordwainer; so are almost all boarders. This suggests that the description of the sturdy cordwainer (secure in his skill, working in his ten-footer surrounded by his sons and fellow jours) that appears in nineteenth-century accounts of the industry is probably accurate.

The location of the ubiquitous ten-footers, as the small workshops of the putting-out era were called, in the yards of the cordwainers' houses reinforced the strong role of the family. Home and workplace were close together, making movement between the two easy and natural. A ten-footer was a small building, about twelve feet square, with work space for five or six workers. Each work space, called a berth in the trade, had a bench, or seat, and was far enough from the others to permit the cordwainer to move his arms freely as he stitched. The men who worked in each ten-footer were called its crew, another reflection of the nautical influence on the argot of the craft.

What did these young men do during the five or six years they spent as the "boy" in a ten-footer learning the gentle craft? Fortunately, while

[7] *Register*, 8:56; William Stone, "Lynn and Its Old Time Shoemakers' Shops," in *Register*, 15:84.

there are no detailed accounts of the day-to-day activities of a crew, there are a number of general descriptions from which we can reconstruct the duties of the trainee and the steps through which he learned how to make shoes. The younger boys, those just beginning the long learning process, were often used as errand runners. They were sent to the house to bring out bound uppers or down the block to borrow a particular size and style of last from a nearby crew. One of the boy's first responsibilities was to arrive early, especially during the winter, to start the fire in the shop stove and to prepare the candles that might be needed. One of the first jobs the boy learned was how to prepare wax for the thread. Shoemaker's wax was made from black pitch, a quarter part rosin, and "as much oil as the season requires." The mixture had to be heated in an earthen or iron pot over a slow fire and the ingredients mixed thoroughly together. The whole mass was poured into a tub of cold water (every shop had a tub which also served to soak sole leather) and then kneaded by hand, much like taffy, until it developed the proper consistency. Between errands the boys watched and listened to the men work. Gradually they might be asked to help hold a piece of work and then to do a few stitches or to wax a thread and attach the bristle. During the years of their apprenticeship the boys came to be familiar with the tools in the shoemaker's kit learning what each could and could not do. When the crew felt he was ready the youth made his first pair of shoes, putting together all the knowledge he had been accumulating and practicing. When he was finished the shoes were passed around the shop with each jour examining them closely, checking the stitchwork and, finally, bending the sole to see how tightly it had been sewn. A gap, called a smile, was the telltale sign of poor workmanship. If the shoe held up to all this testing, the young man was ready to begin his career as a jour with his own berth in a ten-footer.[8]

The transition from boy to jour was generally accomplished by age twenty, although men as young as sixteen are referred to as cordwainers in the manuscript census schedules just as the more mature men were. This raises the interesting question of just when people were thought of, and thought of themselves, as full-fledged members of the craft. If

[8] Johnson, *Sketches of Lynn*, pp. 27–69; John F. Rees, *The Art and Mystery of a Cordwainer; or, An Essay on the Principles and Practice of Boot and Shoe Making* (London, 1813). I am grateful to Kenneth Carpenter of the Kress Library at Harvard University for calling this item to my attention.

the answers they gave to the census takers are a measure of this—and I think they are—identification as a member of the gentle craft began sometime before one had fully mastered the art. Also, while learning to make a shoe was part of the transition to adulthood, completion of the learning process was not immediately followed by embarking on an independent life either by leaving home or by marriage. These few years between the average age at which young men finished learning their craft and the average age at marriage are intriguing because of the close connection in Lynn between family and work and the place of work in the life cycle. Almost all sons remained at home living, and perhaps working, with their fathers. Almost none of the sons living at home were married, but very few were more than twenty-five years old. Conversely, few boarders were under twenty-five, and while the majority were also single, a larger group were married than was the case among the sons living at home. The family and the household played key roles in the training of young men for their entry into the work force and the community.

The introduction of machinery and the factory system into Lynn between 1852 and 1879 had profound and lasting effects on the process sketched broadly above.[9] The earliest machine to directly affect the hand skills of Lynn's cordwainers and binders was John Brooks Nichols's adaptation in 1851 of the Howe sewing machine to sew the light leathers and heavy cloths used for the uppers of women's shoes. John Wooldredge of Lynn introduced the machine into actual use in the industry the following year, and it was rapidly adopted by other manufacturers in town.[10] Nichols, who had been a cordwainer in Lynn, continued to improve his machine, patenting refinements in 1854 (no. 11,615) and 1855 (no. 12,322). The new machine had several advantages over the hand method of binding, chief among them the evenness of the stitches and the speed at which it operated. Even before the machines were connected to a common power source (the earliest models were powered by a foot treadle), manufacturers and subcontractors brought binders

[9]Two studies that discuss the political and cultural effects of these changes are Alan Dawley, *Class and Community: The Industrial Revolution in Lynn* (Cambridge, Mass.: Harvard University Press, 1976); and Paul G. Faler, *Mechanics and Manufacturers in the the Early Industrial Revolution: Lynn, Massachusetts, 1780–1860* (Albany: State University of New York Press, 1981).

[10]Joseph W. Roe, *The Mechanical Equipment*, vol. 9 of *Factory Management Course* (New York: Industrial Extension Institute, 1922), pp. 459–60.

together to work in large, open rooms filled with sewing machines. In these binding sheds work could be supervised closely and workers introduced to factory time and discipline.

The second major machine to be introduced was a stitcher invented by Lyman R. Blake and patented by him in 1860. This machine, along with an entirely new type of shoe to be sewn on it, solved the serious problem of sewing the soles onto the shoes. Sole leather was much heavier than upper leather and had to be sewn on the inside of the shoe as well as from the outside. Gordon McKay, a machinist, bought Blake's patent rights and, with R. H. Mathies, perfected the machine. He patented several refinements of the machine and the special shoe that was sewn on it. He also developed a marketing technique, practiced by McKay Association and its successor, United Shoe Machine Company, of renting the machinery at a low, uniform rate and providing, at minimal or no cost, a full array of support services including training for machine operatives.[11] Blake himself worked for McKay for a number of years training operatives on the McKay Stitcher. The rental system, which kept overhead very low, made the machinery developed by McKay Association and other shoe machinery firms more attractive and affordable for even the smallest shoe factory. It also greatly accelerated McKay's penetration of the industry at every level. A direct result of the mechanization of the industry was' the rapid obsolescence of the skills of the city's cordwainers and the end of their way of life.

Two other branches of the industry resisted mechanization somewhat longer. Cutting, which had moved into the central shops during the 1830s, saw the introduction of paper and then tin patterns which standardized sizes and styles before dies and presses were developed that could cut leather without stretching or otherwise damaging it. The final aspect of the industry to be mechanized was lasting, the process of attaching the bound upper to a wooden form shaped roughly like a human foot. Long after the other major (and an incredible number of minor) divisions of the production process had been fully mechanized and brought into the factory, lasting remained handwork. A number of lasting machines had been patented but none had proved successful in

[11] William S. Brewster, *USM Corporation: Our First Seventy Five Years*, Newcomen Society in North America Publication, vol. 989 (1974); Roe, *Mechanical Equipment; Dictionary of American Biography*, s.v. "Lyman R. Blake" and "Gordon McKay"; Hazard, *Boot and Shoe Industry*, pp. 121–22.

actual operation. In 1883 Jan Ernst Matzeliger patented his "hand-process" lasting machine.[12] The machine was successful and hand lasting disappeared.

The transformation of shoemaking, from a handicraft practiced by skilled artisans in small workshops to an industry where every process was divided and subdivided into simple tasks done on separate machines in a well-organized factory, occurred very quickly. In 1850 shoes were still being made by hand; even as the Civil War broke out machinery was limited to binding. Yet by 1879 the last of the central shops putting out work to workers in the ten-footers had closed; the factory system was solidly entrenched.

An important, but easily overlooked, aspect of the process of mechanization was the centralizing role of McKay and his firm, McKay Association. McKay not only controlled Blake's patent and his own for the refinements he and Mathies developed, but he also offered manufacturers a growing variety of machines and services: sewing machines for binding, assistance in designing the factory, instructors to train the work force, and repair and maintenance of the machinery—all for a small royalty per pair of shoes. This package made the machinery attractive and affordable and contributed to the speed with which it drove out hand labor from industrial production.

These changes affected the whole relationship between the family and work, but nothing was altered more completely than the transmission of skills. First, of course, the machines made the hand skills that cordwainers and binders had spent years acquiring and developing totally irrelevant to the job of producing shoes. In testimony before the Massachusetts Bureau of Labor Statistics, many shoemakers and manufacturers described the process of mechanization and its destructive impact on the way of life in Lynn and other shoe towns.[13] According to all accounts McKay's representatives could train the entire work force of a factory in two days. The key function of training was removed from the family and taken over by the manufacturers of shoe machinery. In 1919 the Lynn Chamber of Commerce set up a trade school to train machine operatives for the city's shoe industry. The various manufacturers sup-

[12] Sidney Kaplan, "Jan Ernst Matzeliger and the Making of the Shoe," *Journal of Negro History* 40 (1955): 8–33.

[13] Massachusetts Bureau of Labor Statistics, *Second Annual Report* (Boston, 1871), pp. 93–98; Massachusetts Bureau of Labor Statistics, *Fourth Annual Report* (Boston, 1873), pp. 304–6.

ported the school financially, and it was free to all Lynn residents, just as if it had been part of the city school system. In the space of two generations technical training for full participation in the city's key industry passed from a familial responsibility to a public one. At the same time the nature of that training changed from initiation into a skilled craft to training in machine operation.

The implications of these changes were already clear by 1880 and were reflected in the manuscript census schedules of that year. The clear patterns of the 1850 schedule—a reflection of the neat, orderly process of the life cycle in a traditional society where life proceeded from generation to generation at much the same pace, with much the same rhythm—was gone; it was replaced by a much more complex arrangement showing no relationship among family, skill, age, or stage in the life cycle. The sons of shoe workers were pursuing a wide variety of occupations, as were the boarders in those households that took them in. This change was, at least in part, a reflection of a diversification of Lynn's economy; there were more occupational choices available in 1880 than there had been in 1850. But other changes are evident as well. The single designation, cordwainer, which identified the skilled artisans in 1850, had been replaced by myriad descriptions of functional jobs, an inevitable part of the process of making shoes with machinery in a factory. The new diversity of job descriptions is the clearest reflection of the fragmentation of the cohesive world of family and work the cordwainers had enjoyed for so long.

The preceding is a broad picture of what happened to a group of people who enjoyed a way of life based on a hand skill when the technology that was the basis of that life-style changed and their industry was rapidly mechanized. The shoemakers of Lynn, as a group and as individuals, were rapidly brought into a modern way of life with an entirely different technological foundation. It is this process that is my primary concern in this entire research project.[14] The change from a seemingly orderly, timeless world to a less orderly, time-conscious world is one of the profound changes in all of history. Different groups entered this process, and emerged from it, at different times. The cordwainers of Lynn entered this process relatively late, at a time for which relatively

[14] William H. Mulligan, Jr., "The Family and Technological Change: The Shoemakers of Lynn, Massachusetts, during the Transition from Hand to Machine Production, 1850–1880" (Ph.D. diss., Clark University, 1982).

complete records exist, thus allowing a fuller reconstruction of the process generally and of the careers of individuals as well. To understand what happened to Lynn's shoemakers and their world is to gain a better perspective on our own world of rapid technological change.

The broader implications of all of this are related to the changed relationship between work and family life. Unfortunately, it is difficult, and often impossible, to get at the dynamics of family life historically. We know, for example, that Joseph Lye taught his younger brother, Robert, to make shoes and that at that time he was head of his family. In conjunction with an array of other data, that information helps us to understand both the structure and the function of the artisan family in traditional Lynn, but it tells us nothing of how either party looked on their relationship. Who decided that Robert would learn his brother's (and father's) craft? Was Joseph anxious to teach his brother as his father had taught him, or was this an unpleasant duty that had to be done? There is no way to know and little basis for any statement. Joseph's laconic style might be significant if it were not pervasive in his and many other diaries.

The family has proved to be a tenacious institution. Despite periodic predictions of its imminent demise, it retains the same essential structure today that it had many hundreds of years ago. The nuclear household has now been traced far back into the past.[15] The same is true for Lynn. Mechanization did not alter the structure of the family in any significant way. It did, however, profoundly alter the relationship between the family and work and the role the family played in the lives of its members. The relationship between the family and work was not destroyed by the introduction of the factory system, but it was changed. As work was removed from the household, the economic role of the father lost much of its significance; he was no longer the one who taught his sons their trade, who dealt with the boss. Even if he and his sons were together in the factory, his lengthy experience was of little, if any, advantage and not a source of knowledge his sons might seek to draw on. Perhaps in the future we will have data that will allow us to compare the experience of the first generation of factory shoe workers with textile workers. Both Michael Anderson in his study of mid nineteenth-cen-

[15] Peter Laslett, *The World We Have Lost: England before the Industrial Age* (1965; rev. ed., New York: Charles Scribner's Sons, 1971); Peter Laslett, ed., *Household and Family in Past Time* (Cambridge: At the University Press, 1973).

tury Preston, England, and Tamara K. Hareven in her study of late nineteenth-, early twentieth-century Manchester, New Hampshire, have demonstrated that the family played a very important role in helping people to find jobs and housing.[16] Hareven has even been able to show the family operating within the factory itself, directing members toward more desirable jobs and departments. So it is clear that work and the family were still closely interconnected fairly late, at least, in the textile industry. The question remains as to whether shoe workers were able to maintain a similar role.

There were (and are) important differences between the relationship of the family to work in traditional, hand-skill societies and in modern, mechanized societies. In Lynn, before mechanization, the family was at the center of an individual's life. They learned the skills with which they would support themselves and later pass on to their children. Their skills allowed artisans a degree of independence. Prominent in diaries and other accounts are days spent at Nahant fishing and picnicking on the beach, working on a garden, or engaging in any of a variety of diversions. The family provided access to all of these benefits by passing on the skills needed to make shoes. As less time was needed to pass on the skills, the nurture of the family, which sustained young people during their training, became less important, and training for the job was taken over by the employers as an "investment." Once the critical function of training in the craft was taken from the family and transferred to the control of the manufacturer, the family's role became secondary, not primary. While the family continued, perhaps, to help individuals find employment and adjust to new surroundings, work now involved machinery, and operating it was a skill taught by the factory owner or his representative.

The full impact of these changes, in both the technology and the organization of work, was profound. Each separate function, once part of a package of skill and inherited knowledge, had become a separate job. The close relationship between craft and all other aspects of life was gone. The household structure of the city no longer reflected this

[16]Michael Anderson, *Family Structure in Nineteenth-Century Lancashire* (Cambridge: At the University Press, 1971); Tamara K. Hareven, "The Laborers of Manchester, New Hampshire, 1912–1922: The Role of Family and Ethnicity in Adjustment to Industrial Life," *Labor History* 16 (1975): 249–65; and Tamara K. Hareven, "Family Time and Industrial Time: Family and Work in a Planned Corporation Town, 1900–1924," *Journal of Urban History* 1 (1975): 365–89.

strong identification with craft in 1880. The children of shoe workers did not follow their parents into the trade in anything like the numbers they had before machinery replaced hand skill. In short, the artisan life-style and society were gone, swept away by the rush of mechanization. The Massachusetts Bureau of Labor Statistics noted in its report for 1871 that the "use of machinery has virtually swept away the old race of shoemakers who could make up an entire shoe." [17]

At the onset of mechanization the family was still a pervasive institution in the lives of shoemakers, providing many services for its members. It was the prime agency for transmitting the skills needed for full participation in the economic life of the city. As pointed out above, young men and women not only learned their craft in the family but were introduced into the town's major industry through their family as well. As the technological base of that industry changed and became less tied to those hand skills, the role of the family in the lives of individuals began to change. For example, less and less of an individual's work experience took place within a family context as brick factories replaced the ten-footers of the putting-out system. Job training passed from the family to the factory as the machinery manufacturers provided trainers to instruct new operatives. The family remained an important part of people's lives, to be sure, but it was less pervasive.

It is important to keep in mind that while family functions changed in response to changes in the world of work, the structure of the family changed imperceptibly if at all. [18] Structure is quite resilient, and the nuclear family, while certainly not a creation of industrialism, was well suited to the demands of the new economic order. Function, on the other hand, is more fragile because it is not as free from outside influence, involving the family's contact with the wider society. And while cultural tradition is a strong influence on role definition, economic forces outside the family are equally, or almost equally, important, especially as they define possibilities and horizons. This study of the role of the family in training shoemakers is one example of the process of adaptation to a changing environment.

[17] *Second Annual Report*, p. 242.
[18] See Mulligan, "Family and Technological Change," chaps. 3, 5.

Latrobe, His Craftsmen, and the Corinthian Order of the Hall of Representatives

Charles E. Brownell

In March 1796 the thirty-one-year-old architect and engineer B. Henry Latrobe arrived in Norfolk, Virginia, from England. For the next quarter century, down to his death in 1820, he practiced his two professions in a wide variety of commissions at a wide variety of places, principally in the region from Richmond to Philadelphia along the Atlantic Seaboard, in Pittsburgh, and in New Orleans. His activities involved him in both extensive and diverse relations with craftsmen.

To discuss Latrobe's relations with architectural craftsmen coherently requires drawing upon his oeuvre selectively. His architectural works range from Baltimore's Roman Catholic cathedral and the United States Capitol at one pole, through domestic architecture, to utilitarian

This essay dispenses with footnotes. As to the subject of B. Henry Latrobe and his craftsmen, the principal source of information is the architect's letters and other papers. I have cited relevant Latrobe documents in the text in such form that the interested reader can consult them in the microfiche edition of *The Papers of Benjamin Henry Latrobe*, ed. Thomas E. Jeffrey (Clifton, N.J.: James T. White for the Maryland Historical Society, 1976). Other sources of information on Latrobe's craftsmen (for example, the Washington *National Intelligencer*) are treated comparably. As to other topics, such as the evolution of the Hall of Representatives, the reader will find more extensive information in Charles E. Brownell, *The Architectural Drawings of Benjamin Henry Latrobe*, in *The Papers of Benjamin Henry Latrobe*, ed. Edward C. Carter II et al. (New Haven: Yale University Press, forthcoming).

and industrial buildings at the other pole. But Latrobe made his central contribution in the field of public buildings. Essential to these public buildings and to Latrobe's brand of neoclassicism is the union of Roman inspiration for planning and structure with Greek inspiration for ornamentation. The Roman inspiration reached its finest expression in the monumental all-masonry dome, while the Greek inspiration reached its finest expression in the monumental all-masonry order of columns. Two realizations of a particular Corinthian order, Latrobe's first and second colonnades for the Hall of Representatives (now Statuary Hall) at the national Capitol, stand at the core of his art. Thus the story of how the architect and his craftsmen brought them into being holds special interest in any case. But this story is also exceptionally rich. Elaborately documented, it runs from 1803 to 1817 with one short break. A long and complicated strand, it knots with many others that represent basic kinds of relations between Latrobe and his men. By discussing this subject one can endeavor to sketch out basic issues that belong to the general topic of Latrobe and the men who executed his designs.

This paper will first touch on Latrobe's neoclassicism—represented by the Corinthian order in question—as a brilliant but initially alien intrusion into the architectural world of the young United States. Second, it will review the history of the two colonnades, respectively during Latrobe's first building campaign at the Capitol, or campaign one (1803–12), and his second, or campaign two (1815–17). Third, it will close with some generalizations about Latrobe and his craftsmen.

When Latrobe reached this country in 1796, the craftsman and the gentleman architect largely divided the practice of architecture between them. For their knowledge of architectural possibilities these men relied extensively on a narrow range of commonly limited and outdated books. They made much use of wood and much use of brick but on the whole only a rudimentary use of stone. Into this setting Latrobe carried a conception of architecture almost unknown to his American public.

Latrobe belonged to the mainstream of that classical tradition that stretched behind him back to the rebirth of the Greco-Roman visual arts in the Italian Renaissance. That is, he belonged to a tradition that identified the true architect as a self-conscious artist who must produce wholly unified conceptions based upon and controlled by a broad range of higher learning. As a universal man, Latrobe had intellectual interests that far exceeded the requirements of his profession. Time and again

these interests played a part in shaping his architecture; they expanded his power to control his designs in minute and subtle detail. A further point applies to Latrobe's learned art: by the later eighteenth century, its British practitioners had begun to recognize a parallelism between their learned techniques and those of the legal and medical professions, and they had begun to crystallize the concept of architectural professionalism.

Upon his learning rested Latrobe's style. He brought with him to America the most radically advanced kind of architecture possible at the time, the architecture of the second phase of neoclassicism. As a neoclassicist he consciously participated in an international movement that sought to purify the entirety of Western art by restoring the supposed fundamental principles of the arts. Latrobe sought for certain of these principles in Greek architecture, notably the principles governing simplicity in ornament. In particular, he believed that he had abstracted from Greek architecture the principles that should govern the orders of column (elements structural in origin but ordinarily used as decoration outside Greek antiquity). Believing that the Romans had deviated from the pure Greek principles of ornamentation, Latrobe had scant use for the Roman orders. But, on the basis of Roman as well as Greek and other precedents, he devoted himself in civic architecture to the ideal of all-masonry construction, incombustible construction of brick and stone which would challenge the destroying power of time itself. For the orders, the ideal of masonry construction meant stone, and beyond permanence it also meant the beauty of fine stone handsomely wrought.

The two colonnades will illustrate the nature of Latrobe's architecture, but first they demand some attention in their own right. Of the first version no single good likeness survives, but the architect's drawings and remarks permit one to piece together its appearance. The second colonnade still exists, along with a quantity of drawings (for example, fig. 1) and written documentation.

Latrobe used fundamentally the same Corinthian order both times. Both sets of columns measured 26 feet 8 inches in height from base through capital, but the two versions differed in plan, materials, and details. At the outset of his work at the Capitol Latrobe wished to treat the Hall of Representatives as a version of a classical, semicircular theater without a colonnade. President Thomas Jefferson, who acted as both patron and virtual collaborator, insisted that Latrobe approximate the elliptical colonnaded hall that George Washington had approved, and

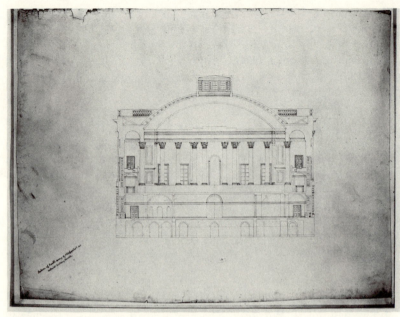

Figure 1. John H. B. Latrobe, after B. Henry Latrobe, section of south wing, U.S. Capitol, Washington, D.C., looking south. 1817. Pencil and pen-and-ink; H. 21⅝″, W. 28¾″. (Prints and Photographs Division, Library of Congress.)

Jefferson further wished him to use a highly enriched Roman Corinthian order. Latrobe produced and executed a compromise design that arranged an enriched, Greek-looking Corinthian colonnade around a plan of two semicircles abutting a rectangle. Necessity thrust upon him a far from ideal material, Aquia sandstone from Virginia. (He discussed this stone revealingly in his 1807 American Philosophical Society paper, "An Account of the Freestone Quarries on the Potomac and Rappahannoc Rivers," which drew upon material of August 1806 in his journal and his Sketchbook 9.) He built each of the twenty-four columns from a series of drums and, in order to protect the material, left the lowest portion of the columns unfluted.

After the British ruined the first chamber in 1814, Latrobe revised his scheme for a classical theater to include a highly enriched colonnade. It seems very likely that he added the columns partly in order to

lessen the difference between his theater and the hall that Washington had approved. More important, he added the columns because much in the effect of his first colonnade had won him over. This time around, working from a far more satisfactory budget, he chose superior materials. Expressly determined to rival the polychromatic richness of Roman architecture, he selected for the shafts a conglomerate stone that, as a geologist, he had discovered himself—the richly figured Potomac breccia (also called Potomac marble and calico rock). He planned to make each of the twenty-two column shafts a monolith, to polish the stone, to dispense with fluting because the figure in the rock would ornament the shafts sufficiently by itself, and to complete the order with elements of white marble and warm Aquia stone.

Now for a closer look at the two colonnades, concentrating on the essential sameness of the Corinthian order in both. The order in question consists of two primary parts, the post, or column, and its beam, or entablature. The column consists of three secondary parts—base, shaft, and capital—and the entablature also consists of three parts—architrave, frieze, and cornice. In this case there is an extra element on the architecture, a blocking course. Latrobe intended each colonnade to support solid masonry vaulting, which in both instances a president prevented him from using.

Underneath the design of this order lies rich and diverse learning. Even if a full analysis of the subject were not premature, such a commentary would exceed the bounds of the present essay. Instead, two points about the shaft, one about the capital, and two about the cornice must stand in place of a full discussion.

Normally a column shaft diminishes in diameter as it rises. It has become common knowledge that the Greeks and, imitating them, the Romans employed the principle of entasis, or swelling; in other words, they tapered the shaft on a curve. Andrea Palladio discussed entasis in his *Four Books of Architecture* (1570), and it seems likely that his treatment became standard in North America via the Anglo-Palladian builders' manuals of the eighteenth century. But Latrobe subscribed to a substantial body of neoclassical opinion in believing that entasis had originated as a post-Greek corruption and that the Greeks had tapered their columns on a straight line, in effect as fragments of elongated cones. He mentioned his view in a letter of August 5, 1804, to John Lenthall, his second in command at the Capitol.

The shafts of the second colonnade entail a further point. Encour-

aged by the budget for rebuilding the Capitol, Latrobe determined to compete with the splendor of the polychromatic stonework employed by the Romans themselves. His conception depended upon using shafts of Potomac breccia, a gray stone overall, but one spangled with color. He meant to make each shaft a monolith, its figure unmarred by joints, and thus he contemplated what probably would have been the grandest monolithic order to date in the short history of monumental American masonry construction. And he composed a play of color with this stone, white marble for the bases and capitals and tawny Aquia stone for the entablature. Writing to his friend Robert Goodloe Harper (August 13, 1815), he quoted from the Roman poet Propertius (*Elegies* 2.34.65) to spell out his ambition of challenging Roman colorism: if he overcame official resistance to the breccia, then he could say, "Cedite Romani [Yield to me, Romans]."

For the capitals Jefferson had preferred the Corinthian order of the Temple of Castor and Pollux in Rome. Latrobe, the man who had introduced the Greek orders into American practice at the Bank of Pennsylvania (1799–1801 and later) and the Centre Square Engine House of the Philadelphia Waterworks (1799–1801 and later), had wished to use another Greek order. He gave in to Jefferson's preference for the Corinthian, but with both versions of the colonnade he followed a Greek model for the capital, the model of the Choragic Monument of Lysicrates in Athens (fig. 2). Believing that the United States held no one capable of working the capitals satisfactorily, he had the first set carved in Washington by Giovanni Andrei, an Italian imported for the purpose, and the second set carved in Italy under Andrei's supervision. Finding skilled hands solved one problem but created another, the need to reform minds habituated to the Roman orders. When Latrobe wrote to the commissioners of the public buildings (May 2, 1815) to urge that Andrei accompany the order for the capitals to Italy, he explained:

Mr. Andrei himself, accustomed on his arrival in America to the roman finery of his country, found it very difficult to accomodate [*sic*] his chisel to the simplicity of the Grecian taste which I have labored to introduce into our country,

Figure 2 *(facing page)*.　Detail of the Corinthian order of the Choragic Monument of Lysicrates, Athens. Late fourth century B.C. From James Stuart and Nicholas Revett, *The Antiquities of Athens*, vol. 1 (London: Printed by John Haberkorn, 1762), chap. 4, pl. 6. (Winterthur Museum Library.)

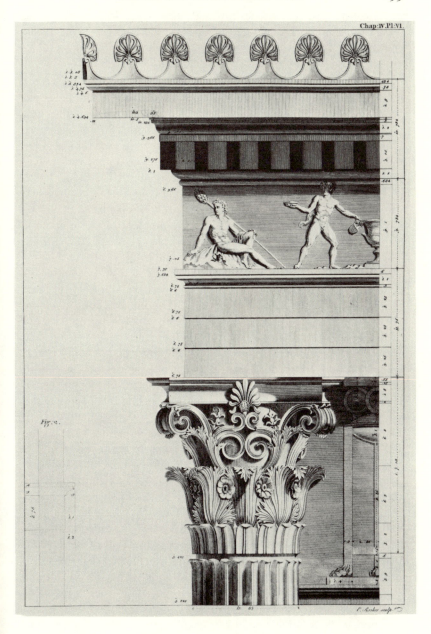

Chap:IV.Pl:VI.

Fig:2.

I. Roche sculp.

and which he now infinitely prefers. And unless he remains [in Italy] long enough to get one quarter of a Capital executed as a model, I should despair entirely of the taste in which they would be sent hither.

The cornice presents a twofold issue because it rests on brackets, or modillions. Nothing of the sort supports the cornice of the Choragic Monument of Lysicrates. Apparently Jefferson insisted on this rich treatment, in the manner of the Temple of Castor. In consequence, Latrobe had two problems. First, he had to create a modillioned treatment that would assimilate to the qualities of his Greek order. The second problem is yet more important. Despite all the thought that architects have devoted to the orders in the course of more than two millennia, the orders tend to run into trouble—trouble based on geometry—when they turn corners. Unlike the problem of Doric corners, the difficulty in turning a modillioned Corinthian cornice around more than one angle is no longer well known. The ideal cornice of this sort would obey an intricate set of rules; suffice it here to note three. A column, an element of support, must always have a bracket, likewise an element of support, centered over it. The brackets must alternate regularly with square panels. And the square panels must do the work of turning corners. However Latrobe handled this matter in the first Hall of Representatives, his second cornice turns its compound corners with seemingly effortless regularity, panel alternating with bracket in unbroken sequence, and a panel making each turn. But a comparison of two sheets of Latrobe drawings demonstrates that this treatment did not come easily. In a generally messy early attempt (fig. 3, upper left), the sequence running from left to right breaks off with a panel at the first corner, around which the sequence picks up again with a modillion. This ruptured treatment is simply a confession of embarrassment. An alternative, drawn to a smaller scale at the upper right of the same sheet, tries to turn the corner with three panels in succession and is equally a confession of embarrassment. Only by taking further pains with proportions did Latrobe reach his final, satisfying outcome (fig. 4).

Such, then, was the Corinthian order of the Hall of Representatives, predicated upon the renewal of antique principles and steeped in learning of many kinds. Successful execution of such a design required exact fidelity to the architect's intentions—deviation from those intentions would merely defeat the purpose by mutilating the forms. Given a nation with no established tradition of monumental masonry con-

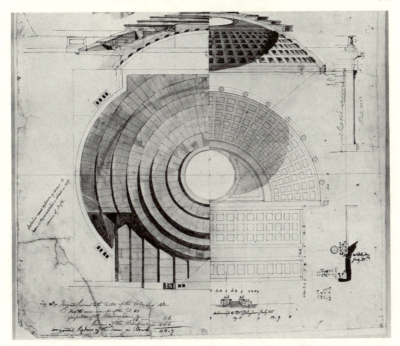

Figure 3. B. Henry Latrobe, studies for south wing, U.S. Capitol, Washington, D.C. 1815. Pencil, pen-and-ink, and watercolor; H. 27⅛″, W. 18⅜″. (Prints and Photographs Division, Library of Congress.)

struction, and given the alienness of Latrobe's architectural elements to the experience of American craftsmen, how did Latrobe fare in building his two colonnades?

The initial period of construction at the Capitol began in 1793 and ended in 1800 (by which time the design had become the hybrid creation of at least three minds, those of William Thornton, Etienne Sulpice Hallet, and Thomas Jefferson). The north, or senate, wing now stood complete, but its monumental sandstone facades concealed defective wooden construction that would decay rapidly. Across the gap for the center, or rotunda, block, the south wing, built still worse, had risen enough above ground level to hold a temporary chamber for the representatives. In this state the Capitol languished until 1803.

In March 1803 Jefferson committed to Latrobe the task of resuming

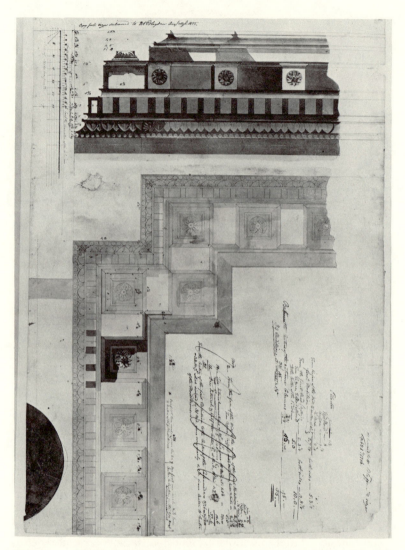

Figure 4. B. Henry Latrobe, details of cornice of the Hall of Representatives, U.S. Capitol, Washington, D.C. 1815. Pencil, pen-and-ink, and watercolor; H. 18⁷⁄₁₆″, W. 27⅜″. (Prints and Photographs Division, Library of Congress.)

work on the south wing. Latrobe determined to raze the defective construction. He drew up his own astylar theater design as an alternative to the elliptical colonnaded hall laid down on the inherited plans. And he gathered his men. In an often-quoted journal entry of August 12, 1806, the architect discussed the misfortune of those craftsmen who had optimistically thrown their lot in with that of the city of Washington, only to find themselves stranded when the metropolis failed to materialize. Of the men Latrobe found at hand, two merit singling out.

First and foremost comes the English-born carpenter John Lenthall (ca. 1762–1808). Because Jefferson could not offer Latrobe an adequate salary (only $1,700), the architect accepted responsibility for the Capitol on condition that he not move to Washington but instead appoint a clerk of the works to direct operations, with Latrobe exercising control by means of correspondence and visits. In Lenthall he found his clerk. Lenthall remains a somewhat mysterious figure, best known from Latrobe's correspondence with him and from Latrobe's obituary of him in the Washington *National Intelligencer* (September 23, 1808). But three points are clear. First, the technology of raising a masonry structure depended heavily on wooden devices, so that the choice of a carpenter for clerk of the works made excellent sense. But, second, Lenthall was no ordinary carpenter. He brought to his job a variety of experience with mechanical contrivances in English mills, mines, and elsewhere. He had rigorous standards of workmanship. He possessed a good mind, he read eagerly, and Latrobe thought highly enough of his understanding to discuss architectural principles with him. Indeed, the Latrobe letters to Lenthall rival those to Jefferson as revelations of the theoretical ideas that their author did not frequently put into writing. Still more impressive, in a rare instance of confidence in a craftsman's taste, Latrobe permitted Lenthall to make decisions affecting the design of the south wing, principally in the form of adjustments of structural detail. Third, in Lenthall the architect gained a friend and confidant. Lenthall did have a difficult temperament, a matter connected with both his high standards and his physical illnesses. Initially his personality led to trouble with other men on the work force, not with Latrobe.

Fortune also favored Latrobe with the services of George Blagden (d. 1826), the English-born stonemason who supervised the Capitol masons in every period of construction from around 1795 to his death. Writing to the commissioners of the public buildings on August 26, 1815, Latrobe declared, "[Blagden] is deservedly at the head of his art

in this country, & I have not seen his superior in Europe." But Blagden would see fit to turn his invaluable expertise against Latrobe during the rebuilding of the Capitol. It is important to note that, unlike Lenthall, Blagden figured prominently in the life of his city. For example, his obituary in the *National Intelligencer* (June 5, 1826) identifies him as an alderman and a director of the Bank of Washington.

A third individual who worked under Latrobe in 1803 had no significant connection with the colonnade of the Hall of Representatives, but he offers a convenient opportunity to mention a significant kind of relation between Latrobe and craftsmen. In three major instances Latrobe gave the son of a building craftsman training that led to a career as an architect and engineer. In 1803 Latrobe's office included an undependable fifteen-year-old pupil, William Strickland (1788–1854), the son of a carpenter and ultimately one of Latrobe's most important successors. In 1799 another carpenter's son, Frederick Graff (1774–1847), had entered the office. A favorite pupil, Graff became not only an eminent engineer but also a significant architect, a role that the Graff papers lately acquired by Winterthur do a good deal to clarify. By late March 1817 Latrobe had taken as a pupil William F. Small (1798–1832), the son of a prominent Baltimore builder and lumber dealer. Small, principally active as an architect, would play a major part in the creation of neoclassical Baltimore.

The year 1803 saw the defective south wing construction removed, and 1804 saw the form of the Hall of Representatives arrived at by way of a succession of compromises between Latrobe and Jefferson. Although Latrobe would not succeed in his wish to raise a brick dome over his colonnade, he preserved the important principle of using only stone for the order. The principle of expedience in respect to both materials and labor—a principle important to Jefferson—threatened Latrobe's principles of permanence and beauty, but he dealt with a series of challenges to his goal. On November 27, 1803, he wrote to Lenthall that he would resign rather than use wooden columns at the president's suggestion and thus "build a temple of disgrace to [himself] & Mr Jefferson." In February 1804 he faced a more general problem that resulted from his inevitable reliance on private quarries. The firm of Cook and Brent attempted to raise the price of Aquia stone. Latrobe outmaneuvered them by reopening the public quarry, but he could not put that quarry on its feet. And he got around Jefferson's suggestion (February 28) of using stuccoed brick column shafts on the example of Palladio. Con-

sulting his own ideas of expedience, Latrobe recommended to Jefferson (March 29) the use of the relatively simple foliate capital of the Tower of the Winds in Athens, a capital that he could have cast in iron—presumably he meant to rely on the privately incorporated rolling and slitting mill that ran on the excess power of the Philadelphia Waterworks and in which he had an interest. Jefferson's preference for the Corinthian order killed the possibility. The architect informed the president (April 29) that casting this more complex order would cost as much as carving it in stone.

A basic problem made itself felt in 1804. Throughout Latrobe's first building campaign at the Capitol, Congress appropriated the funds annually—any year could have been the last. Laborers hired themselves out for the year on January 1; thereafter there were fewer men available, and the available men demanded higher wages. Until each year's appropriation passed, Latrobe and his quarriers did not know whether to sign on men. Congress did not pass the 1804 appropriation until March 27 (and appropriated only $50,000 for all the public buildings, whereas Latrobe had wished $50,000 for the south wing alone). Off to a bad start, the year did not proceed well. At its end Latrobe could only report (December 1) that he had made a little progress and exceeded his budget.

In 1805 Congress appropriated $110,000 for the south wing on January 26 and came up with the unrealistic demand that Latrobe have the wing finished within the year. In this year Latrobe achieved some happy results. On March 6 he wrote Jefferson's old friend Philip Mazzei in Italy to request that Mazzei find him a first-rate Italian ornamental carver with an assistant. Latrobe's search for craftsmen for the Capitol had become international. Mazzei misunderstood, fortunately enough, and as of September 12 wrote of his discoveries, Giuseppe Franzoni (d. 1815), a sculptor, and Giovanni Andrei (1770–1824), the decorative carver that Latrobe had had in mind. On the home front, after paying Lenthall out of his own pocket, in March and April Latrobe finally settled Lenthall's compensation, a retroactive $4 per day plus an office in which the Lenthall family could live.

But the year 1805 did not smile on the south wing and its colonnade. In Latrobe's report of December 22, he recorded that the men had completed building the cellar, the ground story, and the upper walls and had some of the stone for the colonnade ready for construction. Progress had suffered from a shortage of workmen and trouble in

providing stone of a grade appropriate for the interior. As to the work-men, the Capitol had to compete with other construction projects in Washington and Baltimore. Latrobe, who had foreseen the problem for some time, had written Jefferson (August 31) some interesting details. The public buildings in Washington—the Navy Yard, the President's House, and the Treasury fireproof—competed for stonecutters. The Baltimore mason William Steuart had lately visited Washington "for the avowed purpose of enticing away as many of [their] hands as he could," but had failed. Latrobe's best stonecutter had taken with him three or four others to work on the Bank of Columbia in Washington. The architect foresaw that in 1806 the construction of his own cathe-dral, of Union Bank in Baltimore (by the carpenter-architect Robert Cary Long, Sr.), and of other buildings would draw off men.

Franzoni and Andrei arrived in January 1806. Mazzei's error had provided Latrobe with a sculptor. The architect set Franzoni at work on the great eagle designed for the House frieze and later had him execute reclining allegories of agriculture, art, science, and commerce for the portion of the frieze opposite the eagle. Pleased with his Italians, in a letter of December 19/28, 1806, Latrobe would write Mazzei asking what Franzoni's father would charge to carve fifty Corinthian capitals for the exterior of the main block of the Capitol. But the time had not yet come for such a measure.

A singularly interesting letter of March 3, 1806, from Latrobe to Lenthall discusses the House order. Evidently Latrobe had let Lenthall try his hand at working out the modillions. He accepted his clerk of the work's design over his own tries, although with some reservations, the principal one concerning the corner problem.

On the whole, 1806 went badly. Congress did not make its appro-priation until April 21. The House turned to the president to see to the completion of their hall within the year. Jefferson demanded a detailed schedule from Latrobe and regular reports from Lenthall. But that sum-mer the insufficiency of the force of stonecutters put the freestone work further and further behind, and this in turn retarded the carpentry and the plastering. Matters came to a head in July. Authorized by Jefferson (July 1 and 17) to hire additional hands at any cost, Latrobe hunted in Philadelphia and Baltimore. But a large number of Philadelphia stonecutters had moved to Manhattan to work on New York City Hall (a commission that Latrobe had lost in 1802 to Joseph François Mangin and John McComb, Jr.). And when Latrobe's emissary, probably his

pupil Robert Mills, reached New York, he found that he had to proceed further north, because a shortage of funds had stopped work on the city hall and the stonecutters had moved on to Albany to work on Philip Hooker's statehouse there. The quest for craftsmen, then, had a national as well as an international character. When Latrobe reported to Jefferson on August 14, the endeavor to sign on stonecutters had not yet proved highly fruitful, but in any case it was now a shortage of stone that held up the work. In the end, the attempt to ready the south wing for an impatient House failed, although the men did finish putting up the colonnade and its wood-framed dome.

Latrobe made two important public statements in November 1806. His annual report justified his expenditure of $134,000 on the south wing, his estimate for completing this project, and it promised completion for 1807. Pointing to the evils of uncertain annual appropriations, his *Private Letter to the . . . Members of Congress* stated that the $250,000 cumulatively appropriated for the public buildings under him would have covered developing the quarries properly, assembling a sufficient force of permanent stonecutters, and, hence, finishing the wing, if he could have counted on this sum from the beginning.

In 1807 Latrobe fulfilled his promise of opening the south wing, in the face of a series of troubles. Despite his explanations of architectural economy, the appropriations bill did not pass until the last day of the session (March 3), and it provided $42,000 rather than the $45,000 that Latrobe had requested for the wing. The July decision to convene Congress in late October, not early December, further curtailed the working time. And a sad complication arose. After Latrobe moved from Philadelphia to Washington in June, relations deteriorated between him and Lenthall, who had become accustomed to supervising the work in his own way. Lenthall's resignation became a possibility. On September 12, the architect wrote Jefferson that he had composed the differences, but he spoke too soon. On October 17, Latrobe held a banquet for the workmen to celebrate the completion of major labors on the south wing. Lenthall sprang an embarrassing surprise on him by deciding at the last moment not to show up, on the grounds that Latrobe had not invited the laborers as well as the craftsmen. And the Latrobe-Lenthall problem continued in 1808.

But the House took possession of its new home on October 26, 1807. It would appear from Latrobe's description of the Hall in the *National Intelligencer* (November 30) that, although the multiple com-

promises in the architecture still distressed him—here and elsewhere he claimed only the credit of having overcome difficulties—the effect of the colonnade had won him over to no inconsiderable degree. The Hall remained unfinished. For instance, it would take Andrei years to complete the carving of the modillions and the capitals. (In fact, he left the rear faces of the latter unfinished because curtains covered them, according to Latrobe's letter of May 2, 1815, to the commissioners of the public buildings.) And there were problems, which Latrobe acknowledged in his report (March 23, 1808) for 1807: defective acoustics, defective ventilation, defective heating, and a deficit of some $39,000 (for the south wing, out of a defiicit of $51,949 for the entire public buildings budget). As to the three former issues, Latrobe ameliorated them. As to the deficit, the House exonerated Latrobe, although a stigma remained. But the deteriorating north wing (with its decaying wooden colonnade in the Senate), almost immediately to undergo reconstruction, as of 1808 had cost roughly $61,000 more than its solid mate to the south.

In Latrobe's report of March 1808 he stated that of the twenty-four columns, only two had their capitals entirely finished, fourteen had merely "bosted," or rough-hewn, capitals, only part of the cornice moldings had reached completion, and Franzoni had not finished the allegories in the frieze, but Franzoni and Andrei now had an American pupil named (David) Somerville. While the House sat, however, Andrei and Franzoni could not work on their respective parts of the order, so during the spring they took on commissions in Baltimore. They worked for Latrobe's friend Maximilian Godefroy on Saint Mary's Chapel, where Latrobe's plasterer, William Foxton, molded and cast Andrei's capitals and corbels, and they collaborated on work for the Union Bank, their tympanum for which survives in the collections of the Peale Museum.

Lenthall's career terminated grimly but swiftly on September 19, 1808, in the newly built Supreme Court chamber in the north wing. Lenthall had redesigned Latrobe's system of vaulting in the interest of saving construction money. When the vault showed signs of failing, Lenthall seems to have lost his judgment and removed the centering—the timber framework used to construct vaulting—in an erratic fashion. His procedure brought the vault down, killing him. Latrobe did not replace his clerk of the works. Instead, he redistributed duties, assumed much of Lenthall's responsibility, and brought his own sixteen-year-old son, Henry Sellon Latrobe, into the office at the outset of 1809.

The story of the first colonnade now winds down. Jefferson, its sponsor, left office in 1809, the last year for major construction in the first campaign. On December 28, 1810, Latrobe reported to President James Madison on progress at the Capitol. Work on the capitals—suspended, of course, during the sessions of the House—had reached the west side of the Hall and there was "far advanced," while only the two capitals at the entry remained untouched. Andrei now had four American pupils. With their aid, Latrobe predicted, the Italian could complete the capitals in another twelve months.

Meanwhile, another Baltimore edifice, Latrobe's cathedral, had become the beneficiary of the craft skills that had accumulated at the Capitol. In 1810 Andrei and his pupils George Henderson, Thomas McIntosh, and David Somerville had undertaken the private project of carving ten white marble capitals for the giant Ionic order within the church. In 1811 the undertaking fell afoul of a misunderstanding and the financial troubles of the patron, the Roman Catholic board of trustees. The carvers proceeded no further than the ornamented necks below the volutes. None of the necks would reach Baltimore before 1817. Not until 1819 would the trustees resolve to accept and pay for the full set, and Latrobe would complete the capitals with volutes cast in metal (apparently bronze) as an economy measure.

Campaign one closed somberly enough. Around July 1, 1811, Latrobe volunteered—in the absence of funding—to remain in office without salary. On June 18, 1812, the United States declared war on Great Britain. An act of July 5 treated Latrobe's position as extinct by twelve months, although the architect directed some work at the Capitol thereafter. In the autumn of 1813 he moved to Pittsburgh to work for Robert Fulton's Ohio Steam Boat Company, a disastrous venture for him. And on August 24, 1814, the British burned as much of the Capitol as they could—much of Latrobe's construction defied them. But in the Hall of Representatives they heaped up the wooden furnishings, added rocket fuel, and lighted the mass. In the sudden and intense heat, the surfaces of the sandstone colonnade expanded and scaled off, leaving a frightful ruin that threatened imminent collapse.

The commission to rebuild the Capitol summoned Latrobe from grim straits in Pittsburgh. In Washington, on April 18, 1815, he accepted his appointment and entered a situation materially unlike the one that he had formerly occupied.

Latrobe had contracted to serve as "Architect or Surveyor of the Capitol"; that is, he had no responsibilities but the Capitol. Congress had appropriated $300,000 for the restoration. This sum, exceeding any architectural budget that Latrobe had ever had, obviated the annual uncertainty of campaign one and permitted him to plan comprehensively. The architect had no Jefferson to support him—or to hinder him. He answered to a bureaucracy, the three commissioners of the public buildings (1815–16), succeeded by the single commissioner of the public buildings (1816–17), four men unqualified to oversee the erection of a public edifice. Under them Latrobe had a minimum of authority.

As to his artisans, Latrobe found himself happily situated. Replying to Jefferson (who had hoped for positions for two of his Charlottesville house joiners), Latrobe declared (July 12/18, 1815) that the commissioners had permitted him to assemble "a corps of Mechanics capable of executing any Work of any degree of difficulty or magnitude." The commissioners had favored those local men of ability who had suffered—and suffered miserably—with the city since the outbreak of the war.

The position of clerk of the works went to Shadrach Davis, a carpenter who had served similarly under Latrobe at the Washington Navy Yard from 1805. Latrobe held a high opinion of Davis's abilities and had declared to Secretary of the Navy Paul Hamilton (July 3, 1812) that "it will not be easy to find such another Foreman of Carpenters & Joiners, as Shadrach Davis." To the Baltimore builder Jacob Small, Jr., Latrobe wrote (June 30, 1816) that Davis "is perfectly master of the whole business of Centers [that is, centering] let them be ever so complicated, & having worked under me for 10 Years he understands me in a moments [sic], & saves me a vast deal of trouble in drawing, by his habitual perception of my intentions. But besides this, his fidelity & integrity cannot be replaced by any superior." The same document notes the attachment of Davis's men to him. One suspects that Davis did suffer from one defect, an imperfect degree of literacy, which may partly account for his obscurity in the general history of Washington.

A second key figure was, of course, George Blagden. Material in the report of the House Committee on the Public Buildings of February 18, 1817, identifies him as "inspector of stone and superintendent of the stone cutters and setters" at both the Capitol and, under James Hoban, the President's House.

And Andrei stood ready, with some of his pupils. Latrobe's letter of May 2, 1815, to the commissioners records that the Italian now had two assistants, McIntosh and Henderson. (When Latrobe drew up a bill for the cathedral necks on November 5, 1817, he identified Henderson and Somerville as then working for Andrei. Thus, at least three of Andrei's pupils had some part to play in campaign two.) As to the other men, although Latrobe had by no means a flawless work force, he could draw upon individuals whom he had accustomed to his wishes over a long period of time.

Won over by his first Hall of Representatives to the idea of a mighty colonnade in the House chamber, in 1815 Latrobe united his order of campaign one with his 1803 notion of a theaterlike hall. The history of the colonnade in campaign two revolved around the superior materials that he now determined to use, particularly for the shafts and the capitals. As of spring 1815, he had in mind employing white marble from Loudoun County, Virginia, for the shafts. On May 2 he wrote the commissioners urging that they send Andrei to Italy to have the capitals worked in marble there under his supervision in the interest of economy, expedience, and quality. In reviving the solution that he had devised for the unexecuted center part of the Capitol in campaign one, Latrobe noted that Jefferson had approved that earlier scheme.

Latrobe secured his wish: Andrei left for Italy in August, and at some point he further received authorization to prepare the Ionic capitals for the Senate there too. In the course of the summer Latrobe learned that the old quarries could no longer provide the best grade of Aquia stone that he had used formerly and that he could not hope to quarry the Loudoun County white marble. But the potential of Potomac breccia for sumptuously varicolored, monolithic shafts had seized his imagination, as witness the already quoted letter of August 13 to Robert Goodloe Harper. A tale of mighty exertion begins here.

In 1815 the men removed the ruins of the first colonnade. As of July 18 Latrobe informed the commissioners that better wages elsewhere in the District of Columbia were luring his hands away. The commissioners agreed to competitive pay the next day, but they and their architect had not seen the last of labor problems, which included a stonecutters' strike in late August.

Confronted with competition from other public buildings in Washington and Baltimore—the latter group included Robert Mills's Washington Monument, Godefroy's Battle Monument, and Latrobe and

Godefroy's exchange—Latrobe proposed to the commissioners (January 23, 1816) that they import French stonecutters for the Capitol. On February 1 the commissioners acquiesced, but the plan somehow died.

March 1816 brought Latrobe humiliation. The commissioners first extracted from their architect his admission that his position depended on obedience to them, and subsequently they fired an indeterminate number of workers. Latrobe pleaded for the men and against this inroad on the Capitol's resources, but he pleaded fruitlessly. After all this ugliness, he repeatedly acknowledged that the system under which he worked vested no authority in him.

That spring was otherwise eventful. On a quarry trip of March 11–25 Latrobe decided in favor of the breccia shafts. On April 10, arguing for his choice, he informed the commissioners that he could have breccia monoliths ready for August 1817, the earliest that he could plan to set the House entablature. The contract for this stone went neglected, however. Congress ousted the three commissioners and replaced their positions with a single post, filled by Col. Samuel Lane in May. Meanwhile, and ominously, whereas the completed capitals ought to have left Italy on April 1, they did not, nor did any word of them reach Washington then.

Two developments in June 1816 have a place here. On June 2 Latrobe wrote to Samuel Clapham, the owner of the land on the Potomac in Montgomery County, Maryland, and Loudoun County, Virginia, where the breccia deposit lay, that Commissioner Lane had made some kind of contract with a quarrier named John Hartnet (or Hartnett) to quarry the stone. About Hartnet one knows very little other than that he had lately arrived from England and that Latrobe had confidence in him. In the same month Lane misguidedly decided to dismiss Shadrach Davis, a disaster that Latrobe labored to forestall. He went so far as to solicit his friend and Lane's contact Jacob Small (who had contracted to build the Baltimore Exchange and whose son William would shortly become a Latrobe pupil) to send the commissioner a carefully calculated letter, for which Latrobe supplied the model (June 30). Davis kept his place—this time.

In the ensuing months, Latrobe's initially good relations with Lane began to go bad, and Hartnet encountered a series of costly failures at the quarry. But as of November 3, when Latrobe reported on the subject to Lane, the architect believed that Hartnet could provide monoliths for some if not all of the House shafts (that is, the remainder would

have to be constructed from multiple drums) and advised Lane to con-
tract for breccia columns and pilasters for the Senate apartments. On
November 28 Latrobe wrote in his report for 1816 that he expected the
first piece of breccia, a block for one of the antas, or pilasters, within a
few days. Via Andrei the year netted him two more Italians, Giuseppe
Franzoni's sculptor-brother Carlo (1786–1819) and the ornamental carver
Francesco Iardella. When Latrobe wrote to Lane on December 3 he
said of the House and Senate capitals only that he expected them on
the first public ship from the Mediterranean.

The first block of breccia reached Washington, and, in response to
the curiosity that it excited, Latrobe wrote an account of it, with a slight
notice of the quarrying enterprise, which appeared in the *National
Intelligencer* (January 24, 1817). Immediately after a visit to Hartnet,
he wrote to Lane a more detailed account of the quarry (January 31).
On February 1, Lane informed the House Committee on the Public
Buildings that obstacles to supplying the breccia, an endeavor that now
looked less promising, and the mysterious absence of the Italian capitals
retarded the work on the Hall of Representatives. By now, Latrobe found
it a misery to work under Lane. Hartnet's financial means had begun
to ebb perilously; Latrobe had already involved his own resources in the
attempt to keep the quarrier from going under. The architect hoped to
win the support of the next president for the breccia, and on February
28 he wrote to the man on whom he pinned his hope.

On March 3, 1817, Congress appropriated an additional $100,000
for the public buildings; on March 4 James Monroe, a president deter-
mined to expedite the completion of the Capitol, took office. Monroe
judiciously resorted to Brig. Gen. Joseph G. Swift, head of the Corps
of Engineers, and Lt. Col. George Bomford of the Ordnance Depart-
ment, for architectural counsel. Swift, Bomford, and Latrobe, all for-
mer members of the extinct United States Military Philosophical Society,
worked together well, even congenially. And Lane's star sank.

An undercurrent of the preceding year, a set of challenges to Latrobe's
competence, now reached the surface. The early history of the problem
is unclear, but apparently Blagden played a leading role in the formu-
lation of the challenges. Broadly, the contentions stated that Latrobe's
proposed north and south wings would collapse. In a related but distin-
guishable set of issues, the case ran that the breccia could not be wrought
and polished nor could breccia columns support even their own weight.
(A Latrobe letter of March 26, 1806, to Bishop John Carroll regarding

an analogous challenge to his fifth design for the Baltimore Cathedral makes clear his opinion of artisans who opposed rule of thumb to the scientific calculations of an architect.) The two military engineers altogether vindicated Latrobe's ability as a structural engineer. But Monroe, following their recommendation, vetoed the masonry domes for the House and Senate in the interest of expedience, to Latrobe's pain. Even so the architect would look with gratitude upon the president (who interested himself so far as to visit the breccia quarries with Latrobe, Swift, and Bomford) for saving the breccia columns.

Now, with Swift and Bomford's advice and Monroe's support, came a phase of boldly scaled measures. A conference of president, engineers, and architect of March 21, 1817, resulted in the decision to send the quarrier employed for the national arsenals, with all the men he could hire, to Hartnet. Latrobe, reporting to the latter on the meeting, exuberantly declared, "in fact, you are to have all America to help you, if necessary." After the trip to the quarry Swift and Bomford made recommendations to Monroe (March 31). Among other points, they advised hiring a hundred good men and a leader in New York or Boston, they outlined a system for federal operation of the breccia quarry, and for that quarry they advised hiring not only the available men in the district and Maryland but also thirty to forty quarrymen and twenty stonecutters in Philadelphia and a like contingent in New York. Swift, shortly to depart for New York State to oversee the provision of stone for the Senate orders per these recommendations, would handle the latter. They also advised that Latrobe hire draftsmen (long a sore point with him and now an urgent matter), and this measure gave him William F. Small. Swift and Bomford thought that the new program could ready the Capitol for the House and the Senate by the end of the year.

Spring rolled into summer. At some point arrangements secured American marble bases and upper cinctures (the ornamental element between the shaft and the capital) for the House columns. On June 28 Latrobe informed Jefferson that nine unpolished drums of breccia, enough for three columns, had reached the Capitol, where work proceeded at maximum intensity, while a hundred men now labored in the breccia quarry. On July 24 he shared with Jefferson the bad news that the collapse of the locks on the lower Potomac Canal forced the breccia now to come overland. On August 12 he wrote Jefferson exultantly over the future of the breccia, but he still had only nine drums and these not yet

finished. By September 26 an order had gone out for fifteen marble polishers from Philadelphia.

Before the summer ended, Latrobe had fallen into Monroe's disfavor and Lane had gained ground. Friends of Charles Bulfinch, the gentleman architect turned professional, had begun fostering the idea of replacing Latrobe, Lane, or both men with him, while artisan-builders had started eyeing Latrobe's position. In September, learning that the wings could not go into use that year, Monroe—so Latrobe believed—angrily put the blame on him. At the end of October Lane decided to transfer Davis to the President's House and bring the clerk of the works there to the Capitol, apparently owing—like the firing of the men in March 1816—to the machinations of Latrobe's incompetent foreman of the carpenters. On October 31, after Latrobe opposed the transfer, Lane wrote him an authoritarian letter directing him to mind his own business. Latrobe's current work on the Baltimore Exchange became a bigger and bigger bone of contention between him and the commissioner. At last finding his position intolerable, the architect resigned on November 20.

Bulfinch succeeded Latrobe and executed his designs for the south and north wings with a high degree of fidelity. By the time that Bulfinch took over early in 1818, the long-awaited House and Senate capitals had reached Washington. On November 21 of that year Bulfinch reported that the House colonnade had gone into place and he had the wooden dome over it in hand. The House and the Senate took possession of their new apartments at the end of 1819. Expenses had far exceeded Latrobe's calculations. Thus, on December 20, 1819, Lane informed the House that, because of the painful disappointments at the quarry, the House shafts had cost not the $1,550 apiece estimated by Latrobe but something like $5,000.

What of the results of all the labor? One can fault the execution of the second colonnade. For example, the Italian capitals suffer from a degree of stiffness. A close look at the shafts reveals the evidence of the struggle with the stone. Thus, the joints between drums fail to align from column to column, and inserted patches compensate for the fragments of breccia that broke off during fabrication. Indeed, one wonders what Latrobe would have made of the finesse of garden-variety classical masonry buildings erected about a century after his time, when American architects could rely on a major industry for elements worked of

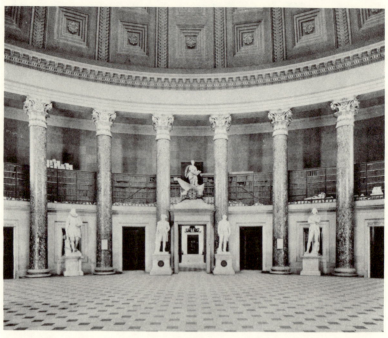

Figure 5. B. Henry Latrobe, Statuary Hall (old Hall of Representatives), U.S. Capitol, Washington, D.C. 1815–19, with later alterations. From Glenn Brown, *History of the United States Capitol*, vol. 1 (Washington, D.C.: Government Printing Office, 1900), pl. 101. (Winterthur Museum Library.)

stone. Nonetheless, in the old Hall of Representatives, today's Statuary Hall (fig. 5), Latrobe's mighty conception transcends its imperfect execution as well as the drastically altered state of the room, and the hall ranks as a genuinely great neoclassical interior.

Latrobe's kind of architecture, initially a novelty in the United States, in essence depended on the detailed working out of a unified conception within a single, learned mind, the mind of the architect. But to migrate from mind to matter, or rather from the architect's drawings to brick, stone, timber, and metal, the design required the labors of craftsmen. One can make nine points here about Latrobe in relation to his artisans in the United States.

1. Latrobe repeatedly found the kind of craftsman that he needed at hand, even in the field of monumental masonry construction. While his conception of all-masonry construction was novel to Americans around 1800, the nation had begun to grope toward a grand civic architecture before his arrival. Practitioners of relevant crafts—Lenthall and Blagden can stand for the group—thus stood ready for Latrobe.

2. But circumstance did not uniformly meet Latrobe's needs, conspicuously at the Capitol. Building this grandest of Latrobe's architectural works required national measures, measures national both in the geographic sense (for instance, the hunts for men in 1806 and 1817) and in the sense of federal facilities (as witness the role of the Washington Navy Yard, the parts played by army personnel in 1817, and the federal takeover of the breccia quarry). Building the Capitol further required international measures in the case of the most important class of ornamental carving, the capitals of the most enriched interior orders.

3. Latrobe wrote to his brother Christian Ignatius (November 4, 1804), "[I have] to make the Men who are to execute, as well as [make] the designs of my works. Now and then indeed I pick up a ready made English artisan, the rest I manufacture out of American Carpenters, who, to do them justice are incomparable Jacks of all trades." He shaped his men to suit his special requirements, men such as Andrei, and Lenthall—Latrobe's expositions of theory to him seem germane to this issue—and Davis, whose responsiveness to the architect's wishes represents the desired result. Latrobe's labors further extended to numberless humble names that history has lost.

4. Latrobe reshaped craftsmen, but in the case of an artisan such as Blagden or Andrei or Davis, he valued the mastery of craft intricacies that the individual had developed on his own. When Latrobe had such a man in his service, he had an expert whom he could consult about such technical matters as estimates or problems of execution.

5. In rare instances Latrobe had an artisan on whom he could rely to make decisions affecting his design. That is, he actually relinquished his otherwise absolute control over the unity of his conception by permitting such a man to decide on the form of some detail. In this small class of men Lenthall stands preeminent.

6. Time and again Latrobe's role as an architect set him in opposition to artisans, both to individuals and to the class, particularly for two reasons. First, on the strength of tradition these men claimed the lion's share of building opportunities. Second, in repeated cases they

presumed—often successfully—to interfere with the execution of Latrobe's designs, as Blagden did in campaign two.

7. It was not Latrobe and his patrons alone who profited from the skills of his men. The Baltimore works of Andrei in 1808 may stand as cases in point. The extent of this is hard to calculate until one assembles more information on such subjects as the activities of Latrobe's artisans and the careers of Andrei's pupils.

8. In three instances, all important, Latrobe initiated the sons of artisans—Graff, Strickland, Small—into the ranks of his two professions, architecture and engineering.

9. In Latrobe's greatest stone buildings—the Bank of Pennsylvania, the Capitol, the Baltimore Cathedral—one can recognize shortcomings in the masonry work. These very shortcomings, standing as they do at the outset of monumental stone architecture in the United States, tell how grand a task Latrobe set himself and his men.

The Moravian Craftsman in Eighteenth-Century North Carolina
Paula Welshimer Locklair

After traveling through woods for many days, the sight of this little settlement of Moravians is highly curious and interesting. Between 200 and 300 persons of this sect here assembled live in brotherly love and set a laudable example of industry, unfortunately too little observed and followed in this part of the country. Every man follows some occupation; every woman is engaged in some feminine work. . . . I found every one hard at work; such a scene of industry, perhaps, exists no where in so small a place.[1]

This 1790 description of the Moravian town of Salem, North Carolina, from the journal of William Loughton Smith expresses the admiration felt by many eighteenth-century visitors to Salem (fig. 1). The Moravians' dedication to an exemplary life was not only admirable but also successful. They aspired to perfection, and although their continual efforts to attain it—efforts evident in their religion, economy, and society in general—were often hindered by unforeseen obstacles, their strength of character and spirit prevailed. The community prospered and grew.

Craftsmen in Salem worked diligently at their trades, but much of their time was also devoted to church services, council meetings, and

[1]*Journal of William Loughton Smith, 1790–1791*, ed. Albert Matthews (Cambridge: At the University Press, 1917), p. 73.

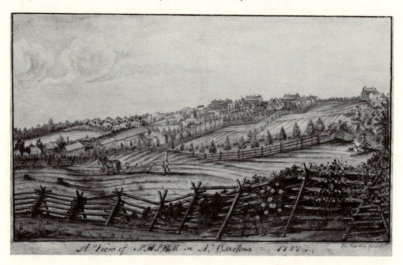

Figure 1. Ludwig Gottfried von Redeken, A *View of Salem in N. Carolina*, 1787. Watercolor on paper; H. 10¼", W. 16¼". (Old Salem, Inc.)

their families. The Moravian craftsman was not an independent agent. At all times he was held accountable for his behavior and was expected to accept the respect as well as the responsibilities he merited. It is important to emphasize that no more or less was required from the craftsman than from any other member of a Moravian community. When a craftsman or anyone else in eighteenth-century America said that he lived in Salem he was revealing a dedication to a way of life focused on Christian principles which were established by the church and which directed a person's religious, economic, and social affairs. As part of a community so centrally influenced, the craftsman produced artifacts that embody the values of Moravian culture. My study, then, is not so much concerned with the art or the artifact as it is with defining some of the elements of a developing culture that directly affected the craftsman.

To begin this investigation we must look at who the North Carolina Moravians were. The idea to involve the Unity of Brethren—*Unitas Fratrum*, commonly called the Moravians—in the colonization of a portion of North Carolina originated with a British nobleman, John, Lord Carteret, Earl Granville, who was heir to one of the eight lords

proprietors from whom Carolina received its founding charter. Granville, who admired the Moravians' industry and stability, offered their leaders in London the opportunity to purchase some of his land in North Carolina if they would settle there. In the fall of 1752, August Gottlieb Spangenberg, the leader of the Unity in America, set out for Carolina with his surveying party on a mission to choose a tract of land. Fortunately for us, he kept a detailed diary of this strenuous and enlightening venture. The entry for January 8, 1753, records, "Towards the end of the year we came into this neighborhood and found a 'body of land' which is probably the best left in North Carolina." They bought this tract of 98,985 acres from Lord Granville. But Spangenberg also noted with dismay and surprise, "Trade and business are poor in North Carolina. . . . Almost nobody has a trade. In Edenton I saw one smith, one cobbler, and one tailor at work. . . . whether there are others I do not know."[2] Edenton at that time was the largest city in North Carolina. The startling dearth of craftsmen certainly challenged the ambition of this exploring party and encouraged them to proceed with their plans to establish an organized and productive trade center.

Interspersed throughout Spangenberg's diary are detailed observations of springs and available pasture land as well as potential mill sites and other geographical features, which leave the reader with a vivid image of this uninhabited wilderness. From reading discussions and descriptions contained in other early Moravian documents, it becomes clear that only through continuing faith, untiring efforts, and detailed planning was this group able to develop not only its theocratic society but also a reputation for excellent craftsmanship.

On November 17, 1753, the first pioneering band of fifteen Moravian men from Pennsylvania arrived in the newly acquired land they called Wachovia and began the arduous task of founding a settlement, which they named Bethabara (Hebrew for "House of Passage"). Since maximum production would be required from a minimum number of dedicated workers, these men had been carefully selected according to their abilities and skills. Most of them were multitalented, like Henrich Feldhausen, for example, who was thirty-eight and a shoemaker, carpenter, millwright, cooper, sievemaker, turner, and farmer. It was fortunate that the Brethren anticipated their remote situation realistically

[2] Adelaide L. Fries, *Records of the Moravians in North Carolina*, 6 vols. (Raleigh: North Carolina Historical Commission, 1922–43), 1:59, 38–39.

and supplied themselves with capable craftsmen because, in the absence of stores and trading posts, they had "to manufacture all . . . household furnishings, which otherwise could be bought and time saved thereby."[3]

Gradually the frontier settlement of Bethabara grew as more land was cleared and cultivated. As additional people were needed and as sufficient accommodations became ready for them, more brave souls were sent from Pennsylvania. This increased the population of the "Oeconomie"—the housekeeping system in which an individual's private property remained his own, but income from the land, farm products, and industries automatically became part of a common fund, and life's necessities, such as food and housing, were supplied to all. As success encouraged independence of families, the Oeconomie gradually dissolved. There can be no question that the Moravians' isolation inspired self-sufficiency. By meeting their needs as best they could, they learned a new kind of respect for their past training, acquired an appreciation for the life they had left in Pennsylvania, and developed a patience that was continually tested.

Although by 1780 there were six Moravian congregations in Wachovia, the producing craftsmen lived and worked primarily in the three earliest settlements of Bethabara (1753), Bethania (1759), and Salem (1771). Most of what we now know about Bethabara comes from two sources, the written records and the gleanings from an extensive archaeological excavation that took place in 1964. There also remain a few pieces of furniture attributed to this early period (figs. 2, 3, 4) as well as an outstanding collection of pottery from the shop of master potter Gottfried Aust. It is obvious from the records that the people of Bethabara were interested first and foremost in providing themselves with the basic necessities and what few comforts they could manage. But the Moravians were not an aesthetically plain or dull people. They enjoyed, for example, Brother Aust's colorful glazes and slip decoration (fig. 5) as well as what decoration their short supply of tools and manpower would allow in the production of furniture (figs. 6, 7). Special interest in more sophisticated products is evident as early as February 1755 when records reveal that a turning lathe was made.[4]

The bedstead, both a necessity and a comfort, is the first specific

[3] Fries, *Records*, 1:73; August Gottlieb Spangenberg to the Brethren in Bethabara, North Carolina, June 29, 1755, Archives of the Moravian Church in America, Southern Province, Winston-Salem (hereafter cited as AMCA).
[4] Fries, *Records*, 1:124.

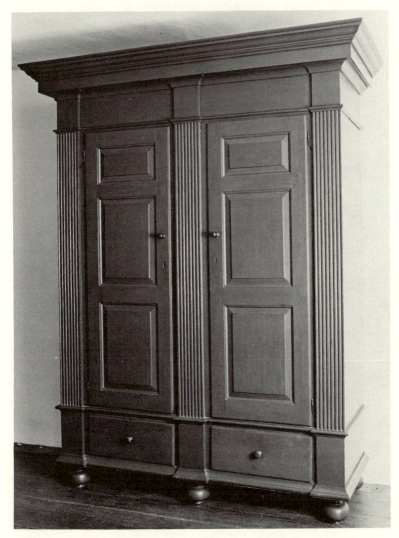

Figure 2. Schrank. Bethabara or Bethania, 1760–80. Yellow pine with "Spanish brown" paint (paint restored); H. 90⅜″, W. 72¾″, D. 26⅜″. (Old Salem, Inc.)

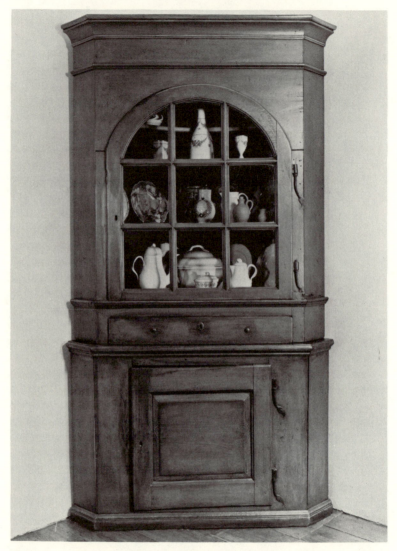

Figure 3. Corner cupboard. Bethabara or Salem, 1760–76. Yellow pine with blue and orange paint (paint restored); H. 82⅝″, D. 33″. (Wachovia Historical Society.)

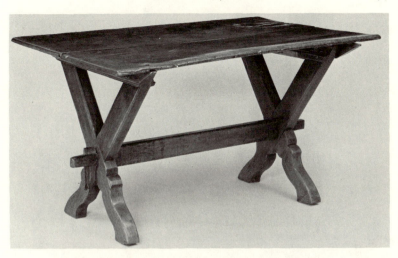

Figure 4. Table. Bethabara, 1753–60. Walnut; L. 52⅝₆″, H. 29″, W. 32″. (Old Salem, Inc.)

furniture form mentioned as being made in Wachovia (fig. 8). In June 1755 an anonymous Bethabara diarist noted the need for bedsteads: "we held a conference as to the best and cheapest and most satisfactory way to make bedsteads," and he continued a week later: "We put all the Brethren to work making bedsteads, and completed as many as we need, that is twenty-three."[5] These were built for the newly completed Single Brothers House. Such diary references suggest not only the importance of the bedsteads but also the makers' sense of success at the completion of the project.

The Moravians' success was not just luck. Throughout the records one is aware that a method was developing to deal with life and its demands: a problem or a need would be identified, discussion would follow, and finally, if possible, some action would be taken to resolve the situation. Procrastinating or ignoring a problem was simply never allowed. Community pride and a sense of history, even in those early days, are consistently apparent. Accomplishments were frequently noted, as when the same Bethabara diarist recorded in September 1755 that

[5] Fries, *Records*, 1:131–32.

Figure 5. Plate, attributed to Gottfried Aust. Bethabara, ca. 1780. Green, brown, and red slip over a white slip wash; Diam. 13⁹⁄₁₆″. (Old Salem, Inc.)

"Work at the mill continues. Today the frame was raised, and we sang several verses to the Saviour as we laid the foundations of this building in His name, placing our names under the sill at the south-east corner."[6] The practice of singing hymns of praise and thanksgiving during the raising of a building continued for many years among the Moravians. To hear the songs and witness the solemn, grateful mood of the working men laboring in the quiet of the wilderness must have been a moving experience.

[6]Fries, *Records*, 1:137.

Figure 6. Table. Bethabara or Salem, 1760–70. Walnut with poplar and yellow pine secondary woods; L. 47⅞″, H. 28½″, W. 27⅞″. (Old Salem, Inc.)

After the Brothers had completed the primary structures necessary to sustain life, they began to add buildings to house some of the trades. In November 1755 the craftsmen began to furnish "their quarters in the small houses with tables, chairs, and benches, arranging them to suit their trades." With working areas established, more organized production could begin. We also know that Aust "made a small oven and burned some earthen-ware" in April 1756, and in August of the same year "Br. Aust burned earthenware in his new kiln for the first time, and was pleased with it." The Brothers' joy was increased a month later with Aust's next success: "Br. Aust burned pottery for the second time, the glazing did well, and so the great need is at last relieved."[7] It took time to establish the trades, but the production of necessary household items was always very important (fig. 9), and through intense perseverance, the quantity and variety of Bethabara output increased.

November 1756 was another important month for the artisans because "The new joiner's shop was finished on the 26th. . . . Ceilings

[7] Fries, *Records*, 1:147, 158, 159, 172.

Figure 7. Side chair. Salem, 1770–75. Walnut; H. 41⅛″, W. 18¾″, seat height 17″. (Old Salem, Inc.)

were placed in the kitchen, pottery, and Brothers House. Br. Aust burned stove tiles, and when they were ready he set up stoves in the Gemein Haus and the Brothers House, probably the first in Carolina" (fig. 10).[8] It is not only we who are impressed with these early accomplishments and "firsts," so were the Brothers themselves. Today we analyze Moravian tile stoves primarily for their aesthetic qualities, but surely for the Brethren it was more important that Aust had helped to solve a critical heating problem.

By the end of 1759 the settlement at Bethabara had made great strides; an admirable example had been set for those who were to come

[8] Fries, *Records*, 1:161.

Figure 8. Bed. Wachovia area, possibly Salem, 1765–80. Walnut;
L. 71⅛″, H. 35⅜″, W. 32¾″. (Wachovia Historical Society.)

later. With a population of only seventy-three, the Brethren were jus-
tified in feeling pride in their successes. "In addition to the ordinary
work of each day on the farm and in the trades we have cleared 60 acres
of land this year; have built a house for those who look after the cows,
also a large shed, a new smithy, a new house at the tanyard, a laboratory
for the doctor, a new wash-house for the Single Brethren." There were
thirty-eight Single Brothers, ten married men, and one widower in this
small population; thus over half of the citizenry were able-bodied and
skilled men. Although personal letters and the church records reveal
the hardships and often the homesickness felt by the Brethren, they
managed to maintain themselves. Their spirit, by and large, was
undaunted as "All went again contentedly and cheerfully to work."[9]

In 1768 Frederic William Marshall, administrator of Wachovia,
wrote to the Unity Board in Herrnhut, Saxony, declaring of Bethabara
that "in this land, and so far from the sea, there is [no other town] like
it." But Bethabara was primarily agricultural, while the Brethren's pur-

[9] Fries, *Records*, 1:208, 246.

Figure 9. Water jug, Gottfried Aust pottery site. Bethabara, ca. 1765. Black glaze on interior and shoulder; H. 11⅜". (Old Salem, Inc.)

pose in coming to North Carolina had been to establish a permanent town that could supply manufactured goods to fellow Moravians and to trade with their neighbors. This was to be the function of Salem, as Marshall outlined in 1768 when he wrote to Herrnhut that the settlement was "intended not so much for farming as for the various businesses; and for the Choir Houses and other establishments, and for the supervision of all Wachovia." Unlike the country congregations of Bethabara and Bethania, Salem was to be a congregation town, which "differ[ed] from other Congregations in that it [was] more like one family, where the religious and material condition of each member [was] known in detail."[10]

[10] Fries, *Records*, 2:605, 606, 1:313.

Figure 10 *(facing page)*. Tile stove, attributed to Gottfried Aust or Rudolph Christ. Bethabara, ca. 1780. Unglazed and finished with stove black; H. 59", W. 17¾", D. 43⁵⁄₁₆". (Old Salem, Inc.)

Because of a multitude of delays and hindrances beyond the Brothers' control, the site for Salem had not been chosen until 1765, and construction, according to a definite town plan, had not begun until 1766. But the Moravians were intensely aware of the passage of time and of the possibility that others might open stores and operate trades that would preempt their market. Finally in 1772, after six years of clearing land for planting crops, chopping out streets, and constructing buildings, the town of Salem was ready for habitation.

The organization of the religious and financial aspects of church affairs that had been predetermined for Bethabara were appropriately adjusted for Salem. The craftsmen and all other members of the society were subject to the same rules as established by a management hierarchy which systematically directed all aspects of life in Moravian communities. The Unity Elders Conference in Herrnhut directed the affairs of all congregations around the world through local administrators. There were four principal governing boards at Salem: the Elders Conference, the *Aufseher Collegium* (Board of Overseers), the Greater Helpers Conference, and the Congregation Council. Each consisted of a leader and board members.

The Elders Conference was concerned primarily with spiritual supervision, passing on all applications for reception into the congregation and for confirmation, administering church discipline, and establishing religious services. Only the elders could put a question to the lot, which was a method by which important community matters were decided. Only one of three answers was possible: *ja*, *nein*, or a blank. The Aufseher Collegium supervised the material welfare of the community and in particular regulated the finances of the Community Diacony (a term defined later), and supervised the trades, the professions, and all commerce in Salem. The Greater Helpers Conference had no executive powers, but was to act as the "eyes" of the congregation, thereby keeping the other boards informed of matters needing their attention. The Congregation Council dealt mainly with issues that affected all members of the community. It met upon request of the Elders Conference and the Aufseher Collegium or if five Brothers made a written request for a meeting.

Women served along with the men on all boards except the Aufseher Collegium, an indication of the high degree of equality between the sexes. However, the husband's professional standing in the town seems to have directly affected that of his wife, as shown by an Elders

Conference that recorded: "That Sr. Aust is a member of the congregation council is not to be questioned, since her husband is a master."[11]

Except for the Congregation Council, all boards met on a regular basis, generally once a week, some first thing in the morning and some in the early evening. Each kept accurate minutes, and it is largely due to these extraordinary published volumes that we have such varied and precise information about the Moravians in Wachovia.

In addition to the governing boards, there were three business organizations called diaconies: Congregation, Single Brothers, and Single Sisters. Each had its own overseer and internal hierarchy, and each operated its own businesses. The Congregation Diacony, representing the whole community, operated the pottery, store, tavern, red tannery, and mill. It required these businesses to present a yearly inventory, which would then be compared year by year. Because of these accounts we know a great deal about the materials and tools used by the craftsmen. The inventory also originally served to distinguish between tools and materials owned by the diaconies and those owned by the craftsmen. In order to organize such matters further each adult in Salem was encouraged to write a will specifying the disposal of his possessions.

The Single Brothers Diacony operated the slaughterhouse, the brewery and distillery, a plantation, and the trades in the Single Brothers House and Workshop (fig. 11). The Single Sisters Diacony (fig. 12) was not quite so clearly defined in terms of actual producing industries, but the Sisters generated income by weaving, knitting, spinning, glovemaking, and laundering; and they received wages for working in private households and gardens. One of their most important functions, however, was providing teachers for the Little Girls School, begun in 1772. The Aufseher Collegium emphasized in 1786 that "It must be expressly understood that the Single Sisters shall not lose the spirit of service for the other Choirs, especially in families and at harvest time."[12] Each person, craftsman and noncraftsman alike, was a member of a "choir." In all Moravian congregation towns the people were divided for religious training and interests into choirs by age, sex, and marital status: married people, single men, single women, widows, widowers, older girls, older boys, and children.

[11] Edmund Schwarze, Elders Conference, June 28, 1780 (unpublished translations made for Old Salem, Inc.), AMCA.

[12] Erika Huber, Aufseher Collegium, April 6, 1786 (unpublished translations made for Old Salem, Inc.), AMCA.

Figure 11. Single Brothers House, 1769 with 1786 addition, and Single Brothers Workshop, 1771; reconstructed. Winston-Salem. (Old Salem, Inc.)

In a diacony there could be only one master of each trade or business, thus eliminating competition and friction. As the Salem trades were getting under way in 1772, the Helpers Conference clearly stated that "In a Gemein Ort [Congregation Town] no one can start a business, open a store, or begin a profession, until the Congregation has recognized and installed him as a Master-workman. If a business, store, or profession is already being carried on in the town all other Brethren who wish to work in it, whether they come from Europe or Pennsylvania, or grow up here, shall be considered as journeymen under the Master-workman, and shall be personally responsible to him." But the basic and most important reason for anyone to become a resident of a Gemein Ort was "a special call from the Lord to live in that place." After one felt such a call he would be received into the congregation upon signing the "Brotherly Agreement" and promising willingness to abide by the "Rules and Regulations" drawn up by the General Synod in Herrnhut. According to these rules, the "Master-workmen must give Bond that they will not treat their apprentices in any manner contrary

Figure 12. Single Sisters House, 1786 with 1819 addition. Winston-Salem. (Old Salem, Inc.)

to the Congregation Rules."[13] Many craftsmen happily joined the Moravians, but others sometimes found life too restricted and left.

Boys were bound into a seven-year apprenticeship when they were about fourteen. However, if a boy demonstrated little aptitude or liking for a craft, he could change trades and try to find a more suitable one. By the time he was indentured, he had already attended Salem Boys School for about eight years. Therefore, by the age of apprenticeship, he had completed a well-rounded curriculum, which included arithmetic, English, surveying, history, and geography. Once apprenticed, he moved into the Single Brothers House, where he lived until he married, at which time he built or purchased his own home. The church leased the land, but any improvements made were the owner's. Also, when a master craftsman married, and the shop was moved out of the Single Brothers House, he was allowed a shop sign giving his name and profession and perhaps displaying a sample or a picture of the finished goods. At the time of his marriage he was released from his debts in

[13] Fries, *Records*, 2:724, 725, 726.

order that the Sister would not be entering into poverty.

Respect for a master's position and authority was expected from the journeymen and apprentices. "[They] must stand in proper subordination to their masters, and no journeyman much less apprentice, leaves his work or remains away from work whenever he pleases." The "greatest duty" of the trade master was to supervise apprentices and journeymen and keep them "industriously" at work so that they did not "just hang around all day." A journeyman or an apprentice was not to take on new work without the direction of the master, since this would foster too great a sense of independence, which might cause a "terrible disorder."[14]

In principle, the Moravians did not believe in slavery. Blacks were neither taken into a craftsman's shop nor taught a trade, although occasionally several worked in the community as day laborers or perhaps in service at the tavern. The paucity of black labor surprised two men from Virginia, who spent a day in Salem in 1773. "Among other questions they asked how many negroes we had? Answer, two. They were the more surprised to find that white people had done so much work."[15]

Even before the establishment of Salem and the new organization of trades offered by the facilities in the Single Brothers House and the diacony system, the Moravians' purpose—to rear and train their boys to be responsible members of society—had been well known. The English rector of Braunschweig on the Cape Fear River asked the Moravians to take care of his son, as he, the father, was returning to England. "The Reason I choose to have him brought up under this Care is, that I look upon them to be a sober, pious and exemplary prudent society of Christians, who will bring him up in a laudable and virtuous Education and some Profession."[16]

Order in all aspects of life was important in a Moravian community. The Moravians believed that an organized and orderly life was more productive and, therefore, of higher quality than a life left to chance. Punctuality was stressed: the boys were expected to be at work by a certain time each day, to take only a reasonable amount of time for meals, and never to leave their work until the shop was closed. The master decided the working hours by taking into consideration the

[14] Edmund Schwarze, Helpers Conference, October 12, 1772, AMCA; Huber, Aufseher Collegium, September 20, 1775, October 12, 1772.

[15] Fries, *Records*, 2:788.

[16] Fries, *Records*, 1:244.

demands of the trade and the strength of the apprentice, the master often becoming personally involved in the welfare of his helpers. Some masters relaxed their shop rules by the 1780s and permitted the boys to leave early on Saturday (which, as the Sabbath, was already a slightly shortened workday). The Aufseher Collegium, however, recommended that such leniency be stopped.[17]

In 1774 an agreement was made guaranteeing a set salary for trade masters who worked for the diaconies. The journeymen were usually paid a weekly wage. In 1775 a "Trade Conference" was held to discuss salaries and wages more fully and to encourage close contact among the tradesmen. At this conference it was also resolved that some more or less seasonal trades—such as those of the carpenter and the mason—would be paid accordingly; the daily wage for the long summer day was to be more than for a short winter day. This arrangement also applied to the master joiner when he worked by the day. By 1780 the Elders Conference had decided that masters who had accounts with the Congregation Diacony would receive 6 percent of the profit of the shop, and those who had been especially diligent during the year would receive a bonus. Later it was also decided to encourage the journeymen and apprentices a bit more, so a loyal and diligent boy received a bonus or a gift.[18]

Many craftsmen suffered financial difficulties through the years, but apparently the strain was particularly severe for some in 1774, as the Elders Conference that year admonished each person serving in a Congregation Diacony trade to take only what had been assigned to him, "otherwise it is sinning."[19] But a craftsman could make an honest appeal for an increase in wages and dire circumstances would be considered, the Brethren believing it always best to avoid debt.

The Moravian communities were automatically set apart from other towns of the southern colonies, not only because of their remote locations but also because of the laws established by their governing body, the church. The Brethren, specifically the Trade Conference, tried to enforce the insular regulations, but conditions were changing and influ-

[17] Huber, Aufseher Collegium, September 25, 1787.

[18] Schwarze, Helpers Conference, November 14, 1774 (set salary agreement); Fries, *Records*, 2:899 (seasonal salaries); Schwarze, Elders Conference, October 11, 1780 (masters' percentage of profit); Erika Huber, Congregation Council, November 7, 1793, AMCA (journeyman and apprentice bonuses).

[19] Schwarze, Elders Conference, July 19, 1774.

ences from the outside were becoming stronger. Consequently, in 1777, the Elders Conference had to face infiltrations and deal with infractions. The elders were "anxious that [their] Brethren might not be torn out of the congregation-plan into a world-conforming way of life." They admonished the Brethren not to stray away from "correct congregation principles."[20]

Occasionally a master would request permission to take a "stranger" into his shop for a time. Usually this was not permitted, because it was feared that these outsiders would have a bad effect on the community's young people, infecting them with worldly rather than worshipful motives for production. The Aufseher Collegium was worried, declaring, "Our Brothers and Sisters must never disregard the principles [which explain] why we are together in this community. All our Brothers should go after their profession as if it were done for the Lord and his sake."[21] The spirit in which a product was crafted was as important as the product itself.

Repeatedly in the records there are discussions about wages, bonuses, and individual master-apprentice and master-diacony conflicts. Most seem to have been resolved with little difficulty. Probably one of the most surprising and distressing events, however, took place in April 1778. The congregation at large and the older members of the Single Brothers Diacony in particular were extremely dismayed when a strike took place among their young apprentices. The dispute was over a wage supplement and the amount to be paid for dinner in the Single Brothers House. The young men "calmly walked away from their work, their leaders looking on sadly," but the next day all returned repentant. The elders decided to "let patience and sympathy have way instead of strict Church discipline." Nevertheless, the offenders were not permitted to attend church services in which the kiss of peace was given. In the eyes of the elders they were rebelling against "Leaders and Conferences which the Lord had approved as constituted authority."[22] No observance of a "wrong" could be ignored, and according to the rules, all were bound in charity to confront an errant Brother with his error.

Although every effort was made to establish and maintain a stable economy, there were often times when Salem was in great need of

[20] Schwarze, Elders Conference, July 19, 1774.

[21] Huber, Aufseher Collegium, October 27, 1795.

[22] Schwarze, Elders Conference, April 3, 1778.

importing master workmen who had the "pilgrim spirit." In Salem there was no lack of work, and the wages were said to be higher than those in Europe. At various times the Moravians in Salem negotiated with Unity officials in Europe for additional craftsmen. For example, in 1786 the Single Brothers were willing to finance the journey to America of a shoemaker, a linen weaver, a tailor, a cook, and a housekeeper. There was also plenty of work for a clockmaker, a silversmith, a cooper, and a pewterer, they explained, but these men would have to bear their own expenses. In that year they did not need a tinsmith, a bookbinder, a glazier, or a painter (whose work was done by the cabinetmaker). They also did not advise the elderly or married people with several children to come. The Brethren examined their needs and were selective about the choices they made.[23]

Frederic Marshall quite candidly enumerated some of the difficulties that would confront a craftsman once he had decided to commit himself to be "faithful, industrious, economical, and obedient to the rules of the congregation." Marshall wrote that one "must think of the large outlay for travel expenses, the difficulty of language, the establishing or taking over of a trade, the thought of marrying before circumstances warrant it, the shortage of family houses which sometimes exists, the expense of building suitable houses, and especially that there is no fund to cover all this except the industry and economy of the Brother himself."[24]

After a Brother arrived in Salem, he not only was responsible for the success of his trade but also had responsibilities to the church, to his peers, and to his family, responsibilities so closely intertwined with his trade that they are hardly distinguishable from it. Like any member of the community, the newly arrived craftsman was assigned to the choir appropriate to his sex, age, and marital status. Each choir had its own responsibilities, meetings, and festival days, and in the cases of the Single Brothers and Single Sisters in Salem, its own choir house where members lived and worked together. The strict order was firm but fair, making life productive and rewarding.

Each choir usually had several religious services each day—morning, noon, and evening—which all choir members were expected to attend. These were "special meetings for edification . . . yea, it is cus-

[23] Fries, *Records*, 5:2147.
[24] Fries, *Records*, 5:2147.

tomary for each Choir to begin and to conclude the Day with appearing fellowshiply before the Lord to implore His blessing." During a week there were often additional services, such as lovefeasts, weddings, funerals, and special choir services. Saturday afternoon was held as the Sabbath, for a rest from daily toil, and appropriate services were conducted. The Unity Constitution established the ideal order of the religious services; if all of these services had been held on a regular basis in Wachovia, the Sunday church services would have been almost continual: 8 A.M., litany; 10 A.M., the preaching; 2 P.M., the children's meeting and doctrinal text; 3 P.M., the married people's service; 5 P.M., the liturgical meeting of the Communicants and a song service; toward night, an entire congregation meeting; and at 9 P.M., the evening blessing of the whole congregation.[25] Such services were vitally important elements in the structure of the craftsman's life, and much of his time each day was spent in some kind of religious activities.

Allowances were sometimes made for very inclement weather, during which services were canceled. Seasonal changes also affected them; one record notes: "The winter order of services began today, that is, a service at twilight, before supper, and singstunde at half-past eight when the weather permits." The *Singstunde* was an important—relaxing, yet inspiring—song service which all were encouraged to attend. It was held early enough in the evening so that the "elderly Brethren who [were] tired from the day's work and [could not] keep awake till nine o'clock" could participate.[26]

The lovefeast, a gathering for worship, fellowship, and the sharing of a simple meal, symbolized the unity of secular and religious life in Moravian communities. The lovefeast was held for many reasons, and occasionally there was one specifically for the masters in the workshops of the Congregation Diacony and for Single Brothers, who "were encouraged to thankfulness for the blessing of God on [their] trade during the past year."[27] As they were blessed, they were in turn expected to contribute to the work of the church in foreign missions and missions among the American Indians. Also, each person contributed a certain amount for the lovefeast, and all members of the community over sixteen years of age made contributions to the Poor Fund. These funds

[25] Fries, *Records*, 3:1006, 1010–11.
[26] Fries, *Records*, 5:2056, 3:778.
[27] Fries, *Records*, 5:2086.

were available to help not only the poor of Salem, but also, upon occasion, beggars who would come to town seeking help.

The members of the congregation also donated funds to projects that affected the entire community, such as the new clock tower built in 1780. They also contributed according to their means to the "collections for the Heathen, for the Children, and for the poor of the Unity . . . and [for] arrangements made to cover the cost of copying and sending the *Gemein Nachrichten*," a newsletter written weekly in Herrnhut and sent periodically to all the Moravian provinces, where it was copied and sent to individual towns. This was an important means by which the Moravians kept abreast of the situation of the Brethren. "In our isolation the Gemein Nachrichten have been a blessed means of keeping in touch with our dear Brethren and Sisters."[28]

In Wachovia not only were the Moravians interested in their own settlements throughout the world, but they were also anxious for news of America at large. By 1772 they were receiving the Wilmington, North Carolina, newspaper—one copy each for the store, the Single Brothers House, and the tavern.[29]

Much correspondence was exchanged between the Wachovia and Pennsylvania settlements—not a casual activity, since one had to plan well ahead to have letters ready for transporting. As one Brother noted, "I am writing this in advance because in harvest time there is little travel, and opportunities to send letters come only unexpectedly and go just as quickly." The Brethren were always very anxious to receive any news of their friends and loved ones in America and abroad: "With regard to having news," one wrote, "we must learn to wait and even when all patience is at an end, still learn to wait." The postal service would not be improved until the 1790s, when a post rider would make a stop in Salem every fourteen days.[30] This not only made general communications easier and more frequent but also facilitated the ordering of materials for the craftsman.

By 1762 there was such success in some areas of production that it became necessary to establish reliable trade patterns with other cities. Accordingly, trade was established between Salem and Charleston, South

[28] Fries, *Records*, 4:1586, 2:661, 5:2166.

[29] Fries, *Records*, 2:706.

[30] Frederic William Marshall to Johannes Ettwein, June 29, 1787; John Daniel Koehler to Ettwein, April 20, 1788; Moravian Archives, Bethlehem, Pa. Fries, *Records*, 5:2349.

Carolina, and with Petersburg, Virginia. In addition to the already established trade with the Philadelphia Moravian settlements, Charleston and Petersburg became the primary trade centers for Wachovia. Even before Salem became a center of production, Bethabara had been exporting whatever products it could. For example, in March 1763 one wagon was sent to Charleston with 3,000 pounds of deer hides, 80 pounds of beaver pelts, and 120 pounds of butter. At that time the best prices were to be found in Charleston. The trades producing household goods in 1763, however, were barely manufacturing enough for the use of the local inhabitants. "The pottery is best and brings in something. . . . The gun-smith trade makes great talk but has turned out only two guns since I am here. . . . Hardly anything has come out of the cabinet-making trade."[31] From these meager beginnings the Moravians persevered to become acknowledged as the leading craftsmen in interior North Carolina.

A reason for new hope was the opening of roads in 1770 from Salem to Cross Creek and to Salisbury, which allowed trade to begin with neighboring settlements. The prospering of this small group caused neighbors to try "to ruin [their] commerce and draw people away from [them]," but that year they "had more than ever coming to buy." By the eve of the Revolution, Salem had soundly established its reputation as the largest trade center in interior North Carolina. The quality of Salem products was held in great esteem, as attested to in September 1775 when, at the Provincial Congress in Hillsboro, North Carolina, the encouragement of domestic industry was discussed. "Premiums were offered for certain goods if made in this country, for instance linen, woolen cloth, iron for needles, knitting needles, and so on. One man in Congress wanted to debar the *Moravians*, for they would win all premiums, but . . . his suggestion was not accepted."[32]

The demand for products was often greater than the supply. Accounts of the pottery sales provide the most vivid evidence of the importance of Salem trades:

Such a crowd gathered that the street from the tavern to the blacksmith shop was so full of people and horses that it was difficult to pass through. The potter-

[31] Abraham Van Gammern to Nathanael Seidel, March 9, 1763, Moravian Archives, Bethlehem, Pa.
[32] Fries, *Records*, 1:397, 2:883.

shop was kept closed, and the persons who had ordered pottery, had paid for it in butter, and had received tickets, were served through the window. Col. Armstrong did good services, threatening the people with his drawn sword if they did not keep quiet; and for a wonder they were still, for there were not as many pieces of pottery in the shop as there were people outside.[33]

This encounter was in 1778, when the pacifist Moravians often found themselves overrun by American and sometimes British troops. In that same year the Moravians unanimously declared, "We Brethren do not bear arms, and we neither will do personal service in the army nor enlist others to do it; but we will not refuse to bear our share of the burden of the land in these disturbed times if reasonable demands are made."[34] In order to be exempt from military duty, many Single Brothers were required to pay fines. The Brethren also curtailed production in some trades such as gunsmithing, which could have had military applications. The hopeful attitude of the Brethren prevailed during these turbulent years despite a shortage of money. Although people were not buying and tradesmen often had to settle for items of poor quality, the Brothers and Sisters were urged not to fret over the war conditions. Nevertheless, the cost of almost everything rose so drastically that in spite of their care the Congregation and Choir diaconies suffered heavy financial losses.

The Moravians of Wachovia in general, and the residents of Salem in particular, were a cosmopolitan society. Their roots reached to many parts of Europe. Their personal education and industrial training were varied. The society was an amalgamation of personalities and people with a broad spectrum of skills. Accepting in common the same purposes and goals, they contributed to the church, their trades, and their society in individual ways. Their collective reason for being in Salem was summed up by Frederic Marshall, who, contemplating the move from Bethabara to Salem in 1771, wrote: "The present building of Salem is an extraordinary affair, which I would not have undertaken had not the Saviour Himself ordered it. I verily believe that the rich city of London could not do that which we must accomplish,—move the entire town and its businesses to another place."[35]

[33] Fries, *Records*, 3:1231.
[34] Fries, *Records*, 3:1231.
[35] Fries, *Records*, 2:618

This faith in their own ability was shared by all. There was never any doubt that a central town—Salem—would be established, would grow, and would prove to be the commercial and religious success that they anticipated. Their united and individual efforts resulted in a society where excellence in workmanship was second only to worship.

Craft Processes and Images: Visual Sources for the Study of the Craftsman
Jonathan Fairbanks

Visual sources for the study of craftsmen are as numerous as they are diverse. Countless images of craftsmen and their wares can be found in broadsides, trade cards and catalogues, billheads, dictionaries, directories, newspapers, journals, and other printed or engraved advertising sources. Such pictorial materials, together with paintings, drawings, and photographs, form our historic image of the early American craftsman. They provide background for interpretive programs and restorations at historic villages and museums. While this essay will not serve as a catalogue or survey of these various pictorial sources, it will offer thoughts on some problems encountered when one makes scholarly use of them.

A potter, a broommaker, and a candlemaker are only three of many craftsmen at Old Sturbridge Village, Massachusetts, who reenact the work routines of early American craftsmen. Historic craft demonstrators who perform these roles at early sites and open-air museum reconstructions create the most direct impression the public has of the historic craftsman at work. Members of the professional staff of craftspeople at Colonial Williamsburg or Plimoth Plantation are artisans whose insights, skill, and work routines have become familiar to thousands through films and sightseers' photographs. Such accomplished contemporary craft demonstrators are important interpreters of history, who share their work experiences and research based on their knowledge of the limitations

imposed by old tools, early methods of fabrication, and the use of traditional materials. Educational slide sets sold at Colonial Williamsburg show the operations of the gunsmith shop, the Geddy silversmith shop, and the Anthony Hay cabinetmaker's shop. The legend on one of the slides showing the master printer notes that he uses eleven distinct hand operations to print a single sheet. Such a note attempts to convey a sense of craft process. Demonstrations by craftsmen actually operating their shops have enormous impact on the public. Living craft reconstructions may constitute the public's single most important exposure to historic craft practices. Better than any pictorial sources, the *well-researched* craft demonstration is perhaps the best way to understand the whole spirit and process of early craftsmanship.

Related to the crafts practiced in historical villages and museum reconstructions are crafts surviving from a bygone era. Sometimes an elderly craftsman can be found who works in traditional ways with old-fashioned tools. These individuals are often studied by younger craftsmen who want to understand the roots of their discipline. Although unorthodox and not always reliable as research sources, these traditional craftsmen can provide insights into tools and techniques that have survived over many generations. Craftsmen's work patterns and perceptions of their techniques are accessible through oral history as well as through observation. By persuading veteran craftsmen to explain their crafts, the folklorist or novice craftsman is able to study master craft practices and gain insight into the past. In this process of extrapolating backward in time, one must take care to sort fact from fiction. It is important to identify which generation added what techniques in the evolution of craft processes. For example, Brother Delmar Wilson, a Shaker, began to make traditional crafts in the late nineteenth century and continued working into the twentieth. Significantly, however, Brother Wilson was not strictly a handcraftman in the accepted sense of the Shaker tradition. He developed a highly technical machine shop which speedily produced Shaker boxes for sale until his death around 1960.[1] Many highly varnished boxes found in prominent collections of early Shaker artifacts were made by Brother Wilson. His are considered the lightest and strongest of all Shaker boxes.

Those who learn their business through apprenticeship (watching and imitating a master) are one kind of contemporary craftsman; another

[1] Rob Emlen, assistant curator, Rhode Island Historical Society, supplied information about Brother Delmar Wilson.

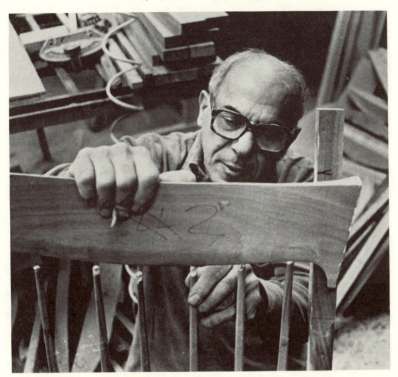

Figure 1. Sam Maloof. Alta Loma, Calif., 1981. (Photo, Jonathan Pollock.)

relies less on traditional training and is largely self-taught. Yet both groups of contemporary craftsmen normally turn to modern machine tools and manufacturing techniques to facilitate production.

An example of a self-taught, innovative modern craftsman is furniture designer and maker Sam Maloof of Alta Loma, California (fig. 1). He started his career designing and making furniture for himself and his wife in the 1940s. Finding that many others wanted to purchase his works, he gave up employment as a graphic designer to produce furniture full time, becoming an internationally recognized leader in the new crafts movement. Although he respects the past, and his work shows the influence of traditional forms, Maloof does not consciously imitate any traditional style. Technologically, he is fully equipped as a contemporary craftsman with a power machine shop; but spiritually he has

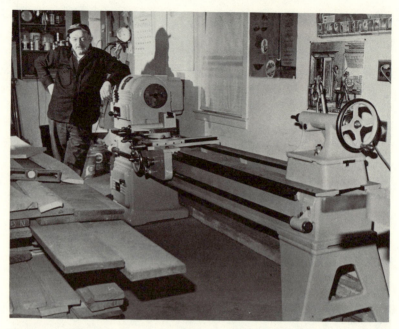

Figure 2. Harold Ionson. Westwood, Mass., 1981. (Photo, courtesy Harold Ionson.)

rebelled against machine-made objects and dull factory-produced furniture. Although he sensibly makes good use of modern power tools, his furniture is not a factory product. Each piece is individually constructed, personally finished, and sold directly to the customer. Sales are made as they were in the eighteenth century—furniture "bespoke for" by the individual client.

In contrast, the second category of modern craftsman is represented by cabinetmaker Harold L. Ionson (fig. 2), who was employed in the late 1940s by Irving and Casson, the venerable Boston and Cambridge furniture company that began in the nineteenth century and went out of business in the early 1970s. In his own words, Ionson was used as a "human machine for production" in the Irving and Casson workshop. Today, he makes furniture in his own shop located behind his home in Westwood, Massachusetts. His work is modeled after examples of neoclassical furniture made by the early nineteenth-century Boston cabinetmaker Thomas Seymour (1771–1842). Although Ionson relishes

hand-planed boards, hand-cut dovetails, and other historical joinery details, he is no slavish copyist. Rather, he makes what he calls "improvements" on Seymour's designs by modifying certain construction features of the original furniture.

Both Maloof and Ionson have small shops. Both produce limited quantities of highly specialized furniture and have a deep affection for and understanding of fine tools and excellent workmanship. Competitive in today's market, their products rival commercial cabinetmaking. Not surprisingly, when these two craftsmen were introduced to one another in 1979, they responded sympathetically, displaying a sincere regard for each other's accomplishments and approaches to their craft.[2]

Pictures of these two craftsmen in their shops present a basic problem encountered when pictorial sources are used for interpretive purposes. The layouts of their shops and the step-by-step processes followed in their production routines can hardly be explained through the static medium of still photography. With this in mind, one can better understand the interpretive limits imposed by such famous images as John Singleton Copley's portrait (ca. 1770) of Paul Revere (see Schlereth, fig. 1). Posed with teapot in hand and with some of the tools of his profession spread before him on a table, Copley's Revere is a rare and compelling eighteenth-century image of an American craftsman planning his work. Few paintings or prints of American craftsmen depicted with the implements of their trade exist from the pre-Revolutionary period, and none is known that documents shop interiors. Copley's painting, then, is an extraordinary record of a young goldsmith. Deliberately arresting and thought-provoking, it nevertheless has all the limitations of a single composed image. It can only hint at processes. It does not explain the steps involved in silversmithing and engraving.

Tracing simple construction from beginning to end makes quickly apparent the difficulty of capturing a process in paint, with a camera, or by other means. Sometimes such pictorial limitations can be purposely overlooked when a single splendid image presents itself, like

[2] For Maloof, see John Dreyfuss, "The California Home of Sam and Alfreda Maloof," *American Craft* 41, no. 5 (October–November 1981): 4–8; Robert L. Breeden et al., eds., *The Craftsman in America* (Washington, D.C.: National Geographic Society, 1975), pp. 39, 41; and John Makepeace, *The Art of Making Furniture* (New York: Sterling Publishing Co., 1981), pp. 34–35. For Ionson, see Rick Mastelli, "In Search of Period Furniture Makers: What They Do about What the Old Guys Did," *Fine Woodworking*, no. 23 (July–August 1980): 32–40.

a

Figure 3. State Parlor Frame shop, Roxbury, Mass., 1980: *a*, loading area; *b*, storage and shipping area; *c*, milling or planing area; *d*, ripping the lumber to widths; *e*, squaring off lengths; *f*, boring machine; *g*, band sawing; *h*, carving; *i*, sanding; *j*, turning; *k*, job assembly; *l*, finished chair frames stacked for shipping. (Photos, Jonathan Fairbanks.)

Copley's Revere, which shows one craftsman at work. Nevertheless, the single image cannot tell the whole story. By attentively studying living craftsmen at work in their shops, one can better realize the problems of using pictorial sources to document craft routines. Consider a modern chair shop in Roxbury, Massachusetts. State Parlor Frame Company produces commercial frames for upholstered easy chairs and couches, which interior decorators and upholsterers buy to provide clients with furniture in Queen Anne and Chippendale styles. It is a production shop but does not rely on—or even own—a moving conveyor belt. The manufacturing techniques employed at the shop are not much different from those used by inexpensive furniture factories in the second half of the nineteenth century. There are only a few modern improvements: electrical power sources, high-speed tools, and electric lighting. Employing seven men, the shop is owned by three members of the Winer family, who do all of the skilled work themselves. Figure 3 illus-

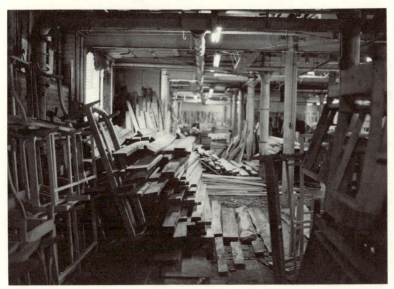

b

c

d

e

f

g

h

i

j

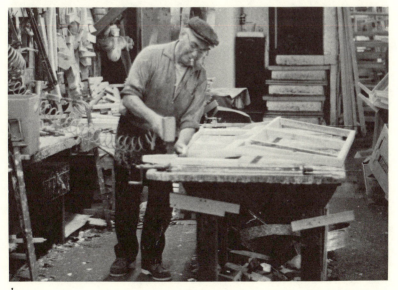

k

1

trates—really only hints at—the steps involved in producing a frame for a wing chair.

The illustrations cannot tell us everything about the organization of the Winers' shop. An interview with the owners revealed that they do not have a precise term to describe each step in the assembly process, but they do share a sense of mutual understanding about what needs to be done. Masses of (interchangeable) parts are made by one man or a team of men who then move on to another work area of the shop, bringing with them necessary parts for the next operation. Thus, while the shop has no moving assembly line requiring constant attention by employees doing the same job year in and year out, it does use some of the techniques of the modern factory. Work is subdivided and assigned to individuals as separate tasks, and assembly operations are simplified down to their most basic steps. However, there is flexibility and variety for the worker because those who make the parts may also assemble

them. Every piece of furniture made in the seventeenth, eighteenth, or nineteenth centuries, no matter how it was fastened together—joined, framed, dovetailed, doweled, or screwed together—went through similar steps in the manufacturing process.

From these illustrations and the interview, the problems involved in isolating complex craft processes or even suggesting the appearance of an active shop in a single engraving, painting, drawing, or photograph become apparent. The illustrators of Denis Diderot's *Encyclopédie* had a formidable task before them when they sought to picture craftsmanship in eighteenth-century Europe. Even modern motion pictures fail to convey completely a schematic sense of craft processes. The necessary delays and repeated actions for curing, setting, coloring, and finishing most products escape the edited film. The spatial organization of a shop and its appearance of activity change constantly during the frantic moments of peak production. The intrusion of an artist or a photographer interferes with routine procedures, and the act of picturemaking itself, like the writing of history, is selective.

With these warnings about the limitations of pictorial documents in mind, let us consider some historical images of early craftsmen to determine what they can tell us about the nature of certain crafts. Fifth-dynasty stone carvings from the tomb of Ti, in Saggara, near Cairo, Egypt, shows men shaping wood, about 2494–2435 B.C. (fig. 4). The image of the carving is difficult to interpret without knowing the meaning of the hieroglyphics or looking at a genuine piece of early Egyptian furniture. The hieroglyphics explain that the craftsmen are smoothing a bed of ebony, sawing wood, and drilling a hole in a chest. Recent research indicates that the round legs characteristic of early Egyptian furniture were fashioned by rasping round sticks. That this was a common production process is apparent from examining heartwood at the core of Egyptian furniture legs. To shape a leg the artisan held the wood vertically with the aid of a hand pad and manipulated it with a rasplike device made of punched copper sheeting attached to a stick. The arrangement of this vertically held wood stock prefigured the design of the turning lathe. Although the Egyptians knew how to use a bow drill, they failed to convert it for use as a lathe, preferring to shape furniture legs in their traditional time-consuming way because plentiful and cheap labor was available to execute such painstaking hand-shaping procedures. There was no demand for a labor-saving lathe, a machine that did not come into use until the eighth century B.C. Even so, this most

Figure 4. Relief carving. Egypt, fifth century B.C. From Georg Stein-
dorf, *Das Grab Des Ti* (Leipzig: J. C. Hinrichs'sche Buchhandlung,
1913), pl. 133 (detail). (Museum of Fine Arts, Boston.)

basic tool of the wood craftsman was not recorded pictorially until 330–
300 B.C., on a tomb of Petosiri in the cemetery of Hermopolis. At least
no pictures of lathes earlier than this survive.[3]

To leap from the ancient world to the early Renaissance in the
Netherlands, we may consider a famous image of Joseph and his car-
penter's tools represented in *The Merode Altarpiece* (fig. 5), completed
by Robert Campin about 1428 and now owned by the Cloisters in New
York City.[4] The tools painted on the right section of the triptych are
convincingly real—they seem to have been observed from life and
therefore present a useful record of fifteenth-century tool forms. But,
even so, their selection is symbolic, like other elements in the triptych,

[3] A translation of the hieroglyphics by Edward Brovarski, assistant curator of the
Egyptian Department, Museum of Fine Arts, Boston, describes the activities of the three
craft groups as follows: "Sawing with a saw, . . . smoothing a bed of ebony by the polisher
of the mortuary estate, . . . drilling a chest by a carpenter." The figures in the upper
register illustrate the process of making sculpture. Fred Lucas (revised by J. R. Harris),
Ancient Egyptian Materials and Industries (London: Edward Arnold, 1962), pp. 448–
54, shows that the basic tools for Egyptian woodworking included adzes, axes, chisels,
reamers, saws, bow drills, polishing blocks, and wooden mallets. Other useful books
about ancient craft methods and tools include Hollis S. Baker, *Furniture in the Ancient
World: Origins and Evolution*, 3100–475 B.C. (New York: Macmillan Publishing Co.,
1966); and W. M. Flinders Petrie, *Tools and Weapons* (London: British School of
Archaeology in Egypt, 1917).

[4] Erwin Panofsky, *Early Netherlandish Painting*, vol. 2 (Cambridge, Mass.: Harvard
University Press, 1953), pl. 91.

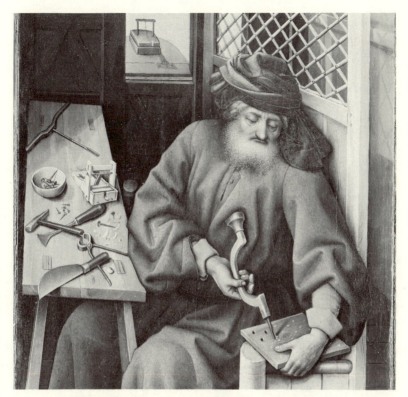

Figure 5. Robert Campin, *The Merode Altarpiece*. Ca. 1428 (detail of right panel). Oil on wood. (Metropolitan Museum of Art, Cloisters Collection, New York.)

and they probably do not represent a full range of carpenter's equipment.

A more complete assortment of woodworker's tools is found in Moxon's *Mechanick Exercises*, first published in London in 1679. It is the earliest illustrated book in the English language that explains craft processes and tools in an orderly fashion (fig. 6). The book was probably of little use to seventeenth-century craftsmen, who had produced elaborate workmanship for generations without the aid of printed pictures or instruction books. Moreover, the usefulness of the plates for understanding the process of craftsmanship is fairly limited; the illustrations

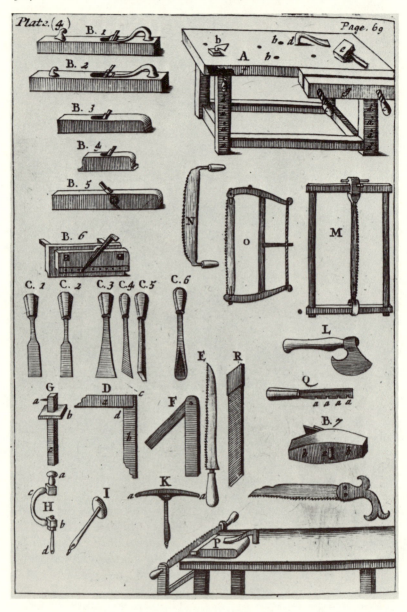

would hardly have served as an instructive guide to anyone who had even rudimentary experience in shop practice. But *Mechanick Exercises* does help the modern scholar to identify terms associated with tools, and, in its own time, the book did serve an important purpose. Without its standardization of terms and illustrated plates, there would have been no way for widespread craft industries to develop since it would have been impossible to purchase reliably through agents parts and tools sight unseen.

In the eighteenth century, to satisfy further the need for standardization, Diderot and other encyclopedists were instrumental in cataloguing and publishing in systematic order the tools and working procedures of craftsmen at labor. The famous illustrations from Diderot are too well known to discuss at length. However, it should be observed that in many of his plates several craft activities or different sequential steps in the assembly process are pictured in a single image, as if they were occurring simultaneously. Potentially misleading for the modern viewer, this was actually a conventional graphic device used for the sake of economy. It was a standard practice readily understood by most contemporary viewers.

Making intelligent use of such pictorial sources as Andre-Jacob Roubo's great work, *L'art du Menuisier* (1769–75), Diderot's *Encyclopédie* (1751–65), illustrated trade catalogues, and such modern books as Charles Hummel's *With Hammer in Hand* (1968), the student of early industrial history may gain a fair notion of actual craft processes now largely things of the past.[5] In the case of Hummel's book, which catalogues and discusses the Dominy shops and tools at Winterthur

[5] Andre-Jacob Roubo, *L'art du Menuisier*, 3 vols. (Paris: L. F. Delatour, 1769–75); Denis Diderot, ed., *Encyclopédie, ou dictionnaire raisonné des sciences, des arts, et des metiers*, 17 vols. (Paris: Briasson, 1751–65). Charles F. Hummel, *With Hammer in Hand: The Dominy Craftsmen of East Hampton, New York* (Charlottesville: University Press of Virginia, 1968), sets high standards for American studies in systematic analyses of tools used by the Dominy family of craftsmen in their eighteenth- and nineteenth-century East Hampton, Long Island, shops. Worth noting also is Paul B. Kebabian and William C. Lipke, eds., *Tools and Technologies: America's Wooden Age* (Burlington: University of Vermont, 1979), which deals with woodworking methods and tools from both historical and contemporary viewpoints.

Figure 6 *(facing page).* Joiner's tools. From Joseph Moxon, *Mechanick Exercises; or, The Doctrine of Handy-works* (London: Printed for D. Midwinter and T. Leigh, 1703), pl. 4. (Winterthur Museum Library.)

Museum, there is the rare advantage of being able to study woodworking and clockmaking tools of the eighteenth and nineteenth centuries from a single, well-preserved historical site. One can move from the book to the museum display and even see the tools in actual use.

No better opportunity is provided for understanding the nature of tools than from live demonstrations. Through these, the craftsman's shop gains a dynamic character: chips of wood fly, templates guide scribed lines, planes reveal the elegance of freshly shaped wood. Sharp-edged tools are beautiful in themselves, but even more so when put to use making something fine under an intelligent hand. The word *craftsmanship* takes on a special meaning for the observer of craft processes. No written description or two-dimensional image can do justice to the actual experience of making a deftly riven piece of oak or a beautifully mitered, mortised, tenoned, pegged, or bent piece of wood. The sensations of touch and smell cannot be fully and finally conveyed with words or pictures. These senses crave exposure to the bench, where multiple parts come together systematically in an environment that, to a passing observer, may seem only chaotic.

Lest we retreat entirely into romantic nostalgia for the good old days of handcraftmanship, it must be observed that fine craftsmen are the first to welcome labor-saving devices into their shops. They especially desire to use those machines that help systematize and increase production. English ceramic entrepreneur Josiah Wedgwood (1730–95) was distinguished in the eighteenth century for his perfection of efficient production methods. In 1790, 178 men, women, and children at his Etruria works were arranged in a protomodern production line. All but five of these laborers had specialized tasks to perform. The pottery at Etruria moved continuously from hand to hand and person to person, a procedure that replaced the traditional method in which the potter moved from piece to piece. Through this basic change in work habits, production was increased immensely and the quality of workmanship was improved.

In 1866 Eliza Meteyard wrote an illustrated history of Wedgwood's life that, unfortunately, failed to represent accurately the factory in its heyday of productivity. The book's illustrator, identified only as Mr. Pearson, depicted the throwing room at Etruria as it was supposed to have appeared in June 1769 when Wedgwood and his friends came riding into the new factory and summarily threw six vases, to the cheers of admiring visitors. What the illustrator depicted was a conventional

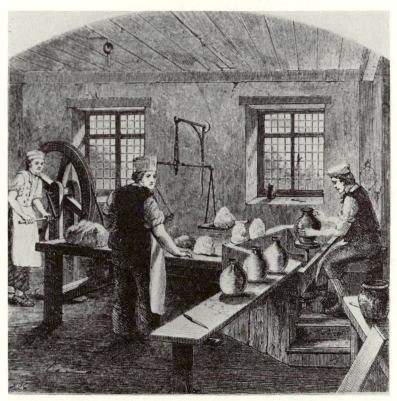

Figure 7. [Mr. Pearson], *Throwing Room, Ornamental Works, Etru-ria.* From Eliza Meteyard, *The Life of Josiah Wedgwood*, vol. 2 (Lon-don: Hurst and Blackett, 1866), p. 111.

small-scale pottery shop hardly big enough to have produced the quan-tity of goods Wedgwood regularly displayed for sale in London (fig. 7). Meteyard's biography of Wedgwood and the illustrations it contains fail to note the single most important innovation of the Wedgwood pottery operation, the assembly line, which, of course, had a profound impact upon other crafts at the turn of the century.[6]

The successful craftsman-entrepreneur of the nineteenth century

[6]Eliza Meteyard, *The Life of Josiah Wedgwood*, 2 vols. (London: Hurst and Blackett, 1865–66). I am indebted to Gale Andrews Trechsel, assistant director, Birmingham (Ala-bama) Museum of Arts, for the Wedgwood references.

Figure 8. Billhead, R. Gleason and Sons. Dorchester, Mass., 1870s.
(Museum of Fine Arts, Boston.)

usually had his home, office, and factory close together, as illustrated
in a late nineteenth-century woodcut of a billhead for Britannia-metal
manufacturer and pewterer Roswell Gleason (1799–1887) of Dorches-
ter, Massachusetts (fig. 8). The office and factory were owned and man-
aged by Gleason, whose home was no more than a block or two away.
The buildings still survive, although vastly altered in appearance. Daily
surveillance of the factory to insure that production levels were being
maintained was essential to the success of manufacturers like Gleason,
whose small tinsmith's shop had rapidly evolved into a successful metal-
working factory. Significantly, then, it was not until assembly-line pro-
duction became commonplace that manufacturers could afford the luxury
of offices and homes far removed from factory sites. The assembly-line
method of production made it possible to measure with some accuracy
and without continued observation the failure of any single person to
keep pace.[7]

Productive and cheap labor was one important ingredient of suc-
cess; another was proximity to cheap transport for raw materials and
distribution of products. An 1820 New York advertisement for Thomas
Ash, a fancy and Windsor chair manufacturer, illustrates his shop near
a wharf (fig. 9). Whether the engraving represents a real or an idealized
relationship of shop and wharf is unimportant. The message of the image
is clear: transportation and profitable manufacturing enterprises go hand
in hand.

[7] Many of my thoughts on craft processes derive from Melvin Kranzberg and Joseph
Gies, *By the Sweat of Thy Brow: Work in the Western World* (New York: G. P. Putnam's
Sons, 1975), a study of the social issues of craft, work, and the production process.

Figure 9. Advertisement for Thomas Ash, Windsor- and fancy-chair manufacturer. From *Longworth's American Almanac, New-York Register, and City Directory* (June 1820): inside back cover. (Winterthur Museum Library.)

During the nineteenth century, as America underwent vast national growth and internal improvements, advertisements often excluded representations of craftsmen at work. Instead, information notices such as an 1822 trade card for J. and L. Brewster (fig. 10), hatmakers of New York City, simply illustrated the familiar allegorical figure of America seated with shield, eagle, and packing crates before tall masts of ships in the distance. Patriotism, federal protection of trades, and encouragement of commerce are ideas embodied in innumerable engravings of the early nineteenth century.

A wood engraving of a craftsman planing a board at his bench (fig. 11), published in *Parley's Magazine* in 1836 is a fairly representative image for its period. Accompanying an article titled "The Joiner," it illustrates a master and his apprentice or journeyman surrounded by a typical clutter of tools and materials. It is highly simplified in its composition, almost to the point of abstraction from reality. Several interesting observations can be made about the picture. The most obvious is the prominence given to the workbench in front of a window. Almost all early illustrations of workbenches feature this arrangement, as it was necessary to shed daylight on the work at hand. With the invention of

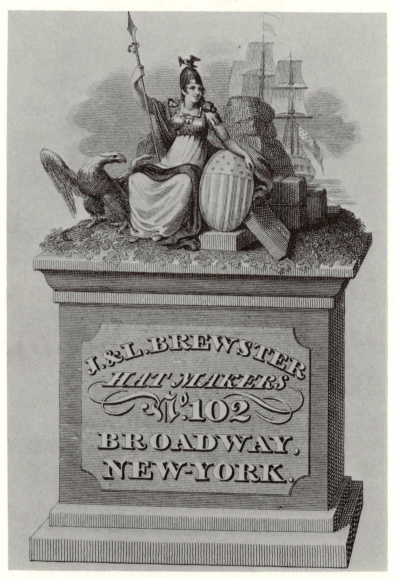

Figure 10. Trade card, J. and L. Brewster. New York, 1822. (Winter-thur Museum Library.)

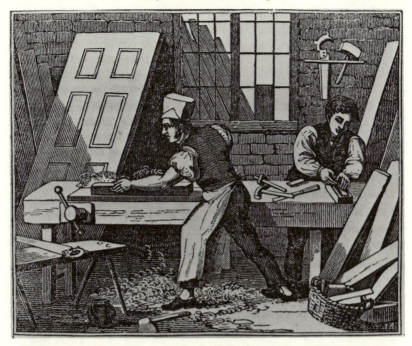

Figure 11. [Alexander Anderson], *The Joiner*. From *Parley's Magazine*, pt. 15 (New York and Boston: Charles S. Francis and Joseph H. Francis, [1836]), p. 249. (Winterthur Museum Library.)

the incandescent electric light bulb in 1879, the necessary relationship between workbench and window began to change, as did working hours. Greater efficiency of production came not only through changing alignments of working spaces with conveyor belts but also through continuous use of shop machinery at all hours, day and night.

The illustration in *Parley's Magazine* brings to mind another basic issue associated with using early pictorial materials to glean historical data about early craftsmen. Most illustrations derive from secondary sources unrelated in time or location to the specific subject pictured. Although this wood engraving shows an American craftsman at work, there is no reason to believe that it was based on actual observation of an American scene. Indeed, the print, by wood engraver Alexander Anderson (1775–1870), composed in the long-standing tradition of quick hack illustrating, may have been based on an earlier, more detailed

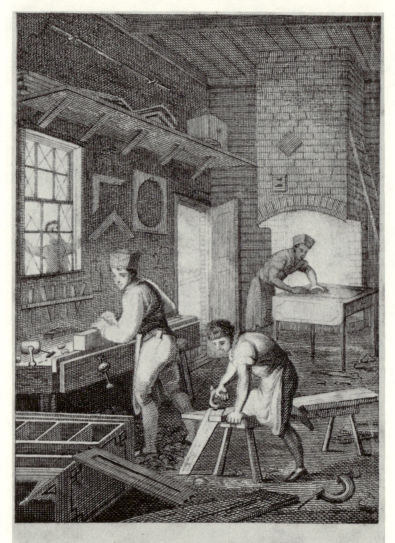

CABINET MAKER'S

GUIDE.

illustration, like the one etched in London in 1825 to face the title page of a book printed in Dublin entitled *The Cabinet Maker's Guide* (fig. 12).

Historians should be wary of the historical accuracy of illustrations that modern picture editors often provide for texts. More often than not, the illustrations most readily available are most misleading. It is advisable to steer clear of—or at least to question—the generalized, often inventive illustrations frequently ornamenting the pages of old trade books such as Edward Hazen's *Popular Technology*, published in New York in 1842, the first trade book to feature illustrations by an American artist of American craftsmen at work. Although quaint, decorative, and visually compelling, these cuts fail to render specific details about the nature of the crafts depicted because their imagery is generalized and sometimes overly propagandistic. Their accuracy is often further compromised by interpretive translations from the draftsman to woodcut artist and finally to printer.[8]

In contrast to such prints of doubtful accuracy, a wonderful example of *specificity* is provided by an early nineteenth-century oil painting in the collection of the Newark Museum (fig. 13). Attributed to Johann Heinrich Jenny, the painting portrays the home, shop, and store of fancy-chair maker David Alling (1777–1855) on Broad Street, Newark. In front of the shop and store are painted side chairs similar to, but not quite identical with, those made by Alling, also now in the collection of the Newark Museum. This unusual and welcome historical convergence of image with documented object—especially in the same collection—often stimulates the development of instructive exhibitions.

In an 1842 Boston almanac, a view appears of a portion of S.N. Dickinson's printing office (fig. 14). The legend at the base of this woodcut

[8] Edward Hazen, *Popular Technology; or, Professions and Trades*, 2 vols. (New York: Harper and Co., 1842). Generous use of pictorial sources showing craftsmen at work and their products continues to gain favor with book publishers despite rising printing costs. See Breeden et al., *Craftsman in America*, as an indication of the public taste for illustrated books on craftsmen; and a more historically directed book, Edward Lucie-Smith, *The Story of Craft: The Craftsman's Role in Society* (Ithaca: Cornell University Press, 1981).

Figure 12 *(facing page)*. Frontispiece, George A. Siddons, *The Cabinet Maker's Guide; or, Rules and Instructions in the Art of Varnishing, Dying, Staining, Japanning, Polishing, Lackering, and Beautifying Wood, Ivory, Tortoiseshell & Metal* (Dublin: Printed for Knight and Lacy, 1825).

Figure 13. *House and Shop of David Alling, Newark Chair Maker,* 1777–1855, attributed to Johann Heinrich Jenny. Newark, N.J., early nineteenth century. Oil on canvas; H. 21″, W. 30″. (Newark Museum.)

print informs the reader that the business has expanded from one to five stories on Boston's Washington Street over a ten-year period, suggesting that it is now large enough to do all manner of printing required by the most skilled workmen in the trade. To demonstrate the kind of fancy printing available, Dickinson cleverly exhibits a specimen page in his ad, embellished in ornamental classical fashion. Dickinson apparently was proud of his up-to-date rotary press and what it could accomplish. The illustration of the shop interior combined with an example of the shop's product is a powerful evocation of the craftsman's world. The shop interior and its legend, as well as the specimen page, are obviously advertising propaganda for the printer, but we can sense the presence of the printer here, who probably supervised the execution of his advertis-

Figure 14 *(facing page).* *View of One Section of Dickinson's Printing Office.* From S. N. Dickinson, *The Boston Almanac for 1842* (Boston: Thomas Groom, 1842), facing p. 8. (Winterthur Museum Library.)

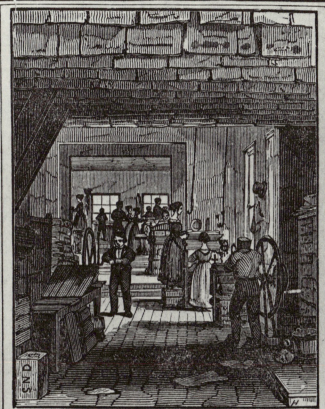

View of one Section of Dickinson's Printing Office.

No. 52 Washington St., Boston.

From the above view the beholder may gather some idea of the results of our labor. Ten or twelve years ago, we commenced our business in one small room. Since then we have added room after room, as our business required, till we have spread ' the implements of the world's intelligence,' over five stores on Washington street, and pushed our *territory eastward* from Washington street, as far back as Wilson's Lane ; and which, for the present, seems to be the *boundary line* to our ambition in that quarter. Well, we begin to think our office large enough, and full enough of every requisite thing for the execution of all the kinds of Printing the world ever saw — certainly enough, we think, to suit the fancy of any customer that may come along : from him whose wants are of the most ordinary kind, to him who aspires to the most costly and elaborate productions of our office. To sum up the whole, WE ARE PREPARED TO EXECUTE ALL KINDS OF PRINTING IN THE BEST AND MOST EXPEDITIOUS MANNER ; having an abundance of room and materials, and some of the most skilful workmen belonging to the trade. Jan. 1842.

ing illustration. The woodcut in *Parley's Magazine*, for example, lacks such immediacy.

Although the crafts of printing books and printing wallpaper are quite different, there are similarities between them in materials and techniques. Both crafts are governed by yet another craft, that of papermaking. As long as papermaking was confined to a reliance on hand-held frames in which paper pulp was scooped and strained, the dimensions of both wallpaper and printing paper were restricted. In the late eighteenth century, however, this process underwent important changes. By 1799 the technology for making a continuous web of paper had been developed by Nicholas-Louis Robert in France. In 1804 the patent for Robert's invention was purchased by Henry and Sealy Fourdrinier of London, who developed a machine in the early nineteenth century that made printing on a continuous roll practical. This invention enabled Thomas Gilpin to install the first American continuous papermaking machine along the Brandywine Creek near Wilmington, Delaware. Soon a diversity of papermaking machines vied for popularity, as suggested by the numerous illustrations of these devices featured in *Knight American Mechanical Dictionary* of 1874. Edward Knight's three-volume dictionary provides for decorative arts scholars a rich source of pictorial images of machines and explanations of their operation.[9]

Continuous papermaking was a precursor of the moving production line in other crafts. Obviously, the production of wallpaper in large quantities depended upon the availability of paper in rolls. The commercial advantage lay in the elimination of much hand labor that had been necessary in block printing designs onto individual sheets of paper. Web-fed rotary presses were the new means of producing designs on paper for decorative purposes—virtually the same machines, of course, that made possible large-scale printing of books, magazines, and newspapers. Note, however, that an 1881 view of a twelve-color printing machine shows that Fr. Beck and Company failed to realize fully the advantages of continuous printing (fig. 15). At the end of the line, the paper is shown looped for drying. A more enterprising manufacturer would have kept the line moving by using a drying chamber or other fast-drying method to insure that the finished product could be immediately readied for shipping.

[9] Edward H. Knight, *Knight's American Mechanical Dictionary*, 3 vols. (New York: J. B. Ford and Co., 1875).

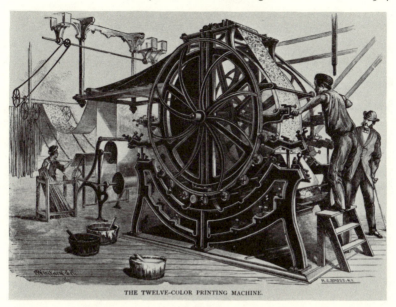

THE TWELVE-COLOR PRINTING MACHINE.

Figure 15. *The Twelve-Color Printing Machine.* From Fr. Beck and Company, *Artistic Wall Papers Designed and Manufactured by Fr. Beck and Company* (New York: New York and Brooklyn Publishing Co., 1881), n.p. (Winterthur Museum Library.)

By the late nineteenth century the continuous manufacture of goods made possible, through standardization of machine parts, the development of precision tooling. The efficient use of employees—the so-called American system of manufacture—now became the wonder of the modern industrial world. But the story of mass production, which led to automation in the twentieth century, carries us away from our focus on handcraftmanship.

Not all historical images celebrate industrial progress. Toward the end of the nineteenth century there was a renewed interest in the handicraft tradition. Two illustrations make this point (figs. 16, 17). In both paintings the central figures are old, wise men who have something important to teach their viewers. *The First Lesson*, by Henry Alexander (1860–94), shows an old taxidermist skinning a meadowlark as a young boy watches him. The interior of his shop is rendered with intense sensitivity. The room is filled with exotic stuffed birds and animals,

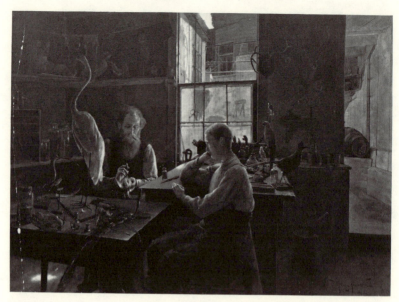

Figure 16. Henry Alexander, *The First Lesson*. San Francisco(?), 1890. Oil on canvas; H. 25″, W. 34″. (M. H. de Young Memorial Museum, Mildred and Anna Williams Fund.)

translucent bottles, and light that streams through a window across the workbench. Splendid beams of prismatic light rake across the taxidermist's hands and fall in a white splash on the floor. The dusty window-panes are meticulously rendered; every detail in the room seems magically alive and real. Yet for all the brilliance of his observation, the painter has committed technical errors. No skillful taxidermist would handle the bird as we see here, nor would he hold his knife in such a peculiar manner to slit the skin on the bird's sternum. The specimen would be positioned on a table with some sawdust or cornmeal readily available to dust the opening made as the bird was skinned. No doubt the artist has taken some liberty with his subject for the sake of clarity and poetic emphasis; criticism of the artist's observations in no way detracts from the remarkable luminosity of the painting and its authoritative treatment of detail, texture, depth, and character.

The second painting, executed in 1899 by Jefferson David Chal-fant, is entitled *The Old Clockmaker*. An obvious tribute to old age and

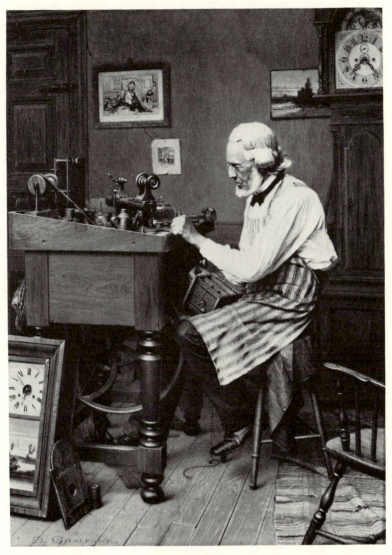

Figure 17. Jefferson David Chalfant, *The Old Clockmaker*. Wilmington, Del., 1898 or 1899. Oil on copper; H. 13⅛″, W. 9½″. (M. H. de Young Memorial Museum, Collection of Mr. and Mrs. John D. Rockefeller 3rd: Photo, O. E. Nelson.)

antiques, it was painted in the heyday of the colonial revival, an era of nostalgic taste. Conceived at a time when mass production and large factories were becoming increasingly dominant in the world of the American craftsman, the painting represents a reaction against progress. The scene, although particular in detail, embodies a universalized notion of craftsmanship. The image reflects what was considered the simple dignity and personal control of life and product that craftsmen of bygone days enjoyed. The painting pays homage to the era of handcraftmanship that the painter must have felt was jeopardized by the modern world, and to some degree the success of its message rests on our own curiosity about past craft processes.

While it is impossible to turn with full confidence to early pictures as trustworthy sources for precise information about early American crafts, this does not mean that early pictorial sources are useless in understanding and appreciating our past. Indeed, early pictures serve as mirrors to the past, sometimes distorted or imperfect, but nonetheless means by which we may reflect upon and, in part, enter into a visual world now gone.

Index

Page numbers in **boldface** refer to illustrations.

9143

ELIZABETHAN MUSIC

and

Musical Criticism

By

MORRISON COMEGYS BOYD

SECOND EDITION

Philadelphia

UNIVERSITY OF PENNSYLVANIA PRESS

To

Miss Amy Comegys

Preface

IT is the purpose of this book to assemble the comments concerning English music, its practices and composition, during the period represented by the reigns of Queen Elizabeth and King James (1558–1625); to summarize the works on musical theory published in England between those dates; and to illustrate the Elizabethan attitude and opinion as to music in theory and practice. It is a commonplace of history that the artistic and literary impulses of these two reigns were one and continuous. This is equally true of music. But with the conclusion of the reign of James, this artistic impetus failed and taste was changing. The noble madrigal especially was dying, and the music of the reign of Charles I was so comparatively unimportant and spiritually remote from that of Elizabeth's time that it has seemed best to conclude our main inquiry with the death of James. But there were writers on the theory of music who though writing in Charles's time, like Bevin and Butler, express the views of the past. Those have been therefore included, with Anthony Wood as well, who, writing at Oxford during the latter half of the seventeenth century concerning the music of an earlier day, is far too important to ignore. Wood's information was much of it doubtless derived by word of mouth, for it is well known that he was accustomed to quote his older contemporaries in the conduct of his antiquarian researches.

Although it was my original intention to present only criticism written by Elizabethans, I soon realized that I should have to describe briefly the object or music criticized and add a modern appraisal of it, otherwise no reader not blessed with omniscience could picture or grasp what the Elizabethan commentator was discussing, let alone agree or disagree with him. Consequently this book has become, somewhat unexpectedly, a short account of Elizabethan music. It is in essence a com-

pilation, and I shall be glad to hear of any interesting material that has escaped my notice.

Elizabethan spelling has been preserved in the quotations of this study, except that the vowel *v* and the combination *ij* have been replaced by our modern *u* and *ii,* and the consonants *u* and *i* by *v* and *j.* The original punctuation, too, has been retained except in a few instances where such marks would be misleading. The word *Elizabethan* refers here to the reigns of both Elizabeth and James I. The date of any year covers a period from the first day of January to the last day of the December following, in accordance with our present system.

I wish to express my gratitude to Professor Felix E. Schelling of the Department of English of the University of Pennsylvania for his unfailing kindness and numerous constructive suggestions.

In this second edition certain minor changes have been made in the text, and the bibliographies have been enlarged and brought up to date.

M.C.B.

Contents

Illustrations

I

Music in High Places

ENGLAND was young again in the reign of Elizabeth. The reigns of Henry VII and Henry VIII had given time for a middle class to develop, and for minds to turn to culture. With Erasmus came a new interest in the humanities; and increasing intercourse with Italy brought in Italian literature, architecture, art, and music. The discoveries in the New World fired men's imaginations, and England's pride in her growing political power resulted in an ever growing power of self-expression. Incessant religious controversies acted as a leaven in men's minds. The atmosphere at court was comparatively democratic. Men of talent flocked to the universities, and as a result of their contact there with the classics carried on interesting dramatic, metrical, and stylistic experiments. Elizabeth herself, the eternal feminine, capricious but intelligent, who loved valor and could inspire it in others, was well educated and a patron of the arts, a figure to whom the country looked with admiration, a vivifying force. Each of these factors contributed its share toward making the Elizabethan era the greatest in the history of English literature.

The advance of music during her reign in social importance and artistic excellence closely paralleled that of literature. During the first years after her accession the serious study of music had seemed to many a pursuit both unnecessary and unworthy, since it had been associated chiefly with the composition and singing of complicated Papist music. Secular music had not yet risen to the dignity of a fine art, and the only religious music considered suitable for church use early in her reign was of the simple harmonic type preferred by the Puritans. The production of masterpieces was hardly possible under such conditions. Never-

theless the Queen and other friends of music rallied to its support, some contrapuntal compositions were written by such men as Tallis and Tye, and when the ecclesiastical authorities became more tolerant toward the end of the century many glorious compositions of that kind appeared. Byrd in particular wrote Latin masses for the Catholic service, Latin motets more suitable for Catholic than for Anglican use, and, in addition, anthems in English intended for the latter church. When these men with Catholic sympathies passed away they were succeeded, in the time of King James, by a generation of Anglican composers, such as Gibbons, who set all of their religious music to English words, for their own liturgy. They abandoned the stiffer Puritan style, without committing the contrapuntal absurdities to which the Puritans objected in some of the more extravagant pre-Reformation composers. The importance of Elizabethan religious music has become well recognized in the last few years, and Byrd now ranks with Palestrina, di Lasso, and Victoria as one of the four greatest composers of the sixteenth century, whether or not we agree with certain modern British critics in calling Byrd the greatest of the four.

But the chief glory of the Elizabethan musical age was its secular music for voices. This consisted of madrigals for several voices unaccompanied, and ayres[1] for solo voice accompanied by a lute. The madrigal arose in Italy, but reached a fuller development in England. Only one collection of madrigals was printed in England prior to the appearance of Byrd's first set in 1588. Before 1600, twenty sets had been published. The ayre is characteristically English, although the Florentines

[1] The word *ayre* means an Elizabethan song for a single voice. Nowadays the word has commonly come to imply that the accompaniment was for lute. Therefore in this book ayre means a solo song with lute accompaniment. To use the word also in the modern sense of *part-song*, meaning that the tune is sung by the soprano or top voice and the accompaniment is for other voices, is historically correct but confusing. It has never been easy to draw hard and fast lines between part-songs and similar compositions of a more contrapuntal character; and it is consequently convenient to classify as madrigals all Elizabethan secular compositions, whether contrapuntal or not, that were written for several voices singing in parts and lacked even optional instrumental accompaniments.

had been experimenting with solo singing. The first English ayres, by Dowland, were published in 1597. Some of the earliest were among the best. No keyboard music was published before the reign of King James, presumably because earlier printers reckoned that the cost of setting up such complicated music in type[2] would be greater than the sales would warrant. Numerous excellent compositions, however, have come down to us in manuscript. A fair amount of music for other instruments, particularly lute and viols, was printed. Among theoretical works may be mentioned *The Praise of Musicke,*[3] 1536, by John Case, who was so seriously alarmed by the bitter attacks then being made upon our art that he deemed it necessary to issue this defense of it. Treatises were also published dealing with counterpoint, composition, sight-singing, acoustics, and lute-playing. But there were no musical histories, no biographies, no works of comment, and no general account of contemporary music, either English or continental.

Before we set forth in detail the ideas of the Elizabethans concerning their own music, let us digress into some account of the enjoyment they must have received from it, from part singing or congregational singing, for example.

From Morley's *A Plaine and Easie Introduction to Practicall Musicke* (1597) we learn that a well-educated Elizabethan was expected to be able to sing at sight. In the imaginary conversation that forms the framework of the book, one of the characters confesses that while he was spending the previous evening at a friend's house, music books were passed about and he had had to confess his inability to sing at sight. General incredulity followed, and finally "every one began to wonder, yea some whispered to others, demanding how I was brought up."[4] Later, Henry Peacham the Younger urges an ability "to sing your part sure, and at the first sight, to play the same upon your violl"

[2] See p. 178. [3] For a description of this book see pp. 29–31, and Appendix C.

[4] For modern books tying Elizabethan music to its environment, see *Music and Poetr of the English Renaissance,* by Bruce Pattison, 1948, and *A Social History of Englis Music,* by E. D. Mackerness, 1964.

and lute, as among the requisites to the equipment of his Compleat Gentleman.[5] The frequency with which Elizabethan stage characters are required in their rôles to sing or play upon the lute, furnishes a further proof that musical accomplishment was widespread and a part of Elizabethan everyday life. And yet human nature was much the same then as now. Robert Burton, in *The Anatomy of Melancholy* (1621), tells us,

Our young women and wives, t ley that being maids took so much pains to sing, play and dance, with su(h cost and charge to their parents to get these graceful qualities, now beir g married will scarce touch an instrument, they care not for it.[6]

William Chappell wrote of this era,

Tinkers sang catches; milkmaids sang ballads; carters whistled; each trade, and even the beggars, had their special songs; the base-viol hung in the drawing room for the amusement of waiting visitors; and the lute, cittern, and virginals for the amusement of waiting customers, were the necessary furniture of the barber's shop. They had music at dinner; music at supper; music at weddings; music at funerals; music at night; music at dawn; music at work; and music at play.[7]

A remarkable manifestation of the popular enthusiasm for music took place shortly after Elizabeth's accession. During this period of great religious and political thanksgiving the people could best express

[5] *The Compleat Gentleman,* p. 100 in the 1634 edition.

[6] Robert Burton, *The Anatomy of Melancholy,* Partition 3, Section 2, Member 3 (p. 577 in the 1907 edition). Richard Mulcaster also made this observation in his *Positions . . .,* 1581. See the edition by R. H. Quick, 1888, p. 177.

[7] *Old English Popular Music,* 1893, p. 59. Chappell quotes various Elizabethan allusions to music-making by barbers, smiths, tinkers, cloth-workers, etc., on pp. 61–68. A reference to the enthusiasm of shoemakers for music occurs in *The Gentle Craft,* by Thomas Deloney, 1597. In his story of "Master Peachey and His Men," Chapter 2, shoemakers ask Harry (who is masquerading as a shoemaker) "if he could sing, or sound the trumpet, or play on the flute, or recon up his tooles in rime . . ." and when Harry admits he can do none of these, his friend pretends to account for this strange state of affairs by alleging that Harry has only recently become a shoemaker.

their emotions through music. In 1560 Bishop Jewel wrote to Peter Martyr:

A change now appears more visible among the people; which nothing promotes more than the inviting them to sing Psalms. This was begun in one church in London, and did soon spread itself, not only through the city, but in the neighboring places: sometimes at Paul's Cross, there will be six thousand people singing together.

That this enthusiasm continued to animate the people is proved by what we hear of the singing of psalms in York Cathedral while York was besieged in 1644:

Abundance of people being shut up in the city, all or most of them came constantly every Sunday to hear public prayers and sermon, the number was so exceeding great, that the church was (as I may say) even *cramming* and *squeezing full*. Now here you must take notice, that they had then a *custom in that* church, (which I hear not of in any other cathedral, which was) that always before the *sermon,* the *whole congregation sang a Psalm,* together with the *quire and the organ;* and you must also know, that there was then a most *excellent-large-plump-lusty-full speaking organ,* which cost (as I am credibly informed) a *thousand pounds.* This *organ,* I say, (when the *Psalm* was set before the *sermon*) being let out, into all its fulness of stops, together with the quire, began the *Psalm.* But when *that vast-conchording unity* of the whole *congregational-chorus,* came (as I may say) *thundering in,* even so, as it made the very *ground shake* under us; (*Oh the unutterable ravishing soul's delight!*) in the which I was so *transported* and *wrapt* up into *high contemplation,* that there was no room left in my *whole man,* viz. *body* and *spirit,* for any thing below *divine* and *heavenly raptures.*[8]

The Tudor monarchs were intellectually talented, and all were interested in music. Henry VIII could sing at sight—an accomplishment that became fashionable and common only in the reign of Elizabeth. He was a composer of some ability, wrote anthems and two masses, and

[8] Thomas Mace, *Musick's Monument* (1676).

could play the flute, recorder, virginals, and lute.[9] Peacham says in his *Compleat Gentleman,* 1622:

> King Henry the eight could not only sing his part sure, but of himselfe compose a Service of foure, five and sixe parts; as Erasmus testifieth.

Edward VI is said to have been taught music by Tye,[10] and played the lute. His sister Mary at the age of ten performed upon the virginals and lute before company; at this youthful debut "she played very well, and was of all folk there greatly praised." Her cousin Mary Queen of Scots played the virginals. Rizzio entered the employ of the Scottish queen as a bass singer:

> Now there came here [to Edinburgh] in company with the Ambassador of Savoy, one David Riccio of the country of Piedmont, who was a merry fellow, and a good musician. Her Majesty had three valets of her chamber who sung three parts, and wanted a bass to sing the fourth part. Therefore they told her Majesty of this man, as one fit to make the fourth in concert. Thus he was drawn in to sing sometimes with the rest; and afterward when her French Secretary retired himself to France, this David obtained the said office.[11]

He also took part in masques, of which she was very fond. Her son James I was not musical. His surprising eagerness to hear a young girl play the jew's harp was probably due to the fact that she was reputed to be a witch.[12] But he saw to it that both of his sons, Henry and Charles, received a good musical education.

[9] The Venetian ambassadors in 1515 wrote of Henry VIII: "He is so gifted and adorned with mental accomplishments of every sort that we believe him to have few equals in the world. He speaks English, French, and Latin, understands Italian well, plays almost every instrument, and composes fairly; is prudent, and sage, and is free from every vice."

[10] In Samuel Rowley's play *When You See Me You Know Me,* 1613. The excerpts in question are given in Appendix D.

[11] *Memoirs of Sir James Melville of Halhill,* 1537–1617, edited by Archibald Francis Steuart, 1929, p. 103.

[12] Percy A. Scholes, *The Puritans and Music in England and New England,* 1934, p. 382.

Queen Elizabeth's musical accomplishments and predilections were so well known, and must have served as models for so many of her subjects, that she is an excellent example of a cultured amateur of the period. Her tutor, Roger Ascham, observed with refreshing candor in 1550: "In music she is very skilful but does not greatly delight." Still, she was only seventeen at the time, and he was not very fond of music. Richard Mulcaster wrote in 1575:

> The Queen, the glory of our age and isle
> With royal favor bids this science smile;
> Nor hears she only others' labor'd lays,
> But, artist-like herself both sings and plays.[18]

And Camden adds:

Neither did she neglect Musicke, so farre forth as might beseeme a Princesse, being able to sing and play on the Lute prettily and sweetly.[14]

She herself said:[15]

I maintain at least sixty musicians, and in my youth I danced very well, composed ballets and music, and played and danced them myself.

She enjoyed music of many kinds. More than once on her way from Hatfield to London she took the trouble to stop at Shoreditch Church in order to listen to the fine bells, which she praised with her usual en-

[18] "Regia majestas, aetatis gloria nostrae;
 Hanc in deliciis semper habere solet,
 Nec contenta graves aliorum audire labores
 Ipsa etiam egregie voce manuque canit."
The English translation, in *Biographia Britannica,* 1746–66, p. 1007, is from Mulcaster's Latin in Tallis and Byrd's *Cantiones Sacrae* of 1575.

[14] William Camden's *Annales rerum Anglicarum et Hibernicarum regnante Elizabetha,* 1615, translated by "R. N. Gent." as *Annales, or the History of the Most Renowned and Victorious Princesse Elizabeth, late Queen of England,* 3d edition 1635, p. 7 of the Introduction.

[15] To the French Ambassador, according to Frederick Chamberlin in *The Sayings of Queen Elizabeth,* 1923, p. 306.

[7]

thusiasm; and Tirwitt, Subdean of her Majesty's Chapel, wrote to Lord Burghley that Queen Elizabeth had commanded him "to devise her a chime . . . to have it playe pavens and galliardes, or any other songe." In 1591 she was entertained by Lord Hertford at Elvetham. Music that she heard there included settings of "Eliza is the fayrest Queen" and "Come againe," probably by Edward Johnson. At the concert that included the former of these, "This spectacle and musicke so delighted her Majesty, that shee commanded to heare it sung and to be danced three times over." A pavane by Thomas Morley also pleased her, and her host entertained her with a great variety of other music as well, including madrigals probably by Byrd and Michael East. At the close of her visit,

As her Majestie passed through the parke gate, there was a consort of musicions hidden in a bower; to whose playing this dittie of "Come againe" was sung, with excellent division, by two that were cunning. . . . As this Song was sung, hir Majestie, notwithstanding the great raine, staied hir coach, and pulled off hir mask, giving great thanks.[16]

Queen Elizabeth inclined toward a ritualistic type of church service, and so was not in sympathy with the extremists of the Protestant party.[17] When she came to the throne, the Catholic form of worship was in use. Her personal preference was for a similarly ornate service, with contrapuntal music; but because of the strong Puritan sentiment of the time she made no demand for it, and insisted merely that the choirs left by Queen Mary should be kept at their previous strength, and that the whole service should be sung or intoned, not spoken. She expressed these wishes in her injunctions of 1559 concerning the clergy and laity:

[16] The description of Queen Elizabeth's visit to Elvetham is quoted by John Nichols in *The Progresses and Public Processions of Queen Elizabeth . . .*, 2d ed. 1823, pp. 109–121, from *The Honorable Entertainment gieven to the Quene's Majestie, in Progresse, at Elvetham in Hampshire, by the Right Hon'ble the Earle of Hertford, 1591*, printed 1591. For a good summary see *The English Madrigal* (1925) by Dr. E. H. Fellowes, pp. 22–25.

[17] See Sir John Hawkins, *A General History of the Science and Practice of Music*, 1776, Chapter CXI.

Item, because in dyvers collegiate, and also some parishe churches, there
hath been lyvynges appoynted for the mayntenaunce of menne and chyldren,
to use syngynge in the churche, by meanes whereof the lawdable scyence of
musicke hath ben had in estimation, and preserved in knowledge: The
queenes majestie, neyther meanynge in any wise the decaye of any thynge
that myght conveniently tende to the use and continuance of the saide sci-
ence, neyther to have the same in any parte so abused in the churche, that
thereby the common prayer should be the worse understande of the hearers:
Wylleth and commandeth that fyrst no alteration be made of such assigne-
mentes of lyvinge as heretofore hath been appointed to the use of syngynge
or musicke in the churche, but that the same so remayne. And that there
bee a modeste and deystyncte song so used in all partes of the common
prayers in the churche, that the same may be as playnely understanded as yf
it were read without syngyng. And yet neverthelesse for the comforting of
such as delite in musicke, it may be permytted that in the begynninge or in
the end of common prayers, either at mornynge or evenynge, there may be
sunge an hymne or such lyke songe, to the prayse of Almighty God, in the
best sorte of melodye and musicke that may be conveniently devysed, hav-
ynge respecte that the sentence of the hymnne may bee understanded and
perceyved.

Thanks to this last clause, hymns and simple anthems could be used,
whereas the extreme Protestant party would have permitted only
psalms. Hawkins[18] notes further that

It is certain she had a crucifix in her chapel. See a letter from Sandys, bishop
of Worcester, to Peter Martyr, expressing his uneasiness at it. Heylin[19] says
that it remained there for some years, till it was broken to pieces by Patch

[18] Hawkins, *op. cit.,* Chapter CXIV.

[19] *Ecclesia Restaurata, or the History of the Reformation of the Church of England,* by
Peter Heylyn, London, 1661, p. 124. Heylyn adds: "When one of her Chaplains (Mr.
Alexander Nowel Dean of St. Pauls) had spoken less reverently in a Sermon preached
before her of the sign of the Cross, she called aloud to him from her closet window, com-
manding him to retire from that ungodly digression, and to return unto his Text. And on
the other side, when one of her Divines had preached a Sermon in defence of the Real
Presence, on the day commonly called Good Friday, Anno 1565 she openly gave him
thanks for his pains and piety."

the fool, no wiser man daring to undertake such a desperate service, at the solicitation of Sir Francis Knolles, a near relation of the queen. Neal goes much farther, and says "that the altar was furnished with rich plate, with two gilt candlesticks, with lighted candles, and a massy crucifix in the midst, and that the service was sung not only with organs, but with artificial music of cornets, sacbuts, &c. on solemn festivals. That the ceremonies observed by the knights of the garter in their adoration towards the altar, which had been abolished by Edward VI and revived by Queen Mary, were retained. That, in short, the service performed in the queen's chapel, and in sundry cathedrals, was so splendid and showy, that foreigners could not distinguish it from the Roman, except that it was performed in the English tongue." By this method, he adds, most of the Popish laity were deceived into conformity, and came regularly to church for nine or ten years, till the pope, being out of all hopes of an accommodation, forbad them, by excommunicating the queen, and laying the whole kingdom under an interdict.

In 1564 Mary Queen of Scots sent a trusted servant, Sir James Melville,[20] on a diplomatic mission to her "dearest sister, the Queen of England." Elizabeth's irrepressible personality is revealed in the conversation that took place. When she told him her determination never to marry, he replied, "I know the truth of that, Madam; you need not tell it me. Your majesty thinks if you were married you would be but Queen of England, and now you are both King and Queen. I know your spirit cannot endure a commander." She asked him, no less frankly, which of the Queens he judged fairer. He replied, "You are the fairest queen in England, and my queen is the fairest queen in Scotland."

Yet she appeared earnest. I answered, They were both the fairest ladies in

[20] See his *Memoirs,* previously mentioned, pp. 95 ff. Melville was probably a fair musician himself, if we may judge from this personal reminiscence in the same work: "Mairower, in these yeirs I learned my music, wherein I tuk graitter delyt, of an Alexander Smithe, servant to the Primarius of our Collage, wha had been treaned upe amangis the Mounks in the Abbay. I learned of him the gam, plean-song, and monie of the treables of the Psalmes, whereof sum I could weill sing in the Kirk."

their countries; that her Majesty was whiter, but my Queen was very lovely. She inquired which of them was of highest stature. I said, My Queen. Then, saith she, she is too high; for I myself am neither too high nor too low. Then she asked what kind of exercises she [Queen Mary] used. I answered that when I received my dispatch, the Queen was lately come from the high-land hunting: that when her more serious affairs permitted, she was taken up with the reading of histories; that sometimes she recreated herself by playing upon the lute and virginals. She asked if she played well. I said, reasonably for a queen.

This seems to have moved the vivacious queen with a desire to go Mary one better; at any rate,

that same day after dinner my lord of Hunsdon[21] drew me up to a quiet gallery, that I might hear some music (but he said he durst not avow it) where I might hear the Queen play upon the virginals. After I had heark-ened a while, I took by the tapestry that hung before the door of the cham-ber, and seeing her back was towards the door, I entered within the cham-ber, and stood a pretty space hearing her play excellently well. But she left off immediately so soon as she turned her about and saw me. She appeared to be surprised to see me, and came forward, seeming to strike me with her hand; alleging she used not to play before men, but when she was solitary, to shun melancholy. She asked how I came there. I answered, as I was walking with my lord of Hunsdon, as we passed by the chamber door I heard such melody as ravished me, whereby I was drawn in ere I knew how, excusing my fault of homeliness, as being brought up in the court of France, where such freedom was allowed; declaring myself willing to en-dure what kind of punishment her majesty should be pleased to inflict upon me for so great an offence. Then she sat down low upon a cushion, and I upon my knees by her; but with her own hands she gave me a cushion, to lay under my knee; which at first I refused, but she compelled me to take it. She then called for my Lady Stafford out of the next chamber; for the Queen was alone. She enquired whether my queen or she played best. In that I felt obliged to give her the praise.

[21] Queen Elizabeth's first cousin.

That should have been sufficient triumph even for Elizabeth, but she kept Melville at court two days longer so that she could dance before him and ask him for a comparison between Mary and herself in this regard also. Elizabeth was so obviously interested in her northern cousin that Melville suggested "to convey her secretly to Scotland by post, clothed like a page . . . telling her that her chamber might be kept in her absence as though she were sick"—to which her reply was, "Alas, if I might do thus!"

She inspired homage to the end. When she reached the age of sixty-eight and decided with pathetic vanity never to use a looking-glass again, the greatest composers of the realm united in the composition of a set of magnificent madrigals in her honor, each ending,

> Long live fair Oriana.

Elizabeth's personal service to the art of music in England should not be underestimated. With no intention of belittling the talent of such earlier composers as Taverner and Merbecke, we may yet say that during her lifetime English music grew from adolescence to maturity. She increased the value of music as a social accomplishment by playing it herself, and she aided it with her praise and her purse in every possible way, in church, at court, and in the theater, bestowing the royal favor on composers, on singers in the sacred choir and in the secular play and masque, both men and boys, and on instrumentalists of all kinds, players on bowed, plucked, and keyboard instruments. At the same time she rendered valuable aid to the drama. Thus she played an energetic part in that simultaneous forward movement which at its culmination produced in England between 1590 and 1615 both the plays of Shakespeare and the best European music of that quarter century.

II

Music Attacked and Defended

THE Calvinists, dominant in Scotland and powerful in England throughout Elizabeth's reign, were opposed to all forms of church music except psalm singing. The Reformation consequently affected music in England detrimentally in two important ways: first, choirs and choirboys became unnecessary, the schools therefore stopped teaching boys to sing, and the general level of musical knowledge declined; and second, this proscription of all church music except psalm tunes killed the composition of artistic sacred music in Scotland and discouraged it in England. Scotland was further hampered by a restrictive and long-continued monopoly on printing. The first secular music was printed there at so late a date as 1662, and its publisher was fined for issuing it.[1]

To appreciate the condition of music during the latter half of the sixteenth century we will first take up the attitude of the schools toward musical study, before we describe the grimmer battles in which prominent representatives of church and state participated. "Song schools," as those for the training of choirboys were called, flourished in Scotland before the Reformation,[2] after which time some of them declined greatly; in 1574 the Scotch Parliament passed a measure,

. . . instructing the provest, baillies, and counsale, to sett up ane song scuill, for instruction of the youth in the art of musick and singing, quhilk is almaist decayit and sall schortly decay without tymous remeid be providit.

This Edinburgh school does not seem to have thriven, and the one in Glasgow died in 1588. On the other hand, in the middle of the next

[1] *British Music Publishers,* by Frank Kidson, 1900, p. 174.
[2] See *Grove,* v. 76.

century Mace, in England, pointed to the Scotch song schools of his day as models for his own country. In England most of the song schools were discontinued when Edward VI confiscated the chantries, although a few survived that were connected with cathedrals or colleges, and we can thank these for the musical education of some[3] of the greatest composers of the age.

In most English schools of the Elizabethan period music was probably not taught at all. It was early replaced by arithmetic in the curriculum for the smaller children, and was also crowded out in the grammar schools.[4] In some schools psalms were sung. No musical instruction would be necessary for this simple practice beyond singing the tunes over until the boys had memorized them. At Kirkby Stephen grammar school it was enjoined that

. . . every morning and evening at six of the clock, the scholars two by two and the schoolmaster shall go from the schoolhouse into the parish church, . . . say some devout prayer, and sing together one of these [fifteen designated] psalms.[5]

During the daily evening service at Thame School, the students sang the school hymn (in which the students pray that they may so obey their masters as to avert their wrath) to the tune of the first psalm in Sternhold and Hopkins' metrical version, and the 111th Psalm, both in Latin.[6] In at least a few schools the provisions for music were more elaborate, due probably to the enthusiasm of individual headmasters or citizens of influence. In 1561 Sir Nicholas Bacon drew up a curriculum for the education of her Majesty's Wards, according to which they were to spend the hours from twelve to two every day with the music mas-

[3] Bull, Gibbons, Ravenscroft, probably Byrd and Thomas Tomkins, and doubtless others.

[4] Foster Watson, *The English Grammar Schools to 1660: Their Curriculum and Practice,* p. 212. 1908.

[5] J. H. Brown, *Elizabethan Schooldays,* pp. 55, 58. 1933.

[6] *Ibid.,* pp. 55, 58.

ter, and were again to "apply themselves to music" under his instruc-
tion before they went to bed at nine. In the scheme for Queen Eliza-
beth's Academy, about 1572, there was to be one teacher of music, "to
play the lute, the bandora and cittern, 26 li. per annum." This good
salary was unfortunately exceptional. The music master at Christ's Hos-
pital,[7] now known as the Bluecoat School, was less fortunate, long re-
ceiving only £2.13s.4d. a year. In 1587 a music lover named John Howes
urged that the children of this school

. . . learne to singe, to play uppon all sorts of instruments, as to sounde
the trumpett, the cornet, the recorder or flute, to play uppon shagbolts,
shalmes,[8] & all other instruments that are to be plaid upon, either w^th winde
or finger.

But in 1589 the governing body ordered that

Henceforth none of the children in this Hospital shall be apprenticed to
any musyssionar other than such as be blinde, lame, and not able to be put
to other service.

An instructor named John Farrant was appointed in 1607 and proved
so efficient that in 1609 his salary was raised to £4 a year. Robert Dow
thought this so small that he added £12 to it from his own purse, and
later £4 more, enjoining the singing master so benefited "to teach the
art of music to 10 or 12 only of the said children," and to "traine them
up in the knowledge of prickesong." Three or four of these the master
should teach

[7] For an historical account of music at Christ's Hospital, see the article by F. G. Ed-
wards in the *Musical Times* for September, 1905, pp. 573–583.

[8] Shagbolts were sackbuts, i.e., trombones. The shalm or shawm family were played
with a double reed, and included also curtals and pommers. They developed into our
modern oboes, English horns, and bassoons. A letter of 1575, referring to the festivities
at Kenilworth during Queen Elizabeth's famous visit that year, tells us, "This Pageaunt
waz clozd up with a delectable harmony of Hautboiz Shalmz Cornets and such other
ooud muzik." We read in *Batman upon Bartholme,* 1582, that "The common bleting
musicke is ye Drone [i.e., bagpipe], Hobius, and Curtoll." See Cecil Forsyth, *Orchestra-
tion,* 1914, pp. 204, 230.

. . . to play upon an instrument, as upon the Virginalls or Violl, but especially upon the Virginalls, thereby to adorne their voice and make them worthy members both for the Church and the Commonweale. . . . For the better furtherance thereof the said Robert Dow hath provided and bought two pair of Virginalls and a Bass Violl and hath set them up within the School-house.

The total cost of the "Virginalls, Violls and Books," etc., was £10.6s.4d. Farrant was succeeded by Thomas Ravenscroft, who was there from 1618 to 1622.

Writers upon education differed as widely in their opinions on music as did the curricula described above. William Kempe in 1588 drew up a definite scheme for the instruction in each "Form" or grade in specified subjects, and omits music.[9] Nor does John Brinsley mention it.[10] Roger Ascham quoted Galen's remark, "Much music marreth man's manners," and distrusted excessive use of it, although he did not object to it in moderation. But Richard Mulcaster championed it wholeheartedly in two progressive works.[11] He was both headmaster and music master at the Merchant Taylors' School, and later high master of St. Paul's School. Sir James Whitlocke[12] testifies that "His [Mulcaster's] care was my skill in musique in which I was brought up by daily exercise in it, as in singing and playing upon instruments."[13] Mulcaster's pupils acted plays and masques before Elizabeth with such excellence as to win him the Queen's praise. He was one of the most progressive

[9] William Kempe, *The Education of Children in Learning*, 1588.

[10] John Brinsley the elder, *Ludus Literarius or the Grammar Schoole*, 1612.

[11] Richard Mulcaster (1530?–1611), *Positions wherein those primitive circumstances be examined, which are necessarie for the training up of children, either for skill in their booke, or health in their bodie.* 1581. See especially Chapter 5. Also Mulcaster's *The First Part of the Elementarie Which Entreateth Chefelie of the right writing of our English tung.* 1582, pp. 9, 22, 24, 26, 58–60. He unfortunately never issued "The Second Part," in which he expected to tell in detail how pupils should be taught to sing, compose, and play the virginals and lute.

[12] Sir James Whitlocke, 1570–1632, was a prominent judge, father of the Bulstrode Whitelocke mentioned on p. 25.

[13] *Liber Famelicus*, in *Camden Society Reprints*, 1868, p. 12.

[16]

educators of his time, stressing the importance of music and physical training, and advocating for girls an education equal to that for boys.

I saie therefor that these five principles, *reading, writing, drawing, singing,* and *playing* . . . besides exercise . . . be the onelie artificiall means to make a minde capable of all the best qualities.[14]

He urges early study of the lute and virginals as a useful means of making youthful fingers nimble, before they become stiff from age, "and to put Musicians in minde, that they be no brawlers, least by some swash of a sword, they chaunce to lease [lose] a joynte, an irrecoverable jewell unadvisedly cast away,"[15] and suggests the writing of exercises in counterpoint and composition to develop one's power of musical criticism.[16] He also praises singing as a mild but wholesome form of physical activity, and dancing as good bodily exercise, if not indulged in "with full stomacke." As for music in general, "It is verie comfortable to the wearyed minde: a preparative to perswasion . . . the princesse of delites, and the delite of princes."[17]

Music was an approved accomplishment for the young ladies of Tudor England. When Nicholas Wotton reported upon the eligibility of Anne of Cleves as a prospective wife for Henry VIII he found the titled womenfolk of Germany less cultured than those of his own country:

Frenche, Latyn or other langaige, she hath none, nor yet she canne not synge nor pleye enye instrument, for they take it heere in Germanye for a rebuke and an occasion of lightnesse that great ladyes shuld be lernyd or have enye knowledge of musike.[18]

In Queen Mary's time an English girl, Grace Sherrington, wrote of herself: "Every day I spent some tyme in playing on my lute and set-

[14] Mulcaster, *The First Part of the Elementarie* . . ., 1582, pp. 24, 58–60. "Artificial" here means "well designed."
[15] Mulcaster, *Positions* . . ., 1581, p. 39.
[16] Mulcaster, *The First Part of the Elementarie* . . ., pp. 24, 58–60.
[17] Mulcaster, *Positions* . . ., p. 36.
[18] See Dorothy Gardiner, *English Girlhood at School*, 1929, p. 172; also pp. 120, 182.

ting songs of five parts thereunto, and practiced my voice in singing of psalms and prayers and confessing my sins"; and two young ladies of Elizabeth's reign are mentioned as having been "broughte uppe in writinge, readinge, sewinge, both white worke and blacke worke, and playenge of the lute and virginalls, as yonge gentlewomen and maydes of theire ages are accustomed."[19]

In the foregoing discussion of the place occupied by music in education during the sixteenth century we have seen that although our art had its strong champions, particularly toward the close of the period, other prominent men were indifferent to it; and though many young girls were doubtless taught it in their homes, its study by boys in the schoolroom was much neglected during the earlier part of Elizabeth's reign.

If we leave the school and consider the progress of music in general, we find its path also was for a time not an easy one. Soon after the Queen's accession the decrease in the number of church positions open to organists and choir singers diminished the number of those studying music, with a resulting decline in the general level of musical knowledge; but effective and logical propaganda by John Case and others brought a limited prosperity to church music and prepared the way for the magnificent flowering of secular music from 1587 onwards.

Early Elizabethan lovers of music were much disheartened. John Bossewell, while describing in his *Workes of Armorie*, 1572, a coat of arms in which organ pipes are represented, bursts out with this exclamation:

But what saie I, Musicke? One of the seven Liberall sciences? It is almost banished this Realme. If it were not the Queenes majestie did favour that excellente Science, Singinge men, and Choristers might goe a begging, together with their Maister the player on the Organes.[20]

[19] *Early Chancery Proceedings,* ii. 167/88. Mulcaster wished young women to "sing sweetly and play and draw well."
[20] *Workes of Armorie,* Book 3, folio 14.

Probably many a "player on the Organes" did go abegging. Organ playing must have ceased in many parish churches by 1563, if we may judge from a homily[21] of that year. It quotes an imaginary complaint of a woman to her neighbor:

Alas, Gossip, what shall we now do at church, since all the saints are taken away, since all the goodly sights we were wont to have are gone, since we cannot hear the like piping, singing, chanting, and playing upon the organs, that we could before?

and answers her:

But, dearly beloved, we ought to rejoice and give God thanks, that our churches are delivered of all those things which displeased God so sore, and filthily defiled his holy house and place of prayer.

An early seventeenth-century writer surveys the standards of musical performance in divine worship throughout the "late Queenes raigne" and pronounces a gloomy judgment:[22]

The first occasion of the decay of Musick in Cathedrall Churches and other places, where musick and singing was used and had yearly alowance began about the nynthe yeare of Queene Elizabeth,

when some persons in authority thought that foundations and stipends for that purpose might well be dispensed with, or at least decreased. And most of the Deans and Canons being overawed yielded to this request, while some of the Puritan clergy welcomed it because they hoped

[21] *The Seconde Tome of Homelyes. . . . Set out by the aucthoritye of the Quenes Maiestie: And to be read in eurey paryshe Churche agreablye,* reprinted in 1864 in *Certain sermons or Homilies Appointed to be Read in Churches in the Time of Queen Elizabeth of Famous Memory.* London, S.P.C.K. The quotations are from the Second Part of the "Homily of the Place and Time of Prayer."

[22] §§1–4 of British Museum MS 18B. xix, *The praise of musick y*e *profite and delight it bringeth to man & other the creatures of God, And the necessarye use of it in y*e *service & Christian Churche of God.* The anonymous writer takes up only the period from Elizabeth's accession onwards.

that some of the revenues thus diverted might come their way. The writer continues:

And it is to be remembered, that about the same tyme not so fewe as an 100 paire of organs were pulled downe (and many of them sold and imploide to make pewter dishes). . . . And commands [were] given [by the Puritan clergy] for short playinge, or none at all, for shorteninge and alteringe of their songes and service to give place for preachinge, and castinge service as it were quite out of doore. So as fewe or none of yᵉ people would vouchsafe to come into the Quyres during the singinge service but would stand without[,] dauncinge and sportinge themselves untill the sermons and lectures did begin, scorning and derydinge both yᵉ service and those which were imployed therein, so as hereby the practize and use of skillfull musick and those which exercised the same began to be odious, and the professors to be accompted but as rogues, drunkards & idle persons, which was the cause that all indevour for teachinge of musick or the forminge of voices by good Teachers was altogether neglected as well in men as children, which neglect (and little better reputation) continueth to this day. . . . A poore singingmans maintenance in a Churche of a new erection doth not answere the wages and entertainment that any of them giveth to his horskeeper.

The training of choirboys has been so neglected that in a college or even the Chapel Royal, of

16. 12. or 10. Choristers scarce 4. of them can singe a note, [and] the sufficiency of voice and skille in Cathedrall Churches is utterly decayed. . . . Obiection will be made that Musick is in as great request and as much esteemed as ever it was, which obiection may be answered, that it is true indeed for noble men and Gentlemens private service and delight in their houses;

such rich men by offering decent wages take away the best players and singers, both men and boys, from even St. Paul's and Westminster Abbey, according to our gloomy writer of King James's time.

Case's important book, *The Praise of Musicke*, 1586, intended as a

trumpet call to wake England from its Philistine indifference to good music, laments the current lack of interest:[23]

> I am glad that I have any small occasion to revive that studie which laie as dead for a time, and I would be as glad to have it continue in good credit and liking after it is once received.

Music had enemies within as well as outside its ranks. Case regrets that musicians themselves have done music much harm:

> So fareth it with musick, which because it is excellent, and for that naturally subject to the envie and malice of many, is therefore ill spoken of, because it falleth out, that shee is oftentimes blemished with the faults of them that professe to have some knowledge in her.

Morley, in his dialogue, *A Plaine and Easie Introduction to Practicall Musicke*, 1597, makes the "Master" say to his pupil, Philomathes: "I have heard you so much speake against that art, as to tearme it a corrupter of good manners, and an allurement to vices: for which many of your companions tearmed you a Stoick." Case complains that people who like music often refuse to make it themselves, regarding it with suspicion like all other learning. "Bring a harp or other good instrument to Lacedemon, they will cry away with it." Farmer in 1591 was afraid men thought of music "but bassely."[24] And finally Morley, in the *Introduction* mentioned above, laments that music "by the negligence of its professors is almost fallen into the nature of a mechanicall arte, rather than reckoned amongst other sciences." He advises musicians to study other useful things as well as music—advice which musicians have needed ever since. Some religious enthusiasts wanted to drive out secular vocal music. "Since morally edifying music is available," asked one of these, "why sing any other?" Edward Hake[25] recommended that

[23] In the Dedication written by its printer, Joseph Barnes, printer to the University of Oxford.

[24] John Farmer, *Divers and sundry waies of two parts in one . . .* 1591 [canons].

[25] William Daman, *The Psalmes of David in English Meter*, 1579.

[21]

psalms be sung "in stede of unseemeley Ballades"; and in Archbishop Parker's *Psalter* a versifier turned out seventy-four stanzas on the "vertue of the Psalmes":

> Depart, ye songs lascivious,
> from lute, from harpe depart:
> Give place to Psalmes most vertuous,
> and solace there your harte.
> Ye songes so nice, ye sonnets all,
> of lothly lovers layes:
> Ye worke mens myndes but bitter gall,
> by phansies pevishe playes.

Parker was evidently the declared enemy of lyrical poetry.

The Puritan viewpoint with regard to church music is not illogical. The contrapuntal masses and motets of the great Catholic composers, with long-drawn-out syllables and several different words sung at the same time in the various parts, often made the sense unintelligible. Even Morley criticizes the absurd medieval device called "hocket" (literally *hiccough*), whereby a singer would take a rest in the middle of a word:

> We must also take heed of seperating any part of a word from another by a rest, as som dunces have not slackt to do, yea one whose name is *Iohannes Dunstaple*, . . . which is one of the greatest absurdities which I have seene committed in the dittying of musicke.[26]

Antiphonal singing, a frequent practice of the old ritual, seems especially to have irritated some of these Puritan objectors. Hake states the general Puritan position with much justice:

> Nevertheless in any thyng by me here written, I have not meant to defende any [of] the abuses of Musicke whatsoever committed in the Church

[26] *A Plaine and Easie Introduction*, p. 178. The Englishman John Dunstable, c. 1390–1453, was no dunce, but the best European composer of his time.

of God, or rather the prophanyng of Gods divine service by Musicke (as in tyme of Popery) namely by over curious, yea, and as I may say over tragicall dismembring not onely of wordes but of letters and sillables in the holy Psalmes and Anthemes appointed to the praysing of God: For what hath either Musicke or any thing els betwene heaven and earth to be commended for, farther, then that it shall serve to set forth the glory and comfort of the eternall word? which thynge whensoever it shall cease to doe, and shall advaunce it selfe above or before the sence thereof, it is not onely not to be allowed of, but also with all force of law to be thrust out of the Church. But this our Musicke well imployed upon these Psalmes, is altogether free from such abuses. God graunt we may use it to our comfort and to the prayses of his name. Amen.[27]

A more extreme point of view is that represented by *An Admonition to the Parliament* (1572) written by Rev. John Field, minister of Aldermary, London, with regard to the new order of service:

In all theyr order of service there is no edification, according to the Rule of the Apostle, but confusion, they tosse the Psalmes in most places like tennice-balles. . . . As for organes and curious singing, thoughe they be proper to popyshe dennes, I meane to Cathedrall churches, yet some others also must have them. The Queenes chapell, and these churches must be patternes and presidentes [precedents] to the people of all superstition. . . . We should be to long to tell your honoures of Cathedrall churches, the dennes aforesaide of all loytering lubbers, wher master Deane . . . squeaking queristers, organ players . . . live in great idlenesse.[28]

Two of the greatest Tudor composers, John Merbecke and Taverner, gave up composition altogether on adopting Puritan views. The former

[27] *The Psalmes of David in English meter, with Notes of foure partes set unto them by Gulielmo Damon, for John Bull, to the use of the godly Christians for recreatyng them selves, in stede of fond and unseemely Ballades. Anno 1579. At London.*

[28] Field also objected to merrymaking at weddings, when "women are suffered to come bare headed, with bagpipes and fidlers before them, to disturbe the congregation." See that section of the *Admonition* entitled "A view of Popishe abuses yet remaining in the Englishe Church," §§9, 13, 17. Prynne's *Histriomastix*, 1633, contains a savage attack on choir singing.

writes with regret in his *Concordance,* 1550: "In the study of Musike and plaiyng on Organs I consumed vainly the greatest part of my life." Because of his Calvinistic views Merbecke was condemned to be burned at the stake in 1543, but was reprieved: he was merely a musician and consequently considered innocuous. John Taverner (c. 1495–1545) stopped composing when he aided in the suppression of the monasteries, even assisting in the burning of the large statues of the crucified Christ which are known as roods. He publicly regretted his "vain ditties." Acrimony between the high and low church parties continued throughout Elizabeth's reign, with the queen trying to steer a middle course, the majority of her people perhaps with her. No wonder then that Case when he discusses, in 1586, the use of music in civil matters should say, "I dare not speake of dauncing or theatricall spectacles, least I pull whole swarmes of enemies upon me."

But Merbecke and Taverner were extremists, as controversialists sometimes are. What was the usual Puritan attitude toward music? One can best answer this question by examining the general state of music under Oliver Cromwell, when the Puritans were able to regulate it as they wished. Vilification of the Puritans over a period of two centuries has been so successful that the very word *puritanical* has come to imply a code of stern and joyless living, which would have been abhorrent to the Puritans themselves. Musical criticism in particular has long ascribed to them the doctrine of music's essentially sinful influence, which indeed we know was held by some of their spiritual descendants during the nineteenth century. This "puritanical" doctrine did not emanate from the Puritans, but from the Quakers of the seventeenth century, and particularly the oppressed evangelical sects of the eighteenth. Percy A. Scholes in his important book, *The Puritans and Music in England and New England,*[29] 1934, has shown that the Puritans were not opposed to music as such, and that although strict sabbatarians they

[29] See pp. 1–12, 106, 130, 133, 142, 144, 156, 194, 204, 243, 296, 312, 345 ff., 380.

enjoyed life much as other Englishmen. Many Puritans danced, though some disapproved. Bulstrode Whitelocke, Cromwell's ambassador to Sweden, was asked by Queen Christina if dancing was prohibited in England. He replied, "Some there are that do not approve of it; but it is not prohibited by any law and many there do use it." He then danced with the Queen. The Puritans opposed music in church, except psalm-singing, and during the Commonwealth they banned public performances of plays. Nevertheless, in that same period inoffensive private theatricals were not interfered with, Italian operas were given in London, and plays could be published. Several times as much music was printed in England under the Commonwealth as during the much longer reign of Charles I. The Puritans at the helm of state would have been astonished at our modern misconceptions of their manner of living. Cromwell himself had a suit of purple velvet, wore his hair long, approved of horse-racing and cock-fighting, and smoked. He enjoyed listening to the organ in Hampton Court Palace, and had an orchestra of forty play for mixed dancing until five in the morning on the occasion of his daughter's wedding. We may quote some verses by his staunch supporter George Wither, which though published early (1619)[30] reflect the sympathy their writer continued to feel toward music in the days of the Lord Protector:

> From the earth's vast hollow womb
> Music's deepest bass shall come,
> Seas and floods from shore to shore
> Shall the counter-tenor roar.
> To this consort (when we sing)
> Whistling winds your descant bring,
> Which may bear the sound above
> Where the orb of fire doth move,
> And so climb from sphere to sphere,
> Till our song th' Almighty hear.

[30] George Wither, *Preparation to the Psalter*, 1619.

We have seen that there was opposition in the earlier part of Elizabeth's reign to serious musical study because its chief end was the composition and performance of complicated "Papist" music in church. Attacks were also made on music because of the unworthy manner of life led by some who made it their profession. Choir singers in particular were censured again and again as disorderly fellows. At the beginning of the sixteenth century some singers were related to have played a practical joke on a drunken priest during divine service in St. Paul's Cathedral;[31] and in the next century John Earle, Bishop of Salisbury, wittily describes the choirs of his day:[32]

The Common Singing-men in Cathedral Churches are a bad Society, and yet a Company of good Fellowes, that roare deep in the Quire, deeper in the Taverne. They are the eight parts of speech, which goe to the syntaxis of Service, and are distinguish't by their noyses [the music they make] much like Bells, for they make not a Consort but a Peale [they sound out one after the other, not singing the notes of the same chord at the same instant]. Their pastime or recreation is prayers, their exercise drinking, yet herein so religiously addicted that they serve God oftest when they are drunke. Their humanity is a legge [a bow] to the Residencer, their learning a Chapter, for they learne it commonly before they read it, yet the old Hebrew names are little beholden to them, for they mis-call them worse then one another. Though they never expound the Scripture, they handle it much, and pollute the Gospell with two things, their Conversation and their Thumbes. Upon

[31] Dr. Samuel Knight, in his *Life of Dean Colet*, p. 87, quotes the anecdote from a "Remnant of an old English book, printed in the latter End of Henry VII": "Certeyne of Vycars of Poules dysposed to be merye on a Sondaye at hye Masse tyme, sent another madde Felowe of theyr Acquayntance unto a folishe dronken Preest upon the Toppe of the Stayres by the Chauncell Dore, and spake to hym, and sayd thus, Syr, my Maistre hath sent you a Bottell to putt your Drynke in, because ye can kepe none in your Brayne. Thys Preest beyinge therewith very angrye, all sodenly toke the Bottell, and with his Fote flange it down into the Bodye of the Churche upon the Gentylmennes Heddes." These "Vycars" were vicars-choral, members of the choir.

[32] *Microcosmographie, or a Piece of the World discovered in Essays and Characters,* 1628. For a later sarcastic allusion to "singing-men's religion," see Abraham Cowley's *Sylva,* 1636.

worky-dayes they behave themselves at Prayers or at their pots, for they swallow them downe in an instant. Their Gownes are lac'd commonly with steamings of ale, the superfluities of a cup or throat above measure. Their skill in melody makes them the better companions abroad, and their Anthemes abler to sing Catches. Long liv'd for the most part they are not, especially the base, they overflow their banke so oft to drowne the Organs. Briefly, if they escape arresting, they dye constantly in God's Service: and to take their death with more patience, they have Wine and Cakes at their Funerall: and now they keepe the Church a great deale better, and helpe to fill it with their bones as before with their noyse.

Then, as now, people were criticized for what is called the artistic temperament. Hermogenes, in Jonson's *Poetaster,* is a singer who will not sing when asked and, prevailed on to begin, will not stop; and Lyly, in *Euphues and His England,* censures the froward "Musition, who, being entreated, will scarce sing sol fa." But music and musicians seem to have escaped the charge of effeminacy. Various princes and young nobles were given lessons in music, and it is recommended to men as a worthy accomplishment by several writers, notably Castiglione. His *Cortegione,* or description of the perfect courtier, was published in an English translation in 1561, and influenced English education and thought. He thus criticizes a well-born but unmusical boor:

Not that we would have him [our Courtier] look fierce, or go about blustering, or say that he has taken his cuirass to wife . . . because to such men as this, one might justly say that which a brave lady jokingly said in gentle company to one . . . who, being invited by her out of compliment to dance, refused not only that, but to listen to the music, and many other entertainments proposed to him, saying always that such silly trifles were not his business; so that at last the lady said, "What is your business, then?" He replied with a sour look, "To fight." Then the lady at once said, "Now that you are in no war and out of fighting trim, I should think it were a good thing to have yourself well oiled, and to stow yourself with all your battle harness in a closet until you be needed, lest you grow more rusty than

you are"; and so, amid much laughter from the bystanders, she left the discomfited fellow to his silly presumption.[33]

Minstrels had become little short of public nuisances. "London is so full of unprofitable Pipers and Fidlers, that a man can no soner enter a taverne, but two or three of them hang at his heeles," Gosson tells us.[34] And Dekker warns,[35] "If you desire not to be haunted with Fidlers, who by the statute have as much liberty as Roagues to travell into any place, having the passport of the place about them, bring then no women along with you." Some musicians are unskilful, and when they are mendicants as well, they are intolerable. Case observes,[36] "There are a great many cocks and to use a domesticall proverb, a great many asses at the harp," and such "have made themselves a by-word & skorne in al places; Our alehouse, vagabond & begging minstrelsie I defend not." From 1572 minstrels and players were to be dealt with as rogues and vagabonds unless they could produce a license signed by two magistrates. Even this license was taken away in 1603.[37] Weelkes alludes to "the banished Philomele, whose purest blood the impure Minstrelsie hath stained,"[38] and in 1614 Ravenscroft regrets the growing ill-favor into which minstrels were dragging music.[39]

John Case has been mentioned above as a champion of music. He was a Fellow of St. John's, Oxford, and is described by Anthony Wood as the "most noted disputant and philosopher that ever set foot in that college . . . a man of an innocent, meek, religious, and studious life

33 *The Book of the Courtier*, by Count Baldesar Castiglione, Book 1, §17; translation by Leonard E. Opdycke, p. 26.

34 Stephen Gosson, *A Short Apology*, 1587. In Edward Arber's *English Reprints*, 1868, vol. i, p. 70.

35 Thomas Dekker, *Guls Horn-Booke*, 1609, in the chapter entitled "How a Gallant Should Behave himself in a Taverne."

36 *The Praise of Musicke*, 1586.

37 Some English houses of the present day display the sign: "No hawkers, beggars, nor musicians allowed."

38 *Balletts and Madrigals to five voyces*, 1598.

39 *A Briefe Discourse.*

. . . a lover of scholars, beloved by them again, and held in high veneration." He wrote two books in praise of music, the one in English, the other in Latin that it might win favor with the learned.[40] In these works he dwells eloquently on the antiquity, the dignity and what he calls the suavity—what we might call the cultural value—of music, inquires into the nature, the necessity and the use of music under social, civic, and warlike conditions, and concludes with several chapters on sacred music, its practice and justification.

The Praise of Musicke is an important work and formidable in its array of authority. It covered the ground so thoroughly that the treatment of the topic by any other author would seem quite superfluous. Case was keenly aware of the criticism leveled against his art. So he begins on the defensive, but warming to his subject and piling on evidence soon carries the war into the enemy's camp to the encouragement of all lovers of music. Some of his arguments in behalf of the art he so loved are today outmoded, and their copious presentation here would prove tedious. The inclusion of a specimen or two, however, may well be justified.

The importance attached to music in the education of the ancient Greeks is cited by Case to persuade his contemporaries. He quotes from Aristotle and other writers to show that music is a necessary part of any well-ordered education: first, because the study of music is a profitable pursuit for one's spare time, which might otherwise be wasted in idleness; second, because music refreshes the wearied mind, just as gymnas-

[40] *The Praise of Musicke,* 1586, and *Apologia musices tam vocalis quam instrumentalis et mixtae,* 1588. Copies of both works are in the British Museum, and the former may also be found in the New York Public Library and the Library of Congress at Washington. *The Praise of Musicke* discusses at length the effects of music upon our minds and bodies, its place in education and religion, and the affectionate regard in which it has been held by some of the world's most famous philosophers, statesmen, soldiers, and divines. The Puritan attitude toward church music is also given in detail. Numerous extracts from the work are given in Appendix C, since more completely than any other source it answers the question, Why did the educated Elizabethan consider music a Fine Art?

tics strengthen the body; and third, because it has a wholesome effect upon our actions and manner of life:

Many of the auncient Grecians among whome this Art was in highe estimation, instructed their children in Musicke, as profitable to the correction of life and manners, that thereby they might bee incited to temperance and honestie: for it is the property of liberall Sciences to ingenerate a gentle, and liberal action in their hearers.

As to the power of music, he cites:

A most manifest proof is that which is said of Alexander the great, who sitting at a banquet amongst his friends, was nevertheles by the excelent skil of Timotheus a famous musician so inflamed with the fury of *Modus Orthius,* or as some say of *Dorius,* that he called for his spear & target as if he would presently have addressed himself to war. Neither is this a more apparent proof for this part than that which followed is for the next. The same Timotheus seeing Alexander thus incensed, only with the changing of a note, pacified this moode of his, & as it were with a more mild sound mollified & asswaged his former violence.

The student of literature will recall here that Dryden's famous poem *Alexander's Feast* is modeled on the same anecdote. Our excellent champion of music goes further to show the power of his beloved art even on animals in a long and intricate passage in which he declares, "I am verily persuaded that the plowman & carter . . . do not so much please themselves with their whistling as they are delightsome to their oxen and horses"; and concludes:

There is also a third kinde of living creatures, which by the Philosophers are called *amphibia,*[41] because they live both on the land & in the waters. Of these, I will only name the Swanne, which bird . . . finisheth her life with singing and with joy.

[41] Case prints it in Greek, ἀμφίβια; it was not yet accepted as an English word.

In the last chapters Case gives as his own reasons for the use of music, especially in church: It is the gift of God, "putting us in mind of our Maker and of that mutuale unitie and consent which ought to bee as of voices so of mindes in Gods church and congregations"; it is "a pleasant bait" to allure men to the service; and it enforces the memory as "men . . . doe more firmely carry away with them those things which they heare song than those which they hear barely spoken and pronounced." When he says, in conclusion, "The use" of music in the church "is ancient and of great continuance," the sternest Puritan could not contradict him.

The Praise of Musicke came from the press of Joseph Barnes, printer of the University of Oxford, and in 1586, as we have seen above. Two years later Barnes published Case's other book, the *Apologia musices,* the author reverting to the learned tongue this time.

The *Apologia* is dedicated to Sir Henry Unton and Sir William Hatton. He praises their skill in music as remarkable: "altero non multi, altero vix aliquis peritius." Case's reasons for writing this new work must remain doubtful. He had covered the ground so thoroughly in the former book that the *Apologia* contains little that is new. The same arguments are set forth, even to the familiar anecdotes from Pliny; the fish in the pool at Alexandria entertain us again. He evidently thought that serious scholars would be more impressed by music's claims if they were set forth in Latin. In Chapter 6 he praises instrumental music, as an aid to the contemplation of the divine, and singing, but the two in combination he regards as best, "for here art and nature sing together." Two new topics do, however, receive discussion in the *Apologia:* music in the theatre, and the relative importance of the eye and the ear. Music in the theatre he approves because it refreshes us. His comments on the eye and ear receive some authority from the fact that he was a physician. In the family circle, he feels that moral philosophy and history are a greater aid to the mind than music, and he makes the obvious enough observation that reading exhausts the mind, whereas music refreshes it.

He calls upon the English people to honor "Byrd, Mundy, Bull, Morley, Dowland, [Edward?] Johnson, and many others, just as not long ago they honored Taverner, Blitheman, Tallis, [William] More, and other distinguished musicians." We thus learn what contemporary musicians he considered greatest, as well as what earlier musicians had been the most revered in England.

Case was rewarded for his labors in behalf of music in a novel and interesting way. Two of his associates in music wrote and published a couple of madrigals designated *A Gratification* "unto Master John Case for his learned booke lately made in the praise of Musicke." The authors were Thomas Watson, the well-known translator of *The first sett of Italian Madrigalls Englished,* who wrote the words, and William Byrd, greatest of English composers of his age, who composed the music. The two madrigals are written for six voices. Only one page has come down to us.[42]

Watson's first stanza reads as follows:

A gratification unto Master John Case, for his learned booke,
lately made in the praise of Musicke

> Let others prayse what seemes them best,
> I like his lines above the rest
> Whose pen hath painted Musickes prayse
> He soundly blames the senceles foole
> And barbarous Scithyan of our dayes.
> He wrytes of sweetly turning Sphaeres,
> How Byrds and Beasts & Worms rejoyce,
> How Dolphyns lov'd Arions voyce
> He makes a frame for Midas eares.

[42] Now in the University of Cambridge Library, it has been reproduced in the illustration facing this page. It will be noticed that the soprano clef, with middle C on the bottom line, is used, and the indication of tempo is "Imperfect Time of the Lesser Prolation in Diminution." This is our common time; the bisected C, together with our tempo sign C, are the only medieval time signatures that are still in use. The bisected C indi-

MADRIGALS IN PRAISE OF JOHN CASE

(Cantus Secundus)

by

WILLIAM BYRD

Nearly a generation later, Henry Peacham, the notable writing-master and author, gave his opinions on music (besides many other topics) in two works, *Minerva Britanna* and *The Compleat Gentleman*. Peacham belonged to the schoolmaster tradition of Elyot, Ascham, and Brathwait, and went out of his way to write of music specifically. Like Case, and true to the mannerism of his age, Peacham sets great store on the authority of the ancients: "Plato calle h music 'a divine or heavenly practice'"; Lycurgus refused the Laced monians various pleasures but allowed them music; and "Aristotle avereth Musicke to bee the only disposer of the mind to Vertue and Goo nesse."[43]

Peacham shares with Byrd and Case a r petition of the accepted commonplaces as to music: that it is "a great lengthener of life," that it "openeth the breast and pipes," and cures disease;[44] he even anticipates Burton's declaration that music is "an enemy to melancholy."[44] With Case he deprecates that any nobleman or gentleman should neglect his weightier duties for it, but declares it, as a recreation, worthy of the greatest prince. "No Rhetoricke more perswadeth or hath greater power over the mind";[44] and he asserts somewhat quixotically that music can maintain mankind in unity and concord.[44]

In 1630, at the close of our period, another book of the same species appeared, *The English Gentleman*, by Richard Brathwait. The author lacked Peacham's enthusiasm for music. He pays it lip service by quoting a few clichés from the ancients, but in a long discussion of recreations befitting a gentleman fails to mention it at all; and in his essay *Of Hearing*[45] he frankly says he will not waste his time listening to it:

cates not two beats to a bar, but that the notes were to be sung twice as quickly as if the signature had been an unbarred C. There was no distinction in those days between duple time (our 2/4) and quadruple (4/4). The x's are sharps. Half- and whole-note rests were vertical strokes, not horizontal. Quarter rests (in the form of a hook) and rests to the value of a double whole note and quadruple whole note also occur. Under the last note is a pause.

43 Henry Peacham, *The Compleat Gentleman*, 1622.

44 *The Compleat Gentleman*.

45 One of Brathwait's *Essays upon the Five Senses*.

"Finding it but an aery accent, breathed and expired in one instant, I thought . . . my attentive sense fitter to be employed in a delight more permanent."

Barring an occasional crusty proverb such as "much music marreth men's manners," the Elizabethan chorus as to music is one of ecstatic and none too discerning praise, whether with Wilbye there is lamentation that "Musicke sits solitary among her sister Sciences and often wants the Fortune to be esteemed,"[46] or with Allison it is affirmed that the high estate of music is too obvious to argue about. It is Allison who quotes an interesting encomium from "Father Martin Luther":

Musicke, saith he, to Divels we know is hateful and intollerable, and I plainely thinke, neither am I ashamed to averr it, that next to Theologie, there is no Arte comparable with Musicke: for it alone next to Theologie doth affect that, which otherwise onely Theologie can performe, that is, a quiet and a chearefull minde.[47]

There is a quaint glorification of music by Pilkington, smacking of the shop when he writes:

The sacred Art of Musicke (being chiefly illustrated by Voyces) notwithstanding all Artists, in respect of the compasse and quality of voyces and instruments, doe limit it within scales and other certaine dimensions, is in its owne nature infinite; reaching from the base Earth (being as it were the GAM-UT or ground) to the highest E-LA.[48]

And he adds:

God to his great Glory, doth diversly and wonderfully enable his creatures thereunto, teaching man upon earth, not onely in mellifluous Notes to

[46] Wilbye, *The Second Set of Madrigales*, 1609.

[47] Richard Allison, *An Howres Recreation in Musicke*, 1606 (madrigals).

[48] Francis Pilkington, *The First Set of Madrigals*, 1614. *E-la* (4th space E) was theoretically the topmost note of the top hexachord, and so was an Elizabethan synonym for the "highest point."

chant; but also upon variety of Instruments sweetly to expresse the hidden secrets of that sacred Science; & not leaving the vast Ayre empty of his glory, he instructeth the early Larke to warble forth his prayse; who, (as some hould) learneth his layes from the musicall motions of the heavenly Spheares, and from thence to transcend up to the seate of the most highest, the elected Saints and Angels do in heavenly Himmes, sing perpetually *Te Deum* to the holy Trinitie, sitting on the throne of most Majesticke glorie.

Among all these superlatives as to music it is somewhat strange, in the age of Sidney, to find scarcely a word which can be designated aesthetic criticism. Later, in 1614, Ravenscroft touches on the relations of music to love, in this anticipating Burton, who was his contemporary:

I have heard it said that Love teaches a man Musick, who ne're before knew what pertayned thereto: And the Philosophers three Principall Causes of Musick, 1. Doulour, 2. Joy, 3. Enthusiasme or ravishing of the Spirit, are all found by him within Loves Territories. Besides, we see the Soveraignty of Musicke in this Affection, by the Cure and Remedy it affoords the Dispassionate, and Infortunate Sonnes of Love, thereby to asswage the turmoyles, and quiet the tempests that were raised in them.[49]

When all is said, there are few finer appreciations of the expressiveness of music than that of Bishop Hooker in his famous work *Ecclesiastical Polity,* whether we accept or reject his engaging notion that music has power to draw men to righteousness or tempt them to sin. Music, writes Hooker, is

A thing which delighteth all ages, and beseemeth all states; a thing as seasonable in grief as in joy; . . . the reason hereof is an admirable facility which music hath to express and represent to the mind more inwardly than any other sensible mean, the very standing, rising, and falling, the very steps and inflections every way, the turns and varieties of all passions whereunto the mind is subject; yea, so to imitate them, that whether it resemble unto us the same state wherein our minds already are, or a clean contrary,

49 Ravenscroft, *A Briefe Discourse* . . ., 1614.

we are not more contentedly by the one confirmed, than changed and led away by the other. In harmony the very image and character of virtue and vice is perceived, the mind delighted with their resemblances, and brought, by having them often iterated, into a love of the things themselves; for which cause there is nothing more contagious and pestilent than some kinds of harmony, than some nothing more strong and potent unto good. And that there is such a difference of one kind from another we need no proof but our own experience, inasmuch as we are at the hearing of some more inclined unto sorrow and heaviness, of some more mollified and softened in mind; one kind apter to stay and settle us, another to move and stir our affections. There is that draweth to a marvellous grave and sober mediocrity;[50] there is also that carrieth as it were into ecstasies, filling the mind with an heavenly joy, and for the time in a manner severing it from the body.

Enough has perhaps been suggested as to the Elizabethan attitude toward music. Their language, like most of the language of encomium, courts extravagance and hyperbole; but most of this, be it remembered, was like the ruffs, the laces, and farthingales, merely the costume of the age. The musicians of Tudor times, like their fellows in other arts and sciences, worshipped the ancients and were accustomed to still many an objection with the single word "antiquity." But if their praises lack variety and that discrimination which can alone advance the history and understanding of an art, their fervor and devotion claims the admiration and approval of a more critical age.

[50] Moderation, equanimity.

III

Music Sung in Church

THE historical continuity of the Roman Catholic Church and the
Church of England is exemplified in their forms of government
and the words and music of their services. The familiar plainsong of
the latter church is Roman in origin, changed only in minor respects.
The Catholic motet became the English anthem, the Mass in adapted
form the Holy Communion. The Reformation, however, was respon-
sible for the substitution of English for Latin in the Church, for a sim-
plification of the texture of the music in order to make the sacred words
that were sung intelligible, and for the invention of the psalm tune. The
Elizabethans, like the Scotch, sang psalms instead of hymns.[1]

In the earlier part of this chapter we will consider the English Psalter
and its psalm tunes, and in its later pages take up such music as was
primarily intended to be sung by choirs, in particular the Roman and
English musical services, motets, and anthems.

The Elizabethans sang the psalms both in prose and verse. The prose
texts were reprinted in the Prayer Book from Coverdale's *Great Bible*
of 1539-40, and Coverdale's words were required to be said or sung in
all Anglican churches, as they are today. The tunes, slightly modified

[1] The English Church retained the familiar Roman canticles, such as the Benedicite
(from the Apocrypha); the Magnificat (from the New Testament) and the Te Deum,
which is a non-Biblical "hymn"; and some Scotch psalters have metrical versions of these,
e.g., *The Psalmes of David in Scottish meter: After the forme that they are used to be
song in the Kirk of Scotland,* Edinburgh, 1614, which contains the Veni Creator, a me-
dieval hymn. *The Courte of Vertue* (London, about 1565) includes several religious
songs with tunes, e.g., "Blame not my lute though it doe sounde the rebuke of your
wicked sinne" and such moral music as "A short song exhorting all men to abstayne
from the use of false weyghtes and measures." These were to be sung at home or (by a
singer *sans peur et sans reproche*) in the grocer's shop. But during divine worship, the
practice in Great Britain was to sing only texts from the Bible and the service of the
early Church.

to fit the English words, were Gregorian, and familiar from pre-Reformation days.[2] But we will concern ourselves only with the metrical versions or "paraphrases," since several printed editions of these contain prefaces which throw light upon Elizabethan musical opinion.

The metrical psalms published in the earlier collections were intended for personal or recreational use. They were becoming popular during the time of Edward VI, and then after the intervening reign of his reactionary successor we have read how they were sung by glad multitudes in London upon the accession of Elizabeth. The phrase "This was begun in one church in London" may indicate that metrical versions of the psalms had never been sung in English churches before. In December 1559, some of these enthusiastic Londoners who were worshipping in Exeter Cathedral interrupted the service by singing metrical psalms, and thereby greatly annoyed the clergy. News of the disturbance was carried to the ecclesiastical commissioners in London, and they sanctioned the singing of metrical psalms in church in future.[3]

It is possible that psalms were sung in metrical English before the Reformation, at least outside the church. Sir Thomas Wyatt the elder and the Earl of Surrey had translated several. In the early years of the Reformation the three most important metrical editions of the psalms in English were those by Coverdale (1539?), Crowley (1549), and Sternhold and Hopkins (1549). We will consider each of these in turn and then take up some later psalters.[4]

Coverdale's[5] is probably the first English metrical version of any of

[2] From this Gregorian type the Anglican chant of the present day evolved during the seventeenth century by a minor change in meter.

[3] W. H. Frere, *The English Church in the Reigns of Elizabeth and James I*. London, 1904.

[4] For a chronological list of all the important early metrical psalters in English see p. 339.

[5] *Goostly psalmes and spirituall songes drawen out of the holy Scripture for the comforte and consolacyon of such as loue to reioyce in God and his worde. Imprynted by me Johan Gough. Cum priuilegio Regalj*. The Address "Unto the Christen reader" is by "Myles Couerdale." The only known copy is in the library of Queen's College, Oxford,

the psalms to be printed with tunes. His rendering of the 46th Psalm, set to Luther's "Ein' feste Burg" is given below and shows the irregular rhythm of the earlier German chorales:

THE XLV. PSALME OF DAVID

¶ Deus noster refugium

Oure God is a de - fence and towre a good armoure and good weap - en he hath been euer oure helpe and sucoure in all the troubles y[t] we have ben in ther- fore wyl we neuer drede for any wonderous dede by water or by londe in hilles or y[e] see sonde our god hath them al in his hond

The *Goostly psalmes* were intended to be sung by "the lovers of Gods worde," at their homes or daily work, in place of "balettes of fylthynes," also by children, "in godly sports to passe theyr tyme." Coverdale writes:

Yee[a] wolde God that our mynstrels had none other thynge to playe upon, neither oure carters and plowmen other thynge to whistle upon, save Psalmes, hymnes, and soch godly songes as David is occupied with all [i.e., withal]. And yf women syttinge at theyr rockes [distaffs] or spynninge at the wheles, had none other songes to passe theyr tyme withall, than soch as

77.B.17 (Select). Its setting of the 46th (45th) Psalm employs the alto clef and uses no bar lines nor time signatures. The original words, pitch, and note values have been retained in our version printed here.

Moses sister, Elchanas wife, Debbora, and Mary the mother of Christ have song before them, they shulde be better occupied, than with hey nony nony, hey troly loly, & soch lyke fantasies.

In 1549 appeared the first known metrical translation of the whole psalter into English, by Robert Crowley.[6] It was set to music in four parts, in the style of the Anglican chant. Its hybrid form was not imitated in later psalters.

The most famous of all metrical psalters was that of Sternhold and Hopkins, which served as the accepted English version from the middle of the sixteenth century until the early years of the nineteenth. In its earliest form it was a collection of paraphrases of only nineteen psalms by Thomas Sternhold, published without music in 1548 or 1549.[7] To later editions more and more paraphrases were added, including some by J. Hopkins and the Rev. William Whittingham, John Knox's successor at Geneva. Tunes first appear in the 1556 edition, published in that Swiss city during the Marian persecutions. The first edition of Sternhold and Hopkins to give us music in four parts was printed in 1560, and the first to include all the psalms in 1562. The psalm[8] on page 41 may well have been one of those sung with such fervor during the early days of Elizabeth's reign.

Although "Sternhold and Hopkins," as it was familiarly called, continued to hold the field against all competitors, as its numerous reprints

[6] *The Psalter of David newely translated into Englysh metre in such sort that it maye the more decently, and wyth more delyte of the minde, be read and songe of all men. Whereunto is added a note of [= music to be sung in] four partes, with other thynges, as shall appeare in the Epistle to the Readar. Translated and Imprinted by Robert Crowley in the year of our Lorde MDXLIX the XX daye of September . . .* One of the musical settings is printed in *Grove,* iv. 268.

[7] *Certayne Psalmes chosen out of the Psalter of David and drawen into Englishe Metre by Thomas Sternhold, Grome of y*ᵉ* Kynges Maiesties Robes. London, Edvardus Whitchurche.*

[8] Words and music are taken from the rare Geneva Psalter of 1561: "*Four score and seven Psalmes of David in English mitre by Thomas sternholde and others . . .*" The alto clef is used, without bar lines or time signatures.

show,[9] several later psalters merit attention on account of their intrinsic worth or comments on music.

PSALM XXIII

Words by W. Whittingham

1. The Lord is one-ly my sup-porte, and he that doeth me fede:
How can I then lacke any-thing, where-of I stand in nede?

2. He doeth me folde in cottes most safe,
 the tendre grass fast by:
 And after driveth me to the streames,
 which ranne moste pleasantly.

3. And when I fele my selfe nere lost,
 then doeth he me home take,
 Conducting me in his right paths, even
 for his owne names sake.

4. And thogh I were even at deaths dore,
 yet wolde I fear non eil.
 For with thy rodde and shepheards
 croke I am comforted stil.

5. Thou hast my table richely deckt in
 despite of my foe:
 Thou hast mine head with baume re-
 fresht, my cuppe doeth overfloe.

6. And finally while breth doeth last, thy grace shall me defende,
 And in the house of God will I my life for ever spende.

Among these belongs Archbishop Parker's Psalter,[10] as it is now called. The tunes, nine in number, were composed expressly for the work by Tallis. The paraphrases are presumably by the Archbishop himself.

On August 6, 1557, he had written that by the inspiration of "my Lord and Savior Jesus Christ . . . I have finished the Book of Psalms turned into vulgar verse." His biographer, Strype, evidently never heard

[9] At least twenty-two editions of various psalters were printed in England during Queen Elizabeth's reign, almost all of these editions using Sternhold and Hopkins' words. But the list of tunes and the harmonizations vary considerably.

[10] *The whole Psalter translated into English Metre, which contayneth an hundred and fifty Psalmes. Imprinted at London by John Daye. Cum gratia et privilegio Regiae Maiestatis per Decennium.* No date.

of the psalter, for he writes, "What became of his Psalms, I know not."[11]
We can account for Strype's ignorance by the fact that the work was
never placed on sale. It was printed in 1567 or 1568. Parker then prob-
ably realized that because both its words and tunes were entirely un-
familiar it could not hope to vie in popularity with the verse and music
of Sternhold and Hopkins already beloved throughout the land. There
is a foreword "Ad Lectorem":

> Haec quincunque legis, tu flexu et acumine vocis
> In numeros numeros doctis accentibus effer,
> Affectusque impone legens, distinctio sensum
> Auget, et ignavis dant intervalla vigorem.

This is obligingly translated for our benefit into fourteeners:

To the Reader
> Accent in place your voyce as needth,
> note number, poynte, and time.
> Both lyfe and grace good reading breedth
> flat verse it reysth sublime.

The verse is flat enough. Perhaps Archbishop Parker perceived that just
in time. Parker, if it were indeed he, so enjoyed dashing off verses that
for good measure he adds in the same meter a poem of seventy-four
stanzas on "The vertue of the Psalmes."

Parker's psalter is really important to us, however, for not only are all
the tunes the work of Thomas Tallis, the most important English com-
poser of his immediate time, but the valuable comments on the first
eight of these constitute seemingly the only specific criticism of Eliza-
bethan psalm tunes that has come down to us from that period, and
were doubtless written or sanctioned by the distinguished composer
himself. As this psalter is of interest as representative of the quality of
the best church music of the age, and as it is inaccessible to the ordinary
reader, having not been reprinted, I give the eight tunes here, printing

[11] *The Life and Acts of Matthew Parker*, by John Strype, 1711, Book 1, Chapter 7.

them for the first time in short score.[12] The tune in every case is in the tenor part, not the treble. In its original form each tune with its three accompanying parts is printed on one double page, as follows:

THE MEANE TENOR

THE CONTRA TENOR BASE

It is likely that Tallis composed some of the tunes to the very verses here printed, although we cannot be sure of this. Certain musical niceties as to the fitness of word and sound are interesting, e.g., his repetition of the musical phrases in the latter half of the sixth tune to fit the rhyming half lines, and an ascent to the highest note of the third tune at the words "The kings arise."[13] Furthermore, the one use of E ♭ as a melody note anywhere in the book is to accompany the word "griefe," in the sixth tune. Palestrina sometimes uses chords containing flatted notes to express grief, and the two "sad" tunes of the eight (the second and the

[12] I have omitted No. 9, "Veni Creator," for it was printed by Parker without comment, and was not a psalm tune. It occurs in some modern hymnals, with the name of its composer as its title: "Tallis."
[13] Composers like Palestrina, in whose music vivid pictorial expression of a word or phrase is comparatively infrequent, nevertheless show a naïve fondness for rushing up the scale at the word "ascendit" and down for "descendit"; it was a common musical device of the period.

sixth) are the only ones with which chords containing the note E ♮ are used.

The editor of the psalter comments on the tunes as follows:

The nature of the eyght tunes

⌐[14] 1. The first is meeke: devout to see,
\ 2. The second sad: in majesty.
\ 3. The third doth rage: and roughly brayth.
/ 4. The fourth doth fawne: and flattry playth,
/ 5. The fyfth delig[hte]th: and laugheth the more,
\ 6. The sixt bewayleth: it weepeth full sore,
\ 7. The seventh tredeth stoute: in froward race,
⌐ 8. The eyghte goeth milde: in modest pace.

The following significant words show that the book was designed for use both in church and in the home:

☞ The Tenor of these partes be for the people when they will sing alone, the other parts, put for greater queers,[15] or such as will syng or play them privatelye.

I have ventured to add modern time signatures, there being none in the original, and have substituted modern barring; the original bar lines were placed only at the ends of lines or at punctuation marks. The soprano, alto, tenor, and bass parts of an Elizabethan choral work were always printed as separate units, usually in different volumes or at least on different pages. Hence one cannot tell how the composition will sound from reading it, for it is impossible to read the four vocal parts at the same time; in order to hear and judge it, therefore, it is necessary in every case either to rewrite it laboriously in modern "vocal score," or to hear it sung.

As was the custom of the time, these harmonized psalm tunes by Tallis all have the melodies in the tenor part, not the soprano:

[14] Above each tune and many of the psalms is printed one of these three arbitrary symbols, so that a psalm of trust, or rejoicing, or lamentation might be sung to a tune of appropriate character.

[15] Harassed choirmasters will approve this spelling of the word.

ARCHBISHOP PARKER'S PSALTER

THE EIGHT TUNES

~ PSALM 1. THE FIRST TUNE[16]
["The first is meeke: devout to see"]

The Meane
The Contratenor

Man blest no dout who walkth not out: in wicked mens affayres:

Tenor [the melody]
Base

And standth no day in sin - ners way: nor sitth in scorners chayres[17]

day in sinners way

But hath his will in Gods law still this law to love a - right

And will him use on it to muse to keepe it day and night.

ᵹ. Talys

[16] Novello publishes a fine modern choral prelude on this tune for organ by Harold Darke.

[17] The Meane has no punctuation mark here, the Contratenor has a colon, the Tenor a period and the Base a comma!

[45]

PSALME. 68. THE SECOND TUNE

["The second sad in majesty"]

Let God aryse in mai-es-tie: and scat-red be his foes: yea

flee they all, his sight in face: to hym which hateful goes: As

smoke is driven and comth to nought re-pulse theyr tyr-an-ny: At

face the bad mought fly

face of fire: as waxe doth melt: Gods face the bad————— mought fly

face————— the bad mought fly.

ƒ. Talys

[46]

\ PSALME. 2. THE THIRD TUNE[18]

["The third doth rage and roughly brayth"]

Why fumeth in sight: the Gentils spyght: in fury ragyng stout. Why takth in hand: the people fond: vayne thinges to bryng about, The kyngs arise: the lordes de - vise: in counsayles met ther- to: A - gaynst the Lord: wyth false accord: agaynst hys Christ they go.

Talys.

[18] The leger line at the end of the base part is the only one in the book, and a rarity in Elizabethan printed music. Vaughan Williams has based his impressive *Fantasia on a Theme by Tallis,* for string orchestra, on the above tune.

[47]

PSALM. 95. THE FOURTH TUNE

["The fourth doth fawne and flattry playth"]

O come in one, to prayse the lord, & him recount: our stay & health, all harty ioyes, let us record: to this strong rocke: our Lord of health. His face with prayse, let us pre - vent: his factes in sight, let us denounce,[19] Joyne we I say: in glad assent: our psalmes & hymnes, let us pronounce.

ß. Talys

[19] I.e., let us proclaim his deeds.

["The fyfth delig[hte]th and laugheth the more"]

Even lyke the hunt-ed hynd: the .wa-ter brokes de-sire

Even thus my soule: that faint-ie —— is: To thee would fayne as-

pire, My soule did thirst to —— God: to —— God of lyfe and grace:

It sayd[22] even thus: when shall I —— come, to see Gods live-ly —— face

℥. Talys.

[20] Dot omitted.
[21] Whole rest in tenor.
[22] fayd in treble.

PSALME. 5. THE SIXT TUNE

["The sixt bewayleth: it weepeth full sore"]

my plaint

Ex-pend O Lord my plaint of worde: in griefe that I do make, My

musing mynd: re-count most kynd: geve care for thine owne sake,

O harke my groñe: my cry-ing none: my kyng, my God thou art,

Let me not stray: from thee a way: to thee I pray in hart.

I pray —

�§. Talys.

[50]

/ PSALME. 52. THE SEUENTH TUNE

["The seventh tredeth stoute in froward race"]

Why bragst in mal-ice hie, O thou in mis-chief stout, Gods good-nes

yet is nye, all day to me no doubt: Thy tongue to muse all evill, it doth it

selfe in - ure: As ra - sor sharpe to spill, all guile it doth pro-cure.

℣. Talys.

²³ The Contratenor has C by mistake.

∼ PSALME. 67. THE EIGHT TUNE[24]

["The eyghte goeth milde in modest pace"]

God graunt with grace, he us im - brace, in gen - tle part, blesse he our

hart, with lov - ing face: shine he in place: his mer - cies all: on us to

fall. That we thy way: may know al day: while we do saile, this world so

fraile Thy healthes re - ward: is nye de - clard: as playne as eye: all Gen-tils spy.

ꝑ. Talys.

[24] The composition known today as Tallis' Canon is similar but shorter. Both canons are between the soprano and tenor at the octave. There is some canonic imitation here in the bass also.

Further evidence of the attempt to induce people to sing psalms instead of objectionable ballads at popular gatherings appears in the titles of the next three psalters: *Day's Psalter of 1563, Daman's of 1579,* and *Cosyn's* (1585). The first of these was published in four separate part-books, headed "Medius" (soprano), "Contratenor" (alto), "Tenor," and "Bassus" respectively, in the manner of the printed collections of madrigals. For four-part harmony each member of the group would sing from the part-book that suited his or her range of voice. The first part-book is entitled:

Medius of the whole psalmes in foure parts, whiche may be song to al musicall instrumentes, set forth for the encrease of vertue: and the abolishyng of other vayne and triflying ballades. Imprinted at London by John Day . . . 1563.

The harmonizations by Daman, published without his leave, were entitled:

The Psalmes of David in English meter, with Notes of foure partes set unto them, by Guilielmo Daman, for John Bull,[25] to the use of the godly Christians for recreatyng them selves, in stede of fond and unseemley Ballades. Anno 1579. At London Printed by John Daye. Cum privilegio.

John Cosyn, in the dedication of his psalter[26] to Sir Francis Walsingham, writes:

And having . . . set Six and Five parts upon the tunes ordinarily sung to the Psalmes of David, I was encouraged by some to publish them for the private use and comfort of the godlie, in place of many other Songs neither tending to the praise of God, nor conteining any thing fit for Christian eares.

By 1592 several collections of madrigals had been printed in England,

[25] Not the musician of that name.

[26] *Musike of Six, and Fiue partes. Made upon the common tunes used in singing of the Psalmes. By Iohn Cosyn.* LONDON. *Imprinted by Iohn Wolfe. 1585. Cum privilegio Regiae Maiestatis.* The British Museum contains no copy of this exceedingly rare work, and the Bodleian only a Bass part (Mus. 55. g. 2).

and, contrary to the practice in the psalters just mentioned, Thomas East in that year was able in the dedication of his psalter to mention secular music without censure:

Some have pleased themselves with Pastoralls, others with Madrigalls, but such as are endued with Davids hart, desire with David to sing unto God Psalmes & Hymnes and spirituall songs.

To harmonize the traditional psalm tunes East employed some of the best composers of the age—"J. Douland B. of Musick, G. Farnaby B. of Musick, R. Allison, M. Cavendish, John Farmer, G. Kirby, E. Jhonson, W. Cobbold, E. Blancks and E. Hooper"—

beeing such as I know to be expert in the Arte, & sufficient to answere such curious carping Musitions, whose skill hath not bene employed to the furthering of this work.

The last four names mean little to us today, yet Johnson's music delighted the Queen, Cobbold was organist of Norwich Cathedral, and Hooper organist of Westminster Abbey. The consequent excellence of the harmonizations made the book popular, and it was reprinted in 1594 and 1604. The title would indicate its probable use both outside the church and during divine service:

The whole booke of psalmes: with their wonted tunes, as they are song in Churches, composed into foure parts: All vvich are so placed that foure may sing, ech one a several part in this booke . . . Imprinted at London by Thomas Est, the assigné of William Byrd . . . 1592.

In 1599 an admirable Psalter was published, with the customary tunes simply and tastefully harmonized by Richard Allison:

The Psalmes of David in Meter. The plaine song beeing the commun tunne to be sung and plaide upon the Lute, Orpharyon, Citterne or Base Violl, severally or altogether, the singing part to be either Tenor or Treble to the Instrument, according to the nature of the voyce, or for fowre voyces . . .

Burney, who was a poor judge of Elizabethan music, gives the work scant praise,[27] while Wooldridge considers it perhaps the finest psalter ever issued.[28] It will be noticed that the chief tune appears in the soprano part, not the tenor. In 1591 Daman had issued his second psalter in two editions, one having the tunes in the tenor part, the other in the soprano. We here observe music in the process of evolution: the sovereignty that in medieval music belonged to the tenor part was now passing to the soprano. Here is Allison's setting of "Winchester" to Psalm 84. The music is transitional in style also: it is obviously in the modern key of G Major, but the key signature has not appeared. The first F natural was perhaps sung F sharp, following the medieval rule of *musica ficta:*

<center>"PSALME 84"</center>

<center>Harmonized by Richard Allison, 1599</center>

[27] Charles Burney, *A General History of Music,* 1776–1789, iii. 57.

[28] See *Grove,* iv. 277, footnote. Harry E. Wooldridge, M.A. (1845–1917), Slade Professor of Fine Art at Oxford University, wrote the article on the Psalter in *Grove's Dictionary,* iv. 267–281. He was also the author of the first two volumes of the *Oxford History of Music,* 1st Edition, 1901–1905.

<center>[55]</center>

How pleasant is thy dwelling place,
O Lord of Hosts to me,
The tabernacle of thy grace,
How pleasant Lord they be.

Two of the prefatory poems are by John Dowland and Sir William Leighton,[29] and may be given here as evidences of friendship between these prominent musicians:

Commendatory Verses

John Dowland Batcheler of Musicke in commendation of
Richard Allison, and *this most excellent work*

IF Musicks Arte be Sacred and Divine,
And holy Psalmes a subject more Divine;
If the great Prophet did the words compile,
And our rare Artist did these smooth notes file,
Then I pronounce in reason and in love,
That both combinde, this most Divine must prove,
And this deare friend I recommend to thee
Of thine owne worth a prooved veritie:
Whose high desert doth rather urge me still,
To shew my weakenes, than to want good-will.

William Leighton Esq. in praise of the Author

GOE silly Muse, and doe my love present
to Musickes praise the Author of this worke:
Plead his desert tha[t] is so excellent,
in whose swete notes so secrete skil doth lurke:
Let all that loves this Sience so Divine,
afford him grace that haps this worke to see:

29 Dowland was the greatest Elizabethan composer of songs. For Leighton's *The Tears or Lamentacions of a Sorrowfull Soule,* see p. 57.

Whose eares may judge what Concord can combine
 by Musicks arte, consists in notes but three,[30]
Conjoinde in parts with true concent of art,
 as may appeare by every Close contrivde,
How concords three containeth every part
 within this Booke, from whence notes are derivde:
Admire his skill: let God have laude and praise,
 whose holy words these swete Consorts doe raise.

Let this grave Musick give your eares content
Sith Musickes arte is drawne from this Concent.

In 1614 this same Sir William Leighton published a collection of metrical paraphrases and hymns of which he was the author, entitled

The Teares or Lamentacions of a Sorrowfull Soule: composed with Musicall Ayres and Songs, both for Voyces and divers Instruments. London. Printed by William Stansby. 1614.

The music is by the greatest array of distinguished composers represented in any Elizabethan volume.[31] Leighton was in jail for debt at the time, and these names, and poems lauding him by a dozen friends, suggest that his imprisonment may indeed have been unjust, as he claims. One friend, "I.D." (John Dowland, probably) quotes the Italian proverb

Who loves not Musicke and the heavenly Muse,
 That man God hates

and adds Leighton to the list of sweet singers, beginning with David. John Layfield rejoices that he can henceforth

Say *Well-i* am when griefes *Leight-on* my part

[30] Concord, i.e., what we should call a Common Chord. It consists of three notes, e.g., C E G, or D F A. Leighton shows one in the diagram.

[31] Bull, Byrd, Coprario, John Dowland, Ferrabosco, Ford, Orlando Gibbons, Nathaniel Giles, Edmund Hooper, Robert Johnson, Jones, Robert Kindersley, John Leighton himself, Thomas Lupo, John Milton (father of the poet), Peerson, Pilkington, Ward, Weelkes, and Wilbye.

but a poem by Simon Sturtevant is placed last, since it is the most enlightening of all:

> Was ever *Light-on* Table set before
> To *light* our men with heavenly dulced Layes,
> . . . since worthy Cedmons daies,
> Whose singing spirit hath *Light-on* this good knight.

Most of the compositions are for four or five voices unaccompanied, but the volume is not intended primarily for church use, since the remainder have accompaniments for lute and similar plucked instruments.

In 1621 Thomas Ravenscroft, who was a good musician but whimsical and sometimes pedantically attached to obsolete conventions, issued his edition of *The whole Book of Psalmes,* with the tunes in the tenor.[32] A number of the settings are from East's fine psalter (1592), and the fifty-one harmonizations by Ravenscroft himself are musicianly. Two settings by the poet Milton's father are included. Ravenscroft had pretensions to learning, and his Dedication is full of quaint information and misinformation. He speculates on the character of David's own music to the psalms, and decides,

> Whatsoever the tunes were in David's time, there is no question but they were concordant and harmonious, which could not be, had they not beene divided in parts,

and he vainly quotes *I Chronicles* 15.16 as proof. He might better have cited *II Chronicles* 5.15 in favor of the music being in unison:

> It came even to pass, as the trumpeters and singers were as one, to make one sound to be heard in praising and thanking the Lord; and when they lifted up their voice with the trumpets and cymbals and instruments of musick, and praised the Lord, saying, For he is good; for his mercy endureth

[32] John Dowland's skilful harmonization of "Old Hundredth," from this psalter, is printed in *Grove,* iv. 278.

for ever; that then the house was filled with a cloud, even the house of the Lord.

In the University of Pennsylvania Library in Philadelphia there is the MS Cantus part-book of a psalter harmonized by Giles Farnaby. It once belonged to Francis Hopkinson (1737–1791), who was both the first graduate of this university and the first American composer of secular works; and his descendant Mr. Edward Hopkinson, Jr. has kindly lent it to the university. Francis Hopkinson may have used this psalter while he was preparing *A Collection of Psalm Tunes with a few Anthems and Hymns . . . for the Use of the United Churches of Christ Church and S*ᵗ *Peter's Church in Philadelphia 1763*. He also owned music by leading European composers of his own century, and his intelligent interest in music during the American colonial period is noteworthy. Farnaby's work is entitled:

> *The Psalmes of David, to fower*
> *parts, for Viols and voyce,*
> *The first booke Doricke Mottoes,*
> *The second, Divine Canzonets,*
> *Composed by Giles Farnaby Bachilar*
> *of Musicke*
> *with a prelud, before the Psalmes, Cromaticke*

In Farnaby's dedication of the work to Henry King, "Doctor of Divinitie and chiefe prebend of the Cathdirall [*sic*] Church of Saint Paul," we read:

Having a long time had a desire to present to the vew, Davids Psalmes into more privatt exercise for Gentlemen, they being more laudable then any other Musicke, have composed them not as formerly they were, I desire therefore . . . that you would (pardoning my boldnesse) vouchsafe to take in good worth this my composed laboure . . .

> Your worships in all duty
> GILES FARNABY.

[59]

This may not be his signature, for the handwriting resembles that of the professional copyist. But we need not doubt the authenticity of the work. It is on watermarked paper of approximately the middle third of the seventeenth century. Its chief interest is not musical but biographical. Since King received his doctorate in 1625, Farnaby therefore must have dedicated this work after that event[33] but before Dr. King became Dean of Rochester in 1639. The Dedication is elaborate, and the composer may have hoped that the prelate would have the work published. King, when Bishop of Chichester, did indeed publish a psalter in 1651, but it contained only eight tunes and owed little or nothing to Farnaby, who had died in 1640.

It is impossible to determine the exact character of Farnaby's *Psalmes of David,* for the three lower parts have not survived. These were doubtless contrapuntal, for rests in the Cantus part are frequent. The peculiar title may suggest that the work (or at least the "first booke") was for solo voice and three viols. Yet the word *Canzonets* would imply four vocal parts. Possibly the two books may thus differ by having instrumental and vocal accompaniments respectively, for the surviving Cantus parts are almost identical. Each "booke" consists of the psalms (in Sternhold and Hopkins' version) almost complete, the same psalm having the same "church tune" in both books. The numerous melodies are the familiar ones, such as "Winchester," "Cheshire," "Dundee," "Martyrs," and "Dutch Tune." In addition, the first book has the customary paraphrases of the canticles, Lord's Prayer, etc., also with tunes. "Doricke Mottoes on the psalms" probably means solemn musical commentaries on them; Charls Butler uses the word "Doric" in this curious

[33] As Dr. Otto E. Albrecht noted in *The University of Pennsylvania Library Chronicle,* March, 1938, p. 8. For Francis Hopkinson's varied musical interests see the above article and the following books: O. G. Sonneck, *Francis Hopkinson and James Lyon,* and Dr. Robert A. Gerson, *Music in Philadelphia.*

To the right worshipfull, Henry king, by the Divine providence
of God, Doctor of Divinitie and cheife prebend of the Cathdirall
Church of Saint Paul, The Glorious comforts of grace heere, and
the blessednesse of immortalitie and eternitie in Glory hereafter.

Right worshipfull sir, humbly crabeing your favour to tolerat my bouldnesse
of these my labors, being perswaded partly, and knowing your worshipe
to bee well seene, and a great favourer of Musicke, and well affected to it,
And having a long time had a desire to present to the vew, Davids psalmes
into more privatt excercise for Gentlemen, they being more laudable
then any other Musicke, have composed them not as formerly they were,
I desire therfore, In most submissive manner this one thing att your
worships hands, that you would (pardoning my boldnesse) vouch
safe to take in good worth this my composed laboure, which thing, if
your worship shall vouchsafe to doe, It shall not onely be an incur
agment to my future proceedings, but also itt shalbe an invincible
bond to tie me in all duty, and all love to your worships so long as life
shall last, Thuse humbly taking my leave of your worship, nothing doub=
ting of the goodnesse of your nature in the acceptance of this my present la=
boure, I committ you with yours to the safe protection of the Allmightie
all waies begging before the Throne of his most glorious Maiesty, that he
would in this life infuse his holy Spirill with all his graces into your
heart aboundantly, and in the world to come, Crowne you with the =
croune of immortall Glory, and that for Christ Jesus his sake our Lord
and onely Saviour, Amen.

Your worships in all duty
Giles Farnaby.

The Dedication to
THE PSALMS OF DAVID
about 1630
by
GILES FARNABY

sense in *The Principles of Musik,* 1636: "The Dorik Moode consisteth of sober Notes, generally in Counter-point, set to a Psalm or other pious canticle, in Meeter or Rhythmical vers."

It would hardly serve our purpose to examine other metrical psalters of a late date. The one written by George Wither (1623), like Archbishop Parker's Psalter, suffered from the unfamiliar newness of its words and tunes, and it is to be regretted that this and several other new metrical translations of the seventeenth century were not able to supplant in public favor the somewhat plodding texts of Sternhold and Hopkins. The noble religious poetry of Herbert, Crashaw, Vaughan, and Traherne should have been wedded to music in its own century or the next for the purpose of enabling man to express his deepest religious aspirations in congregational worship. Unfortunately it was not. Our modern preference for non-biblical hymns can hardly be said to have antedated the days of Isaac Watts and Charles Wesley. The metrical psalter and its music are not among the greatest achievements of Elizabethan art, yet they have an interest of their own, and in addition a very real influence upon our worship today. When shortly after the death of Queen Mary enthusiastic congregations in the south of England insisted on singing psalms during the church services, they were initiating a practice that has endured uninterruptedly from that day to this.

The foregoing discussion of psalters and psalm-singing, and the account in Chapter II of the acrimonious disputes concerning church music, will serve as a useful background as we now devote our attention to Elizabethan anthems, masses, and other service music.[34]

[34] Anglican "service music" is music set to any of the fixed portions of the Anglican service, to be sung by either the choir or the congregation, e.g., the responses, canticles (Te Deum, Magnificat, etc.), and parts of the Litany and Communion Service. But the phrase today is commonly and popularly restricted in its meaning to indicate a more or less elaborate musical setting (not in chant form, but similar in style to anthems) for choir of one or more of the following: 1. Two morning canticles, usually the Te Deum and Benedictus; 2. Two evening canticles, usually the Magnificat and Nunc Dimittis; 3. Certain parts of the Communion Service.

Those of us who live in cities take it for granted that the choir of every Protestant church will perform some elaborate music each Sunday, either anthems or service music or both. This present custom is comparatively recent and is partly a result of the Oxford Movement, when the choirs of many Anglican churches were augmented, dressed in vestments, and given music to sing in imitation of the procedure in cathedral churches. Probably very few parish churches in Elizabethan times sang any music except psalms. Bossewell's statement of 1572, previously quoted,[35] is clear enough: "Musicke . . . is almost banished this Realme."

The printing of Elizabethan anthems and service music could not have been profitable. Not only was the market too small, but there were no copyright restrictions to prevent choirboys from copying the music for almost nothing. There is no way of finding out the prices of Elizabethan printed music, but with so common a work as Handel's *Messiah* costing a pound a century ago (in 1914 it cost a shilling), few choirs could have owned any. At first sight even the following list of sacred music published in England during the Elizabethan period (psalters excepted) may consequently seem fairly lengthy:

1560 DAY: (publ.) *Certaine notes.* Services for Mattins, Evensong, and Holy Communion to be sung by church choirs.

1575 TALLIS and BYRD: *Cantiones sacrae.* Latin motets. They were a financial failure.

1588 BYRD: *Psalms, Sonets, & songs of sadnes and pietie, made into Musicke of five parts.* Sacred and secular. *English Madrigal School,* No. 14.

1589 BYRD: *Songs of sundrie natures, some of gravitie, and others of myrth.* Sacred and secular. E.M.S. 15.

1589 BYRD: *Liber primus sacrarum cantionum quinque vocum.*

1591 BYRD: *Liber secundus sacrarum cantionum.*

[35] Page 18. See also the quotations on pp. 19 ff.

1594 JOHN MUNDY: *Songs and Psalmes.* Sacred and secular. E.M.S. 35.

1598 DI LASSO: *Novae . . . cantiones.* Published in London "for amateurs."

1605 BYRD: *Gradualia* [1st Book] ⎫ Written for Catholic use; reprinted
1607 BYRD: *Gradualia* [2nd Book] ⎭ as Vol. 7 of *Tudor Church Music.*

1608 CROCE: *Musica Sacra.* The Penitential Psalms, translated into English sonnets.

1610? BYRD: Three Masses, for 3, 4, an l 5 voices.

1611 BYRD: *Psalmes, Songs and Sonne ι :, some solemne, others joyfull.* Sacred and secular. E.M.S. 16.

1614 LEIGHTON: *The Teares or Lameni ιcions of a Sorrowfull Soule.* Psalms and hymns; see p. 57.

1615 AMNER: *Sacred Hymns of 3. 4. 5. and 6 parts for Voices and Vyols.* Cathedral libraries contain contemporary MS copies of some of these compositions, showing their use by choirs. Usually a note to a syllable.

1624 M. EAST: *The Sixt Set of Bookes.* Anthems.

A few compositions to sacred words will be found among the madrigals of Allison, Tomkins, and Pilkington.

To this list should be added:

1641 BARNARD, REV. JOHN: (publ.) *The First Book of Selected Church Musick, consisting of Services and Anthems . . .*

This is the first printed general collection of English anthems, and we know it was widely used by choirs. Evidently most of the copies became frayed and were destroyed, for it proved difficult in the nineteenth century to find a copy of each of the different voice parts. The compositions are by Byrd (21), Tallis (12), Orlando Gibbons (10), Batten (7), W. Mundy (5), Tye (4), Morley, Ward, and Hooper (3 each), Farrant, Shepherd, Parsons, and Giles (2 each), and Strogers, Bevin,

Robert White, Weelkes, Bull, and Woodson (1 each)—82 in all. If quantity is any criterion as opposed to quality, Barnard must have preferred Byrd, Tallis, and Gibbons.

By this time several perplexing questions may have presented themselves to the reader: Why did Byrd compose so much Catholic Church music? why was he allowed to publish it? and who would buy it? For it must have been bought, as second editions of the *Gradualia* testify. To sincere Catholics, of whom Byrd was one, the composing of sacred music to the Latin texts of their own liturgy was a labor of love, and Protestant composers trained n the older school sometimes employed Latin because of the spiritual and artistic superiority of the contrapuntal style so long associated with the use of that language, rather than the cruder musical idiom that after the Reformation was for a time associated with the English tongue. The Latin works published during the reign of Queen Elizabeth doubtless had her approval. But no explanation can be given for the daring appearance of the three Masses, except that they seem to have been issued surreptitiously and without title pages. By the time the *Gradualia* came out the Government's attitude toward the Catholic Church had become more lenient. Finally, who bought and used the Latin music of Byrd? The anthem repertories of the English cathedrals in Elizabethan times have not come down to us, nor do we know what compositions were sung at any one service on any one day. Furthermore, the copies of the music from which the choir actually sang have almost completely perished, owing partly to ordinary wear and tear and partly to destruction by the Puritans in Cromwell's time. Therefore it is hard to say where and how often these Latin works were sung. But some performances must have been allowed, for busy Protestant organists, such as Morley, wrote considerable music to Latin words. Tallis and Byrd while organists of the Chapel Royal dedicated their *Cantiones sacrae* in 1575 to Queen Elizabeth. She certainly had no objection to motets in Latin, and doubtless often heard

these very works in her chapel. But, as might have been expected in that Puritan period, they were a financial failure. Then why were the later *Cantiones* and the *Gradualia* a success? It will have been noticed that the only compositions printed in England with Latin words were those by Byrd and the collection by di Lasso. Now the latter was avowedly "for amateurs." So it would seem too that Byrd's later *Cantiones sacrae* were bought and performed by amateurs in their homes. It has been surmised that the *Gradualia*, which were published after the *Cantiones*, found a market in Catholic countries through the good offices of those English Catholic friends of Byrd who one after another had taken refuge on the Continent. By that time Byrd's fame had doubtless reached the ears of many foreign musicians.

In glancing again at the preceding list, we see that the only printed books likely to have been much used by English choirs before the death of James I were those by Day (1560), Leighton (1614), Amner (1615), East (1624), and possibly Giovanni Croce. Barnard includes in his collection two madrigals from Byrd's *Songs of Sundrie Natures* (1589)— "Christ rising" and "Christ is risen again"—but it is impossible to say whether he became acquainted with them in church or at the house of a friend. Byrd's printed madrigals would hardly have been bought by churches because of the large proportion of secular works included. Elizabethan choirs, therefore, sang from manuscript, and those few Elizabethans who commented on the sacred compositions of others did so on actually hearing the music.

Composers who have either commented on their own sacred music or received honorable mention from their contemporaries may be arranged in two groups. First we may list the earlier men, with a word of comment regarding each.

WILLIAM BLITHEMAN (d. 1591), organist of the Chapel Royal and teacher of John Bull.

JOHN MERBECKE (d. 1585), arranger of the music for the first English

[65]

Protestant Prayer Book. His music to the Versicles and Responses is still in use today in all churches of the Episcopal communion.

WILLIAM MUNDY (d. about 1591), Gentleman of the Chapel Royal.

OSBERT PARSLEY (1511–1585), a "singing man" (choir singer) of Norwich Cathedral.

ROBERT PARSONS (d. 1570), Gentleman of the Chapel Royal.

THOMAS TALLIS (c. 1505–1585), organist of the Chapel Royal.

JOHN TAVERNER (c. 1495–1545), the greatest English composer during the period when Henry VIII was still affiliated with the Roman Church.

JOHN THORNE (d. 1573), perhaps organist of York Cathedral.

CHRISTOPHER TYE (c. 1500–1572), so-called "father of the anthem," and probably the music master of Prince Edward.

ROBERT WHITE (c. 1530–1574), Master of Choristers at Ely Cathedral, Chester Cathedral, and Westminster Abbey successively.

First among these in point of both time and importance were Taverner, Tye, and Tallis.

TAVERNER is one of the most interesting figures in English church music. The amazing vigor, originality, and mastery of complex and effective counterpoint in his music make him "without question (Fellowes says) pre-eminent among the English composers of his own day."[36] Meres praises him in *Palladis Tamia,* and Morley praises "Farefax, Taverner, Shepherde, Mundy, White, Persons [Parsons], M. Birde and divers others" as equal in merit to the greatest continental composers of the day. When Morley says that these devout English composers would rather spit upon the image of a saint than write two consecutive fifths or octaves,[37] he is praising the perfection of their workmanship, not hinting that they might be guilty of impiety. He does go on, however, in an imaginary conversation to quote and censure the following passage:

[36] *Grove,* v. 275.
[37] Morley, *A Plaine and Easie Introduction,* p. 151.

[66]

Master. Although Maister Taverner did it, I would not imitate it.

Polymathes. For what reasons?

Master. First of all, the beginning is neither pleasing nor artificiall [artistic], because of that ninth taken for the last part of the first note, and first of the next, which is a thing untolerable, except there were a sixt to beare it out: for discords [dissonant intervals] are not to be taken, except they have unperfect cordes to beare them out: likewise between the trebble and counter parts, another might easily be placed. All the rest of the musick is harsh, and the close in the counter part is both naught and stale, like unto a garment of a strange fashion, which being new put on for a day or two, will please, because of the novelty, but being worne thread bare, will grow in contempt.

He criticizes the beginning as being bare, and Polymathes complains that you can hear it several times in a service at St. Paul's.[38]

Taverner was Master of the Choristers at St. Frideswide's (now Oxford Cathedral) from 1526 to 1530, and played the organ there. He must have ceased composing in or about 1530, for heretical (probably Lutheran) books were found in his possession at St. Frideswide's, and he might have suffered severely had not Cardinal Wolsey "for his musick excused him, saying that he was but a musitian, and so he escaped." Foxe says, "This Taverner repented him very muche that he had made Songes to Popish Ditties in the time of his blindnes." Taverner's church

[38] We do not know just whom Morley is criticizing at St. Paul's Cathedral. Morley himself had been organist there in 1591, but it is not known when he resigned or who succeeded him. Morley's criticism was published in 1597.

music is published in Volumes 1 and 3 of *Tudor Church Music* (1923 ff.). During the precious last fifteen years of his short life, when he might have been producing still greater compositions, he was taking part in the suppression of the monasteries and engaging in Protestant polemics, with his musical pen laid aside forever.

The second among the earlier composers of important Tudor church music was "Doctour TYE." "Doctour" he indeed was, having received the degree of Doctor of Music from both Cambridge and Oxford; in those days a man holding a degree from one university might also receive it at the other by paying a stipulated sum. Cambridge had already granted him the degree of Bachelor of Music; the University's "Grace,"[39] or official permission for this degree, records that for ten years he had been engaged in composition and in training choirboys; and its suggestion that the mass which he was required to compose for the degree might be performed on the occasion of the King's visit to the University presumably shows confidence in his ability.

It is probable that Tye taught music to Prince Edward, although this assumption is based upon a play published as late as 1605, Samuel Rowley's *When You See Me, You Know Me*.[40] Edward addresses Tye as "our music's lecturer" and says,

> I oft have heard my Father merrily speake
> In your hye praise, and thus his Highnesse sayth,
> England, one God, one truth, one doctor hath
> For musickes art, and that is Doctor Tye,
> Admired for skill in musicks harmony.

[39] Quoted by Arkwright, *Old English Edition*, x. 11, from Grace Book Γ, 1536: "In primis conceditur Christophero Tye ut studium decem annorum in arte musica cum practica multa in eadem, tum componendo, tum pueros erudiendo, sufficiat ei ad intrandum in eadem, sic ut componat unam missam vel paolu post comitia canendam, vel eo ipso die quo serenissimi principis observabitur adventus, saltem ut manifestum ac evidens aliquod specimen eius eruditionis sic ostendat comitiis." The Grace for his Cambridge Doctor's degree is uninteresting. For further information regarding degrees in music see p. 272 of the present volume.

[40] The portions of the play that concern Tye are given in full in Appendix D.

Tye asks Edward if he may dedicate to him his "Acts of the holy Apostles turn'd into verse" and the Prince replies,

> Ile peruse them, and satisfie your paines,
> And have them sung within my fathers Chappell.

This work of Tye's was entitled:

The Actes of the Apostles, translated into Englyshe Metre and dedicated to the kynges most excellent Majestye, by Christofer Tye, Doctor in Musyke, and one of the Gentylmen of hys graces moste honourable Chappell, wyth notes to eche Chapter, to synge and also to play upon the Lute, very necessarye for studentes after theyr studye, to fyle theyr wyttes, and also for all Christians that cannot synge, to read the good and Godlye storyes of the lyves of Christ hys Appostles. 1553.

In his preface to the *Actes,* which he dedicated to Edward VI, Tye writes first of his poetry, then his music:

> Unto the text I do not ad
> Nor nothyng take awaye
> And though my style be grosse and bad
> The truth perceyve you maye.
>
>
>
> And thoughe they [the notes] be not curious[41]
> But for the letter mete:
> Ye shall them fynde harmonious
> And eke plesaunt and swete.
>
> That such good thinges your grace might move
> Your lute when ye assaye:
> In stade of songes of wanton love
> These stories then to playe.

[41] Curious = erudite, complicated.

The accompanying four-part music could not possibly be played on the lute. Tye was no poet:

> It chauncèd in Iconium
> > As they oft tymes did use;
> Together they into dyd cum
> The sinagoge of Jues.[42]

He was also a priest but "not skilful at preaching,"[43] as a report to Archbishop Parker states in 1561, when Tye was rector of Doddington, near Ely. In 1559, during his twenty years' service as Master of Choristers at Ely Cathedral, he was given a special "Donatio" "pro diligenti servitio." Anthony Wood tells this unlikely tale in his MS *Biographical Notes on Musicians:*

> Dr. Tye was a peevish and humoursome man, especially in his latter dayes, and sometimes playing on ye Organ in ye chap. of qu. Elizab. wh. contain'd much musick, but little delight to the ear, shee would send ye verger to tell him yt he play'd out of Tune: whereupon he sent word yt her eares were out of Tune.

Wood is usually good-natured enough, but he had no intelligent sympathy for the earlier Elizabethan music. He writes that "William Forrest [born c. 1510] was well skill'd in Music and Poetry, had a collection of the choicest compositions in Music that were then in use"; after his death William Heather got them and gave them to Oxford University, "where they yet continue, and are kept only as matters of Antiquity. Among them are the Compositions of Joh. Taverner . . . Joh. Marbeck, Rob. Fairfax, Dr. Christ. Tye, John Sheppard, John Norman, et al." Evidently both the University and Wood were so ignorant of the works of Taverner and his contemporaries as to consider them unmu-

[42] Tye's version of *Acts* 14.1.

[43] Tye "est Sacerdos ac residet ibidem et est Doctor Musice non tamen habilis ad predicandum." Probably his preaching matched his poetry.

sical. Wood nevertheless was a good amateur musician and capable violinist, and his musical opinions are usually worthy of consideration.[44]

After writing Latin masses in the days of Henry VIII, Tye wrote anthems in the severer note-to-note style with the coming of the more thorough Protestantism of Edward VI. He was the most prominent of the first composers who wrote anthems to English words, and so not unjustly has been called the "Father of the Anthem." This constructive achievement by Tye is referred to by Fuller, who writes,

Musick, which received a grievous wound in England at the dissolution of Abbyes, was much beholding to him for her recovery; such his excellent skill and piety, that he kept it up in credit at Court and in all Cathedrals during his life.[45]

Thomas Nash makes one of his characters refer to "Doctour Ty (of which stile there was a famous musition some few yeres since)."[46]

THOMAS TALLIS (c. 1505–1585) was the greatest Elizabethan composer before Byrd. To most people today he is known only for his simple harmonizations of the responses in the prayer books of the Anglican and Episcopal Churches. But his numerous Latin motets show extraordinary contrapuntal ingenuity and complexity, and in musical genius he surpasses the other Englishmen of his generation. He wrote an

[44] Wood collected books on music, on one occasion buying Case's *Apologia Musices* and another book for 1*s*.4*d.*, and says of himself, "All the time that A.W. could spare from his beloved studies of English history, antiquities, heraldry and genealogies, he spent in the most delightful facultie of musick, either instrumental or vocal: and if he had missed the weekly meetings [at which he played the violin] in the house of William Ellis, he could not well enjoy himself all the week after."—Anthony Wood's *Autobiography*, printed in *Wood's Life and Times*, 1891 ed., vol. i, p. 273.

[45] *The History of the Worthies of England*, 1662, by Thomas Fuller, 1608–1661, p. 244, under "Westminster." Anthony Wood, in his MS *Biographical Notes on Musicians*, several times quotes from Fuller. Fuller's musical knowledge seems to have been small. He mentions Tye, praises the vague writer Flud, probably because he did not understand him, gives a vivid account of Merbecke's narrow escape from martyrdom, and a superficial sketch of Dowland, ending with the incorrect surmise that that composer died in Denmark; but includes no other composers whatsoever in his list of "Worthies."

[46] Thomas Nash, *Have with You to Saffron-Walden*, 1596, reprinted in Collier's *Miscellaneous Tracts*, Part II, No. 9, p. 39.

amazing motet in forty real parts, ending with the words "respice humilitatem nostram"—although, as the Editor of *Tudor Church Music* dryly remarks, no composer attempts a forty-part composition in a spirit of "humilitas." The list of his works comprises two Masses, two Magnificats, Lamentations, and fifty-one motets in Latin; and eighteen anthems and several psalms, preces, responses, etc., in English. Tallis was organist or choirmaster of Waltham Abbey, still a show-place a few miles north of London, and Henry VIII visited it during Tallis' tenure of office more than once. When the foundation was dissolved in 1540, Tallis received a larger sum than any other of its seventy servants. He was in favor with Henry VIII, Edward VI, and Elizabeth. He was praised as a teacher: Sir John Harington says[47] that his father was "much skilled in musicke . . . which he learnt in the fellowship of good Maister Tallis."

In 1575 Queen Elizabeth gave Tallis and Byrd a monopoly on music printing in England, and they published during the same year a collection of noble Latin motets of their own composition, under the following title:

Cantiones, quae ab argumento sacrae vocantur, quinque et sex partium, autoribus Thoma Tallisio & Guilielmo Birdo Anglis, Serenissimae Regineae Majestati a privato Sacello generosis,[48] & Organistis.

Cum Privilegio

Excudebat Thomas Vautrollerius typographus Londoniensis in claustro vulgo Blackfriers commorans, 1575.

The fact that these motets were dedicated to Queen Elizabeth is clear proof that she did not share the Puritans' objections to sacred music in

[47] In a letter to Lord Burghley, quoted in *Tudor Church Music,* Vol. 6. Sir John Harington, 1561–1612, a brilliant and learned man, was the godson of Queen Elizabeth and translated *Orlando Furioso* by her command. Essex vainly sent him to her to beg her forgiveness. The father,. John Harington, married a daughter of Henry VIII, and was imprisoned in the Tower at the same time as the Princess Elizabeth.

[48] Gentlemen of the Chapel Royal.

Latin. The first of its five prefatory Latin poems, "De Anglorum Music," I may translate as follows:

British music, preparing for battle, saw that she could pursue her course in safety only if the Queen should declare herself her patron, and promised to equal the nine muses in artistry if she could number as her authors those who, if they would but compose, would astound the people. Therefore, strengthened by the support of so learned a Ruler, she fears no nation's boundaries or censure. Proclaiming Tallis and Byrd her parents, she advances boldly for every voice to sing.[49]

Mention has been made of the fact that religious music (except psalters) could not be printed profitably in Elizabethan England. Tallis tempted fortune with his *Cantiones . . . sacrae,* his only publication of his own works. He did not repeat the experiment, for it evidently failed disastrously: in 1577 the two composers wrote in a petition to the Queen that Tallis was "now verie aged" (he was about 72), that a lease worth £91 given him by Queen Mary was about to expire, and that their monopoly on music printing had "fallen oute to oure greate losse and hindreance to the value of two hundred marks at the least." Elizabeth, "in consideracon of their good service don to her highnes," gave them another lease, in lands.[50] For twelve years after the appearance of *Cantiones . . . sacrae* no music of any kind (except psalters) was published in England, the pessimistic patentees refusing to issue any, and all other publishers being forbidden. Music did not resume its

[49]
De Anglorum Musica
Musica iam praelum meditans Britanna videbat
 Vna se tutam pergere posse via,
Eius si assereret sese Regina patronam,
 Quae nulli e Musis cederet arte novem:
Autoresque operis si tales posset habere,
 Qui sua dum pangunt, caetera turba stupet.
Ergo patronatu tam doctae Principis aucta
 Oras nullius gentis, & ora timet.
Tallisium, Birdumque suos testata parentes
 Audacter quo non ore canenda venit.
[50] *Tudor Church Music,* Vol. 6.

progress until Byrd sold the monopoly to Thomas East and printing recommenced in 1587.[51] Then the famous madrigalian era began in England, and many published works appeared. In 1610 the composer William Corkine wrote in the Dedication to his first book of *Ayres:*

It was long before the use of Notes and Tableture came in to our English Presse, but having found the way, there are few Nations yeeld more Impressions in that kind then ours. Every Musition according to his abilitie increasing the number.

Music printing had become profitable.

To return to Tallis. MSS 984 to 988 in the Library of Christ Church, Oxford, contain 133 Elizabethan compositions and also a number of interesting comments by the owner, Robert Dow,[52] who seems to have been the copyist as well. We have already met him in the rôle of musical benefactor to the Bluecoat School.[53] In the Tenor book, at the end of No. 42 occurs:

> Quatuor illustris vixit sub Regibus iste
> Tallisius magno dignus honore senex.
> Sub quibus eximius si Musicus esset habendus
> Tallisius semper gloria prima fuit.

(Renowned Tallis lived under four monarchs, an aged man deserving of great honor. If in their time any one musician had been singled out as exceptional, Tallis would always have been their chief glory.)

In the Bass part, p. 20:

> Talis es et tantus Tallisi musicus, ut si
> Fata senem auferrent musica muta foret.[54]

[51] East published Byrd's *Psalms, Sonets and Songs of Sadnes and Pietie* in 1588, the year after Byrd relinquished the monopoly. Evidently the latter realized he was no business man.

[52]
> Sum Roberti Dowi
> Vinum et Musica Laetificant Cordas.

[53] Page 15.

[54] Burney quotes this passage in his *History* and prints five errors in the two lines.

The pun "Tal(l)is es" is untranslatable: "Thou art so renowned and great a musician, Tallis, that if fate should carry thee away in thine old age, music would be mute."

He was buried in Greenwich parish church. His epitaph,[55] long since swept away by structural alterations, once ran:

> Enterred here doth ly a worthy Wyght
> Who for long Tyme in Musick bore the bell:
> His Name to shew, was Thomas Tallys hyght
> In honest vertuous Lyff he dyd excell.
> He serv'd long Time in Chappell with grete prayse,
> Fower Sovereynes Reynes (a Thing not often seen)
> I mean Kyng Henry and Prynce Edward's Dayes,
> Queene Mary, and Elizabeth our Quene.
> He maryed was, though Children he had none,
> And lyv'd in Love full thre and thirty Yeres,
> Wyth loyal Spowse, whos Name yclyipt was Jone,
> Who here entomb'd him Company now bears.
> As he dyd lyve, so also did he dy,
> In myld and quyet Sort (O! happy Man)
> To God ful oft for Mercy, did he cry,
> Wherefore he lyves, let Death do what he can.

ROBERT WHITE (c. 1530–1574) is the other name that was important during the earlier period. He received the degree of Bachelor of Music from Cambridge, December 13, 1560, and was Master of Choristers at Westminster Abbey. Several of his contemporaries praise him, Baldwin for one.[56] The first composition in the Christ Church manuscripts mentioned under Tallis is White's "Lamentations." After the Contratenor and Tenor parts is written:

[55] Quoted in *Tudor Church Music*, Vol. 6, from Strype's continuation of Stow's *Survey of London*, Appendix 1, page 92.
[56] See his poem in Appendix F.

> Non ita moesta sonant plangentis verba prophetae
> Quam sonat authoris musica moesta mei.

> (Sad as the mourning Prophet's words fall on the ear
> More sad to me the music's tones appear.)

After No. 3 ("Precamur sancte domine") in all the part-books:

> Maxima musarum nostrarum gloria White
> Tu peris aeternùm sed tua musa manet.

> (Thou diest, White, chief splendour of our art,
> But what thy art hath wrought shall nevermore depart.[57])

Dow must have liked wine, for after No. 7, by White, he praises it for the second time:

> Vinum et musica laetificant cor.
> Spiritus tristis exiccat ossa.

> (Wine and music gladden the heart.
> Doleful sighs dry out our bones.)

Morley mentions White with approval. Hawkins writes:

There was also a Robert White, an eminent Church musician, the composer of several anthems in Barnard's collection. Morley celebrates one of this name, but whether he means either of these two persons [Robert White or Matthew White] cannot be ascertained.

Robert White was meant; Matthew White did not receive his degree of Doctor of Music from Oxford until 1629, and Morley in 1608 could not have mentioned him in the same list with Fayrfax,[58] who died in 1521. "Burney's judgment of polyphony is seldom without prejudice but he

[57] Arkwright's translation.
[58] Wood speaks of Fayrfax as "In great renowne and accounted the prime musitian of the nation."

appreciated White fully. Burney liked formal structure, and White's music had it."[59]

WILLIAM BLITHEMAN (died 1591), organist of the Chapel Royal, deserves mention as the teacher of the greatest Elizabethan virtuoso, John Bull.[60] His epitaph in St. Nicholas Cole Abbey was destroyed in the Great Fire. It is quoted by Hawkins:

> Here Blitheman lies, a worthy wight,
> Who feared God above,
> A friend to all, a foe to none,
> Whom rich and poore did love;
> Of princes chappell gentleman
> Unto his dying day,
> Whom all tooke great delight to heare
> Him on the organs play;
> Whose passing skill in musickes art
> A scholar left behinde,
> John Bull by name, his masters vaine
> Expressing in each kinde;
> But nothing here continues long,
> Nor resting place can have,
> His soule departed hence to heaven,
> His body here in grave.

WILLIAM MUNDY (died about 1591), Gentleman of the Chapel Royal, is mentioned by Morley as one of those who would not use consecutive fifths. The anthem, "O Lord The Maker of All Thing" has been variously attributed to him and to Henry VIII. Baldwin praises him and Dow includes some of Mundy's compositions in his own Christ Church manuscript collection.[61] The possibilities that Mundy's name afforded for pun making were too tempting to be neglected by Dow. The thirty-sixth anthem in this collection is by Byrd. After the Alto part of

[59] *Tudor Church Music,* Vol. 5, which contains the church music of Robert White.
[60] Wood, *Fasti Oxon.* [61] See Appendix F.

Mundy's anthem "Sive Vigilem" (No. 37) Dow wrote as the composer's name "Dies Lunae" (Monday), and a Latin distich, which translates as follows:

> As the moon's light follows that of the sun,
> So thou, Munday, followest after Byrd

a not unkind acknowledgment that Mundy's music has worth but is eclipsed by Byrd's.

OSBERT PARSLEY (1511–1585) was a "singing man" at Norwich Cathedral. Morley in his *Plaine and Easie Introduction* quotes in music type a clever strict canon in three parts, twenty-five bars long, by Parsley, and his church compositions were considered by the editors of *Tudor Church Music* sufficiently important to be printed there. He was buried in Norwich Cathedral; the inscription,[62] now illegible, follows:

OSBERTO PARSLEY

Musicae Scientissimo
Ei quondam Consociati
Musici posuerunt Anno 1585

Here lies the Man whose name in spight of Death
Renowned lives by Blast of Golden Fame,
Whose Harmony survives his vital Breath,
Whose Skill no Pride did spot, whose Life no Blame,
Whose low Estate was blest with quiet Mind
As our sweet Cords with Discords mixed be,
Whose life in Seventy and Four Years entwin'd,
As falleth mellow'd Apples from the Tree,
Whose Deeds were Rules, whose Words were Verity:
Who here a Singing-man did spend his Days,
Full Fifty Years, in our Church Melody;
His Memory shines bright whom thus we praise.

[62] This, and his compositions, are printed in *Tudor Church Music*, Vol. 10 (1929).

JOHN THORNE (died 1573), composer of church music, was "buried in the middle aisle from the west door" in York Cathedral, where he was probably organist. He is mentioned by Morley and Baldwin. His epitaph too has become illegible:

> Here lyeth Thorne, musician most perfect in his art,
> In Logick's Lore who did excell: all vice who set apart:
> Whose Lief and conversation did all men's Love allure,
> And now doth reign above the Skies in joys most firm and pure
> Who dyed Decemb. 7, 1573.

We now come to the other and later group of church musicians, whose compositions appeared during the last years of the sixteenth century and the earlier part of the seventeenth. Two talented Roman Catholic organists, Richard Dering (d. 1630) and Peter Philips (d. 1628), spent most of their lives abroad, and are mentioned in a later chapter.[63] Of the others, Byrd, Gibbons, and Thomas Tomkins are preeminent and will be discussed first, with the rest following in the order named:

WILLIAM BYRD (1542-1623), the greatest Elizabethan composer.

ORLANDO GIBBONS (1583-1625), second only to Byrd as an Elizabethan composer of sacred music.

THOMAS TOMKINS (1573-1656), organist of Worcester Cathedral and an important composer of madrigals also.

JOHN AMNER (d. 1641), organist of Ely Cathedral.

WILLIAM INGLOTT (1554-1621), organist of Norwich Cathedral.

JOHN MUDD, organist of Peterborough Cathedral from 1583 to 1639.[64]

JOHN PARSONS (d. 1623), organist of Westminster Abbey, perhaps the son of Robert Parsons.

NATHANIEL PATTRICK (d. 1595), organist of Worcester Cathedral.

[63] Chapter VIII, Relations with the Continent, pp. 217, 218.
[64] The dates are from Grattan Flood's "New Light on Late Tudor Composers," in the *Musical Times*.

WILLIAM BYRD (1542 or 1543–1623), organist of Lincoln Cathedral before he was twenty-one, and later organist of the Chapel Royal, was acknowledged in his own time as the outstanding Elizabethan composer. He received more recorded praise, and has handed down to us more compositions, than any other Elizabethan musician. His church music rivals that of Palestrina in contrapuntal skill and beauty, and surpasses it in expressiveness. Whether it was superior to it or not, after Palestrina's death Byrd was the leading composer in Europe. Fellowes places him

. . . above all his contemporaries. . . . Like Tallis, Tye, and Robert Whyte, he excelled in music for the English Church, whether for the Latin or English rites. Like Marenzio, Wilbye, and Weelkes, he could write finely in the madrigalian style, not only when treating the severer subjects, where again he stands alone, but also in the lighter vein. . . . Like Bull, Gibbons and Giles Farnaby, he wrote with exceptional fertility of invention for the keyed instruments of his day, yet here again he excelled the others; while for the viols he produced chamber music which today amazes the students of musical form when its date is borne in mind.[65]

In the first rank may be placed Byrd's three Masses, his *Gradualia* or Latin motets for offices of the Catholic Church, his later *Cantiones* or motets in Latin suitable for both the Roman rite and such Protestant churches as admitted the use of that language, and his Anglican service music in English. More unequal, yet including many compositions of high value, are his English anthems and those early motets published in 1575.

Byrd was a pupil[66] of the great composer Tallis and, though thirty-five years younger, was his associate also. That each enjoyed the respect of the other is clear, for both Tallis and his wife remembered Byrd in their wills, and Tallis acted as godfather to Byrd's son. His pupils

[65] Edmund H. Fellowes, *William Byrd. A Short Account of His Life and Work,* 1923.
[66] If Richardson's line is taken in its natural meaning: "Birdus tantum natus decorare magistrum [Tallisium]." See Appendix B.

honored him, as he himself admits.[67] Morley, who was one of these, said that Byrd was "never without reverence to be named of the musicians,[68] and Thomas Tomkins called him his "ancient & much reverenced Master."[69] Charls Butler in 1636 names a dozen composers, English and foreign, as worthy of study and imitation, but prints the name of Mr. BIRD alone in capitals. The copyist John Baldwin included only compositions by Byrd in his MS volume for virginals, *My Ladye Nevells Booke*, 1591, and in the same year wrote a poem in his praise, ranking him above all contemporary composers and players in such lines as the following:

> In Ewroppe is none like to our Englishe man

and

> With fingers and with penne he hathe not now his peere.

Baldwin says that Byrd's fame had spread to the Continent:

> For to strange countries abroade his skill dothe shyne.[70]

This statement is presumably correct, but in support of it we at present know only the meager fact that Byrd and Philippe de Monte, who was Kapellmeister to the Austrian Emperor, sent compositions to each other in 1583 and 1584.

The Dow manuscripts alluded to[71] contain 133 madrigals and sacred choral works. Of these 58 are by Byrd, 18 by Robert White, 17 are anonymous, 8 are by R. Parsons, 6 by Tye, 5 each by Strogers and Tallis, and the rest are by various composers; three are by di Lasso. The manuscripts are dated 1581, too early to contain works by Gibbons and

[67] *Gradualia*, 1605 set, by Byrd. See pp. 64, 65 *supra* for comment on the reasons for publishing Byrd's Latin works.

[68] Thomas Morley, *A Plaine and Easie Introduction*, p. 115.

[69] No. 14 of Tomkins' set of madrigals is dedicated in these terms to Byrd.

[70] See Appendix F. For Byrd's relations with de Monte see E. H. Fellowes, *William Byrd*, 1936, p. 110.

[71] On pp. 74–78, from Christ Church MSS 984–988.

Thomas Tomkins. The compiler has given Byrd the lion's share not merely of the compositions, but of the praise also. After No. 36, by Byrd, in the Soprano, Contratenor, and Bass books he writes:

Cantores inter, quod in æthere sol, bone Birde:
Cur arctant laudes disticha nostra tuas?

(Among singers, good Byrd, you are what the sun is in the sky;
Why should our distichs fetter your fame?)

After the Alto part of No. 41, two and a half lines are filled up with the following quotation from "Cicero ad Atticum lib. 4°" and the Englishman's rejoinder:

Britannici belli exitus expectatur; etiam iam cognitum est, neque argenti scrupulum esse ullum in ea insula, neque ullam spem prædae, nisi ex mancipiis, ex quibus nullos puto te literis aut musicis eruditos expectare.
Unus Birdus omnes Anglos ab hoc convicio prorsus liberat.

(The end of the British war is expected; it is certainly clear by this time that there is not a trace of silver on the island, nor is any plunder expected, except slaves, and of these I do not think you will find any skilled in either reading, writing or music.
One man, Byrd, completely frees all the English from this reproach.)

After the Contratenor part of No. 34, by Byrd, is written:

Birde suos iactet si Musa Britanna clientes;
Signiferum turmis te creet illa suis.

(Byrd, if the Britannic muse should parade its supporters, it would appoint you standard-bearer for its regiments.)

In the Bass book after No. 33, by Byrd:

Qui decus es generi genti Philomelaque nostrae;
Birde precor longùm voce manuque canas!

(How you grace our nation and race, O nightingale; I pray you, Byrd, may you long give us music with your voice and fingers!)

In considering Byrd's life, friendship, dedications, and compositions, the Earl of Northumberland's recommendation for Byrd sums him up admirably: "The mane is honeste."[72] He was a sincere Roman Catholic: "[May I] live and dye a true and perfect member of his holy Catholicke Churche (withoute which I beleeve there is noe salvacon for me)";[73] his wife was fined several times for not attending the established church, and it was perhaps owing to his influential friends that he did not suffer worse inconveniences; but he gave loyally of his musical abilities to the new church, and it was his Protestant friends who surrounded his name with the highest praise.

No thought of religious controversy could have been present in the mind of Byrd when composing his three magnificent Masses on the one hand, or the superb "Great Service," in which he set the English Canticles and Nicene Creed, on the other.[74]

Henry Peacham writes in *The Compleat Gentleman,* 1622:

For Motets and Musick of piety and devotion, as well for the honour of our Nation, as the merit of the man, I prefer above all our Phoenix M[aster] William Byrd, whom in that kind, I know not whether any may equall, I am sure none excell, even by the judgement of France and Italy, who are very sparing in the commendation of strangers, in regard of that conceipt they hold of themselves. His *Cantiones Sacrae,* as also his *Gradualia* are meer Angelicall and Divine; and being of himself naturally disposed to Gravity and Piety, his vein is not so much for leight Madrigals or Canzonets; yet his Virginella and some others in his first Set, cannot be mended by the best Italian of them all.

The dedications of Byrd's first and second books of sacred motets (*Sacrarum cantionum*) issued in 1589 and 1591, are not of special inter-

[72] Letter from the Earl of Northumberland to Lord Burghley, Brit. Museum MS Lansd. 29, No. 38.
[73] Byrd's will, Nov. 15, 1622, printed in E. H. Fellowes' biographies of William Byrd.
[74] Fellowes, *William Byrd. A Short Account of His Life and Work,* 1923, p. 22.

est. They are Latin works designed primarily but not exclusively for Catholic use. The two sets of *Gradualia* (1605 and 1607) occupy definitely Catholic ground.[75] The dedication of the first of these to Lord Northampton is important inasmuch as it describes Byrd's method of composition and reflects the man himself. The composer commences with a reference to his age:

The swan, they say, sings more sweetly upon the approach of death. Its sweetness I in the extremity of my old age cannot equal in these motets, which I thought should be dedicated to you, but I should at least attempt to follow its example.

He was only sixty-three! He then refers to the nobility of the sacred words and says,

There is a certain hidden power, as I learnt by experience, in the thoughts underlying the words themselves; so that, as one meditates upon the sacred words and constantly and seriously considers them, the right notes, in some inexplicable manner, suggest themselves quite spontaneously.[76]

In the second set (1607) he refers to his old age again, and to his unfitness for the task, but wishes to set to music the passages enjoined for use at Christmas and other festivals. A poem in his honor follows, probably by George Gage:

To my very dear friend, cultivated by many and admired by all, Master William Byrd, the Father of British Music. Epigram, [by] G.Ga.[77]

Those which of olde were skil'd in Augurie
By Flight, by Song, by Colour did devine
Of Future haps, and labour'd to discrie
What was above us, by each outward signe.
But blind Antiquity was led a-stray,
Enforcing things of absurd consequence:

[75] No copy of the 1605 set is known, but a second edition (1610) is extant.
[76] Fellowes' admirable translation of this sentence.
[77] "Amicissimo mihi, multis colendo / omnibus suspiciendo, D. Gulielmo Byrde, /

Will you bee guided by a truer way?
Loe heer's a *BYRDE* explaines the difference
Twixt what hee shewes, and what they did inferre,
And proves perspicuously that those did erre.
 They to the Divel sacrifis'd oppressed,
 By this your hearts are unto God addressed.

ORLANDO GIBBONS (1583–1625) was born more than a generation later, and in some ways his music is more modern, even though he lived but two years longer. Whereas Byrd gradually withdrew from public life and devoted himself to the composition of works for a banned church, Gibbons was a man of affairs. Four famous cities record important events in his life, for he was born in Cambridge, was baptized in Oxford, spent his mature years in London, and died in Canterbury. He was a choirboy in King's College, Cambridge, organist of the Chapel Royal at twenty-one, and for the last two years of his life he held the same position in Westminster Abbey. His masterly contrapuntal church music, all written to English words, ranks with the best Elizabethan work. He was also a remarkable player, as his appointments show. Anthony Wood wrote:[78]

This Orlando, who was accounted one of the rarest Musicians and Organists of his time, hath extant . . . admirable Compositions that are printed in several books of Musick.

During the year in which he had been appointed organist of Westminster Abbey, the French ambassadors that visited London to arrange for

Brittanicae Musicae Parenti / Epigramma / G.Ga." The use of "suspicio" in the Ciceronian sense of "look up to" is one of the numerous examples of the fact that Elizabethan Latin is often an accurate reflection of idiomatic classical Latin, and not a mere clumsy transliteration of English words into dog Latin. Similarly, "colendo" expresses not an English word, but a thought: they were eager to be his friends. The usual translation "cultivate" for "colo" is here unfortunate. Dr. Fellowes suggests the author may have been George Gascoyne, but he died forty years earlier. George Gage, a fellow Catholic, is a more likely guess.

[78] *Fasti Oxonienses*, 2d Ed., Vol. 1, column 222, quoted more fully in Appendix G.

the marriage of Henrietta Maria, daughter of Henri IV of France, to Prince Charles, visited the Abbey.

At the door of the quire, the Lord Keeper besought their Lordships to go in . . . and at their Entrance the Organ was touch'd by the best Finger of that Age, Mr. *Orlando Gibbons*. While a Verse was plaid, the Lord Keeper presented the Embassadors . . . with our Liturgy. The Lord Embassadors and their Great Train took up all the Stalls, where they continued about half an hour, while the Quiremen, Vested in their Rich Copes, with their Choristers, sang three several Anthems with most exquisite Voices, before them.[79]

In 1625, with James I scarcely in his grave, Charles and Henrietta Maria were married by proxy in Paris; he did not leave England. The young bride crossed to Dover and he met her there. It was the duty of the Chapel Royal of those days to accompany the sovereign on important occasions, and Gibbons, who in becoming organist of Westminster Abbey had not given up his position as organist of the Chapel Royal, was consequently summoned to Canterbury. There he died suddenly, throwing the court into a panic, as there was a smallpox scare in the town. The Old Cheque Book of the Chapel Royal[80] records the event:

Mr. Orlando Gibbons organist, died the 5th of June, being then Whitsonday at Canterbury, when the Kinge was then to receave Queene Mary [Henrietta Maria], who was then to come out of Fraunce.

On the 12th of June, John Chamberlain wrote[81] Sir Dudley Carleton:

That which makes us the more afraid is that the sickness increaseth so fast . . . Orlando Gibbons the organist of the chappell (that had the best hand in England) died the last weeke at Canterburie not without suspicion of the sickness.

[79] John Hacket, *Scrinia Reservata*, Part I, p. 210, 1692, quoted by Miss Glyn in her book *About Elizabethan Virginal Music and Its Composers*, 1924.
[80] Edited by E. F. Rimbault, p. 11.
[81] Quoted in *Tudor Church Music*, Vol. 4.

But two doctors who had attended him and examined the body found no cause for anxiety. He died of apoplexy. He was buried in Canterbury Cathedral. The epitaph reads:

ORLANDO GIBBONIO CANTABRIGIAE INTER MUSAS ET MUSICAE NATO
SACRAE R CAPELLAE ORGANISTAE SPHAERUMQ HARMONIAE
DIGITORUM PULSU AEMULO
CANTIONUM COMPLURIUM QUAEQ EUM NON CANUNT MINUS
QUAM CANUNTUR CONDITORI
VIRO INTEGERRIMO ET CUIUS VITA CUM ARTE SUAVISSIMIS MORIBUS
CONCORDISSIME CERTAVIT
AD NUPT C R CUM M B DOROBERN ACCITO ICTUQ HEU SANGUINIS
CRUDO ET CRUDELI FATO EXTINCTO CHOROQ COELESTI TRANSCRIPTO
DIE PENTECOSTES A D N MDCXXV
ELIZABETHA CONIUX SEPTEMQ EX EO LIBERORUM PARENS
TANTI VIX DOLORIS SUPERSTES MERENTISSo MAERENTISSa P
VIXIT A M D[82]

(To Orlando Gibbons born at Cambridge amidst the Muses and for music, organist of the Royal Chapel and rivaling by the stroke of his fingers the harmony of the spheres, composer of many anthems which sing his praises as often as they themselves are sung, a man of most upright character, whose personality vied (though most harmoniously) with his musicianship in charm, summoned to the marriage [festivities] of King Charles and Marie of Bourbon at Dover and deprived of life by a lamentable rush of blood and the cruel hand of fate and translated to the choir of heaven on Whitsunday in the year of our Lord's birth 1625—Elizabeth his wife and mother of his seven children, barely surviving her most admirable husband in her extreme grief and wretchedness, has erected this. He lived years months days.)

Who could add any praise after this eulogy?

THOMAS TOMKINS (1573–1656) surpassed in length of years not only

[82] We know the date of birth of very few Elizabethan composers; evidently Orlando Gibbons' wife did not know that of her husband, for the length of his life in years, months, and days is not filled in.

the octogenarian Byrd, but indeed all of the important composers with the possible exception of Tallis, whose life stretches back vaguely into the indefinite past. He was organist of Worcester Cathedral for fifty years, and his work was finally ended not by old age but by the Civil War. His church music is in the stricter Elizabethan style.[88] Charls Butler, in *The Principles of Musik,* 1636, praises Thomas and John Tomkins as Tomkins "that *Aureum par Musicorum."*[84] Butler singles out for special mention

that passionate Lamentation of the good musical King, for the death of his Absalom: Composed in 5. parts by M. Th. Tomkins, now Organist of his Majesties Chappel. The melodious harmoni whereof, when I heard in the Musik-schoole, wheither I shoolde more admire the sweete wel governed voices (with consonant instruments) of the Singers; or the exquisit invention, wit, and Art of the Composer, it was hard to determin.

John Toy's *Worcester Elegy and Eulogy* (1638) contains the following poem:

> *To Master Thomas Tomkins, Bachelor of Musicke.*
>
> And thou great Master of melodious skill,
> This holy harmony didst helpe to fill;
> When in this dismall Cadence, no sound else
> Was heard but Mournefull groanes[85] and mortall bels.
> Thy hand an Organ was of ample good
> To act in tune, and cheere our mourning mood.
> According to thy Tenor,[86] thou didst lend
> Us Meanes, our low and base state to mend.

[88] It has been published as Volume 8 of *Tudor Church Music.*

[84] John Tomkins (1586–1638), the second of "that golden pair of musicians," was organist of St. Paul's Cathedral and was buried there. He was Thomas's half brother. Eight musical members of the Tomkins family are described in *Grove,* v. 353–5.

[85] A reference to the plague at Worcester in 1637.

[86] *Tenor, Mean, Bass,* and *Treble* were voice parts. *Brief, Large,* and *Long* were the names of musical notes, and *Rest* is also a musical term.

> T'accomplish now this song of courtesie,
> In triple time our thanks shall trebbles be.
> These lines are Briefe, but know, thy Restlesse song
> Of fame, shall stand in notes both large and long.

JOHN AMNER (d. 1641) has been mentioned as the composer of one of the few collections of church music printed in England during our period, *Sacred Hymns of 3. 4. 5. and 6 parts for Voices and Vyols,* 1615. Possibly his patron, the Earl of Bath, financed the publication. Seventeenth-century manuscript copies of these and other "Hymns" (or anthems, as we should call them) by Amner exist in several cathedrals, and we may accept the accuracy of Anthony Wood's comment:

> Amner (John) . . . famed for his *sacred Hymnes of three, four five and six parts for voyces & viols* . . . also for certaine Anthemes, wh were in his time & after sung in Cathedralls.[87]

WILLIAM INGLOTT's epitaph may be given here, to swell the graveyard anthology. Born in 1554, he was organist of Norwich Cathedral from about 1608 until his death in 1621. Very little music by him has come down to us.

> For Descant most, for Voluntary all
> He past, on Organ, Song and Virginall.

This presumably means that Norwich considered Inglott to be a good composer for voices, and an unsurpassed organist and virginals player.

JOHN MUDD, organist of Peterborough Cathedral from 1583 until 1639, is named by Meres in *Palladis Thamia* in his list of the sixteen "excellant musicians" of England.

JOHN PARSONS (d. 1623) immediately preceded Gibbons as organist of Westminster Abbey. The position of organist at "the Abbey" is today the most honorable in the kingdom, and was perhaps equally esteemed in the Elizabethan era, if we may judge by the men who accepted the

[87] Anthony Wood, MS *Biographical Notes on Musicians,* folio 11.

post. A Burial Service by Parsons was performed under Purcell's direction at the funeral of Charles II in the Abbey, and there is extant a copy in Purcell's handwriting. Parsons' epitaph in the Abbey cloisters is interesting:

Upon Master Parsons, Organist at Westminster

Death passing by and hearing Parsons play,
Stood much amazed at his depth of skill,
And said "This artist must with me away,"
For Death bereaves us of the better skill.
But let the quire, while he keeps time, sing on,
For Parsons rests, his service being done.[88]

NATHANIEL PATTRICK (d. 1595) was organist of Worcester Cathedral, c. 1590–1595. Sir Ivor Atkins, organist of the cathedral from 1897 to 1950, called him one of the greatest composers of the age.[89] Pattrick was criticized by Bishop Fletcher in 1593 for not training the choirboys well. But that has been a common fault; Bach was guilty of it. We learn from the following list what musical instruments Pattrick owned at his death, but unfortunately nothing is said of musical compositions:

Item an old virginall and an ould recorder x[s]
Item an ould bible and his other pnted and pap bokes xiii[s]iiii[d].

Permission was granted after his death to publish a volume of his madrigals. No copy is known today, and Fellowes thinks it was never printed. So far as we know, no other Elizabethan printed madrigals have completely disappeared.

Many, but not all, of the great Elizabethan composers wrote religious

[88] Quoted in Camden's *Remains*, Hawkins' *History*, and the *Dictionary of National Biography*. *Skill* is misprinted *still* by Hawkins.

[89] Sir Ivor Atkins, *The Early Occupants of the Office of Organist . . . of the Cathedral . . .*, Worcester, 1918.

music of outstanding importance. The preceding pages have recorded the superiority of Tallis, Taverner, Tye, and Robert White among the earlier Elizabethans, and of Byrd, Thomas Tomkins, and Orlando Gibbons in the later group. Nevertheless, four of the most famous men have scarcely been mentioned, all of them composers of madrigals. Two of these, Wilbye and Farnaby, wrote almost no religious music, the other two, Weelkes and Morley, have left us a considerable number of sacred compositions, which have been overshadowed by their secular works and so have remained largely in manuscript. With such names, and many others, the next chapter is concerned.

The Treasury of English Church Music, a 5-volume miscellany of music "from early polyphony to the present time," is very convenient for one wishing to examine the styles of many composers in a single volume. So Vol. 2 (1965) contains one or more sacred works dating from 1545 to 1650 by each of 23 Englishmen from Tye, Merbecke, and Tallis through Byrd, Morley, Gibbons, and others to William Child (1606–1697). It prints the vocal parts with a keyboard reductio, also comments on the music, a bibliography, discography, and lists of modern editions.

IV

Madrigals

A MADRIGAL was a secular composition for unaccompanied voices (two to eight), each singing a separate part. Amorous poetry was commonly but not always used, and the music was sometimes contrapuntal, sometimes harmonic like our modern part-song with the main tune in the treble. For no very good reason, the term is not applied to modern compositions, although we have no word to take its place. Five voices were more commonly employed than four; some churchgoers of the present day who are accustomed to listen to quartet singing may have noticed the surprising increase in dignity and sonority that the addition of a fifth part gives to the harmony. Like many good things, the madrigal came out of Italy; the Italian *madrigale* was literally a composition in the mother tongue.[1] The *madrigale* appeared about 1340, and after flourishing for a time was apparently forgotten until a new and greater era of madrigal writing commenced in 1533. In this later period the important names at first were Flemish—Arcadelt, Verdelot, Willaert, and de Rore—but in the latter half of the sixteenth century the distinguished madrigalists, with the exception of the Fleming di Lasso, were Italians again: Marenzio, Gabrieli, Monteverde, and Gesualdo. There were countless lesser names. The madrigal was also introduced into other countries, such as France, Spain, and Germany, but only in England did it become sufficiently important to rival and probably in some respects surpass its Italian prototype.

We look back to the reign of Elizabeth as the great age of the madrigal. But there was no marked recognition of that fact at the time. The Elizabethans could not know that their work in both literature and

[1] For the etymology of *madrigale*, see E. H. Fellowes, *The English Madrigal Composers*, pp. 43–49. Madrigals were intended for singers, but instruments could join in.

music had reached a climax not attained previously and perhaps never to be surpassed in their nation's history. What pride they would have taken in that realization! For they rejoiced in mighty achievements. But although the madrigal in its own day was hardly recognized as a great art form—there is occasional apologetic reference to the fact that its purpose was only to amuse—yet they proudly stated that in music they yielded the palm to no nation, and they rewarded their greatest musicians with university degrees[2] and appointments at court. Some of the composers have furnished us a valuable commentary to their own compositions by describing their aims and methods in the prefaces to their printed works. References by sixteenth- and seventeenth-century writers to English madrigals and madrigal composers were various in nature, as the following pages will show.

Only two sets of madrigals were published in England before 1588, and because few madrigals of the same period have come down in manuscript (there were numerous sacred works), it is safe to assume that few were written. I shall discuss in order the madrigals:

Printed by

WYNKYN DE WORDE in 1530. Composer unknown.

Composed by

RICHARD EDWARDS (c. 1523–1566), poet, playwright, coach, and musician.

THOMAS WHYTHORNE (1528–1590), who published his sets in 1571 and 1590.

WILLIAM BYRD (1542/43–1623), whose 1588 set opened the chief period of the English madrigal, and was followed by his other sets in 1589 and 1611.

Then for the reader's convenience I shall take up in alphabetical rather than chronological order all the others whose madrigals appeared in

[2] See p. 272.

print. The dates of publication, though given below, are of minor importance, for such modern qualities as maturity of style, expressiveness, and the use of daring harmonies appear more prominently in the earlier compositions than the later. Judged by surviving manuscripts, the composers who did not publish do not seem to have possessed outstanding ability. The names of the greatest composers are printed in capital letters.

RICHARD ALLISON (publ. 1606). Unimportant as a madrigal composer.

THOMAS BATESON (c. 1570–1630; publ. 1604 and 1618). Good but not outstanding. He set fine poems.

JOHN BENNET (publ. 1599). Melodious, tasteful madrigals.

RICHARD CARLTON (c. 1558–1638; publ. 1601). Peculiar clashes of tonality.

MICHAEL CAVENDISH (c. 1565–1628; publ. only eight madrigals, 1598).

MICHAEL EAST (c. 1580–1648); publ. four sets: 1604, 1606, 1610, 1619). Unimportant.

JOHN FARMER (publ. 1599). Pleasant works.

GILES FARNABY (fl. 1590-1625; publ. 1598). His interesting and highly original madrigals and virginal music contain the most daring harmony of the Elizabethan era.

ALFONSO FERRABOSCO the Elder (d. 1588). See Chapter VII.

ORLANDO GIBBONS (1583–1625; publ. 1612). Polyphonic, rather austere.

THOMAS GREAVES (publ. 1604). Unimportant.

JOHN HILTON the Younger (1599–1657; publ. 1627).

WILLIAM HOLBORNE (publ. 1597). Unimportant. See p. 155.

EDWARD JOHNSON (no set published). He contributed to *The Triumphes of Oriana,* 1603.

ROBERT JONES (b. 1575; publ. 1607). Greater as a song composer.

GEORGE KIRBYE (d. 1634; publ. 1597). Fine, austere.

HENRY LICHFILD (publ. 1613). Unimportant.

THOMAS MORLEY (1557–c. 1603; publ. 1593, 1594, 1595 [two sets],

1597). One of the best theorists, and the most popular madrigalist today. In spite of his ill health and consequent depression, his madrigals are noted for their cheerfulness.

JOHN MUNDY (d. 1630; publ. 1594). Unimportant.

FRANCIS PILKINGTON (d. 1638; publ. 1614, 1624). Good, but not outstanding.

WALTER PORTER (c. 1595–1659; publ. 1632 a set with instrumental accompaniment).

THOMAS RAVENSCROFT (c. 1590–c. 16:3). Unimportant as a madrigalist.

THOMAS TOMKINS (1573–1656; publ. 1622). His expressive madrigals are by a man of unusual talent.

THOMAS VAUTOR (publ. 1619). Unimportant.

JOHN WARD (publ. 1613). Expressive and beautiful works.

THOMAS WEELKES (d. 1623; publ. 1597, 1598, 1600 [two sets], 1608). Expressive and original. Perhaps second only to Wilbye.

JOHN WILBYE (1574–1638; publ. 1598, 1609). Generally considered the greatest English madrigalist.

HENRY YOULL (publ. 1608). Pleasant three-part madrigals.

WYNKYN DE WORDE in 1530 printed twenty madrigals—"ix of iiii ptes and xi of thre ptes"—of which only the bass part has survived. The composer's name is unknown.[3] Little can be said today about these first madrigals printed in England except in praise of their typography, which is more beautiful than that of most later Tudor music.

RICHARD EDWARDS (c. 1523–1566), who wrote some music but published none, was a versatile and interesting Elizabethan. He is known today musically by his madrigal "In going to my naked bed." Some of his poems were published in *The Paradise of Dainty Devices*. As master of the children of the Chapel Royal, he trained the choirboys to act

[3] See the informative, but too condensed, article entitled "Printing of Music" in *Grove*, iv. 253–256.

his play *Damon and Pythias* on February 2, 1565, of interest in the history of the drama; and his last play, *Palamon and Arcite,* was acted in the great hall of Christ Church, Oxford, Sept. 3, 1566, before Queen Elizabeth. Anthony Wood describes the performance interestingly.[4] The Queen was so pleased that she gave him "promise of reward." His excellence both as poet and musician won for him the posthumous eulogy (1567) "the flower of all our realm and Phoenix of our age" from Dr. Thomas Twyne, Fellow of Corpus Christi College, Oxford. Dr. Twyne refers to his musical ability:

> Thy tender tunes and rime wherein thou wontest to play,
> Each princely dame of Court and town shall bear in mind alway.

Professor Wallace in *The Evolution of the English Drama Up to Shakespeare*[5] said that "As lyricist, he was the highest achievement England had yet attained." Barnaby Googe in *Eglogs, Epytaphes, and Sonettes* (1563) praised his plays as not likely to be surpassed by any future poet.[6] Hollybande,[7] the Huguenot schoolmaster, praises Edwards in perhaps the only description that we have of early Elizabethan madrigal singing (1573). The scene is a private house, it is snowing:

"Roland, shall we have a song?"

"Yea Sir: where bee your bookes of musick? for they bee the best corrected."

"They bee in my chest: Katherin take the key of my closet, you shall find them in a litle til at the left hand: behold, therebee faire songes at fouer partes."

"Who shall singe with me?"

"You shall have companie enough: David shall make the base: Jhon, the tenor: and James the treble."

[4] *Athenae Oxonienses,* 2d ed., vol. i, entry 172.

[5] Charles William Wallace, *op. cit.,* p. 107.

[6] For the sonnet in question, see Edward Arber's *English Reprints,* Dec. 1, 1871.

[7] Claudius Hollybande (Claude de Saintliens), *The French Schoolemaister,* 1573, pp. 126–132. See also p. 202 of this present work.

"Begine: James, take your tune: go to: for what do you tarie?"

"I have but a rest."

"Roland, drinke afore you begine, you will sing with a better corage."

"It is well said: geve me some white wine: that will cause me to sing clearer."

"You must drink greene wine."

"Yea trulie to cause me to lose my voice."

"Oh, see what a fonell, for he hath powred a quarte of wine without anie takinge of his breath . . ."

"There is a good song: I do marvell who hath made it."

"It is the maister of the children of the Queenes chapell."

"What is his name?"

"Maister Edwards."

The Paradise of Dainty Devices contains his poem:

IN COMMENDATION OF MUSICK[8]

Where gripyng griefs the hart would wound
& dolful domps the minde oppresse,
There Musick with her silver sound,
Is wont with spede to give redresse.
Of troubled minde for every sore,
Swete Musick hath a salve therefore.

In joye it makes our mirth abound,
In grief it chers our heavy sprights,
The carefull head realease hath found,
By Musicks plesant swete delights.
Our sences, what should I saie more,
Are subject unto Musicks lore.

[8] From Dr. Leicester Bradner's *The Life and Poems of Richard Edwards,* Yale University Press, 1927. Differences may be noted between this authentic text and the one Shakespeare used. *The Paradise of Dainty Devices* was published in 1576, ten years after Edwards' death.

A setting of this poem by Adrian Batten (d. 1637) is printed in Hawkins' *History of Music,* Vol. 5 (p. 924 in the edition of 1853).

The Godds by Musick hath their praie,
The foule therein doth joye,
For as the Romaine Poets saie,
In seas whom Pirats would destroye,
A Dolphin saved from death most sharpe,
Arion plaiyng on his harpe.

A heavenly gift, that turnes the minde,
Like the sterne doth rule the ship,
Musick whom the Gods assignde
To comfort man, whom cares would nip,
Sith thou man & beast doest move,
What wise man than wil thee reprove?

Shakespeare in *Romeo and Juliet*, Act IV, Scene 5, quotes the first four lines of this poem, in a passage given below. Its numerous musical allusions and puns exemplify Shakespeare's well-known interest in music. His actual knowledge of music will receive more explicit consideration in Chapter VII. Musicians enter to escort Paris and Juliet to the church, where they are to be married. They find her in a trance, and think she is dead.

First Musician. Faith, we may put up our pipes[9] and be gone.

Juliet's Nurse. Honest good fellows, ah, put up, put up; for, well you know, this is a pitiful case.[9] [*Exit.*]

First Mus. Ay, by my troth, the case may be amended. *Enter* Peter [the Nurse's servant].

Peter. Musicians, O musicians, "Heart's ease,"[10] "Heart's ease:" O, an you will have me live, play "Heart's ease."

First Mus. Why "Heart's ease"?

[9] Pipes: probably recorders. Cf. *Hamlet*. Professor Schelling suggests that after the words "pitiful case" the next player would hold up his instrument case, as not too shabby but that it could be amended. This would bring a laugh.

[10] Heart's Ease: a popular tune. Thomas Rychardes set words to it in his play *Misogonus,* before 1570.

Peter. O, musicians, because my heart itself plays "My heart is full of woe;"[11] O, play me some merry dump,[12] to comfort me.

First Mus. Not a dump we; 't is no time to play now.

Peter. You will not, then?

First Mus. No.

Peter. I will then give it to you soundly.[13]

First Mus. What will you give us?

Peter. No money, on my faith, but the gleek;[14] I will give you the minstrel.[15]

First Mus. Then will I give you the serving-creature.[16]

Peter. Then will I lay the serving-creature's dagger on your pate. I will carry no crotchets:[17] I'll *re*[18] you, I'll *fa* you. Do you note[18] me?

First Mus. An you *re* us, and *fa* us, you note us.

Second Mus. Pray you, put up your dagger, and put out your wit.

Peter. Then have at you with my wit! I will dry-beat you with an iron wit, and put up my iron dagger.—Answer me like men:

"When griping grief the heart doth wound,
And doleful dumps the mind oppress,
Then music, with her silver sound"—

Why "silver sound"? why "music with her silver sound"? What say you, Simon Catling?[19]

[11] My heart is full of woe: this is a quotation from a ballad.

[12] Dump: this perplexing word usually indicated in music a mournful tune. It was also applied to a slow dance, and occasionally seems to have meant any tune. If the first meaning was intended, its incongruity would serve as an Elizabethan joke.

[13] Soundly: an obvious musical pun. "Note" is also.

[14] Gleek: to "give you the gleek" meant to "make a fool of you." If, as some commentators suggest, "minstrel" is a pun on glee(k), it is a very far-fetched one.

[15] Give you the minstrel: call you a minstrel and treat you so. Compare *Macbeth*, I, iii, 119, "Those that gave the Thane of Cawdor to me."

[16] Give you the serving-creature: treat you like a servant.

[17] Crotchets: quarter notes, also whims. "I'll put up with no nonsense."

[18] I'll re you, I'll fa you: Shakespeare may have chosen these two musical notes from the six at random; or the phrase may have conveyed to the audience the additional meaning of "I'll ray you [make you muddy], I'll faugh you [say 'faugh' to you]."

[19] Catling: catgut.

[99]

First Mus. Marry, sir, because silver hath a sweet sound.
Peter. Pretty! What say you, Hugh Rebeck?[20]
Second Mus. I say "silver sound," because musicians sound for silver.
Peter. Pretty too!—What say you, James Soundpost?[21]
Third Mus. 'Faith, I know not what to say.
Peter. O, I cry you mercy! you are the singer: I will say for you. It is "music with her silver sound," because musicians have no gold for sounding:

> "Then music, with her silver sound,
> With speedy help doth lend redress." [*Exit.*]

THOMAS WHYTHORNE (b. 1528; d. after 1590) wrote the only secular vocal works printed in England between 1530 (by Wynkyn de Worde) and 1588 (Byrd). They are part-songs, with the following title:

Songs for three, fower, and five voyces composed and made by Thomas Whythorne, Gent. the which songes bi of sundry sortes, that is to say, some long, some short, some hard, some easie to be songe, and some betweene both: also some solemne, and some pleasant or mery: so that according to the skill of the singers (not being Musitians) and disposition and delite of the hearers, they may here finde songes for their contentation and liking. Now newly published An. 1571. At London, Printed by John Daye, dwelling over Aldersgate.

No one seems to have taken the trouble to examine them until Dr. Fellowes scored several of them a quarter of a century ago and recommended them. Previous to that time writers either ignored or vilified them. Eleven of them were reprinted (for the first time) in 1927, and it is now obvious that at times they show considerable contrapuntal skill, while their melodies are often fluent and their harmony is satisfactory from a modern standpoint. Their neglect by the Elizabethans them-

[20] Rebeck: a primitive bowed stringed instrument, predecessor of the viol and violin. By Shakespeare's time it had lost caste and was no longer included among the instruments at court. It was primitive and countrified, hence Shakespeare's choice of the name.

[21] Soundpost: inside the body of a violin, a post supporting the weight and pressure of the bridge.

selves is difficult to account for except on the assumption that England had but few madrigal singers in 1571, consequently these compositions were little sung and promptly forgotten. Later critics followed either Hawkins, who assumed that Whythorne must have been an inferior composer because he was unknown, or Burney, who with his customary contempt for the Elizabethan madrigal calls them "barbarous." His recently discovered autobiography — the only one we know of by an Elizabethan composer—reveals him to be a poor gentleman who could play the virginals and lute, and who was at various times a student at Magdalen College, Oxford, a music teacher, and a servant in wealthy houses. In the long preface[22] to his Tenor part-book—a piece of crabbed and at times almost unintelligible doggerel that has some historic interest—Whythorne tells more about himself:

Music [he says] had reached a low ebb, whence the Queen, her ministers, and other intelligent lovers of music have revived it. The consequent initiative which others have shown in sending forth [manuscript] copies of their works has emboldened me to publish this; indeed Dutch, French, and Italian composers print most of their compositions. In this work I have set some of the Psalms to bring "heav'nly solas to heavy harts," and also (I hope without offense to religious men, of whom I am one) worldly works and sonnets of my own authorship, "to recreat th' over burdened and sore afflicted minds." But no more worldly works shall proceed from my pen. Some of these compositions date from the time when I was a young man, and those of you that have copies will find I have made changes in words or music. Some are of a kind that will be unfamiliar even to those of you that are Musicians (and only those that can ably compose songs are worthy of that name). So I will explain that I have traveled in sundry foreign lands, lived among the people, and observed their various kinds of music, especially among the Italians; they have a pretty, merry one called the *Napolitane*. Some of my pieces, therefore, are English in style, others foreign. But the notation is English and clear. I wish nothing from this publication but its grateful acceptance. But in spite of my good intentions, I know it will en-

[22] See Appendix A. The *Autobiography* is publ. by the Oxford Univ. Press.

counter criticism, first from those who from their ignorance, lack of artistic taste, or warped natures are unable to judge fairly; second, from petty people, who examine every work minutely solely to pick as many flaws as possible, and last from jangling jays, who find fault with everything, even the best. To those I would reply: it is easier to criticize than to amend, and easier to amend than to compose.

Many of the above ideas are expressed by the later Elizabethan composers also: they apologize for publishing at all, or for including secular music, proclaim their devout purpose in composing sacred music, admit their dread of criticism, and sometimes confess their imitation of the Italian style. A note of apology runs through the prefaces of many Elizabethan books, and is largely conventional.

The Latin eulogies written by his friends, which differ in the various part-books, unfortunately give no additional information. Those in the Medius book repeat ideas taken from the Preface.

Whythorne's second book, published in 1590, is less important. It consists of *Duos, or Songs for tvvo voices, composed and made by Thomas Whythorne Gent.* In his Dedication to Francis Hastings, brother to the Earl of Huntingdon, Whythorne tells us that since he published his previous set, duets for two voices had been printed abroad but not in England, and he thought that many would appreciate such, especially in country districts where singers were few. Unaccompanied duets are not popular today, and Whythorne was probably soon disillusioned, for his seem to have produced neither praise nor imitation, if we may judge by negative evidence. A fine picture of Whythorne is printed at the end of the Cantus part. It is, I think, the only picture of an Elizabethan composer printed in an Elizabethan music book. The illustration doubtless interested his friends, but could hardly have helped sell the book to people that had never heard of him. Whythorne probably paid for the whole publication.

It is somewhat difficult to estimate Whythorne's importance accurately, but he seems to represent a fortuitous and isolated outcropping

THOMAS WHYTHORNE

of a high level of secular musical intelligence which could not make itself visible until music printing became profitable.

This change took place during the lifetime, and partly owing to the genius, of William Byrd (1542/3–1623).

The age of the madrigal in England began with the publication of four famous works:

1588 *Psalmes, Sonets, & songs of sadnes and pietie,* by Byrd.

1588 *Musica Transalpina,* Vol. 1, consisting of madrigals by Italian composers, selected by Nicholas Yonge and literally translated into English.

1589 *Songs of sundrie natures . . .,* by Byrd.

1590 *The first set of Italian Madrigalls Englished,* edited by Thomas Watson. English texts unrelated to the original Italian are used.

Numerous Elizabethan references to Byrd, as we have already seen, bear witness to the extraordinary veneration in which he was held by his contemporaries. Both of the above-mentioned collections of Italian madrigals pay Byrd the exceptional compliment of including two madrigals by him, as if his genius transcended earthly boundary lines and man-made limitations. YONGE's title is:

Musica Transalpina. Madrigales translated of foure, five, and sixe parts, chosen out of divers excellent Authors, with the first and second part of La Verginella, made by Maister Byrd, upon two Stanz's of Ariosto, and brought to speak English with the rest.

And in his Dedication to justify its publication, Yonge states that

. . . albeit there be some English songs lately set forth by a great Maister of Musicke, which for skill and sweetnes may content the most curious: yet because they are not many in number, men delighted with varietie, have wished more of the same sort.

Byrd's set evidently had been well received, and probably had made money.

The title of Watson's publication is:

The first sett of Italian Madrigalls Englished, not to the sense of the original dittie, but after the affection of the Noate. By Thomas Watson. There are also heere inserted two excellent Madrigalls of Master William Byrds composed after the Italian vaine at the request of the sayd Thomas Watson.

Byrd's first set of madrigals came out in 1588, under the following title:

Psalmes, Sonets, & songs of sadnes and pietie, made into Musicke of five parts: whereof, some of them going abroade among divers, in untrue coppies, are heere truely corrected, and th' other being Songs very rare and newly composed, are heere published, for the recreation of all such as delight in Musicke: By William Byrd, *one of the Gent. of the Queenes Maiesties honorable Chappell. Printed by Thomas East the assigne of W. Byrd, and are to be sold at the dwelling house of the said T. East, by Paules Wharfe. 1588 Cum privilegio Regiæ Maiestatis.*

Then follow his famous "Reasons briefly set downe by th'auctor to perswade every one to learne to singe" (in those pioneer days some propaganda was necessary!):

First, it is a knowledge easely taught and quickly learned, where there is a good Master, and an apt Scoller.

2. The exercise of singing is delightfull to Nature, and good to preserve the health of Man.

3. It doth strengthen all parts of the brest, and doth open the pipes.[23]

4. It is a singuler good remedie for a stutting and stamering in the speech.[24]

[23] The physical benefits of singing are also mentioned by Charls Butler in his *Principles of Musik,* 1636, Book 2, Chap. 3, Sec. 2, where he tells us that singing is "a special means to cleere and strengthen the Lungs: so that," if he also takes outdoor exercise, "a Singing-man" need "never fear the Astma, Peripneumonia, or Consumption."

[24] In agreement with this, Henry Peacham writes in *The Compleat Gentleman* (p. 98, 1634 edition), "I my selfe have knowne many Children to have bin holpen of their stammering in speech, onely by it [singing]." But singing is not a cure for stuttering,

5. It is the best meanes to procure a perfect pronunciation, and to make a good Orator.

6. It is the onely way to know where Nature hath bestowed the benefit of a good voyce; which guift is so rare, as there is not one among a thousand, that hath it: and in many, that excellent guift is lost, because they want Art to expresse Nature.

7. There is not any Musicke of Instruments whatsoever, comparable to that which is made of the voyces of Men, where the voyces are good, and the same well sorted and ordered.

8. The better the voyce is, the meeter it is to honour and serve God therewith; and the voyce of man is chiefely to be imployed to that ende.

> Since singing is so good a thing,
> I wish all men would learne to singe.

> omnis spiritus laudet Dominum.

The work has some likeness to Whythorne's in several respects, for Byrd says in the Epistle to the Reader that in some madrigals the main tune is in the treble while the other parts accompany, and that the madrigals are greatly diversified, some being sacred and others secular:

If thou be disposed to praye, heere are Psalmes. If to be merrie, heere are Sonets. If to lament for thy sinnes, heere are divers songs, which being originally made for Instruments to expresse the harmonie, and one voyce to pronounce the dittie, are now framed in all parts for voyces to sing the same. If thou desire songs of smal compasse & fit for the reach of most voyces heere are most in number of that sort. . . . If ther be any jarre or dissonance, blame not the Printer, who . . . doth heere deliver to thee a perfect and

though it is true that persons thus afflicted do not stutter while they sing. Francis Bacon makes the following contribution to this subject (*Sylva Sylvarum,* Experiment 386): "Divers, we see, do stut. The cause may be (in most) the refrigeration of the tongue; whereby it is less apt to move . . . And so we see, that they that stut do stut more in the first offer to speak than in continuance, because the tongue is by motion somewhat heated."

true Coppie. . . . If thou finde any thing heere worthy of lykeing and commendation, give prayse unto God, from whome (as a most pure & plentifull fountaine) all good guifts of Scyence doe flow: whose name be glorified for ever. The most assured friend to all that love or learne Musicke: William Byrd.

The composer here expects criticism for his dissonant harmonies, and his work contains such. At the end of "Blessed is he" he jumps to a

dominant seventh note, as illustrated. As the dominant seventh chord was the first of the many modern dissonant harmonies to come into accepted use, this extremely early example has some historical interest. The first specimen quoted in Grove's *Dictionary* (ii. 530), by Monteverde, dates from 1599. Like the other significant composers of history, Byrd was a progressive.

The Dedication to Sir Christopher Hatton regards "this first printed worke of mine in English" as "unworthie . . . the view . . . of so worthie a Personage." If my faults are excused, "it shall incourage me to suffer some other things of more depth and skill to follow these, which being not yet finished, are of divers expected and desired." Such self-depreciation was conventional in Elizabethan prefaces. Consequently we cannot be sure that Byrd really preferred his forthcoming set (1589), to which he here was looking forward. His modern biographers, E. H. Fellowes and Frank Howes, prefer the 1588 set, but his contemporary public liked both, for both were reprinted during his lifetime.

The 1589 set was his

Songs of sundrie natures, some of gravitie, and others of myrth, fit for all companies and voyces. Lately made and composed into Musicke of 3. 4. 5. and 6. parts . . .

He tells the "curteous Reader" that "Some are easie and plaine to sing,

other more hard and difficult, but all such as any yong practicioner in singing, with a little foresight, may easily performe." In his Dedication Byrd makes important record of both the success of his first set, and the increase of interest in music shown by prominent men: "Having observed . . . that since the publishing in print of my last labors in Musicke, divers persons of great honor and worship, have more esteemed & delighted in the exercise of that Art, than before. And being perswaded that the same hath rather encreased, through their acceptation of my former endevors, I" have composed these.

Byrd's third and last collection of madrigals, interspersed with miscellaneous sacred works, appeared in 1611 under the following title:

Psalmes, Songs and Sonnets: some solemne, others joyfull, framed to the life of the words; Fit for Voyces or Viols of 3. 4. 5. and 6. Parts.

The composer was sixty-nine years old at the time, and his address "To all true lovers of Musicke" includes words of wisdom that he had tested during a lifetime:

Being exited by your kinde acceptance of my former travailes in Musicke, I am thereby much incouraged to commend to you these my last labours, for myne *ultimum vale.* Wherein I hope you shall finde Musicke to content every humor: either melancholy, merry, or mixt of both. Onely this I desire; that you will be as carefull to heare them well expressed, as I have been both in the composing and correcting of them. Otherwise the best song that ever was made will seem harsh and unpleasant, for that the well expressing of them, either by Voyces, or Instruments, is the life of our labours, which is seldome or never well performed at the first singing or playing. Besides a song that is well and artificially[25] made cannot be well perceived nor understood at the first hearing, but the oftner you shall heare it, the better cause of liking you will discover: and commonly that song is best esteemed with which our eares are most acquainted. As I have done my best endeavour to

[25] Artistically.

give you content, so I beseech you satisfie my desire in hearing them well expressed, and then I doubt not, for *Art* and *Ayre* both of skilfull and ignorant they will deserve liking. Vale. Thine W. Byrd.

The phrases "framed to the life of the words" and "Fit for Voyces or Viols" at first sight seem contradictory. The first shows that he wished his music to express the meaning of the words. Then how could he say that this vocal music was "fit for viols"? The answer is that most (though not all) of the music written for strings was so similar in style to that for voices that the viol players probably welcomed the addition of madrigal music to their slender published repertory,[26] while the composers were doubtless pleased to be able thus to sell more copies. The present dislike of musical transcriptions arose comparatively recently. Bach did not share it. We know that Byrd wrote his solo songs with viol accompaniment and then rearranged some of them as madrigals. He would not object to viols again taking part in their performance. Robert Jones intended his madrigals of 1607 "for viols and[27] voices, or for voices alone, or as you please." Evidently the composers did not object to having their compositions performed by varying combinations of voices and instruments. None of the madrigals contain any ungrateful passages fit only for strings.

The other madrigal composers will now be taken up in alphabetical order. It has been said that a chronological arrangement would serve no good purpose. Nevertheless, a preliminary summary showing the number of sets of English madrigals printed during each decade, and the date at which each composer published his first set may be of interest. *The Triumphes of Oriana,* and the madrigals of Ferrabosco (represented in the collections of Italian madrigals dated 1588, 1597, and 1598) and Ravenscroft (whose unclassifiable collections appeared 1609, 1611, and 1614) are not included in the following list:

[26] A list of the music printed for viols is given on pp. 162, 163.
[27] Not "viols *or* voices."

Years or decades	Total number of sets printed during each decade	Name of each composer and the date at which he published his first set of madrigals
1571	1	Whythorne (1571).
1588, 1589	2	Byrd (1588).
1590–1599	13	Morley (1593); Mundy (1594); Kirbye and Weelkes (1597); Cavendish, Farnaby, and Wilbye (1598); Bennet and Farmer (1599).
1600–1609	10	Carlton (1601); Bateson, East, and Greaves (1604); Allison (1606); Jones (1607); Youll (1608).
1610–1619	9	Gibbons (1612); Lichfild and Ward (1613); Pilkington (1614); Vautor (1619).
1620–1629	3	Tomkins (1622); Hilton (1627).
1632	1	Porter (1632, madrigals with instrumental accompaniment).

RICHARD ALLISON (dates of birth and death unknown; he published his set of madrigals in 1606) need not detain us. Anthony Wood states that he "was then most excellent in his facultie, as several of his compositions which we have in our musick school shew."[28] But his *Psalter,* mentioned on page 54, is of more interest to us than his madrigals.

THOMAS BATESON (c. 1570–1630; publ. 1604 and 1618) speaks of "these curious and hard-pleased times," and in both sets expects critical censure. Since his death, at least, comment has been favorable. Wood wrote:

He was a person esteemed very eminent in his profession, especially after he had published the first Set of English madrigals to three, 4. 5 & six voices, as also his Second set.[29]

Bateson was among those honored by an invitation to compose a madrigal for the *Oriana* collection. He was organist of Chester Cathedral, and later of Christ Church Cathedral, Dublin, and was the first recipient of the degree of Bachelor of Music from Trinity College, Dublin.

[28] Anthony Wood, MS *Biographical Notes on Musicians,* folio 10.
[29] Anthony Wood, *op. cit.,* folio 16.

The words and music of his madrigals are wedded together with care and quaint pictorial expressiveness.[30]

JOHN BENNET's set was published in 1599.[31] Bennet and Edward Pearce contributed several light part-songs to Ravenscroft's *A Briefe Discourse* in 1614. Pearce had been his choirmaster at St. Paul's, and as theatrical coach evidently knew how to please the popular taste. Why Ravenscroft should have called on Bennet rather than any one of a dozen others it is impossible to say. But Bennet's madrigals, including the one in the *Oriana* set, had been mostly bright and gay, and Ravenscroft wanted such as examples. In the Preface to *A Briefe Discourse* we read,

The second I name, as partner in this worke, is Maister John Bennet, a Gentleman admirable for all kind of *Composures,* either *in Art, or Ayre, Simple or Mixt,* of what nature soever. I can easily beleeve he had somwhat more than *Art,* even some *Naturall Instinct* or *Better Inspiration,* by which, in all his workes, the very *life* of that *Passion,* which the Ditty sounded, is so truely exprest, as if he had measured it alone by his owne Soule, and invented no other *Harmony,* than his owne sensible feeling in that *Affection* did affoord him.

He also harmonized five psalm tunes in Ravenscroft's Psalter (1621). His madrigals, though creditable, do not rank among the best examples of their kind.

RICHARD CARLTON (c. 1558–1638) published his single set in 1601:

Madrigals to Five voyces: Newly published by Richard Carlton Preist: Batchelor of Musique. London. Printed by Thomas Morley, dwelling in Little Saint Helens. 1601 Cum Privlegio [sic] *ad imprimendum solum.*

With one printer's error on the title page and several in the Latin dedication it would seem that the daring discords imputed by Fellowes to both insufficient technique and printer's errors might be due chiefly to

[30] And see Dr. Fellowes' comments in *Grove,* i. 242.
[31] *Grove,* i, 340.

the latter. It may be fanciful to conjecture that Carlton was a man of conservative tastes merely because of the lines he chose for his first madrigal:

> Yet find I not that love of change in me
> But as I am so will I always be,

but his music has a more distinctly medieval and modal flavor about it than that of some of his more progressive contemporaries.

MICHAEL CAVENDISH (c. 1565–1628), probably a musical amateur, issued in 1598 an admirable set of twenty ayres and eight madrigals. The only known copy was discovered as late as 1918, and is now in the British Museum. In the dedication to his second cousin, Lady Arbela Stuart,[32] he writes like a "poor relation," thankful for small favors.

MICHAEL EAST[33] (c. 1580–1648) had seven sets of his compositions published without making much impression upon the history of music. Only the first four were madrigals with words. The publisher of his first set was the busy music printer Thomas East. If he was Michael's father, Michael's start toward fame is explained. In the dedication of the fourth set (1619) to Robert, Earl of Essex, after some clumsy compliments he more neatly begs him to

Vouchsafe therefore your honored name, to help to grace this heavenly Science, which is the chiefest, and most innocent of all pleasures, which was one of the first Arts in which we praise God, and shall be the last.

JOHN FARMER issued a solitary set in 1599. He says he has "fitly linkt Musicke to Number,[34] as each give to other their true effect, which is to make delight, a virtue so singular in the Italians, as under that ensign only they hazard their honor." In accordance with this pronouncement

[32] Lady Arbela or Arabella Stuart was King James's first cousin, and would have succeeded him had he died childless.

[33] The first three sets (1604, 1606, 1610) successively spell the composer's name Este, Est, and Easte.

[34] Poetry.

he has evidently tried to make his music melodious and attractive. More important than his madrigals were his book of canons—*Divers and sundry waies of two parts in one*[35]—and his harmonizations of psalm tunes in East's *Whole Book of Psalms* (1592), to which he contributed more than any other composer, Kirbye coming second. In 1591 Farmer was living in London near the Royal Exchange. Later he was organist of Christ Church Cathedral, Dublin, for a period, and according to Grattan Flood was offered substantial pecuniary inducements to stay, but in 1599 the attractions of London induced him to return there.

GILES FARNABY wrote a set of excellent madrigals (1598) under the title of *Canzonets to foure voyces with a Song of eight parts*. Like his still greater virginal pieces, they are highly original, harmonically most daring, and expressive. They are neatly dedicated, in a manner characteristic of the composer's vigorous mind, to "Maister Ferdinando Heaburn, Groome of her Majesties Privie Chamber":

Pithy and pleasaunt was that invention of our auncient English poet Jeffray Chaucer, in his booke intituled *the parliament of Birdes* wherein hee describeth the straunge and sweete harmonie amonge the fowles of all kindes, no one refusing to utter such melodie as nature in her course affoorded. The consideration whereof (right worshipfull) emboldneth me to shew my simple skill in these poore Canzonets. Although many excellent and famous musicions have set foorth in Impression many and excellent workes, yet as the sillie sparrow presumeth to chirpe in presence of the melodious nightingall, so bluntly and boldly as a poore member among the musicall sort, I make bold to intrude these sillie works as the first fruits of my labor . . .

Had Farnaby read the *Parliament of Fowls?* Quite possibly, even though Chaucer's phraseology is slightly different. Chaucer names both birds in the same line:

<div align="center">

The sparwè, Venus sone; the nyhtyngale, (351)

That clepeth forth the grene leves newe; (352)

</div>

[35] See p. 262.

but makes no comparison between them, and does not mention the sparrow's song.[36]

Sir Ferdinando Heybourne (c. 1558-1618) had been a pupil of Tallis, and was an amateur composer under the name of Ferdinando Richardson; under that name too he wrote a long Latin poem for Tallis and Byrd's *Cantiones . . . sacrae* (1575). A monument bearing his effigy in the parish church of Tottenham, Middlesex (where he is buried),[37] recorded that "he wayted at the feete of Q. Elizabeth of famous memorye, and our Soveraigne Lo. King James in their privie chamber. He was a careful majestrate without respect of persons, and a true friend of the cause of the poore." There is no reference to music. His use of a *nom de plume,* and his apparent disinclination to be known as a composer are unique in the musical history of the period.

The dedication to Farnaby's set is followed by four disappointing poems in praise of the composer. Their authors were all men of some prominence. Antony Holborne was a courtier and expert lute maker, Allison was the madrigal composer already mentioned, Dowland was the famous lute player, and Hugh Holland was a Cambridge don and poet. Holborne's neat Latin distichs laud Farnaby in general terms, Allison's English verses record that Farnaby published his madrigals only after much persuasion by his friends. The other two poems are quoted as curious specimens:

M. Io. Dowland to the Author

Thou only shalt have Phyllis,
 Only thou fit (without all further gloses)
Crouned to be with everlasting Roses,
 With Roses and with Lillies,
 And with Daffadoundillies,

[36] The only other references to Chaucer in Elizabethan musical literature are made by the poet-composer Thomas Campion and the learned Thomas Morley; see pp. 133, 150 n.

[37] Robinson, *History of Tottenham* (1840), ii. 42.

But thy songs sweeter are (save in their closes)
Than are Lillies or Roses:
Like his that taught the woods sound Amaryllis.
Goldings: you that have too too[38] dainty noses,
Avaunt, go feede you them elsewhere on roses.

M. Hu. Holland to the Author

I would both sing thy praise, and praise thy singing:
That in the winter nowe are both aspringing.
But my Muse must be stronger,
And the daies must be longer,
When the sunne's in his hight with y[e] bright Barnaby[39]
Then should we sing thy praises gentle Farnaby.

ORLANDO GIBBONS (1583-1625) wrote *The First Set of Madrigals and Mottets of 5 Parts: apt for Viols and Voyces*. It appeared in 1612. The dedication mentions "these harsh notes," "my want of abilitie," "their imperfections." Such stock expressions mean little. The madrigals are contrapuntal and severe but most able. He was better known as an organist and by his music for the church and for viols and virginals.

THOMAS GREAVES in 1604 published a less important collection containing both ayres and madrigals. Of five prefatory poems in his honor only the last is of interest. The initials "R.B." are insufficient to prove that Richard Barnfield wrote it, but it is not unworthy of him:

Said Pithagor true, that each man's severed soule
 Must be a Pilgrime? then if ere [e'er] thou dye,
Thy spirit must not drinke of Lethes boule,
 But into a silver plumed Swanne shall flye,
That though thou diest, it may inshrined be
In her that is th' embleme of Harmony.

R. B.

[38] *Sic.*
[39] Barnaby-bright was St. Barnabas' day, June 11th, the longest day of the year by the Old Calendar, and mentioned by Holland because he could not find any other rhyme.

JOHN HILTON (1599–1657; publ. 1627) was probably the son of the John Hilton who contributed a madrigal to *The Triumphes of Oriana.* The 1627 set (*Ayres, or Fa Las for Three Voyces*) was republished in 1644, but not in Fellowes' *English Madrigal School* (1913–24). It was dedicated to Dr. Heather in the last year of his life as "but a drop which I receiv'd from you the Fountaine"—another tribute to that unusual man. Hilton did his best work in the time of Charles I. Anthony Wood picturesquely wrote of him[40] that

> He died in the time of Oliver, and was buried in the Great Cloysters at Westminster; at which time the singing at burials being silenced, as popish, the Fraternity of Musitians who intended to sing him to his grave, sang the Anthem in the House over the corps before it went to the church, and kept time on his coffin.[41]

Hilton, however, was not actually buried in the Abbey, but close by in St. Margaret's, of which he had been the organist.

EDWARD JOHNSON contributed a madrigal to *The Triumphes of Oriana* (1601), but furnished no printed set. The delight his music afforded Queen Elizabeth at Elvetham has been mentioned.[42] He also was engaged by the Earl of Leicester to supervise the musical arrangements for the visit of Queen Elizabeth to Kenilworth.[43] Meres names him in his list of England's sixteen finest composers.

ROBERT JONES in 1607 published *The First Set of Madrigals of 3.4.5.6.-7.8 Parts.* The set is of little practical importance because only two of the part-books seem to have survived. Nine of the madrigals have been printed in *The English Madrigal School* because they exist complete in manuscript. In his dedication he mentions that Plato and Aristotle stress

[40] *Grove,* ii. 634.

[41] We can picture the scene, with the conductor tapping out the time with his long, heavy baton upon the coffin, instead of on the floor, as he would ordinarily.

[42] See p. 8.

[43] Gage, *History of Hengrave,* 1822. See the article by Flood, *Musical Times,* 1927, p. 126.

the importance of music in education, "and *Cicero* reporteth, that although *Themistocles* was endowed with many graces, yet was hee the lesse esteemed, being ignorant thereof," and "though the death of *Nero* was exceeding joyfull to the people, yet was it much lamented, that his excellency in Musicke should perish with him." *The Triumphes of Oriana* contains one of his madrigals. He was more important as a composer of five books of ayres. In addition he was a theatrical manager.

GEORGE KIRBYE (d. 1634; publ. 1597). In his dedication of *The First Set of English Madrigalls to 4.5. & 6. voyces* he says that he need not praise music, even if he could—"besides that many learned men have learnedly written in commendation thereof"—for

. . . the examples of times past, and our owne experience every day, doth give sufficient testimonie both of the pleasure & proffit that it bringeth to a distressed & melancholy mind. Also I think it convenient not to answere (otherwise than with silence) to those (more sencelesse than brute beastes) that with open mouthes doe in-veigh, & speak all the evill they can against that excellent knowledge. But it standeth mee in hand, rather to crave pardon, for this my boldnes, in putting to the view of so many learned Musitions (which this age & Realme affordeth) these first fruites of my poor knowledge in Musicke . . .

At his death he bequeathed his music to his maid, who sold it for forty shillings. We know that it contained a number of "Italian & Latin songs to 5 and 6 voyces" by good composers, for copies were made by a Thomas Hamond and are to be seen in the Bodleian Library.[44] Kirbye, Morley, and Wilbye are practically the only Elizabethan composers about whose musical possessions and reading anything detailed is

[44] Bodleian, MS Mus. f. 1–6. The madrigals and motets for five voices are by Felis (15), Vecchi (9), Pevernage (7), Alfonso Ferrabosco (6), Philips (6), Bona (4), "Gio. Fra. violanti" [della Viola?] (1), Stabile (1), Renaldo Paradiso (1), and Thomas Lupo (1); those for six voices, by Fabritius (20), Ferretti (5), Felis (3), Philips (3), de Monte (3), Vecchi (2), Gastoldi (2), Croce (2), Massaino (2), Marenzio (1), Victoria (1), and del Mel (1). Presumably Kirbye was acquainted with some of these works.

known.[45] The wills of many Elizabethan composers have come down to us, but the contents of their musical libraries (which would be much more significant than the lists of furniture and clothing) are not mentioned.

HENRY LICHFILD's set (1613) is unimportant. It is dedicated "To . . . my most Noble Lady and Mistris, the Lady Cheyney." Dr. Fellowes thinks he was household steward and, like John Ward, not a professional musician.

THOMAS MORLEY, one of the greatest Elizabethans, was born in 1557, and died, aged 45, in 1602. Although his twenty-one-year royal monopoly of the printing of music and music paper made it easy for him to publish his madrigals, it was his merited fame that secured him the monopoly, not the monopoly his fame. His five sets were dated 1593, 1594, 1595 (two), and 1597. Morley's popularity is shown not merely by the large number of his publications, but by the fact that five of them went through second editions in a few years—an unusual honor for Elizabethan compositions.

Although he was subject to constant ill health, and often wished to die, his madrigals are heroically among the lightest and most cheerful of the period, and his music has been enjoyed and praised by many auditors from his day to our own. At the Elvetham Revels, in September, 1591, one of his pavans delighted Queen Elizabeth; Nichols in his *Progresses* tells us that it was the composition of "Master Thomas Morley, then organist of Paules Church." Two contemporaries, Francis Meres and Henry Peacham, mention Morley in their lists of the greatest English composers of that period. Doni (c. 1593–1647), in his *Discorso sopra la perfettine de Melodia*,[46] styles him "Tommaso Morley,

[45] Tallis owned a manuscript containing musical treatises which is now in the British Museum (Lansdowne MS 763). Regarding Wilbye, see Fellowes' article in *Musical Association Proceedings*, 1914.

[46] Published with Doni's *Compendio* in 1635. See Sir John Hawkins, *A General History . . . of Music*, 1875 edition, ii. 494.

erudito musico Inglese." Anthony Wood tells of the popularity enjoyed
by one of Morley's madrigals at New College, "There was somtime an
auntient custom belonging to New College fellows," whereby on Holy
Thursday of every year some of them, "going up to a well or spring in
the grove, which [was] strewd with flowers round about for them, they
sung a song of 5 parts, lately one of [Mr. Morley's] *principium* 'Hard
by a cristall fountaine.' "[47] *The First Booke of Balletts to Five Voyces*,
by Morley, contains the following tribute by "Mr. M. D. to the Author":

> Such was old Orpheus['] cunning
> That senceless things drew neare him,
> And heardes of beastes to heare him,
> The stock, the stone, the Oxe, the Asse came running.
> MORLEY! but this enchaunting
> To thee, to be the Musick-God is wanting.
> And yet thou needst not fear him;
> Draw thou the Shepherds still and Bonny-lasses,
> And envie him not stocks, stones, Oxen, Asses.

"M. D." was the poet Michael Drayton,[48] who also wrote a quaint son-
net that attests his interest in music:

> Love once would daunce within my Mistris eye,
> And wanting musique fitting for the place,
> Swore that I should the Instrument supply,
> And sodainly presents me with her face:
> Straightwayes my pulse playes lively in my vaines,
> My panting breath doth keepe a meaner time,
> My quav'ring artiers be the Tenours straynes,
> My trembling sinewes serve the Counterchime,

[47] Anthony Wood's *Autobiography*, in *Wood's Life and Times*, 1891 edition, i. 289.
Wood wrote "Mr. Wilbye's" by mistake; the madrigal is by Morley.
[48] J. W. Hebel, *Works of Michael Drayton*, i. 493.

My hollow sighs the deepest base doe beare,
True diapazon in distincted sound:
My panting hart the treble makes the ayre,
And descants finely on the musiques ground;
 Thus like a Lute or Violl did I lye,
 Whilst he proud slave daunc'd galliards in her eye.

These *Balletts* by Morley were also published in an Italian edition in London the same year. In it an Italian poem seems to imply that the composer was expecting his own death; it compares him to a "sweet and tuneful swan," who quiets the winds with his celestial notes, and is worthy of eternal laurel.[49]

It is quite possible that Morley knew Shakespeare well, and that he wrote his musical setting of "It was a lover and his lass" at the poet's request. Grattan Flood[50] notes that both Morley and Shakespeare lived in the parish of St. Helen's Bishopgate; both of their names appear in the Rolls of Assessments for Subsidies in 1598 and 1600, and for the same amount, namely 13*s*.4*d*. as assessment on goods valued at £5; and both appealed against the assessment.

An interesting tribute to the composer's genius is a madrigal by his great contemporary Weelkes, entitled "A Remembrance of my friend M[aster] Thomas Morley"; although the words, by John Davies of Hereford, were written not in honor of Morley, but as "A Dump upon the death of the most noble Henrie, late Earle of Pembrooke":

[49] IL SIG[OR] V. H. ALL' AUTORE
Cigno dolce e canoro,
 Che lung' al bel Tamigi, acqueti i venti
Co i tuoi celesti accenti
 Degni d'eterno Alloro
Deh non ti lamentare
 Piu del dolor che Senti nell' andare
A che n' andar voresti
 Ch' a volo vai, a pied' ove non potresti?
[50] *Musical Times* for 1927, p. 228. See also *Illustrations of the Life of Shakespeare*, by Rev. Joseph Hunter, 1845.

DEATH hath deprived me of my dearest friend;
My dearest friend is dead and laid in grave.
In grave he rests until the world shall end.
The world shall end, as end all things must have.
All things must have an end that nature wrought;
That Nature wrought must unto dust be brought.

FRANCIS PILKINGTON was a singing man of Chester Cathedral. He published madrigals in 1614 and 1624. His panegyric on music from his first set has been quoted on page 34. Two sonnets in his honor form prefaces to the second set. The writer of the first of these singles out for special mention four Elizabethan musicians. Few today would find fault with the list.

To my approoved Friend, Master FRANCIS PILKINGTON,
Batchelar of Musicke. A Sonnet

Thou great Atchievements our Heroicke Spirits
Have done in Englands old or later Victories
Shall we attribute wholly to the Merrits
Of our Brave Leaders? And faire Industries
Which their not-named Followers have exprest
Lie hid? And must the Matchlesse Excellencies
Of Bird, Bull, Dowland, Morley, and the rest
Of our rare Artists (who now dim the lights
Of other lands) be onely in Request?
Thy Selfe, (and others) losing your due Rights
To high Desert? nay, make it (yet) more plaine,
That thou canst hit the Ayres of every vaine.
Their praise was their Reward, and so 'tis thine;
The Pleasure of thy paines all mens: and mine.

WILLIAM WEBBE.[51]

[51] Possibly the "W.W." who wrote a poem in honor of Greaves. Webbe (*fl.* 1568–91) was the author of *A Discourse of English Poetrie.*

In the second sonnet his fellow chorister Henry Harpur extols "old Chester," and Pilkington, "for glorious fame chiefe in our Clyme":

Arts praise, and Skills high pitch, are not so tyed
 To banks of Po, or silver Thames (we see)
But Joves faire bird may haunt fine streames beside,
 And chaunt sweet layes on brinkes of Antique dee[*i.e.*, Dee].

With the conventional modesty of the period Pilkington calls his first set "unworthy," and brings his second set forward as "this my little Bundle of Rushes."

He also wrote a book of songs which was published in 1605 and dedicated to the Earl of Derby. A canon by "I.M." printed on the title-page probably points to a friendship with John Mundy, who succeeded Merbecke at Windsor. The second set of madrigals "contains also a Pavin made for the orpharion, by the Right Honourable William, Earle of Darbie, and by him consented to be in my books placed." The Earl has been brought forward in modern times by a solitary critic as the writer of Shakespeare's works, the Earl's musical ability being held responsible for Shakespeare's musical allusions.[52]

Walter Porter (c. 1595–1659) was "an English pupil of Monteverde."[53] His madrigals, published in 1632, contain instrumental accompaniments and florid vocal passages, and so are only partly in the Elizabethan spirit.

Thomas Ravenscroft (c. 1590–c. 1633) is more notable for his Psalter (1621) and *A Briefe Discourse* (1614) than for his madrigals. A scholarly but whimsical young man who preferred certain outworn methods of notation, he nevertheless did not disapprove of popular music, and published the first English collections of rounds. Their authorship is not stated; some, perhaps most of them, were already well known, *e.g.*,

[52] Abel Lefranc, *Sous le Masque de Shakespeare*, 1919. The reference is to the sixth Earl of Derby, c. 1561–1642.
[53] Arkwright, in the *Musical Antiquary*, vol. 4, p. 236.

"Three blinde mice." The first of Ravenscroft's collections of rounds was *Pammelia* (1609). His purpose is stated in the Address to the Reader: "The onely intent is to give generall content, composed by Art to make thee disposed to mirth." *Pammelia* apparently became popular immediately, for in *Deuteromelia,* published the same year, he speaks of "the kinde acceptation of the former Impression." His few madrigals occur in *Melismata* (1611), where again he merely aimed to please, and in *A Briefe Discourse.* The only stated reason for his introduction of compositions into this work on theory is to show the correct use of time signatures.

THOMAS TOMKINS (1573–1656) also did much of his best work in the time of King James. He was organist of Worcester Cathedral. His only set was published in 1622. As a second edition was published the same year, Dr. Fellowes reasonably considers that the work must have proved immediately popular. Tomkins apologizes, quite unnecessarily, "for the lightnesse of some of the words," which are in the best Elizabethan vein. Each of the twenty-eight madrigals is dedicated to a different man, but since two of the lightest—*Fa la's*—were inscribed to the great Byrd and Dowland, it seems useless to try to ascertain Tomkins' opinions of the twenty-eight men[54] by examining the madrigals dedicated to them. His brother John Tomkins, who was made organist of St. Paul's Cathedral that very year, wrote this prefatory poem:

To my Brother the Author [*i.e.,* composer]

Yet thou wert mortall: now begin to live,
 And end with onely Time[;] Thy Muses give
 What Nature hath deny'd, Eternitie:
Gladly my younger Muse doth honour thee,

[54] His father Thomas, his brothers Giles, John, Nicholas, Peregrine and Robert, his son Nathanael; the composers Byrd, Carlton, Coprario, John Daniel, Dowland, Gibbons, Giles, Henry Molle, Myriell, Ward; the organist Thomas Warwicke; the singing man William White; the patron of music Dr. Heather; the organist Thomas Day; the poet

But mine's no praise. A large increase it has
That's multiply'd through strong affections glas.
Yet is thy worth the same, and were no other
Though as a Judge I spake, not as a Brother.
 This comfort have, this Art's so great, so free,
 None but the good can reach to censure thee.

<div align="right">IOHN TOMKINS</div>

THOMAS VAUTOR was probably the household musician of Sir George Villiers, father of the first and grandfather of the notorious second Duke of Buckingham. A prefatory poem to Vautor's only set (1619) praises his "pleasant notes" with disappointing generalities.

JOHN WARD also was a household musician. His master, Sir Henry Fanshawe, seems to have valued him highly both for his music and his business ability, and left him in his will all his musical instruments "except the greate Wind Instrument in my howse in Warwyck Lane." His only set of madrigals was published in 1613. The best of them are admirable examples of their art, displaying a mastery of contrapuntal technique, effective chord progressions, and particularly a rich expressiveness. These descriptive phrases apply equally well to the madrigals of

THOMAS WEELKES (d. 1623), while Weelkes is in addition distinguished by an even greater originality of style, so that he is the most daring of the madrigalists, employing harmonic clashes and modernities to achieve pictorial and emotional effects that were extraordinary for their time. He is hardly inferior to Wilbye, the greatest of the English madrigal composers. Weelkes published five sets of madrigals, in 1597, 1598, 1600 (two sets), and 1608. Their dedications unfortunately contain little of interest. He was organist of Winchester College and later of Chichester Cathedral. He received the degree of Bachelor of Music from Oxford University in 1602, when mention was made of his

Phineas Fletcher; and Dr. Ailmer, Robert Chetwode, William Crosse, John Steevens, William Walker, and Humfrey Witby. See Denis Stevens' excellent life of Thomas Tomkins, pp. 41–45.

sixteen years' study and practice of music. Entertaining details of his life have been unearthed by Dr. Dart and W. S. Collins (*Music and Letters* July 1961, April 1963) on his forced marriage, family affairs, and arraignment by the Bishop of Chichester for drunkenness.

JOHN WILBYE (1574–1638; publ. 1598, 1609) is the last of the madrigalists of whom we should make mention. The researches of Dr. Fellowes have ascertained more interesting and minute details about his life and surroundings than we have regarding any other Elizabethan composer; but his merit does not seem to have been widely acknowledged in his own time. His employers, Sir Thomas and Lady Kytson, of Hengrave Hall,[55] Suffolk, recognized his ability, and her ladyship gave him the lease of a large farm in recognition of his services. In 1602 there were available in Hengrave Hall for the use of Wilbye and the musicians under him six viols, six violins, seven recorders, four cornetts, four lutes, two sackbuts, three oboes, two "flewtes," two virginals, a bandore, a cithern, and a large number of compositions, including madrigals, dances, and unspecified works, for lute, consort, and voices unaccompanied. Unfortunately the titles and composers' names are not recorded, but the list, though incomplete, gives us our best idea of the musical resources at the disposal of a wealthy Elizabethan family. Wilbye died rich. He bequeathed a fine viol to Prince Charles, later Charles II, in recognition (one would think) of some favor done Wilbye by one of the royal family; Prince Charles was only eight when the will was made. If one may compare the madrigals of Wilbye and Weelkes without becoming invidious, it may be said that those of Wilbye show at times greater perfection and finish, without at all falling short in emotional power. "Viewed as a whole, they reach a uniformly high standard, while certain individual compositions stand out to defy comparison with anything in the whole range of madrigal literature. In the

[55] Exquisite illustrations of this stately mansion where Wilbye spent so many years have been published by *Country Life* in *English Homes, Period II*, vol. i, pp. 231 ff., 1924.

opinion of many well-qualified judges he is the greatest of all madrigal writers, whether English or continental."[56]

When we survey the English madrigal in retrospect we can explain its rise more easily than its decline. While English literature and art were being strongly influenced by Italian exemplars in the sixteenth century it was inevitable that English composers similarly should look for guidance to Italy, then the leading musical nation of the world. A concerted work such as a madrigal or oratorio, because of its ever changing texture, the different colors of the individual parts, and the climactic effects obtainable from massed voices, makes a combined emotional and intellectual appeal more attractive to some cultivated musicians than that of the vocal solo or folk song.

Indigenous compositions that we might classify as madrigals were written in England long before 1587, or even 1533,[57] but the earlier specimens were crude and seem not to have suited the general taste, such as it was. The madrigal at its height, however, was an artistic, though sophisticated, union of elaborate verse[58] and complicated music that naturally appealed to the highly educated intelligentsia of Elizabethan England when mature examples of the form were introduced from Italy at a propitious time.

The decline and fall of the madrigal are somewhat harder to explain. We cannot hold Queen Elizabeth's unmusical and uninspiring succes-

[56] Dr. E. H. Fellowes, in *Grove*, v. 717, and *The English Madrigal Composers*, p. 212. See also Dr. Fellowes' long preface to *The English Madrigal School*, vol. vi, which gives practically everything now known about Wilbye.

[57] The year referred to on p. 92 as marking the revival of madrigal writing in Italy.

[58] The words of the printed madrigals and ayres have been collected and published by E. H. Fellowes in his volume of *English Madrigal Verse*, 1920. The authorship of much of the verse is unknown, since the poets' names were not printed in the Elizabethan music books. Some of the poems, however, have been discovered to be the work of Sidney, Spenser, Jonson, Robert Greene, Christopher Marlowe, Thomas Campion, Walter and Francis Davison, Michael Drayton, John Donne, Walter Raleigh, Nicholas Breton, Samuel Daniel, and others. Shakespeare is not included.

sor responsible for its demise, for the madrigal was losing favor on the Continent at the same time. No doubt the critics are right in assuming a decline in English musical taste, but concerted compositions for viols, less popular in their appeal today than madrigals, remained in high esteem until the restoration of Charles II. It is possible to name more definite causes. When the madrigal had attained perfection, it suffered the same fate that has befallen other forms in the history of art: ambitious composers recognized the impossibility of bettering it and turned to new and more promising fields of endeavor. Then, too, Elizabethan music sounded archaic long before the end of the seventeenth century, owing to the change in style. Furthermore the madrigal, itself introduced from Italy, lost ground toward the end of James I's reign to a rival visitor from that same country—declamatory recitative in the style of the Florentine monodists. As practised by Henry Lawes and others, this required both more skilful singing and a power of dramatic expression which had been unnecessary for the madrigal or even the early Elizabethan ayre. Thus began the glorification of the solo singer in England.

If we except some fine madrigals by Pearsall (1795–1856), and may speak in general terms, the composing of secular works for several unaccompanied voices between the death of James I and the coming of Parry and Stanford was largely confined to that of catches in the seventeenth century, glees in the eighteenth, and harmonic part-songs in the nineteenth. All of these derivative forms may be regarded as inferior to the madrigal.

The English Madrigal School, Fellowes' great compilation of madrigals, 1913–1924 (see p. 330), was revised by Thurston Dart as *The English Madrigalists* (1961); changes were needed in musical text, historical perspective, and even in completeness. Sir J. A. Westrup, in recommending Kerman's *The English Madrigal* (1962), feels Fellowes did not realize that the Elizabethans (except Wilbye, Weelkes, and Kirbye) had "little of that passionate feeling for the words that characterizes the work of men like Marenzio and Gesualdo."

V

Songs

THE Elizabethans spoke of their songs for solo voice as ayres. In the printed collections each ayre was usually provided with two accompaniments, one being for lute and viola da gamba, the other for three voices. When the instrumental accompaniment was used in performance, the viola da gamba was doubtless sometimes dispensed with, since the notes written for it were usually also present in the lute part, and the singer could play his or her own accompaniment upon the lute without requiring the presence of a second performer. If the alternative accompaniment for several voices was used, the composition closely resembled a madrigal of the harmonic type, and indeed the Elizabethans referred to both these classes of compositions as ayres, since in both the soprano part carried the main air throughout, the other voices being merely subsidiary to it. But today, if no instrumental accompaniment exists, we call the composition a madrigal. If one does exist, we call it an ayre, no matter what form of accompaniment is actually used in performance.

Folk songs and troubadour songs were common in the Middle Ages, but our modern art-song, with every note of the melody and accompaniment fitted together with care by a composer well aware of its artistic importance, dates from the Elizabethan period. William Howes names Byrd as the composer of the earliest art-song. The ayre, then, was an artistic creation not exactly paralleled on the Continent, and is an achievement of which the British people may justly be proud. Like the best madrigals, the best ayres come almost without exception from the printed collections. The composers of these, and the year in which each collection was published, are here listed:

JOHN ATTEY: 1622.

JOHN BARTLET(T): 1606.

THOMAS CAMPION: 1601 (the set containing ayres by himself and Rosseter), c. 1613 (two collections), c. 1617 (two); also songs for one masque in 1607 and three in 1613. Notable as a composer, Campion was greater as a poet.

MICHAEL CAVENDISH: 1598 (a collection of both ayres and madrigals).

JOHN COOPER, also called Coprario: 1606, 1613, and masques.

WILLIAM CORKINE: 1610, 1612.

JOHN DANIEL: 1606. He was the brother of Samuel Daniel, the poet.

JOHN DOWLAND: 1597, 1600, 1603, 1612. He wrote the best songs of his time, and in addition was the most skilful lute player in Europe.

ROBERT DOWLAND, his son, published a collection of vocal duets in 1610.

ALFONSO FERRABOSCO THE YOUNGER: 1609, and songs for Ben Jonson's masques. Ferrabosco was one of the leading Jacobean composers, and one of the best viol players in Europe.

THOMAS FORD: 1607. His ayres are noted for their fine melodies.

THOMAS GREAVES: 1604. Unimportant.

TOBIAS HUME: 1605. Unimportant.

ROBERT JONES: 1600, 1601, 1608, 1609, 1610. His ayres are inferior to those of Dowland in depth, but second to none in charm and spontaneity.

JOHN MAYNARD: 1611. Inferior works.

THOMAS MORLEY: 1600.

MARTIN PEERSON: 1620.

FRANCIS PILKINGTON: 1605.

PHILIP ROSSETER: 1601 (the collection also containing ayres by Campion).

THOMAS CAMPION (1567–1620) was "an admired poet and musician in the reign of James I," as Anthony Wood rightly called him. Campion was in favor at court, for he wrote two songs for the marriage of Sir

James Hay, a favorite of the king, and the music of masques for the marriages of Princess Elizabeth to the Elector Palatine—ancestors of King George VI—and of the Earl of Somerset to Lady Frances Howard. Another masque by him was given before Queen Anne, the wife of James I. Grattan Flood[1] notes that his tune "What if a day" was used by the Dutch in their patriotic anthem "Bergen op Zoom," and van den Borren[2] mentions another foreign setting of the air. Meres in his *Palladis Thamia* (1598) included him in his list of great English composers. Camden in 1605 ranked him among "the pregnant wits of the time," with Sidney, Spenser, Samuel Daniel, Hugh Holland, Jonson, Drayton, Chapman, Marston, and Shakespeare. His contemporary, John Davies, praises both Campion's poetry and his music in these lines:

> Never did lyrics' more happy strains,
> > Strained out of Art by Nature, so with ease
> So purely hit the moods and various veins
> > Of Music and her hearers as do these.

Campion in turn was generous in his judgment of others, for he wrote a Latin poem in praise of his chief rival as a composer of songs, John Dowland, and verses in English to honor Ravenscroft and the younger Ferrabosco.

Campion's first published songs comprise the first half of:

A Booke of Ayres, Set foorth to be song to the Lute, Orpherian, and Base Violl, by Philip Rosseter Lutenist . . . 1601.

The first twenty-one ayres are by Campion, the other twenty-one by his dearest friend ROSSETER. Campion apologized for the inclusion of his own ayres, as "superfluous blossoms of his deeper studies," but yielded to Rosseter's desire to publish them because some of them had previously been pirated and printed with many mistakes.[3] The authorship

[1] *The Musical Times* for 1927, p. 895. [2] *Musical Quarterly*, July 1923.
[3] So says Rosseter in his Dedication of the volume to Sir Thomas Monson, an old friend of Campion.

of the poems is a matter of some interest. Campion is usually credited with having written them all. Bruce Pattison has advanced the theory[4] that Rosseter, although not hitherto known as a poet, may have written the words of his half of the book, for he calls this half "mine owne" immediately after censuring the practice of making false claims to authorship. To be consistent, then, if Campion had written the words, Rosseter would have said so. Rosseter then comments at some length upon the nature of ayres in general as well as on his own in particular, and his opinions may be summarized here as presumably representing the views of both men, since this joint volume was published with Campion's consent:

Ayres, like epigrams, should be short, and in this volume their shortness is atoned for by their large number. Most of them are light love lyrics, "eare-pleasing rimes without Arte," without complicated fugal imitations. I do not attempt here to write complicated counterpoint, nor to express every single word in the music, but only those that are important or emphatic. "For the Note and Tableture,[5] if they satisfie the most, we have our desire, let expert masters please themselves with better. And if anie light error hath escaped us the skilfull may easily correct it, the unskilfull will hardly perceive it. But there are some, who to appear the more deepe, and singular in their judgement, will admit no Musicke but that which is long, intricate, bated with fuge, chained with sincopation, and where the nature of everie word is precisely exprest in the Note, like the old exploded action in Comedies, when if they did pronounce *Memeni,* they would point to the hinder part of their heads, if *Video,* put their finger in their eye. But such childish observing of words is altogether ridiculous, and we ought to maintaine as well in Notes, as in action a manly cariage, gracing no word, but that which is eminent and emphaticall. Neverthelesse, as in Poesie we give the preheminence to the Heroicall Poeme, so in Musicke we yeeld the chiefe place to the grave, and well invented Motet, but not to every harsh and dull confused Fantasie, where in multitude of points the Harmonie is quite drowned. Ayres have both their Art and pleasure, and I will conclude of them as the

[4] *Musical Times,* November 1931, p. 988. [5] Tableture: i.e., the lute accompaniment.

Poet did in his censure, of *Catullus* the Lyricke, and *Vergil* the Heroicke writer:

> Tantum magna suo debet Verona Catullo:
> Quantum parva suo Mantua Vergilio."[6]

So Campion's ayres are less complex and studied than Dowland's, but are notable for their spontaneity and charm. What is here said of Campion's ayres is true also of Rosseter's, although the latter often strike a deeper note.

Rosseter also compiled a book of *Lessons for Consort,*[7] published in 1609. He was a court lutenist under James I. Campion thought so highly of him as to bequeath him all his property—£20—and to wish "that it had bin farr more."

About twelve years later were published Campion's

Two Bookes of Ayres. The First Contayning Divine and Morall Songs: The Second, Light Conceits of Lovers. To be sung to the Lute and Viols, in two, three, and foure, vocal Parts or by one Voyce to an Instrument. Composed by Thomas Campian.

The composer explains that the mixed character of its contents is due to the desire of the publisher "to content all palates." He composed them "first for one voyce with the Lute, or Violl" and wrote the alternative accompaniment for voices later. He suggests that this second arrangement will give a richer harmony than if the solo voice is accompanied only by the viol in thin two-part counterpoint, and that over-enthusiastic bystanders should be invited to sing this vocal accompaniment, to prevent them from joining in with extempore parts of their own and spoiling the harmony. This quaint remark by Campion throws some light on the musical enthusiasm of the day. He comments further on musical prejudice, his own purpose as composer, and the nature of the English language:

[6] Huge Verona owes as much to its Catullus as tiny Mantua to its Virgil.
[7] See p. 174.

Some there are who admit onely *French* or *Italian* Ayres, as if every Country had not his proper Ayre, which the people thereof naturally usurpe in their Musicke. Others taste nothing that comes forth in Print, as if *Catullus* or *Martials* Epigrammes were the worse for being published. In these *English* Ayres I have chiefely aymed to couple my Words and Notes lovingly together, which will be much for him to doe that hath not power over both. The light of this will best appeare to him who hath pays'd[8] our Monasyllables and Syllables combined, both which are so loaded with Consonants as that they will hardly keepe company with swift Notes, or give the Vowell convenient liberty. To conclude; mine owne opinion of these Songs I deliver thus:

> *Omnia nec nostris bona sunt, sed nec mala libris;*
> *Si placet hac cantes, hac quoque; lege legas.*
> Farewell.

> [Not all in our books is good, and yet not all is bad;
> Be pleased to dip in here and there, and sing what you like best.]

The *First Booke,* as the title states, is serious, and in contrast to the second. *The Second Booke of Ayres* is bound with it, but has a separate title-page, dedication, and address. The dedication is a sonnet, and refers to the practice, still common, of printing holidays on a calendar in red: just as some days are holy, and marked in red, while others are "low-dayes undistinguished," so there are sacred songs in this volume, and secular too. The Address to the Reader is worthy of Martial:

To the Reader

THAT holy Hymnes with Lovers cares are knit
 Both in one Quire here, thou maist think't unfit;
Why do'st not blame the Stationer as well
Who in the same Shop sets all sorts to sell?
Divine with stiles prophane, grave shelv'd with vaine;
And some matcht worse, yet none of him complaine.

[8] Payse: to poise, weigh, consider.

Campion's *Third* and *Fourth Bookes* also were published together in one volume. In dedicating the *Third Booke* to his intimate friend Sir Thomas Monson,[9] Campion states that he composed much of it in earlier years while he was a guest at Sir Thomas's house:

> These youth-borne Ayres then, prison'd in this Booke,
> Which in your Bowres much of their beeing tooke,
> Accept as a kinde offring from that hand
> Which joyn'd with heart your vertue may command.

The Dedication of the *Fourth Booke* to Sir John Monson contains the fine lines,

> And since that honour and well-suted Prayse
> Is Vertues Golden Spurre.

In the Address to the Reader which is here summarized, Campion again refers to the extreme lightness of his ayres, and makes a poor apology for the impropriety of some of his verses:

Ayres resemble gold-leaf: though light as air, they are both ornamental and useful. If the verses toward the end of this book offend, at least they are not so objectionable as some by Chaucer. I wrote the words of all the poems; some of them have been set by other composers, some I myself set earlier and have reprinted here after revising the music.

Campion is here referring to the fact that the verses of the seventh ayre had also been set by Allison and Jones, those of the ninth by Ferrabosco, the seventeenth by Dowland, and the eighteenth by Corkine; and that the twenty-second and twenty-third, previously published in the Campion-Rosseter collection are here "revived with Additions."

[9] Sir Thomas Mo(u)nson, 1564–1641, knighted by Queen Elizabeth and friend of James I, showed his genuine interest in music by paying for the musical education of Robert Dowland and others. Sir John Mo(u)nson, K.B., D.C.L., 1600–1683, the son of Sir Thomas, was a valued legal adviser to Charles I.

Campion left over a hundred songs. In general their music is charming but deficient in emotional quality. Peter Warlock writes:

It cannot be said that Campion is as distinguished a composer as he is a poet. . . . This, of course, is largely due to the superlative excellence of the poems. . . . Extreme neatness of workmanship is always apparent in the music as in the poems; but there is a complete absence of any deeper quality than surface charm in the music, where the words demand a certain measure of intensity for their adequate expression.[10]

JOHN COOPER (c. 1570–1627), an Englishman, was better known in his own day by the Italianate name Coprario, which he had adopted while traveling in Italy. His printed volumes are funeral songs on the deaths of the Earl of Devonshire (1606) and Prince Henry (1613). He was a good craftsman but not a genius. He instructed in music the children of James I, and also the important composers William Lawes (born c. 1585 or 1590, d. 1645) and Henry Lawes (1595–1662). Anthony Wood says of him:

When he returned into England [from Italy] he was e[s]teemed famous for instrumental musick and compositions of Fancies and thereupon was made composer to k[ing] Ch[arles] I. He was one of the first authors yt set Lessons to the viol Lyra-way.[11]

JOHN DANIEL or Danyel (c. 1565–1630) was the brother of Samuel Daniel the poet, published his works, acted as his executor, and succeeded him in his position as censor of the plays to be performed by the Children of the Queen's Revels. Daniel's songs are cast in a larger

[10] Warlock, *The Elizabethan Ayre*, p. 105. Campion's delightful prefaces are worth reading in full in Warlock's book.

[11] Anthony Wood's MS *Biographical Notes on Musicians*, folio 36. Wood makes this last statement about Daniel Farrant (son of Richard Farrant) also. By "lyra-way" he meant the practice of composing pieces for the viol in lute notation and lute style, using chords.

mold than Campion's. Peter Warlock wrote of John Daniel that "As a composer of serious songs in extended form he stands second only to John Dowland in the Elizabethan song," and suggested that Thomas Tomkins dedicated the two parts of his madrigal "O let me live for true love" to Dowland and Daniel "as though he would name them together as the two greatest living masters of accompanied song among his fellow-countrymen."[12] Such novel chromaticisms as the succession of semitones in Daniel's song cycle "Can doleful notes to measured accents set" rank him with Farnaby, Weelkes, and Dowland as the most daring of Elizabethan composers.

JOHN DOWLAND (1563–1626; publ. 1597, 1600, 1603, 1612) was notable as composer, lute player, and translator. He wrote numerous pieces for lute, some of which were printed without permission, but under Dowland's name, in Barley's *A Newe Booke of Tabliture*, 1596. The numerous foreign publications[13] containing pieces by him for lute or for viols testify to his international reputation. The most famous of his instrumental compositions, "Lachrimae," was published in England. It will be mentioned in the next chapter. In addition, he translated Andreas Ornithoparcus' *Micrologus*, dealing with musical theory. What Dowland did not do is of some interest: he seems to have written no madrigals, church music, or pieces for keyboard instruments, either virginals or organ. Dowland may well have been kept busy practising his lute. Mr. Arnold Dolmetsch has testified to the difficulty of playing it, and Mattheson, Handel's contemporary, asserted that a player spent most of his life tuning it! It is to be regretted that Dowland never carried into effect his intention of writing an instruction book on lute playing; it would have become the standard work of its kind.

Anthony Wood, although aware of John Bull's dazzling feats as composer and performer, called Dowland "The rarest Musician that his age did behold," and with reference to his compositions added, "It is

[12] *The English Ayre*, by Peter Warlock, 1926, p. 52.
[13] A list is given in *Grove*, ii. 88.

questionable whether he excelled in vocal or instrumental musick."[14]
In 1598 Richard Barnfield praised Dowland and Spenser in the follow-
ing sonnet:

If Musique and sweet Poetrie agree
As they must needes (the Sister and the Brother),
Then must the Love be great, twixt thee and mee,
Because thou lov'st the one, and I the other.
Dowland to thee is deare; whose heavenly tuch
Upon the Lute, doeth ravish humaine sense:
Spenser to mee; whose deepe Conceit is such,
As, passing all Conceit, needs no defence.
Thou lov'st to heare the sweete melodious sound,
That Phoebus Lute (the Queen of Musique) makes:
And I in deepe Delight am chiefly drownd,
When as himselfe to singing he betakes.
One God is God of Both (as Poets faigne),
One Knight loves Both, and Both in thee remaine.

In 1595 John Scudamore, priest, praised Dowland from Florence for
his "exquisiteness upon the lute" and "cunning in music."[15] Dowland
was a Catholic between the years 1589 and 1595, and his failure to ob-
tain a position at Elizabeth's court in 1594 may have been due to this
fact. From 1598 to 1606 he was chief lutenist to the King of Denmark
at Elsinore, at a salary equal to that of ministers of state. This period
marks both the highest point of his career and its decline, for in 1606
he was dismissed for habitual financial carelessness. We may infer that
this unfortunate event was proclaimed in his native country by Queen
Anne of England, the sister of the King of Denmark, and prevented
him from obtaining another position, for in 1612 Henry Peacham

[14] Anthony Wood's MS *Biographical Notes on Musicians,* folios 44 ff.
[15] Warlock, *The English Ayre,* p. 28.

likened Dowland to a nightingale, forlorn and neglected in the cold of winter:[16]

> Ad amicum suum Iohannem Doulandum
> Musices peritissimum

> So since (old frend,) thy yeares have made thee white,
> And thou for others, hath consum'd thy spring,
> How few regard thee, whome thou didst delight,
> And farre, and neere, came once to hear thee sing:
> Ingratefull times, and worthles age of ours,
> That lets us pine, when it hath cropt our flowers.

But in the same year he was made one of the King's Musicians for the Lutes, and from that time on was probably not in want.

Dowland published four books of songs. The composer's Addresses to the Reader give valuable information regarding himself, his compositions, and his fame. Other composers feigned to hide their light under a bushel, but not Dowland. In 1597 appeared

The First Booke of Songs or Ayres of foure parts with Tablature for the Lute. So made, that all the parts together, or either of them severally, may be sung to the Lute, Orpherian, or Viol de gambo. Composed by JOHN DOWLAND, *Lutenist and Batcheler of Musick in both the Universities. Also an invention by the said Author for two to play upon one Lute. Newly corrected and amended . . . 1597.*

We learn of his fame abroad in his long Address:

> *To the Courteous Reader . . .*

About sixteene yeres past, I travelled the chiefest parts of France, a nation furnisht with great variety of Musicke: But lately, being of a more confirmed judgement, I bent my course toward the famous provinces of Ger-

[16] In *Minerva Britanna or garden of heroical Devises, furnished and adorned with Emblems and Impresa's of sundry natures* . . ., 1612, by Henry Peacham the Younger. Dowland is specially honored here, since the emblem and poem to him are the only ones dedicated in the book to a musician.

many, where I found both excellent masters, and most honorable Patrons of musicke: Namely, those two miracles of this age for vertue and magnificence, *Henry Julio* Duke of Brunswick, and learned *Maritius Lantzgrave of Hessen,* of whose princely vertues & favors towards me I can never speake sufficiently. Neither can I forget the kindnes of *Alexandro Horologio,* a right learned master of musicke, servant to the royall Prince the *Lantzgrave* of *Hessen,* & *Gregorio Howet,* Lutenist to the magnificent Duke of *Brunswick,* both whom I name as well for their love to me, as also for their excellency in their faculties. Thus having spent some moneths in Germany, to my great admiration of that worthy country, I past over the Alpes into *Italy,* where I found the Citties furnisht with all good Artes, but especially musicke. What favour and estemation I had in *Venice, Padua, Genoa, Ferrara, Florence,* and divers other places I willingly suppresse, least I should any way seeme partiall in mine owne indevours. Yet can I not dissemble the great content I found in the proferd amity of the most famous *Luca Marenzio,* whose sundry letters I received from Rome, and one of them, because it is but short, I have thought good to set downe, not thinking it any disgrace to be proud of the judgement of so excellent a man.

Multo Magnifico Signior mio osservandissimo.

PER una lettera del Signior Alberigo Malvezi ho inteso quanto con cortese affeto si mostri desideroso di essermi congionto d'amicitia, dove infinitamente la ringratio di questo suo buon' animo offerendo megli all' incontro se in alcuna cosa la posso servire, poi che gli meriti delle sue infinite virtù, & qualità meritano che ogni uno & me l'ammirino & osservino, & per fine di questo le bascio le mani. Di Roma à 13. di Luglio. 1595.

<div style="text-align:right">

D. V. S. Affettionatissimo servitore,

LUCA MARENZIO[17]

</div>

[17] Translation: Most honored and noble Sir: In a letter from Signore Alberigo Malvezi I learned with what warmth of courtesy you expressed a desire of cultivating my friendship. For this kind thought of yours I thank you from the depths of my heart, and offer you my services in whatever capacity I can be of assistance; for your infinite excellence and merit deserve the admiration and homage of myself and everyone; and in closing I kiss your hands. Rome, July 13, 1595.

<div style="text-align:right">

Your most affectionate servant,
LUCA MARENZIO

</div>

Not to stand too long upon my travels, I will only name that worthy master *Giovanni Crochio,*[18] Vicemaster of the chappel of S. Marks in Venice, with whome I had familiar conference. And thus what experience I could gather abroad, I am now readie to practise at home, if I may but find encouragement in my first assaies. There have been divers Lute-lessons[19] of mine lately printed without my knowledge, false and unperfect, but I purpose shortly myself to set forth the choisest of all my Lessons in print, and also an introduction for fingering, with other bookes of Songs, whereof this is the first: and as this findes favor with you, so shall I be affected to labor in the rest. Farewell. *John Dowland*

A crabbed Latin epigram of five lines by Thomas Campion follows, stating that Music has fittingly allowed Dowland the enjoyment of his fame during his own lifetime.[20]

Dowland gives further information about the welcome he received abroad in a letter[21] to Sir Robert Cecil from Nuremberg dated Nov. 10, 1595:

When I came to the Duke of Brunswick he used me kindly and gave me a rich chain of gold, £23 in money, with velvet and satin and gold lace to make me apparel, with promise that if I would serve him he would give me as much as any prince in the world. From thence I went to the Lantgrave of Hessen, who gave me the greatest welcome that might be for one of my quality, who sent a ring into England to my wife, valued at £20 sterling, and gave me a great standing cup with a cover gilt, full of dollars, with many great offers for my service. From thence I had great desire to see Italy and came to Venice and from thence to Florence, where I played before the Duke and got great favors.

[18] Croce was choirmaster of St. Mark's and a good composer. A volume of church music by him, to English words, was published in London as *Musica Sacra* in 1608.

[19] Barley's *A Newe Booke of Tabliture,* 1596.

[20] It and another Latin epigram by Campion in praise of Dowland may be found in *Campion's Works,* edited by Percival Vivian, 1909, pp. 346, 351.

[21] Printed in full in the *Musical Times* for December 1896, p. 793, with comments by W. B. Squire in the February number, 1897, p. 92; and in *The English Ayre,* by Warlock, pp. 24–27.

In 1600, while Dowland was lutenist to King Christian IV, his *Seconde Booke of Songs or Ayres* was published by George Eastland with the same variety of possible accompaniments that occur in the first book. Eastland's Address to the Reader says in effect:

The energy and money I have put into this publication do not justify themselves, were it not that the fame of Dowland, the worth of these compositions, and the pleasure you will receive from them, warrant it. If this work pleases you, I shall issue a work by a prisoner taken at Cales that will delight you, unless I am a very bad judge.

It is impossible to name the prisoner taken at Calais, for his work was not printed. The sale of Dowland's second book evidently exceeded the expectations of its publisher, for only three years later, in 1603, appeared his *Third and Last Booke of Songs or Aires,* in which the composer tells his readers:

My first two bookes of aires speed so well that they have produced a third, which they have fetched so far from home, and brought even through the most perilous seas, when having escapt so many sharpe rocks, I hope they shall not be wrackt on land by curious and biting censures.

This so-called last book of Dowland's was followed by a fourth, *A Pilgrimes Solace,* in 1612. Here he tells us that

Some part of my poore labours have found favour in the greatest part of Europe, and been printed in eight most famous Cities beyond the seas, viz.: Paris, Antwerpe, Collein, Nurenberge, Franckfort, Leipsig, Amsterdam, and Hamburge: (yea, and some of them also authorized under the Emperours royall priviledge), yet I must tell you, as I have beene a stranger;[22] so have I againe found strange entertainement since my return: especially by the opposition of two sorts of people that shroude themselves under the title of Musicians. The first are some simple Cantors, or vocall singers, who although they seeme excellent in their blinde Division-making, are meerely

[22] I.e., living in Denmark.

ignorant, even in the first elements of Musicke, and also in the true order of the mutation of the Hexachord in the Systeme, (which hath been approved by all the learned and skillful men of Christendome, this 800 yeares,[23]) yet doe these fellowes give their verdict of me behind my backe, and say, what I doe is after the old manner: but I will speake openly to them, and would have them know that the proudest Cantor of them dares not oppose himselfe face to face against me. The second are young-men, professers of the Lute, who vaunt themselves, to the disparagement of such as have beene before their time (wherein I my selfe am a party) that there never was the like of them. To these men I say little, because of my love and hope to see some deedes ensue their brave wordes, and also being that here under their owne noses hath beene published a Booke in defence of the Viol de Gamba, wherein not onely all other the best and principall Instruments have been abased, but especially the Lute by name, the words, to satisfie thee Reader I have here thought good to insert, and are as followeth: *From henceforth, the statefull instrument Gambo Violl, shall with ease yeeld full various, and devicefull Musicke as the Lute: for here I protest the Trinitie of Musicke, Parts, Passion, and Devision, to be as gracefully united in the Gambo Viol, as in the most receiurd* [sic] *instrument that is, &c.*

Dowland is referring to Hume's *Musicall Humors,* 1605. It would have consoled Dowland to know that Hume went crazy. Dowland warns the young teachers that they had better bestir themselves to prove their alleged superiority in practice, and thus uphold the honor of the lute, which he is too old (fifty!) to do. As if in answer to the charge of being an old fogy, he introduces various novelties into *A Pilgrimes Solace—* daring suspensions, and the addition sometimes of two viols to the lute accompaniment. Hume was arguing that the viol be used "lyra way," i.e., that the system of triple and quadruple stopping used upon the lute to produce chords should be applied to the viol. Dowland's fears were well founded, for the viol played lyra way soon became popular, used alone or sometimes in an instrumental ensemble. As the usual accom-

[23] Less than six hundred years in fact; *Grove* gives the approximate date of 1024 for Guido d'Arezzo's system.

panying instrument for the voice, however, the lute was not superseded by the viol—no one would think today of playing chords upon a violin or 'cello to accompany a singer—but the virginal, improved as a harpsichord, was to vanquish the lute in this field within a few years.

Why should Dowland have felt himself too old at fifty? Lute players sang to their own accompaniment, and it may have been that his voice was failing, not his fingers.

Particularly galling to Dowland must have been the spiteful stings of these lesser men at a time when he was conscious of still possessing his fullest powers as a composer. The twentieth century with a fuller sympathy recognizes him and Purcell as England's greatest song composers of all time, and in none of Dowland's works did his flame of genius burn brighter than in this last book of songs, published when, as Peacham said, "Thy yeares have made thee white."

ROBERT DOWLAND (c. 1586–1641), John Dowland's son, compiled and published in 1610 *A Musicall Banquet,* which is a volume of songs with accompaniments for lute. The composers are John Dowland, Antony Holborne, Richard Martin, Robert Hales, Daniel Batchelar, Tessier, Domenico Megli, and the famous Caccini.[24] There are also anonymous compositions—English, French, Spanish, and Italian. It is dedicated to his godfather, Sir Robert Sidney, after whom Robert Dowland was named. The composer explains that the "banquet" is so varied as to suit all tastes and abilities, and hopes those that come in good-will will enjoy it; as for those that come "as Promooters into a country Market,

[24] The three songs by John Dowland and the single examples by Robert Hales, Daniel Batchelar, and Richard Martin have been reprinted in *English Ayres.* Hales and Batchelar held posts at court. Martin was a Member of Parliament, a poet, and a wit; "King James was much delighted with his facetiousness," according to Anthony Wood, and in 1613 he acted in a masque before the King. Domenico Megli was a lesser composer in various fields. Charles Tessier, a French lutenist, composed *Le Premier Livre de chansons et airs de court,* printed in London in 1597 with a dedication to Lady Penelope Rich, the Stella in Sir Philip Sidney's sonnets. Giulio Caccini was one of the famous Florentine group of the late sixteenth century who wrote the world's first operas. His two contributions to *A Musicall Banquet* had been previously printed in his famous book *Le Nuove Musiche,* 1601.

to call our viands into question, . . . I wish their lips such Lettuce as Silenus Asse, or their owne harts would desire." A generous Latin poem in praise of both Dowlands was contributed to the volume by Henry Peacham. It may be thus epitomized: "John Dowland has conquered more lands than Orpheus; may world-wide fame be Robert Dowland's also."

ALFONSO FERRABOSCO THE YOUNGER[25] (c. 1575–1628; publ. 1609) was a talented composer and performer. He was the second of three musicians bearing the same name. Alfonso the Elder,[26] known in his own time as Master Alfonso, was the brilliant but untrustworthy Italian madrigalist who won favor at the court of Elizabeth. He died in 1588. Alfonso the Younger was his son, born and bred in England. He in turn had a son Alfonso, less noted musically, who probably died during Cromwell's time.

Alfonso the Younger must be considered an Englishman and an English composer. He was one of James I's violinists at a salary of £40 a year, music master to Prince Henry and, after Henry's death, to Prince Charles. We may believe that he and his associate Coprario taught the future king well, for Playford says Charles I often chose the service music and anthems himself,

. . . being by his Knowledge in Musick, a competent Judge therein, and could play his Part exactly well on the Bass-Viol, especially of those Incomparable Phantasies of Mr. *Coperario* to the Organ.[27]

Wood wrote of Ferrabosco:

From his childhood he was trained up to musick, & at mans estate he became an excellent composer for instrumental musick in the raigne of K.

[25] See "Alfonso Ferrabosco the Younger," by G. E. P. Arkwright, in his *Studies in Music*, p. 199.

[26] See pp. 214, 215 *infra* for an account of Alfonso the Elder.

[27] John Playford, *An Introduction to the Skill of Musick*, 1654, chapter "Of Musick in General . . ." Coprario composed Fancies for viols and organ playing together. For a definition of the Fancy, Fantasie, or Fantazia, see p. 239 *infra*.

Jam. I. & K. Ch. I. He was most excellent at the Lyra Viol & was one of the first yt set lessons Lyra-way to the viol, in imitation of the old English Lute & Bandora. The most famous man in all ye world for Fantazias of 5 or 6 parts.[28]

André Maugars, one of the two best viola da gamba players in France at the time, wrote from Rome in 1639:

> The lyra is in high favor with them [the Italians], but I have heard none who could be compared with Farabosco in England. . . . The father of the great Farabosco, an Italian, made known the instrument [the viol] to the English, who since then have surpassed all nations. . . . The English play the viol to perfection. I confess that I am somewhat indebted to them and that I have imitated their chords, but those only.

Ferrabosco was highly regarded in his own day as having written the music for several of Ben Jonson's masques—*The Masque of Blackness,* 1604–5; *Hymenaei,* 1605–6; *The Masque of Beauty,* 1607–8; *The Masque for Lord Haddington's Marriage* (*The Hue and Cry after Cupid*), 1607–8; and *The Masque of Queens,* 1608–9. The following tribute to Ferrabosco's efficient aid in the production of *Hymenaei* was thus acknowledged by Jonson:

> And here, that no mans Deservings complain of injustice (though I should have done it timelier, I acknowledge), I doe for honours sake, and the pledge of our Friendship, name Ma. ALPHONSO FERABOSCO, a man, planted by himselfe, in that divine Spheare; & mastring all the spirits of Musique: To whose judiciall care, and as absolute Performance, were committed all those Difficulties both of Song and otherwise. Wherein, what his Merit made to the Soule of our Invention, would aske to be exprest in Tunes, no lesse ravishing than his. Vertuous friend, take well this abrupt testimonie, and think whose it is. It cannot be Flatterie, in me, who never did it to Great ones; and lesse than Love, and Truth it is not, where it is done out of Knowledge.

[28] Anthony Wood, MS *Biographical Notes on Musicians,* Bodleian Library, Wood, 19 D. (4).

Ferrabosco evidently sang in the production. The omission of this eulogy from the 1616 edition may point to a quarrel between the two.

The younger Alfonso had much of his father's independent spirit. He dedicated his ayres to Prince Henry, with these words:

I am not made of much speach. Onely I know them worthy of my Name: And, therein, I took paynes to make them worthy of yours.

The composer was enterprising enough to secure for his book commendatory verses by Ben Jonson, Thomas Campion, and N. Tomkins.[29] The first two poems are given here in full:

> To urge my lov'd *Alfonso* that bold fame
> Of building Townes, and making wild Beasts tame,
> Which Musique had; or speake her knowne effects,
> That She removeth cares, sadness ejects,
> Declineth anger, perswades clemency,
> Doth sweeten mirth, and heighten pietie,
> And is to a body, often, ill inclinde
> No lesse a soveraigne cure, than to the minde;
> To olledge, that greatest men were not asham'd
> Of old, even by her practise, to be fam'd;
> To say, indeed, she were the Soule of Heaven,
> That the eight Spheare, no lesse than Planets seaven
> Mov'd by her order; And the ninth, more high,
> Including all, were thence call'd Harmony:
> I, yet, had utter'd nothing, on thy part
> When these were but the praises of the Art
> But when I have saide, The proofes of all these be
> Shed in the Songs; Tis true: But short of thee.

<div align="right">BEN: JONSON</div>

[29] Fellowes says "Nathaniel Tomkins," but the only Nathaniel Tomkins known to fame was then only ten years old. Possibly Nicholas Tomkins, brother of the famous Thomas Tomkins who was organist of Worcester Cathedral, was the man, but he could not have been more than twenty-two.

To the Worthy Author

MUSICKS maister, and the offspring
Of rich Musicks Father,
Old Alfonso's image living,
These fair flowers you gather
Scatter through the Brittish soile;
Give thy fame free wing
And gaine the moat of thy Toyle:
Wee whose loves affect to praise thee,
Beyond thine owne deserts, can never raise thee.

By T. CAMPION, Doctor in Physicke.

The third poem ends:

O Musicae artis quanta potentia,
Ferra-bosco Non in *ferarum* sola vagum *nemus*
Sed in virorum plus catervas
Participes melioris aurae!
Alfonse, dux rex Lyrici gregis;
Pulsare dignus coelicolmum[?] lyram,
Excellis omnes sic canendo
Semper ut ipse sies canendus.

N. TOMKINS

[How great is music's power, not only over wild beasts, prowling in the forest, but still more over the human flock as they drink in the sweet-sounding air! Alfonso, leader and king of the musical race, well able to play the celestial lyre, you so excel others in your singing, that you yourself will always be sung.]

THOMAS FORD (c. 1580–1648) published *Musicke of Sundrie Kindes* in 1607. Besides instrumental dances, the book contains ayres for solo voice to be accompanied either by the lute, orpharion, or bass viol, or by three other voices. The author's statement that no "musickes . . . are so much in request or more generally received than of those kindes"

would imply that ayres were more popular than madrigals in 1607. This no doubt was true, for within a few more years the supremacy of the ayre and decline of the madrigal became clearly marked.[30] Anthony Wood writes[31] that Robert Johnson and Thomas Ford "were accounted famous and excellent in their faculties." Both men were lutenists in the employ of Prince Henry and later of Charles I. Johnson's settings of "Where the bee sucks" and "Full fathom five" may have been written for the first performance of *The Tempest,* and Ford's "Since first I saw your face" in its arrangement for four voices is today one of the most popular Elizabethan ayres.

ROBERT JONES, born in 1575, published no less than five books of his ayres, in 1600, 1601, 1608, 1609, and 1610. They were popular in his own time and should be today, since many of them are charmingly tuneful and vivacious, and the music accurately catches the expression and rhythm of the words. They are more often genial or humorous than sad. Here, put into modern English, is the opinion Jones seems to give of himself in his early works—but we must discount the conventional self-depreciation of Elizabethan authors: "I am a timid person, poor and buffeted about, and not a great composer; but I have studied hard, done my best, and naturally like my own compositions, which, whatever their faults, at least do not suffer from many technical errors." Despite this statement, strange harmonic clashes abound, particularly in the last two books, which offend more in that respect than any other Elizabethan books of music.[32] Two of his remarks in the Address to the Reader in his *First Booke* may be borne in mind when we listen to his later ayres as well: we need not be surprised that he wrote so suitably for the voice, for he tells us that "Ever since I practiced speaking I have practiced singing"; and the expressiveness of his music is seen to have

[30] See pp. 125, 126.

[31] *Ath. Oxon.,* 2d edition, vol. 1, entry 680.

[32] Some of the apparent mistakes, however, are examples of the use of major and minor thirds in the same chord, a strange Elizabethan license of which Jones was particularly fond. E.g., he uses the chord D F ♮ A F ♯.

been his primary purpose—"My chiefest care was to fit the Note to the Word." Indeed, he even apologizes for thus making the music of the *First Booke* too simple, promising to "take more paines to shew more points of musicke" in the next. Sure enough, the *Second Booke of Songs and Ayres* does contain examples of imitation and canon. He engagingly adds that he would welcome instruction as to their faults, but also "friendly approbation." *Ultimum Vale, or the Third Booke of Ayres,* is dedicated to Henry, Prince of Wales; Jones is looking up! The first two books must have sold well, for he mentions "the kinde applause wherewith I have been rewarded in my former Ayres." The *Fourthe Booke* is "A Musicall Dreame"; he mentions his previous decision never to publish any more songs, but he had a musical dream, many more came to him, and here they are! The unusual address is a savage diatribe against his opponents, of which this is a picturesque sample:

It is hard if all this paines reape not good commendations, and it is water wrung out of a Flint in Thee, sith thou never thinkst well of any, and wert in thy selfe so unskilfull ever, as thy Tutor from the first howre could never make thee sing in Tune; be as thou art a lumpe of deformity without fashion, bredde in the bowels of disdaine, and brought forth by bewitcht Megaera, the fatall Midwife to all true merite.

Any opponents not overwhelmed by this rebuke must have been laid low by the misprints and harsh chords, which are exceptionally numerous. In the *Fift Booke,* he hopes the previous book has given

. . . some reasonable contentment, and now if you please to bee awaked out of that Dreame, I shall for your recreation and refreshing, guide you to the Muses Garden, where you shall find such varietie of delights, that questionlesse you will willingly spend some time in the view thereof. In your first entrance into which Garden, you shall meet with Love, Love, and nought but Love, set foorth at large in his colours, by way of decyphering him in his nature. In the midst of it you shall find Love rejected, upon in-

constancie and hard measure of ingratitude: Touching them that are lovers, I leave them to their owne censure in Loves description. And now for the end, it is variable in another maner, for the delight of the eare to satisfie opinion. I am not so arrogant to commend my owne gifts, neither yet so degenerate, as to beg your tolleration. If these delights of Flowers, or varietie of Fruites, may any wayes be pleasing to your senses, I shall be glad. Otherwise I will vow never to set, sow, plant, or graft, and my labours henceforth shall cease to trouble you, if you will needs mislike, I care not. I will prevent your censures, and defie your malice, if you despise me, I am resolute, if you use me with respect, I bid you most heartily

<div align="center">Farewell.</div>

<div align="center">R. I.</div>

Here end the labors of Robert Jones, not one of the greatest figures, but a quaint and interesting one. A number of his tunes became popular and were sung on the stage, so we shall hear a little more of him in the chapter devoted to that subject.

A peculiar interest attaches to THOMAS MORLEY's book of ayres[33] owing to the fact that it was the only important Elizabethan musical work to which modern scholars had no access as late as 1932. The only known complete copy perished when the Birmingham Public Library burned in 1878. The sole surviving copy, which lacks the last nine compositions, belonged to Henry Clay Folger of New York, and is now in the Folger Shakespeare Library in Washington.[34] Though Morley's ayres are creditable enough, when they were made known to the world

[33] *THE FIRST BOOKE OF AYRES OR LITTLE SHORT SONGS, TO SING AND PLAY TO THE LUTE, WITH THE BASE VIOLE. NEWLY PUBLISHED BY THOMAS MORLEY Bachiler of Musicke, and one of the Gent. of her Maiesties Royal CHAPPEL Imprinted at London in litle S. Helen's by VVilliam Barley, the assigne of Thomas Morley, and are to be sold at his house in Gracious streete. 1600 Cum Priuilegio.*

[34] In *The English School of Lutenist Song Writers* Dr. E. H. Fellowes, the editor, explains: "Mr. Folger specialized in collecting every kind of manuscript and printed book connected with the work of Shakespeare; and this book had its attraction owing to the fact that it included Morley's setting of the lyric 'It was a lover and his lass,'" twenty-three years before the First Folio was printed.

in 1932 they occasioned some disappointment in view of the fame of the composer and the extravagant expectations that had been aroused by pent-up curiosity. Nor do Morley's prefaces, or the words of the songs, throw valuable light on the composer. He acknowledges he is no skilled composer ("no professor") "of Lute Ayres," and has given these to the world to try his skill, to please his friends, and "to satisfie the world of my no idle howers." He mentions his illness (which was soon to prove fatal), yet hopes, if these ayres are well received, to publish others. He dedicates his book "to the worthie and vertuous lover of musicke, Ralph Bosvile Esquire," whose "favours" to the composer were perhaps monetary, in recompense for teaching or playing. The charm of Morley's personality, so evident in his *Plaine and Easie Introduction to Practicall Musicke,* appears in the concluding words of the Dedication:[35]

But see the folly of me, who whilst I look for a Patrone, have lighted on a judge. This must be the comfort that, as they must endure the censure of your judicious eare: so shall they bee sure of the protection of your good word. And herewith once more I humbly commend them and me to your good opinion.

At your devotion now and ever

THO. MORLEY

The printed collections of ayres by other composers may be passed over briefly, since their songs were unimportant, or were eclipsed by their work in other fields. The volumes by CAVENDISH and GREAVES contain both ayres and madrigals. Both composers were noticed in the

[35] In the Dedication Morley gives his opinion that without an intimate knowledge of music one cannot love it as Bosvile does, "for uncouth unkist saith venerable Chaucer." This phrase had almost become a proverb by Morley's time, and the composer may have first seen it in some contemporary work; in 1579, e.g., Edward Kirke wrote, "Uncouthe, unkiste sayde the olde famous Poete Chaucer" in his prefatory letter to Spenser's *Shepheardes Calender.* It is an inexact quotation from Chaucer's *Troilus and Cressida,* i. 809, where Pandarus advises Troilus to declare his love to Cressida, since a woman is "Unknowe, unkist, and lost, that is unsought."

chapter on the Madrigal.[36] The reader is referred to the same chapter for a discussion of PILKINGTON,[37] since this composer is little known by his ayres. Those by HUME[38] are mostly unimportant. The man himself, a picturesque figure, is mentioned in the chapter dealing with instrumental music, since he contributed to that field.[39] ATTEY and BARTLETT are lesser men. PEERSON, in his collection printed 1620, advises that the instrumental accompaniment be played by three viols, but he also recommends the lute or virginals; he is the only Elizabethan composer to suggest the use of the virginals as an accompanying instrument. MAYNARD, "Lutenist at the most famous Schoole of St. Julians in Hartfordshire," may be placed at the bottom of the list. His small collection of ayres is "the only song-book of the period which is of poor quality from start to finish."[40]

The Elizabethan ayre has not yet attained its deserved popularity. Very few specimens were available in modern notation until the appearance in 1920 of the first volumes of Dr. Fellowes' *English School of Lutenist Song Writers,* whereas the madrigal was at least kept alive by the performances of the Madrigal Society from its foundation in 1741, and excellent examples were reprinted during the earlier part of the nineteenth century for the few musicians who appreciated them. The music of any age long past requires repeated acquaintance before it can be taken to the heart. To the neophyte the words and music of the ayres do not fit each other: the dying groans of an Elizabethan lover are expressed in impassioned English and set to music that to us sounds faintly wistful.[41] The modern piano can be tender, sweet, majestic, or impassioned, but it is not by nature dainty. The lute is, and so in gen-

[36] Pp. 111, 114. [37] P. 120.
[38] Five of Hume's songs were printed in his first volume, *The First Part of Ayres* . . ., 1605. *Captaine Hume's Poeticall Musicke* . . ., 1607, which contains his other four songs, was reprinted by the New York Public Library in 1935. Most of his compositions in both volumes are for instruments only.
[39] P. 168. [40] Warlock, *The English Ayre,* p. 122.
[41] Dowland's "In darkness let me dwell" is an exception.

eral are the accompaniments written for it—dainty, with the appropriate atmosphere of joy or sorrow expressed in delicate pastel shades, not vivid oils. The pizzicato tone of the lute is characteristic also of the virginals and harpsichord, but hopelessly foreign to the piano. Since the piano is likely to remain the domestic maid of all work, we shall have to try to play as daintily as we can, and where we inevitably fall short, draw upon our imaginations. But the attempt is worth making.

Dr. Fellowes' historic series *The English School of Lutenist Song Writers,* published by Stainer and Bell 1920 to 1932, contained the bulk of the lute songs printed during the reigns of Elizabeth I and James I. The same firm reprinted the series, under the title *English Lute Songs,* 1958–1966, thoroughly edited and revised by Thurston Dart. This edition contains some additional songs, such as Robert Johnson's *Ayres, Songs and Dialogues,* Thomas Greaves' *Songs* of 1604, the 1618 set of ayres by George Mason and John Earsden, and *Funeral Teares* by Coprario (John Cooper). Editing a modern edition of an Elizabethan ayre or madrigal requires an expert, not a mere copyist, to decide and indicate how many notes (if more than one) should belong to one syllable, for in 1600 modern slurs, tying two or more notes to one syllable, were not yet in use. This series of Professor Dart's is a standard work.

VI

Instruments and Instrumental Music

MUSIC FOR LUTE, CITHERN, AND LYRA VIOL

SUCH instruments as the guitar, banjo, and mandolin, which are played by plucking strings suspended over a fretted[1] fingerboard, are not taken very seriously nowadays, but they have an honorable ancestry. John Dowland tells us that as the lute "of all instruments that are portable is, and ever hath been most in request, so is it the hardest to manage with cunning and order, with the true nature of fingering."[2] Allison intended the singing of his Psalms to be accompanied upon the "Lute, Orpharyon, Citterne or Base Violl, severally, or altogether."

There were two general types of plucked instruments, the *lute* and the *cither(n)* (spelled in various ways, e.g., citterne, as above). "The difference between a cither and a lute is in the shape of the body, flatbacked in the former, pear-shaped in the latter; the cither has wire strings and is played with a plectrum, while the lute has catgut strings to be touched with the fingers."[3] Both used a tablature notation; i.e., each line represents a string, not a note, and the various letters show the position of the fingers on the strings. The *orpharion* was a kind of cithern, and the *pandora* or *bandora* was a large orpharion. The *lyra viol,* though it was a kind of viola da gamba and was not related to the lute, is best mentioned here, for it was tuned and fingered exactly like a lute, and lute music was played upon it from lute notation—tablature.

[1] Frets were tiny strips of wood or gut permanently fixed across the fingerboards of all viols, lutes, and citterns. They showed the player exactly where to place his fingers; and their absence from the violin adds to the difficulty of playing that instrument.

[2] The Address to the Reader in Dowland's translation of Andreas Ornithoparcus' *Micrologus.*

[3] *Grove,* i. 653.

Consequently it played chords, again like a lute, not single notes like a viol. It would seem that a bow was generally used, although in 1652[4] plucking the strings in lute fashion is mentioned as an alternative method.

Several instruction books appeared for members of the lute-cithern family. No extant copy is known of Adrien le Roy's famous *Instruction de partir toute musique des huit tons divers en tablature de luth,* 1557, but there are English translations by John Alford, 1568, and "F. K. Gentleman," 1574. Other Elizabethan instruction books for plucked instruments are:

> *The Science of Luting, licensed to John Allden in 1565*
> *A nevv Booke of Tabliture,* 1596, printed by William Barley
> *The Cittharne Schoole,* 1597, by Antony Holborne
> *The Schoole of Musicke,* 1603, by Thomas Robinson
> *New Citharen Lessons,* 1609, by Thomas Robinson
> *Varietie of Lute-lessons,* 1610, by Robert Dowland.

These elementary instruction books differ in arrangement and clearness, but not in fundamentals, since all draw upon le Roy.

It was WILLIAM BARLEY's *A nevv Booke of Tabliture* (1596) to which John Dowland referred in his ire in 1597: "There have been divers Lute-lessons of mine lately printed without my knowledge, false and unperfect." Barley's twenty-four rules to learn to play the lute are clear —except the rule for tuning; it would have been easier if he had given the pitch of each string in staff notation as well, or the letter-names of the notes. Almost all the pieces given (in tablature) as exercises are by either Dowland or a Francis Cutting, who at present is a mere name in musical history. The book is in three divisions, treating the lute, orpharion, and bandora. Reprinted 1966, piano arr. by W. W. Newcomb.

ANTONY HOLBORNE, who was born about 1565[5] and died in 1602, was

[4] John Playford, *Musick's Recreation on the Lyra Viol.*
[5] According to W. H. Grattan Flood, in "New Light on Late Tudor Composers," *Musical Times* for 1928, p. 511.

an instrumental composer, highly regarded in his own time, but now almost unknown because his work lies outside the three fields of Elizabethan music that are popular today—the madrigal, the ayre, and compositions for virginals. His earliest publication came in 1597:

The Cittharne Schoole, by Antony Holborne, Gentleman, and servant to her most excellent Majestie. Hereunto are added sixe short Aers Neapolitan like to three voyces, without the Instrument: done by his brother, William Holborne.

This includes thirty-two compositions for cithern solo, twenty-three duets for cithern and bass viol, and two quartets for cithern and three viols.

John Dowland in his *Second Booke of Songes or Ayres,* 1600, dedicates "I saw my lady weep," one of the finest Elizabethan songs, "to the most famous Anthonie Holborne."[6] Robert Dowland includes a duet by Holborne, "My heavie sprite," in his own *Musical Banquet,* 1610, and calls him "this most famous and perfect artist." Francis Derrick wrote from Antwerp in 1594 asking Henry Wickham to procure "some principal lessons for the bandora of Holborne's making, and other most cunning men in that instrument."[7] Holborne was an expert lute maker. He must have been esteemed by his fellow composers for his musical ability, his friendship, and his literary attainments, for Morley included a commendatory sonnet by him in his own *Plaine and Easie Introduction,* and Farnaby a Latin poem similarly in *Canzonets,* 1598. Holborne was also a Gentleman Usher to Queen Elizabeth.

His *Pavans, Galliards, Almains, and other short Æirs . . . for Viols . . .,* 1599, will be discussed on page 164.

In 1603 an instruction book by THOMAS ROBINSON was printed, entitled

The Schoole of Musicke: wherein is taught, the perfect method, of true

[6] William Holborne's ayres are reprinted in *English Madrigal School,* Vol. 36.
[7] Quoted by Grattan Flood, *op. cit.,* from Hatfield MSS, Parts 3 and 12.

fingering of the Lute, Pandora, Orpharion, and Viol de Gamba; with most infallible generall rules, both easie and delightfull. Also, a method, how you may be your owne instructer for Prick-song, by the help of your Lute, without any other teacher: with lessons of all sorts, for your further and better instruction. Newly composed by Thomas Robinson, Lutenist. London . . . 1603.

Musical exercises and compositions occupy most of the book. The instruction is verbose, imparted in an imaginary conversation in the manner of Morley's *Plaine and Easie Introduction,* 1597, but using le Roy's principles.[8] It is dedicated to King James, and since it was printed the year of James's accession, Robinson takes up half of the dedication with asseverations of loyalty. He introduces himself to the unmusical monarch with this recommendation: "I can say for myselfe, that once I was thought (in Denmark at Elsanure) the fittest to instruct your Majesties Queene, our most gracious Ladie and Mistres" when she was Princess Anne of Denmark.

The Address "To the Reader" amplifies somewhat the information given in the title:

Right courteous Gentlemen, and gentle Readers, your favorable acceptance of my first fruits[9] from idlenesse, hath eccited mee further to congratulate your Musicall endeavours. [This book will] enable you to instruct yourselves to play (upon your best beloved instrument) the Lute, also the Orpharion, Pandora, and Viol de Gamba, any lesson (if it bee not too too trickified) at the first sight. . . . Also . . . some lessons of all sorts . . . all myne owne setting, and the most of them, mine owne invention.

But Gentlemen, once more I will make you promise, that if these Masterlike rules, and Scholerlike lessons, doe but any whit content you, I will come forth, *With Cracke mee this Nut,* (I meane) only lessons for one, two, and

[8] Sir John Hawkins, *General History of the Science and Practice of Music,* p. 567, Novello Edition (1853).

[9] The work referred to must have been a manuscript, as no earlier printed book by Robinson is known.

three Lutes, and some with ditties, wherein I will strive either (for ever) to winne your favours, or starve in the dole of your disgrace. Vale.

More for you, than for him-selfe,

THOMAS ROBINSON.

Robinson called himself "Student in all the seven liberall sciences,"[10] and was one of the first to stress their importance to the musician.

In the imaginary conversation which follows he criticizes the teachers of former days:

. . . for in older times they strove (onel'e) to have a quick hand upon the Lute, to run hurrie hurrie, keeping a Catt in the gutter upon the ground,[11] now true then false, now up now downe, with such painfull play, mocking, mowing, gripeing, grinning, sighing, supping, heaving, shouldring, labouring, and sweating, like cart Jades, without any skill in the world, or rule, or reason to play a lesson, or finger the Lute, or guide the bodie, or know any thing, that belongeth, either to skill or reason.

He advises a good lute, even for beginners, for both the sight and the sound of it inspire them and help them over the tedious stage; and then gives certain "generall rules." Among them is an explanation of the way to hold the lute (omitted in Dowland's book), the names of the strings and frets, note values, rules for tuning, fingering, and striking the strings—the player should strike downwards normally, but in quick tempo up and down alternately. His directions for pitch are necessarily vague:[12] "First set up the Treble, so high as you dare venter for breaking."

Robinson boldly promises to give later in the same book instruction whereby the reader can learn to sing, and to play the viol:

[10] In *New Citharen Lessons*. These sciences were the medieval trivium (grammar, logic, and rhetoric) and quadrivium (arithmetic, music, geometry, and astronomy).

[11] Robinson evidently means that their playing sounded like caterwauling. In addition, Dr. Fellowes suggests to me that the clause is merely an elaborate pun: the lute-player "plays on a *ground*" or ground bass on the *catgut* strings of his instrument.

[12] The tuning fork was not invented until 1711.

Now, when you can play upon the Lute, I will (God willing) shew you how your Lute shall instruct you to sing; insomuch that you may be your owne teacher, and save the charge of a singing man, and then what by your skill in playing upon the Lute, and the knowledge you have in the prick-song, you may verie easilie attaine to play upon the Viol de Gambo, either by Tabliture or by pricksong notes.

This free instruction he gives on a single page, limiting his vocal instruction[18] to an account of the gamut (scale). But he clarifies this meager information satisfactorily by printing a number of tunes, each of which he writes out in two notations—staff and tablature—with the lute fingerings and sol-fa syllables as well. The pupil was expected first to learn to play the lute. Next he was to acquire the ability to sing at sight, using for practice the scales and tunes printed with their sol-fa syllables in the book, and checking his vocal accuracy by playing them on the lute. Finally he would learn to play the viol by tuning its six strings to the same pitch as those of the lute and using the same frets and fingerings as printed for the latter instrument. Robinson's system was logical and practical, especially for the lute and voice, but we may question his bold claim that his book was a sufficient tutor for the viol, when he devotes only three sentences to that instrument:

In comming from the Trebles of the Viol, to the Base, of necessitie you must somewhat thrust the neck of the Viol from you, and shrink in the bow hand, to come fitly unto it.

Hould your Viole somewhat strongly betweene your legs, and in all points, carrie your left hand upon it, as you doe upon the Lute.

Hould your bow or stick, hard by the Nut of it, with your forefinger, above the stick, your second and third finger (in the hollow of the Nut) betwene the heire and the stick, and your little finger beneath the heire, slack quite from it.

VALE.

18 It seems probable, from this and other evidence of a negative character, that the Elizabethans (for better or worse) sang naturally, without worrying over such matters as chest tones, head tones, resonators, or complicated theories of tone production.

Robinson had promised[14] that if *The Schoole of Musicke* were well received he would "cracke mee this Nut" and issue a second volume. This came out in 1609, under the title of

New Citharen Lessons, with perfect Tunings of the same, from Four course of Strings to Four teene course, even to trie the sharpest teeth of Envie, with Lessons of all sortes, and methodicall Instructions for all Professors and Practitioners of the Citharen.
By THOMAS ROBINSON, *Student in all the seven liberall Sciences.*

Robinson addresses his readers rather boastfully:

Gentlemen, blame me not although I have been so long cracking of this nutte, sith at last I have given you the sweetest Cornell of my conceited[15] Cithering.

The book is not so clear as his earlier work. For example, when in explaining note-values he gives the signs for "semibriefe," "minim," etc., he does not explain that the duration of each is twice that of the next; he does not explain the exact method of holding the instrument; gives no detailed explanations for fingering; and does not tell what notes or frets are used for the "relishes."[16] Compositions occupy most of this book also.

The best of the instruction books is the

Varietie of Lute-lessons: viz. Fantasies, Pavins, Galliards, Almaines, Corantoes, and Volts: Selected out of the best approved Authors, as well beyond the Seas as of our owne Country. By Robert Douland. Whereunto is annexed certaine Observations belonging to Lute-playing: By John Baptisto

[14] See p. 156. Nevertheless his 1609 volume was not for the lute, as he had promised, but for the cithern.

[15] *Conceited* means "ingeniously contrived"; here "skilful," or "careful."

[16] Relishes, also called "graces," "ornaments," and in French "agréments," were written signs directing the performer to play (or sing) certain notes not appearing on paper; the trill and mordent are modern examples.

Besardo of Visonti. Also a short Treatise thereunto appertayning: by John Douland Batcheler of Musicke, London: Printed for Thomas Adams, 1610.[17]

Robert Dowland evidently considered the compositions in the book more important than the instruction, but the latter is nevertheless superior to Robinson's. In the address to his readers Robert implies that his father was writing at that time a more extended treatise on lute-playing. Unfortunately this work never appeared. Besardo's advice, which covers eight pages, is wholesome. It may be summarized thus:

I, Besardo, intend this work for beginners, who cannot study with a master. I admit that there are various satisfactory ways of teaching the lute, so I shall not criticize the methods of others. The learner must have no great defect, must be patient, and not over-practise. He should choose a medium-sized or large lute. Starting with easy lessons, he should go over them many times without a book. He will find the position of the hands and fingers described here, with special explanation given when the same fret has to be stopped two or three times in one chord. I give numerous chords of this sort in lute notation, with the fingerings marked ("1" for first finger to "4" for little finger), but I cannot teach here all the complexities of fingering. The player should not take his fingers off the strings until another chord is to be sounded. "I have set down no rules for transposing out of Musicke [i.e., staff notation] to the Scale of the Lute, because you have that delivered in the most elegant field of Emanuel Adrianus,[18] an excellent Musitian, and in many other Bookes."

John Dowland himself adds "Other necessary observations belonging

[17] It is dedicated to Sir Thomas Monson. Robert Dowland expresses gratitude for Monson's defraying part of the cost of his education while his father John Dowland was out of the country. We owe Monson a debt of praise as the friend and patron of two great song composers of the age—John Dowland and Campion. It is surprising that Dowland could not afford to educate his son. When the boy was about nine the father received magnificent offers and presents from the Duke of Brunswick, when he was twelve the father received his appointment to the King of Denmark. The inevitable conclusion is that John Dowland could not manage his own financial affairs.

[18] Emmanuel Adriaensen, lutenist: *Pratum musicum* (musical field), 1584, and *Novum pratum musicum*, 1592.

to the Lute," which are practical and clear. He tells how to choose good lute strings, determining by their color and other qualities. Next he gives the history of the frets, the names of those that first used them, and a table of fractions for fixing them correctly on the fingerboard. His rule for tuning the lute, with a diagram, is simple and direct, compared with Barley's involved and almost unintelligible method. Dowland tunes the bass strings first. At the end of the volume are printed the "Fantasies, Pavins, Galliards, Almaines, Corantoes, and Volts," seven of each. The composers are extravagantly praised, and evidently form a roll of lutenist fame.[19]

CONCERTED MUSIC FOR VIOLS AND OTHER INSTRUMENTS

Viols were stringed instruments, first cousins to the violin-viola-'cello family, and fairly similar to them in size, shape, and tone. The treble viol corresponded to the violin in these respects, the tenor viol to the viola, and the viola da gamba to the violoncello. A viol usually had six strings, whereas a violin has four. The two instruments differ slightly in design, and the fingerboard of the viol had frets, the violin being without them. The tone of the viol was a little reedier than that of the violin and (dare it be said?) somewhat nasal. Although the *violin* dates

[19] "The most famous Diomedes of Venice
The most famous, the KNIGHT of the Lute
The most famous Jacobus Reis of Augusta
The most famous and divine Laurencini of Rome
The most Artificiall and famous Alfonso Ferrabosco of Bologna
The most famous Gregorio Huwet of Antwerpe
The most magnificent and famous Prince Mauritius, Landgrave of Hessen," whose Pavin here included was "from him sent to my Father, with this inscription following, and written with his Graces owne hand: Mauritius Landgrauius Hessiae fecit in honorem Ioanni Doulandi Anglorum Orphei
The most famous and perfect artist Anthonie Holborne
The excellent Musition Thomas Morley Batcheler of Musicke,
The right perfect Daniell Batchelar," and John and Robert Dowland themselves.

from the early part of the sixteenth century it was little used in England until the reign of Charles II, when it gradually drove the treble viol from the field. The eloquent viola da gamba remained in favor longer. Bach wrote sonatas for it, but by that time it too was going out of favor, superseded by the 'cello. *Recorders* were woodwind instruments, belonging to the whistle family. They were made in assorted sizes, and so a "consort of recorders" could play both high notes and low. In tone they resembled flutes, and flutes eventually superseded them. At present there is a healthy revival of recorder-making and recorder-playing. The *cornett* was a wind instrument consisting of a single tube, straight or slightly curved, from two to four feet in length, with a cup-shaped mouthpiece that gave it the tone of a brass instrument, and finger holes that enabled it to play scales. Because of this last fact it was a more satisfactory instrument for everyday use than the seventeenth and eighteenth century trumpet, which had a louder and more brilliant tone but could play only a few notes.

Three or more instruments of one kind playing together were called a "consort," e.g., "a consort of viols," and an ensemble consisting of different kinds of instruments, e.g., viols and recorders, was a "mixed consort." Music for consorts of viols was highly popular as late as the Restoration, and numerous compositions of this sort were printed. Several volumes of music for lute with one or more viols also appeared in print. Parts for recorders and cornetts were published in a few instances, but no compositions were printed for wind instruments alone, nor music of any kind for such well-known instruments as the trumpet, trombone,[20] oboe, bassoon, kettledrum, or harp.

The following volumes of music for concerted instruments were published in England before 1625:

1599 THOMAS MORLEY: *The First Booke of Consort Lessons, made by divers exquisite Authors, for sixe Instruments.*

[20] Except one solitary piece by Adson; see p. 176.

1599 ANTONY HOLBORNE: *Pavans, Galliards, Almains, and other short Æirs both grave, and light, in five parts, for Viols, Violins, or other Musicall Winde Instruments.*

1605 JOHN DOWLAND: *Lachrimae . . . for the Lute, Viols, or Violons.*

1605 TOBIAS HUME: *The First part of Ayres.*

1607 TOBIAS HUME: *Poeticall Musicke.*

1607 THOMAS FORD: *Musicke of Sundrie Kindes.*

c. 1609 ORLANDO GIBBONS: *Fantazies of three parts* for viols.

1609 ALFONSO FERRABOSCO THE YOUNGER: *Lessons for 1. 2. and 3. viols.*

1609 PHILIP ROSSETER: *Lessons for Consort: Made by sundry Excellent Authors and set to sixe severall instruments.*

1611 JOHN ADSON: *Courtly Masquing Ayres composed to 5. and 6. Parts for Violins, Consorts, and Cornets.*

The work at the head of this list is

The First Book of Consort Lessons, made by divers exquisite Authors, for sixe Instruments to play together: viz. the Treble Lute, the Pandora, the Citterne, the Base-Violl, the Flute,[21] and the Treble-Violl. Collected by Thomas Morley, Gentleman.

Of the six instrumental parts published, there is a Citterne part in the Bodleian, a Flute part in the British Museum, a Treble Viol part in the Royal College of Music, a Pandora Part in Christ Church (with another copy elsewhere), while the parts for Treble Lute and Bass Viol have disappeared altogether.[22] A performance without these missing

[21] The "flute" was doubtless a recorder. The lowest note Morley wrote for it was the G below middle C, too low for flute.

[22] When we consider that few Elizabethan musical works exist in more than four copies, and many in only one or two, it is surprising that so few works have perished. Publications entirely missing are Byrd and Ferrabosco's *Medulla Musicke*, Dering's *The Cryes of London*, Pattrick's set of Madrigals, and Vautrollier's *A Brief Introduction to Musicke*. And the last three works, though approved for publication, were possibly not printed. Portions of a few other works have been lost, such as Bull's inaugural lecture, Byrd's madrigal in honor of John Case, Jones's *First Set of Madrigals*, and Morley's *First Booke of Ayres* and *First Book of Consort Lessons.*

parts would not have troubled Morley, for in dedicating his collection to the Lord Mayor of London he tells him—and us: "They be set for divers Instruments: to the end that whose skill or liking regardeth not the one, may attempt some other." The names of the composers are unfortunately omitted. "Phillips Pavin" was presumably by the distinguished Peter Philips. Morley explains his method of selecting the compositions and urges the Mayor to have them played by his "waits" or official musicians, in the following words:

The songs are not many, least too great plenty should breede a scarceness of liking: they be not all of one kind, because mens fantasies seeke after varietie: th[e]y be not curious[28] for that men may by diligence make use of them. . . . Your honourable acceptance shall be a sufficient warrant that my time is well spent, for I desire not to satisfie bablers, which are baser than brute beasts in reproving excellencie, never attaine to the first degree of any commendable Science or Misterie. As the auncient custome of this most Honourable and renowned Citie hath beene ever, to retaine and mantaine excellent and expert Musitians, to adorne your Honours favours, feasts, and solemne meetings: to those your Lordships *Wayts,* after the commending these my labours to your Honourable patronage: I recommend the same to your Servants carefull and skilfull handling.

We know from Rosseter that this work of Morley's caught public favor, for Rosseter published his *Lessons for Consort* for the same six instruments, saying that "The good successe and franke entertainment which the late imprinted Set of Consort bookes generally received, have given me incouragement to second them with these my gatherings."

Two years after ANTONY HOLBORNE published his *Cittharn Schoole* he issued a collection of pieces for viols, violins, or wind instruments (no doubt recorders and cornetts in particular):

Pavans, Galliards, Almains, and other short Æirs both grave, and light, in five parts, for Viols, Violins, or other Musicall Winde Instruments Made

[28] Curious: elaborate, complex.

[164]

by Antony Holborne Gentleman and Servant to her most excellent Majestie
Imprinted at London . . .1599 Cum privilegio ad Imprimendum solum.[24]

In dedicating this to Sir Richard Champernowne he tells him that some
of these pieces "from the experience of many yeres can feelingly witnesse
& sing with what grace-full favors they have beene nourished at your
hands." Probably, therefore, Holborne had received fees from Sir Rich-
ard for playing to him. To Berlioz music seemed such an exact lan-
guage that he believed the feelings and even the thoughts expressed in
a composition would be apparent to the sensitive and intelligent listener
of the future. Then what can we learn about Holborne from his piece
entitled "My selfe"?

MY SELFE

Very little, doubtless; except that the counterpoint, in spite of the con-
secutive octaves, is excellent, and that the piece, though in what we

[24] In one of these compositions of 1599 Holborne jumps to a dominant seventh note,
but Byrd had used this daring procedure as early as 1588 (p. 106).

would call a minor key, is tuneful and pleasant and evidently not intended to give a mournful picture of the composer.

The reference to violins in the title raises a question. The violin had been used in England from the time of Henry VIII. What did the Elizabethans think of it in comparison with the viol? We do not know, but it is a safe assumption that they preferred the viol, for they mentioned it so much more frequently. Certainly it is easier to play, for the raised frets on a viol fix the pitch and enable even a beginner to play in tune. Anthony Wood writes late in the seventeenth century that gentlemen before the Restoration preferred to play on viols, "for they esteemed a Violin to be an instrument only belonging to a common fidler."[25] Thomas Mace in 1676 lamented the growing popularity of the violin, partly because of its brighter tone, partly because the giddy, shallow, monophonic music played on it was superseding the fine old counterpoint written for viols, and tended to fill a man's "brains full of frisks," rather than to "sober his mind."[26]

In 1605 appeared JOHN DOWLAND'S

Lachrimae, or Seaven Teares Figured in Seaven Passionate Pavans, with divers other Pavans, Galiards, and Almands, set forth for the Lute, Viols, or Violons, in five parts.[27]

By 1605 Dowland's famous tune "Lachrimae" must have already gained much of its extraordinary popularity. Three earlier versions of it exist, in:

1594 William Ballet's MS collection of lute music;
1596 William Barley's *A nevv Booke of Tabliture;* and
1600 John Dowland's *The Second Booke of Songes or Ayres.*

[25] *Athenae Oxonienses.*
[26] Mace, *Musick's Monument.* For other early references to violins in England see Francis W. Galpin, *Old English Instruments of Music*, pp. 93–95, and Gerald R. Hayes, *The Viols and Other Bowed Instruments*, pp. 189 ff.
[27] It was reprinted in 1927 in modern notation, edited by Peter Warlock.

Perhaps its original form was that of the ayre published in 1600. Otherwise it is difficult to explain so unusual a title as "Lachrimae" (tears). The first and some of the last lines run:

> Flow, my tears, fall from your springs!
>
>
>
> Never may my woes be relieved,
> Since pity is fled;
> And tears and sighs and groans my weary days
> Of all joys have deprived.
>
>
>
> Hark! you shadows that in darkness dwell,
> Learn to contemn light.
> Happy, happy they that in hell
> Feel not the world's despite.

Byrd and Farnaby evidently enjoyed the tune "Lachrimae," for they made arrangements of it for virginals.[28]

It is mentioned in a remarkable number of dramatic productions, and evidently came to stand for the popular idea of sorrow. In Beaumont and Fletcher's *Knight of the Burning Pestle* (written before 1611) it was necessary for the audience to be acquainted with it in order to enjoy the joke properly. The musicians are playing it at the end of Act II, when the Citizen calls out, "You musicians, play 'Baloo.'" But his wife, who cannot recognize a tune when she hears it, announces in turn, "No, good George, let's ha' 'Lachrymae.'" He retorts: "Why, this is it, cony." That would bring a laugh from the male part of the audience. In Middleton's *No Wit, No Help Like a Woman*, 1613, a servant announces bad news and is answered: "Now thou plaiest Dowlands Lachrymae to thy master." It is also mentioned by several other dramatists:

[28] *Fitzwilliam Virginal Book*, No. 121: "Pavana Lachrymae: John Dowland, sett foorth by Wm. Byrd," and No. 290: "Lachrimae Pavan, J. D. Sett by Giles Farnaby."

MASSINGER, *The Maid of Honour*, 1621:
Such music as will make your worships dance
To the doleful tune of "Lachrymae."

MASSINGER, *The Picture*, 1629:
Is your Theorbo
Turn'd to a distaff, Signor? and your voice
With which you chanted "Room for a lusty Gallant"
Tun'd to the note of "Lachrymae"?

WEBSTER, *The Devil's Law Case*, 1623:
You'll be made dance "Lachrymae," I fear, at the cart's tail.

FLETCHER, *The Bloody Brother*, c. 1617:
Arion, like a dolphin, playing "Lachrymae."

BEN JONSON's Masque *Time Vindicated*, 1624:
 No, the man
In the moon dance a coranto, his bush
At 's back a-fire; and his dog piping "Lachrymae."

Captain TOBIAS HUME was one of those writers of the second rank whose unquestioned originality springs from eccentricity rather than from genius. Indeed in his latter days his mind became definitely unbalanced. Though we may laugh at him when he boasts of imaginary military victories and promises Parliament to subdue the Irish rebels if granted a hundred or six score instruments of war,[29] he was probably the first Englishman to suggest in print that chords could be played on the viol with as pleasant effect as upon the lute.[30] John Dowland resented this comparison as an insult to his own instrument, the lute. Nevertheless, playing the viol "lyra way"—i.e., performing upon it mu-

[29] *The True Petition of Colonel Hume . . . to . . . Parliament*, 1642.
[30] See the quotation at the end of p. 170 from the address to the reader in *Captaine Humes Musicall Humors*. John Dowland's criticism of Hume's statement has been quoted on page 141; it is from *A Pilgrimes Solace*, 1612.

sic suitable for the lute and written in lute notation—soon became popular and remained in favor for a hundred years. This use of the viol originated with the English.[31] The bows of that day were loosely strung, consequently a whole chord could be sustained, in a manner impossible for a violinist using a Tourte bow of the present day.

The lengthy titles of the two works by Hume are given below in full, since the first contains the earliest reference to the lyra viol (i.e., the viola da gamba played lyra way),[32] and the other tells us what stringed instruments would probably be used together at a little evening party of Jacobean chamber music:

The First Part of Ayres, French, Pollish, and others together, some in Tabliture, and some in Pricke-Song: With Pavines, Galliards, and Almaines for the Viole De Gambo alone, and other Musicall Conceites for two Base Viols, expressing five partes, with pleasant reportes one from the other, and for two Leero Viols, and also for the Leero Viole with two Treble Viols, or two with one Treble. Lastly, for the Leero Viole to play alone, and some Songes to bee sung to the Viole, with the Lute, or better with the Viole alone.[33] Also an Invention for two to play upon one Viole. Composed by Tobias Hume *Gentleman. 1605.* [This work is sometimes referred to as *Musicall Humors,* each page being so headed.]

Captaine Humes *Poeticall Musicke. Principally made for two Basse-Viols, yet so contrived, that it may be plaied 8. severall waies upon sundry Instruments with much facilitie. 1. The first way or musicke is for one Bass-Viole*

[31] See the quotation from Jean Rousseau's *Traité de la Viole,* 1687, in Gerald R. Hayes's *The Viols and Other Bowed Instruments,* 1930, p. 137.

[32] Thomas Ford, Alfonso Ferrabosco the Younger, Coprario, and Daniel Farrant also composed for the lyra viol during the reign of James I. Ford's *Musicke of Sundrie Kindes . . .,* 1607, contains, besides ayres, "a Dialogue for two Voices, and two Basse Viols in parts, tunde the Lute way," and "Pavens, Galliards, Almains, Toies, Iigges, Thumpes and such like, for two Basse-Viols, the Liera way, so made as the greatest number may serve to play alone, very easie to be performde."

[33] Dowland's annoyance must have been increased when he read that the viol was a better instrument than the lute to accompany these songs.

*to play alone in parts, which standeth alwaies on the right side of this Booke.
2. The second musicke is for two Basse-Viols to play together. 3. The third
musicke, for three Basse-Viols to play together. 4. The fourth musicke, for
two Tenor Viols and a Basse-Viole. 5. The fift musicke, for two Lutes and
a Basse-Viole. 6. The sixt musicke, for two Orpherions and a Basse-Viole.
7. The seventh musicke, to use the voyce to some of these musicks, but es-
pecially to the three Basse-Viols, or to the two Orpherions with one Basse-
Viole to play the ground. 8. The eight and last musicke, is consorting all
these Instruments together with the Virginals, or rather with a winde In-
strument and the voice. 1607.*

Musicall Humors contains one hundred and fifteen compositions,
most of them solos for lyra viol printed in lute tablature, the rest con-
sisting of the five songs and of miscellaneous compositions for one or
more viols. It is dedicated to William, third Earl of Pembroke.[34] The
Address criticizes plagiarists and proclaims his own unaided composer-
ship:

To the understanding Reader

I doe not studie Eloquence, or professe Musicke, although I doe love Sence,
and affect Harmony. My Profession being, as my Education hath beene,
Armes, the onely effeminate part of me, hath beene Musicke; which in mee
hath beene always Generous, because never Mercenarie. To prayse Musicke,
were to say, the Sunne is bright. To extoll my selfe, would name my labors
vaine glorious. Onely this, my studies are far from servile imitations, I
robbe no others inventions, I take no Italian Note to an English Dittie, or
filch fragments of Songs to stuffe out my volumes. These are mine owne
Phansies expressed by my proper *Genius,* which if thou dost dislike, let me
see thine, *Carpere vel noli nostra, vel ede tua.* . . . And from henceforth,
the statefull instrument *Gambo Violl,* shall with ease yeelde full various and
as devicefull Musicke as the Lute. For here I protest the Trinitie of Musicke,

[34] Pembroke College, Oxford, was named after him. As a boy he was tutored by
Samuel Daniel. After he became earl he aided Ben Jonson, Massinger, William Browne,
and Inigo Jones financially, and Shakespeare's First Folio was dedicated to him. He was
a poet himself, and Henry Lawes and Nicholas Laniere wrote songs to words by him.

parts, Passion, and Division, to be as gracefully united in the *Gambo Violl,* as in the most received Instrument that is, which here with a Souldiers Resolution, I give up to the acceptance of al noble dispositions.

The friend of his friend,

Tobias Hume.

If you will heare the Viol de Gambo in his true Majestie, to play parts, and singing thereto, then string him with nine stringes, your three Basses double as the Lute, which is to be plaide on with as much ease as your Violl of sixe stringes.

Each composition in *Captaine Humes Poeticall Musicke* has parts for three instruments, two of these being printed in lute tablature and consisting of chords, the third being an optional part for bass viol playing only one note at a time. The work, dedicated to Queen Anne, contains the same address that he included in *Musicall Humors,* but the phrase which annoyed Dowland is now so altered as to exalt the lyra viol to a position of equal musical importance with not only the lute but all instruments:

. . . And from henceforth, the statefull instrument *Gambo Violl,* shall with ease yield full various and devicefull Musicke as any other instrument.

And after his own name he substitutes this postscript giving necessary directions for tuning that were lacking in his previous book:

Your Viols must be tuned as the Lute, Beeing the best Set that ever was invented, for these kind of Musickes, which may bee compared with the highest and curious musicke in the world.

What English composer is accused here of taking an "Italian Note to an English Dittie"? Surely not Watson, for though the latter in *The first sett of Italian Madrigalls Englished* imprudently uses English texts that have no connection with the original Italian, the names of the Italian composers are duly given. Morley in his *Plaine and Easie Intro-*

duction counsels his pupil not to put bits of other men's compositions in his own, yet his own *Balletts* contain brief musical phrases taken consciously or unconsciously from Gastoldi. So far as I know, however, no one has discovered any wholesale "filching" from an Italian madrigal by an English composer.

ORLANDO GIBBONS' *Fantazies of three parts* for viols (c. 1609) was the first music engraved in England, and the first published work by this composer. It is not now possible to guess why these pieces should have been engraved, for viol music could easily be set up in type. A work sells more easily if its author is famous, and the renown of young Gibbons as organist of the Chapel Royal may have persuaded his publisher to issue the book.

ALFONSO FERRABOSCO the Younger published *Lessons for 1. 2. and 3 viols* in 1609. They are short dances and other pieces, printed in tablature, lyra way. They are not elementary exercises in the modern sense, and there is no instruction. The composer dedicates them, in respectful but self-respecting terms,

> To the Perfection of Honour, My Lord Henry, Earle of South-hampton . . . It is true, that I made these Compositions solely for your Lordship and doe here professe it. By which time, I have done all that I had in purpose, and return to my silence:

> Where you are most honor'd

> by

> ALFONSO FERRABOSCO

The composer, like his father, evidently had a reasonable sense of his own importance.[35] He states in his Address "To the World" that he is publishing these pieces because some of them had got abroad and been falsely claimed by other composers. He adds dedicatory sonnets by Ben Jonson and Walter Quin. That of Jonson shows the weary bitterness of

[35] See also Ferrabosco's words to Prince Henry, on p. 145.

a courageous man who has experienced many buffetings, and advises his friend to pursue his own way, regardless of carping fools:

> When We do give, *Alfonso,* to the light
> A worke of ours, we part with our owne right
> For then, all mouthes will judge; and their own way:
> The Learn'd have no more priviledge, than the Lay.
> And, though we could all men, all censures heare,
> We ought not give them taste, we had an eare:
> For, if the humerous[36] World will talke, at large,
> They should be fooles, for me, at their owne charge.
> Say, this, or that man they to thee preferre;
> Even those, for whom they doe this, know they erre:
> And would (being ask'd the truth) ashamed say,
> They were not to be nam'd, on the same day.
> Then stand unto thy selfe, nor seeke without
> For Fame, with breath soone kindled, soone blowne out.
>
> BEN: JONSON.

Quin's words are less distinguished:

> S'Ogni arte tanto piu da noi s'apprezza
> Quanto ha più nobil senso per oggetto,[37]
> & quanto n'e peu degno il soggetto,
> Vince l'altre arti harmonica dolcezza.
> Quella a dar gusto & contento s'avezza
> Al nostro udir, de sensi il piu perfetto;
> Per sogetto ha numero[38] uguale, & retto
> & di bella aria, & suoni la vaghezza.

[36] Humorous: peevish.
[37] The following words in the original have been changed here: Line 2: *aggetto.* 7: *h'a.* 8: *tuôni,* "thunders."
[38] *Numero* means both "rhythm" and "number" here, and is used in praise; cf. Mulcaster's prefatory poem to Tallis and Byrd's *Cantiones sacrae,* 1575: "How valuable a thing music is, is shown by those who teach that numbers constitute the foundation of everything which has form, and that music is made up of these."

Questa arte dungue essendo di tal merto
Alfonso mio, chi d' *Orpheo* porti il vanto,[39]
Convien pregiarti, & questi tuoi concenti;
Tanto piu ch'essi con doppio concerto,
A gl'istromenti attando il dolce canto,
Di piacer doppio ne appagan le menti.

GUAL: QUIN[40]

(*Translation:* If every art is the more admired by us insofar as it both appeals to a nobler physical sense and has a more worthy subject, sweet music is superior to the other arts. It is wont to give pleasure and contentment to our hearing (the most perfect of the senses); for subject it has Number,[38] equal and regular and exquisitely melodious, and it sounds forth its sweetness. This art, then, being of such merit, dear Alfonso, those who give glory to Orpheus must esteem you and your harmonies, all the more since the latter with a double harmony adapt sweet singing to instruments and thus charm our minds with a double pleasure.)

Anthony Wood speaks highly of Ferrabosco:

He was most excellent at the Lyraviol. . . . The most famous man in all y^e world for Fantasies of 5. or 6. parts.[41]

PHILIP ROSSETER, who jointly with Campion published an important book of ayres in 1601, later issued this collection of instrumental compositions:

Lessons for Consort: Made by sundry Excellent Authors, and set to sixe severall instruments: Namely, the Treble Lute, Treble Violl, Base Violl, Bandora, Citterne, and the Flute. Now newly set forth by Philip Rosseter, one of his Majesties Musitions. London: Printed by Tho. Este alias Snod-

[39] "Those who give glory to Orpheus": i.e., all music lovers.

[40] Walter Quin (c. 1575–c. 1634), who was something of a poet, studied at Edinburgh University. He also tutored the sons of James I and so must have known their music teacher Ferrabosco very well. His Italian is clumsy.

[41] Anthony Wood, *Biographical Notes on Musicians*, folio 49.

ham, for John Browne, and are to be sould at his shop in S. Dunstones Churchyard in Fleetstreet. 1609.

Campion had complained in the joint volume of ayres mentioned above that some of his ayres had been pirated without his permission. Rosseter is careful to avoid this offense, as he says in his address:

To the Reader

The good successe and franke entertainment which the late imprinted Set of Consort bookes generally received, have given mee incouragement to second them with these my gatherings; most of the Songs being of their inventions whose memorie onely remaines, because I would be loth to rob any living men of the fruit of their owne labours, not knowing what private intent they may have to convert them to their more peculiar use. The Authours names I have severally prefixt, that every man might obtaine his right; And as for my industry in disposing them, I submit to thy free censure.

PHILLIP ROSSETER

There are twenty-five compositions written by himself, Allison, John Baxter, Campion, John Farmer, A. Holborne, Edmund Kete, Lupo, Morley, and "incertus." Rosseter dedicated the compositions to Sir William Gascoyne of Sedbury, whose household musicians, Rosseter assures us, could play them.[42] Our composer may well praise Sir William for keeping in his employ no less than six musicians, able to form such a versatile chamber orchestra.

The last work for consorts published during King James' reign was:

Courtly Masquing Ayres, Composed to 5. and 6. Parts, for Violins, Consorts, and Cornets, by John Adson. London. 1611.

[42] Rosseter thus addresses Sir William: "Sir your affection to Musicke, and beneficence to the Professours thereof, and particularly your favours to my selfe, have emboldened me to present to your worthy protection these flowers gathered out of divers Gardens. . . . To whom may I then better recommend these my Labours than to you? who maintaines in your house such as can lively expresse them, and whose name abroad is alone sufficient to protect them."

"Consorts" would imply viols and recorders of various sizes. "Cornets" are not the modern instruments of that name, although both varieties have the cup-shaped mouthpieces characteristic of the brass instruments and both have been soprano members of that family at different times. The seventeenth-century cornet (German *zinke*), nowadays usually spelled cornett, looked like a piece of gas pipe with holes punched down the side. It is obsolete. One of these pieces by Adson is for cornetts and trombones ("sagbuts"). The composer dedicated the collection to George, Marquis of Buckingham,[48] and may have been one of the musicians in his household. Later Adson was similarly employed by Charles I. He writes:

These my poore labours . . . are all (for the most part) Courtly Masquing Ayres, framed only for Instruments; of which kinde, these are the first that have beene ever printed.

The compositions are rather short and doubtless served as introits and dances in the masques of the period. They must have been well received, for a second edition was printed in 1621.

On the whole, it is perhaps surprising that the list of English viol music was not longer. Bull seems to have written none; that by Byrd is unimportant. Viol music was, however, well regarded, and English instrumental music and instrumentalists were also popular abroad, particularly in Germany. Davey lists seven instrumental collections published there between 1609 and 1621 that contained numerous pieces by Englishmen. Besard, in an instruction book for lute published in 1603,[44] calls English harmonies "sweetest and tasteful." Reissmann, in *Illustrirte Geschichte der deutschen Musik,* 1881, says that most of the instrumental players at German courts in the late sixteenth century

[48] First Duke of Buckingham, 1592–1628, chief favorite of James I.
[44] *Thesaurus Harmonicus,* Cologne, 1603.

were English, and Max Seiffert[45] mentions English players holding prominent positions at Dresden, Stuttgart, and Hamburg. Even in Bach's time there were many English players in Germany. After a dull period in England during the reign of Charles I, instrumental music had a great revival during the time of Cromwell, so that Christopher Simpson wrote in his book *A Compendium of Practical Musick*, 1667, "You need not seek Outlandish Authors, especially for Instrumental Musick; no Nation (in my opinion) being equal to the English in that way." See *Jacobean Consort Music* [for viols], *Musica Britannica*, Vol. 9, 1955.

MUSIC FOR VIRGINALS

The instrumental music of Elizabethan times, though historically noteworthy and often interesting, hardly ranks with the madrigals, religious choral music, and ayres, in intrinsic worth. The expressive qualities of the various instruments had not yet been thoroughly explored. Viols should have led the way (considering how closely they are related to the versatile modern violin and 'cello), yet some of the best composers were still writing madrigals "fit for voices and viols," as if these instruments had no distinctive character of their own. Leger lines were still so sparingly used that long runs and wide leaps were practically out of the question. Organ compositions also tended to be vocal in style, as if they were to be sung by the choir. It is rather surprising, then, that the instrumental compositions which seem to us the most original and interesting were written for the one inexpressive instrument of the day—the virginal. The virginal (or "virginals," for the plural was often used to denote a single instrument) may be defined as a small, rectangular harpsichord with only one keyboard. It had no legs, and so was commonly laid on a table. No gradations in volume were possible, for light and heavy pressures of the finger on the same key produced the same effect. Otherwise the resources of the modern

[45] *Vierteljahrsschrift für Musikwissenschaft*, 1891.

pianist were available to the virginalist, who could play slow or fast, high or low, one note or half a dozen at a time, rhythmical chords or smooth counterpoint, runs, wide skips—and music in grave keys or gay, for the modern minor and major scales were then emerging from the numerous medieval modes.

Contemporary comment is absent from the most of the collections of virginal music, since this is all in manuscript (except the two engraved volumes of 1611 and 1614) and lacks the informative prefaces and dedications of the printed books. The typesetting of lute music presented no great obstacles, for letters were used instead of notes, and could be placed between the lines. Vocal music required perhaps a dozen signs for clefs, tempos, and accidentals, plus thirty pieces of five-line staff, each piece having a note on one of the lines or spaces. But the printing of keyboard music is difficult, as chords consisting of two or more notes, often of differing time-values, require breaking up the staff. About four hundred different kinds of type are required nowadays.[46] So no keyboard music was printed in England until 1611, when *Parthenia* was engraved, not printed from type. As the chief virginal compositions have come down to us only in manuscript, the manuscripts should come first in a bibliography of Elizabethan virginal music.

IMPORTANT MANUSCRIPT COLLECTINGS OF VIRGINAL MUSIC

The Fitzwilliam Virginal Book. 297 compositions. Not earlier than 1621. Edited by J. A. Fuller Maitland and W. Barclay Squire and published by Breitkopf & Härtel.

My Ladye-Nevells Booke. 42 compositions, all by Byrd, copied by John Baldwin, who finished his task September 11, 1591. Edited by Hilda Andrews and published by Curwen, 1926.

Will. Forster's Virginal Book. 78 compositions, including 35 by Byrd, 9 by Ward, 3 by Bull, 3 by Morley, one by Englitt, the rest anonymous. 1624.

[46] Frank Kidson, *Grove,* iv. 256.

INSTRUMENTAL MUSIC

Benjamin Cosyn's Virginal Book. 90 compositions for virginals, including 29 by Cosyn, 29 by Bull, 25 by Orlando Gibbons, two by Yves (probably Simon Ives, 1600–1662), one by Tallis, one by Byrd, and three anonymous. Also several choral works. Perhaps c. 1620.

ENGRAVED MUSIC FOR VIRGINALS

Parthenia or the Maydenhead of the first musicke that ever was printed for the Virginalls Composed by three famous Masters, William Byrd, Dr. John Bull and Orlando Gibbons Gentilmen of his Ma^{ties} most Illustrious Chappell. Ingraven by William Hole. [1611.] Reprinted by W. Reeves, ed. by Margaret H. Glyn.

PARTHENIA IN-VIOLATA; Or, Mayden-Musicke for the Virginalls and Bass-Viol Selected out of the Compositions of the most famous in that Arte By Robert Hole and Consecrated to all True Lovers & Practicers Thereof. About 1614. It consists of duets for virginals and viola da gamba.

MODERN EDITIONS OF ELIZABETHAN VIRGINAL MUSIC

The Fitzwilliam Virginal Book, My Ladye-Nevells Booke, and *Parthenia,* all mentioned above. Also *The Mulliner Book,* a MS. of about 1545.

The collected keyboard works of Byrd, Tallis, and Thomas Tomkins.

Selected Pieces from the Fitzwilliam Virginal Book. Ed. by J. A. Fuller Maitland and W. Barclay Squire. Publ. by Chester.

25 Pieces for Keyed Instruments from Benjamin Cosyn's Virginal Book, by Bull, Byrd, Cosyn, Gibbons. Same editors and publisher. 1923.

Fourteen Pieces. Same editors. Publ. by Stainer and Bell.

Thirty Virginal Pieces. Edited by Margaret H. Glyn. Publ. by Stainer and Bell, 1927.

Dances Grave and Gay. Ed. by Margaret H. Glyn. Publ. by Winthrop Rogers.

The Byrd Organ Book. Ed. by Margaret H. Glyn. Publ. by Reeves.

William Byrd. Forty-five Pieces for Keyboard Instruments. Ed. by Stephen D. Tuttle. Éditions de l'Oiseau-Lyre, Paris.

John Bull: *Keyboard Works.* Publ. as *Musica Britannica,* Vols. 14 and 19.

Orlando Gibbons: *Complete Keyboard Works,* 5 vols. M. H. Glyn.

Orlando Gibbons: *Keyboard Music: Musica Britannica,* Vol. 20. 1962.

Old English Suite and *Album of Selected Pieces by Giles Farnaby.* Ed. by Granville Bantock. Publ. by Novello.

The Golden Treasury of Music, Vol. 1. Ed. by Oesterle. Publ. by G. Schirmer.

Easy Elizabethans. Ed. by Harold Craxton. Oxf. Univ. Press.

BIBLIOGRAPHY

Henry Davey, *History of English Music.* Curwen, 1921.

Charles van den Borren, *The Sources of Keyboard Music in England.* Novello, 1914.

Margaret H. Glyn, *About Elizabethan Virginal Music and Its Composers.* Reeves, 1924.

The historical importance and characteristic style of the Elizabethan virginal compositions as a group and of their leading composers have been well summed up by Charles van den Borren, in his standard work[47] on the subject:

Neither Frescobaldi in Italy, nor Scheidt nor Froberger in Germany, nor the French harpsichord players, forerunners of the great Couperin, present us with examples of figuration so varied and original as the English of the first third of the 17th Century.[48] Continental artists, it is true, furnish us with happy compensation in the progressive refinement of musical forms; thanks to them the variation, the suite, the toccata, the fugue become little by little better balanced constructions, answering better to the conception of

[47] Charles van den Borren, *The Sources of Keyboard Music in England,* 1914, pp. 152 and 353.

[48] Van den Borren's "16th Century" is evidently a misprint.

an organism and a style. But they do not possess that blooming freshness, that expansion, that is characteristic of somewhat unregulated primitifs, and their creations have not that perfume of the wild flower, that playful and fantastic physiognomy by which the work of the virginalists, looked on as a whole, is distinguished. . . . At a time when on the Continent keyboard music was in general only a pale reflection of vocal music, in England it flew with its own wings, created its own domain.

The greatest of the English virginal composers were Byrd, Bull, Giles Farnaby, Orlando Gibbons, and Philips. Van den Borren's opinion of them is briefly paraphrased here:

Byrd is profoundly English, a pastoral poet who loves misty distances, graduated tints, softly undulating landscapes. Virtuosity was foreign to him. He is a rustic, whose rural lyricism decks itself in the most exquisite graces that an artistic temperament at once simple and refined can imagine. *Bull* was a strong man, vigorous, but lacking in feeling. *Farnaby,* like Byrd, is profoundly English, but represents the humorous side, Byrd the dreamy side. He is one of the most graceful musicians possible, an improviser of melody like Schubert, whose qualities and defects he shares. He is also full of audacities, and is the most original of all the virginalists. *Gibbons* was a romanticist, attaining a concentrated and pathetic lyricism. Italy dazzled *Philips* with its brilliant arabesques and its elegant virtuosity. But an underlying severity and austerity, reminding us of the Spanish composer Cabezon (1510–1566), probably comes from the sadness of his life.

Mention is made elsewhere of the high regard in which four of these composers were held by their contemporaries,[49] but this seems the proper place to speak of Bull, since he is chiefly associated with keyboard instruments and their music.

JOHN BULL (c. 1562–1628) was celebrated as the most skilful performer on keyboard instruments in England at the commencement of the reign of James I. While he had been an organist of the Chapel Royal

[49] For Byrd see pp. 80–85, 103, 107, Farnaby, pp. 113, 114, Gibbons, pp. 85–87, 172, 185, and Philips, pp. 217, 218.

his skill received the admiration of Queen Elizabeth, and in 1597 on her recommendation he became the first Lecturer in Music in Gresham College, newly founded under the will of Sir Thomas Gresham. His duties were as follows:

The solemn musick lecture is to be read twice every week, in manner following, viz. the theorique part for half an hour, or thereabouts; and the practique by concent of voice or of instruments, for the rest of the hour.

This was a well-balanced arrangement. As he could not write Latin, he was allowed by special permission to give his lectures in English. His inaugural lecture was printed, but unfortunately nothing of it has survived but the title-page. He received the degree of Doctor of Music at Cambridge and (by "incorporation") at Oxford also. He was one of a number of persons for whom James I ordered gifts of "gold chains, plates or medals." In 1607, while the King and Prince Henry were dining in the Merchant Taylors' Hall, London, Bull played for them "most excellent melodie upon a small Payre of Organes"—perhaps the first English organ recital on record.[50] In 1611 his name stood highest on the list of the musicians of Prince Henry. In 1617 he became organist of Antwerp Cathedral, and in that edifice he was buried on March 15, 1628.[50] Anthony Wood's account of Bull, more colorful than anything we have about him from his own time, should be read.[51] Finally, the virtuoso's name must have endeared itself to all true Elizabethans by the rich opportunity it afforded for puns. His famous portrait in the Bodleian, reproduced in color in *Grove's Dictionary,* has the following lines painted around its frame:

> The Bull by force
> In field doth Raigne
> But Bull by Skill
> Good will doth Gayne

[50] *Grove,* i. 493, 494.
[51] See Appendix G, pp. 318, 319.

An admirable detailed account by W. Barclay Squire of the four important manuscript collections of virginal music is printed in *Grove*, v. 545–552. *My Ladye-Nevells Booke* includes compositions by Byrd only. Cosyn's book contains twenty-nine compositions by Cosyn himself, twenty-nine by Bull, and twenty-five by Gibbons. Most of the pieces in Will. Forster's book are by Byrd, a few are by John Ward. In the Fitzwilliam book Byrd leads with seventy-two compositions (including five arrangements of tunes by others), Farnaby following with fifty-two (including five arrangements), Bull with forty-five, and Peter Philips with nineteen.[52] No composition by Ward is included. Thus if quantity counts for anything, Byrd, Farnaby, Bull, Gibbons, and Philips are the most important of the English virginal composers.

Tunes were not copyrighted in those days, and there are a number of interesting cases, mostly noted by van den Borren, of tunes harmonized by men who were not the original composers. Whether the tunes used were chosen for their popularity it is impossible now to discover, but certainly their foster fathers must have liked them. Byrd wrote variations on Dowland's famous "Lachrymae," and there are harmonizations of it by Farnaby, Morley, and the German composer Melchior Schildt. Bull wrote a Fantasia on a Fugue by the great Dutch organist Sweelinck, Sweelinck in turn wrote variations on a pavan by Philips, and Philips made transcriptions for virginals of madrigals by Marenzio and Orlando di Lasso. Giles Farnaby harmonized "Rosseter's Galliard" and tunes by Robert Johnson; Byrd wrote harmonizations of tunes by Edward Johnson and James Harding, and borrowed the tune of a Volte from Morley. Borrowing was usually but not always acknowledged. The well known "Kings Hunt," ascribed to Bull because his

[52] *The Fitzwilliam Virginal Book* also contains eight compositions by Morley, eight by Ferdinando Richardson, five each by Thomas Tomkins and "Mundy," four each by M. Peerson, the Dutchman Sweelinck, Richard Farnaby, and W. Tisdall, and one or two by R. and E. Johnson, Oldfield, Strogers, Tallis, Warrock, Marchant, Parsons, Hooper, Inglott, Gibbons, and the foreigners Picchi, Galeazzo, and Oystermayre.

name is attached to it in the Fitzwilliam and Forster books, is really by Cosyn, since it occurs under his name in the collection he himself made. Miss Glyn says in her book *About Elizabethan Virginal Music and Its Composers* that it was clearly "part of the business of the Fitzwilliam compiler to *edit,* for one of Bull's own pieces is altered almost past recognition, and this is also the case with a Toye and Variations by Gibbons, and a variation-set 'Pakington's Pounde' by Cosyn, all shortened, mutilated, and inserted anonymously."

Parthenia and *Parthenia In-Violata,* the two books of engraved music, are best treated here, in spite of the fact that the latter contains a viol part in addition to the virginals score. The titles are puns. *Parthenos* is the Greek word for virgin, and the second title refers to the fact that the book is made up of duets for virginals and viol. The first of these works came out in 1611 and was popular for many years, no less than three editions of it appearing during the time of the Commonwealth. The second edition, of 1613, is dedicated to Prince Frederick (the Elector Palatine) and his affianced, Princess Elizabeth:

Musick like that miraculous tongue of th' Apostles having but one and ye same Caracter is alike knowne to all the sundry nations of ye world. And what wonder since Harmony is the Soule thereof multipliciously varied of fowre bare notes as ye Body is of the fowre Elements. These lessons were composed by three famous Masters in the faculties. whereof one[53] had ye honor to be your teacher most Illustrious lady; and (had he not had it before) thereby deserved the stile of a Doctor . . .

Commendatory verses follow by Hugh Holland[54] and George Chapman (the translator of Homer):

[53] John Bull; he composed an anthem for her wedding.

[54] Hugh Holland was a poet and fellow of Trinity College, Cambridge. A sonnet by him is prefixed to the First Folio of Shakespeare, and he contributed a eulogistic poem to Farnaby's set of madrigals (1598). He died in 1633.

INSTRUMENTAL MUSIC

Mr. Hugh Holland *On his worthy frend W.H. and his Triumviri of Musicke*

List to that sweet Recorder;
How daintily this BYRD his notes doth vary.
As if he were the Nightingalls owne brother!
Loe! where doth pace in order
A braver BULL, than ever did Europa cary:
Nay let all Europe showe me such an other.
Orlando though was counted Musicks Father;
Yet his ORLANDO parallels di LASSO,
Whose triple praise would tire a very Tasso;
Then heere in one these three men heare you rather
And praise thaire songes; and sing his praise who maried
Those notes so well which they so sweetely varied.

Mr. Geo. Chapman *In worthye love of this new work, and the most Autenticall[55] Aucthors*

By theis choice lessons of theise Musique Masters,
Ancient, and heightn'd with the Arts full Bowles,
Let all our moderne mere Phantastique Tasters,
(Whose Art but forreigne Noveltie extolls)
Rule and confine theyr fancies; and prefer
The constant right and depthe Art should produce,
To all lite flashes, by whose light they err;
This wittie Age hath wisdom least in use;
The World, ould growing, Ould with it grow Men;
Theyr skylls decaying, like theyr bodies strengthe;
Yonge Men to oulde are now but Childeren,
First Rules of Art encrease still with theyr lengthe:
Which see in this new worck, yet never seene;
Art the more oulde, growes ever the more greene.

[55] Authentic in the sense of accepted, established, reliable, no longer applied to persons. The "W.H." mentioned by Holland was William Hole, who engraved the music.

The praise of these three famous musicians by such a famous poet as Chapman is significant. His complaint that Englishmen unfortunately prefer foreign art to English is worthy of note. Considering the evident success of *Parthenia,* it is surprising that other collections of virginal music were not printed. In the Music School on the Bodleian quadrangle there is a portrait of that patron of music, Dr. Heather, holding a copy of *Parthenia.*

Parthenia In-Violata or Mayden-Musicke for the Virginalls and Bass-Viol was issued about 1614. The only known copy is in the New York Public Library.[56] The composers' names are not given. It is engraved throughout, whereas the title-page of the earlier volume, *Parthenia,* is printed in type. The stems of successive eighth or sixteenth notes are connected as in modern printing; such notes are always printed separately in Elizabethan type-set music. Some solid black whole notes are used as equal in time value to half-notes, in accordance with medieval practice. All the twenty pieces are duets, each bar of the viol part being conveniently printed underneath the same bar of the virginal part. Curiously enough, though the virginal part has bar-lines, the viol part has not. All the accidentals are written out, sometimes above the notes if there is not room before them. The virginal part uses two staves of six lines each, the G clef being on the 3d line and the F clef usually on the 4th. The viol part uses the ordinary modern F clef on the 4th line of a five-line staff. The volume is beautifully engraved.[57]

RECORDERS

The recorder, as has been said, is a member of the whistle family, along with the flageolet, the "penny whistle," and most organ pipes. Its tone is not unlike that of the flute, although quieter and even sweeter.

[56] Where it may be seen by any one without special formalities; certain other libraries please copy.

[57] See also the article by Ernest Brennecke, Jr., "Parthenia Inviolata," in the *Musical Times* for August 1934, vol. 75, pp. 701–706.

Duet for Virginals and Viol da Gamba
from
PARTHENIA IN-VIOLATA

When it is considered that only one collection of solos for any key-board instrument was published in England before the time of Cromwell, it is not surprising that other instruments suffered also. Parts printed during that period specifically for "flute"—which in England usually meant the recorder—were exceedingly few; Morley's consort lessons of 1599 contained one; and there are scarcely any Elizabethan compositions extant in manuscript for that instrument. But when Antony Holborne in 1599 published sixty-ive dance tunes under the title of *Pavans, Galliards, Almains, and other short Æirs both grave and light* for five "Viols, Violins or other Musical Wind Instruments," he meant they could be played either on bow d stringed instruments or on recorders of varying sizes. Musical gentlefolk kept sets or "consorts" of recorders, as of viols, for use by their household musicians. Hamlet shows a recorder to Guildenstern.[58] It was popular throughout the seventeenth century. Pepys on February 27, 1668, saw Massinger's *Virgin Martyr,* a "poorish play but finely acted," and adds: "But that which did please me beyond anything in the world, was the wind-musique when the angel comes down.". He consequently resolved "to practice wind musique" and to make his wife do the like. So on April 8th he went to buy a recorder, "which I do intend to learn to play on, the sound of it being, of all sounds in the world, most pleasing to me."

Why have such particularly charming instruments as the recorder been laid aside? "The clue is given by the happy phrase of a writer in *Grove's Dictionary,* wherein the selective evolution of orchestral instruments is said to have proceeded on the principle of 'the survival of the loudest'."[59] Recorder playing has been widely revived in the twentieth century.

HARPS

The harp was much used among the Irish, whose admiration for it through the centuries has been remarkable. Sir Francis Bacon's opinion

[58] *Hamlet,* Act III, Scene 2.
[59] Gerald R. Hayes, *The Treatment of Instrumental Music,* p. 17.

of it was no less favorable. He did not care for the virginals, the tone of which he calls "shallow and jarring." In *Sylva Sylvarum,* §§221–223, he commends the tone of recorders and flutes, and then says,

No instrument hath the sound so Melting, and Prolonged, as the Irish Harpe. So as I suppose, that if a Virginall were made with a double Concave, the one all the length as the Virginal hath, the other at the End of the Strings, as the Harp hath, it must needs make the Sound perfecter, and not so Shallow and Jarring.

The uncanny wisdom of Bacon's recommendation that a virginal be "made with a double Concave" has been proved by the development of the concert grand piano.

The harp in England does not seem to have been held in such esteem. Only one player of importance is mentioned during this period, WILLIAM MORE (c. 1492–1564), chief harper to Henry VIII, Edward VI, Mary, and Elizabeth. He was a Roman Catholic, and known to be such. He was blind, and thus escaped suspicion while he carried illicit and possibly treasonable messages for Catholic prelates. He was imprisoned for several weeks under Henry VIII, but released when he was needed to play for a function at court. A Protestant wrote, "I wiss, More, thou wrestest thine harp strings clean out of tune when thou thoughtest to set the bawdy bishop of Rome above the King's majesty." Grattan Flood mentions various fees paid him from 1512 on. In January 1544 Princess Mary gave him five shillings, and on June 3, 1559, under her successor he was decreed a salary of 12*d.* a day "for life." This act of favor shows clearly that Queen Elizabeth had no intention of dismissing Catholics as such. In 1520 the corporation of Shrewsbury called him "principalis citherator Angliae." He also wrote anthems. Case named him with Taverner, Blitheman, and Tallis as distinguished and well-paid musicians. No one succeeded him, it seems.

[60] Sir J. A. Westrup calls my attention to regular posts as harpist held by Jean de Flelle and Charles Evans among the personal musicians of Charles I and II respectively, and to a Lewis Evans whose youthful career as a harpist was aided by James I.

VII

Music on the Stage

NO subject connected with Elizabethan life has been so thoroughly
worked over as the stage. It is my intention therefore to give only
a few typical facts to illustrate the important place music held on the
stage and to show the curious relationship between church musicians
and the stage that resulted from the training of choirboys as actors.

MUSIC IN THE ELIZABETHAN PLAYS[1]

The modern play rarely calls for music during the acts. The Eliza-
bethan play, on the other hand, commonly contained songs, and, indeed,
the Puritan Prynne tells us that every play had music connected with
it:

That which is alwaies accompanied with effeminate lust-provoking Musicke
is doubtless inexpedient and unlawfull unto Christians. But stage-plays are
always accompanied with such Musicke. Therefore they are doubtless in-
expedient and unlawfull unto Christians.[2]

[1] For a detailed treatment of this subject see:

Edward W. Naylor, *Shakespeare and Music,* 1896. Revised 1931, reprinted 1965.

Edward W. Naylor, *Shakespeare Music,* 1913. This prints much of the music referred
to in Shakespeare's plays, with comment.

Louis Charles Elson, *Shakespeare in Music,* 1901.

G. H. Cowling, *Music on the Shakespearian Stage,* 1912. This deals with the other
dramatists as well as Shakespeare.

J. R. Moore, "The Function of the Songs in Shakespeare's Plays," in *Shakespeare Stud-
ies,* Univ. of Wisconsin, 1916.

Richmond Noble, *Shakespeare's Use of Song with the Text of the Principal Songs.*

F. W. Sternfeld's essay in *Shakespeare Survey No. 15: The Words and Music,* Cam-
bridge Univ. Press, 1962. C. R. Baskervill, *The Elizabethan Jig,* 1929.

[2] Prynne, *Histriomastix,* 1633, Act v, Scene 10.

The secular drama inherited this association with music from its medieval forebears, the religious drama and the performances by minstrels, for the medieval religious plays were sung by priests who had been trained in music in order to perform the offices of the Church, and the minstrels were primarily singers.

Early in the Elizabethan drama, composers were called upon to supplement the art of the playwright. William Byrd wrote songs for several plays, including *Ricardus Tertius* by Thomas Legge, given at Cambridge in 1579, and probably *Tancred an* Gismunda, by Robert Wilmot, Christopher Hatton, and others, 1 7–68. In *Gorboduc* (acted in 1562) violins, cornetts, flutes, oboes, and drums were called for by the stage directions. The instruments owned by the Lord Admiral's Company of actors in 1598 comprised three trumpets, one drum, one treble viol, one bass viol, one pandore, one cithern, one sackbut (trombone), three tymbrells (tambourines), and bells. "Eight or ten" musicians may have been employed in each important theatre from 1600.[8]

Actors were frequently required by their rôles to play instruments or sing. Viols are played by important characters in Jonson's *Poetaster*, Marston's *Antonio and Mellida*, and Middleton's *Roaring Girl*, and lutes similarly in Heywood's *A Woma: Killed by Kindness*, Dekker's *Honest Whore*, and Marston's *Dutch Courtesan*. Even organs are occasionally asked for. Parts in numerous plays must be taken by singers, e.g., Merrythought in Beaumont and Fletcher's *Knight of the Burning Pestle*, and Stremon in their *Mad Lover*. Beaumont and Fletcher lack Shakespeare's deeper appreciation of music, yet their plays contain excellent songs.[4] Valerius in Heywood's *The Rape of Lucrece* (1608) has to sing seventeen songs. "My mistris sings none other song," from Robert Jones's *First Booke of Ayres*, was sung by Franchschina in Marston's *Dutch Courtesan*, and is quoted by James Shirley; and Jones's

[8] Cowling, *Music on the Shakespearian Stage.*

[4] The words of no less than fifty songs, and the music of six, are printed in *Songs and Lyrics from the Plays of Beaumont and Fletcher*, London, 1928.

"Now what is love?" to words by Sir Walter Raleigh was sung in Heywood's *Rape of Lucrece*. Conversely, musicians in the theatre orchestras were sometimes pressed into service to take small speaking parts; and in Jonson's *Every Man out of His Humour* the trombone player spoke the prologue.

The musician's dramatist is Shakespeare. Numerous allusions to music in his plays attest both his love for the art and some technical knowledge of it. We should like to think that he could play one or more instruments, but we have no proof. He refers to the fingering of the recorder, but not in detail, and mentions the succession *Fa Sol La Mi* (F G A B, going up the scale) as unpleasant; it was forbidden by the theorists of the day because of the augmented fourth—"tritone"—between F and B. He knew something about frets, the scale, notes, rests, "division," "descant," and "pricksong." In Sonnet 128 he refers to the keys of the virginals as "jacks"[5]:

> I envy those jacks, that nimble leap
> To kiss the tender inward of thy hand.

This poetic license made possible his pun on the word "jacks," and thus gives additional point to the sonnet. "Shakespeare knew his audience well, and it cannot be a coincidence that the two plays whose titles imply that he was giving it what it wanted contain the most songs. *As You Like It* and *Twelfth Night, or What You Will* contain no fewer than six songs each."[6] In *Troilus and Cressida* Pandarus accompanied his song "Love, love, nothing but love" on the lute. Balthasar sings in *Much Ado about Nothing*,[7] and Amiens sings in *As You Like It*. "It was a lover and his lass" is a duet, sung by two pages. Ariel's songs in *The Tempest* were sung by a boy. There are fairy songs in *Midsummer*

[5] The jack was not the key, but the part of the action that held the quill and plucked the string.

[6] Cowling, *op. cit.*

[7] William Kempe, who created the part of Dogberry in *Much Ado about Nothing*, is

Night's Dream and a dirge for two voices in *Cymbeline*. Ophelia sings in *Hamlet,* and Desdemona in *Othello.* Robert Johnson's settings of "Full fathom five" and "Where the bee sucks" from *The Tempest* may have been written for the first performance of the play.

So frequent a use of song requires explanation. On a modern stage various songs by Shakespeare sound unnecessary and even out of place. But the Elizabethan theatre lacked modern front drop-curtains, pictorial painted scenery, and means to change the amount of light. Shakespeare therefore in several situations introduced songs to get characters on and off the stage gracefully and plausibly, and also to create atmosphere and to conjure up imaginary stage settings to the audience. Thus the Clown in *Twelfth Night* maintains the note of comedy to the very end of his scene with Malvolio by singing as he leaves. In *Cymbeline,* after Iachimo has stolen the bracelet by night, the song

> Hark, hark the lark at heaven's gate sings
> And Phoebus gins arise

both tells the time and dispels the previous mood of villainous gloom. In a number of instances Shakespeare calls upon music to aid his auditors' acceptance of whatever is supernatural, abnormal, or strange.[8] Thus

celebrated for his dancing in a madrigal by Weelkes (*Ayeres . . . for three voices,* 1608, No. 20. The Robin Hood legend was a stock subject for strolling players):

> Since Robin Hood, Maid Marian,
> And Little John are gone,
> The hobby horse was quite forgot,
> When Kempe did dance alone.
> He did labor
> After the tabor.
> For to dance
> Then into France
> He took pains
> To skip it in hope of gains
> He will trip it on the toe,
> Diddle, diddle, diddle doe.

[8] Dr. Percy A. Scholes called attention to this, in his article "Shakespeare as Musician," in *The Music Student* for May 1916, Vol. VIII, No. 9, pp. 243–246.

music prepares us in *The Winter's Tale* for the miraculous restoration of the statue to life and for the appearance in *Cymbeline* of the spirits, and in *Julius Caesar* of his ghost. It accompanies the fairies in *Midsummer Night's Dream* and the witches in *Macbeth,* it restores Thaisa to life in *Pericles* and calms the disordered brain of King Lear.

Shakespeare has been unjustly accused of suggesting that music had an effeminate influence on Count Orsino in *Twelfth Night*. It is true that in the earlier scenes of this play Orsino is overfond of languishing songs, but his sentimentality is caused by his lovesickness, not by his love for music, and passes away as soon as its cause is removed. We may believe that Shakespeare's own opinion of music is expressed in the Fifth Act of the *Merchant of Venice:*

> Nought so stockish, hard, and full of rage,
> But music for the time doth change his nature.
> The man that hath no music in himself,
> Nor is not moved with concord of sweet sounds,
> Is fit for treasons, stratagems and spoils.
> The motions of his spirit are dull as night,
> And his affections dark as Erebus.

In general the Elizabethan dramatists spoke well of music and musicians:[9]

Spaniards and Dutchmen, Pedants and Poetasters, Beggars and Constables, Justices and Rogues, come in their turn under the lash, but not musicians. Balthasar and Hortensio are not made a laughing-stock because of their profession like Shallow and Dogberry, or Don Armado and his fellow scrap-stealer Holofernes. [Musicians] were the interpreters of a divine harmony whose perfection was only to be heard by dwellers in the heavenly spheres.[10]

[9] "Except Shakespeare's realism as to the singer's 'ill voice' and reluctance to sing. See *Much Ado about Nothing*."—Dr. Felix E. Schelling.
[10] G. H. Cowling, *op. cit.*

MASQUES

The masque was a histrionic form closely related to both the play and the opera. It unfolded its story in song and spoken word, with frequent dances by the characters and chorus. It was an entertainment not for the common people but for royalty and the court, to whom both actors and spectators belonged. Because its primary aim was to captivate the eye and ear through gorgeous color, skilful dancing, and sweet music, it never quite approached in dramatic power either the drama or the opera proper, but its poetic quality was sometimes of a high order. It was older than its name. An entertainment given at the English court in 1377 contained three features always present in the masque: the performers entered the hall together in disguise, they danced first with each other, and then joined with the courtly spectators in other dances.[11] The name itself was introduced from the Continent early in the sixteenth century. Queen Elizabeth was fond of this form of entertainment, but it did not mature in poetic and dramatic fitness until the close of her reign, and it reached its height under the first two Stuarts. At this time masques were extremely popular, as is attested by the high caliber of the poets and composers employed and by the enormous sums spent on their production. Those by Campion are of special interest to musicians because he wrote both the words and some of the music. Though his masques are inferior to Ben Jonson's in dramatic construction and force, they rank second to none in lyric grace and charm of poetic style. Jonson was less vitally interested in music, but he too appreciated its power adequately and wrote more lines to be sung than to be spoken. Sixty-six musicians took part in his masque *Love freed from Ignorance and Folly,* in 1611.[12] Jonson is usually considered to have

[11] *Ben Jonson,* edited by C. H. Herford and Percy Simpson, 1925, ii. 251.

[12] For an account of how masques were staged see Jeffrey Mark's article, "The Jonsonian Masque," in *Music and Letters,* iii. 358–371, also *Stuart Masques and the Renaissance Stage,* by Allardyce Nicoll. For Jonson's use of music in his masques see *Ben Jonson and Elizabethan Music* by Willa McClung Evans.

written the best masques, but Daniel, Chapman, Davenant, Shirley, Milton, and others essayed the form with success. It received a severe wound in 1642 when the Puritan Parliament banned dramatic entertainments, though some works of the sort were written and performed after the Restoration.

In general the music of the Jacobean masque consisted of choruses, songs for one or more voices, and instrumental dances, these forms alternating so as to rest the performers and avoid monotony. All sorts of instruments were used, particularly of course viols and lutes. Cornetts, drums, and fifes were among those employed in Campion's entertainment for Queen Anne in 1613. Not much masque music was published. The printed descriptions of Campion's masques for Lord Hay, 1607, and the Earl of Somerset, 1614, give the words and music of five songs each. Ferrabosco's *Book of Ayres,* 1609, contains several songs that he had written for Jonson's masques. The instrumental *Courtly Masquing Ayres* by Adson (1611) have been mentioned.[18] In recent years W. J. Lawrence has identified a number of tunes in a MS collection of masque music in the British Museum as coming from various masques by Jonson and (in a few cases) by Campion.[14] The semi-private and "occasional" use of each masque would account for the meager amount of music published.

By way of illustration Campion's first masque[15] is described below, since the opening scene (given here in his own words) exemplifies the important place held in the masque by music and musicians; and the rest of the story, necessarily summarized in present-day English though

[18] Page 175.

[14] "Notes on a Collection of Masque Music," by W. J. Lawrence, pp. 49–58 in the issue of *Music and Letters* for January 1922, being comments on British Museum Additional MSS 10,444.

[15] *The Discription of a Maske, Presented before the Kinges Maiestie at White-Hall, on Twelfth Night last, in honour of the Lord Hayes, and his Bride Daughter and Heire to the Honourable the Lord Dennye, their Marriage having been the same Day at Court solemnized. Invented and set forth by Thomas Campion Doctor of Phisicke. London. 1607.*

the loss of its original charming style exposes Campion's typical thinness of plot, will show how a masque was written to suit an occasion and to please the guests. In this case they were a Lord Hay and his bride, who had been married earlier the same day. In genial flattery Campion's masque describes how the wedding has gratified the immortal gods. At the beginning there is an account of the staging, the musical arrangements, and the entrance of King James and the guests, shortly followed by the actors:

The greate hall (wherein the Maske was presented) received this division, and order: The upper part where the cloth and chaire of State was plac't, had scaffoldes and seates on eyther side continued to the skreene; right before it was made a partition for the dauncing place; on the right hand whereof were consorted ten musicions, with Basse and Meane Lutes, a Bandora, a double Sack-bott, and an Harpsichord, with two treble Violins; on the other side somewhat neerer the skreene were plac't 9 violins and three Lutes, and to answere both the Consorts (as it were in a triangle) sixe Cornets, and sixe Chappell voyces, were seated almost right against them, in a place raised higher in respect of the pearcing sound of these Instruments . . . [On one platform was] a greene valley with greene trees round about it, and in the midst of them nine golden trees of fifteene foote high, with armes and braunches very glorious to behold. . . .

As soone as the King was entred the great Hall, the Hoboyes (out of the wood on the top the hil) entertained the time till his Maiestie and his trayne were placed, and then after a little expectation the consort of ten began to play an Ayre, at the sound wherof the vale on the right hand was withdrawne, and the ascent of the hill with the bower of Flora were discovered, where Flora and Zepherus were busily plucking flowers from the Bower, and throwing them into two baskets, which two Silvans held, who were attired in changeable Taffetie, with wreathes of flowers on their heads. As soone as the baskets were filled, they came downe in this order, First Zepherus and Flora, then the two Silvans with baskets after them: Foure Silvans in green taffatie, and wreathes, two bearing meane Lutes, the third a base Lute, and the fourth a deep Bandora.

As soone as they came to the discent toward the dauncing place the consort of ten ceac't, and the foure Silvans played the same Ayre, to which Zepherus and the two other Silvans did sing these words in a base, Tenor, and treble voyce and going up and downe as they song, they strowed flowers all about the place.

Song. Now hath Flora rob'd her bowers
 To befrend this place with flowers: [etc.]

We may summarize the action of the remainder of the masque:

Flora too strewed flowers in honor of the bridal couple, and wished them well. But Night then entered, servant of Diana (Cynthia, the moon, goddess of virginity) and censured Flora for praising this marriage, since Hymen, the god of marriage, had stolen the bride from Diana's train of virgins. Night explained that the golden trees were once knights of Phoebus Apollo, who in seeking to entice away her maidens by love were thus transformed in punishment by Diana. Night's objection was removed by the entrance of Hesperus, the evening star, who announced that Phoebus had pacified Diana, and that she had agreed to the marriage and to the liberation of the knights. Night thereupon freed them. Their platform sank out of sight; when it rose again they reappeared gloriously dressed. She had them make expiation to Diana for their theft, and when the goddess was satisfied, Night called upon all present to take part in a final dance.

Two of the composers of masques have been mentioned, CAMPION and the younger FERRABOSCO. The latter wrote music for several of Jonson's masques.[16] He acted in some of them as well, and received the warm thanks of the author. Important also was HENRY LAWES, 1595–1662, a leading composer of his generation, who wrote the music to Milton's masque Comus, and NICHOLAS LANIERE, 1588–1666, who like Ferrabosco both acted in masques by Jonson and wrote music for them. Finally mention may be made of JOHN WILSON, 1595–1674, who as a youth wrote music for The Maske of Flowers, 1614. He

[16] See p. 144, supra.

. . . had oftentimes just opportunities to exercise his hand on the Lute (being the best at it in all England) before him [Charles I] to his great delight and wonder; who, while he played, did usually lean or lay his hand on his shoulder.

On March 10, 1645, Wilson received the degree of Doctor of Music from Oxford University, being "now the most noted Musitian of England." Henry Lawes wrote of him,

> For this I know, and must say't to thy praise,
> That thou hast gone in Musick, unknown wayes,
> Hast cut a path where there was none before,
> Like Magellan traced an unknown shore.
> Thou taught'st our Language, first, to speak in Tune,
> Gav'st the right accents and proportion

—words which, as Arkwright says,[17] would fit Lawes himself better than Wilson. It is stranger still that Lawes could not have found some Elizabethan to whom he could pay this noble tribute. But by 1645 the age of giants had passed, and even their stature was forgotten.

CHOIRBOYS AS ACTORS

The connection between music and the important companies of boy actors was close, because they were usually managed or trained by their choirmasters. The affiliations of the important companies, with the names of the men that trained them, are given here:

1. *The Chapel Royal, Whitehall, London*

RICHARD EDWARDS, master of the children from 1561 till his death, 1566.

WILLIAM HUNNIS, master of the children from 1566 till his death, 1597, probably.

NATHANIEL GILES, master of the children from 1597 till his death,

[17] *Grove*, v. 729.

1633. He held the same position at St. George's Chapel, Windsor, of which he was organist.

2. *St. George's Chapel, Windsor*

RICHARD FARRANT, master of choristers from 1564 till his death, 1580.

NATHANIEL GILES, master of choristers and organist from 1585 till his death, 1633.

3. *St. Paul's Cathedral*

SEBASTIAN WESTCOTE, organist and master of choristers from 1551 till his death, 1582.

THOMAS GILES, organist in 1583.

EDWARD PEARCE, organist and choirmaster from 1599. He was still choirmaster in 1607.

4. *Westminster Abbey*

ROBERT WHITE, organist and choirmaster from 1570 till his death, 1574.

5. *The Children of the Chapel at Blackfriars,* 1597–1603

NATHANIEL GILES chose the boys and superintended their musical training, but their manager, Henry Evans, was probably not a professional musician.

6. *The Children of the Revels to the Queene within White Fryars* (from Windsor Chapel)

ROBERT JONES, its founder (1610) and manager, along with PHILIP ROSSETER.

JOHN DANIEL succeeded his brother Samuel, the poet, as textual reviser of the plays.

Two other juvenile companies presented plays early in King James's reign, viz. *The Children of the Revels to the Queen at Blackfriars,* 1604–1608, and *The Children of the King's Revels at Whitefriars,* c. 1603–1609.

RICHARD EDWARDS (c. 1523–1566) has been mentioned on pp. 95–100, with the quotation which Shakespeare made from one of his poems.

WILLIAM HUNNIS[18] (c. 1530–1597) was chosen a Gentleman of the Chapel Royal under Edward VI. Queen Elizabeth in recognition of his ability made him Keeper of the Queen's Gardens for life, at 12d. a day, and in 1566 he succeeded to the post, made vacant by Edwards' death, of Master of the Children of the Chapel Royal in London. From 1568 to 1572 he presented his choirboys as actors in plays at court, and from 1576 to 1580 they and Farrant's boys from Windsor joined forces, acting at court as before. In 1580 he leased the Blackfriars Theatre[19] from Farrant's widow, and continued to use his boys. In 1583 and 1584 his boys and those of St. Paul's, under its organist THOMAS GILES, the father of Nathaniel Giles, gave plays at court. At the Queen's command Hunnis sometimes presented them on Sundays in the sacred chapel itself, to the confusion of the Puritans.

In 1597, on the death of Hunnis, Elizabeth immediately appointed NATHANIEL GILES in his place and sanctioned the opening of a new theatre at Blackfriars under the managership of a Henry Evans. Giles supplied the boys for this and supervised their musical training, but the Queen herself paid for their board, lodging, and apparel, including their sumptuous theatrical costumes. During the time of Shakespeare, with the exception of him and his company the best plays and the best acting of the period were to be seen at the boys' theatres. Here music held so prominent a place that these children had to sing as well as they could act. Lengthy musicales preceded the plays, and the boys were

[18] For information regarding these musician-managers and their youthful charges see *The Children of the Chapel at Blackfriars, 1597–1603,* by Charles William Wallace, 1906; an article by G. E. P. Arkwright, "Elizabethan Choirboy Plays and Their Music" in the *Proceedings of the Musical Association* for 1913–1914; and articles by Grattan Flood entitled "New Light on Late Tudor Composers" published in *The Musical Times* from 1924 to 1929: Vol. 65 (1924) discusses Farrant, Vol. 66 (1925) Westcote and Hunnis, Vol. 69 (1928) Daniel, and Vol. 70 (1929) Pearce.

[19] This was the first Blackfriars Theatre, closed in 1584. The later Blackfriars Theatre was opened in 1597.

given careful instruction upon musical instruments, in solo and choral singing, and in dancing. In 1602 a German visitor[20] thus recorded his impressions of the Blackfriars Theatre:

The Queen maintains a number of young boys who are required to devote themselves earnestly to the art of singing, and to learn to perform on various sorts of musical instruments, also at the same time to carry on their studies. These boys have their special preceptors in all the various arts, and in particular excellent instructors in music. . . . For a whole hour preceding the play one listens to a delightful musical entertainment on organs, lutes, [pandoras, mandores, viol(in)s,] and flutes, as on the present occasion, indeed, when a boy *cum voce tremula* sang so charmingly to the accompaniment of a bass viol.

The untimely death of the choirboy Salathiel Pavy, who acted old men's parts with humor and extraordinary realism, moved Ben Jonson to pen a touching elegy. One of the Lord Chamberlain's Players, Shakespeare, referred to the boy companies from Blackfriars and St. Paul's as "an aerie of children, little eyases that cry out on the top of the question, and are most tyrannically clapped for it; these are now the fashion."[21]

RICHARD FARRANT (c. 1526–1580) founded the earlier Blackfriars Theatre, the first private theatre in London. He managed his choirboys from Windsor in numerous plays; he was required to present one a year before the Queen from 1567 onwards. She was so pleased with his production of *The History of Mutius Scevola* that on January 6, 1577, she gave him an extra fee of £10.

SEBASTIAN WESTCOTE (c. 1523–1582) was organist and master of choristers at St. Paul's Cathedral from 1551 until his death. He was imprisoned for Papistry for nine weeks (1577–1578), but he evidently retained Elizabeth's favor. He presented his choirboys in plays before her

[20] Frederic Gershow, who with his princely master the Duke of Stettin was touring England. The translation is by Dr. C. W. Wallace, *op. cit.*, pp. 106, 107.
[21] *Hamlet*, ii. 2.

both when she was a princess (1551 or 1552) and a queen (1559 and probably at other times). He had directed the music at Queen Mary's coronation and presented her with a book of ditties. Peter Philips and Thomas Mudd were probably his pupils, Morley[22] possibly also. Westcote's choir is praised by Hollybande in *The French Schoolemaister*,[23] a quaint work printed in English and French on opposite pages for students of the latter language. Hollybande and his friends enter St. Paul's:

"Harken, I do heare a sweet musick: I never heard the like."

"See whether wee may get to the quier, and wee shall heare the fearest voyces of all the cathedrall churches in England."

"Escoutes, i' oye vne douce musique: ie n' oui iamais la semblable."

"Regardes si nous pourrons gaigner le coeur & nous orrons les plus belles voix, de toutes les eglises cathedralles d' Angleterre." [*etc.*]

"I beleeve you: who should have them, if the Londonners had them not?"

"I thinke that the Queenes singyng men are there, for I doo heare her baase."

"That may be: for, to tell the trueth, I never heard better singyng."

"Hearken, there is a good versicle."

"I promise you that I would heare them more willingly singe, than eate or drinke."

EDWARD PEARCE (fl. 1586–1614) became a Gentleman of the Chapel Royal in 1588, and organist and Master of the Choristers at St. Paul's in 1599. Thomas Ravenscroft, who was one of his choirboys, includes two part-songs by Pearce in *A Briefe Discourse* (1614), and thus praises his former teacher:

Maister Edward Pearce the first, sometimes Maister of the Children of Saint Paules in London, and there my Maister, a man of singular eminency in his

22 According to an undocumented statement by Grattan Flood.
28 *The French Schoolemaister, wherin is most plainlie shewed, the true and most perfect way of pronouncinge of the Frenche tongue, without any helpe of Maister or teacher . . . by M. Claudius Hollybande, professor of the Latin, Frenche and Englishe tongues* London. 1573. Pp. 74–76.

Profession, both in the Educating of Children for the ordering of the Voyce so as the Quality might afterward credit him and preferre them: And also in those his Compositions to the Lute, whereof the world enjoyes many, (as from the Maister of that Instrument) together with his skilfull Instructions for other Instruments too, as his fruits can beare him witnesse.

Pearce's choirboys gave a play at court on January 1, 1601. *Jack Drum's Entertainment* (1600) referred to the current popularity of Pearce's troupe:

> I saw the Children of Paul's last night,
> And troth, they pleased me pretty, pretty well.
> The apes in time will do it handsomely.

John Marston and Thomas Dekker dignified them by writing plays for them, and gentlemen preferred them to the adult companies because the higher price of admission charged to hear the boys kept away the ill-smelling rabble. I find a reference to Pearce in *A Choice of Emblemes* . . . by Geoffrey Whitney, 1586. Only the initial letters of his name are given, but so many punning allusions to composers are to be found in Elizabethan musical literature that the word "pierce" in the text would seem to identify him.

> You neede not Thracia seeke, to heare some impe of Orpheus playe,
> Since, that so neare your home, Apollos darlinge dwelles;
> Who Linus, & Amphion staynes, and Orpheus farre excelles.
> *E. P. Esquier* For, h[e]artes like marble harde, his harmonie doth pierce:
> And makes them yeelding passions feele, that are by nature fierce.
> But, if his musicke faile: his curtesie is suche,
> That none so rude, and base of minde, but hee reclaimes them muche. . . .

Robert White (c. 1530–1574), famed composer of church music, and "Bacheler of Musicke and Master of the Queristers of the Cathedrall

Churche of St. Peter in the Cittie of Westminster," composed four plays which his choirboys gave at court. It seems strange to meet these men in the rôle of theatrical managers whom we have previously revered from a distance as composers of austere cathedral music or delicate madrigals; but the greater Elizabethans were jewels with many facets.

ROBERT JONES (b. 1575), better known as a composer of ayres and madrigals, was connected with various theatrical performances. In January 1610, he, Rosseter, and others were granted a patent to train "the Children of the Revels to the Queene within Whitefryars."

It speaks well for the tact, musicianship, and culture of these men that they could prepare their young charges to compete successfully with the companies of adult actors before critical spectators, such as the court and royalty. The choirboy, trained by the best talent in the country, practised an art that in the plays of Ben Jonson and others rivaled the successes of Shakespeare.

Musical Relations with the Continent

ENGLAND BORROWS FROM ITALY

SINCE the coming of St. Augustine the English have been borrowing from the Latin peoples. The fact that the latter have rarely seen any occasion to borrow in return merely stamps them as more insular than the English. Chaucer borrowed from Boccaccio, often improving on his model. It is a familiar paradox that Shakespeare, constantly borrowing from Italy, was always original. Musically, England also owed a debt to Italy, and freely acknowledged it. Ravenscroft[1] wrote in 1614:

The Forraine Artist saith, that an Englishman is an excellent Imitator, but a very bad Inventor; and indeed it should appeare; for we observing such Inventions which they ensample to us, as Madrigalls, Pastoralls, Neapolitanes, Ballads, and divers other light Harmonies, doe bend our courses onely to surpasse the tuning of such Strings;

but adds:

Our Artists (as they confesse) farre surpasse them in the accurateness thereof which is upon the Plaine song, and multiplicity of Parts, wherein they doe admire us.[2]

The history of the penetration of the Italian madrigal into England cannot be traced step by step, for details are lacking; but Dr. Fellowes[3] notes the presence in England in 1564 of a collection of Italian madrigals by Willaert, Verdelot, di Lasso, Arcadelt, and others. In 1588 a set of

[1] Thomas Ravenscroft, *A Briefe Discourse*, 1614.
[2] I.e., we write more perfect counterpoint whether as accompaniment to a plainsong canto fermo, or in six or more parts.
[3] E. H. Fellowes, *The English Madrigal Composers*, p. 38.

selected Italian madrigals, entitled *Musica Transalpina,* was printed in England. The compiler, Nicholas Yonge, tells us that a great number of gentlemen and merchants were in the habit of meeting in his house and singing from "Bookes of that kinde yeerly sente me out of Italy and other places, which beeing for the most part Italian Songs, are for sweetnes of Aire, verie well liked of all."[4] The fact that Byrd and Yonge published madrigals in 1588 is the only definite proof that madrigal singing had reached a fair degree of popularity in England at that time. Including *Musica Transalpina,* five[5] sets of Italian madrigals were printed in England, all of them between 1588 and 1598. After that period musical tastes were probably satisfied with the increasing number of madrigals available in English.

Numerous references to Italian influence are found in the works of Thomas Morley. In *The First Booke of Balletts,* 1595, he imitates Gastoldi,[6] and when he defines the madrigal he tells[7] his readers:

In this kind our age excelleth, so that if you wold imitate any madrigals, I wold appoint you these four guides: *Alfonso Ferrabosco* for deep skil, *Luca Marenzo* for good ayre & fine invention, *Horatio Vecchi, Stephano Venturi, Ruggiero Giovanelli,* and *John Croce.*

When he lists and defines the various kinds of secular music for concerted voices then in use, all his terms are Italian, or of Italian origin, e.g., "Canzonets" (which are also called "Neapolitans or Canzone a la Napolitana"), "villanelle," "ballete," "vinate," and "pasterellas." His instrumental forms are chiefly French, such as "Fantasie," "Pavane," and "Galliard." Only two English terms appear—"Hornepypes" and

[4] See *infra,* p. 208.

[5] These five publications, which were edited by Yonge, Watson, and Morley, are mentioned with brief comment on pp. 208–212.

[6] Gastoldi was known in his own day for his *balletti.* We know him as the composer of the familiar chorale "In Dir ist Freude."

[7] Thomas Morley, *A Plaine and Easie Introduction to Practicall Musicke,* 1597; pp. 180 ff.

"Iygges." But Morley hopes that his own *Canzonets* of 1597 will not suffer in comparison with those from the Arno and Po.

It is quite natural for the works of a younger composer to reflect in a general way the style of a revered master. Van den Borren[8] cites several examples to show the stylistic influence of the Italian school on Peter Philips, Byrd, Bull, and Morley. On the other hand, Flood[9] thinks that the Spanish organist Cabezon (1510–1566) was influenced in his virginals style by Tallis; in December of 1554 Cabezon, Orlando di Lasso, and Philippe de Monte were all in London with Philip II of Spain, and Cabezon may have heard compositions by Tallis at that time.

In summary we may say that the English composers, like the English poets, were not servile imitators, and their works can challenge comparison with, and often surpass, those of their Italian models.

ITALIAN MUSIC PRINTED IN ENGLAND

The high regard in which England held the music of Italy is shown by the fact that a surprising amount of Italian music was published in England. The titles are given in the following list; the names of the composers are printed in small capitals, those of the English compilers in ordinary type:

1588 Nicholas Yonge: *Musica Transalpina* . . . [Vol. 1]

1590 Thomas Watson: *The First Sett of Italian Madrigalls Englished, not to the Sense of the original dittie* . . .

1597 Nicholas Yonge: *Musica Transalpina* . . . [Vol. 2]

1597 Thomas Morley: *Canzonets, Or Little Short Songs to foure voyces: Celected out of the best and approved Italian Authors.*

1598 Thomas Morley: *Madrigals to five voyces. Celected out of the best approved Italian Authors.*

[8] Van den Borren, *The Sources of Keyboard Music in England*, 1913, pp. 142–144.
[9] W. H. Grattan Flood, in the *Musical Times* for 1925, p. 510.

1598 ORLANDO DI LASSO:[10] *Novae aliquot . . . cantiones.* Two-part motets.

1603 ALFONSO FERRABOSCO the Elder and WILLIAM BYRD: *Medulla Musicke.* See page 264.

1608 GIOVANNI CROCE: *Musica Sacra to Sixe Voyces.*

1610 Robert Dowland: *Varietie of Lute Lessons,* including lute pieces by the elder Ferrabosco and others.

1613 ANGELO NOTARI: *Prime Musiche nuove a una, due e tre voci.*

1616 Thomas Myriell: *Tristitiae Remedium,* a MS with engraved title-page.

Musica Transalpina (1588) played such a prominent part in bringing the madrigal into popularity in England, and thus in nurturing the English madrigal school, that the Dedication of this set to Gilbert Lord Talbot is given almost in full:

Right honourable, since I first began to keepe house in this Citie, it hath been no small comfort unto mee, that a great number of Gentlemen and Merchants of good accompt (as well of this realme as of forreine nations) have taken in good part such entertainment of pleasure, as my poore abilitie was able to affoord them, both by the exercise of Musicke daily used in my house, and by furnishing them with Bookes of that kinde yeerely sente me out of Italy and other places, which beeing for the most part Italian Songs, are for sweetnes of Aire, verie well liked of all, but most in account with them that understand that language. As for the rest, they doe either not sing them at all, or at the least with litle delight. And albeit there be some English songs lately set forth by a great Maister of Musicke,[11] which for skill and sweetnes may content the most curious: yet because they are not many in number, men delighted with varietie, have wished more of the same sort.

[10] Di Lasso was a Fleming who lived in Munich; I mention his work here so as to include all foreign music, not merely Italian. The eccentric Tobias Hume published in 1605 a collection entitled *The First Part of Ayres, French, Pollish, and others . . . ,* yet says they are all of his own composing!

[11] William Byrd's *Psalmes, Sonets and songs of sadness and pietie,* 1588; see *supra,* p. 104.

For whose cause chiefly I endevoured to get into my hands all such English Songs[12] as were praise worthie and amongst others, I had the hap to find in the hands of some of my good friends, certaine Italian Madrigales translated most of them five yeeres agoe by a Gentleman for his private delight (as not long before certaine Napolitans had been englished by a verie honourable personage, and now a Councellour of estate, whereof I have seene some, but never possessed any). And finding the same to be singulerly well liked, not onely of those for whose cause I gathered them, but of many skilfull Gentlemen and other great Musiciens, who affirmed the accent of the words to be well mainteined, the descant not hindred (though some fewe notes altred), and in everie place the due decorum kept, I asked the gentleman if I might publish them, but he always refused, saying "That those trifles being but an idle man's exercise, of an idle subject, written onely for private recreation, would blush to be seene otherwise than by twilight, much more to be brought into the common view of all men." And he quoted Martial,

> "Seras tutior ibis ad lucernas
> Haec hora est tua, dum furit lyæus,
> Dum regnat rosa, dum madent capilli,
> Tum te vel rigidi legant Catones."

Yonge apologizes for publishing them against this compiler's wish, and hopes that Lord Talbot will deem them worthy of his patronage, since they have been "hitherto well esteemed of all."

This publication met with popular favor, as Yonge tells us in a second collection of the same sort, which was issued in 1597 under the same title:

MUSICA TRANSALPINA.
THE SECONDE BOOKE OF MADRIGALES, to 5 & 6 Voices: translated out of Sundrie Italian Authors & NEWLY PUBLISHED BY NICOLAS YONGE. AT LONDON

Printed by Thomas Este.
1597.

[12] I.e., English madrigals in manuscript.

Yonge says that the compositions in this second volume

> I have carefully culled out of the compositions of the best Authors in Itally. Perhaps they speak not English so well as they sing Italian. And (alas) how colde they, beeing as yet but late sojourners in England?

This is a pleasant apology for the English words of both volumes, which are literal translations, line for line, of the original Italian, but have no stylistic merit. It is a pity that a capable English poet was not employed to make the translations.

The first volume of *Musica Transalpina* includes fifty-seven madrigals: sixteen by the elder Ferrabosco, ten by Marenzio, five by Palestrina, four by Philippe de Monte, three by Conversi, two each by William Byrd and di Lasso, and one or two each by numerous little-known men. Only two composers are represented in both volumes, Ferrabosco and Marenzio, who in the second volume have six and three madrigals respectively. The second volume of twenty-four madrigals includes also three each by Croce and Quintiani, and a few by lesser men whose names may be read in *Grove's Dictionary*.[18] From his dedications Yonge appears as a man of force, charm, culture, and breadth, valued for his friendship by men of prominence in the business world.

THOMAS WATSON, who died before 1592, was a lawyer and poet. He composed the verses[14] in honor of John Case which were set by Byrd, and he also compiled:

> The first sett of Italian Madrigalls Englished, not to the sense of the original dittie, but after the affection of the Noate. By Thomas Watson. There are also heere inserted two excellent Madrigalls of Master William Byrds composed after the Italian vaine at the request of the sayd Thomas Watson.

Twenty-three of the twenty-eight madrigals are by Marenzio, two by Byrd to the same words—"This sweet and merry month of May," in

18 See *Grove*, iii. 590.
14 See *supra*, p. 32.

four and six parts—and one each by Girolamo Conversi, Giovanni Maria Nanino, and Alessandro Striggio. There are two Latin dedicatory poems. One is to Robert Devereaux, Earl of Essex, poet and favorite of Elizabeth: "Who is ignorant of what your muse has given us? . . ." The other, to Marenzio, is charming in its extravagance: "The sweet power of your music stabs me; so may I die often, for in your song is life. When you sing, I dream it is the music of the spheres, the harmony of the Muses."[15]

We now come to the two sets of Italian madrigals[16] (with words in that tongue) that THOMAS MORLEY selected and issued.

Canzonets, Or Little Short Songs to foure voyces. Celected out of the best and approved Italian Authors by Morley, were dedicated by him in 1597 to "Maister Henrie Tapsfield Citizen and Grocer of the Cittie of London," who was accustomed to sing madrigals. Morley with amusing modesty calls them "poore Canzonets," although they were not by him.

His other set of Italian madrigals is entitled *Madrigals to five voices.*

[15] "Hei, quoties morimur nimia dulcedine rapti
 Pulsat Apollineam dum tua Musa chelyn.
O, igitur dulcis plectrum depone Marenzi,
 Ne sit laesa tuis plurima vita sonis.
Attamen o dulcis plectro modulare Marenzi:
 Si morimur, vitam dant tua plectra novam.
O liceat nobis, vitâ sub morte repertâ,
 Saepe tuo cantu vivere, saepe mori.
Mille neces patior, vitas totidemque resumo,
 Dum tua multiplici gutture musa placet:
Somnio septeno gyrantes murmure sphaeras;
 Somnio cantantis Numina blanda sali:
Somnio Thrëiceum Cytharoedam fixa moventem:
 Somnio mulcentem carmine monstra Deum:
Somnio Musarum concentus protinus omnes:
 Omnia Marenzi, dum canis, unus habes."

[16] They comprise six madrigals by Anerio, five each by Croce, Ferrabosco the Elder, and Vecchi, four by Giovanelli, three each by Giovanni Bassano and Ferretti, two each by Peter Philips and Morley himself, and one each by Giulio Belli, Giovanni Macedonio ("di Macque"), Marenzio, Mosto, Orologio, H. Sabino, S. Venturi and Viadana, with one anonymous.

Celected out of the best approved Italian Authors . . . 1598. He dedicated it to Sir Gervis Clifton with a fulsome eulogy.[17]

Three Italian composers received the honor of having collections of their music published separately in London. The publication of each of these was warranted by some special factor. One was ORLANDO DI LASSO's

NOVÆ ALIQUOT ET ANTE HOC NON ITA USITATÆ AD DUAS VOCES CANTIONES SUAVISSIMÆ, omnibus Musicis summe utiles: nec non Tyronibus quàm eius artis peritioribus summopere inservientes ¶ AUTHORE *ORLANDO DI LASSO, Illustrissimi Bavariae Ducis Alberti Musici Chori Magistro. Summa diligentia compositae, correctae, & nunc primum in lucem editae.* ¶ LONDINI. *Excudebat Thomas Este 1598.*

Twelve of these compositions have sacred texts, the other twelve are wordless. These two-part motets, for Cantus and Bassus, were written for amateurs. Music for two voices was rare, other examples being Whythorne's *Duos*, 1590, and Morley's *Canzonets to Two Voyces*, 1595. Di Lasso was one of the greatest composers of the sixteenth century, and new works by him commanded attention. As the composer's name has sometimes been spelled Orlandus Lassus in Latin fashion, the use here of the Italian form, surrounded by Latin words, shows that it was the one known in England. The second collection was:

Musica Sacra to Sixe Voyces. Composed in the Italian tongue by Giovanni Croce. Newly Englished In London Printed by Thomas Este, the assigne of William Barley. 1608.

This included the Penitential Psalms (6, 32, 38, 51, 102 [two parts], and 143). They had been made into Italian sonnets by Francesco Bembo

17 "I must needs say, that Art it selfe was never in any man so renoumed, as in you alone the love thereof is beeloved. And worthily. For it is not with you, as with manye others which for forme, affect it much: yet they but affect it, whereas your affects [i.e., feelings toward music] are best commended by the effects, your substantiall love by your Reall allowance, and your Royall minde by your supersubstantiall mayntenance thereof." From Morley's dedicatory address to Sir Gervis Clifton.

and were then translated with only moderate success into English sonnets for this edition. This collection was no doubt intended to appeal to the English love of psalm-singing. The third collection,

Prime musiche nuove a 1, 2 et 3 voci per cantare con la Thiorba, et altri strumenti,

by ANGELO NOTARI, came out in 1613. Notari was one of Prince Henry's musicians,[18] and it is naturally more convenient for a composer to publish in the country where he is employed.

SOME ENGLISH OPINIONS OF ITALIAN COMPOSERS

The Elizabethan writers on music mentioned numerous continental composers of madrigals. Of these they esteemed Marenzio and the elder Ferrabosco most. Morley[19] named them together, recommending the former for his deep skill, the latter for his tunefulness and originality.

LUCA MARENZIO (1560–1599) is prominently represented in *Musica Transalpina;* and Dowland in his *First Booke of Songs* printed a letter from him as a first-rate guarantee of his own musical ability. Marenzio was ranked first by both Watson and Peacham. Watson's *first sett of Italian Madrigalls Englished* is made up chiefly of Marenzio's compositions, and contains the extravagant Latin tribute[20] to him which has been previously quoted. Henry Peacham wrote:[21]

For delicious Aire and sweet Invention in Madrigals, *Luca Marenzio* excelleth all other whosoever, having published more Sets than any Author else whosoever; and to say truth, hath not an ill Song, though sometime an over-sight (which might be the Printers fault) of two *eights,* or *fiftes* escapt him; as betweene the Tenor and Base in the last close, of *I must depart*

[18] Davey, *History of English Music.*
[19] See p. 206, *supra.*
[20] P. 211, *supra.*
[21] *The Compleat Gentleman,* Chapter XI.

all haplesse: ending according to the Nature of the Ditty most artificially, with a Minim rest. His first, second, and third parts of *Thyrsis, Veggo dolce mio ben chi fa hoggi mio Sole Contava,* or *sweet singing Amaryllis,* are Songs, the Muses themselves might not have beene ashamed to have composed. Of stature and complexion, he was a little and blacke man; he was Organist in the Popes Chappell at Rome a good while, afterward hee went into Poland, being in displeasure with the Pope. . . . Returning, he found the affection of the Pope so estranged from him, that hereupon hee tooke a conceipt and dyed.

ALFONSO FERRABOSCO the Elder has been mentioned several times. His fame in England was aided by his presence for several years at Queen Elizabeth's court. Robert Dowland called him "the most Artificiall and famous Alfonso Ferrabosco of Bologna." Morley once criticizes him unfavorably, for using three consecutive fifths in a madrigal, but he excuses him, because he says Ferrabosco did it out of "Jollitie."[22] He praises him and Byrd warmly for the admirable and ingenious canons that they wrote in "a vertuous contention in love" on the plainsong *Miserere,* and Butler also refers to these as "two Famous Musicians." Morley includes several madrigals by Ferrabosco in his Italian set of 1598, and *Musica Transalpina* contains more compositions by him than by any other composer. Peacham writes of him:

Alphonso Ferabosco the father, while he lived, for judgment and depth of skill,[23] (as also his sonne yet living) was inferior unto none; what he did was most elaborate and profound, and pleasing enough in Aire, though Master Thomas Morley censureth him otherwise. That of his, *I saw my Lady weeping,* and the Nightingale[24] (upon which Ditty Master *Bird* and

[22] *A Plaine and Easie Introduction,* pp. 75, 151, and (the canons) 115.

[23] Peacham, *op. cit.* He occasionally borrows a phrase, as here, from Morley's *Plaine and Easie Introduction.*

[24] G. E. P. Arkwright suggests that the "Miserere," as Morley says, was the theme that Byrd and Ferrabosco used in *Medulla Musicke,* not the "Nightingale," and that Peacham's mistake arose from the fact that both composers had written madrigals to the words "The nightingale so pleasant and gay."

he in a friendly æmulation, exercised their invention) cannot be bettered for sweetnesse of Ayre, or depth of judgement.

Like Richard Wagner, Ferrabosco was sometimes afflicted with an inability to relate "an exact narrative of facts," but his artistic success was not hindered thereby. He broke his promise to remain in the employ of Elizabeth, and died in Turin.

Fewer English comments have come down to us concerning the continental composers of sacred music. Palestrina, the greatest of them all, is not mentioned by Peacham, and Morley lists him with various others, without comment. It must not be forgotten, however, that Englishmen had had very little opportunity to hear the sacred works of the great Catholic composers since the death of Queen Mary. Their opinions, consequently, must have been based partly on occasional performances they had heard on the continent, and partly on hearsay. Peacham is our chief source. He considers William Byrd the greatest of all the composers of sacred music,[25] placing Victoria second and di Lasso third; and his comments on these and other composers are worth quoting:

For Motets and Musicke of piety and devotion . . . I preferre above all other our Phœnix, M. *William Byrd.* . . . For composition, I preferre next *Ludovico de Victoria,* a most judicious and sweete Composer: after him *Orlando di Lasso,* a very rare and excellent Author, who lived some forty yeares since in the Court of the Duke of Bavier. He hath published as well in Latine as French many Sets, his veine is grave and sweet: among his Latine Songs, his seven pœnitentiall Psalmes are the best, and that French Set of his wherein is *Susanna un jour:* upon which Ditty many others have since exercised their invention.

I bring you now mine owne Master, *Horatio Vecchi* of Modena: beside goodnesse of Aire most pleasing of all other for his conceipt and variety, wherewith all his workes are singularly beautified, as well his Madrigals of five and sixe, as those his Canzonets, printed at Norimberge: wherein for

[25] See p. 83, *supra.*

tryall, sing his *Vivo in fuoco amoroso Lucretia mia*, where upon *Io catenato moro*, with excellent judgement, hee driveth a Crotchet thorow many Minims,[26] causing it to resemble a chaine with the Linkes . . .

Giovanni Croce. Then that great Master, and Master not long since of S. Markes Chappell in Venice; second to none, for a full, lofty and sprightly veine, following none save his owne humour: who while he lived was one of the most free and brave companions of the world. His Pœnitentiall Psalmes are excellently composed, and for piety are his best.

Nor must I here forget our rare Countrey-man, *Peter Philips,* Organist to their Altezza's at Bruxels, now one of the greatest Masters of Musicke in Europe. Hee hath sent us over many excellent Songs, as well *Motets* as *Madrigals:* he affecteth altogether the Italian veine.

There are many other Authors very excellent, as *Boschetto,* and *Claudio de Monte Verde,* equall to any before named; *Guionnani Farreti,*[27] *Stephano Felis, Giulio Rinaldi, Phillipo de Monte, Andrea Gabrieli, Cyprian de Rore, Pallaviceno, Geminiano,* with others yet living; whose severall workes for me here to examine, would be over tedious and needlesse; and for me, please your owne eare and fancy. Those whom I have before mentioned, have been ever (within these thirty or forty yeares) held for the best.

I willingly, to avoyde tediousnesse, forbeare to speake of the worth and excellency of the rest of our English Composers, Master Doctor *Douland, Thomas Morley,* M. *Alphonso,*[28] M. *Wilby,* M. *Kirby,* M. *Wilkes, Michael East,* M. *Bateson,* M. *Deering,* with sundry others, inferiour to none in the world (how much soever the Italian attributes to himselfe) for depth of skill and richnesse of conceipt.

ENGLISH INSTRUMENTALISTS FAMOUS ON THE CONTINENT

English instrumentalists were in favor abroad. John Bull was appointed organist of Antwerp Cathedral in 1617 and probably held the

26 One voice sings in quarter notes while another sings in half notes.
27 Giovanni Ferretti is meant.
28 Alfonso Ferrabosco the Elder was often referred to as "Master Alfonso."

post until his death in 1628. Thomas Robinson, who published instruction books for lute and cithern, gave lessons to Queen Anne, wife of James I, when she was in Denmark. Christian IV of Denmark made Dowland royal lutenist, and when Dowland's financial ineptitude led to his dismissal, the King asked his own sister, Queen Anne of England, to send another lutenist to fill his place. She prevailed upon Lady Arabella Stuart to send hers, Thomas Cutting, to the King, in 1607. Again Denmark seems to have proved uncongenial, for Cutting was back in four years to enter the service of Prince Henry. The King of Denmark's selection of Englishmen, rather than of Germans or Italians, is noteworthy. Two other Englishmen in Christian's employ were William Brade (c. 1560–1630) and Thomas Simpson, violists, each of whom published several volumes of compositions in Germany. Brade also held important posts as Kapellmeister at Hamburg, Halle, and Berlin. The first time that Dowland was in Rome he met a Welshman named Thomas or Richard Morris. Cardinal Allen wrote of Morris's skill as a musician at the English Catholic College at Rheims: "Ille hic facile huius ecclesiae et loci omnes musicos . . . longe superat"—he easily excels by far all the musicians of this church and place (Rheims). Another Catholic, Richard De(e)ring (d. 1630) received the degree of Bachelor of Music from Oxford University in 1610, later spent some years in Brussels from 1617 as organist of the English Convent, and then returned to England as organist to Queen Henrietta Maria. Oliver Cromwell enjoyed his Latin motets.[29] A more important figure at Brussels was Peter Philips,[30] organist of the royal chapel there and one of the best composers of his period. He studied music in the choir of St. Paul's Cathedral under Sebastian Westcote from 1572 to 1578,[31] and

[29] For a list of Dering's printed compositions see the Bibliography.

[30] For Philips' picture, career, compositions, and several references to the fame he enjoyed during his lifetime, see W. Barclay Squire's article in *Grove,* iv. 141–144.

[31] Grattan Flood, "New Light on Late Tudor Composers," in the *Musical Times* for April 1929, pp. 312, 313.

was living in Westcote's house in 1582 when Westcote made a will bequeathing him £5.13s.4d. Morley, who may have been a fellow choirboy at St. Paul's, included two of Philips' vocal compositions in his so-called "Italian" *Madrigals to four voices*, 1598, and a pavan and galliard by him in *Consort Lessons*, 1599. The list of Philips' compositions published during his lifetime is a long one. Henry Peacham called him one of the greatest masters of music in Europe. The following verses published at Mons in 1637 concern him:

> Anglus ubique audit, verum magis Angelus ille est
> Sonegiae[82] Clero, Sonegiaeque choro.
> Qui velut eximios semper colit arte canorā
> Sic melodis auctum vocibus ille Petrum.
> Edidit hic sacris Paradisum[83] cantibus aptum,
> Et modo sacratis servit ubique locis.

Numerous English musicians played in Germany, and considerable English music was printed there, e.g., works by Morley. The Frenchman Besard wrote in *Thesaurus Harmonicus* (an instruction book for lute, Cologne, 1603):

> Sunt illi Anglicani concentus suavissimi quidem, ac elegantes.[84]

Another Frenchman, Mersenne, who is ordinarily partial to the music of his own country, quotes an English composition to illustrate music for viols in *L'Harmonie Universelle*, 1636.[35] Good English viol players were in demand on the continent throughout the seventeenth century.

[82] Soignies, Belgium, where Philips was a canon for several years.

[83] Philips composed three books of vocal compositions with organ accompaniments under the title *Paradisus sacris cantionibus consitus* . . .

[84] I.e., English harmonies are certainly most charming, and tasteful, too. Davey, *History of English Music*, 1895, p. 185.

[35] Gerald R. Hayes, *The Treatment of Instrumental Music*, 1930, p. 94.

SOME CONTINENTAL OPINIONS OF MUSIC
IN ENGLAND

Travelers also visited England from the continent. Several of them noted down their impressions of English music, which have been printed in a scholarly book by William Brenchley Rye.[36] Perlin (*Description d'Angleterre*, 1558) remarks that "the English are great lovers of music, for there is no church, however small, but has musical service performed in it." Paul Hentzner of Brandenburg observes in 1598:

The English excel in dancing and music, for they are active and lively, though of a thicker make than the French. . . . They are vastly fond of great noises that fill the air, such as the firing of cannon, drums, and the ringing of bells, so that in London it is common for a number of them when drunk to go up into some belfry and ring the bells for hours together.

It is more likely that these Londoners were entirely sober and were practising change-ringing, a peculiarly English diversion that has struck other foreigners besides Hentzner as not entirely rational. Hentzner also mentions the "excellent music in Queen Elizabeth's Royal Palace at Greenwich."

In 1592 Frederick, Duke of Württemberg, visited England. He was much taken with the idea of the Order of the Garter, and badgered Queen Elizabeth unmercifully to give it to him until she finally had to promise it, saying, however, that he must wait his turn. For thus importuning her, and for his German ways, he is ridiculed by Shakespeare as "Cozen Garmombles" and "Duke de Jamanie" in *Merry*

[36] *England as Seen by Foreigners in the Days of Elizabeth and James the First. Comprising translations of the journals of the two Dukes of Wirtemberg in 1592 and 1610; both illustrative of Shakespeare. With extracts from the travels of foreign princes and others, copious notes, an introduction and etchings. By William Brenchley Rye, Assistant-Keeper of the Department of Printed Books, British Museum. London: John Russell Smith, Soho Square, 1865.* The comments by Perlin, Hentzner, Rathgeb, and Cellius, are taken from this book. The title of Erhard Cellius' book is *Eques Auratus Anglo-Wirtembergicus.* It was published at Tübingen in 1605.

Wives of Windsor (c. 1600). It is probable that Elizabeth must have been bored by him or she would not have allowed such a thinly veiled criticism of a foreign prince to go unrebuked. A detailed account of Duke Frederick's visit to England in 1592 was written by his private secretary, Jacob Rathgeb.[37] At Reading the Earl of Essex welcomed Duke Frederick in the Queen's name, and after a banquet entertained him "with such sweet and enchanting music [which in all probability was furnished by the Queen's musicians] that he was highly astonished at it." Rathgeb's account of Windsor (where the Queen was staying) is interesting:

This castle stands upon a knoll or hill; in the outer or first court there is a very beautiful and immensely large church, with a flat, even roof, covered with lead, as is common with all churches in this kingdom. In this church his Highness [Frederick] listened for more than an hour to the beautiful music, the usual ceremonies, and the English sermon. The music, especially the organ, was exquisitely played,[38] for at times you could hear the sound of cornetts, flutes, then fifes and other instruments; and there was likewise a little boy who sang so sweetly amongst it all, and threw such a charm over the music with his little tongue, that it was really wonderful to listen to him. In short, their ceremonies were very similar to those of the Papists, as above mentioned, with singing and all the rest. After the music, which lasted a long time, had ended, a minister or preacher ascended the pulpit and preached in English; and soon afterwards, it being noon, his Highness went to dinner.

The Duke finally obtained his wish, and was made Knight of the Garter in 1603 by order of King James, who thus loyally fulfilled Elizabeth's promise. The investiture[39] took place at Stuttgart. With Lord

[37] Jacob Rathgeb, *Kurtze und warhaffte Beschreibung der Badenfahrt: welche Friderich, Hertzog zu Württemberg vnnd Teckh . . . in . . . 1592 . . . in . . . Engellandt . . . verrichtet hat.* Tübingen. 1602.

[38] John Mundy and Nathaniel Giles were the organists of the Chapel Royal at Windsor in 1592.

[39] The following account is by Erhard Horn, born at Celle and hence also known as Erhardus Cellius.

Spencer, who was to help conduct the ceremony, were "four excellent musicians, with ten other attendants." They must have given great pleasure during the court banquet at Stuttgart, for they are described as

The royal English music which the illustrious royal Ambassador had brought with him to enhance the magnificence of the embassy and the present ceremony; and who, though few in number, were eminently well skilled in the art. For England produces many excellent musicians, comedians, and tragedians, most skilful in the histrionic art; certain companies of whom quitting their own abodes for a time, are in the habit of visiting foreign countries at particular seasons, exhibiting and representing their art principally at the courts of princes. A few years ago, some English musicians coming over to our Germany with this view, remained for some time at the courts of great princes, their skill both in music and in the histrionic art having procured them such favor that they returned home liberally rewarded, and loaded with gold and silver.

IX

Musical Theory

A SURVEY of the English musical literature of the sixteenth and early seventeenth centuries might have suggested many new fields of effort to an Elizabethan musician with a twentieth-century outlook. He could have been the first to edit a musical magazine, to compile a musical dictionary, to write a history of music. But no such works appeared. There were no instruction books in English for the virginals or viols or wind instruments. The singers of the day wrote no works on how to sing, the virtuosos no reminiscences. Hymn tunes existed, but not hymns in the modern sense;[1] the early English Protestants sang psalms, feeling it unseemly to praise the Lord with man-made verses when the divinely inspired words of David met their religious needs. They gave no concerts, except in private houses for their personal friends. The first opera was given in Italy in 1595, yet this form aroused little interest in England for about a century.

But pioneer work was being done. John Bull, the Paderewski of his day, was perhaps the first to play an organ recital, and to give a public lecture on music. The first book printed in England on musical theory was written by William Bathe, an Oxford man; it appeared in 1584. Then in 1586 appeared an important work in praise of music by another Oxford man, John Case, and after him other writers turned their attention to music. These books about music may be classified under three headings, viz. theory, canons, and acoustics, and are discussed in that order below. In addition to these, works written as apologias for church music,[2] or as books of instruction in lute playing,[3] have been dealt with in previous chapters.

[1] An exception must be mentioned to prove the rule: the *Te Deum*. This hymn had been penned so many centuries ago that most people thought of it as Holy Writ.

[2] *The Praise of Musicke* and *Apologia Musices,* by John Case; see pp. 29 ff.

[3] See pp. 154 ff.

THEORY

The first group of books, on theory, deal with one or more of the following subjects: the rudiments of music and definitions of common musical terms, sight-singing, counterpoint, and composition. These treatises are first summarized very briefly so as to give the reader a general view of the material, then later they are discussed at greater length. Those by Morley, Ornithoparcus, and Butler are general works on the subject.

1597 THOMAS MORLEY: *A Plaine and Easie Introduction to Practicall Musicke.* This, the longest and most interesting work of the group, deals with all the branches of musical theory just mentioned. Part 1 aims to teach a learner how to sing at sight, and explains the scale, sol-fa syllables, and modes.[4] Part 2, *Descant,* gives rules for writing (or singing extemporaneously) two-part counterpoint in various "species," explaining what intervals may be used. Part 3, *"Composition of three, foure, five or more parts,"* gives instruction in the writing of canons (with examples in music notation) and madrigals, explains how to express sorrow and joy in compositions, gives the compass of the voices, and mentions pitfalls to be avoided. An Appendix consists of miscellaneous notes on ancient Greek music, ligatures,[5] the five medieval kinds of "pricks" (dots), proportions,[6] authentic and plagal modes, etc. This was the most important English book on music before the publication of the musical histories of Hawkins and Burney in 1776, but because it is written in the form of a dialogue it is to some extent verbose and lacks conciseness and clearness of arrangement. Morley said it could be used without a teacher. Advanced students probably found it stimulat-

[4] Modes were the medieval scales and keys, two of which have survived to the present day under the names of major scale and major key and minor scale and minor key.
[5] A ligature was a group of two or more notes which were intended to be sung to a single syllable and were written close together or connected in an abbreviated notation.
[6] Proportions were mathematical ratios, with Latin names, to indicate either the relative pitch of two notes (e.g., C and the nearest G above it were in the proportion or pitch ratio of 2 to 3, called "sesquialtera") or the relative speed of two tempos.

ing and valuable, but some pupils may have preferred to study the following books with a teacher:

1609 JOHN DOWLAND'S English translation of Ornithoparcus' *Micrologus,* first printed in Latin, 1517. In spite of its early date, this is a clearly expressed, practical book, well written and well translated. We should call it a textbook on musical theory, since it defines such matters as scales, note-lengths, modes, tempos, accent, concords, and discords; but it also contains rules for writing counterpoint and a few observations on composition. Students could use it as a textbook and other musicians as a convenient work of reference, since every topic is treated in a separate paragraph.

1636 CHARLS BUTLER: *The Principles of Musik.* This textbook covers the same ground in musical theory as does the *Micrologus,* and in addition explains fugue and canon, describes the musical instruments then in use, and gives hints on writing for voices and (to combat the Puritans) opinions of the early church fathers on the character and necessity of church music. The work is systematically arranged but is too compressed and dull. It is also unreliable and out of date, since Butler quotes rules and definitions from the preceding century that no longer applied to the music of his day, and makes a number of curious errors that he could have avoided if he had consulted the *Micrologus.*

The ability to sing at sight was one of the desirable accomplishments of *The Compleat Gentleman,* and all of the works on theory, except the two by Ravenscroft and Flud, include instruction in the art of sight-singing. Indeed, those by Bathe are chiefly concerned with it. He and Butler treat the subject more logically and clearly than Morley.

1584 WILLIAM BATHE: *A Briefe Introduction to the True Art of Musicke.* This was the first printed work in English on musical theory.

1596 WILLIAM BARLEY printed *The Pathway to Musicke,* an anonymous work. It is, according to Davey, "an ordinary elementary work of no value, in catechism form."

1600 WILLIAM BATHE: *A Briefe Introduction to the Skill of Song.*

This short work of twenty-five pages on sight-singing includes information about the scale, note-lengths, tempos, and the use of the sol-fa syllables.

The three remaining works deal with special topics:

1613 THOMAS CAMPION: *A New Way of Making Fowre Parts in Counter-point*. This textbook is concerned not primarily with counterpoint[7] but with harmony, and is the only satisfactory Elizabethan work in that field. Campion, after explaining in the preface an improved method of using the sol-fa syllables, tells the student how to write (1) correct four-part harmony automatically, provided the bass part is already known, (2) cadences in various keys, and (3) note-to-note counterpoint in two parts.

1614 THOMAS RAVENSCROFT: *A Briefe Discourse*. This pedantic and unnecessary book was written in a vain attempt to induce composers to use the correct but obsolescent medieval time signatures. Several compositions are printed in the book as examples.

1617–19 ROBERT FLUD: *Utriusque cosmi, majoris scilicet et minoris, metaphysica, physica, atque technica historia*. A pseudo-philosophical work of little value, with some practical descriptions of musical instruments.[8]

We may commence a more detailed examination of the above works by considering the most important of them, by the well-known composer of madrigals, THOMAS MORLEY. According to its lengthy title it is:

[7] By way of definition it may be explained that in *counterpoint* two or more tunes which differ from each other in rhythm and are of approximately equal interest and beauty, are so written as to sound well together when played or sung at the same time. In harmony, on the other hand, there is only one tune (which is nearly always in the soprano part) and the other voices or instruments sing or play merely a subsidiary accompaniment to that tune. In other words, in counterpoint there are always two or more tunes sounding at the same time, in harmony there is only one tune.

[8] See a fanciful picture by Flud at p. 242 in John Hollander's *The Uptuning of the Sky*, 1961, on Elizabethan occult poetry (such topics as the Harmonies of the Spheres).

A Plaine and Easie Introduction to Practicall Musicke set downe in forme of a dialogue: Divided into three parts. The first teacheth to sing, with all things necessary to the knowledge of pricktsong. The second treateth of descante, and to sing two parts in one upon a plainsong or ground, with other things necessarie for a discanter. The third and last part entreateth of composition of three, foure, five, or more parts, with many profitable rules to that effect. With new songs of 2. 3. 4. and 5. parts. By Thomas Morley, Batcheler of Musicke, and one of the gent.˙of her Majesties Royal Chappell. . . . *1597.*

Its popularity resulted in the appearance of later editions in 1608 and 1771, and a facsimile edition was published in 1937. Morley dedicates the work to his former teacher "The most excellent Musician Maister William Birde, to testifie unto your selfe in some sort the entire love and unfained affection which I beare unto you," and pays him the compliment of acknowledging that what is truly spoken once came from Byrd himself.

Of three poems in commendation of Morley, the first[9] is a commendable effort by Antony Holborne, composer and Gentleman Usher to Queen Elizabeth. The second, by "A. B.," is stilted and poor. A. B. must have been mortified to see his pun in the last line blush unseen because the printer failed to italicize it:

9
> To whom can ye, sweet Muses, more with right
> Impart your paines to prayse his worthy skill,
> Then unto him that taketh sole delight
> In your sweet art, therewith the world to fill?
> Then turne your tunes to *Morleyes* worthy prayse,
> And sing of him that sung of you so long:
> His name with laud and with dew honour rayse,
> That hath made you the matter of his song.
> Like Orpheus sitting on high Thracian hill,
> That beasts and mountaines to his ditties drew:
> So doth he draw with his sweet musickes skill
> Men to attention of his Science trew.
> Wherein it seemes that *Orpheus* hee exceedes;
> For, he wylde beests; this, men with pleasure feeds.

Buy, reade, regarde, marke with indifferent[10] eye.
More goode for Musicke else where doth not *lie.*

The third poem, by I. W., is graced with the same pun, but relates more poetically how carping Momus and Zoilus will shrink back into their darkness when the morning star illuminates the works of Morley with the clear light of fame and truth.

Morley's "Address to the Curteous Reader" contains much useful information: he tells us that though there are many other English musicians more learned than himself, and the precepts of music are much practised in his country of late, they are here set forth in the English language for the first time. He was tempted to give up, he says, for it took him weeks sometimes to find musical examples of certain points, and he discovered that most of his own rules were disregarded in the works of Taverner, Fayrfax, Robert Cooper, and many other earlier composers. He examined many writers, English and foreign, and found many hopeless differences of opinion. However, he has tried to work out a logical method, each rule leading up to the next. Consequently anyone who can sing the scale correctly can by this book, and without a teacher, learn to sing in madrigals and to compose. Morley would welcome corrections, but warns his readers that those who criticize without reason, or to damage his reputation ("malicious caterpillars, who live upon the paines of other men"), will find that he can bite back.

The body of the work consists of a conversation between a teacher, a pupil, and a musical friend. We soon guess that the teacher, or Master, is Morley himself, for when he gives the instance of consecutive fifths in Ferrabosco's madrigal he excuses the composer because he did it out of jollity, whereas "I in my first works of three parts" did the same out of "negligence." He is very sorry, and will not defend his own error. Morley as master also refers to his ill-health:

My health, since you saw me, hath beene so bad, as if it had beene the

[10] Impartial.

pleasure of him who may all things, to have taken me out of the world, I should have beene very well contented; and have wished it more than once,

and says he was induced to write the work because of the "solitarie life which I lead (being compelled to keepe at home)." Morley survived for only about six years, dying at the age of forty-six. The warmth of Morley's personality is felt steadily through the volume, until one thinks of him as a man one would have enjoyed knowing. The work is not so systematically arranged as, for example, the one by Butler, but the combination in Morley of superior insight, knowledge, and human kindness is irresistible.

The Master says to Philomathes, the pupil, "I have heard you so much speak against that art [of music] as to tearme it a corrupter of good manners, and an allurement to vices: for which many of your companions tearmed you a Stoick." But the pupil confesses his change of heart, and the lesson begins. He wishes to acquire the ability to sing at sight, and in order to impart the information necessary to that end Morley devotes Part One of the treatise to a description of the scale and an account of the sol-fa syllables,[11] the duration values of the various kinds of notes, and the usual time signatures. Morley says that of the medieval time signatures only four are still in common use. This is the only allusion in Part One to the changes we know music was undergoing in his time. In the following list of these four Morley should use the word "Time" instead of "Mode"; he admits that the latter word is incorrect, but in popular use:

(a) The Mode perfect of the More Prolation:

$$\odot : 3\; \text{♩} = \text{𝅝}; \; 3\; \text{𝅝} = \square; \; 3\; \square = \square; \; 3\; \square = \square$$

(b) The Mode perfect of the Less Prolation:

$$\bigcirc : 2\; \text{♩} = \text{𝅝}; \; 3\; \text{𝅝} = \square; \; 2\; \square = \square; \; 2\; \square = \square$$

[11] For an account of Morley's method of using the sol-fa syllables, see pp. 249, 252.

(c) The Mode imperfect of the More Prolation:

$$\mathsf{C} \ :3\ \flat = \circ;\ 2\ \circ = \square;\ 2\ \square = \square;\ 2\ \square = \square$$

(d) The Mode imperfect of the Less Prolation:

$$\mathsf{C} \ :2\ \flat = \circ;\ 2\ \circ = \square;\ 2\ \square = \square;\ 2\ \square = \square$$

He adds that the use of the last of these tempos is taken for granted if no sign is employed; and the **C** has remained the commonest time signature to the present day, the other three having become extinct. It was originally a broken circle, indicating the imperfect number 2. The circle symbolized perfection and the perfect number 3, associated with the Holy Trinity. The other sign familiar to both Morley and ourselves is the bisected semicircle ₵. In effect this doubled the speed, for he says that the double whole note, or in some compositions the whole note, occupies only one beat when otherwise it would occupy two. Today by an extension of this definition the sign commonly indicates that it is the half note which should occupy one beat instead of two, although the change in speed is no longer implied.

Part Two of Morley's work deals with Descant. The Master says that this means (1) the art of composition; (2) one of the voices or parts (only if there are more than three); and (3) singing a part extempore on a plainsong; such a singer is called a descanter. According to Morley it is uncertain whether descant (in the sense of playing or singing two notes simultaneously to form any interval but the octave) was known in ancient times, and that authorities have battled much over the question.[12] The Master then classifies concords as perfect (including unisons, fifths, and octaves) and imperfect (thirds and sixths); other intervals are discordant (seconds, fourths, and sevenths). To this the composer William Jackson of Exeter (1730–1803) objected strenuously, noting in a copy[13] of the second edition, "I could never imagine why

[12] It is now known that the ancient Greeks used the device, but sparingly.

[13] This copy, now in the British Museum, belonged to Thomas Linley (1756–1778), child prodigy, brother of Mrs. Richard Brinsley Sheridan, and dear friend of Mozart.

the 4th should be reckoned as a Dischord, as it makes one of the intervals of a Common Chord, which I suppose all the World will allow to be composed of Conchords." Butler calls the unison, octave, major third, and fifth, primary concords, and the minor third, fourth, and major and minor sixth, secondary concords; and quotes Sir Francis Bacon's observation that the unison, octave, and fifth are the most perfect concords, next the third, and the sixth (which is more harsh), and finally the fourth. Morley gives interesting examples of harmony or counterpoint in music type, some quite in the medieval manner. In accordance with the universal practice of his time he allows

which modern teachers would forbid on account of the octaves; also the well-established but curious *nota cambiata*.[14] He also gives admirable examples of correct and incorrect ways to do an exercise, and of two-part counterpoint in various species.[15] Part Two ends with excellent instruction in canon (with examples) and double counterpoint at the twelfth, tenth, and octave.

In Part One the scholar has learned to sing at sight, in Part Two he has received instruction in the writing of counterpoint. Having become acquainted with the tools of the trade he can now use them in *Part Three* in actual composition. We may assume that this last part, like the preceding sections, resembles an actual lesson by Morley, or rather, a series of lessons. He follows a natural scheme: taking up music first in two parts, then in three and four, he quotes in music type both students' faulty exercises (wherein he points out each mistake) and his

[14] See example of the Nota Cambiata in *Grove*, iii. 646, example (c), quoted from Fux, and *Contrapuntal Technique in the Sixteenth Century*, by R. O. Morris, p. 42.
[15] Several of these examples by Morley are quoted in *Grove*, i. 740.

own correct examples, offering the latter as models. Meantime he some-
times digresses to answer questions and add comments. Lastly he defines
and discusses the madrigal and other musical forms, and makes sug-
gestions that he thinks will be helpful to young composers.

We learn in Part Three that Polymathes has been taught by "one
maister Boulde" (an imaginary name), who allowed the use of discords
on accented beats, and permitted discords to be taken or quitted by leap.
The Master censures these licenses as inadmissible, and Morley indeed
allows no departures from what we would call standard sixteenth-cen-
tury counterpoint;[16] he says such were applauded when he was a child;[17]
but because of such crudities he finds no music written in the past as
enjoyable as that of the present day. Nevertheless, Morley next criticizes
certain lax practices of his own time, e.g., the use of octaves reached by
similar motion, even if one part is an inner one:
"Although almost all the composers . . . at all
times & almost in every song of their Madrigals
and Canzonets have some such quidditie." What
must Morley have thought of his own master,

Byrd? and of the delightful Farnaby? For both broke the less impor-
tant rules. Morley's attitude in this respect is pedantic. He is on firmer
pedagogical ground when he criticizes Giovanni Croce for once using
five consecutive fifths in succession, and often using two: and he adds
confidently,

Yet shall you hardly find either consecutive fifths or octaves in master Al-
fonso [Ferrabosco] (except in that place which I cited to you before), Or-
lando [di Lasso], Striggio, Clemens non Papa, or any before them, nor shall
you readily find it in the workes of anie of those famous English men, who

16 See Reginald O. Morris, *Contrapuntal Technique in the Sixteenth Century.*

17 This no doubt is true. Daring and harsh dissonances were written by some of the
English composers in the early part of the sixteenth century; and judging from the un-
couth examples quoted by Morley in music type from the works of Henry Rysbie (*temp.*
Henry VIII?) and Richard Pygott (*fl.* 1517–1552) we may agree with Morley's slighting
remark that "The authors were skilfull men for the time wherein they lived."

have beene nothing inferiour in Art to any of the afore named, as Farefax, Taverner, Shepherde, Mundy, White, Persons, M. Birde, and divers others.

Out of the numerous musical examples in the book it may be interesting to quote two, one of which is to be avoided, the other imitated. The Master complains that this part of a student's exercise has been "robd out of the capcase of some olde Organist." He also criticizes the two
dissonances marked, but not the cross-relation E♭–E♮, which today sounds crude. The second quotation we may make is a remarkable example of some Dominant 7ths (as we would call them) allowed by Morley under sixteenth-century rules because the dissonant notes are "prepared," i.e., tied over. Philomathes and Polymathes both object to the "discords
so taken" and the mixed sharps and flats, but the Master commends the example, as out of the common, and says the "bindings" (ties) are used in many works by excellent musicians.

Morley gives a valuable table that shows the compass of each vocal part in a madrigal. If the madrigal is lively, all the parts should be pitched high ("in the high key," he calls it), within the following limits:

Kind of voice	Compass	Clef advisable
Canto [i.e., Soprano]	D up to G.	Treble clef (G on 2d line)
Alto	G up to C.	Mezzo-soprano clef (C on 2d line)
Tenor	F up to A.	Alto clef (C on 3d line)
Basso	A up to C.	Baritone clef (F on 3d line)[18]

If it is grave and staid, the parts should be pitched low ("in the low key"), for high-pitched voices would ruin the effect:

[18] If the madrigal were in five parts, the fifth, called "Quinto," could be either an extra Canto part or an extra Tenor, according to Morley.

The High Meane	C up to E. Soprano clef (C on 1st line)
The Low Meane	A up to C. Mezzo-Soprano clef
Alto	F up to A. Alto clef
Tenor	D up to F. Tenor clef (C on 4th line)
Basso	G up to B♭. Bass clef (F on 4th line)

When men alone are singing, the limits are:

Alto	F up to G. Alto clef
Tenor Primus	D up to F. Tenor clef
Tenor Secundus	B♭ up to D. Baritone clef
Bassus	G up to B♭. Bass clef.

At the most, these limits can be exceeded by one note only, unless "upon an extremitie for the ditties sake, or in notes taken for Diapasons[19] in the bass." The above tables show that Elizabethan madrigals were sung at approximately the same pitch that is in use today, for their sopranos and tenors sang up to G, occasionally A, and their bass parts descended to G, occasionally F. On the other hand, the terms "alto," "quinto," and "mean" were vague, being applied sometimes to men and sometimes to women. Therefore a host in planning an evening party of madrigal singing had to look at the vocal range of each part to decide which guests to invite; if the part marked "alto" ranged from G up to C, a woman would sing it, but if the alto went from F merely up to G, a man.

Elizabethan composers, though usually progressive in their music, sometimes held reactionary theories. So Morley prints as a horrible example the modern signature of B♭ (in the form he knew): objecting to "the verie sight of these flat cliffes (which stand at the beginning of the verse or line like a paire of staires, with great offense to the eie, but more to the amasing of the yong singer)" because they make his sol-fa syllables fall upon unaccustomed notes. "Strangers

[19] Octaves. We would say: "Notes reached by octave skips in the bass."

[foreigners] never pester their verse with those flats: but if the song bee naturally flat" they put one in the signature and add any others as accidentals. The Master recommends, however, that the most sensible procedure is to avoid such a wholly unnecessary perplexity as two flats by eliminating them entirely and transposing all such music up a tone into the key of C!

The most important section of the work is that entitled *Rules to be observed in dittying.* It aims to instruct the student in the composition of madrigals and sacred music that will express adequately the meaning of the words. Examples are not numerous of a competent artist describing his method of procedure, and indeed when he has done so he is not always to be believed, as when Poe tells us how he composed *The Raven,* and Tchaikovsky his *Fourth Symphony.* All that Byrd could say about the process was that "the right notes, in some inexplicable manner, suggest themselves quite spontaneously." That information is not of much help. Morley was more such a man as Sir Charles Stanford[20]—not a transcendent composer, but a man of much personal charm and unusual musical and intellectual ability and taste, both willing and able to pass on his knowledge of the processes of composition to others. Morley's treatment of the subject of vocal composition is given here almost in full, since it is the only noteworthy contribution to the subject printed in English for over a hundred years:

Rules to be observed in dittying.[21]

You must then when you would express any word signifying hardnesse, cruelty, bitternesse, and other such like, make the harmonie like unto it, that is, somewhat harsh and hard, but yet so that it offend not. Likewise,

[20] Sir Charles Villiers Stanford's *Musical Composition,* 1911, is perhaps the best book in English on that difficult subject.

[21] It is redundant to supply this summary of the very text given above, yet it may serve some use in case Morley's sixteenth-century terminology proves confusing or boring:

Use semitones to express languishing love; use whole tones, major 3ds and major 6ths for hardness and cruelty. Minor 3ds and minor 6ths are sweet. Diatonic harmony is

when any of your words shall express complaint, dolor, repentance, sighs, teares, and such like, let your harmonie be sad and dolefull: so that if you would have your music signifie hardness, cruelty, or other such affects, you must cause the parts proceed in their motions without the halfe note,[22] that is, you must cause them proceede by whole notes, sharpe thirds,[23] sharpe sixes and such like (when I speake of sharpe or flat thirds, and sixes, you must understand that they ought to be so to the base),[24] you may also use Cadences bound with the fourth or seventh, which being in long notes, will exasperate the harmony: but when you would express a lamentable passion, then must you use motions proceeding by halfe notes, flat thirds and flat sixes, which of their nature are sweete, specially being taken in the true tune and naturall aire, with discretion and judgement: but those cords so taken as I have saide before, are not the sole and onely cause of expressing those passions; but also the motions which the parts make in singing doe greatly helpe, which motions are either naturall [diatonic] or accidentall [chromatic]. The natural motions are those which are naturally made betwixt the keyes, without the mixture of any accidental signe or cord [interval], bee it either flat or sharpe: and these motions be more masculine, causing in the song more virility than those accidentall cords which are marked with these signs 𝕏. b. [♯, ♭] which be indeede accidentall, and make the song as it were more effeminate & languishing than the other motions, which make the song rude and sounding: so that those naturall motions may serve to expresse those effects of cruelty, tyrannie, bitternesse, and such others: & those accidentall motions may fitly expresse the passions of griefe, weeping, sighes, sorrows, sobs, and such like.

virile, chromatic harmony effeminate or sad. If the subject is light, use short notes, if lamentable, long ones. [Differences of pace, such as *Allegro* and *Andante* are not indicated in Elizabethan music.] When the subject matter signifies ascending or high heaven, make the music ascend the scale; if descending, depth, or hell, descend. The words should be audible, so that the listeners can understand the meaning. Give a short note to a short syllable like the *a* in gloria; do not draw it out as the composers of church music have done.

[22] Halfe note: semitone.

[23] Major thirds.

[24] This perplexing parenthesis surely implies that a major triad (CEG) sounds strong if its root (C) is in the bass but weak and languishing if its third (E) is in the bass. No wonder that Jackson comments, "A different practice is now most prevalent."

[235]

Also, if the subject be light, you must cause your musick go in motions, which carry with them a celeritie or quicknes of time, as minimes, crotchets & quavers[;] if it be lamentable, the note must goe in slow and heavy motions, as semibreves, breves and such like, and of all this you shal find examples every where in the workes of the good musicians. Moreover, you must have a care that when your matter signifieth ascending, high heaven, & such like, you make your musick ascend: & by the contrarie where your dittie speaketh of descending lowenes, depth, hell, & others such, you must make your musicke descend. For as it will bee thought a great absurditie to talke of heaven & point downward to the earth: so will it be counted great incongruitie if a musician upon the words he ascended into heaven should cause his musick descend, or by the contrarie upon the descension should cause his musick to ascend. We must also have a care to applie the notes to the words, as in singing there be no barbarisme committed: that is, that we cause no syllable which is by nature short, be expressed by manie notes or one long note, nor no long syllable bee expressed with a short note: but in this fault do the practicioners erre more grossely, than in any other, for you shal find few songs wherein the penult syllables of these words, *Dominus, Angelus, filius, miraculum, gloria,* & such like are not expressed with a long note, yea manie times with a whole dossen of notes, & though one should speak of fortie he shuld not say much amisse: which is a grosse barbarisme, & yet might be easily amended. We must also take heed of separating any part of a word from another by a rest, as som dunces have not slackt to do: yea one whose name is Johannes Dunstaple[25] (an ancient English author) hath not only divided the sentence, but in the verie middle of a word hath made two long rests thus, in a song of foure parts upon these words, Nesciens virgo mater virum.

Ipsum regem angelo ▬ rum ▬ so ▬ la vir ▬ go lactabat[26]

For these be his own notes and words, which is one of the greatest absurdities which I have seene committed in the dittying of musick.

[25] This attack on Dunstable (c. 1380–1453) is rather surprising, for he was the outstanding composer of his time. The use of rests inside a word was called "hocket."

[26] Morley quotes the notes in music type on p. 178.

Morley now considers the subject of rests, and praises Stephano Venturi because when setting the word "sospiri" (sighs) he added a quarter rest, just sufficient time for a sigh; a half rest would have been too long.

Lastly, you must not make a close (especially a full close) til the full sense of the words be perfect: so that keeping these rules you shall have a perfect agreement, & as it were an harmonical consent betwixt the matter and the musick . . .

After this general treatment of the subject of vocal music Morley takes up in succession its two main divisions, sacred and secular.

The most artistic and expressive form of sacred music is, according to Morley, the *Motet*. We may define it today as an anthem written without instrumental accompaniment. Morley had been organist of St. Paul's, and from his account of the manner in which motets were sung in church we learn just what he thought of the average choir singer. Of the motet he writes:

This kind of al others which are made on a ditty, requireth most art, & moveth & causeth most strange effects in the hearer, being aptly framed for the dittie & well expressed by the singer: for it will draw the auditor (& specially the skilful auditor) into a devout and reverent kind of consideration of him for whose prayse it was made. But I see not what passions or motions it can stir up being sung as most men doe commonlie sing it: that is, leaving out the ditty, & singing onely the bare note. . . . To return to the expressing of the ditty, the matter is now come to that state that though a song be never so well made & never so aptly applyed to the words, yet shall you hardly find singers to expresse it as it ought to be: for most of our Church men, (so they can crie louder in the quier than their fellowes) care for no more: whereas by the contrarie, they ought to study how to vowel & sing clean, expressing their words with devotion & passion, wherby to draw the hearer as it were by chains of gold by the eares to the consideration of holy things. But this, for the most part, you shall find amongst them, that let them continue never so long in the church, yea though it were twentie yeares, they will never studie to sing better than they did the first day of

their preferment. . . . But to returne to our Motets, if you compose in this kind, you must cause your harmonie to carrie a majesty, taking discords & bindings[27] so often as you can: but let it be in long notes, for the nature of it wil not beare short notes & quicke motions, which denotate a kind of wantonnesse. This musick (a lamentable case) being the chiefest both for art and utilitie, is notwithstanding little esteemed, & in smal request with the greatest number of those who most highly seeme to favor art. . . . Nor is that fault of esteeming so highly the light musicke particular to us in England, but general through the world: which is the cause that the musicians in al countreyes & chiefly in Italy, have imployed most of their studies in it.

This lament over the popularity of light music may have proceeded rather from Morley's head than from his heart, for today he is associated as a composer more closely with this type than any other Elizabethan, and he shows no antipathy to secular music when he discusses it in detail. In doing so he names as its finest exemplar the *Madrigal*. He regrets that more than one composer of madrigals has used shameful words; but

As for the musick it is, next to the Motet, the most artificial, & to men of understanding most delightfull. If therefore you will compose in this kind, you must possess yourself with an amorous humor (for in no composition shall you prove admirable except you put on, & possesse yourself wholy with that vain wherein you compose) so that you must in your musick be wavering like the wind, somtime wanton, somtime drooping, somtime grave & staide, otherwhile effeminat, you may maintain points and revert them, use triplaes & shew the verie uttermost of your varietie, & the more varietie you shew the better shall you please. In this kind our age excelleth, so that if you wold imitate any, I wold appoint you these for guides: *Alfonso Ferrabosco* [the Elder] for deep skil, *Luca Marenzo* for good ayre & fine invention, *Horatio Vecchi, Stephano Venturi, Ruggiero Giovanelli,* and *John Croce,* with divers others who are verie good, but not so generally good as these. The second degree of gravitie in this light musicke is given to *Canzonets,*

27 Suspensions, tied notes.

that is little shorte songs (wherein little art can be shewed being made in strains, the beginning of which is som point lightly touched, & every strain repeated except the middle) which is in composition of the musick a counterfet of the madrigal. Of the nature of these are the *Neapolitans* or *Canzone a la Napolitana,* differing from them in nothing saving in name.

For examples of the latter he refers the reader to the works of Marenzio and Ferretti. Morley concludes this section with definitions of *villanelle,*[28] *ballete, fa las, vinate, iustinias, pasterellas,* and *passamentos;* we see that he is referring here primarily to Italian music rather than to English.

Morley concludes[29] his discussion of compositions by devoting a few paragraphs of lesser interest to instrumental music, commencing with the Fancy or Fantasie. This was a composition with thematic development but in no set form, closely related to the Italian Fantasia.

The most principall and chiefest kind of musicke which is made without a dittie is the fantasie, that is, when a musician taketh a point at his pleasure, and wresteth and turneth it as he list, making either much or little of it according as shall seeme best in his own conceit. In this may more art be showne than in any other musicke, because the composer is tide to nothing but that he may adde, diminish, and alter at his pleasure. . . . You may use at your pleasure . . . bindings with discordes, quicke motions, slow motions, proportions, and what you list. Likewise, this kind of musick is with them who practise instruments of parts in greatest use, but for voices it is but sildome used.

Morley then mentions the pavane, galliard, alman, bransle, volte, and courante (all foreign dances in origin) and ends by saying that there are also "Hornepypes, Iygges, and infinite more."

Morley seems to have known no previous work on the subject of composition. He wrote all the musical examples for his book (except

[28] For Morley's poor opinion of *Villanelle* and W. S. Rockstro's higher one see *Grove,* v. 510.
[29] P. 181.

the few by Dunstable, Rysbie, Pygott, etc., which he introduces for historical reasons), and was proud to have written the first book of its kind. Nor did he borrow other writers' material, except the elementary facts of musical theory:

And though in the first part I have boldly taken that which in particular I cannot challenge to bee mine owne, yet in the second part I have abstained from it as much as possible: for except the cords[30] of descant, and that common rule of prohibited consequence of perfect cordes, there is nothing in it which I have seen set downe in writing by others. . . . And as for the last the third part of the booke, there is nothing in it which is not mine owne.

He ends the work with a rather erudite appendix, entitled:

Annotations necessary for the understanding of the Booke: wherein the veritie of some of the precepts is prooved and some arguments which to the contrarie might be objected, refuted.

The Greeks classified their melodies as diatonic, chromatic, and enharmonic (quarter tones being used in the latter); and when Morley divides the music of his own time under these same three names he is making the common Renaissance mistake of trying to explain and classify modern phenomena in accordance with the scientific theories and definitions of ancient Greece. His recognition of the chromatic scale (E, F, F♯, G, G♯, A, etc.) is interesting. An account of ancient Greek music that follows is mainly correct, so far as it goes, although his printer has made nonsense of a table giving the Greek scale. Greek music was too thorny a subject for writers of the sixteenth century to handle. He commits the contemporary mistake of supposing that the medieval modes were identical with the ancient Greek modes of the same name, but he fortunately avoids the other common error of quoting ancient opinions on the expressive qualities of the modes. In fact, he is

[30] Intervals, such as major thirds, octaves, etc.

silent on this point, as if his practical experience led him to doubt the statements that his revered medieval authorities had accepted from the ancients, while his veneration for them bade him keep silent. He does correct certain minor errors such as the following:

Some also (whom I might name if I would) have affirmed, that the scale is called Gam ut, from Gam, which signifieth in Greeke grave or ancient: as for me I finde no such greeke in my Lexicon: if they can prove it they shal have it.[81]

His further notes concern such miscellaneous subjects as proportions, tempos, ligatures, inductions, the five kinds of pricks or dots (pricks of augmentation—the only kind left today, prolonging the duration of a note by one half—addition, perfection, division, and alteration), red minims and solid black minims. Morley disagrees with the way "proportions" are defined in *The Pathway to Musicke,* printed by Barley the preceding year:

Take away two or three scales which are filched out of Beurhasius, and fill up the three first pages of the booke, you shall not finde one side in all the booke without some grosse errour or other.

Morley proceeds to flay the anonymous author for his mistakes and plagiarisms.

Palestrina, the greatest composer of the century, is mentioned only once by Morley, and then only in a quotation from another author. Morley even misspells the name:

Fryer Lowyes Zaccone[82] . . . proveth it by examples out of the masse of Palestin, called l'home armè.

Morley ends his treatise with a bewildering list of the authorities he

[81] "Gamut" is from "gamma" (the Greek letter) and "ut" (Latin), the two names for the lowest note of the medieval scale (G on the first line of the bass staff). "Gamut" meant (1) this note, low G, (2) the whole scale.

[82] The famous writer on theory, Ludovico Zacconi, 1555–1627.

had "either cited or used in this booke," one hundred and seventeen in number.[33]

Butler mentions the work again and again, and refers his readers to "the most Artful Doctors: such as are Paduanius, Calvisius, and our Countriman Mr. Thomas Morley."

Morley wrote in his treatise,

I may say with Horace, Libera per vacuum posui vestigia princeps, that I have broken the Ice for others.

Ravenscroft in his *Briefe Discourse* refers to this sentence:

The ice is broken, and the Foot-path found; and I hope to finde many Morleyes alive, though He (who did shine as the Sunne in the Firmament of our Art, and did first give light to our understanding with his Praecepts) be long since come to the Close and Period of his Time: But his posterity,

[33] Morley mentions only 47 writers and composers in the main body of his work. Of the 47, 36 occur in the list at the end of the book, and 11 (perhaps "the most part of whose works" he had *not* "diligently perused") do not. Franco of Cologne, Josquin des Pres, and Okeghem are the most prominent names that occur only in the list. Victoria is not mentioned at all. The 47 are given below, also all the English names on the list, whether mentioned in the body of the book or not:

"Late writers": ** Peter Aron, ** Gaforius, ** Glareanus, ** Ornithoparcus, (* de Vitry), ** Zacconi, ** Zarlino.

"Ancient Writers": * Boethius, * Ptolomaeus, * Aristoxenus, * Guido d'Arezzo.

"Practitioners, the most part of whose works we have diligently perused, for finding the true use of the Moods": § Clemens non Papa, (§ Giovanni Croce), § Alfonso Ferrabosco [the Elder], (* Ferretti, * Gastoldi, § Giovanelli), § di Lasso, § Marenzio, * "Io. pierluigi palestina," (§§ Renaldi), § Striggio, § Vecchi, § Stephano Venturi.

"Englishmen": Tho. Ashwell, Averie, Beech, Bramston, §§ M. Byrde, § D[r. Robert] Cooper, Corbronde, § Cornish, §§ Dunstable, § D. Fa[i]rfax, Farding [Farthing], Morgan Grig, Gwinneth, § Hodges, Jacket, Robert Jones, § D. Kirby, Ludford, John Mason, (§ Mundy), § D. Newton, Oclande, Orwell, (§§ D. Parsley), Pashe, § "M. Person" [Robert Parsons], (§ Thomas Preston), § Pyggot, § Redford, * Risby, § Selby, (§ Shepherd), M. Sturton, § M. Tallis, §§ Taverner, Testwood, § Thorne, § D. Tie, Ungle, (§ George Waterhouse), § M. White, M. Wilkinson. Most of the lesser English worthies on this list are pre-Elizabethan, mentioned in Davey's *History of English Music,* but not in *Grove.*

** Morley quotes their opinions. * M. merely mentions the names. §§ M. quotes in music type excerpts of music by them. § M. seems to have personally examined their compositions. The eleven whose names figure in the body of the work but not in the list are printed in parentheses.

as Starres, receiving light and benefit from his Labours, will (I hope) according to his desire and wishes, entertaine and embrace such Opinions, as he himselfe acknowledged to be true.

In 1517 a university lecturer in Germany named Vogelsang published under the pen-name of Ornithoparcus a Latin treatise on music. It passed through five or six editions and was given a happy reincarnation when JOHN DOWLAND translated and published it as an English text-book in 1609 under the following title:

Andreas Ornithoparcus His Micrologus,[34] *or Introduction: Containing the Art of Singing. Digested into Foure Bookes. Not onely profitable but also necessary for all that are studious of Musicke. Also the Dimension and Perfect Use of the Monochord, according to Guido Aretinus. By John Douland Lutenist, Lute-player, and Bachelor of Musicke in both the Universities. 1609. London: Printed for Thomas Adams, dwelling in Paules Churchyard, at the Signe of the white Lion.*

The rather dry musical pabulum of the Middle Ages is served up here

[34] The *Micrologus* consists of four Books, of forty-one chapters in all. This detailed table of contents will give a general idea of the material covered in sixteenth-century works on musical theory:

I. 1. Of the Definition, Division, Profit, and Inventors of Musicke. 2. Of voyces. 3. Of the keyes. 4. Of tones. 5. Of solfaing. 6. Of mutations. 7. Of moodes. 8. Of the Dimension of the monochord. 9. Of the Definition, Division, and Profit of the Monochord. 10. Of Musica Ficta. 11. Of Song and Transposition. 12. Of the Tones in speciall. 13. That divers men are delighted with divers Moodes.

II. 1. Of the Profit and Praise of this Art. 2. Of the Figures. 3. Of ligatures. 4. Of Moode, Time, and Prolation. 5. Of the Signes. 6. Of Tact. 7. Of Augmentation. 8. Of Diminution. 9. Of the Rests. 10. Of Prickes. 11. Of Imperfection. 12. Of Alteration. 13. Of Proportion.

III. [The proper way to chant plainsong and accent its syllables:] 1. In the Praise of Accent. 2. Of the Definition and division of Accent. 3. Of the generall Rules of Accent. 4. Of the speciall Rules of Accent. 5. Of the Points of Accent. 6. Of the Accent of Epistles. 7. Of the Accent of Gospels, and Prophesies.

IV. 1. Of the Definition, division, and Difference of the names of the Counterpoint. 2. Of Concords and Discords. 3. Of the Division of Concords. 4. Of the generall Rules of the Counterpoint. 5. Of the Parts and Closes of a Song. 6. Of the speciall Precepts of the Counterpoint. 7. Wherefore Rests are put in the Counterpoint. 8. Of the divers fashions for Singing.

as adequately and appetizingly as its unattractive nature allows, and English musical students and savants should have been as well pleased with it as their German cousins.

To discuss the book in detail would be tedious and unnecessary, since the table of contents clearly indicates the scope of the work; but a few short quotations may give some idea of its style and the author's personality. Every writer is subject to the limitations of his time. The greatest discoveries of the sixteenth century did not lie in etymology, and in defining the word *semitonus* (semitone), Ornithoparcus blithely derives *semi* from a nonexistent *semum*, "imperfect," and *tonus* from the Latin *tonare* "to thunder"; whereas *tonus*, tone—and also tune— comes from the Greek *tonos*, a "tone" or "stretching," and has no connection with "thunder." Although, as has been said, the sound of the modes had fundamentally changed since classical times, Ornithoparcus dutifully accepts the following ideas from Macrobius, who lived in the fifth century A.D.:

The *Darian* Moode is the bestower of wisedome, and causer of chastity. The *Phrygian* causeth wars, and enflameth fury. The *Eolian* doth appease the tempests of the minde, and when it hath appeased them, luls them asleepe. The *Lydian* doth sharpen the wit of the dull, & doth make them that are burdened with earthly desires, to desire heavenly things, an excellent worker of good things. Yet doth Plato lib. 3 *de Rep.* much reprehend the Lydian, both because it is mournful, and also because it is womanish.

Dowland unfortunately adds no footnotes or corrections of any kind to the book. What Ornithoparcus had written ninety years before was good enough for him.

The author's description of the vocal habits of Europe in the year 1517 is illuminating:[35]

Every man lives after his owne humour; neither are all men governed by the same lawes, and divers Nations have divers fashions, and differ in

[35] In Book 4, Chapter 8.

habite, diet, studies, speech, and song. Hence is it, that the English doe carroll; the French sing; the Spaniards weepe; the Italians, which dwell about the coasts of Ianua[36] caper with their Voyces; the other[s] barke: but the Germanes (which I am ashamed to utter) doe howle like wolves. Now because it is better to breake friendship, than to determine anything against truth, I am forced by truth to say that which the love of my Countrey forbids me to publish. Germany nourisheth many Cantors, but few Musitians. For very few, excepting those which are or have been in the Chappels of Princes, doe truly know the Art of Singing. . . . But why the Saxons, and those that dwell upon the Balticke coast, should so delight in such clamoring, there is no reason, but either because they have a deafe God, or because they thinke he is gone to the South-side of heaven, and therefore cannot so easily hear both the Easterlings, and the Southerlings.

Why did Ornithoparcus write the book? He tells us himself: "To profit the Youth of Germany, whilst others are drousie."

The third and last of these general works on musical theory, by CHARLS BUTLER, disappoints us because almost everything in it had been better said by Morley and Ornithoparcus, and it completely ignores the important changes that had swept over music since 1600, although Butler's treatise was printed as late as 1636:

THE PRINCIPLES OF MUSIK IN Singing and Setting: with the twofold use thereof (Ecclesiasticall and Civil) by CHARLS BUTLER Magd. Master of Arts. London, Printed by John Haviland, for the Author: 1636.

Butler, a clergyman, was music master to the boys of the Magdalen College choir school, Oxford. His mind was both methodical and inquisitive, but not brilliant, and without humor, except of a somewhat whimsical and pedantic type. *Grove's Dictionary* has at last included him. Anthony Wood states in *Athenae Oxonienses* that Butler entered Magdalen Hall, Oxford, in 1579, took a degree in Arts, and was Vicar of Laurence-Wotton for forty-eight years. He wrote several books, which

[36] Genoa.

according to Wood "shew him to have been an ingenious man, and well skill'd in various sorts of learning." Wood mentions this treatise, but without comment. The early date of Butler's matriculation at Oxford shows that he was a contemporary of the composers he wrote about and was born only two or three years later than Morley himself.

He wrote works on music, simplified spelling, and bee-keeping; in *The Feminine Monarchy, or the History of Bees*[37] he states that the queen bee and the princesses sing in triple time, the princess thus: and prints a "Bees Madrigal" of his own composition, in four parts, praising the Feminine Monarchy and representing (in many buzzing repeated notes) the desire of the princess to leave the hive. His later works are printed in simplified spelling, in a system of his own invention that required several extra letters, a horizontal stroke through each of these standing for an omitted *h*, while "Q beeing (as đe Nameᵉ importet) an Abbreviation of c or k and v, an ođer v after it, having noᵉ useᵉ is đerᵉforᵉ omitted, as superfluous." As someone has observed, it is a great pity that he adopted these new letters, which in themselves probably prevented the success of his scheme; for the adoption of a rational system of spelling would have been easier then, when spelling had not become fixed, than now, and would have saved students of the English language untold millions of hours.

In *The Principles of Musik*[38] the medieval modes, having been overthrown in the previous century, received a final amazing blow. So far had they been forgotten that he classifies them according to their emotional character, rather than by their Tonic note:

The Dorik Moode consisteth of sober Notes, generally in Counter-point, set to a Psalm or other pious canticle, in Meeter or Rhythmical vers. . . .

[37] 1609, later editions 1627 and 1633. See Gerald Hayes's entertaining summary of it in the *Musical Times* for 1925, p. 512.

[38] The new letters he used there have not been reproduced here.

This mooveth to sobriete, prudence, modesti, and godlines. Of the Lydian Moode ar those solemn Hymns and other sacred Chyrch-songs, called Moteta, à motu: becaus they moove the harts of the hearers. Of this Moode is that passionate Lamentation of the good musical King, for the death of his Absalom: Composed in 5. parts by M. Th. Tomkins, now Organist of his Majesties Chappel.[39] . . . Of the Tonic Moode are Madrigals and Canzonets. The *Madrigal* is a Chromatik Moode in Discant, whose notes dooe often exceede the number of the syllables of the Ditti; soomtime in Duple, soomtime in Triple Proportion: with qik and sweete Reportes, and Repeats, and all pleasing varietiz of Art, in 4, 5, or 6 Partes: having, in one or more of them, one or more Rests (especially in the beginning) to bring in the Points begun in an other Parte.

By his day the word "tone" had acquired its present meaning of the quality of the sound of a musical note. In the Middle Ages it was synonymous with "mode" or the modern terms "scale" and "key."

As models for students composing in a great number of parts he recommends some of the *Cantiones sacrae* by Tallis and Byrd in six parts, Tallis's "Miserere" in seven, and Byrd's "Deliges Dominum" in eight; and he advises the reader to

. . . narrowly peruse and study the learned and exquisite Precepts of that prime Doctor Mr. Thomas Morley in the second and third Parts of his *Introduction*. Let him heedfully examin, observ, and imitate the Artificial woorks of the best Authors, such as ar Clemens non Papa, Horatio Vecchi, Orlando di Lasso, Olphonso Ferabosco, Luca Marenzo, I. Croche, Doctor Farfax, D. Tye, Mr. BIRD,[40] Mr. White, Mr. Morley, and now excelling Mr. Tho. and J. Tomkins (that Aureum par Musicorum[41]).

Butler gives a choice etymology for "anthem." Instead of deriving it correctly from "antiphon" (= opposite voice), he gets it from the Greek

[39] See p. 88 *supra*.
[40] The only name printed in capitals.
[41] Golden pair of musicians.

"anthos," "flower" (not a bad guess) and then derives "anthos" from ἄνω θεῖν, "run up," because a flower grows upwards!

The Principles of Musik[42] is not a very satisfactory book, for it contains an insufficient number of musical illustrations; devotes too little space to some topics puzzling to students; lacks the lightness and humor of Morley's *Plaine and Easie Introduction;* shows no real enthusiasm for the compositions it mentions; falls into a number of avoidable errors; and quotes ancient and medieval opinions as if they applied to modern music, without suspecting that a musical revolution was going on.

SIGHT-SINGING

The luckless Philomathes in Morley's *Plaine and Easie Introduction* and the basso Janson at Handel's rehearsal of the *Messiah* in Chester were humiliated because they could not sing "at the first sight." Neither one could plead a lack of instruction books or teachers as an excuse. Singers have learned to sing at sight from the time Guido d'Arezzo first used the sol-fa syllables in 1025, and most people still employ his method. But his syllables were only six in number—*ut*,[43] *re, mi, fa, sol,* and *la*—forming a hexachord of six notes, not an octave of eight. There were three hexachords, in which *ut* was G, C, and F respectively, and the other sol-fa syllables were used as in the following table:

	Ut	re	mi	fa	sol	la
The first or Hard Hexachord:	G	A	B♮	C	D	E
The second or Natural Hexachord:	C	D	E	F	G	A
The third or Soft Hexachord:	F	G	A	B♭	C	D

[42] Contents of *The Principles of Musik: Book 1.* Chap. 1. Modes, definition of a madrigal, canzonet, etc. 2. The scale. 3. Of setting (composing), melody, concords, discords, and ornaments. 4. Of setting in counterpoint and setting in discant. *Book 2.* Chap. 1. Of instruments, the voice, and "mixt musik" (i.e., for the two combined). 2. "Of church musik"; "non vox sed votum, non musica chordula sed cor, non clamans sed amans, cantat in aure Dei." 3. "Of civil musik."

[43] *Ut* has been superseded by *do,* except in France.

Phi. Farewell, for I ſit vpon thornes till I be gone: therefore I will make haſte.
But if I be not deceiued, I ſee him whom I ſeeke, ſitting at yonder doore: out of doubt
it is he. And it ſhould ſeeme he ſtudieth vpon ſome point of Muſicke: But I will
driue him out of his dump. Good morrow, Sir.

Maſter. And you alſo, good maſter *Philomathes*, I am glad to ſee you, ſeeing it is
ſo long agoe ſince I ſaw you, that I thought you had either beene dead, or then had
vowed perpetually to keepe your chamber and booke, to which you were ſo much
addicted.

Phi. Indeede I haue beene well affected to my booke. But how haue you done
ſince I ſaw you?

Ma. My health, ſince you ſaw me, hath beene ſo bad, as if it had beene the plea-
ſure of him who may all things, to haue taken me out of the world, I ſhould haue
beene very well contented; and haue wiſhed it more than once. But what buſineſſe
hath driuen you to this end of the towne?

Phi. My errand is to you, to make my ſelfe your ſcholler. And ſeeing I haue found
you at ſuch conuenient leiſure, I am determined not to depart till I haue one leſſon
in Muſicke.

Ma. You tell me a wonder: for I haue heard you ſo much ſpeake againſt that art,
as to tearme it a corrupter of good manners, and an allurement to vices: for which
many of your companions tearmed you a *Stöick.*

Phi. It is true: But I am ſo farre changed, as of a *Stöick* I would willingly make a
Pythagorian. And for that I am impatient of delay, I pray you begin euen now.

Ma. With a good will. But haue you learned nothing at all in Muſick before?

Phi. Nothing. Therefore I pray begin at the very beginning, and teach me as
though I were a childe.

Ma. I will do ſo: and therefore behold, here is the Scale of Muſicke, which wee
tearme the *Gam.*

Phi.

"The Gam," or Scale *from*
A PLAINE AND EASIE INTRODUCTION TO PRACTICAL MUSICKE, 1597
by
THOMAS MORLEY

So C could be either *ut, sol,* or *fa,* depending on what hexachord the singer was using at the moment. The consequent confusion in a learner's mind must have been very great. Still, it was better than no system at all. It lasted, more or less intact, from 1030 to 1599, when the brilliant proposal was made by a Dutchman to expand the C hexachord into an eight-note group by adding a syllable for B. The syllable *si* was suggested for this purpose about 1611 and gradually adopted, although England for a long time preferred the old system. The trend of thought regarding this subject in England may be illustrated from *Sternhold and Hopkins' Psalter* (edition of 1562), Morley's *Plaine and Easie Introduction* (1597), Bathe's *A Briefe Introduction to the skill of Song* (1600), Campion's *A New Way of Making Fowre Parts in Counterpoint* (1613), and Butler's *The Principles of Musik* (1636).

The 1562 *Psalter* (the first complete psalter published in English) does not touch upon the difficult question of deciding which of the various available sol-fa syllables should be sung to a given note, except to say that although G may be sung either *sol, re,* or *ut,* when a tune starts on G and goes up the scale, G should be sung *ut.* To learn to sing the scale "ye must learn to tune aptly of some one that can already sing, or by some Instrument of musicke, as the Virginals." The virginal was certainly the easiest instrument to use for testing the correctness of the pitch of his voice, although some writers suggested the lute.

By the time of MORLEY, *ut* and *re* were going out of use in England, though retained on the Continent. The G hexachord was the normal one, not the one beginning on C as we might expect. *Ut* is never sung, he says, unless it is the lowest note in the singer's part, and *re* is to be avoided. All "flates" (B♭, E♭ A♭), also F sharp, are *fa.* Unlike Campion he adheres to the medieval convention that the scale contains only twenty notes, from G (first line, bass staff) up to E (fourth space, treble staff), supporting it with this absurd statement: "Under *Gam ut* [low G] the voyce seemed as a kinde of humming, and above *E la* [high E] a kinde of constrained shrieking." Our notions of Elizabethan pitch are

somewhat confused, owing to contradictory statements handed down from those days, and possibly different Elizabethan musicians may have used different pitches; but even if Elizabethan pitch differed markedly from ours (which I do not believe) either the basses or the sopranos could easily have sung notes outside the twenty-note limit. To Elizabethans, 𝄢, 𝄡, [B]♭, and [B]♮ were all "cliffes" (clefs), but there was no ♮ sign, the ♯ sign being used with the present meanings of ♯ and ♮. The following examples of solmization printed by Morley will make his practice clear in essentials. Because of the flat "cliffes" (key signatures are a modern idea), the hexachord of G is not used. It is a pity no example is given without a flat in the signature.

BATHE's system is based on two rules. Expressed in modern language they are: (1) When there is no flat in the signature, *ut* is G, when one flat in the signature, C, when two flats, F. (2) In singing up the scale use the syllables *ut, re, mi, fa, sol,*

sol fa sol la sol fa fa la sol fa mi la sol sol fa la sol
[*Ut* is: C F.... .. C.... F C......... F C F ⁽ⁿᵒⁿᵉ⁾ F C]

sol fa fa la sol fa fa sol sol fa fa la sol sol fa sol
[*Ut* is: C F ⁽ⁿᵒⁿᵉ⁾ F C ⁽ⁿᵒⁿᵉ⁾⁽ⁿᵒⁿᵉ⁾ C F C F C...... (C?)C]

la, fa, ut successively, and use the same syllables in reverse order going down. So far, excellent; like a modern sol-faist he has discarded hexachords in favor of an eight-note system, and *ut* always refers to the same note while the key remains the same; he was tending toward the Curwens' *movable do* system, not the awkward *fixed ut* of the French. But then he unfortunately allows exceptions to creep in: whenever the tune goes up to *ut* or *re* and then dips down again, he changes the upper *ut* to *sol* and the upper *re* to *la*, thus:

la fa la sol fa la
Not: la fa re ut fa la

Then he gets into trouble with accidentals. These are of course an inevitable stumbling block in any sol-fa system except that of *movable do*. Some teachers, he says, require that "every note having a sharpe beefore it should be named *mi*," others that it should be called *la*. Bathe prefers to call it *fa*. This is logical in the key of C for F♯ and C♯, because F♮ and C♮ are also *fa* under his system. Instead of thinking *fa* and *fi* for F and F♯ as the modern singer would do, Bathe's pupil would doubtless think *low fa* and *high fa* respectively. But to call G♯ *fa*, or with one flat in the signature to call C♯ *fa*, is laying himself open to his own criticism; for in his preface he complains that under other teachers' systems "notes have names that the places where they stand comprehend not." He is here probably objecting to such a current practice as calling C♯ *mi*, on the ground that C♯ should always have the same name as C♮, i.e., *ut, fa,* or *sol*, never *mi*. Then Bathe says that C B♭ C in succession should be sung *fa fa sol*, the B♭ having changed the key, thus avoiding "*faf, faf, faf*." If Bathe means that every time one comes to a B♭, C becomes *ut* and every time one comes to a B♮, G becomes *ut*, he is "changing the *do*" logically like a modern sol-faist; but this may not be Bathe's intention. For still further quiddities in Bathe the reader is referred to the original text. Bathe was courageous enough to think out a new idea. He then took a fatal look backward at his contemporaries, hesitated, and was lost.

The purpose of CAMPION's treatise is to teach students how to write music, not how to sing; but in his preface he explains his own method of using the sol-fa syllables, as an aid to singers. Like Bathe he uses an eight-note *movable do* system, to cover an octave, changing the position of *ut* only when the key signature changes. But in accordance with the English practice of his time Campion omits *ut* and *re* entirely. He even calls bottom G (first line, bass staff) *sol*, although theoretically there can be no *ut, re, mi* or *fa* below it. His ascending scale G to G (including F♮) consists of the notes *sol, la, mi, fa, sol, la, fa, sol*. With no key signature the first *sol* is G, with a signature of one flat C, with two flats

F. He does not mention accidentals, consequently his system is not usable with any music that contains them, and would have to be supplemented.

BUTLER wrote in 1636, twenty-three years later than Campion. By that time the world had accepted the discovery that the musical universe revolves about the note C. So Butler started with C as *ut* and used Bathe's series—*ut, re, mi, fa, sol, la, fa, ut;* in short, his system is the modern French *fixed ut* system. But Butler's plan, like his simplified spelling, went crying in the wilderness, and England continued to use Campion's four syllables.

After a study of the above methods and the difficulties inherent in the old hexachord system it is surprising that it survived as long as it did; yet we must give credit to Campion and Butler for endeavoring to simplify it by basing their systems on a single octave rather than on the three hexachords, and thus preparing the way for modern methods. The following summary of past and present usages may interest those who, like Philomathes, have through perseverance acquired the ability to sing at sight; Janson probably never did learn, and continued to plague his choirmasters until the end of his days.

Medieval: one correct way
 ut re mi fa sol mi fa sol re mi fa ut re fa sol re mi fa re mi fa sol
Morley, 1597
 ut re mi fa sol la fa sol la mi fa sol la fa sol la mi fa sol la fa sol
Bathe, 1600
 ut re mi fa sol la fa ut re mi fa sol la fa ut re mi fa sol la fa sol
Campion, 1613
 sol la mi fa sol la fa sol la mi fa sol la fa sol la mi fa sol la fa sol
Butler, 1636
 sol la fa ut re mi fa sol la fa ut sol la fa ut re mi fa sol la fa ut
Modern French
 sol la si ut re mi fa sol la si ut sol la si ut re mi fa sol la si ut
Modern English, American
 sol la ti do re mi fa sol la ti do re mi fa sol la ti do re mi fa sol

Most of the Elizabethan books on the theory of music pay some attention to sight-singing, but only three works are chiefly concerned with it. Of these, I have been unable to examine *A Briefe Introduction to the True Art of Musicke,* 1584, by William Bathe, and *The Pathway to Musicke,* printed by William Barley in 1596. Copies are so rare that the British Museum and other important libraries possess none. It is not known who wrote *The Pathway to Musicke.* Thomas Morley's withering opinion was that only its blank pages were without errors, and Davey considered it worthless.[44]

Bathe was a learned Irishman who studied at Oxford and later in Spain, where he died. His two musical works, however, show more egotism than erudition. He states that he published *A Briefe Introduction to the True Art of Musicke* only after he had satisfied himself of its worthiness:

For the worthinesse, I thought it not to be doubted, seeing heere one set forth a booke of a hundred mery tales, another of the battaile between the spider and the fly,[45] another *De Pugnis Porcorum;* another of a monster born at London the second of January, hedded lyke a horse and bodied lyke a man, with other such lyke fictions; and thinking this matter than some of these to be more worthy.

Hawkins comments upon it as follows:

The preface was doubtless intended by the author to recommend his book to the reader's perusal, but he has chosen to bespeak his good opinion rather by decrying the ignorance of teachers, and the method of instruction practiced by them, than by pointing out any peculiar excellencies in his own work. He says that many have consumed a whole year before they could come at the knowledge of song only, but that he had taught it in less space than a month.

But how highly soever the author might value his own work, he thought

[44] *Supra,* pp. 224, 241.
[45] By Thomas Heywood.

[253]

proper some years after the first publication to write it over again in such sort, as hardly to retain a single paragraph of the former edition. . . . And here again the author, according to his wonted custom, censures the musicians of his own time, and magnifies the efficacy of his own rules.

Hawkins was unfavorably impressed with both of Bathe's works. The second of these was:

A Briefe Introduction to the skill of Song: Concerning the practise, set forth by William Bathe Gentleman. In which work is set downe X. sundry wayes of 2. parts in one upon the plaine song. Also a Table newly added of the comparisons of Cleves [clefs], how one followeth another for the naming of Notes: with other necessarie examples, to further the learner.

In addition to Bathe's method[46] for teaching learners to sing at sight the book contains ten canons. In his preface the enthusiastic author writes:

Where [olde Musitions] gave prolixe rules, I have given briefe rules, when they gave uncertaine rules, I have given sure rules, and where they have given no rules, I have given rules. . . . In a moneth and lesee I instructed a child about the age of eight yeeres to sing a good number of songs, difficult crabbed Songs, to sing at the first sight, to be so indifferent for all parts, alterations, Cleves, flats, and sharpes, that he could sing a part of that kinde, of which he never learned any song, which child for strangenesse was brought before the Lord Deputie of Ireland, to be heard sing: for there were none of his age, though he were longer at it, nor any of his time (though he were older) knowne beefore these rules to sing exactly.

He then cites cases of other successful pupils of his. They must have been naturally talented.

The next three books deal with special topics. Campion discovered and published an "infallible" rule for writing harmony correctly, although his idea is unfortunately of limited application:

46 For a summary of this method see pp. 250 and 252 *supra*.

A NEVV VVAY OF MAKING FOWRE parts in Counter-point, *by a most familiar, and infallible* RULE. *Secondly, a necessary discourse of* Keyes, *and their proper* Closes. *Thirdly, the allowed passages of all* Concords *perfect, or imperfect, are declared.* Also by way of Preface, the nature of the Scale is expressed, with a briefe Method teaching to Sing. *By* THO: CAMPION. LONDON: *Printed by* T.S. *for* John Browne, *and are to be sold at his shop in Saint* Dunstanes *Church-yard, in Fleetstreet.* [1613].

In his dedication "To the Flowre of Princes, Charles, Prince of Great Brittaine," Campion absurdly calls his work

. . . a poore and easie invention; yet new and certaine; by which the skill of Musicke shall be redeemed from much darkness, wherein envious antiquitie of purpose did involve it.

This work was sufficiently famous to be reprinted in 1655 and 1664, and then to gain a new lease on life as a part of Playford's *Introduction to the Skill of Musick;* and unlike most Elizabethan books on music it is accessible to the general reader, for it was reprinted in 1909 in Vivian's edition of Campion's works. Vivian shows no great enthusiasm for Campion the musician:

The main value, however, of the "New Way" is, as I have shown with more detail in the Notes, that it affords a rule of thumb for the harmonization of a tune with simple concords. . . . There is little enough in this to warrant his claim that he had effected more in Counterpoint than any man before him had ever attempted. But even this small measure of originality may be doubted, if not denied outright . . . At p. [126 of the *Plaine and Easie Introduction*] Morley gives a Table of proper progressions in three parts; while at pp. [129–130] he gives a table containing the usual chords for the composition of four or more parts, profusely illustrated with examples in score. Campion's rule is a modification of these tables, very possibly derived from them; the difference being that he uses the figures instead of setting down the notes of the common chord.

[255]

This is incorrect: Morley's tables do not show how to write progressions, but separate, unconnected chords. The writing of any book that will enable an unmusical beginner to write correct harmony is quite a feat, and Campion accomplished it. His principles are more easily made clear by means of modern musical terms, for Elizabethans were scarcely thinking of "chords"[47] as yet, and had not arrived at the idea of "roots" or "inversions"; for these, Rameau (1683-1764) was responsible. Campion is one of the earliest to call attention to the fact that music is most naturally written in four parts, rather than in three or five.

These are his rules for writing two successive chords in four-part harmony, each chord containing the 3d, 5th, and octave above the bass:

1. If the bass moves *up* a 2d, 3d, 4th (or down a 5th or 6th),
the 3d above the bass in the 1st chord should be followed by the 8ve
the 5th above the bass in the 1st chord should be followed by the 3d
the 8ve above the bass in the 1st chord should be followed by the 5th
} above the bass in the 2d chord

2. If the bass moves *down* a 2d, 3d, 4th (or up a 5th or 6th),
the 3d above the bass in the 1st chord should be followed by the 5th
the 5th above the bass in the 1st chord should be followed by the 8ve
the 8ve above the bass in the 1st chord should be followed by the 3d
} above the bass in the 2d chord

This diagram summarizes rules 1 and 2: ↑ $\frac{8 \mid 3 \mid 5}{3 \mid 5 \mid 8}$ ↓ .

For Rule 1, read *up* from the numerals representing the first chord (3 5 8) to those representing the second chord (8 3 5). For Rule 2 read *down* from the numerals representing the first chord (8 3 5) to those representing the second chord (3 5 8).

3. To obtain variety, in Rule 1 substitute *down* for *up* (and *up* for *down*).

4. Similarly in Rule 2 substitute *up* for *down* (and *down* for *up*).

5. If a 1st Inversion (bass, and 3d and 6th above the bass) is used, merely substitute "6th" for "5th" in the bottom line, thus: ↑ $\frac{8 \mid 3 \mid 5}{3 \mid 6 \mid 8}$ ↓ .

Example of rules 1 and 2:

[47] William Leighton wrote in Allison's *Psalmes* (1599): "Musickes arte is drawne from this Concent ——◇——." See p. 57 *supra*.

Filling in skips to make them into 1 ins need cause no trouble. To allow two 3ds to be used in succession in the treble, double the 3d in whichever chord has the higher bass note. He curiously objects to the use of two consecutive first inversions if both roots ("sixes") are in the treble.[48]

Accidentals, of course, cause some difficulties; the bass note must not be doubled (1) if it is F♯, (2) if it is E♭ and followed by the chord of D major, because an augmented 2d (which is "unformall") would result. Consequently his essential rule that the bass must be doubled occasionally gives trouble. It is also at variance with the obvious fact that it is often convenient (and correct) to double the 5th, or the 6th, above the bass.

Pedagogically, Campion's system is unsound as a means of teaching harmony, except in the earliest stages, because it is a mere mechanical treadmill; the student should be taught to *hear* what he writes and then write whatever sounds well to him. It also does not allow the use of dominant 7th chords and second inversions; these were accepted into the ordinary system of harmony after Campion's day. Nevertheless it is undeniably clever, could be used with either a given melody or a given

[48] He gives the following illogical reason for his objection: "For sixes are not in this case to be mentioned, being distances so large that they can produce no formality. Besides the sixt is of it selfe very imperfect, being compounded of a third which is an imperfect Concord, and of a fourth which is a Discord: and this the cause is, that the sixes produce so many fourths in the inner parts. As for the third it being the least distance of any Concord, is therefore easily to be reduced into good order." He may mean that he would object to the consecutive fourths produced by successive first inversions with the roots in the treble; but the probable reason is that it would upset his rule hopelessly (3d would have to be followed by 3d and 6th by 6th).

bass, and must have been a great boon to perplexed beginners. A modified form of it is actually still used by a few teachers of harmony.

The second section of the treatise, *Of the Tones of Musicke,* appeared when the tones (by which he means the medieval modes or scales) were rapidly disappearing. He does little more than show what cadences are satisfactory in various keys.

The third and last section, *Of the taking of all Concords, perfect and imperfect,* merely gives a list of what two-part intervals may be used in succession, and under what circumstances. E.g., the major 6th may be followed by another 6th, by an octave, or by a 3d, but hardly by a 5th unless one of the notes of the 6th is tied over into the 5th. The following examples may be of interest to students of counterpoint, because Campion's curious opinions of them are given below. His equally strange reasons for these opinions are not worth giving here, but may be consulted in Vivian's edition.

THOMAS RAVENSCROFT wrote his book on theory to explain the medieval time-signatures, and to urge their revival. Without this explanation the peculiar title of his book might seem rather blind:

A BRIEFE DISCOURSE of the true (but neglected) use of *Charact'ring* the Degrees by their *Perfection, Imperfection,* and *Diminution* in *Measurable Musicke,* against the *Common Practise* and *Custome* of these *Times.*

Examples whereof are exprest in the *Harmony* of 4. *Voyces,* Concerning the Pleasure of 5. usuall *Recreations* 1 *Hunting* 2 *Hawking* 3 *Dauncing* 4 *Drinking* 5 *Enamouring. By* Thomas Ravenscroft, *Bachelor* of Musicke. LONDON Printed by Edw: Allde *for* Tho. Adams 1614. Cum privilegio Regali.

Morley wrote in his *Plaine and Easie Introduction*[49] that only four of the medieval time-signatures remained in use. Ravenscroft's attempt to revive the others was a pedantic[50] effort. We may surmise that the printer accepted the book for publication only because Ravenscroft's previous volumes of music had been of a popular nature, probably selling well, and because this work contains twenty part-songs, which though composed to show the proper use of the time-signatures, were set to texts describing the five alluring recreations mentioned in the title. Of these part-songs five are by Bennet, two by Pearce, twelve by Ravenscroft, and one composer is not named. Contrary to current practice he praises the compositions in his own book: he hopes that musicians "will take in good worth these various Sprightfull Delightfull Harmonies, which now I bring them."

His "Apologie" begins as follows:

Plutarch in his Booke of Musicke saith, that Pherecrates the Comicall Poet presented Musicke in form and habits of a Woman, her body piteously scourged and mangled. . . . If Pherecrates had now lived, well and truely might he have presented her *Pannis annisque obsitam,* with scarce Ligatures left to preserve the compacture of her body, so much is she wrong'd, dilacerated, dismembred, and disjoynted in these our daies; she scarcely hath

[49] *Supra,* p. 228.

[50] The curious lack of proportion in the arrangement of this volume might in itself suggest to the reader that Ravenscroft was probably a man of vagaries. Of its fifty-one pages only twenty-two constitute the actual Discourse. The rest of the book consists of a title page, a Dedication of three pages, an Apologie of six, poems commending Ravenscroft (seven pages), a Preface (seven more, halfway through the volume), errata, and blank pages.

Forme or Habite left, but e'ne as a Sceleton, retaines onely a shape or shadowe, of what she was in her former purity.

—And so on at great length in a similar strain, without actually saying just what is wrong with her.

This is all a tempest in a teapot. One might have thought he was criticizing the strange new harmonies of Farnaby, perhaps, or Monteverde. But Ravenscroft's anger is aroused solely by the contemporary miscalling and miswriting of time-signatures.[51] Morley's *Plaine and Easie Introduction* (1597) accepts, though with protest, the current practice of miscalling "Time" "Moode." Ravenscroft pardons him, begs forgiveness for his own youthful irregularities in the way of tempo signs, and urges return to the medieval practice. He condemns the absurd sign $C3$ (our modern $\frac{3}{2}$), saying correctly that the 3 is superfluous. So today to write $C\frac{4}{4}$ would state the same thing twice. But $C3$ was a practical concession to ordinary musicians, who could not remember that C meant triple time ($\frac{3}{2}$) and C duple ($\frac{2}{2}$). Correctly too he objects to the erroneous use in church music of the sign \mathbb{C}, which meant that half notes were to be sung as fast as quarter notes and if literally followed would make church music giddy enough for dancing.[52] Today the sign has come to mean $\frac{2}{2}$ time, and is perfectly respectable. But in general Ravenscroft's indignation seems impractical and unwarranted today.

Five of the commendatory poems in *A Briefe Discourse* are by men well known to their contemporaries—Nathaniel Giles, Thomas Campion, John Dowland, John Davies of Hereford and Martin Peerson, the composer. The others are by William Austin, Tho. Piers (evidently a

[51] Bathe makes three errors of this kind in his second book (1584), though Ravenscroft does not mention them.

[52] In Elizabethan times slow music, e.g., psalm tunes, were written in whole notes and half notes; fast music, e.g., gay madrigals, in quarters or if still faster in eighths. Nowadays the speed depends on the Italian directions: a sixteenth note in $\frac{3}{16}$ time marked "Largo" is of longer duration than a half note in $\frac{2}{2}$ time marked "Allegro."

relation of Ravenscroft's former choirmaster and teacher, the organist of St. Paul's), T. H. (Tobias Hume?); and "R.LL. Theo-muso-philus," perhaps a clergyman. They are printed as Appendix E.

ROBERT FLUD (1574–1637) was an Oxford student and spent most of his life in England, but his work dealing with music was published abroad. This was *Utriusque cosmi, majoris scilicet et minoris, metaphysica, physica, atque technica historia* . . ., Oppenheim, 1617. Flud was a Rosicrucian. Hawkins thus describes him:

Upon the whole Flud appears to have been a man of a disordered imagination, an enthusiast in theology and philosophy; as such he is classed by Butler with Jacob Behmen and the wildest of the mystic writers:

> He Anthroposophus and Flud
> And Jacob Behmen understood.
>
> *Hudibras,* Part 1, Canto i.

In one section of the treatise

. . . the author supposes the world to be a musical instrument, and that the elements that compose it, assigning to each a certain place according to the laws of gravitation, together with the planets and the heavens, make up that instrument which he calls the Mundane Monochord.

CANONS

A canon is a composition in which two or more performances of the same tune go on simultaneously but begin at different times. For example, in the canon printed on page 265 both voices sing the same tune, but the tenor has already sung five notes of it before the bass starts with the first note.

Canons have been written with one or several purposes in mind. It is recognized that no other short composition requires a tittle of the skill that is necessary for the creation of an involved canon. So from Dufay (c. 1400–1474) onwards the chief motive behind the publication of

some complex canons has been self-advertisement rather than self-expression. Other canons, including perhaps those by Beethoven, were written either good-humoredly for performances at parties of friends or for the personal pleasure one feels in consummating a difficult feat. Some of the earlier vocal canons were designed as musical puzzles. These were rarely printed out in full, and the directions for solving and performing them were often made purposely obscure. Some show amazing cleverness. When considered as spectacular feats or as puzzles the Elizabethan canons are admirable, but they should no more be judged as music than conundrums as literature. A beautiful canon is, however, a worthy musical device when used as part of a larger composition, for it contains the necessary unifying element of repetition that is present in one form or another in all good compositions, notably the fugue, rondo, passacaglia, and the theme with variations. In addition to its use in compositions, canonic writing has its place in pedagogy, for it has long been recommended to students as a means of gaining facility in the writing of counterpoint. Lastly, Elway Bevin expressed the singular hope that his canons of 1631 would redound to the glory of God. Let us hope that they did, as the dances offered by *Le Jongleur de Notre-Dame* were pleasing to Our Lady.

A collection of canons by JOHN FARMER was printed in 1591:

Divers and sundry waies of two parts in one, to the number of fortie, upon one playn Song.

The only known copy is in the Bodleian. It consists of forty canons. Some are complicated; the thirty-fifth specimen has this direction:

2 parts in one in the eight, if you would know how this can be, turne the booke upside downward and look on the Basse, there shall you perceive it, but sing it as it is prickt downe before you, sing the plain-song as it standes.

There are two poems, or rather rhymes, in praise of the composer, by Francis Yomans and Richard Wilkinson. About all that Yomans can

say in sixteen lines is, "I am incompetent to give this work fitting praise, but I wish him well." Here is the other poem:

1. Who so delights in Musickes skill
 and thereof judges right,
 May here perceive a straunge devise
 most plainly in his sight.
2. Two parts in one uppon a ground
 in number fortie wayes
 A thing most rare surpassing farre
 most songsters now a dayes.
3. If this in youth performed be
 as plainly you may see,
 What fruite hereafter may wee hope
 to have of such a tree.
4. As farmer good or busye bee
 still laboreth in the field
 So doth this *Farmer* that he may
 to others much fruite yeeld
5. Farewell with praise and good report
 of those that know thy skill
 What thou desernest in Musicks art
 This booke will witnes still.

RICHARD WILKINSON

Morley wrote in his great treatise that his friend GEORGE WATER-HOUSE composed a thousand canons on one plainsong tune, all different, and adds, "I doe hope very shortly that the same shall be published for the benefit of the world, and his owne perpetuall glory." That wish has not been fulfilled. They repose in manuscript in the Cambridge University Library.

The *Stationers' Register* gives the title of a collection of canons which was approved for publication in 1603:

[263]

Medulla Musicke. Suckęd out of the Sappe of Two of the most famous Musitians that ever were in this land, namely Master William Byrd . . . and Master Alfonso Ferabosco . . . either of whom having made 40 severall waies (without contention), shewing most rare and intricate skill in 2 partes in one upon the playne songe Miserere. The which at the request of a friend is most plainly sett in severall distinct partes to be sunge

No copy is known, and it is possible these canons were not printed. They are, however, mentioned by Morley in his *Plaine and Easie Introduction*,[53] where the student is advised to

. . . diligently peruse those wayes which my loving Maister (never without reverence to be named of the Musicians) M. Bird and M. Alphonso in a virtuous contention in love betwixt themselves, made upon the plaine song of *Miserere,* but a contention, as I saide, in love . . . each making other Censor of that which they had done. Which contention of theirs (specially without envie) caused them both become excellent in that kind, and winne such a name, and gaine such credit, as will never perish so long as Musick endureth.

Part Two of Morley's *Plaine and Easie Introduction* is as good an instruction book for canon as could be desired, except that he might have written out more canons in full as examples. Here is the subject of a *Canon in epidiatessaron,* presumably by Morley, every repetition of which is as he says a whole tone lower. All that Morley prints is: By *epidiatessaron* is meant that the first note of the second voice is a fourth higher in pitch than the note on which the first voice begins. The sign .?.[54] indicates when it is time for the second voice to start. The working out (not printed by Morley) would be as follows:

[53] P. 115.
[54] Printed in the second edition, but not in the first, where the tune is given on p. 175.

Morley sensibly says that the composition of canons is not so important for its own sake as it is for teaching the student to write smooth counterpoint in madrigals, though he evidently rather enjoys the excitement of writing them as an end in itself, being a sufficiently dextrous technician to have such complexities at his fingers' ends. He praises the Italians for knowing how to use a canon in a composition, abandoning the strictness of the imitation before it becomes tiresome and pedantic, whereas "wee are so tedious" that we hang on to the canon to the bitter end. Not, however, that the Italians cannot write lengthy canons: "in that also, you shall finde excellent fantasies both of Maister Alfonso, Horatio Vecci, and others."

The work by BATHE[55] published in 1600 contains ten canons.

In 1631 ELWAY BEVIN, organist of Bristol Cathedral, published:

A BRIEFE AND SHORT INSTRUCTION OF THE ART OF MV-SICKE, *to teach how to make Discant, of all proportions that are in use:* VERY NECESSARY FOR ALL *such as are desirous to attaine to knowledge in the Art; And may by practice, if they can sing, soone be able to compose three, foure, and five parts: And also to compose all sorts of Canons that are usuall, by these directions of two or three parts in one, upon the Plain-song. By* ELVVAY BEVIN. LONDON, *Printed by R. Young, at the signe of the Starre of Bread-street hill. 1631.*[56]

[55] See p. 254, *supra*.
[56] *Grove* prints the title of his book incorrectly.

It is dedicated to the Bishop of Gloucester. Bevin tells us that for years past he had composed "Canons of 2 and 3 parts in one upon the Plain-song," and though unwilling to publish them, did so because his friends desired him, when he "called to minde, that it might tend to the praise and glory of Almighty God, and to the benefit of my native country." His canons are complicated, and the instruction in that subject slightly fuller than Morley's, but so much the same in method as hardly to be worth giving to the world. Perhaps to satisfy the Bishop he makes some far-fetched comparisons between canons and religion:

A Canon of three in one hath resemblance to the holy Trinity, for as they are three distinct persons and but one God, so are the other three distinct parts, comprehended in one. The leading part hath reference to the Father, the following part to the Sonne, the third to the holy Ghost.

At the end he writes,

Thus much have I thought sufficient for young Practitioners at this present, but if I may perceive any to take profit herein, I shall be encouraged hereafter to set out a larger Volume, if it please God to give me life, and unable me thereunto. . . . Thy harty wel-wisher in Christ Jesus, *Elway Bevin*.

Bevin was an old man, and no other volume appeared. He received the foundation of his learning from no less a teacher than Tallis, and in turn had a creditable pupil, William Child (1606–1697).

ACOUSTICS

That Elizabethan of vast learning, Sir Francis Bacon, in his heroic attempt to assemble the scientific knowledge of his time and publish it in systematic form, devotes one Latin treatise and part of a longer English work to the subject of acoustics. These are:

Historia et inquisitio prima de sono et auditu, et de forma soni et latente

processu soni; sive sylva soni et auditus. Written before 1622, published 1688.

Sylva Sylvarum: or A Naturall Historie. In ten Centuries.[57] *Written by the Right Honourable Francis Lo. Verulam Viscount St. Alban* about 1625, published 1627.

The twentieth century considers the writings of Bacon with mixed feelings. On the one hand we are under great obligation to him, for by insisting that we base our scientific generalizations solely on natural phenomena and not on the unprovable presuppositions of the Aristotelians and medieval philosophers, he helped break the medieval stranglehold on science and usher in the modern age. On the other hand he was a child of his own period and was guilty of innumerable mistakes both of omission and commission. He had neither the time nor the modern inclination to test all his statements, so he copied scientific misinformation from numerous respected authors with the same awe for tradition that he criticized in the philosophers. This error he inherited from the middle ages, when

Miracles were simply believed like other marvels. The habit of asking *how* effects are produced had then no existence, and consequently the *a priori* difficulty which hinders men from believing in wonderful stories, except on commensurate evidence, was never felt.[58]

Few scientific laws were known in Bacon's day, and fewer understood. He showed little aptitude for formulating and investigating these, partly no doubt because he felt that the multifarious phenomena of nature should be noted down first. Being unable to foretell the great part that mathematics was to play in the discovery of these laws, he pays negligible attention to measurements of all kinds. A distressing but typical example of this failing is his statement that a man's voice

[57] Each "Century" is a chapter containing one hundred "experiments." Experiments 101 to 290 deal with acoustics.
[58] Robert Leslie Ellis, in Spedding's edition of Bacon's philosophical works, ii. 325.

travels a quarter of a mile "in a space of time far less perhaps than a minute."[59] The actual time is about one and one-tenth seconds. He knows that a bell or string vibrates while it sounds, but he does not suggest that determining the number of vibrations per second might be of value. He is apparently even ignorant of the monochord, an instrument well known to both the ancient Greeks and the medieval writers on music because by means of it they could measure important relationships of pitch. He furthermore made little effort to keep abreast of contemporary discoveries. Thus he seems to have been ignorant of the principle of the lever, and of the recent discoveries of logarithms, Kepler's astronomical laws, and the circulation of the blood;[60] and he rejects the discovery of the rotation of the earth as absurd. To his credit it can be said that he himself made several minor discoveries, and also curiously foreshadowed such modern inventions as balloons, submarines, telephones, and anesthetics.[61]

The chief thought that emerges from a perusal of Bacon's acoustical investigations is not any one discovery of his, but the fact that he missed by a hair's breadth the discovery of sound waves. He plays all around it, now hot, now cold, for such a time that it is rather surprising. One would think that rubbing his finger at varying speeds over ribbed cloth, or listening to the tuning of an organ, with the resultant "beats," would have suggested it; or that since he knew that the beating of a drum will put out the flame of a candle held near the wind-hole[62] of the drum, he would have surmised that sound is produced or carried by a motion of the air too delicate to be measured with the instruments at

[59] *Historia . . . Soni. In Sylva Sylvarum,* Experiment 289, he says "in the space of less than a minute," showing that in the interim he had not bothered to perform the experiment and ascertain the exact time, but on the contrary had become even more vague.

[60] Of Bacon's failure to recognize the importance of the scientific discoveries of Harvey and Gilbert, Sir William Osler wrote, "A more striking instance of mind blindness is not to be found in the history of science."—*Bulletin of the History of Medicine,* April 1939, p. 392.

[61] See *Francis Bacon* by John Nichol, p. 194.

[62] *Historia . . . Soni,* near the end.

his disposal. But he hazards no explanation. He even compares the gradual quieting of the air after striking it has produced a sound, to that of water after an impact has set circles in motion upon it, yet he does not suggest that air too may be affected by wavelike motion. He is correct in saying that sounds are caused by "Pent Aire, that striketh upon Open Aire," also that sound is generated "between the String and the Aire," not between the string and the bow; but is mistaken when he claims that "Sound is without any Locall Motion of the Aire," and that a man's eardrum is broken by sound, not by motion of the air. He has to admit that, after thunder, windows rattle owing to "locall motion of the air," but says that this motion of the air is a concomitant of the sound. The nearest he comes to the idea of sound waves is this confused statement:

In the sounds which we call *Tones* (that are ever equall) the Aire is not able to cast itself into any such variety [as it does when producing noise]; But is forced to recurre into one and the same Posture or Figure, only differing in Greatnesse and Smalnesse.

Although in the *Novum Organum* he conceived of heat as an undulatory motion, he conjectures in the *Historia . . . Soni* that both sound and light are carried by spiritual rather than material means, "for thus we must speak until something more assured shall be found."

He is also unable to solve the much easier question, Why is our major scale the normal one? He answers, Because it is easy to sing. Now it is true that the major scale is easy to sing, but that is merely because we have heard it all our lives. The whole-tone scale or a scale with nine equal steps to the octave would be easy to sing if we had heard it since earliest childhood. Because he knew nothing of the monochord or vibration ratios, he answers the question why "The Diapason or Eight in Musicke is the sweetest Concord" by the guess that "it is in effect an Unison." He observes correctly that there is nothing in the number *8* to cause the concord, for he adds with modern exactness that the octave

is made up of seven whole tones or thirteen half tones, or more correctly, as he adds, six whole tones or twelve half tones if one counts the intervals and not the notes. The true answer should have been that if the ten lowest notes in any harmonic series[63] are sounded, e.g., on any brass instrument, all the intervals so formed[64] happen to be evenly divisible, roughly speaking, by a certain interval; and this important interval, the semitone, is hence the unit of our system of intervals.

A few more of Bacon's ideas about music may be mentioned. In trying to explain the reasons for high and low pitch Bacon hovers between two theories. First he says, "It is evident, that the Percussion of the Greater Quantity of Aire, causeth the Baser Sound: And the lesse Quantity, the more Treble sound." In this he was led astray by the fact that a bass viol string is longer than a treble viol string and may be seen to vibrate through a wider arc. His second idea is, that "the Sharper or Quicker Percussion of Aire causeth the more Treble Sound, and the Slower or Heavier, the more Base Sound"; when strings are more wound up and strained they "give a more quick Start-back." Here too he comes close to discovering the theory of vibrations. He correctly says that the loudness of a sound depends upon the force with which the air is struck. He is partially mistaken when he says, "You can never make a Tone, nor sing in Whispering." He has observed that water can transmit sound, yet he surprises us with the statement that sound passes through solid bodies only by virtue of the air contained in their texture.

He makes numerous observations on the instruments then in use,

The seventh note, B♭, has to be ignored because it sounds slightly out of tune in our Western music.

[64] Octave, minor 7th, major and minor 6th, perfect 5th, perfect 4th, major and minor 3d, and major 2d.

e.g., that the quality of the tone of a wind instrument depends somewhat on the "Matter of the Sides of the Pipe, and the Spirits in them contained; for in a Pipe, or Trumpet, of Wood, and Brasse, the Sound will be divers," and he adds that a smooth surface improves musical tone. So he prefers strings of wire to those of gut, and he considers the tone of a wind instrument with its bore slightly moistened more "solemne," because the bore is "a little more Even and Smooth." "Generally the Straight Line," as in recorders and flutes, "hath the cleanest and roundest sound, And the Crooked the more Hoarse, and Jarring." So the trumpet has a "purling sound." "In Frosty Weather, Musick within doors soundeth better" because the wood or string is drier, and so more porous and hollow. "And we see that Old Lutes sound better than New, for the same reason." This is probably true. He finds that singing in the hole of a drum makes the singing more sweet. He recommends it, but suggests that "for handsomnesse sake" a curtain should be hung between the drum and the audience.

It is easy for us to smile at Bacon's mistakes, just as any schoolboy three hundred years hence will laugh at ours. Bacon could have made important discoveries and inventions if he had used even the scientific apparatus of his own time and had perceived the value of accurate computation and measurement. From the common pendulum he could have invented the metronome, from experiments with the pitch of anvils the tuning fork. Yet we must marvel at the vast interests of the man, who could take the trouble to sound tongs under water, whistle through a cannon, compare the tone of gold, silver, and brass bells, and observe that two voices in unison cannot be heard twice as far as one. And to quote Dr. Felix E. Schelling,

Bacon's rôle was less that of an investigator than an appraiser of human accomplishment and a guide with his face towards the future. Judged by what he accomplished, not what he missed, he remains a very great man.

X

The Musician Himself

IT remains to speak of the composers as human beings—what sort of persons they were, how they gained their musical education and earned their living, and whether they were sufficiently interested in other provinces of knowledge than music to be worthy citizens of a great country.

It must be admitted at the outset that our personal knowledge of them is very scanty, so much so indeed that the year and place of birth of but few of the composers is known with certainty. Consequently we are usually ignorant of such significant facts as their heredity, education, and friendships. Probably many of them were choirboys. Ravenscroft was a choirboy under Pearce, organist of St. Paul's. Orlando Gibbons as a boy sang in the choir of Kings College, Cambridge, under his brother, Edward Gibbons. Bull was in the Chapel Royal under Blitheman, and Byrd was said to have been a choirboy at St. Paul's. He, Thomas Tomkins, John Mundy, the younger Ferrabosco, Nathaniel Giles, and Hilton were sons of musicians. Camden and Heather, who founded the famous chairs of history and music at Oxford, are reputed to have been choirboys, and it has been conjectured that their friendship commenced at that time. Morley and Thomas Tomkins were pupils of Byrd.

There were, however, two honors that the composers of the day printed after their names with such regularity as to show how much they valued them. One was the degree of either Bachelor or Doctor of Music from Oxford or Cambridge. At Cambridge the first recorded recipient of the degree of Doctor of Music was a Thomas Saintwix, who took it about 1463, and at Oxford the important composer Robert Fayrfax, 1511. The first recorded baccalaureate degrees in music were

INTERIOR OF ST. PAUL'S: THE CHOIR

awarded toward the end of the fifteenth century, but such degrees may have been granted to others much earlier. The University of Dublin, founded 1591, gave its first musical degree to Thomas Bateson, the madrigal composer, in 1615. For such degrees at Oxford and Cambridge no examinations were required, and no lectures given, but an original composition and testimonials as to musical study and practice were necessary. What we would call an honorary doctorate was given to William Heather, because he founded a professorship in music. He was not a composer. We do not know if any other honorary degrees were conferred, but if they were, the recipients were composers and had to submit the required compositions. Various applicants were refused degrees. A university's written permission for the degree was called a "Grace."[1] It stipulated the kind of composition that the candidate must submit and recorded the number of years he had spent in the practice of music. This last information gives us some idea as to when the composer was born. Otherwise, these Graces lack interest. The title of Doctor is usually prefixed in Elizabethan books to the names of those holding that honor, but the appellation "Master" so often found was merely a token of respect. The degree of Master of Music, which has occasionally been granted in recent years at Cambridge but never at Oxford, did not exist in Elizabethan times. Recipients of musical degrees were usually at least thirty years of age. Dowland and John Mundy were young to receive their bachelor's degrees when they were about twenty-six. Mundy was not made a Doctor of Music until he was over sixty. Important composers to hold music degrees from Oxford were Bull, John Daniel, Dering, Farnaby, Nathaniel Giles, Jones, Morley, Peerson, Pilkington, Thomas Tomkins, Vautor, and Weelkes; and Farmer, Fayrfax, Edward and Orlando Gibbons, John Hilton the Younger, Edward Johnson, Ravenscroft, Tye, and Robert White took similar degrees at Cambridge.

[1] The Grace for Tye's Bachelor of Music degree has been quoted on p. 68, footnote.

[273]

The other highly valued honor was membership in the Chapel Royal. Gentlemen of the Chapel Royal included Fayrfax, Cornyshe,[2] Tallis, Byrd, Robert Parsons, Morley, Bevin, William Mundy, Orlando Gibbons, Thomas Tomkins, and Nathaniel Giles. Men like Thomas Tomkins were members without actually living in London, and it was the selection of such men as he that made membership in the Chapel Royal so highly prized. It is not possible now to reconstruct a picture of the exact duties of even the men of the Chapel Royal from day to day, and to do so for the composers in general would be still more difficult. Many were organists of cathedrals, such as Bateson, Bull, Byrd, Bevin, Michael East, Farmer, Ellis Gibbons, Morley, Pattrick, Thomas Tomkins, and Weelkes. Orlando Gibbons was one of the organists of the Chapel Royal and, at the end of his life, of Westminster Abbey. Others were choirmasters, or organists in less exalted positions, e.g., Carlton, the Hiltons, John Mundy, Peerson, Pilkington, Porter, Ravenscroft, and Yonge. Some were merely choirmen—"singing men" was the quaint term—such as Parsley, and the learned copyist John Baldwin. Lutenists were in demand, since one of them could entertain a company by singing and playing at the same time. Such were John and Robert Dowland, Daniel, Robinson (at the court of Denmark), Greaves (in a rich household), and Maynard (in a school). Some rich men loved music sufficiently to keep one or more musicians regularly in their employ. Such were likely to be lutenists, as Daniel and Greaves, but we are not certain regarding some of the following "household musicians" whether they were singers or players: Edward Johnson, who superintended the music for the Earl of Leicester during the famous visit of Queen Elizabeth to Kenilworth, Kirbye, Vautor, Ward, Wilbye, and Youll. The lutenist John Cooper (Coprario) instructed Prince Henry Stuart in

[2] Robert Fayrfax (d. 1521) was the leading English composer of his generation. William Cornyshe (c. 1465–1523) "was a noted composer, playwright, actor, and pageant master (and, curiously, on occasion, provider of guttering, paving, and even sanitary conveniences) about the court of Henry VIII" (Dr. Percy A. Scholes, *The Oxford Companion to Music*, 1938, p. 232).

music, and Ford was one of the prince's players or singers. That musicians were often poorly recompensed for their labors was attested by Weelkes, who wrote that "povertie hath debarred them their fellow arts mens companie."[3]

So far as comments have come down to us, leading musicians were highly respected. This was certainly true of Tallis, Byrd, and Case. The British Minister to Brussels made some scurrilous charges against Bull, but as Bull shortly afterwards was appointed organist of Antwerp Cathedral, and had previously served as one of the organists of the Chapel Royal for twenty years with distinguished honors from both Queen Elizabeth and King James, it is hard to credit them. Anthony Wood wrote that Nathaniel Giles "was noted for his religious life and Conversation (a rarity in Musicians)," but Wood lived after the Restoration. Many composers referred with apprehension to the criticism they expected would greet their works, and there consequently must have been considerable jealousy among musicians. Morley mentions this in the following imaginary dialogue:

Polymathes [to his Master, Morley]: Whereas you justly complaine of the hate and backbiting amongst the musicions of our countrey, that I knowe to bee most true, and speciallie in these young fellowes.[4]

Dowland was angry when Hume claimed that the viola da gamba was as fine an instrument as the lute, and Morley criticizes both the organ playing in St. Paul's and the book on theory published by William Barley. But these seem the only recorded instances of specific criticism by one Elizabethan composer of a English contemporary, and here neither Hume nor Barley is mentioned by name. Composers refer to each other by name only in terms of praise. On the other hand we hear little of friendships between the composers. That between Tallis and Byrd was remarkable. Morley always spoke of his teacher Byrd with reverence.

[3] Weelkes, *Balletts and Madrigals to five voyces*, 1598.
[4] Morley, *A Plaine and Easie Introduction*, p. 150.

The distinguished composer and organist Peter Philips studied music under Westcote, the organist of St. Paul's Cathedral, and lived in his house. Living with one's master was characteristic of the 'prenticeships of the time, and the incident points to the possibility that this custom extended to students of music. Westcote left his pupil £5.13s.4d. in his will.[5] Byrd and the elder Ferrabosco were on friendly terms, and perhaps Tye and Taverner, if any significance is to be attached to the fact that a motet "O Splendor Gloriae" was begun by the former and finished by the latter. Watson and Byrd were so grateful to John Case for effectively championing the cause of music that they wrote the words and music of the madrigal in his honor and had it published.

Many musicians were interested in other subjects besides music, and a number attained distinction in these fields. Several were students or "dons" at the universities. John Shepherd, who composed notable church music in the early part of the sixteenth century and died about 1563, was Organist and Fellow of Magdalen College. He may never have been a university student, but the college authorities evidently considered him a man of good judgment. Bathe studied at Oxford, but does not seem to have received any degree. John Case held the degree of Doctor of Medicine from Oxford and was a Fellow of St. John's College. Campion was Fellow of Peterhouse, Cambridge, and a "Doctor of Physic," a distinction which he must have received abroad. Dowland may possibly have attended Trinity College, Dublin, but whether he did or not he acquired a remarkably adequate education somewhere on his journey through life. Flud received from Oxford the degrees of Bachelor of Arts, Master of Arts, Bachelor of Medicine, and Doctor of Medicine. Watson studied poetry at Oxford and law in London. Charls Butler was a Master of Arts of Cambridge University. Several of the lesser composers were clergymen—Tye, Farmer, Carlton, Marson, Thomas Mudd, and Pilkington. Most of these were musicians

[5] Grattan Flood, *The Musical Times* for 1925, p. 718, and 1929, p. 312.

first and clerics afterwards, but Carlton got his Bachelor of Arts degree at Clare College, Cambridge, in 1577, and Mudd (not the John Mudd that Peacham names as one of the sixteen excellent musicians of England) was a Fellow of Pembroke Hall there. The epitaph to John Thorne (c. 1520–1573), organist of York Cathedral, mentions his skill in logic. Wood mentions the excellence of Morley and Byrd in mathematics, which the former learned from the latter. Dowland made a felicitous translation of Ornithoparcus' *Micrologus* into English. Morley owned a Greek lexicon and could use it, and he criticizes incorrect Greek etymology and scansion. As in the modern British tradition, the composers of Elizabeth's reign wore their learning both modestly and lightly. The connection of Richard Edwards, Richard Farrant, Robert White, Hunnis, Giles, Westcote, Pearce, Jones, and Daniel with the theatre has been cited in Chapter VII, although they were primarily musicians. Nicholas Laniere, Master of the King's Musick under Charles I and II, was an excellent connoisseur of art, and bought pictures in Italy for Charles I. But of all the musicians Campion astonishes us most, through both the extraordinary variety of his accomplishments and his proficiency in each. He studied law, and wrote both poetry and music of outstanding excellence, together with technical treatises dealing with the latter two subjects, also a considerable quantity of Latin verse; yet medicine was his profession, and he achieved contemporary recognition in that field as well as in music and poetry.

Indeed, a remarkable number of the composers were either passable poets or at least capable judges of poetry. Antony Holborne, who was a lutenist and gentleman usher to Queen Elizabeth, Allison, Cooper, Dowland, Leighton, Peerson, and Watson, all have left us samples of agreeable verse, and Richard Edwards was a prominent poet and dramatist of his time. Weelkes regretted that music was his only talent: "this small facultie of mine . . . is alone in mee, and without the assistance of other more confident sciences"; yet he wrote excellent dedications to his works. The dedication by Farnaby in which he mentions Chaucer

is neat. The poetry of the ayres is superior to that of the madrigals, possibly because the composers knew that doggerel could not escape detection when pronounced by a single voice; but in both cases the quality of the words is usually satisfactory. The texts set by Bateson and Ward are particularly good. At least five of the men were even able to write Latin verse. These were Campion, Dowland, Byrd, Antony Holborne, and Nathaniel Tomkins. On the other hand, only three composers can be named who wrote clumsy English—Whythorne, Thomas Tomkins (who as a linguist was strangely inferior to his brother Nathaniel), and old Dr. Tye. Tye, music master to Edward VI, wrote reams of doggerel, and was a clergyman but a poor preacher. Fortunately the musical compositions of both Tomkins and Tye are sufficiently admirable to atone for their literary deficiencies. It is just possible that the oblivion which engulfed Whythorne's madrigals was partly due to the wretched English of their preface.

Enough has been said to show the varied accomplishments and interests of a considerable number of the Elizabethan musicians. Their associations with the court, the theatre, the cathedrals, and the universities brought them in contact with stimulating and varied influences. They frankly admired the music of Italy and learned from it, yet they never composed to Italian words, but wrote characteristically English music, each in his own original style. Would that all later English composers had followed their example.

XI

Finale

IN the early sixteenth century Castiglione described the ideal Courtier
with his proficiency in the arts, and this ideal was wisely accepted
by the English. Years passed, and during the reigns of the first two
Stuarts musical taste changed, but not for the better. Interest in madri-
gal singing fell away, and in the reign of Charles I the sharp decrease
in music publishing betokened a declining regard for serious music.
When Cromwell rose to power the madrigal and ayre were already a
memory, but a second and final flowering of music for viols took place
—music that depended on the never-failing interest of well-written
counterpoint and beauty of line for its effect, not upon incisive rhythm
or sheer weight of sound. The Restoration brought back a Stuart, but
not the music of his forefathers. John Evelyn wrote in 1662:

Instead of the ancient, grave, and solemn wind musique accompanying
the organ, was introduced a concert of twenty-four violins between every
pause, after the French fantastical light way, better suiting a tavern or play-
house than a church.

For a time little flourished but the fashions of France, and Charles him-
self set the example for the nation by admiring only music to which he
could keep time with his foot. Toward the close of the century Purcell
provided an inspiring interlude, but after him came unpopular foreign
kings, a foreign composer, and foreign singers. For the depressing *finale*
let us turn to the words of the Sir Walter Raleigh of our own century:

The steady decadence of the English Court, in power and splendor, in-
evitably wrought a gradual emaciation in the ideal of the Courtier. When
Lord Chesterfield attempts to make a perfect Courtier of his son, the

changed conditions are felt at every line. . . . Where the men of the Renaissance hold that the perfect Courtier should be versed in all generous accomplishments, a warrior, a man of letters, a statesman, and skilled in all arts and pastimes, Lord Chesterfield makes it the duty of the man of fashion to be unable to do most things. "If you love music, hear it; go to operas, concerts, and pay fiddlers to play to you; but I insist upon your neither piping nor fiddling yourself."

To strike a happier note in conclusion, let us return to our sixteenth century and quote Castiglione's own description of his ideal Courtier:

And the Counte beginning a freshe: My Lordes (quoth he) you must know I am not pleased with the Courtyer if he be not also a musitien, and besides his understanding and couning upon the booke, have skill in lyke maner on sundrye instruments. For yf we waie it well, there is no ease of the labours and medicines of feeble mindes to be founde more honeste and more praise worthye in tyme of leyser than it. Do ye not then deprive our Courtyer of musicke.

Appendix A

THOMAS WHYTHORNE'S PREFACE TO HIS SET OF MADRIGALS, 1571

Of Musick though the chief knowledge hath long time hindered been,
Because vertu not be'ing maintained, soon ceaseth it is seen,
Yet through the good zeal of a few, who therein pleasure took,
No costs nor pains, it to preserv of long time they forsook,
Beside our princes charge of late to have it eft renew'd,
With verte'ous rulers under her, whose willingness is shewd,
Like loov of gentils and honest hath raizd it from low eb,

.

Part of the matteer or ditties that I have set heerto,
The Psalter, or Psalms of *David,* I have them taken fro.
To the rest of this have I set (the base minds for to pleas)
Such Sonets as I think will sum of their sowr dumps appeas,
Devizd upon common chaunces, and out of worldly wurks,
So, as the reason hath me taught, which in my rude hed lurks,
Sum of them be Poeticall, sum Philosophicall,
On sacred write, I made others to cumfort me withall,
In which is toucht th' affects of youth, the like of riper yeers,
Also of those that do decline, where cold old age appears.
Since erst I sayd, that heer among my Sonets there be sum
Poeticall, whose gods I uzd, as then in mind did cum:

.

Of Poetry thus here I end, my writing take at best,
My pen heerafter from such toys, shall alway be at rest.
This my said Musick made, do I, for voyces thus contrive,
To sum for thre, to most for four, and t'all the rest for five.

Of these songs sum be short, sum long, sum hard, sum easi bi,
And of both sorts between them both, ye shall emong them se,
Heerin bi divers songs also, the which altred have I
By mending of sum the Musick, of others the ditti,
So that they be not now, as they were when I first them gave
Out of my hands, abrode to serv their turns who now them have:
Also becaws sum songs heer bi, whose trades[1] perchauce b' unknown,
Not onely to such who in skill of singing ar well grown,
But eke to sum Musitians, who songs can well compose,
(That name belongs to none others, though sum theron do glose)
Eev'n such with the others (I say) I let them understand,
That I, A traueller have been, in sundry forrein land:
When I among the people did, a certaine time abide,
Whose divers trades[2] of Musick, part (although not all) I spide,
But chiefly the Italian, emong the which is one,
That called is Napolitane (a pretty mery one)

.

What I cowld write in Musicke prays, I will at this time stay,
And let you se what one famows, of that science doth say,
I mean the wurthy gentilman, Doctor *Haddon* by name,
Whose learned Muse, for Musicks sake, these verses thus did frame.

.

A third sort now I must heer towch, a sort of jangling jays,
Whose spightfull pens, to scof and skowld, is prest at all assays,
As Zoylus did to that Poet, who we do *Homer* call,
So wold these Zoylings have vertew unto their pens be thrall,
Therefore I say to the whole crew of all th'infected wights,
Momus' mates, and *Zoylings* (foresayd) who be'in such peevish flights,
That easi'er t'is for sum to find fawts written that doth lurk
Then it is for theim, theim t'amend and make perfect a wurk.

1 Ways, i.e. they were not of a kind known in England.
2 Ways, practices.

And easier it is for other sum t'amend fawts that do rise,
Than out of their brains by study, for to make or devise
A new wurk so great, and perfect in all points as that is,
In which they can amend the fawts, that they do spy amis.

．　　．　　．　　．　　．　　．　　．

Heer to conclude I say that I this wurk do not set owt
To greev any of those foresayd (of whom I may have dowt)
But I do it only therwith, Gods prays ech wher to sing
Together with heav'nly solas, to heavy harts to bring.
For privat use of baser thoughts, not aspyring so hy,
Which like to feed their fansies, all, on wurks that be wordly.
To recre'at th'over burdened, and·sore afflicted minds,
To cumfort eke the powrs and spreets, which man's helth brings and binds.
And so consequently to benefit ech part b'accord,
Of those that do delite to live, alway in trew accord.

<p align="center">FINIS.</p>

Appendix B

CANTIONES SACRAE by Tallis and Byrd, 1575. The Latin dedication by Tallis and Byrd, and Latin poems by Mulcaster and Ferdinando Richardson in honor of the music of Tallis and Byrd.

Serenissimae Principi Elizabethae Dei Gratia Angliae Franciae & Hiberniae Reginae &c virtutis & vitae fortunatum progressum.

Si nobis res esset, Serenissima Princeps, vel cum iis, qui artem Musicam, quia non norunt, non probant, vel cum iis, qui ipsi iudicio ex arte carentes eius praestantiam admirabili sonorum effectu metiuntur: Philosophos, Mathematicos, Rerum pub. architectos advocaremus, qui eius necessarium Reipub. usum argumentis & experimentia, vel infensissimo Musici nominis hosti extorquerent: Poëtas & allegorice docentes quosdam Physicos citaremus, qui apud homines imperitos illos quidem, sed incredibili tamen rei Musicæ admiratione delinitos facile impetrarent, cum ea arte nullam esse aliam quæ de principatu possit contendere. Sed cum apud tuam Maiestatem res agatur quæ delectu tuo iudicium tuum prodidisti, & canendi peritiam tibi probari, in eo probas omnibus, quod ei arti ita semper regie incubueris, ut in ea iam egregie profeceris, & cum summis artificibus comparata, vel vocis elegantia, vel digitorum agilitate facile illis praemineas, satis erit in tua solius scientia & iudicio conquiescere, neque pluribus ad fidem rei faciendam argumentis uti, ne vel dubitando suspicionem ementitae laudis videamur alicui ingenerare, vel nimis curiosa argumentatione, aliquid de tuae Maiestatis praestanti iudicio detrahere, quasi vel parum consideratè eam primo complexa fueris vel iam de priori sententia vacillare coeperis, cui si nostram operam probamus, omnibus eam probatam iri confidimus, cum iudicio tuo ab omnibus tantum tribuatur. Qua itaque es peritia, Illustrissima Princeps, ad tuam Maiestatem, ut iudicem confugimus, qua clementia ut ad patronam nos recipimus, quae prolem hanc nostram tua auctoritate sic apud omnes tueare, ut nos ipsos liberalissimo tuo stipendio hactenus aluisti. Confidentiae

THE DEDICATION BY TALLIS AND BYRD TO
QUEEN ELIZABETH

TO the Most Serene Sovereign Elizabeth by the grace of God Queen of England France and Ireland &c a happy increase in fortitude and length of days.

If, your Majesty, we were dealing either with those who do not approve of music because they are ignorant of it, or with those who because they have no musical taste judge its excellence by its pretty sounds, we would call in philosophers, mathematicians, and statesmen who by arguments and actual tests would wrest from even music's bitterest enemies an acknowledgment that it is essential to the state; we would summon poets and certain natural philosophers who teach allegorically, who would easily convince men lacking in skill indeed but captivated by their extraordinary admiration for music, that no other art can compare with music in importance. But since the matter is in the hands of your Majesty, who have already given your decision of your own free will and prove to all that skill in singing is approved by you in that you have always so devoted yourself royally to that art as to attain your present remarkable proficiency in it and when either artistic singing or skilful playing is the basis of comparison between yourself and the greatest performers you easily excel them, I am content to rest my case before your knowledge and musical taste, and to use no further arguments to win your favor for fear that by our hesitancy we may seem to be arousing the suspicion that our compositions are falsely praised, or by our excessive explanations to be impugning the keenness of your judgment, as if you had embraced that art with too little consideration in the beginning, or had now begun to change your mind; if we can convince you of the worth of our work we feel sure it will be approved by all, your judgment is held in such high esteem by everyone. Your wisdom is so based on practical experience, Most Illustrious Sovereign, that we have recourse to your Majesty as to a judge, your kindness is such that we turn to you as to a patron, in order that you may protect this child of yours by your authority before the world as you have so far supported us by your most generous

nostrae ignoscet Serenissima Maiestas tua, quòd tantum principem sic ausi simus interpellare, cum e solo voluntatis tuae testimonio pendeat, debeamusne ulterius in hoc genere progredi, an hoc uno libro labores nostros terminare. Deus opt. Max. Maiestatem tuam diu, incolumiter, fortunate nobis conservet.

Tuae Maiestatis
humillimi servientes,
Tho. Tall. &
Guil. Birdus

IN MUSICAM THOMÆ TALLISII,
ET GVILIELMI BIRDI

Quanti sit precii res Musica, quamque regendis
 Insanis animi motibus apta, docent,
Qui numeros formae sedem cuiuslibet esse,
 E quibus efficitur Musica forma, docent.
Quid! quod nemo docet, quonam Respublica pacto
 Formanda, & quonam prima inventa modo,
Quin idem doceat, primam quod Musica sedem
 Obtineat, primo sitque docenda loco.
Quid? quod & insignes medici, qui sana valere
 Corpora, & a morbis ante tuenda docent
Haec duo commendant nobis, ut corpora motus
 Conservet, mentem Musica sana regat.
Cum medicis, & philosophis annosa vetustas
 Conspirans hanc est tota sequuta viam.
Sed neque posteritas, quacum nunc vivimus, illam
 Non probat, aut a se prorsus abire iubet,
Quamvis certa loci, & rerum discrimina ponat,
 In quibus hanc nimiam non placet esse sibi.
Hoc tamen obtinuit communi Musica iure,
 Vt quo quisque sapit rectius, ornet eam.
Hoc etiam obtinuit, quo summo iure triumphet,
 Quo vivet, quamvis cætera mortis erunt,

bounty.[1] Your Most Serene Majesty will pardon our boldness in thus inter-
rupting you for so long, for it depends entirely upon the evidence of your
good will as to whether we should proceed further in this kind of work, or
should end our labors with this volume. May God, supremely good and
great, spare your Majesty to us for a long, safe, and happy life.

<div align="right">

Your Majesty's most humble servants,
THOM. S TALLIS and WILLIAM BYRD.

</div>

Richard Mulcaster's ᴾ*oem*

FOR THE MUSIC OF THOMAS TALLIS AND WILLIAM BYRD.

How valuable a thing music is, and how useful for checking the mad im-
pulses of the mind, is shown by those who teach that numbers constitute
the foundation of everything which has form, and that music is made up
of these. What shall I say of the fact that no one teaches how the state
should be regulated, and how it was originally brought about, without his
likewise teaching that music should have the chief place of honor, and be
taught above everything else? Furthermore, distinguished physicians, too,
who teach men how to have healthy bodies and guard them from disease,
advise these two things—that exercise should take care of the body, and
wholesome music govern the mind. Hoary antiquity agreed with the physi-
cians and philosophers, and with one accord followed in their footsteps. But
their posterity, with whom we now live, does not approve of it, or bids it
utterly begone, though it does assign definite bounds of place and circum-
stance within which it is unwilling for music to become too important.
Nevertheless, music has won this much by common consent: that the wiser
a man is, the greater honors he pays to music. It has even won this success,
in which it may exult with the greatest justification, through which it will
live though other things die: her Majesty, the glory of our age, counts it

[1] *Stipendium.* This included Tallis and Byrd's monopoly on music printing, granted
earlier that year, a lease of a Manor on the isle of Thanet to Tallis, and the salaries of
both Tallis and Byrd as Gentlemen of the Chapel Royal.

Regia Maiestas ætatis gloria nostræ
 Hanc in deliciis semper habere solet.
Nec contenta graves aliorum audire labores
 Ipsa etiam egregie voce manuque canit.
Hanc aliæ gentes, ut eam vel semper amarunt,
 Ausæ sunt scriptis nobilitare[2] suis.[,]
Illustres animae, quia, quae cecinere scienter,
 Non inviderunt omnibus illa cani.
Harum nostra prius magnos mirata labores
 Anglia, sed semper passa latere suos,
Tallisium, Birdumque duces iam nacta lubenter,
 Quae peperit, patitur pignora luce frui:[,]
Atque per externas gentes, quæ gratia prælo,
 Iudicio artificum discutienda vehi.
Tantum illis tribuit, quos primos deligit, ut sic,
 Iudicio patriae siquid honoris inest,
Nomen honoratum sibi promereatur uterque,
 Musica quà magnum pervia nomen habet,
Quorum iudicio fidens se pandit aperte
 Musica, quam Oceani Regia dives alit.

<div align="right">RICHARDUS MULCASTERUS.</div>

IN EANDEM THOMÆ TALLISII, ET GVILIELMI BIRDI MUSICAM.

Extera quos genuit tellus, cum nominis alma
 Musica præcones cerneret esse sui,
Illorumque opera per summa cacumina laudum
 Se celebrem vulgo conveniente vehi:
Orlandum numeros divina voce sonare,
 Edere & immensæ posteritatis opus,
Suavia Gombardum modulamina fundere dulcem,
 Clementum placidos concinuisse modos,

[2] Dr. Walton B. McDaniel suggests this emendation for *nobilitate*.

among her chief pleasures; and not content with listening to the serious works of others, she herself both plays and sings uncommonly well. Other nations, even as they have always loved music, have dared to ennoble it by their compositions—illustrious souls, because what they sang with skill they gladly gave to the world to sing. In former days our England admired the splendid works of these men but always allowed her own to lie in obscurity; but now that she has happily found leaders in Tallis and Byrd, to whom she gave birth, she allows her children to enjoy the light, and, such is the favor they have won in battle, to be carried through foreign lands for appraisement by masters of the art. So much does she attribute to those whom she selects as her leaders that, if there is any honor in the judgment of their native land, each of them merits an honored name wherever music, making its way, has a great name. Trusting in the judgment of these two men Music openly spreads herself, nurtured in the rich palace of Oceanus.[3]

<div align="right">RICHARD MULCASTER.</div>

Ferdinando Richardson's Poem

FOR THE SAME MUSIC OF THOMAS TALLIS AND WILLIAM BYRD.

When fostering Music perceived that her heralds had been born in foreign lands, and that she, now famous, was reaching the topmost pinnacles of glory by the assent of the multitude through the labor of these men— Orlando,[4] singing with his heavenly voice and composing his works for the ages, Gombert[5] pouring out his dulcet measures, Clemens[6] harmonizing his gentle strains, Alfonso,[7] the Phoenix of our time, creating songs[8] that Apollo

[3] The court of England, certainly, although Britannia did not "rule the waves" securely until she defeated the Armada, fourteen years later.

[4] Orlando di Lasso, b. at Mons, 1530 or 1532, d. at Munich, 1594. He was internationally famous as a choirboy because of his beautiful voice, and later became one of the greatest composers of the great sixteenth century.

[5] Nicholas Gombert, b. at Bruges, fl. about 1537, Des Pres' best pupil.

[6] Clemens non Papa, b. in Flanders, d. before 1558.

[7] Alfonso Ferrabosco the Elder, Italian, who lived chiefly in England from 1562 to 1578 and died in Turin, 1588.

[8] Some of the Latin musical terms used in Elizabethan times were exceedingly vague, e.g., *numeri, modulamina, modi, carmina, cantus,* and the verb *cano.*

Temporis Alphonsum nostri Phænica creare
 Carmina, quæ Phœbus vendicet esse sua:
Denique nominibus plena omnia talibus, Anglum
 In nullo impressum nomen habere libro.[,]
Pene subirasci coepit, nostro[s]que Britannos
 Indignos donis insimulare suis.
Quos certo scierat multum potuisse canendo,
 Miratur nullos edere velle lib[r]os,
Cuius cum cuperent tristem finire querelam,
 Tallisius magno dignus honore senex,
Et Birdus tantum natus decorare magistrum,
 Promittunt posthac non fore, ut ante fuit.
Cudendosque suos cantus, sua carmina curant,
 Illa aliorum oculis passus uterque legi.
Quæ quo iudicio sint edita, iudicet ille,
 Qui cum iudicio, quæ legit, illa legit.
Certe ego, si pueris rudibus censura daretur,
 Divino auderem dicere nata stylo,
Dignaque quae toto circumferrentur in orbe,
 Anglia quò cives iactitet esse suos[.]
Haec habui, venerande senex, mihi magne magister,
 Danda tibi mentis conscia signa meae.
Haec habui, iuvenis nostrae spes altera gentis,
 Quae fundo in laudem carmina nata tuam.
Communemque mihi tecum sic orno magistrum
 Carmine, ut Harmonici tu potes arte modi.
Quod si quando mihi dederit divina voluntas
 Musica cum linguis iungere ut arma queam,
Nulla voluntatis deerit pars debita nostrae,
 Quin debere mihi se quoque Musa putet.
Interea, mihi dum succrescit longior aetas,
 Haec vobis animi sint bona signa boni.

FERDINANDUS RICHARDSONUS.

might well claim as his own—in short, an overwhelming number of names,[9] with not a single printed book containing an English one[10]—she began to be almost angry, and to accuse our British composers as unworthy of her gifts. She is surprised that those composers whom she knew for certain to have great ability do not wish to publish their works. Because Tallis, an aged man worthy of great honor, and Byrd, who was born to adorn so great a teacher, wish to silence her gloomy complaints, they promise that the previous state of affairs shall not continue. They are carefully preparing their vocal compositions for the press, each having them read by others. The judgment shown in their publication may be judged by him who reads what he reads with judgment. I surely may presume to say, if inexperienced youths[11] were allowed to give their opinions, that they are written in a divine style and are worthy to be circulated the whole world over, so that England may say proudly they are her citizens.

I have composed these verses to be given to you, my revered senior and great teacher, as conscious tokens of my thoughts toward you. I have composed them expressly in praise of you also, the other and youthful hope of our race. Consequently, Byrd, I honor our common master with a *poem,* since your great powers lie in the field of *music.* But if ever the Divine Will shall give me the power to compose for voices accompanied by instruments, I shall dutifully strain every nerve, so that the Muse may recognize that she is indebted to me also. Meantime, as my years increase, may this be a pleasant token of my warm feelings toward you.

FERDINANDO RICHARDSON.

[9] Palestrina, the greatest composer of the time, is not mentioned by Richardson, and seems to have been little known in England.

[10] This is not strictly true. Several musical works were printed in England before the *Cantiones Sacrae,* including missals, Wynkyn de Worde's songs (1530), psalters, Tye's *Actes of the Apostles* (1553), several anthems by Tallis himself (1560–65), and Whythorne's madrigals (1571). Possibly Richardson had seen none of these, except surely the psalters.

[11] Richardson was merely a pen name used by Sir Ferdinando Heybourne (see p. 113). He was only about seventeen when he wrote this; *Grove's Dictionary* says he was born about 1558.

Appendix C

THE PRAISE OF MUSICKE,[1] BY JOHN CASE, 1586: EXCERPTS

Preface to the Reader. The author quotes various stories from antiquity to prove that music, although sometimes practised by unworthy men, is intrinsically noble:

If there bee any such foolish musicians as Arcabius was, having that fault whereof Horace speaketh,

Ut nunquam inducant animum cantare rogati,
Injussi nunquam desistant:[2]
That being praid to sing and shew their skil,
Cannot induced be, say what thou list:
But unrequested keepe a chaunting stil,
And from their folly never will desist.

Straightway musicke is wayward and troublesome, cunning men are either dangerous or phantasticall, as if to be skilfull, were a fault, or to be cunning, worthy reprehension. Great occasion & advantage of inveighing against this art, is taken of that saying which King Philip of Macedon used to his sonne Alexander when he rebuked him, for that he could sing so well and cunningly; as if we did allow the importunitie[3] of Nero, which is said, all a long sommers day, to have sitten in the Theatre, playing on his Harp. Musicke is so to be used of[4] Noble & Gentle men, as Achilles did in Homer: who after that bitter contention between him and Agamemnon, taking to him his harp, (whereon he had learned to play of Chiron the Centaure, who also taught him feates of armes, with Phisicke and surgerie) and playing thereon, sang the martial acts of the Princes of Grece, as Hercules, Perseus, Peritheus, Theseus, & his cosen Jason, & was therewith asswaged of his fury and reduced into his first estate of reason. And this in him was so commendable, that Alexander himselfe, after he had vanquished Ilion, being demanded of one, if he would see the harp of Paris, who ravished Helena: thereat gently smiling answerd, it was not the thing he much desired, but had rather see the harp of Achilles, wherewith he sang not the illecebrous delectations of Venus, but the valiant acts & noble affaires of excellent princes. Some, I doubt not, will exult to drawe a reproach of this art from the ancient Greekes, with whom it was at first in greatest estimation. But I would not have any man suppose that my purpose is in this treatise, otherwise to speake of that science, than so, as it may seem both worthy private delectation, for a mans proper

[1] For a summary, see p. 29, footnote. [2] Horace: *Satires,* Book 1, No. 3.
[3] Approve the inopportune action. [4] Of: by.

solace, and also publickly commodious in matters both civill & ecclesiasticall as in the process shalbe declared. And therefore I refer the reader, for the decent use hereof to the 8. booke of Aristotles *Politiques,* & the 7. chapter of Sir Thomas Eliot's 1st Book of his *Governour.*

If thou be unskilful and ignorant, think that I will not so mildely answer thee as Stratonicus answered King Ptolemy, A scepter o King is one thing and an instrument another.[5]

Chapter 1. The Antiquitie and Original of Musicke: first generally, then more particularlie set down. This tells of music in the days of the gods and the Greek heroes. Music's parentage, he says, is uncertain. The Muses claim her, "as may appear by christening her Musicke after their owne name." But some say the gods invented music. "For proofe hereof may serve the image of Apollo which stoode at Delos, bearing in the one hand his bowe and arrowes as being God of the archers, in the other the three graces with severall instruments as having soveraintie over the Musitians." Singing is ascribed to Jupiter, and the invention of the lyre to Mercury. The origin of the reed instrument called the Pshalme[6] is not so certain. Possibly the Muse Euterpe, or Ardalus the son of Vulcan first made it, but according to most, Minerva the daughter of Jupiter.

And because everie artificer loveth his owne worke, Minerva was delighted with her pipe, and used even in the assemblie of the gods to winde it: till such time till both they drave her both from her Musicke and their presence by laughing at her blowen cheekes. Shee to make triall of the matter went down to a river side, and beholding her swelling face in Neptunes glas bid her pipe farewell in a great choler, loathing & disgracing the same as much as it disfigured her.

Chapter 2. The Dignitie of Musicke proved both by the rewardes and practise of many and most excellent men. Among its friends—all of them of course from ancient Greece and Rome!—are mentioned Themistocles, Mark Antony, Julius Caesar, Nero, Galba, Vespasian, Diodorus, and Alexander the Great. The musician Terpander was called upon to quell a tumult of the Lacedemonians, and Greece ordained that the same men should be their sages, prophets, and musicians. Cimon of Athens and Epaminondas of

[5] ἕτερόν ἐσ[τ]ι τὸ σκῆπτρον καὶ τὸ πλῆκτρον, ὦ βασιλεῦ.
[6] Or *shalmey.* Cf. the *chalumeau* register of the clarinet.

Thebes were capable musicians, and Nero won a garland for his victory over the harpers. Socrates when "faire stricken in yeares, and having in a manner one foote in the grave, yet of an old master became a young scholer unto Conus for the attaining of this science." Nevertheless, some musicians have brought their profession into ill repute,

So that I marvel the lesse if Diogenes the cynick Philosopher, amongest other his dog-trickes put up a formal bil of inditement against the musicians in open and ordinarie court, for shewing greater skill in concordes and unisons of their notes, than unitie and consent of manners.

Antisthenes said of someone, "He is a naughty man: if he were honest he would never be a musician"; Case retorted that Antisthenes was a "Tom Fool."

Chapter 3. The Suavitie of Musicke. "I shall first therefore speak of the swetenes and delectation of Musicke: and afterwards of the use and necessity thereof." So by numerous anecdotes and examples he tells how by the nature of things music soothes and refreshes mankind, and, as he goes on to say, animals:

Neither do I here so attribute this delectation unto man, as denying it to other creatures, for I am verily persuaded, that the plowman & carter of whom I spake before[7] do not so much please themselves with their whistling, as they are delightsom to their oxen & horses. Again the warhorse is so inflamed with the sound of the trumpet, that he cannot keepe his standing, but maketh an open way to his rider, through the midst of his thickest enemies. And here may it please the reader for his recreation, to call to mind one speciall history of the Sibarits: whose horses were not only delighted with Musick, but also taught to dance to the instrument: insomuch that one of their musicions at a certain time, having some discurtesy & injury offred him took occasion to forsake his country, & fled to the Crotoniats, which were enemies to the Sibarits, forasmuch as not long before that time the Sibarits had given them the overthrow in battle. This tibicen, or plaier on the shalm, comming among the crotoniats, made his speech unto them to this purpose & effect, that if they could afford him credit, he wold work such a device, as they shold easily obtain the conquest of the Sibarits horsmen. Credit was given unto his tale, & he ordained captain of the war, instructed all the fluters and shalmers of the

[7] Chapter 3, page 43: "Even the ploughman and carter, are by the instinct of their harmonicall soules compelled to frame their breath into a whistle, thereby not only pleasing themselves, but also diminishing the tediousnes of their labors."

Crotoniates, what note they shold play, and how they should addresse themselves against their enimies. Now the Sibarites on the other side being insolent, & having taken hart & grace & courage unto them by reason of their former victory, prepare themselves to meete their enimies in the field. Wherefor the Shalmers of whome I spake before having received a watchworde of the Captaine, on a suddaine sounded their Flutes and Shalmes. The horses of the Sibarites hearing their country Musicke, whereunto they had beene accustomed, reared themselves on their hinder feete, cast their riders, and as they were wont to daunce at home, so now they did it in the skirmish, and by this policy, the Crotoniats wan the victory of the Sibarits. Whereby may be gathered not onely how pernicious clandestine treason is to a commonwealth, but also what strange & incredible delight musick impresseth even in these dumbe and unreasonable creatures. So mules are wonderfully alured with the sound of bels: & sheepe follow their sheepheards whistle. And it is recorded also, that the Hart and other wilde beastes are by sweete and pleasant notes drawen into the toiles and gins of the huntesman. Ælianus in his *varia historia* testifieth, that Pythocaris a musition playing upon his Cornet, mitigated the fierce and ravenous nature of wolves, and that the mares of Libia and Oliphantes of India woulde followe the sound of Organes and divers other instruments. Now as these terrestrial beasts have their peculiar and proper delightes, so aquaticall creatures also living in another element, offer themselves voluntarily to the sound of Musicke: so, as Martianus recordeth, certaine fishes in the poole of Alexandria are with the noice of instruments inticed to the bankes side, offering themselves to mens hands, so long as the melody endureth.[8]

Chapter 4. The Effects and Operation of Musicke. In the previous chapter the author proved the sweet influence of music by considering the causes, particularly the agreement that music has with our natures. In this chapter he shows its effects, recounting the extraordinary powers that music has of either rousing a man to action, or of changing his purpose altogether. Case, like medieval writers, unhesitatingly copies from Macrobius the remarkable effects of music written in the various ancient scales:

Modus Dorius is a giver of wisdom, and a causer of chastitie.
Lydius sharpneth dull wits, and to men oppressed with earthly cares, it bringeth a desire of heavenly things.

[8] Robert Burton in the *Anatomy of Melancholy,* Part 2, Sec. 2, Memb. 6, Subsec. 3, also testifies to the extraordinary effect of music on fishes, and quotes a traveler who "saith of whales, that they will come and show themselves dancing at the sound of a trumpet"; also a philosopher's statement that in a lake in Lydia "there be certain floating islands that after music will dance." Burton conscientiously tells us that he does not quite believe this.

Modus Phrygius provoketh to fight, and maketh courageous.

Aeolius quieteth the mind, & giveth sleepe to the Pacified senses.

Its medicinal effects were equally extraordinary:

Thales a musician of Creet, with the sweetnes of his harmonie, banished the plague from his citie. I durst in no wise affirme the last effect & operation of this worthie arte, were it not that Plato with his credite and authoritie did embolden me: "The chaunging of Musicall notes, hath caused an alteration of the common state." Likewise in Apulia when anie man is bitten of the Tarrantula, which is a certain kind of flie [!], verie venimous and full of daunger, they finde out the nature and sympathie of the sicknesse or humor, with playing on instrumentes, and with diversitie of Musicke, neither doe they cease from playing, untill the often motion and agitation, have driven the disease away.

Chapter 5. The Necessitie of Musicke.

Musicke, unlike a laboring mans garment, is not necessary to existence, but, like a gentlemans apparel, is profitablie necessary for the comlinesse of life. Pythagoras his Scholers, as Tullie recordeth were woont . . . to withdraw their mindes from intentive and deepe cogitations with singing and with instruments. Homer in the same sense termeth musicians Sophronistas, that is to say, Moderators or teachers of Temperance, and Strabo called them the masters and correctors of maners. . . . Aristotle considered that musicke ought to be accompted of and embraced, for that it is liberal. [Yet] hee counselleth noble men rather to use it for their private solace, than publicke ostentation. Jupiter is never made to sing, or to plaie upon any instrument, although they deny him not most exact knowledge and judgement. . . . In a word, Aristotle's resolution touching the civil necessity is, that musicke hath relation to these three things, to delectation, to discipline, and to an happy life. To delectation, because Musicke with the sweetness thereof doth refresh the minde and make it better able to greater labours. To discipline, because it is a cause of breeding in us chastitie, temperance, and other morall virtues. To an happy life, because that cannot consist without judgement and liberall delectations.

Chapter 6, The Use of Musick generallie in the course of our life, disappoints us, for its illustrations are drawn from classical life rather than from sixteenth-century England.

Chapter 7 concerns *The Particuler use of Musicke in Civill matters, especially in sacrifices, feasts, mariages and Burials;* "for I dare not speake of daunsing or theatricall spectacles, lest I pull whole swarmes of enemies upon me." One gathers, however, that he approves of dancing and plays under proper conditions.

[296]

Chapter 8 deals with *The Particular Use of musicke in war-like matters,* again chiefly among the ancients.

Chapter 9. The Lawful Use of Musicke in the Church confirmed by the practise of the church. The Puritans were opposed to all music in church except psalm-singing unaccompanied by instruments. A quotation from St. Jerome gives authority for this practice, but other passages from the Bible and early Fathers show that instruments, hymns, and antiphonal singing were used. The stricter Puritans objected to all three of these in church.

The ancient church of the Jews sang unto the Lord. When the Ark was brought to the city of David, the four thousand Levites song and made melodie, but David himself also sang, rejoiced, and daunced before it. When the temple was builded by Solomon, the Levites sang unto the Lord, songs of praise and thanksgiving, lifting up their voices with trumpets and Cimbals, and with instruments of Musick; which service the Lord did so gratefully accept, that hee vouchsaved his visible presence, and filled the temple with his glory. St. Paul said, I will sing with the spirit, but will sing with understanding also. [St. Jerome urges a woman to visit Jerusalem with the argument that she will find there] divers languages, but one religion, and so many quiers of singers as there is diversities of nations. . . . And in the same epistle they ad, *In christi villula.* Here in christ his village is no pride but al plainnes, and besides the singing of Psalms, nothing but silence. The husbandman holding the plough singeth Alleluia, the harvest man sweating at his labour doth solace himselfe with Psalms, and hee which cutteth the vines singing some Psalme of David. These are our verses in this countrie, these are our amarous songs.

The Western Church at first provided no music for its worshippers. Milan was the first of its congregations to sing anthems and hymns. St. Ambrose, its bishop, introduced them there, and psalms also, "least the people being in continual watchings and labor should faint and pine away for sorow." The psalms had been sung antiphonally in the church at Antioch, and Isidorus says St. Augustine first introduced the singing of anthems into his church, as done by the Greeks, antiphonally, "like the 2. Seraphins or the 2. testaments answering one another." The singing of hymns is mentioned in quotations from Jerome, Eusebius, Basil, St. Augustine, Theodoret, Epiphanius, and Rabbi Samuel. Case does not always trouble to quote verbatim:

For commandement it is said, Praise him with Virginals & organs, praise him with

cimbals, praise him with high sounding cimbals, let everie thing that hath breath praise the Lord Jesus Christ. Psalme 150.[9]

Chapter 10. The Lawful Use of Church Musicke proved by authorities out of the Doctours. The preceding chapter described the use of music in the early church; this sets forth the views of the church Fathers regarding the art. *St. Augustine* is quoted: "How great abundance of teares did I shed at the hearing of thy hymnes and Psalmes, and how inwardly was I moved with the voice of thy sweete singing congregation." And *Tertullian:* "Let Psalmes and hymnes be song even of two, and let them provoke one another, whether of them can sing better to his God." *Gregory Nazianzen* commended his sister Gorgonia because "she was skilful in singing and used it very often." *Athanasius* extols singing in church, "for the soule being made mery with the pleasant sound is brought to a sense and feeling of Christ, and most excellent and heavenly cogitations." Emperors approved it. *Constantine* "first began the psalme, praied together with the people." *Theodosius II* "went in the middest before them [the congregation] in the habite of a private person while they song their hymnes. When the emperor *Valens* entred into the church where Saint Basil preached hearing the sound of the psalms he was stricken as if it had been with thunder. When so ever" *Charles the Great* "came to anie cittie hee went to the Psalmody and sang him-selfe." Case admits that some of the later ecclesiastics "I confesse be earnest against pricksong and artificiall musicke in the church. . . . But I am so farre from allowing of the abuse, and of popish church Musicke, that I detest both the one and the other. Read the comments of Bullinger, Peter Martyr, Calvin, . . . and the Lutherans, and you shall find all the contention to be against the abuse: no one word against the right and lawfull use thereof."

Chapter 11. Sentences of the Scripture, for the use of Church Musick, are quoted.

[9] In this learned chapter Case quotes, naming book and chapter, from the Old and New Testaments, Isidorus, Pliny the Younger, Eusebius, Zozomenus, Nicephorus, Socrates Scholasticus, Athanasius, St. Augustine, St. Jerome, Hilary, Theodoret, Basil, Dionysus Alexandrinus, Hymni Ambrosii, Damasus, Platina, Bishop Jewel's answer to Master Harding, Gregory the Great, Epiphanius and Rabbi Samuel, fifty-eight quotations in all.

Chapter 12. A refutation of objections against the lawful use of Musicke in the Church. This chapter is illuminating, for it lists each of the Puritans' objections to church music, with an Anglican refutation.

Case divides the Puritans into two classes. Those holding moderate views dislike only singing by the minister, or by singing men deputed for the purpose, and though they cannot do away with exquisite and cunning music, nor instruments in the church, "thinke plainesong farre more meete for Gods congregation." They urge three objections to the use of ornate music in church, which are substantially as follows:

First Puritan Objection. Away with complicated music; all men should sing together.
Answer. Some cannot sing at all; why cannot they derive good from hearing others sing, as they do from hearing others pray?
Second Objection. Exquisite music contains too much repetition, and is hard to understand.
Answer. This objection contradicts itself; if the words are hard to understand, repetition will make them clear. Contrapuntal music generally uses words the people know well. The remedy is to train the choir to sing more distinctly.
Third Objection. "Cunning Musicke pleaseth more with the note than the matter."
Answer. The fault lies in the listener, not in the music. "When Augustine said he did sinne mortally when he was more moved with the melody than with the ditty that was sung," he did not "condemne Musicke and the sweete sound thereof, but his owne fraile and weake nature, which took occasion of offense at that, which in it selfe was good."

The other class of Puritans are extreme and would banish all music from the church. These urge as their

First Objection. "God is a spirite and will be worshipped in spirite and trueth."
Answer. God made both our bodies and our souls; surely he would have us worship him with both. When a singing man's manner of life contradicts his pious words, Gregory answers:

> "Non vox sed votum, non cordula musica sed cor,
> Non clamans sed amans cantat in aure Dei."

—Not your voice but your devotion, not your music but your heart, not your shouting but your love sings in the ear of God.
Second Objection. "Pricksong is not verbally nor literally commanded in the Gospell."
Answer. "Many things have beene very acceptable unto God, which had no expresse commandement in the Scriptures: As the precious box of spiknard, wherewith Marie Magdalen anointed his blessed feete."

[299]

Case concludes with a quotation from St. Augustine:

Austen saith of himselfe, That the voices of the singers did pierce into his eares, & Gods truth did distil into his hart, & that thence was inflamed in him an affection of godlinesse which caused tears to issue from him so that he felt himself to be in a most blessed and happy state. FINIS.

Appendix D

Prince. Doctor Tye,
 Our musick's lecturer? Pray draw near: indeed I
 Take much delight in ye.

Tye. In musicke may your grace ever delight,
 Though not in me. Musicke is fit for kings,
 And not for those know not the chime of strings.

Prince. Truely I love it, yet there are a sort
 Seeming more pure than wise, that will upbraid it,
 Calling it idle, vaine, and frivolous.

Tye. Your grace hath said, indeed they do upbraid
 That tearme it so, and those that doe are such
 As in themselves no happy concords hold,
 All musicke jarres with them, but sounds of good,
 But would your grace awhile be patient,
 In musicke's praise, thus will I better it:
 Musicke is heavenly, for in heaven is musicke,
 For there the seraphin do sing continually;
 And when the best was born that ever was man,
 A quire of angels sang for joy of it;
 What of celestial was revealed to man
 Was much of musicke: 'tis said the beasts did worship
 And sang before the deitie supernall;
 The kingly prophet sang before the arke,
 And with his musicke charm'd the heart of Saul:
 And if the poet fail us not, my lord,
 The dulcet tongue of musicke made the stones
 To move, irrationall beasts and birds to dance.
 And last the trumpets' musicke shall awake the dead,
 And clothe their naked bones in coates of flesh,
 T'appeare in that high house of parliament,
 When those that gnash their teeth at musicke's sound,
 Shall make that place where musicke nere was found.

Prince. Thou givest it perfect life, skilful doctor;
I thanke thee for the honour'd praise thou givest it,
I pray thee let's heare it too.

Tye. 'Tis ready for your grace. Give breath to
Your loud-tun'd instruments.

(Loud musicke)

Prince. 'Tis well: methinkes in this sound I prove
A compleat age,
As musicke, so is man govern'd by stops
And by dividing notes, sometimes aloft,
Sometimes below, and when he hath attaind
His high and lofty pitch, breathed his sharpest and most
Shrillest ayre; yet at length 'tis gone,
And fals downe flat to his conclusion.

(Soft musicke)

Another sweetnesse and harmonious sound,
A milder straine, another kind agreement;
Yet 'mongst these many strings, be one untun'd,
Or jarreth low or higher than his course,
Nor keeping steddie meane amongst the rest,
Corrupts them all, so doth bad man the best.

Tye. Ynough, let voices now delight his princely eare.

(A song)

Prince. Doctor, I thank you, and commend your cunning,
I oft have heard my father merrily speake
In your high praise; and this his highness saith,
England one God, one truth, one doctor hath
For musickes art, and that is Doctor Tye,
Admired for skill in musicks harmony.

Tye. Your grace doth honour me with kind acceptance,
Yet one thing more I do beseech your excellence,
To daine to patronize this homely worke,
Which I unto your grace have dedicate.

Prince. What is the title?

[302]

APPENDICES

Tye. The Actes of the holy Apostles turn'd into verse,
Which I have set in several parts to sing:
Worthy acts and worthily in you remembred.

Prince. I'll peruse them, and satisfy your paines,
And have them sung within my father's chapel.

(Later in the play Tye is present when Cranmer orders the Prince whipped by proxy, a boy named Browne suffering for the Prince's laziness in studies.)

Appendix E

A BRIEFE DISCOURSE, BY RAVENSCROFT, 1614:
PREFATORY POEMS[1]

In Approbation of this Worke.

IN former Age, among Musitians rare,
Regard was had of Measures then in use
And Characters; ordain'd by speciall care,
 Least after-Comers should the same abuse;
But forasmuch as those Composers Sage
 Occasion had not to apply each thing
Unto the divers Humours which this Age
 Hath studied out, and to the world doth bring:
I well approve this Authors Diligence,
 Who by his Labour Characters hath found,
To shew what heretofore by negligence
 Hath beene omitted, and for certaine ground
To make that plaine, that wanting was before
 In Measures, Times, Prolations well observ'd.
Wherein his Commendations is the more,
 His Songs, and Skill high Praise hath well deserv'd.

NATHANIELL GYLES Bachelar of Musicke,
 Maister of the Children of His Maiesties
 Chappels, of Household, and Windsor.

[1] I have omitted twenty-eight crabbed lines by John Davies of Hereford, and two
complete poems, viz. the sixth, by William Austin, who tells us that Ravenscroft "for
Love doth This, and not for Gaine"; and the eighth, which is a Latin poem of eight
lines by "T.H." entitled In Laudem huius opusculi.

Of this Ensuing Discourse.

Markes *that did limit* Lands *in former times*
None durst remove; somuch the common good
Prevail'd with all men; 'twas the worst of crimes.
 The like in Musicke *may be understood,*
For That *the treasure of the* Soule *is, next*
 To the rich Store-house of Divinity:
Both *comfort* Soules *that are with care perplext,*
 And set the Spirit Both *from passions free.*
The Markes *that limit* Musicke *heere are taught,*
 So fixt of ould, which none by right can change,
Though Use *much alteration hath wrought,*
 To Musickes Fathers *that would now seeme strange.*
The best embrace, which herein you may finde,
 And th' Author *praise for his good* Worke, *and* Minde.

<div align="right">THO: CAMPION.</div>

IOHN DOWLAND *Bachelar* of *Musicke,* and *Lutenist* to the *Kings*
 Sacred *Maiestie,* in commendation of this *Worke.*

Figurate Musicke *doth in each* Degree
 Require it Notes, *of severall* Quantity;
By Perfect, *or* Imperfect Measure *chang'd:*
 And that of More, *or* Lesse, *whose* Markes *were rang'd*
By Number, Circle, *and* Poynt: *but various use*
 Of unskild Composers *did induce*
Confusion, *which made muddy and obscure,*
What first Invention *fram'd most cleere, and pure.*
These, (worthy RAVENSCROFT) *are restrain'd by* Thee
To one fixt Forme: *and that approv'd by* Me.

<div align="center">[305]</div>

In the Most just praise of *Musicke*, this praiseworthy *Worke*,
and my deare, vertuous, and right expert friend,
the most judicious *Author*.

T*He ten-fold* Orbes *of* Heaven *are said to move*
 By Musicke; *for, they make* Harmonious din:
And all the Powres subordinate *above*
 Spend Time, *nay, spend* Eternity *therein.*

 · · · · ·

Thy Nature, Manners, *and thy* Notes *doe make*
 A Three-fold-Cord, to drawe all hearts it gaines:
Thy Musickes Cordes *hold Eares and Eyes awake*
 (*Yet lullaby in pleasure*) *with their Straines.*
So, then this latter Musicke (*though alone*)
 'T*wixt* Fame *and* Thee *doth make an* Unison,
Through which consent, though Deaths *clouds thee o'rerun*
Thy glory still shall shine, and cloud the Sun.

<div align="right">Io: Davies, Heref:</div>

In Approbation of this ensuing *Discourse;* and the *Author* therof
my deare friend, Maister Thomas Ravenscroft.

A*Rts are much alt'red from their* Pristine State,
 Humors *and* Fancies *so Predominate.*
Ould Artists *though they were* Plaine, *yet were* Sure,
Their Præcepts *and their* Principles *were* Pure:
But now a dayes We *scarce retaine the* Grounds,
W'are *so* Extravagant *beyond our* Bounds.
Among the Rest, Musicke (*that noble* Art)
In this sad Elegie *must* beare a Part;
Whose Purity *was such in times of yore,*
(*When* Theory *the* Practise *went before*)

<div align="center">[306]</div>

That then She *was had in as great* Esteeme
As now of Her *the* Vulgar *basely* Deeme.
Errors in Figures, Characters, *and* Note
Doe Now *cause many* Teach, *and* Learne by rote.
This my deare Friend *doth seeke heere to amend;*
Wherein he travail'd farre, great paines did spend
To right his Mother; *he seekes to reduce*
Her *to her auntient* Grounds, *and former* Use,
To beate downe Common Practise, *that doth range*
Among the Commons, *and her* Præcepts *change.*
Heere shall you finde of Measures *divers sorts,*
For Church, *for* Madrigalls, *for sundry* Sports;
Heere shall you finde true Judgement, *store of reading,*
All for the Ould true Rules *of* Musicke *pleading.*
Numbers of 3. *among the* Meane *respected*
Are hence exil'd, and (*worthily*) *rejected,*
As being crept in by Custome, *and* Use
Among the Vulgars, *which the* Wise *refuse.*
Much might be said more of this Little Booke:
But let the Reader *judge that on't shall looke.*
This of the Author *onely I will say,*
That in One poynt *to no man he gives way;*
Composing *of a* Song *unto some* Ditty
He is so Judicious *and so* Witty,
That waighing first the Nature *of each* Word
He findes fit Notes, *that thereunto accord,*
Making both Sound *and* Sence *well to agree;*
Witnesse his sundry Songs *of* Harmonie.
What shall I say more? this Worke *I approove,*
And for his Skill, *and* Paines *the* Author *love.*

<div align="right">

Martin Peerson
Bachelar of Musicke.

</div>

To my deare Friend Maister Thomas Ravenscroft, upon this *Worke*.

I *Prophesie* (deare Friend) *that thou which giv'st*
 The Dead *deserved* Bayes, *shalt while thou liv'st*
Never want Garlands *of that* Sacred Tree
To Crowne *thee in Aeternall memorie:*
Thou that hast made the dying Coales *to* Glowe
Of ould Ed: Piers *his name; which now shall growe,*
('Gainst all that envious or malicious bee)
In high Opinion *'mongst* Posteritie;
Nor shall they touch Worth *without* Reverence,
In whome once dwelt such perfect Excellence
In Heavn'ly Musicke; *I may call it so,*
If ould Pythagoras *said truely, who*
Affirm'd that the Sphaeres *Cælestiall*
Are in their Motion *truly* Musicall:
And Man, *in whome is found a humane* Minde,
(Then Whome, *(Angells except) who e're could finde*
A Nobler Creature) *some affirme consisteth*
Onely of Harmony, *wherein existeth*
The Soule *of* Musicke; *and yet (but for* Thee)
This Man *had dy'd to all mens memorie;*
Whose Name *(now cleans'd from rust) this* Worke *of thine*
(While there are Times *or* Men*) I doe devine*
Shall keepe Alive; *nor shall thy owne* Name *die,*
But by this Worke *live to* Æternitie:
And from it men hereafter shall pull out
Scourges, *to lash the base* Mechanicke Rout
Of Mercenary Minstrels, *who have made*
(To their owne scorne) this Noble Art, *a* Trade.

<div align="right">THO: PIERS</div>

De ingenuo Iuvene T.R. (annos 22. nato) *Musicæ Studiosissimo, huius Libelluli Authore.*

R Ara avis *Arte Senex* Iuvenis; Sed rarior est, si
　Aetate est juvenis, *Moribus* ille Senex.
Rara avis est *Author;* (poené est pars (1) *Nominis* una)　(1) *Ravenscroft.*
　Namque annis juvenis, *Moribus, Arte* Senex.
(2) Non vidit tria Lustra *Puer,* quin *Arte* probatus,　(2) *Ad annos*
　Vitâ laudatus, Sumpsit in *Arte* Gradum.　14. *Creatus est*
Quale fuit studium, *Liber* hic testabitur; in quo　*Baccalaureus*
　Vim, Vitam Numeris reddidit ille *Novam.*　*facultatis Mu-*
Quám bené castigat, malé quos induxerat *Usus*　*sica in Academ:*
　Errores, *Priscas* hîc renovando *Notas?*　*Cantabrig.*
　　Arte Senex, *Virtute* Senex, *ætate* Adolescens
　　I bone, *Rara avis es;* Scribe *bonis avibus.*

R. LL. Theo-muso-philus.

FINIS.

Appendix F

BALDWIN'S POEM AND DOW'S COMMENTS
ON COMPOSERS

John Baldwin was a tenor in St. George's Chapel, Windsor, from 1598 until his death in 1615. He wrote out (1) *My Ladye Nevells Booke,* consisting of virginal compositions by Byrd; (2) a MS book now in the British Museum (Royal Music Library, 24. D. 2.) containing motets and miscellaneous pieces and ending with the poem given below dated 1591; (3) Christ Church MSS 979–983 (part books); and (4) part books, not all in his handwriting, in the Bodleian (Music School MSS e. 376–381).

1. *Baldwin's Poem*

Reede here, behold and see all that musicions bee;
What is inclosde herein, declare I will begine.
A storehousse of treasure this booke may be saiede
Of songes most excelente and the beste that is made,
Collected and chosen out of the best autours
Both strainger and English borne, which bee the best makers
And skilfulst in musicke, the scyence to sett forthe
As herein you shall finde if you will speake the truthe.
There is here no badd songe, but the best cann be hadd,
The chiefest from all men; yea there is not one badd,
And such sweet musicke as dothe much delite yeilde
Both unto men at home and birds abroade in fielde.
The autours for to name I maye not here forgett,
But will them now downe put and all in order sett.
I will begine with WHITE, SHEPPER, TYE, and TALLIS,
PARSONS, GYLES, MUNDIE th'oulde one of the queenes pallis,
MUNDIE yonge, th'oulde mans sonne and like wyse others moe;
There names would be to longe, therefore I let them goe;
Yet must I speak of moe even of straingers also;
And first I must bringe in Alfonso FERABOSCO,

A strainger borne he was ain Italie as I here;
Italians saie of him in skill he had no peere.
Luca MERENSIO with others manie moe,
As Philipp DEMONTE the Emperours man also;
And ORLANDO[1] by name and eeke CREQUILLION,
Cipriano RORE: and also ANDREON.
All famous in there arte, there is of that no doute;
There workes no lesse declare in everies place aboute,
Yet let not straingers bragg, nor they these soe commende,
For they may now geve place and sett themselves behynde,
An Englishman, by name, William BIRDE for his skill.
Which I shoulde heve sett first, for soe it was my will,
Whose greater skill and knowledge dothe excelle all at this tyme
And far to strange countries abroade his skill dothe shyne;
Famous men be abroad, and skilful in the arte
I do confesse the fame and not from it starte;
But in Ewroppe is none like to our Englishe man,
Which dothe so farre exceede, as trulie I it scan
As ye cannot finde out his equale in all thinges
Throwghe out the worlde so wide, and so his fame now ringes.
With fingers and with penne he hathe not now his peere;
For in this worlde so wide is none can him come neere,
The rarest man he is in musicks worthy arte
That now on earthe doth live: I speake it from my harte
Or heere to fore hath been or after him shall come
None such I feare shall rise that may be calde his sonne.
O famous man! of skill and judgemente great profounde
Lett heaven and earth ringe out they worthye praise to sounde;
Ney lett they skill itselfe they worthie fame recorde
To all posteritie they due desert afforde;
And lett them all which heere of they greate skill then saie
Fare well, fare well thou prince of musicke now and aye;

[1] I.e., Orlando di Lasso. To facilitate reference I use capitals for the proper names;
Baldwin does not.

Fare well I say fare well, fare well and here end
Fare well melodious BIRDE, fare well sweet musickes frende
All these thinges do I speake not for rewarde or bribe;
Nor yet to flatter him or sett him upp in pride
Nor for affection or ought might move there towe[2]
But even the truth reporte and that make known to yowe
Lo! heere I end farewell committing all to God
Who kepe us in his grace and shilde us from his rodd.'

<div align="right">Finis Jo. BALDWINE.</div>

The above lines are poor poetry, but good criticism.

2. Robert Dow's Comments on Composers, in the Library of Christ Church, Oxford, MSS 984, 985, 986, 987, 988.

These five part books (Soprano, Alto, Contratenor, Tenor, and Bass) contain 133 sacred choral compositions and secular madrigals. Fifty-eight of the numbers are by his favorite composer "Wm. Birde," 18 by Robert White, 8 by R. Parsons, 6 by D[r]. Tie, 5 each by Strogers and Tallis, three by Orlando di Lassus, two each by Farrant, Alfonso [Ferrabosco the Elder], and Woodcock, one each by Bruster, John Bull, N. Giles, "Johnson," Mallorie, W. Mundaie, Francesco Mocheni, Phillips, Shepard, Tailer, and Taverner, and 17 are anonymous. On the first written page there is the following poem by Walter Haddon. All the words in the last four lines begin with *m*.

Ch. Ch. 984. Soprano Book.

<div align="center">

Gualterus Haddonus

Musicen primum docuit voluptas;
Musices auxit studium voluptas;
Musices usum retinet voluptas,
Gaudia fundens.
Musicen lusit placidus Cupido;
Musicen lusit Cytherea mollis;
Musicen lusit cythara suavi
Clarus Apollo.

</div>

[2] Thereto.

Musice mentes tenuit virorum;
Musice sensus tenuit ferarum;
Musice montes et aquas et ornos
 Sede removit.
Musice summis dominator astris;
Musice terrae dominatur imae;
Musice ponto dominatur alto,
 Cuncta pererrans.
Musica mentis medicina m[a]estae;
Musica multum minuit malorum;
Musice magnis, mediis, minutis
 Maxima mittit.

1581

Quisquis es hunc nostrum tacturus forte libellum
Seu quid voce vales seu cecinisse nequis:
Pupillam domini te contrectare putato;
Pars ea vult nitidas sic liber iste manus:

(Whoever you are that are by chance about to touch this little book of ours, whether you sing well or cannot sing at all, remember that you are handling the master's treasure; this Part wishes for clean hands, just as that book of yours does.)

Sum Roberti Dowi
Vinum et Musica Laetificant Cordas

(I belong to Robert Dow. Wine and music make the strings of the instruments rejoice.)

Ubi est concentus, ne effundas eloquium. Ecclesiastici 32.
(Where there is harmony, there is no need of eloquence.)

After No. 3, in all the parts:

Maxima musarum nostrarum gloria White
Tu peris aeternùm sed tua musa manet

(Thou diest, White, chief splendor of our art, but thy music abideth forever.)

[313]

After 7, by White:

Vinum et musica laetificant cor.

Spiritus tristis exiccat ossa.

(Wine and music gladden our heart. Doleful sighs dry out our bones.)

After 10, by Byrde, and the Alto part of No. 48 by R. Parsons:

Musica capitur omne quod vivit si naturam sequitur

(Music charms every living thing if it follows its true nature.)

After 25, by Strogers:

Non est harmonicè compositus qui Musicâ non delectatur.

(A man's nature is not harmonious if he takes no delight in music.)

After 36, by Byrd, in the Soprano, Contratenor, and Bass books:

Cantores inter, quod in aethere sol, bone Birde:

Cur arctant laudes disticha nostra tuas.

(Among singers, good Byrd, you are what the sun is in the sky; why should our distichs fetter your fame?)

CH. CH. 985. ALTO BOOK. At the bottom of the first page:

In Graecia Musici floruerunt, discebantque id omnes; nec qui nesciebat, satis excultus doctrinâ putabatur. Tusculana Prima. Cicero.

(In Greece musicians flourished, and all learned it; if anyone was ignorant of it his education was considered incomplete. Cicero: Tusculan Disputations, Book I.)

After 1, by White:

Ateas Scytha maluit audire hinnitum equi, quàm cantum praestantissimi musici Ismeniae; vox equi non hominibus.

(Ateas the Scythian would rather hear the whinny of his horse than the song of the most distinguished singer in Thebes; men do not have horses' voices.)

After 41:

Cicero ad Atticum lib. 4º. Britannici belli exitus expectatur; etiam iam cognitum est, neque argenti scrupulum esse ullum in ea insula, neque ullam spem praedae, nisi ex mancipiis, ex quibus nullos puto te literis aut musicis eruditos expectare.

[314]

Unus Birdus omnes Anglos ab hoc convicio prorsus liberat.

(The end of the British war is expected; it is certainly clear by this time that there is not a trace of silver on the island, nor is any plunder expected, except slaves, and I do not think you will find a single person that knows anything about writing or music among them.

One man alone—Byrd—is enough to free the English completely from this reproach.)

CH. CH. 986. CONTRATENOR BOOK

After 1, by White, in this and the Tenor books:

> *Non ita moesta[8] sonant plangentis verba Prophetae*
> *quam sonat authoris musica maesta[8] mei.*

(Not even the words of the gloomy Jeremiah sound so sad as the sad music of my composer.)

After 34, by Byrd:

> *Birde suos iactet si Musa Britanna clientes;*
> *Signiferum turmis te creet illa suis.*

(Byrd, if the Britannic muse should parade her supporters, she would appoint you standard bearer for her regiments.)

After 42, *O sacrum convivium* by Tallis:

> *Tallisius magno dignus honore senex[4]*

(The aged Tallis, deserving of great honor.)

After 70, by Birde, in the second handwriting, and the Bass part of 25 by Strogers:

> *Sicut in fabricatione auri signum est smaragdi:*
> *Sicut numerus musicorum in iucundo & moderato vino.*

(Music with pleasant wine that is taken in moderation is like an emerald set in gold.)

CH. CH. 987. TENOR BOOK.

[8] It must have given Dow, as a true Elizabethan, great pleasure to find a Latin word that he could spell in two different ways on successive lines. Few such Latin words exist.

[4] Quoted from Ferdinand Richardson's prefatory poem to Tallis and Byrd's *Cantiones Sacrae*, 1575.

After 35, by Parsons. Usually these Latin *sententiae* have been used to fill in blank lines. There is no such space here, but the poet was evidently determined to honor Parsons rather than be neat:

> *Qui tantus primo Parsone in flore fuisti*
> *Quantus in autumno ni morerere[5] fores*

(Thou who wast so great in the springtime of life, Parsons, How great thou wouldst have been in the autumn, had not death come.)

At the end of *Sive vigilem,* 37, by William Mundy, the composer's name is punningly written *Dies Lunae* (Monday), and the further pun:

> *Ut lucem solis sequitur lux proxima lunae*
> *Sic tu post Birdum Munda secutus erat*

(As the light of the moon follows next after that of the sun, so thou, Mundy, hast followed Bird.)

After 42, *O sacrum convivium* by Tallis. The second line also occurs after the Contratenor part of 42.

> *Quatuor illustris vixit sub Regibus iste*
> *Tallisius magno digno honore senex.*
> *Sub quibus eximius si musicus esset habendus*
> *Tallisius semper gloria prima fuit*

(Renowned Tallis lived under four monarchs, an aged man deserving of much honor. If in their time a musician ought to have been held distinguished, Tallis was always their chief glory.)

51 is by Alfonso Ferrabosco "Italus" and 52 by "Gulielmus Birde Anglus."

CH. CH. 988. BASS BOOK. After 7, by White:

Agamemnon abiens ad bellum Troianum domi reliquit musicum, tum excellentis artis, ut Ægisthus potiri Clytemnestra non potuerit nisi musico occiso. H[ieronymus] Cardan [1501–1576], de Sap.

(When Agamemnon departed for the Trojan War he left at home a musician, of such unusual ability that Aegistheus could not win Clytemnestra until the musician was killed. Girolamo Cardan, *de Sapientia.*)

[5] *Morerere,* from *morior,* is my emendation for *morete,* which is not a word at all and does not fit the scansion of the dactylic pentameter.

After 20, by Tallis:

Talis es et tantus Tallisi musicus, ut si
Fata senem auferrent musica muta foret

(Thou art so renowned and great a musician, Tallis, that if fate should carry thee away in thine old age, music would be mute.)

After 27, an elaborate decoration and

Mr. Wm. Byrde.
Musica mentis medicina maestae

quoted from Haddon's poem.

After 33 by Byrd:

Qui decus es generi genti Philomelaque nostrae;
Birde precor longùm voce manuque canas!

(How you grace our nation and race, O nightingale; I pray you, Byrd, may you long give us music with your voice and fingers!)

After 34 by Byrd

Musica vel ipsas arbores et horridas movet feras

(Music moves the very trees and savage beasts.)

After 43, by:

Magister Thomas Tallis. Mortuus est 23º Novembris 1585
Supultus Grenovici in Choro Ecclesiae parochialis

We have here both the date of Tallis' death, and the place of his burial—Greenwich parish church.

After 48 by Parsons:

Musica laetificat corda

(Music makes glad our minds.)

Appendix G

ANTHONY WOOD'S COMMENTS ON COMPOSERS, 1691–2

ANTHONY WOOD (1632–1695) who was born, was educated, and died at Oxford, sketched the careers of Oxford University men of prominence in his *Athenae Oxonienses*. The second half of each volume consists of *Fasti Oxonienses,* listing under each year the prominent candidates and graduates of that year, with their degrees, often with comments. Below are given only the names of those whom he mentions as "celebrated in their time" or "eminent in their profession."

B. Mus. 1502 HENRY PARKER

B. Mus. 1509 JOHN WENDON

B. Mus. 1509 JOHN CLAWSEY

D. Mus. 1515 ROBERT PERROT, B. Mus.

B. Mus. 1521 JOHN SYLVESTER

D. Mus. 1548 CHRISTOPHER TYE, incorporated f. Cambridge "Was much in renown for his admirable skill in the Theoretical and Practical part of Music. . . . We have also some of his Compositions among the ancient Books in the Public Music School, of Six parts, but long since, with others of that time, antiquated, and not at all valued."

B. Mus. 1550 JOHN MERBICK or MARBECK; supplicated; whether he was granted the degree "appears not."

B. Mus. 1586 JOHN BULL. *"John Bull* who had practised the Fac. of Music for 14 years was then admitted Batch. of Music.—This Person, who had a most prodigious Hand on the Organ, and was famous throughout the Religious world for his Church music (the words of some of which are extant) had been trained up under an excellent Master named *Blithman* Organist of Qu. *Elizabeth's* Chapel, who died much lamented in 1591. This *Blithman* perceiving that he had a natural Geny to the Faculty, spared neither time nor labour to advance it to the utmost. So that in short time he being more than Master of it, which he showed by his most admirable compositions, played and sung in many Churches beyond the Seas, as well as at home, he took occasion to go incognito into *France* and *Germany*. At length hearing of a famous Musician belonging to a certain Cathedral, (at St. Omers as I have heard) he applied himself as a Novice to him to learn something of his Faculty, and to see and admire his Works. This Musician, after some discourse had passed between them, conducted *Bull* to a Vestry, or Music School joyning to the Cathedral, and shew'd to him a *Lesson or Song of forty parts,* and then made a vaunting Challenge to any Person in the World to add one more part to them,

supposing it to be so compleat and full, that it was impossible for any mortal Man to correct, or add to it. *Bull* thereupon desiring the use of Ink and rul'd Paper, (such as we call Musical Paper) prayed the Musician to lock him up in the said School for 2 or 3 Hours; which being done, not without great disdain by the Musician, *Bull* in that time, or less, added *forty more parts* to the said *Lesson or Song.* The Musician thereupon being called in, he viewed it, tried it, and retry'd it. At length he burst into a great ecstasy, and swore by the great God that *he that added those 40 parts, must either be the Devil or Dr. Bull* &c. Whereupon *Bull* making himself known, the Musician fell down and ador'd him. Afterwards continuing there and in those parts for a time, became so much admir'd, that he was courted to accept of any Place Preferment suitable to his Profession, either within the Dominions of the Emperor, King of *France,* or *Spain.* But the tidings of these Transactions coming to the English Court, Qu. *Elizabeth* commanded him home. See more of him under the Year 1592. [This 1586 entry and the next are quoted by me in full.]

[1592] *John Bull* Doct. of Music of the said Univ. of *Cambridge* and one of the Gentlemen of her Maj. Chappel, was incorporated the same day [that Edw. Gibbons Batch. of Music of Cambridge became B. Mus. Oxon.], July 7. This was the same person who was admitted Batch. of Music of this University, An. 1586, as I have told you under that Year, and would have proceeded in the same place, had he not met with Clowns and rigid Puritans there that could not endure Church Music. He was afterwards the first Music Lecturer of *Gresham* Coll. at *London,* and one of three (*Will. Bird* and *Orlando Gibbons* being the other two) that composed and published a Book entit. *Parthenia; or, The Maidenhead of the first Music that ever was printed for the Virginals.* Printed at *London* in fol. but not said when, either in the Title, or at the end. The Book contains 21 lessons printed off from Copper cuts, and was the prime Book for many Years that was used by Novices and others that exercised their hands on that Instrument. There is no doubt but that this Doctor *Bull* hath published other things, besides the making of very many Compositions to be sung and play'd; which being thrown aside upon the coming out and publication of others by other hands, have been since in a manner lost, such is the fate of Music, as well as of Poetry. After the death of Queen *Elizab.,* he became chief organist to K. James I [and] was so much admired for his dextrous hand on the Organ, that many thought that there was more than Man in him. At length being possess'd with Crotchets, as many Musicians are, he went beyond the Seas and died, as some say, at Hamborough [Hamburg?]; or rather, as others who remembred the Man have said, at Lubeck.[1] His Picture hangs at this day, at the upper end of the public Music School in the University of Oxon."[2]

B. Mus. 1588 THOMAS MORLEY. "This Person, Tho' he had not so excellent a hand on the Organ as BULL had, yet his compositions were admirable in their time. [Five are

[1] He died at Antwerp.
[2] And still does in the twentieth century, only a few yards away.

named, ending with:] Introduction to Music, Lond. 1597, &c. in a thin fol. This last Book, which shews the Author to have been admirably well skill'd in the Theoretic part of Music, hath afforded some matter to Christoph. Simpson when he composed his *Compendium of Music*, but more to the Author of An Introduction to Music, Lond. 1655,[3] &c. oct[avo] published by *John Playford*."

B. Mus. 1588 "JOHN DOWLAND one of the Gent. of Her Majesty's Royal Chappel, was then also with Tho. Morley adm. Batch. of Music.—He enjoyed the same place also when King James I. came to the Crown, being then esteemed a most admirable Lutinist; about which time an Anagram was made on his name (Johannes Doulandus) running thus, annos ludendo hausi. He was the rarest Musician that his Age did behold, and therefore admired by Foreign Princes, among whom the King of Denmark was one, who being infinitely taken with his playing, when he was in *England* to visit his sister the Queen, *An.* 1606, took him with him at his return to *Denmark;* where, as 'tis suppos'd, he died . . ." [Wood by oversight omits his name from the general index.]

B. Mus. 1592 GILES FARNABIE "An eminent Musician." [His *Canzonets* of 1598 are mentioned, nothing else, and without praise.]

B. Mus. 1592 GEORGE WATERHOUSE "Supplicated for the degree of Batchelor but was not, as I can find, admitted." [Strange in view of Morley's praise of his contrapuntal skill.]

B. Mus. 1592 "EDW. GIBBONS Batch. of Music of *Cambridge* was then Incorporated in the same Degree—He was now, or about this time, the most admired Organist of the Cath. Ch. at Bristol, was Brother to the incomparable *Orlando Gibbons* whom I shall mention elsewhere, and Brother also to Ellis Gibbons, who hath several compositions in The Triumphs of Oriana."

D. Mus. 1592 JOHN BULL [see following the 1586 entry]

M. A. 1592 "HEN. NOEL Esq . . . was one of the Gentlemen Pensioners to Qu. *Elizabeth,* a Man of excellent parts, and well skill'd in Music. '

B. Mus. 1593 "MATT. JEFFRYE vicar choral in the Church at Wells." He and "George Jeffrye . . . were both eminent Musicians."

B. Mus. 1595 "FRANC. PILKINGTON who being a most excellent artist, his memory was celebrated by many persons, particularly by Sir *Aston Cockain* Baronet, who hath written[4] his Funeral Elegy and his Epitaph."

M. A. 1595 "GEORGE FEREBE . . . well skill'd in Music, did instruct divers young Men of his Parish in that Faculty, 'till they could either play or sing their parts." Then dressed as a bard and shepherds, they serenaded Queen Anne (wife of James I) "on the Downes at Wensdyke . . . to the great liking and content of the Queen and her Com-

[3] *Introduction to the Skill of Musick,* written by John Playford the Elder, 1654. 2d ed., enlarged, 1655. The second part consisted of Campion's rules for composing music in parts.

[4] In his choice *Poems of several sorts,* &c. London, 1658, p. 113.

pany." He later became "Chaplain to his Majesty, and was ever after much valued for his Ingenuity."

B. Mus. 1600 Wood says eighty-nine were admitted this year as Bachelors of Music, but comments on none except Roger Matthew, who was also a poet.

B. Mus. 1602 "WILL. WEELKS. *Quaere* whether the Scribe or Registrary of the University, hath not set down *William,* for *Tho. Weelks.*"[5] Twelve lines are here devoted to Thomas Weelkes and his compositions, but without comment.

B. Mus. 1604 JOH. DANIEL. No criticism.

B. Mus. 1606 "THOM. TOMKINS of Magd. Coll. This eminent and learned Musician was Son of *Thom. Tomkins* Chauntor of the Choir at *Glocester,* descended from those of his name of Listwithyel in Cornwal, Educated under the famous Musician Will. *Bird,* and afterwards for his merits was made Gentleman of His Majesty's Chappel Royal, and at length Organist, as also Organist of the Cath. Church at Worcester. [Compositions follow.] He had a Son named *Nath. Tomkins* Batch. of Div. of *Oxon.,* who was Prebendary of *Worcester* from the Month of *May* 1629 to the 21. of *Oct.* (on which Day he died) An. 1681, as also several Brethren, among whom were (1) Giles Tomkins a most excellent Organist, and Organist of the Cath. Ch. at *Salisbury,* who died about 1662. (2) *Joh. Tomkins* Batch. of Music, who was one of the Organists of St. *Paul's* Cathedral, and afterwards Gentleman of the Chappel Royal, being then in high esteem for his admirable knowledge in the theoretical and practical part of his Faculty. At length being translated to the Celestial choir of Angels on the 27. Sept. An. 1626, Aged 52, was buried in the said Cathedral. (3) *Nich. Tomkins* one of the Gentlemen of the Privy Chamber to his Majesty K. Charles I. who was also well skill'd in the practical part of Music; and others, but their order according to seniority I cannot tell."

1607 ORLANDO GIBBONS was incorporated at Oxford as an M. A. of Cambridge. [But he never was M. A. Cantab. and Joseph Foster thinks it an error for B. Mus. Yet if so incorporated as B. Mus., why did he supplicate for the B. Mus. in 1622?]

B. Mus. 1608 WILL STONARD. Information, but no criticism.

B. Mus. 1610 "RICHARD DEERING" supplicated for the degree and probably got it, because soon afterwards he styled himself Bachelor of Music. "This person . . . was bred up in *Italy,* where he obtained the name of a most admirable Musician. After his Return he practised his Faculty for some time in *England,* where his name" was "highly cried up." Wood then names later events: service as Catholic organist to the English nuns in Brussels, later to Queen Henrietta Maria, and exile during the Commonwealth.

B. Mus. 1613 "MARTIN PEARSON—He was afterwards Master of the Choristers of St. Pauls Cathedral, while *Joh. Tomkins* was Organist, and a composer of certain *Church Services and Anthems.*" Died 1650. "Whereas most Musicians die obscurely and in a mean condition, this died so rich, as to leave to the poor of *Marsh* in the Parish of *Dunnington* in the Isle of *Ely* an hundred Pounds to be laid out for a Purchase for their yearly use."

[5] Wood's supposition is probably correct.

B. Mus. 1616 "JOHN VAUTER of Linc. Coll." No comment at all.

B. Mus. and D. Mus. May 17, 1622. "Orlando *Gibbons*" supplicated for both degrees, but was refused The Baccalaureate and is not mentioned for the Doctorate. [Gibbons did, however, receive the degree of Doctor of Music on this occasion, at the request of his friend Heather. Wood also writes,] "This Orlando, who was accounted one of the rarest Musicians and Organists of his time, hath extant a Set of Madrigals, a hand in Parthenia . . . services and Anthems . . . besides admirable Compositions that are printed in several Books of Music." He died at Canterbury "of the Small-pox to the great reluctancy of the Court, on the Day of Pentecost, An. 1625. Afterwards was a Monument over his grave in the body of the Cathedral there . . . set up at the charge of Elizabeth his Widow . . ."

B. Mus. and D. Mus., May 17, 1622. "WILL. HEATHER or Heyther" was granted both these degrees, a composition by Gibbons being performed in place of the one that would normally have been required of Heather. [Heather founded the Heather Professorship of Music at Oxford in 1626/27, but was not a skilled composer. We should call his degree an honorary one.]

D. Mus. July 5, [1622] "NATHANIEL GILES Batch. of Music. . . . In the Act this year, wherein he proceeded, were certain questions appointed to be discussed between him and Dr. *Heather* afore-mentioned, which being pro forma only, and not customarily to be done, were omitted. The questions were (1) *Whether Discords may be allowed in Music?* Affirm. (2) *Whether any artificial Instrument can so fully and truly express Music as the natural Voice?* Negat. (3) *Whether the practise be the more useful part of Music or the Theory?* Affirm. This Dr. *Giles,* who was noted as well for his religious life and Conversation (a rarity in Musicians) as for the excellency of his Faculty was . . . famous for his compositions of *Divine Hymns and Anthems* . . ." [His posts are mentioned. Wood's opinion of the private lives of musicians is evidently not high. What a pity we do not know Giles's opinions on discords!]

1623 B. Mus. "HUGH DAVYS of New Coll. Organist of the Cathedral Church at Hereford.—He was eminent for the various Compositions of Church Music that he had made, which is all I know of him, only that he died about 1644."

1624 D. Mus. "JOHN MUNDY. Batch. of Music and Organist of his Majesty's Chapel within the Castle of Windsor." He was "in high esteem for his great knowledge in the Theoretical and Practical Part of Music." His compositions are enumerated.

ST. PAUL'S CATHEDRAL CHURCH
1616

Bibliographies

PRINTED TUDOR AND JACOBEAN MUSIC AND MUSICAL TREATISES

The British Museum library contains copies of nearly all of these. But the Bodleian Library, the Library of Congress, the New York Public Library, the Folger Shakespeare Library and the libraries of Cambridge University, Christ Church (Oxford), the Royal College of Music, the Royal Academy of Music, and St. Michael's College at Tenbury all contain important works of this type. Dates given are those of first editions. Several manuscripts mentioning something of value also are included in the bibliography. The catalog of the British Museum should be consulted for titles of Elizabethan compositions printed separately by modern publishers, but three general collections are described below:

ENGLISH MADRIGAL SCHOOL SERIES ("E.M.S."), 36 vols., 1913–24. Edited by Rev. Dr. Horace Fellowes.

ENGLISH SCHOOL OF LUTENIST SONG WRITERS ("E.S.L.S."), 32 publications, in two series: 1:1–15 and 2:1–17. 1920–32. Edited by Rev. Dr. Horace Fellowes.

TUDOR CHURCH MUSIC. 10 vols. 1923 ff. Edited by Dr. R. R. Terry and others.

Adson, John, 1611: *Courtly Masquing Ayres Composed to 5. and 6. Parts, for Violins, Consorts and Cornets.* In the Bodleian and Christ Church Libraries. Reprinted by the New York Public Library, 1935.

Alford, John, 1568: *A Briefe and Easye Instruction to learne the tableture, to conduct and dispose the hande unto the Lute. Englished by J. A.* A translation of Adrien le Roy's book.

Allison, Richard, 1599: *The Psalmes of David in Meter.*

Allison, Richard, 1606: *An Howres Recreation in Musicke.* E.M.S. 33.

Amner, John, 1615: *Sacred Hymns of 3. 4. 5. and 6. parts for Voices and Vyols.* Anthems, mostly one note to a syllable.

Aston, Hugh (born c. 1485): church music in *Tudor Church Music,* Vol. 10. 1929.

Attey, John, 1622: *First Booke of Ayres of Foure Parts.* E.S.L.S. 2:16.

Bacon, Sir Francis, 1627: *Sylva Sylvarum.*

Bacon, Sir Francis, 1688: *Historia . . . Soni.* Written earlier than *Sylva Sylvarum.*

Baldwin, John: MS commonplace book.

Barley, William, in 1596 printed *A nevv Booke of Tabliture* (compositions and lessons for lute). Reprinted 1966 as *Lute Music of Shakespeare's Time. William Barley* . . . arr. for piano by W. W. Newcomb.

Barley, William, in 1599 printed *The Pathway to Musicke contayning sundrie familiar rules for the ready understanding of the scale.*

Bartlett, John, 1606: *A Booke of Ayres.* E.S.L.S. 2:10.

Bateson, Thomas, 1604: *The First Set of English Madrigales.* E.M.S. 21.

Bateson, Thomas, 1618: *The Second Set of Madrigales.* E.M.S. 22.

Bathe, William, 1584: *A Briefe Introduction to the true art of Musicke.*

Bathe, William, 1600: *A Briefe Introduction to the skill of Song.*

Bennet, John, 1599: *Madrigalls to Foure Voyces.* E.M.S. 23.

Bennet, John, contributed a madrigal to *The Triumphes of Oriana,* 1603.

Bennet, John, contributed five hymn tunes to Barley's *Psalter* (after 1604).

Bennet, John. Six compositions in Ravenscroft's *A Briefe Discourse,* 1614.

Bevin, Elway, 1631: *A Briefe and Short Instruction of the Art of Musicke.*

Brade, William, 1609: *Musikalische Concerten.* Hamburg.

Brade, William, 1609: *Newe ausserlesene Paduanen, Galliarden, Cantzonen, Allmand und Coranten. . . .*

Brade, William, 1614: *Newe ausserlesene Paduanen und Galliarden. . . .*

Brade, William, 1617: *Newe ausserlesene liebliche Branden, Intraden, Mascharaden, Balletten. . . .*

Brade, William, 1619: *Melodiensis Paduanis. . . .*

Brade, William, 1621: *Newe lustige Volten, Couranten, Balletten. . . .*

Bull, John, 1597: *The oration of Maister John Bull. . . . In the New erected Colledge of Sir Thomas Gresham. . . .* 1597. No complete copy is known, but the title-page has been preserved and is quoted in *Grove's Dictionary.*

Bull, John, 1611: Virginal pieces engraved in *Parthenia.*

Bull, John, 1614: Two vocal compositions (for 4 and 5 voices) in Leighton's *The Teares or Lamentacions of a Sorrowful Soule.*

Butler, Charls, 1636: *The Principles of Musik.*

Byrd, William, *The Collected Works of.* 22 vols. Ed. by Fellowes and Dart.

(Byrd, William), 1575. The permit granting Byrd and Tallis the exclusive right to print and sell music is reprinted in Fellowes' *William Byrd.*

Byrd, William, 1575: *Cantiones, quae ab argumento sacrae vocantur.* 18 compositions by Byrd and 16 by Tallis.

Byrd, William, 1588: *Psalmes, Sonets, and songs of sadnes and pietie, made into Musicke of 5 parts.* . . . 2nd edition 1590. E.M.S. 14.

Byrd, William, 1588: Two madrigals in the 1st Book of Nicholas Yonge's *Musica Transalpina.*

Byrd, William, 1589: *Songs of sundrie natures.* . . . 2nd edition 1610. E.M.S. 15.

Byrd, William, 1589: *Liber primus sacrarum cantionum quinque vocum.*

Byrd, William, 1590: Two settings of "This sweet and merry month of May" in Thomas Watson's *First Sett of Italian Madrigalls Englished.*

Byrd, William, 1591: *Liber secundus sacrarum cantionum.*

Byrd, William, 1603: *Medulla Musicke* . . . "Shewing most rare and intricate skill in 2 partes in one upon the playne song Miserere." Possibly never printed; no known copy is extant.

Byrd, William, 1605: First book of *Gradualia.* Only the 2nd edition (1610) is known, reprinted with the 2nd book as Vol. 7 of *Tudor Church Music.*

Byrd, William, 1607: Second book of *Gradualia.* 2nd edition 1610.

Byrd, William, 1610?: Three Masses, for 3, 4 and 5 voices. No title-pages nor prefaces.

Byrd, William, 1611: *Psalmes, Songs and Sonnets.* . . . E.M.S. 16.

Byrd, William, 1611: *Parthenia.* Virginal music by Byrd, Bull, Gibbons.

Byrd, William: *My Ladye-Nevells Booke,* a MS of the year 1591, in the hand of John Baldwin, printed in 1926. It contains only virginals pieces by Byrd.

Byrd, William, 1939: *William Byrd. Forty-five Pieces for Keyboard In-*

struments. This, the two preceding works, and *The Fitzwilliam Virginal Book* (1899) contain all his known pieces for virginals.

Byrd, William: *Tudor Church Music:* Vol. 2 Services and Anthems; Vol. 7 Gradualia; Vol. 9 Masses, Cantiones and Motets. 1923 ff.

Byrd, William (no date): Two madrigals to verses by Thomas Watson in honor of John Case. Only the Second Soprano part has survived.

Campion (Campian), Thomas, 1613: *A Booke of Ayres . . . by Philip Rosseter Lutenist.* The first 21 ayres are by Campion (E.S.L.S. 1:4, 13), the other 21 by Rosseter (E.S.L.S. 1:8, 9).

Campion, Thomas, 1613?: *Two* (First and Second) *Books of Ayres.* E.S.L.S. 2:1, 2.

Campion, Thomas, 1617?: *The Third and Fourth Booke of Ayres.* E.S. L.S. 2:3, 4.

Campion, Thomas, 1607: *The Description of a Maske presented before the Kinges Majestie at White-Hall on Twelfth Night, in Honour of the Marriage of the Lord Hayes and His Bride.*

Campion, Thomas, 1613: *A Relation of the Late Royall Entertainment Given by the Right Honorable the Lord Knowles* [Baron Knollys, later Earl of Banbury] *at Cawsome-House* [Caversham House] *neere Redding: to our most Gracious Queen Anne, in her Progress toward the Bathe, upon the seven and eight and twentie days of Aprill, 1613. Whereunto is annexed the Description, Speeches, and Songs of the Lords Maske, presented in the Banqueting-House on the Mariage night of the High and Mightie, Count Palatine, and the Royally descended the Ladie Elizabeth* (daughter of James I). The music was not printed.

Campion, Thomas, 1613: *A New Way of Making Fowre Parts in Counter-point.* Reprinted 1909 in Percival Vivian's edition of *Campion's Works.*

Campion, Thomas, 1614: *The Description of a Maske: Presented in the Banqueting roome at Whitehall, on Saint Stephens night last, At the Mariage of the Right Honourable the Earle of Somerset: And the right noble the Lady Frances Howard. Written by Thomas Campion. Whereunto are annexed divers choyse Ayres composed for this Maske that may be sung with a single voyce to the Lute or Base-Viall.* Campion wrote the words of the

masque. The music of five songs is included: three of these settings are by Coprario, the others by Campion and Nicholas Lanier.

Campion, Thomas, 1597: A Latin epigram in praise of Dowland in Dowland's *First Booke of Songes or Ayres.*

Campion, Thomas, 1609: A Latin epigram in praise of Alfonso Ferrabosco the Younger in the latter's *Ayres.*

Campion, Thomas, 1614: An English poem in Ravenscroft's *A Briefe Discourse.*

Carlton, Richard, 1601: *Madrigals to Five Voyces.* E.M.S. 27.

Case, John, 1586: *The Praise of Musicke.*

Case, John, 1588: *Apologia Musices.* . . .

Cavendish, Michael, 1598: *Booke of Ayres and Madrigalles.* It contains twenty ayres (E.S.L.S. 2:11) and eight madrigals (E.M.S. 36).

Cavendish, Michael, also contributed to East's *Whole Booke of Psalmes,* 1592.

Chilston: 15th Century MS, *Of musical proporcions and of theire naturis and denominacions,* most of it printed in Hawkins' *History of Music,* Chapter LVI.

Christ Church Library MSS 984–988 (part-books), dated 1581, contain 58 compositions by Byrd, 18 by Robert White, 8 by Robert Parsons, 6 by Tye, 47 by other composers, and comments on the music of Byrd and others.

Cooper (Coprario), John, 1606: *Funeral Teares for the Death of the Right Honorable the Earle of Devonshire.* . . . Six songs and a vocal duet.

Cooper, John, 1613: *Songs of Mourning Bewailing the Untimely Death of Prince Henry.*

Cooper, John, 1614: the music of three songs in Campion's *Maske Presented . . . at the Mariage of . . . the Earle of Somerset,* q.v.

Corkine, William, 1610: *Ayres to Sing and Play to the Lute and Basse Violl.* E.S.L.S. 2:13.

Corkine, William, 1612: *The Second Booke of Ayres.* E.S.L.S. 2:14.

Cosyn, Benjamin, compiler of the MS called *Cosyn's Virginal Book.* Most of its compositions are by him, Bull, and Gibbons. Reprinted only in part

as *Twenty-five Pieces for Keyed Instruments from B. Cosyn's Virginal Book,* 1923, ed. by J. A. F. Maitland and W. B. Squire.

Croce, Giovanni, 1608: *Musica Sacra to Sixe Voyces.* Published in London.

Croce, Giovanni, 1597: three madrigals in Yonge's *Musica Transalpina,* Vol. II.

Cutting, Francis, 1596: several compositions for lute, orpharion and bandora in Barley's *A New Booke of Tabliture.*

Daman (Damon), William, 1579: *The Psalmes of David in English Meter.*

Daman, William, 1591: *The former booke of the Musicke of M. William Damon.* The tunes for his 1579 psalter are kept in the Tenor but reharmonized.

Daman, William, 1591: *The second Booke of the Musicke of M. William Damon.* Here the tunes are in the highest voice.

Daniel (Danyel), John, 1606: *Songs for the Lute Viol and Voice.* E.S. L.S. 2:12.

Davies, Sir John, 1596: *Orchestra.* Verses in praise of dancing.

Day, John, printed in 1560: *Certaine notes set forth in foure and three parts to be song at the morning Communion and evening praier.* . . . See also under "Psalter."

Dering, Richard, 1597: *Cantiones sacrae sex vocum.* Published at Antwerp.

Dering, Richard, 1617: *Cantiones sacrae quinque vocum.*

Dering, Richard, 1618: *Cantica sacra . . . senis vocibus.*

Dering, Richard, 1619: *Cantiones sacrae quinque vocum.*

Dering, Richard, 1620: *Canzonette.* Two books.

Dering, Richard, 1662: *Cantica sacra ad duos et tres voces.* London.

Dering, Richard: *The Cryes of London,* a MS edited and published by Sir Frederick Bridge. A probable printed edition of 1599 has been lost.

Dowland, John, 1597: *The First Booke of Songes or Ayres.* E.S.L.S. 1:1,2.

Dowland, John, 1600: *The Second Booke of Songes or Ayres.* E.S.L.S. 1:5, 6.

Dowland, John, 1603: *The Third and Last Booke Of Songs Or Aires.* E.S.L.S. 1:10, 11.

Dowland, John, 1603: *Lachrimae, Or Seven Teares . . . for the Lute, Viols, or Violons in five parts.*

Dowland, John, 1612: *A Pilgrimes Solace,* ayres. E.S.L.S. 1:12, 14. Now publ. with *"Bookes"* 1, 2, and 3 as *Musica Britannica,* Vol. 6.

Dowland, John, 1596: some lute pieces published without permission in Barley's *A nevv Booke of Tabliture.*

Dowland, John, 1599: verses in Farnaby's *Canzonets,* and a sonnet in R. Allison's *Psalmes.*

Dowland, John, 1609: a charming translation of Andreas Ornithoparcus' *Micrologus* (1517).

Dowland, John. See *Grove* ii. 88 for collections by various composers published on the Continent in 1600, 1603, 1607, 1610, 1612, 1615, 1617, 1621, containing lute or viol compositions by John Dowland.

Dowland, Robert, 1610: *Varietie of Lute Lessons.* It contains observations on lute playing by John Dowland, Robert's father. Publ. by Schott both in lithographic facsimile (1958) and in modern notation.

Dowland, Robert, 1610, edited *A Musical Banquet: Furnished with Varietie of Delicious Ayres, Collected out of the Best Authors in English, French, Spanish, and Italian.*

Dunstable, John: *Complete Works.* Now Vol. 8 in *Musica Britannica.*

East, Michael, 1604: *Madrigales to 3. 4. and 5. parts.* E.M.S. 29.

East, Michael, 1606: *The Second Set of Madrigales to 3. 4. and 5. parts.* E.M.S. 30.

East, Michael, 1610: *The Third Set of Bookes: Wherein are Pastorals, Anthemes, Neopolitanes, Fancies, and Madrigales to 5. and 6. parts.* EM 31a.

East, Michael, 1619: *The Fourth Set of Bookes.* Dart's E.M. 31b.

East, Michael, 1618: *The Fift Set of Bookes . . . as apt for Vyols as Voyces.* Three-part madrigals, but only the first phrase of each poem is printed.

East, Michael, 1624: *The Sixt Set of Bookes.* Anthems, one secular song.

East, Michael, 1638: *The Seventh Set of Bookes.* Instrumental music.

East, Michael, contributed a madrigal to *The Triumphes of Oriana,* 1603.

East (Easte, Este, Est), Thomas, published in 1592 *The Whole Booke of Psalmes, with their wonted tunes, in four parts.*

Elizabethan Songs, The First (Second, Third) Book of, that were origi-

nally composed for one voice to sing and four stringed instruments to accompany: transcribed from 16th and early 17th Century MSS by Peter Warlock. In 3 books, Oxf. Univ. Press. 1926. It attempts "to bridge the gap that occurs in our secular music between the time of King Henry VIII and the publication of Byrd's *Psalmes* . . . in 1588." By Farrant, Parsons, Byrd, Whythorne, Pattrick, Nicholson, Strogers, Wigthorp, and anonymous.

English Ayres Elizabethan and Jacobean, 1927–31. Ed. by Peter Warlock [Philip Heseltine] and Philip Wilson. 122 songs. 6 vols., also publ. in one. Contents: 6 songs anonymous, Bartlett 1, Batchelar 1, Campion 17, Cavendish 7, Cooper 2, Corkine 3, Daniel 11, John Dowland 9, Ferrabosco the Younger 8, Greaves 4, Hales 1, Handford 1, Hume 2, Jones 33, Martin 1, Peerson 4, and Rosseter 12. Attey, Ford, Holborne, Maynard, Morley, and Pilkington are not represented.

English Madrigal School, The. Ed. by E. H. Fellowes, 1913 to 1924. Vols. 1–4 by Morley; 5 Gibbons; 6, 7 Wilbye; 8 Farmer; 9–13 Weelkes; 14–16 Byrd; 17 Lichfild; 18 Thomas Tomkins; 19 Ward; 20 Farnaby; 21, 22 Bateson; 23 Bennet; 24 Kirbye; 25, 26 Pilkington; 27 Carlton; 28 Youll; 29–31 Michael East; 32 *The Triumphes of Oriana;* 33 Allison; 34 Vautor; 35 Jones, Mundy; 36 Cavendish, Greaves, Holborne. Thoroughly revised as *The English Madrigalists* by Thurston Dart, 36 vols., 1956.

English School of Lutenist Song Writers, The. Ed. by E. H. Fellowes, 1920 to 1932. Revised 1958–1966 by Thurston Dart, 36 vols. (Stainer and Bell) as *The English Lute Songs*: 1st Series: Vols. 1, 2, 5, 6, 10, 11, 12, 14 John Dowland; 3 Ford; 7, 15 Pilkington; 4, 8, 9, 13 Rosseter and Campion's book; 16 Morley; 17 Coprario. 2nd Series: Vols. 1, 2, 10, 11 Campion; 3 Bartlett; 4, 5, 6, 14, 15 Jones; 7 Cavendish; 8 John Daniel; 9 Attey; 12, 13 Corkine; 16, 19 *Ayres,* and MS songs, by Ferrabosco the Younger; 17 Robert Johnson; 18 Greaves, Mason, Earsden.

ENGLISH ENGRAVED MUSIC BOOKS. The first was Orlando Gibbons' *Fantazies* for viols, 1609; then *Parthenia* for Virginals, 1611; Notari's *Prime Musiche,* 1613; *Parthenia In-violata* for virginals and viol, 1614. Next came William Child's *Choise Musick to the Psalmes,* 1639, and others.

Farmer, John, 1591: *Divers and sundry waies of two parts in one.* Canons.

Farmer, John, 1599: *The first set of English Madrigals to Foure Voyces.* E.M.S. 8.

Farmer, John, skilfully harmonized many of the tunes in Thomas East's *Whole Booke of Psalmes*, 1592.

Farnaby, Giles, 1598: *Canzonets to Fowre Voyces*. E.M.S. 20.

Farnaby, Giles, between 1625 and 1639: MS, *The Psalmes of David, to fower parts, for Viols and voyce, The first booke Doricke Mottoes, The second, Divine Canzonets*. The Cantus part, belonging to Mr. Edward Hopkinson, Jr., is in the University of Pennsylvania Library, Philadelphia.

Farnaby, Giles: Numerous keyboard compositions in *The Fitzwilliam Virginal Book*. Novello publishes for piano an excellent *Album of Selected Pieces by Giles Farnaby*, edited by Granville Bantock.

Ferrabosco, Alfonso the Elder, 1603: *Medulla Musicke*. Canons on a plain song, by Byrd and Ferrabosco. No known copy extant.

Ferrabosco, Alfonso the Elder. Sixteen madrigals by him are printed in *Musica Transalpina*, 1588; six in *Musica Transalpina*, 1597; five in Morley's *Madrigals to five voyces. Celected out of the best approved Italian Authors*, 1598; two lute pieces in Robert Dowland's *Varietie of Lute Lessons*, 1610. Also MSS and continental publications.

Ferrabosco, Alfonso the Younger, 1609: *Book of Ayres*. E.S.L.S. 2:15.

Ferrabosco, Alfonso the Younger, 1609: *Lessons for 1. 2. and 3. viols*, printed in lute tablature.

Fitzwilliam Virginal Book, The (MS) printed in 1899. Most of the compositions are by Byrd, Bull, Giles Farnaby and Philips.

Flud, Robert, 1617–19: *Utriusque cosmi majoris, scilicet et minoris metaphysica, physica atque technica historia*. See *Grove's Dictionary*.

Ford, Thomas: *Musicke Of Sundrie Kindes*. E.S.L.S. 1:3. Songs with lute, and instrumental dances.

Ford, Thomas, contributed two anthems to Leighton's *Teares or Lamentacions*, 1614.

Will. Forster's Virginal Book. A MS of 1624. Most of its compositions are by Bull, Byrd, and Ward; three are by Morley.

Gibbons, Ellis: Two of his madrigals are printed in Morley's *The Triumphes of Oriana*, 1603.

Gibbons, Orlando: *The Teares or Lamentacions of a Sorrowful Soule*, 1614 (by Leighton), two anthems.

Gibbons, Orlando. Barnard's *First Book of Selected Church Musick,* 1641, contains both of his Services, and some Preces, Psalms and Anthems.

Gibbons, Orlando, 1925: Vol. 4 of *Tudor Church Music* contains all his known church music.

Gibbons, Orlando, 1612. *The First Set of Madrigals and Mottets of 5 Parts.* E.M.S. 5.

Gibbons, Orlando, 1928: *Cries of London.* Street cries, for voices and strings.

Gibbons, Orlando, 1611: *Parthenia,* 1611, contains six compositions for virginals by him, eight by Byrd and seven by Bull.

Gibbons, Orlando, 1925: *Complete Keyboard Works,* compiled by Miss Margaret Glyn. 5 vols. She has also published a volume of *40 Keyboard Pieces* by him.

Gibbons, Orlando, 1609: *Fantazies of Three Parts* for viols. This is the first English engraved music.

Gibbons, Orlando, 1623: George Wither's *The Hymnes and Songs of the Church* contains 16 hymn tunes by Gibbons.

Gibbons, Orlando, 1924: All his *Works for Strings.* Collected by E. H. Fellowes.

Giles, Nathaniel: A "Lesson of Descant of thirtie-eighte Proportions" from John Baldwin's Commonplace Book is published in the Appendix of Hawkins' *History of Music,* 1776.

Greaves, Thomas, 1604: *Songes of sundrie kindes: First, Aires to be sung to the Lute, and Base Violl. Next, Songs of sadnesse, for the Viols and Voyce. Lastly, Madrigalles for five voyces.* For the madrigals see E.M.S. 36. Four of the ayres have been reprinted in *English Ayres.*

Heath (John?), contributed to *Certaine Notes set forth in foure and three parts to be song at the morning, Communion, and evening praier,* 1560.

Hilton, John the Elder. One madrigal: "Fair Oriana, Beauty's Queen" published in *The Triumphes of Oriana,* 1603.

Hilton, John the Younger, 1627: *Ayres or Fa la's for Three Voyces.* Not in E.M.S.

Hoby, Thomas, in 1561 published his translation of Baldassare Cas-

tiglione's *Cortegiano* (1528, in Italian) as *The Courtyer of Count Baldessar Castilio.*

Holborne, Antony and William, 1597: *The Cittharn-Schoole* for cittharn, and cittharn and viols, by A. Holborne, with six madrigals (E.M.S. 36) by W. Holborne. In the Royal College of Music, and at Cambridge.

Holborne, Antony, 1599: *Pavans, Galliards, Almains and other short Æirs both grave, and light, in five parts, for Viols, Violins, or other Musicall Winde Instruments.* Reprinted by the New York Public Library, 1935.

Holborne, Antony: Dowland's *Varietie of Lute Lessons,* 1610, contains compositions by him.

Holborne, Antony. Dowland's *A Musicall Banquet,* 1610, contains a duet by him, "My heavy sprite."

Holborne, Antony. Commendatory verses by him are printed in Morley's *Plaine and Easie Introduction,* 1595, and Farnaby's *Canzonets,* 1598.

Hume, Tobias, 1605: *The First part of Ayres, French, Pollish, and others* . . . containing 116 airs in tablature and five songs. Not reprinted. Also referred to as *Musicall Humors,* this alternative title being printed at the head of every page.

Hume, Tobias, 1607: *Captain Humes Poeticall Musicke* . . . 18 instrumental and 4 vocal compositions. Reprinted by the New York Public Library, 1932.

Hunnis, William, 1578: *A hyvefull of hunnye containing the first booke of Moses called Genesis turned into English meetre,* with music.

Hunnis, William, 1581: *VII Steppes to Heaven, alias the vij* [penitential] *Psalmes reduced into meter by Will Hunnys.* Reprinted by him in 1583 as *Seven Sobs of a Sorrowful Soull for Sinnes,* with tunes.

Inglott, William. *The Fitzwilliam Virginal Book* contains two of his compositions.

Johnson, Edward. *The Triumphes of Oriana,* 1603, contains his madrigal "Come blessed byrd."

Johnson, Edward. Three virginal pieces in *The Fitzwilliam Virginal Book.*

Johnson, Edward, contributed three harmonizations to East's *Whole Booke of Psalmes,* 1592.

Johnson, Robert. Leighton's *Teares or Lamentacions,* 1614, contains two pieces. For other compositions published abroad see *Grove,* ii. 783. Also catches, instrumental pieces, settings of "Full Fathom Five" and "Where the Bee Sucks" probably performed at the first production of the Tempest, etc.

Jones, Robert, 1600: *The First Booke of Songes and Ayres.* E.S.L.S. 2:5.

Jones, Robert, 1601. *The Second Booke of Songs and Ayres.* E.S.L.S. 2:6.

Jones, Robert, 1608: *Ultimum Vale, or The Third Booke of Ayres . . .* (ayres and vocal duets). In the Royal College of Music. Also E.S.L.S. 2:7.

Jones, Robert, 1609: *A Musicall Dreame, Or the Fourth Booke of Ayres.* E.S.L.S. 2:8.

Jones, Robert, 1611: *The Muses Gardin for Delights, or the Fift Booke of Ayres. . . .* The only known copy is owned by Edward Huntingdon of New York. Reprinted as E.S.L.S. 2:9, and by Blackwell, Oxford, in 1926.

Jones, Robert, 1607: *The First Set of Madrigals of 3. 4. 5. 6. 7. 8. Parts.* E.M.S. 35.

Jones, Robert: A madrigal, "Oriana seeming to wink at folly," in *The Triumphes of Oriana,* 1603.

Kirbye, George, contributed to Thomas East's *The Whole Booke of Psalmes,* 1592.

Kirbye, George, 1597: *The First Set of English Madrigalls.* E.M.S. 24.

My Ladye Nevells Booke. Virginals pieces by Byrd, q.v.

Lasso, Orlando di, 1598: *Novae aliquot et ante hac non ita usitatae ad duas voces cantiones suavissimae.* Motets printed in London by Thomas East.

Le Roy, Adrien, 1557: *Instruction . . .* in lute playing, translated by (1) J. Alford, 1568, as *A Briefe and Easye Instruction to learn the tableture;* (2) by F. K. E. Gentleman, London, 1574, as *A Briefe and Plaine Instruction.*

Leighton, Sir William, 1614: *The Teares or Lamentacions of a Sorrowful Soule.* Psalms and hymns for voices, most of them without accompaniment. The compositions with accompaniment were reprinted by the New York Public Library in 1935.

Lichfild, Henry, 1613: *The First Set of Madrigals of 5 parts.* E.M.S. 17.

Lodge, Thomas, 1579–80: *A Defence of Poetry, Musick, and Stage Plays.*

Lupo, Thomas. MS *Fantasias for Five Viols.* Printed by the New York Public Library in 1935.

LUTE PLAYING. *The Science of Luting, licensed to John Allden in 1565.*

Marenzio, Luca, 1588 and 1597: Madrigals in Yonge's *Musica Transalpina* (10 in Vol. 1, 3 in Vol. 2).

Marenzio, Luca, 1590: 23 Madrigals in Watson's *The first sett of Italian Madrigalls Englished.*

Mason, George, and John Earsden, 1618: *The Ayres that were sung and played, at Brougham Castle in Westmerland, in the Kings Entertainment.* . . . Words by Campion, probably.

Maynard, John, 1611: *The XII Wonders of the World, Set and composed for the Violl de Gambo, the Lute and the Voyce to sing the Verse, all three jointly and none severall; also Lessons for the Lute and Base Violl to play alone; with some lessons to play Lyra-waye alone, or if you will to fill up the parts with another Violl set Lute-way.* Twelve solo songs with accompaniment, also dance pieces for lute.

Melvill, David. MS *The Melvill Book of Roundels.* Scotch. Printed 1906.

Merbecke (Marbeck), John, 1550: *The Booke of Common Praier Noted,* known as "The First Prayer Book of Edward VI."

Merbecke, John. His church music is published in *Tudor Church Music,* Vol. 10, 1929.

Meres, Francis: *Palladis Tamia.* Aphorisms and pithy comparisons. For "Musicke" see pp. 287b, 288a, 288b.

Milton, John, Sr. (father of the poet). One madrigal in *The Triumphes of Oriana,* 1603.

Milton, John, Sr. Four anthems in Leighton's *Teares or Lamentacions, 1614,* including "O had I wings," reprinted by Hawkins and recently by Joseph Williams, and "Thou God of Might," reprinted by Burney.

Milton, John, Sr. Harmonizations of two psalm tunes in Ravenscroft's *Psalter,* 1621.

Morley, Thomas, 1593: *Canzonets, or Little Short Songs to Three Voyces.* Later editions 1606 and 1631. E.M.S. 1.

Morley, Thomas, 1594: *Madrigalls to Foure Voyces*. 2nd edition 1600. E.M.S. 2.

Morley, Thomas, 1595: *The First Booke of Balletts to five voyces*. 2nd edition 1600. E.M.S. 4. Italian edition 1595, London. German edition 1609, Nuremberg.

Morley, Thomas, 1595: *The First Booke of Canzonets to two voyces*. 2nd edition 1619. E.M.S. 1.

Morley, Thomas, 1597, edited *Canzonets, Or Little Short Songs to foure voyces. Celected out of the best and approved Italian Authors*. Two madrigals by Morley himself are included, reprinted in E.M.S. 2.

Morley, Thomas, 1597: *Canzonets or Little Short Aers to five and sixe voices*. E.M.S. 3.

Morley, Thomas, 1597: *A Plaine and Easie Introduction to Practicall Musicke*. It includes eight compositions by Morley. Facsimile reprint by Oxf. Univ. Press, 1937, 218 pp. Modern edition ed. by R. A. Harman, 1952.

Morley, Thomas, 1598, edited *Madrigals to five voyces. Celected out of the best approved Italian Authors*.

Morley, Thomas, 1599, edited *The First Booke of Consort Lessons, made by divers exquisite Authors, for sixe Instruments*. Reprinted by the New York Public Library in 1959.

Morley, Thomas, 1600: *The First Booke of Ayres or Little Short Songs, to sing and play to the Lute, with the Base Viole*. The only known copy is in the Folger Shakespeare Library, Washington, D. C. Reprinted in 1932 in E.S.L.S., ii:17.

Morley, Thomas, 1603, compiled *The Triumphes of Oriana*. It includes two madrigals by Morley. E.M.S. 32.

Morley, Thomas, contributed four harmonizations to *The whole booke of Psalmes. With their woonted tunes*. 1604–14.

Morley, Thomas, contributed three harmonizations to Ravenscroft's *Psalter*, 1621.

Morley, Thomas. Eight compositions in *The Fitzwilliam Virginal Book*, q.v.

Morley, Thomas. Three compositions in *Will. Forster's Virginal Book*.

Mulliner Book, The: a MS collection of 117 compositions for keyboard in-

struments, made about 1545 by Thomas Mulliner, Master of the Choir of St. Paul's Cathedral. Printed 1951. 97 pp. Ed. by Denis Stevens.

Mundy, John, 1594: *Songs and Psalms* . . . E.M.S. 35.

Musica Transalpina. See Nicholas Yonge.

Myriell, Thomas, 1616?: *Tristitiae Remedium.* English and Italian music, including probably some of his own. In MS except the engraved title-page.

Nicholson, Richard: One madrigal in *The Triumphes of Oriana,* 1603.

Notari, Angelo, 1613: *Prime Musiche Nuove a Una, Due e Tre Voci.* . . . Publ. by Wm. Hole, London.

Old Hall Manuscript, The, 2 vols., 1933–35: religious choral compositions by Lionel Power, Pycard, Sturgeon, King Henry VI, and other fifteenth-century Englishmen.

Palestrina, G. P. da: Five madrigals in *Musica Transalpina,* Vol. 1, 1588.

Parsley, Osbert: Church music in *Tudor Church Music,* Vol. 10, 1929. His epitaph is in Norwich Cathedral.

Parthenia. 1611. The first virginal music printed in England and the second music printed in England from engraved plates (copper). By Byrd, Bull and Gibbons. Reprinted 1927 as *Twenty-one Old English Compositions of the 16th and 17th Centuries,* ed. by M. H. Glyn; and in facsimile, 1942.

Parthenia In-violata. 1614. Engraved for virginals and bass viol. The only known copy is in the New York Public Library.

Pattrick, Nathaniel: *Songes of Sundrye Natures.* Approved for printing in 1597, but perhaps never issued. No copy is known.

Peacham, Henry the Younger, 1622: *The Compleat Gentleman* devotes a chapter to music.

Peerson, Martin, 1620: *Private Musicke, or the First Booke of Ayres and Dialogues, Contayning Songs of 4. 5. and 6. parts.* . . . This publication and the next contain instrumental accompaniments.

Peerson, Martin, 1630: *Mottects or Grave Chamber Musique, Containing Songs of five parts of severall sorts, some ful, and some Verse and Chorus . . . with an Organ Part.* . . .

Philips, Peter, 1591: *Melodia Olympica.* . . . Madrigals. Antwerp.

Philips, Peter, 1596: *Il primo libro de madrigali a sei voci.*

Philips, Peter, 1598: Madrigals for 8 voices.

Philips, Peter, 1603: 2d Book of madrigals for 6 voices.

Philips, Peter, 1612: *Cantiones sacrae* for 5 voices. Dedicated to the Blessed Virgin.

Philips, Peter, 1613: *Cantiones sacrae* for 8 voices. Dedicated to St. Peter.

Philips, Peter, 1613: *Gemmulae Sacrae Binis et Ternis Vocibus cum Basso Continuo ad Organum.*

Philips, Peter, 1616: *Les Rossignols spirituels.* . . . Motets or hymns. Valenciennes.

Philips, Peter, 1616: *Deliciae sacrae binis et ternis vocibus cum basso continuo ad organum.*

Philips, Peter, 1623: Litanies of Loreto.

Philips, Peter, 1628: *Paradisus sacris cantionibus consitus, una, duabus et tribus vocibus decantantis. Cum basso generali ad organum.* First part.

Philips, Peter, 1633. Same, 2d and 3d parts. The first editions of his works so far mentioned were published at Antwerp, except *Les Rossignols spirituels.* Many soon reached second and third editions.

Philips, Peter, *The Fitzwilliam Virginal Book* contains 19 pieces, some with dates ranging between 1580 and 1605.

Philips, Peter, 1598: Two madrigals by him were printed in Morley's collection of "Italian" madrigals.

Philips, Peter. A Pavan and Galliard in Morley's *Consort Lessons,* 1599. This Pavan is also printed in Robinson's *New Citharen Lessons,* 1609.

Philips, Peter. An "Aria a 4" in *Taffel Concert,* edited by Thomas Simpson, Hamburg, 1621. For other single compositions scattered through continental collections, see *Grove,* iv. 142, 143.

Pilkington, Francis, 1605: *The First Booke of Songs or Ayres of 4 parts,* intended to be performed either as solo songs with lute, or as four-part madrigals unaccompanied. E.S.L.S. 1:7, 15.

Pilkington, Francis, 1614: *The First Set of Madrigals and Pastorals of 3, 4 and 5 Parts.* E.M.S. 25.

Pilkington, Francis, 1614: Two madrigals of his appeared in Leighton's *The Teares or Lamentacions of a Sorrowful Soule.*

Pilkington, Francis, 1624: *The Second set of Madrigals and Pastorals of 3, 4, 5, and 6 parts.* E.M.S. 25.

[338]

Porter, Walter, 1632: *Madrigales and Ayres. Of two, three, foure and five Voyces* with instrumental accompaniment. Reprinted 1935 by The New York Public Library, 212 pp.

PSALTERS. The most important are here listed, but for their complete titles the reader is referred to *Grove's Dictionary,* iv. 267 ff.

1539 Coverdale's hymns and thirteen *Goostly psalmes . . .* with tunes. Suppressed the same year by Henry VIII.

1549 Crowley's. The first complete psalter in English, and music in four parts.

1549 Sternhold's first metrical translation: *Certayne Psalmes.* No music.

1556 Geneva: *One and fiftie Psalmes* with a different tune for each. No harmony. Thirty-seven of the translations are by Sternhold.

1560 by Sternhold and others, with tunes. London.

1562 Sternhold and Hopkins' first complete edition.

1567 or 1568 Archbishop Parker's *The whole Psalter,* containing nine tunes by Tallis.

1563 Day's, containing 141 compositions in four parts.

1579, 1591 Daman's.

1592 East's.

1599 Allison's.

Between 1604 and 1614 *"The whole booke of Psalmes. With their woonted Tunes . . ."* containing four fine new harmonizations by Morley, five by Bennet, and one by Farnaby. Printed by Barley.

1621 Ravenscroft's.

1623 George Wither's, containing 16 original compositions by Orlando Gibbons.

Between 1625 and 1639 Giles Farnaby's MS *The Psalmes of David.*

Ravenscroft, Thomas, 1609: *Pammelia. Musick's Miscellanie.* Contains 100 rounds and catches. The compositions in this and the other publications of Ravenscroft are by various composers, whose names are not given, except that six compositions in the *Briefe Discourse* are stated to be by Bennet.

Ravenscroft, Thomas, 1609: *Deuteromelia: or the Second part of Musick's Melodie.*

Ravenscroft, Thomas, 1611: *Melismata.* Mostly humorous little madrigals.

Ravenscroft, Thomas, 1614: *A Briefe Discourse of the true (but neglected) use of Charact'ring the Degrees by their Perfection, Imperfection, and Diminution in Measurable Musicke, against the Common Practise and Custome of these Times. Examples whereof are exprest in the Harmony of 4. Voyces, concerning the Pleasure of 5 usuall Recreations, 1. Hunting. 2. Hawking. 3. Dauncing. 4. Drinking. 5. Enamouring.*

Ravenscroft, Thomas, 1621: *The whole Booke of Psalmes.*

Ravenscroft, Thomas: *Treatise of Musick.* Brit. M. Add. MSS 19,578/19.

Richardson, Ferdinand(o). *The Fitzwilliam Virginal Book* contains eight of his compositions.

Robinson, Thomas, 1603: *The Schoole of Musicke: wherein is taught the perfect method of the true fingering of the Lute, Pandora, Orpharion and Viol de Gamba.*

Robinson, Thomas, 1609: *New Citharen Lessons.*

Rosseter, Philip, 1601: *A Book of Ayres, . . . by Philip Rosseter Lutenist.* The first 21 ayres are by Campion (E.S.L.S. 1:4, 13), the last 21 ayres by Rosseter (E.S.L.S. 1:8, 9).

Rosseter, Philip, in 1609 published *Lessons for Consort: made by sundry Excellent Authors, and set to sixe severall instruments. . . .* Reprinted by the New York Public Library, 1935.

Simmes, William. Myriell's *Tristitiae Remedium,* 1616, contains an anthem of his. MS compositions also exist.

Simpson, Thomas, 1610: *Opusculum neuer Pavanen, Galliarden, Couranten und Volten.* Frankfort.

Simpson, Thomas, 1611: *Pavanen, Volten und Galliarden.* Frankfort.

Simpson, Thomas, 1617: *Opus Newer Paduanen, Galliarden, Intraden . . .* Hamburg.

Simpson, Thomas, 1621: *Taffel Consort allerhand lustige Lieder von 4 Instrumenten und Generalbass.* Pieces by Simpson, Philips, John Dowland, Robert and Edward Johnson, etc. Hamburg.

Straloch MS. is probably the "earliest manuscript containing Scottish airs." For lute, 1627 and 1629.

Stubbs, Simon. Myriell's *Tristitiae Remedium,* 1616, contains two anthems.

Stubbs, Simon. Ravenscroft's *whole Booke of Psalmes,* 1621, contains harmonizations by him.

Tailour, Robert, 1615: *Sacred Hymns, consisting of Fifti select Psalms.*

Tallis, Thomas, 1575: *Cantiones, quae ab argumento sacrae vocantur.* 16 compositions by Tallis and 18 by Byrd.

Tallis, Thomas. Five anthems in John Day's *Certaine Notes,* 1560.

Tallis, Thomas. All nine Psalm Tunes in Archbishop Parker's *Psalter,* 1567.

Tallis, Thomas. His church music is publ. as Vol. 6 of *Tudor Church Music.*

Tallis, Thomas, The Complete Keyboard Works of. Ed. by Denis Stevens.

Taverner, John. His church music is published in Vols. 1 and 3 of *Tudor Church Music,* 1923 ff.

Tessier, Charles, 1597: *Le Premier Livre de chansons et airs de court, tant en françois qu'en italien et en gascon à 4 et 5 parties.* London, Thomas East.

Tomkins, Thomas, 1622: *Songs of 3. 4. 5. and 6. Parts.* Madrigals; E.M.S. 18.

Tomkins, Thomas. Some church music was published in *Musica Deo Sacra,* 1668; and all his *Keyboard Works* 1955, 205 pp. Ed. by S. D. Tuttle.

Tomkins, Thomas. Church Services: *Tudor Church Music,* Vol. 8, 1928. Another volume of his sacred music is planned.

Triumphes of Oriana, The. 1603. Madrigals by various composers in honor of Queen Elizabeth. Collected by Thomas Morley. E.M.S. 32.

Tudor Church Music, 1923 ff.: Vols. 1, 3 Taverner; 2, 7, 9 Byrd; 4 Orlando Gibbons; 5 White; 6 Tallis; 8 Thomas Tomkins; 10 Merbecke, Aston, and Parsley.

Tye, Christopher, 1553: *The Actes of the Apostles, translated into Englyshe Metre . . . by Christofer Tye . . . to singe and also to play upon the Lute. . . .*

Tye, Christopher. Modern editions of a few compositions are listed in *Grove,* v. 417, 418.

Vautor, Thomas, 1619: Madrigals. *The First Set: Beeing Songs of divers Ayres and Natures, of Five and Sixe parts: Apt for Vyols and Voyces.* E.M.S. 34.

Vautrollier, Thomas, in 1574 printed *A Brief Introduction to Musicke*. No copy is known.

Virginal Music. For a list of some modern editions see p. 179 *supra*. The chief Elizabethan collections (the first four being in manuscript) are:

1. *The Fitzwilliam Virginal Book*, publ. 1899.
2. *My Ladye-Nevells Booke*, by Byrd, q.v. Publ. 1926.
3. *Will. Forster's Virginal Book.*
4. *Benjamin Cosyn's Virginal Book.*
5. *Parthenia*, 1611.

Ward, John, 1613: *The First Set of English Madrigals*. E.M.S. 19.

Watson, Thomas, edited in 1590 *The first sett of Italian Madrigalls Englished, not to the Sense of the original dittie, but after the affection of the Noate. By Thomas Watson. There are also heere inserted two excellent Madrigalls of Master William Byrd's composed after the Italian vaine at the request of the sayd Thomas Watson.*

Weelkes, Thomas, 1597: *Madrigals to 3. 4. 5. & 6. voyces*. E.M.S. 9.

Weelkes, Thomas, 1598: *Balletts & Madrigals to five voyces*. E.M.S. 10.

Weelkes, Thomas, 1600: *Madrigals of 5. and 6. parts*. E.M.S. 11, 12.

Weelkes, Thomas, 1608: *Ayeres or Phantastique Spirites for three voices*. E.M.S. 13.

Weelkes, Thomas, contributed one madrigal to *The Triumphes of Oriana*, 1603.

White, Robert. His church music is published in Vol. 5 of *Tudor Church Music*, 1923 ff.

Whythorne, Thomas, 1571: *Songs for three, fower, and five voyces*. . . . The Oxford University Press has reprinted several, ed. by Peter Warlock.

Whythorne, Thomas: *Autobiography*. Ed. by James M. Osborn, 1961.

Whythorne, Thomas, 1590: *Duos, or Songs for two voices*.

Wilbye, John, 1598: *The First Set of English Madrigals to 3. 4. 5. and 6. voices*. E.M.S. 6.

Wilbye, John, 1609: *The Second Set of Madrigales to 3. 4. 5. and 6. parts*. E.M.S. 7.

Wilbye, John. Leighton's *Teares or Lamentacions*, 1614, contains two sacred compositions.

Wilbye, John, contributed one madrigal to *The Triumphes of Oriana.*

Wynkyn de Worde in 1530 printed, in beautiful music type, *XX Songs.* Only the bass part is extant, and the composer is unknown.

Yonge, Nicholas, compiled *Musica Transalpina.* Vol. 1, 1588, is the first printed collection of Italian madrigals with English words. Vol. 2 appeared in 1597.

Youll, Henry, 1608: *Canzonets to Three Voyces.* E.M.S. 28.

SOME MODERN BOOKS ON ELIZABETHAN MUSIC

Anderton, H. Orsmond, 1920: *Early English Music.* Deals with all the important composers at fair length. Goes down to Samuel Wesley.

Arkwright, Godfrey E. P., 1889–1902: *Old English Edition.* Now largely superseded. The prefaces contain Weelkes' will, etc.

Arkwright, Godfrey E. P., 1913: "Elizabethan Choirboy Plays and Their Music." In *Proceedings of the Musical Association,* 1913–14, p. 117.

Atkins, Sir Ivor, 1918: *The Early Occupants of the Office of Organist and Master of the Choristers of the Cathedral of Christ and the Blessed Virgin Mary, Worcester.*

Barnard, Rev. John, 1641: *The First Book of Selected Church Musick . . . Whereby such bookes as were heretofore with much difficulty and charges, transcribed for the use of the Quire, are now to the saving of much Labour and expence, publisht for the general good of all such as shall desire them either for publick or private exercise. Collected out of divers approved Authors.* The first printed collection of anthems and service music by various English composers.

Baskervill, Charles Read, 1929: *The Elizabethan Jig.* 642 pp.

Bradner, Leicester, 1927: *The Life and Poems of Richard Edwards.* Yale Univ. Press.

Brennecke, Ernest, Jr., 1939: *John Milton the Elder and His Music.*

Bridge, Sir Frederick, 1920: *Twelve Good Musicians.*

British Museum: *The Catalogue of Printed Music published between 1487 and 1800 now in the British Museum.* Compiled by W. Barclay Squire.

British Museum: *Catalogue of Manuscript Music in the British Museum.* Compiled by A. Hughes-Hughes.

Burney, Charles, 1776 ff.: *A General History of Music.* 4 vols. Contemporary judgment preferred Burney and neglected Hawkins. But Burney, in spite of a fuller knowledge of music in general, did not understand Elizabethan music. Reprinted 1936.

Campion's Works, ed. by Percival Vivian, 1909. Omits the music of the ayres and masques, but prints the musical illustrations to *A New Way of Making Fowre Parts in Counter-point.*

Chappell, William, 1855–59: *Popular Music of the Olden Time.* Edition revised by H. E. Wooldridge, 1893.

Collins, H. B., 1912: "Latin Church Music." *Proceedings of the Musical Association,* 1912–13, pp. 55–83.

Cowling, G. H., 1912: *Music of the Shakespearian Stage.*

Davey, Henry, 1895: *History of English Music.*

Dictionary of National Biography: Biographies of John Parsons, etc.

Dolmetsch, Arnold, 1898: *Select English Songs and Dialogues of the 16th and 17th Centuries* by Morley, Henry Lawes, etc. Words and music.

Dolmetsch, Arnold, 1915: The Interpretation of the Music of the 17th and 18th Centuries. Technical, but "invaluable to students"—Colles.

Emden, Cecil S., 1926: "Lives of Elizabethan Song Composers: Some New Facts." *Review of English Studies,* Oct. 1926. No musical criticism.

Evans, Willa McClung, 1929: *Ben Jonson and Elizabethan Music.* Lancaster Press, Inc., Lancaster, Pa. Also her book on *Henry Lawes,* 1941.

Farmer, Henry George, 1930: *Music in Medieval Scotland.* 23 pp. Reeves.

Fellowes, Rev. Dr. Edmund Horace, 1923: *William Byrd. A Short Account of His Life and Work.* 126 pp. Second edition, 1928.

Fellowes, Rev. Dr. E. H.: *William Byrd.* 2d ed. 1948.

Fellowes, Rev. Dr. E. H., 1913–24: *English Madrigal School.* Contains in music notation practically all the English madrigals that were printed, 1588–1624. 36 vols. Also prefaces.

Fellowes, Rev. Dr. E. H., 1920 ff.: *English School of Lutenist Song Writers.* Does the same for the solo songs written to lute accompaniment. Winthrop Rogers, later by Stainer and Bell. Complete except for one less important volume.

Fellowes, Rev. Dr. E. H., 1921: *The English Madrigal Composers.* An account of the composers' lives, compositions, and musical styles. 2d ed. 1949.

Fellowes, Rev. Dr. E. H., 1925: *The English Madrigal.* 111 pp.

Fellowes, Rev. Dr. E. H., 1920 (editor): *English Madrigal Verse.* A complete collection of the poetry of the printed madrigals and ayres. No music. 2d ed. 1931.

Fellowes, Rev. Dr. E. H., 1926: *Orlando Gibbons.*

Fellowes, Rev. Dr. E. H., 1928 (editor): *Songs and Lyrics from the Plays of Beaumont and Fletcher.* Contains 62 poems, and 17th Century musical settings of six of these.

Flood, Chevalier William Henry Grattan, Mus.D., 1924: *Early Tudor Composers.*

Flood, Chevalier William Henry Grattan, Mus.D.: "New Light on Late Tudor Composers"; articles on later Tudor composers in the *Musical Times,* 1924–1929. The numerous facts here first published should not be accepted unquestioningly, for he rarely cites his authorities.

Galpin, Francis W., 1911: *Old English Instruments of Music.*

Glyn, Margaret H., 1924: *About Elizabethan Virginal Music and Its Composers.* Reeves.

Grove's Dictionary of Music and Musicians. Page numbers quoted are from the 3d edition, 5 vols.

Hawkins, Sir John, 1776: *General History of the Science and Practice of Music.* 5 vols. He was more painstaking than Burney. Both were sometimes inaccurate.

Hayes, Gerald R., 1928 ff.: "Musical Instruments and Their Music, 1500–1750." A Series of Five Books: I. *The Treatment of Instrumental Music,* 1928; II. *The Viols,* 1930; III. The Lute; IV. Keyboard Instruments; V. Wind Instruments. The last three have not yet been issued.

Howes, Frank, 1928: *William Byrd.*

Kastendieck, Miles M., 1938: *England's Musical Poet, Thomas Campion.*

Morris, R. O., 1922: Contrapuntal Technique in the Sixteenth Century.

Naylor, Edward W., 1896: *Shakespeare and Music.*

Naylor, Edward W., 1910: "Music and Shakespeare." Article in the *Musical Antiquary,* April 1910.

[345]

Naylor, Edward W., 1913: *Shakespeare Music*. Gives much of the music referred to in Shakespeare's plays, with comments. Curwen.

Pulver, J., 1923: *A Dictionary of Old English Music and Musical Instruments.*

Pulver, J., 1927: *A Biographical Dictionary of Old English Music.*

Rimbault, Edward F., 1847: *Bibliotheca Madrigaliana*. Important early research work, but not always dependable.

Rye, William Brenchley, 1865: *England as Seen by Foreigners in the Days of Elizabeth and James the First*. Contains several musical references.

Scholes, Percy A., 1934: *The Puritans and Music in England and New England.*

Scott, Charles Kennedy, 1931: *Madrigal Singing.*

Smith, Leo, 1931: *Music of the 17th and 18th Centuries.*

Stanford, Sir Charles V., and Cecil Forsyth, 1914: *History of Music.* Vivid chapter on Elizabethan Music.

Steele, Robert, 1903: *Earliest English Music Printing.*

Stopes, Mrs. C. C., 1910: *William Hunnis*. Louvain, Belgium.

Terry, Sir R. R., and others, 1923 ff.: *Tudor Church Music*. Published for the Carnegie United Kingdom Trust by the Oxford University Press. Ten volumes.

Terry, Sir R. R., 1907: *Catholic Church Music.*

Terry, Sir R. R., 1929: *A Forgotten Psalter and Other Essays*. The first essay, of 26 pp., is on the important Scotch Psalter of 1564. Other essays deal with Merbecke, Tallis, etc.

Van den Borren, Ch., 1914: *The Sources of Keyboard Music in England.* Novello.

Van den Borren, Ch.: "The Aesthetic Value of the English Madrigal." *Proceedings of the Musical Association*, 1925–6.

Walker, Ernest: *History of Music in England*. Rewritten by Westrup, 1952.

Warlock, Peter (*nom de plume* for Philip Heseltine): *Thomas Whythorne. An Unknown Elizabethan Composer.* 1925. 11 pp. Oxford Univ. Press.

Warlock, Peter, 1926: *The English Ayre.*

Welch, Christopher, 1911: *Six Lectures on the Recorder.* Henry Frowde.

Williams, Charles Francis Abdy, 1893: *A Historical Account of Musical Degrees at Oxford and Cambridge.*

Wood, Anthony (1632–1695): *Athenae Oxonienses,* including *Fasti Oxonienses.*

Wood, Anthony: MS *Biographical Notes on Musicians.* Bodleian Library MS Wood 19D(4) No. 106.

Carpenter, Nan Cooke: "The Study of Music at the University of Oxford in the Renaissance (1450–1600)." *Musical Quarterly,* April 1955, pp. 191–214.

Einstein, Alfred, 1949: *The Italian Madrigal.*

Harrison, Frank L., 1958: *Music in Medieval Britain.*

Kerman, Joseph: *The Elizabethan Madrigal: A Comparative Study.* 1962.

King's Musick, The, 1909. Ed. by H. C. de la Fontaine.

Lefkowitz, Murray, 1960: *William Lawes.* 350 pp.

Long, John H., 1955: *Shakespeare's Use of Music.* 213 pp.

Manifold, John S., 1956: *The Music in English Drama from Shakespeare to Purcell.* Also his article on "Theatre Music in the Sixteenth and Seventeenth Centuries" in *Music and Letters,* Oct. 1948, pp. 366–397.

Meyer, Ernst H., 1946: *English Chamber Music. The History of a Great Art from the Middle Ages to Purcell.* See also its review by Alfred Einstein, *Musical Quarterly,* July 1947.

Music and Letters: "Thomas Weelkes and the Madrigal" by D. M. Arnold, Jan. 1950; "Music and Musicians at Chichester Cathedral, 1545–1642" by Thurston Dart, July 1961; "William Byrd" by J. A. Westrup, July 1943; and articles on Morley and Giovanni Croce, July 1953 and Oct. 1954.

Newton, Richard: "English Lute Music of the Golden Age" in *Proceedings of the Musical Association,* 1938–9, pp. 63–90.

Pattison, Bruce, 1948: *Music and Poetry of the English Renaissance.*

Stevens, Denis, 1957: *Thomas Tomkins: 1572–1656.*

Stevens, Denis, 1955, 1961: *Tudor Church Music.* A survey of liturgical music from 1485 to the first decade of the seventeenth century.

Woodfill, W. L., 1954: *Musicians in English Society from Elizabeth to Charles I.*

Index